The Annotated Mona Lisa

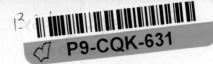

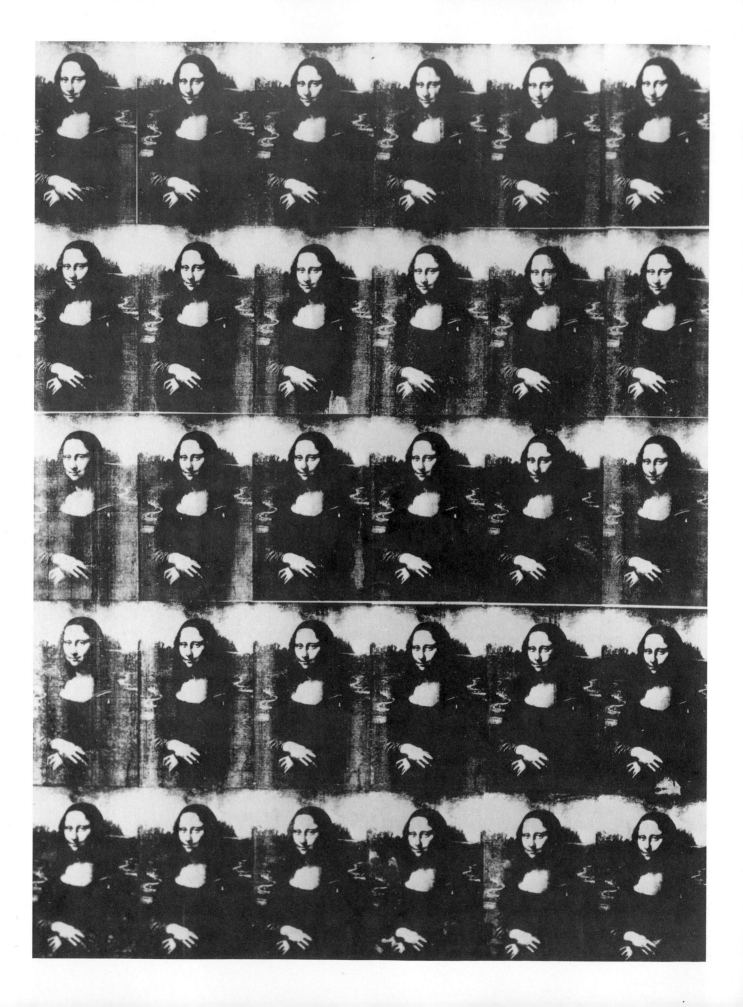

The Annotated Mona Lisa

A CRASH COURSE IN ART HISTORY FROM PREHISTORIC TO POST-MODERN

Carol Strickland, Ph.D.,
and John Boswell

Book Designer: Barbara Cohen Aronica
Assistant Designer: Jan Halper Scaglia
Cover Designer: Rich Rossiter
Photographic Researcher: Toby Greenberg
Managing Editor: Patty Brown

A John Boswell Associates Book

Andrews and McMeel
A Universal Press Syndicate Company
Kansas City

In memory of my Mother and Father, Rebecca and John Colclough

To the families in New Orleans and Memphis, thanks for your encouragement.
And to Sid, Alison, and Eliza, special gratitude for your enthusiasm when it began
to seem the adage "Vita brevis est, ars longa" was all too true.

—C. S.

Abbreviations used in text:

MMA Metropolitan Museum of Art
MoMA Museum of Modern Art
Whitney Whitney Museum of American Art
NG National Gallery

Typeset in Simoncini Garamond and Futura by TAW, Inc., Wilton, Connecticut

Library of Congress Cataloging-in-Publication Data

Strickland, Carol.
 The annotated Mona Lisa: a crash course in art history from prehistoric to
post-modern/Carol Strickland and John Boswell.
 p. cm.
 ISBN 0-8362-8009-1. — ISBN 0-8362-8005-9 (paperback)
 1. Art—History—Outlines, syllabi, etc. I. Boswell, John, 1945–. II. Title.
 N5302.S76 1992
 709—dc20 92–27904
 CIP

ATTENTION: SCHOOLS AND BUSINESSES

Andrews and McMeel books are available at quantity discounts with bulk purchase
for educational, business, or sales promotional use. For information, please write to:
Special Sales Department, Andrews and McMeel, 4900 Main Street, Kansas City,
Missouri 64112.

PHOTO CREDITS

CONTENTS

INTRODUCTION:
HOW TO LOOK AT A PAINTING

Like music, art is a universal language. Yet, even though looking at most works of art is a pleasurable enough experience, to appreciate fully what's going on requires certain skills and knowledge. In *The Annotated Mona Lisa* 25,000 years of art history have been condensed into 208 pages in order to quickly provide some of the necessary skills and knowledge.

The Annotated Mona Lisa also presents this essential information as simply as possible, with a minimum of technical jargon but with a wealth of anecdote and biographical asides to lend a human dimension to the world of art. Timelines, summaries, and comparison charts appear throughout the book to help the reader absorb and retain important points.

Yet, while many of the critical tools for forming independent aesthetic judgments are provided here, ultimately, the reward comes in using these tools to draw your own conclusions about why a particular painting touches or moves you, or even why it doesn't. The more time spent in museums and galleries, the more rewarding the act of encountering art becomes.

There is a world of difference between viewing a work of art and really seeing it — the difference between sight and insight. When I began to research this book, I already knew a great deal about art, had taught it in American culture courses, loved it, and spent much time in museums and galleries. But after two years of total immersion in art history, I found my experience of looking at paintings and sculpture totally transformed. My increased knowledge led to enriched, stimulating, give-and-take engagement with art. It was like switching from passively watching a film in a foreign language to actively debating in one's mother tongue. I hope my experience will be a microcosm for readers, who will also appreciate art in direct proportion to the amount of knowledge they bring to it.

Choosing one example from the book, "The Raft of the Medusa" by Théodore Géricault (see p. 76), here's how one might go about analyzing a painting using several traditional criteria:

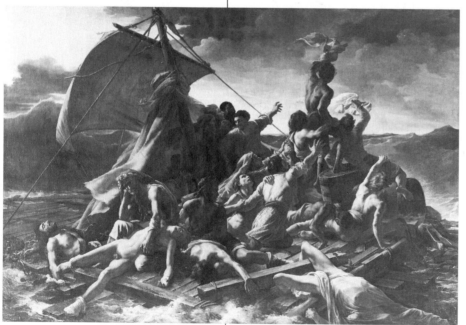

Géricault, "The Raft of the Medusa," 1818–19, Louvre, Paris.

COLOR, COMPOSITION, MOOD, AND LIGHTING

"The Raft of the Medusa" portrays victims of a shipwreck, adrift on the sea without food or water, at the moment they signal to a distant ship. The painter chose to represent a dramatic moment — the instant when survivors regain hope of rescue — but he conveyed their desperate situation through an array of painterly devices. Géricault used the full range of painter's tools — color, composition, mood, and lighting — to convey his theme of man's struggle against nature.

1. COMPOSITION. Géricault divided the scene into two overlapping triangles. The triangle at left, defined by the mast and two ropes, includes the dead and dying. The triangle at right, whose peak is the standing man waving a shirt, is composed of dynamic figures, with arms outstretched to indicate their surging hopes. The placement of this triangle at far right, the direction of glances, gestures, and arrangement of drapery all contribute to the effect of forward thrust and direct the viewer's eye to the focal point of the figures frantically waving.

2. MOVEMENT. Géricault created the impression of motion through contrasting the postures of his figures. The picture as a whole seems to surge upward from the prone figures at lower left to the upper right, with its concentration of sitting and reaching figures. The waving man at the peak of the right triangle is the climax of this mood of rising hope and advancing motion.

3. UNITY AND BALANCE. To prevent the two triangles — one of despair, the other of hope — from splitting the picture into unrelated halves, Géricault overlaps the triangles, with transitional figures appearing in both. An arm cuts across the rope (the strongest line of the left triangle) to point to the peak of the main triangle and unify the two halves. The two off-center triangles also lean in opposite directions, each balancing the other.

4. COLOR AND LIGHT/DARK CONTRAST. Géricault painted the storm clouds and cresting waves dark to create a menacing mood. The horizon — where the rescue ship is located — is bright, like a beacon of salvation. The extreme light/dark contrasts throughout the painting imply the alternating emotions of hope and hopelessness.

5. MOOD. Jumbled lines of the writhing bodies suggest a mood of turbulence, in keeping with Géricault's theme of titanic struggle against the elements.

When looking at any works of art, the viewer should consider elements like these, which artists use to create their intended effects. The more profound the thought, feeling, skill, and invention an artist puts into his or her work, the more it unfolds to an alert spectator. Appreciating art is a gradual, never-ending endeavor, which is why art from all eras still engages and enriches us.

—Carol Strickland

The Birth of Art: Prehistoric Through Medieval

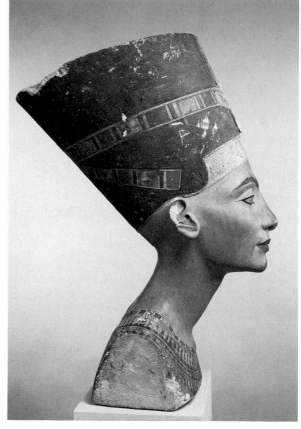

Art was born around 25,000 years ago, when the subhuman Neanderthal evolved into our human ancestor, Cro-Magnon man. With greater intelligence came imagination and the ability to create images in both painting and sculpture. Architecture came into being with the construction of ritual monuments.

For thousands of years, as civilizations waxed and waned, these three art forms — painting, sculpture, and architecture — embodied the ambitions, dreams, and values of their cultures. Although early artists are anonymous, most of what we know about their societies comes from the art they left behind. Ruins of Mesopotamian ziggurats and bas-relief sculpture, as well as Egyptian pyramids, testify to complex civilizations. Greek art reached a pinnacle of beauty as respect for the individual flourished in Athens, and Roman relics attest to the might of the greatest empire in the ancient world.

Artists became increasingly accomplished in representing the human figure in realistic space until the Middle Ages, when art changed radically. With the triumph of Christianity, interest in the body and the world plummeted. Stylized painting and sculpture existed only to teach religion and adorn cathedrals — the true masterpieces of the Middle Ages.

From 25,000 B.C. to A.D. 1400, the history of art is not a story of progress from primitive to sophisticated or simple to complex — only a story of the varied forms the imagination has taken in painting, sculpture, and architecture.

WORLD HISTORY		ART HISTORY
	25,000 – 20,000 B.C.	Venus of Willendorf sculpted
	15,000 – 10,000	Cave paintings created
Asians migrate across Bering Strait land bridge into Americas	11,500	
Urbanization begins, writing invented	3500 – 3000	
	2610	Imhotep, first recorded artist, builds pyramid
	2150	Ziggurat at Ur constructed
	2000	Stonehenge erected
Tutankhamen reigns	1361 – 1352	
First Olympiad held	776	
	742 – 706	Sargon II builds Royal Palace
	650	Wall reliefs sculpted at Nineveh
	c. 650	Freestanding sculpture developed
Athenians establish democracy	600	
	500 B.C. – A.D. 200	African sculpture begins
Pericles rules Athens	450 – 429	
	448 – 432	Parthenon built
Alexander the Great conquers known world	332	
Romans build first highway	312	First aqueduct built
	190	Nike of Samothrace sculpted
	80	Pompeii mosaics created
Pompey constructs first stone theater	55	
Octavian proclaims self Emperor Augustus, 150-year Pax Romana begins	27	
Rome burns, Nero blamed	A.D. 64	
Pompeii destroyed by volcano	79	
	82	Colosseum opens
	118 – 25	Pantheon constructed
Greece absorbed into Roman empire	146	
	300 – 900	Mayans create Classic culture
Roman empire divided, Byzantine era begins	395	
Visigoths sack Rome	410	
Theodoric founds kingdom in Ravenna	493	
Justinian reigns, Byzantine Empire flowers	527 – 65	
	532 – 37	Hagia Sophia built
	547	Ravenna mosaics executed
	600 – 800	Irish monks illuminate manuscripts
Mayan civilization collapses	900	African bronze sculpture made by lost-wax casting method
	1000 – 1200	Romanesque churches built
	1200 – 1500	Gothic style reigns
	1261	
Crusaders capture Constantinople	1305	Giotto paints frescoes in Padua
Aztecs found Mexico City	1325	
Black Death epidemic wipes out one-third of Europe	1347 – 50	
Incan empire in Peru begins	1438	
Constantinople falls, Byzantine Empire collapses	1453	
Columbus discovers New World for Europeans	1492	
Spain conquers Montezuma, king of Aztecs	1519	
Champollion deciphers hieroglyphics	1821	
	1922	Carter discovers Tut's tomb

PREHISTORIC ART: THE BEGINNING

Although human beings have been walking upright for millions of years, it was not until 25,000 years ago that our forebears invented art. Sometime during the last glacial epoch, when hunter-gatherers were still living in caves, the Neanderthal tool-making mentality gave way to the Cro-Magnon urge to make images.

The first art objects were created not to adorn the body or decorate the cavern but out of an attempt to control or appease natural forces. These symbols of animals and people had supernatural significance and magic powers.

SCULPTURE. The oldest surviving art objects are sculptures made from bone, ivory, stone, or antlers. These were either engraved (by incising an outlined figure with a sharp tool), carved in deep relief, or fully rounded three-dimensional sculptures.

VENUS OF WILLENDORF
c. 25,000–20,000 B.C., Museum of Natural History, Vienna. *This tiny female statuette is one of the earliest known human figures. With its enormous breasts, protruding belly, and stylized round head, the sculpture is more a cluster of spheres than an individualized woman. It was probably a fertility fetish, symbolizing abundance.*

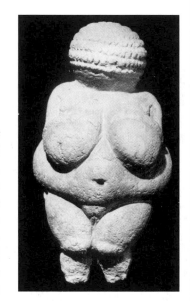

CAVE PAINTING. The first "paintings" were probably made in caves approximately 15,000 years ago. These pictures of bison, deer, horses, cattle, mammoths, and boars are located in the most remote recesses of the caves, far from the inhabited, sunlit entrances. Archeologists speculate artists created the animal images to guarantee a successful hunt. Many are portrayed pierced with arrows, and gouges in the rock indicate cave-dwellers may have flung spears at the painted game.

HORSE

Cave Painting at Lascaux, France, c. 15,000–13,000 B.C. *To create these images, cave artists used charcoal to outline irregularities in the walls of caves that suggested forms from nature. Bulges in the rock implied bulk, and tonal shading with earth-tone pigments lent contour and perspective. The "paints" used were chunks of red and yellow ocher ground into powder and applied with brushes or blown onto the surface through hollow bones. Drawings were often superimposed randomly, perhaps because new images were necessary before each hunt. The images — almost entirely animal figures — were represented in two-dimensional profile and seem to float in space, with no hint of background surroundings.*

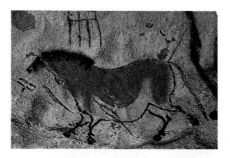

A PREHISTORIC TREASURE TROVE: DISCOVERY OF CAVE ART

In 1879, Marcelino de Sautuola took his small daughter with him to explore the Altamira Caves in northern Spain. Since the ceiling was only a few inches above his head, he did not notice what was immediately above him. From the youngster's lower perspective, however, she spotted marvelous beasts that appeared to cavort on the cave roof. Although de Sautuola was sure the paintings were prehistoric, skeptical archeologists pronounced them forgeries. It was only after the French discovered similar paintings, partially obscured by millennia-old mineral deposits, that the Altamira drawings were pronounced authentic. Today they are recognized as one of the most spectacular finds in art history.

The other major site of cave paintings in Lascaux, France, was also discovered by accident. In 1940, two French boys were out for a walk when their dog suddenly disappeared. They found him in a hole leading to a cave covered with thousands of engravings and paintings. Sealed in the dry underground chambers, the paintings had survived virtually intact for more than 17,000 years. Once hordes of visitors tramped through the cave, however, moisture and carbon dioxide accumulated underground, and fungi crept up the cave walls, concealing the images. Since 1963, the caves at Lascaux have been closed to the public.

FIRST ARCHITECTURE. Once the glaciers receded, the climate grew more temperate, and the Paleolithic (or old stone) period was replaced by the Neolithic (new stone) age. Early human beings emerged from caves to become herdsmen and farmers, and, with a now secure food supply, they began crafting the first monumental "sculpture." As early as 5000 B.C., colossal architecture of massive, upright stones appeared. These took three basic forms: the dolmen, consisting of large, vertical stones with a covering slab like a giant table; the menhir, or single stone set on its end (the largest is 164 feet long, weighing 350 tons); and a cromlech, or circular arrangement of stones, such as Stonehenge.

STONEHENGE: ENGLAND'S FIRST ROCK GROUP. In the Middle Ages, this mysterious group of stones was believed to be either the creation of an ancient race of giants or conjured by Merlin the Magician, who allegedly transplanted it from Ireland. Actually, it seems to be an accurate astronomical calendar. The outer ring consists of trilithons, or ∏-shaped rocks like gigantic doorways. Next comes a ring of smaller upright stones like cemetery gravemarkers, then a horseshoe of carefully finished trilithons, 13'6" high. Isolated from these concentric circles is a heel-stone, marking where the sun rises in the East at the summer solstice.

At Carnac, in the French province of Brittany, rows of thousands of megaliths (large, unhewn boulders up to 12' high) stretch for several miles, a dozen or so abreast in parallel lines. Local legend has it that these rows represent columns of Roman soldiers, changed to stone by the resident saint. More likely, they were associated with worship of the sun or moon.

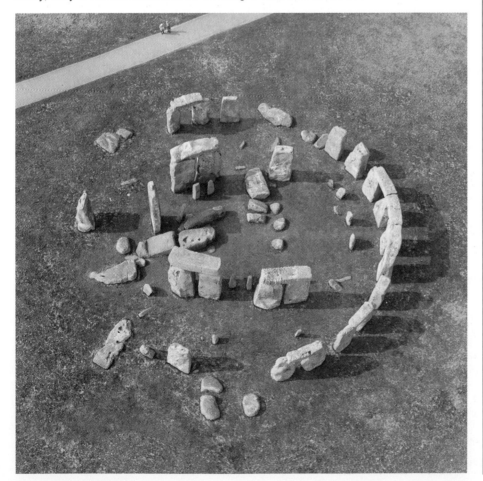

Stonehenge, c. 2000 B.C., 97' diameter, Wiltshire, England.

THE EASTER ISLAND MONOLITHS: HOW THEY DID IT

Anyone who has ever observed the construction of a modern building, aided by bulldozers, huge cranes, and hydraulic lifts, can't help but wonder how prehistoric men managed to erect their monoliths. In the case of Stonehenge, apparently hundreds of men dragged stones weighing up to 50 tons for 24 miles.

The most detailed knowledge we have of megalith construction comes from Easter Island, where descendants of the prehistoric people who created the 30-foot-tall statues demonstrated their ancestors' techniques. First, using crude stone picks, they quarried a giant statue from the crater of an extinct volcano. Next they lowered it to the base of the volcano, where they set it upright in a hole to finish carving and polishing. One hundred eighty natives then moved the 25-ton statue, encircled with a padding of reeds, cross-country by hauling it with ropes on a wooden sledge. Now all they had to do was get it upright and raise it onto its six-foot-high base. How'd they do it? Using two poles or levers they raised the massive carving a few inches off the ground, then inserted rocks underneath the raised side. They repeated this process over and over again, using more and more rocks until voilà! it stood upright. It took approximately one year to carve a statue and two weeks to erect it. At one time, more than 600 of the gigantic figures stood sentry on this tiny Pacific island.

MESOPOTAMIA: THE ARCHITECTS

"The navel of the world" is what King Nebuchadnezzar called his capital city of Babylon. This premier city was the cradle of ancient art and architecture, as well as the site of both the Hanging Gardens and Tower of Babel.

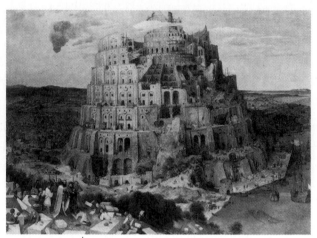

Biblical writers saw the magnificent, 270-foot-high Tower of Babel as an emblem of man's arrogance in trying to reach heaven. The Greek historian Herodotus described it as a stack of eight stepped towers, with gates of solid brass and 120 lions in brightly colored, glazed tiles leading to it. A spiral stairway wound around the exterior, mounting to the summit where an inner sanctuary contained an elaborately adorned couch and gold table. The Babylonians claimed this was the chamber where their god slept.

The Hanging Gardens, one of the Seven Wonders of the Ancient World, was similarly grandiose. It consisted of a series of four brick terraces, rising above the Euphrates River, with lush flowering shrubs and trees spilling over the city. Some believe Mesopotamia was the site of an even more famous historical garden — the garden of Eden.

As far back as 3500 B.C., the Sumerians, the original inhabitants of this area, mastered irrigation and flood control to create a fertile oasis amid the sandy plains of what is now Iraq. In their settlements of the Tigris and Euphrates valley, they also invented the city-state, formal religion, writing, mathematics, law, and, to a large extent, architecture.

Bruegel the Elder, "Tower of Babel," 1563, Kunsthistorisches Museum, Vienna.

THE FIRST URBAN PLANNERS. Using sun-dried brick as a basic building block, the Mesopotamians devised complex cities centered around the temple. These vast architectural complexes included not only an inner shrine but workshops, storehouses, and residential quarters. For the first time, life was regularized, with division of labor and communal efforts, such as defense and public works projects.

The Palace of Sargon II above Nineveh covered 25 acres and included more than 200 rooms and courtyards, including a brilliantly painted throne room, harem, service quarters, and guard room. It stood on a 50-foot-high, man-made mound above the one-square-mile city. Towering above the elevated palace was a ziggurat (a stepped pyramid-shaped tower). This vast brick temple consisted of seven 18-foot-high stories, each painted a different color. The ziggurat's immense height reflected the belief that the gods dwelled on high. It was destroyed around 600 B.C.

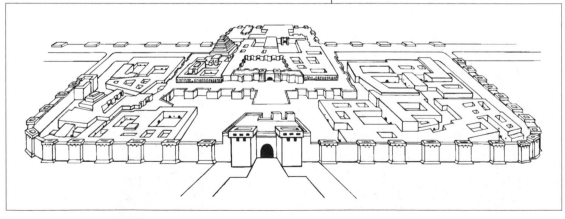

Artist's rendering: "Citadel of King Sargon II," c. 742–706 B.C., Iraq.

THE PERENNIAL PYRAMID

The pyramid shape recurs throughout history and in diverse cultures, many of which have thought the shape itself had magic powers. Man-made landmarks like Mesopotamian ziggurats or flat-sided Egyptian pyramids dominated their landscapes, creating a visual effect as stunning as the amount of effort required to build them. The Mayan stepped pyramids of Mexico's Yucatán peninsula and I. M. Pei's glass entrance to the Louvre in Paris are but two examples of the pyramid shape of different times in different cultures. Is it merely coincidence that the pyramids of Mesopotamia, the cradle of architecture, have served as a symbolic shape for twentieth century architects?

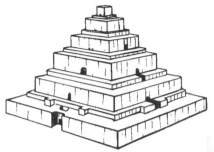

The Ziggurat

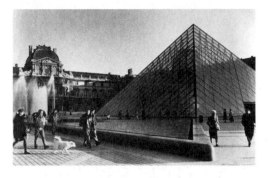

I. M. Pei's Glass Pyramid, the Louvre

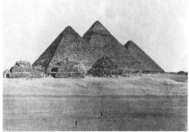

Pyramids of Giza

BAS-RELIEF SCULPTURE. Besides architecture, the predominant art form of Mesopotamia was bas-relief sculpture. Combined with wedge-shaped cuneiform writing, scene after scene of these wall carvings scrupulously detail military exploits.

Another favorite theme seen in bas-reliefs was the king's personal courage during hunting expeditions. At a typical hunting party, servants would goad lions to fury, then release them from cages so the king could slaughter them. "The Dying Lioness" portrays a wounded beast, paralyzed by arrows. The figure's flattened ears and straining muscles convey her death throes with convincing realism.

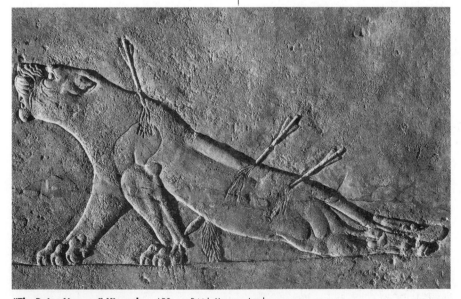

"The Dying Lioness," Nineveh, c. 650 B.C., British Museum, London.

EGYPT: THE ART OF IMMORTALITY

Considering Egyptian society's obsesssion with immortality, it's not surprising that Egyptian art remained unchanged for 3,000 years. Their overriding concern was assuring a comfortable after-life for their rulers, who were considered gods. Colossal architecture and Egyptian art existed to surround the pharaoh's spirit with eternal glory.

In the pursuit of permanence, the Egyptians established the essentials of a major civilization: literature, medical science, and higher mathematics. Not only did they develop an impressive — albeit static — culture, but, while elsewhere lesser civilizations rose and fell with the regularity of the Nile's annual floods, Egypt sustained the world's first large-scale, unified state for three millennia.

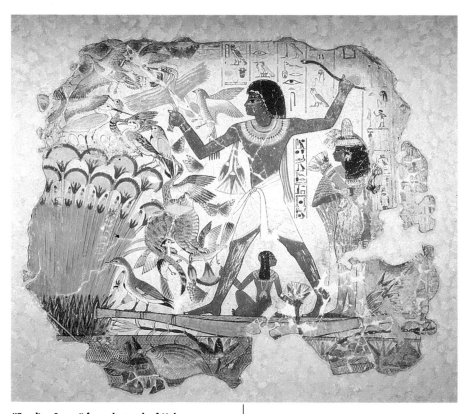

"Fowling Scene" from the tomb of Nebamun, Thebes, c.1450 B.C., British Museum, London. *Egyptian art, built on rigid formulas, was static.*

WHAT IS EGYPTOLOGY?

A special branch of the science of archeology, Egyptology reconstructs Egyptian civilization from the huge storehouse of surviving antiquities.

Egyptology began in 1799 when Napoleon invaded Egypt. In addition to 38,000 troops, he took along 175 scholars, linguists, antiquarians, and artists. These early archeologists brought back to France a huge trove of relics, including the Rosetta Stone, a slab of black basalt with the same inscription in three languages, including Greek and hieroglyphics.

For fifteen centuries, scholars had studied hieroglyphics uncomprehendingly; but in twenty-two years, the brilliant French linguist Jean-François Champollion cracked the code. His discovery spurred intense interest in ancient Egypt. Early Egyptologists often plundered tombs and temples and carried off artifacts for European collections, and perishable papyrus, fabric, and wooden articles that had survived thousands of years unscathed were destroyed overnight. Fortunately, painstaking excavation and scientific examination eventually replaced such heavy-handed tactics.

These tombs, each a time capsule of information on the daily life of its occupant, have yielded detailed knowledge of this vanished civilization.

Much of what we know about ancient Egypt comes from the surviving tombs. Since Egyptians believed the pharaoh's ka, or spirit, was immortal, they stocked the tomb with every earthly delight for it to enjoy in perpetuity. Wall paintings and hieroglyphics were a form of instant replay, inventorying the deceased's life and daily activities in minute detail. Portrait statues provided an alternative dwelling place for the ka, in case the mummified corpse deteriorated and could no longer house it.

Sculpture and paintings followed a rigid formula for representing the human figure. In acres of stone carvings and drawings, the human form is depicted with a front view of the eye and shoulders and profile view of head, arms, and legs. In wall paintings, the surface is divided into horizontal bands separated by lines. The spare, broad-shouldered, narrow-hipped figure wears a headdress and kilt, and stands rigidly, with arms at his side, one leg advanced. The size of a figure indicated rank, with pharaohs presented as giants towering over pygmy-size servants.

Since statues were intended to last eternally, they were made of hard substances like granite and diorite. Whether standing or seated, they included few projecting, breakable parts. The pose was always frontal and bisymmetrical, with arms close to the torso. Human anatomy was usually, at best, an approximation.

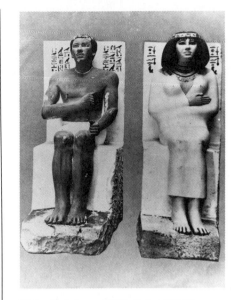

"Prince Rahotep and Wife Nofret," 2610 B.C., *Egyptian Museum, Cairo. These limestone sculptures are typical of the motionless, impassive poses of Egyptian portrait statues.*

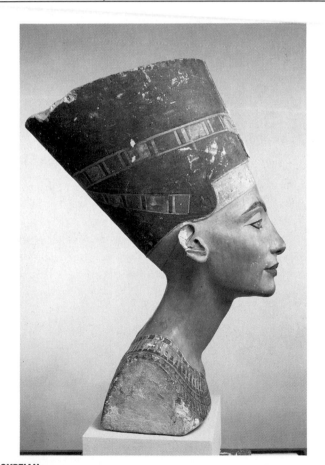

Queen Nefertiti, c.1360 B.C., *Egyptian Museum, Berlin.*

LOOKING LESS LIKE AN EGYPTIAN

Nefertiti's husband, Pharaoh Akhenaton, was a radical reformer and an artist, who encouraged a temporary loosening of artistic conventions, seen in this more naturalistic representation of his wife.

MUMMY ART

The Egyptians believed the ka, or life force, was immortal. To provide a durable receptacle for the deceased's spirit, they perfected the science of embalming. Preserving the body began with extracting the deceased's brains through the nostrils with a metal hook. Viscera, like the liver, lungs, stomach, and intestines, were removed and preserved in separate urns. What was left was then soaked in brine for more than a month, after which the pickled cadaver was literally hung out to dry. The shriveled body was then stuffed, women's breasts padded, the corpse swaddled in layers of bandages, and finally interred in nested coffins and a stone sarcophagus. In fact, Egypt's dry climate and absence of bacteria in sand and air probably aided preservation as much as this elaborate chemical treatment.

In 1881, 40 dead kings' bodies were discovered, including that of Ramses II, whose dried skin, teeth, and hair were still intact. The 3,000-year-old monarch, in whose court Moses grew up, was called "The Great" and with good reason; he sired more than 100 children during his opulent 67-year reign. Yet, when a customs inspector surveyed Ramses' mortal remains during the transfer of the mummy to Cairo, he labeled it "dried fish."

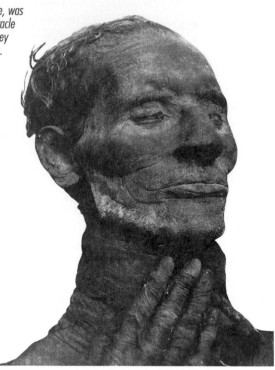

Head of Ramses II, Mummy
The Egyptian Museum, Cairo.

GENERAL CONTRACTING FOR THE GREAT PYRAMID

One of 80 remaining pyramids, the Great Pyramid of Cheops at Giza is the largest stone structure in the world. Ancient Egyptians leveled its 13-acre site — the base a perfect square — so successfully that the southeast corner is only one-half inch higher than the northwest. Since the interior is an almost solid mass of limestone slabs, great engineering skill was required to protect the small burial chambers from the massive weight of stone above. The Grand Gallery's ceiling was tiered and braced, while the king's chamber had six granite-slab roofs above separate compartments to relieve stress and displace the weight of overhead blocks. Built in 2600 B.C. to last forever, so far it has. If you were to construct the Great Pyramid, this is what you'd need:

SUPPLIES:

2,300,000 limestone blocks, each weighing an average of 2 1/2 tons

Rudimentary copper-and-stone-cutting tools

Barges to float blocks from quarry on east side of Nile to west bank

Log rollers, temporary brick ramps, wooden sledges to haul stone to construction site

Pearly white limestone facing to surface finished 480-foot-tall pyramid

LABOR:

4,000 construction workers to move blocks weighing up to 15 tons, without benefit of draft animals, the wheel, or block-and-tackle

ESTIMATED COMPLETION TIME:

23 years (average life span at the time was 35)

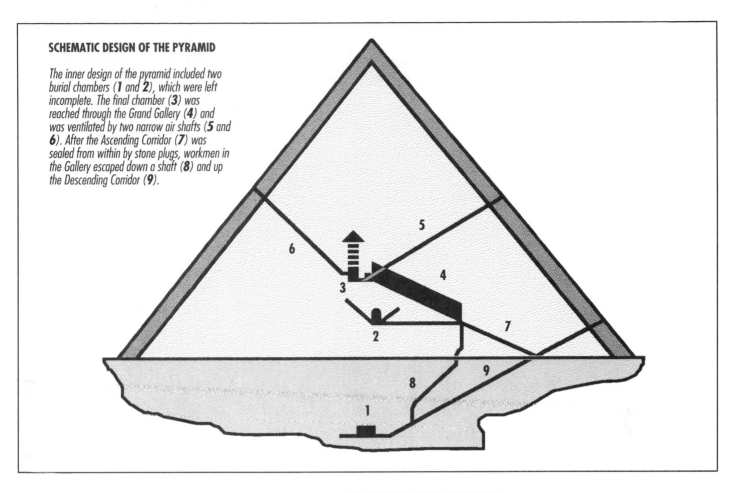

SCHEMATIC DESIGN OF THE PYRAMID

The inner design of the pyramid included two burial chambers (**1** and **2**), which were left incomplete. The final chamber (**3**) was reached through the Grand Gallery (**4**) and was ventilated by two narrow air shafts (**5** and **6**). After the Ascending Corridor (**7**) was sealed from within by stone plugs, workmen in the Gallery escaped down a shaft (**8**) and up the Descending Corridor (**9**).

THE DISCOVERY OF KING TUT'S TOMB

In life, King Tutankhamen, who died at the age of 19, was unimportant. Yet in death and 3,000 years later, he became the most celebrated pharaoh of all. His tomb is the only one to be discovered in its near-original condition.

The British archeologist Howard Carter was alone in his belief the tomb could be found. For six years he dug in the Valley of Kings, twice coming within two yards of the tomb's entrance. In 1922 he literally struck pay dirt. When he lit a match to peek into the darkness, he saw "everywhere the glint of gold."

Our knowledge of the magnificence of a pharaoh's funerary regalia comes from Tut's tomb. The contents ranged from baskets of fruit and garlands of flowers still tinged with color, a folding camp bed and a toy-box, to four chariots completely covered with gold. Indeed, gold was the prevailing decorating motif: golden couches, gilded throne, gold walls, a 6'2" coffin of solid gold, as well as the now famous solid gold death mask covering the royal mummy's face in the innermost of three nested coffins.

More than 20 people connected with unsealing the tomb died under mysterious circumstances, giving rise to lurid "curse of the pharaoh" stories. Such superstition didn't, however, prevent the King Tut tour of the world's museums from attracting more visitors than any other single art show in history.

Mask of King Tutankhamen, 1352 B.C., The Egyptian Museum, Cairo. *Even within the final coffin, the face of the mummy was concealed by a beaten-gold mask.*

GREECE:
THEY INVENTED A LOT MORE THAN THE OLYMPICS

The history — some would argue the zenith — of Western civilization began in ancient Greece. For a brief Golden Age, 480–430 B.C., an explosion of creativity resulted in an unparalleled level of excellence in art, architecture, poetry, drama, philosophy, government, law, logic, history, and mathematics. This period is also called the Age of Pericles, after the Athenian leader who championed democracy and encouraged free thinking.

Greek philosophy was summed up in the words of Protagoras: "Man is the measure of all things." This, combined with other philosophers' emphasis on rational inquiry and challenging the status quo, created a society of intellectual and artistic risk-takers.

Just as man's dignity and worth were central Greek concepts, the human figure was the principal motif of Greek art. Where Greek philosophy stressed harmony, order, and clarity of thought, Greek art and architecture reflected a similar respect for balance.

PAINTING. The Greeks were skilled painters. According to literary sources, Greek artists achieved a breakthrough in realistic trompe l'oeil effects. Their paintings were so lifelike that birds pecked murals of painted fruit. Unfortunately, none of these works survive, but we can judge the realistic detail of Greek painting by the figures that adorn their everyday pottery.

VASE PAINTING. Vase painting told stories about gods and heroes of Greek myths as well as such contemporary subjects as warfare and drinking parties. The earliest (c. 800 B.C.) vase design was called the Geometric Style, because the figures and ornaments were primarily geometric shapes. The later Archaic Period was the great age of vase painting. In the black-figured style at the outset of this period, black forms stood out against a reddish clay background. The artist scratched in details with a needle, to expose the red beneath. The red-figured style, starting around 530 B.C., reversed this color scheme. The figures, on a black background, were composed of natural red clay with details painted in black.

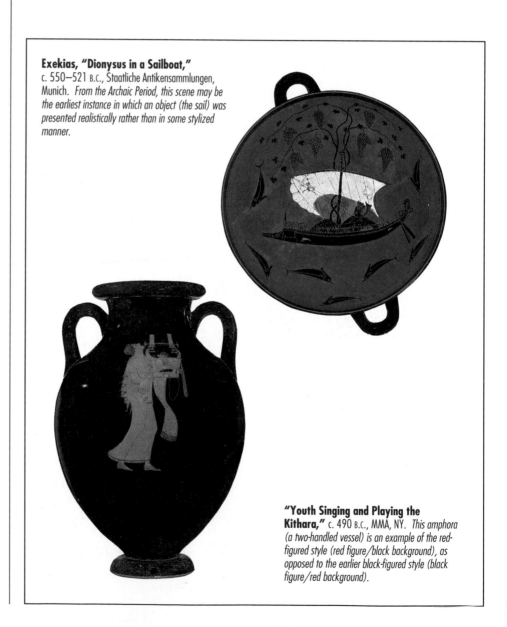

Exekias, "Dionysus in a Sailboat," c. 550–521 B.C., Staatliche Antikensammlungen, Munich. *From the Archaic Period, this scene may be the earliest instance in which an object (the sail) was presented realistically rather than in some stylized manner.*

"Youth Singing and Playing the Kithara," c. 490 B.C., MMA, NY. *This amphora (a two-handled vessel) is an example of the red-figured style (red figure/black background), as opposed to the earlier black-figured style (black figure/red background).*

SCULPTURE: THE BODY BEAUTIFUL. The Greeks invented the nude in art. The ideal proportions of their statues represented the perfection of both body (through athletic endeavor) and mind (through intellectual debate). The Greeks sought a synthesis of the two poles of human behavior — passion and reason — and, through their artistic portrayal of the human form (often in motion), they came close to achieving it.

Greek statues were not the bleached white marble we associate with Classical sculpture today. The marble was embellished with colored encaustic, a mixture of powdered pigment and hot wax applied to hair, lips, eyes, and nails of the figure. Although male nudity was always acceptable in sculpture, the representation of female images evolved from fully clothed to sensually nude. In earlier statues, clinging folds of drapery united the figure in a swirling rhythm of movement. Another innovation was the discovery of the principle of weight shift, or contrapposto, in which the weight of the body rested on one leg with the body realigned accordingly, giving the illusion of a figure in arrested motion.

ETERNAL YOUTH: INFLUENCE OF THE GREEK IDEAL

The ideal proportions of Classical statues, as well as the Greek philosophy of humanism reflected in Nike ("Winged Victory"), influenced the heroic style of Michelangelo's "David." In turn, Rodin's study of Michelangelo's Renaissance sculpture made his work less academic, inspiring "The Age of Bronze."

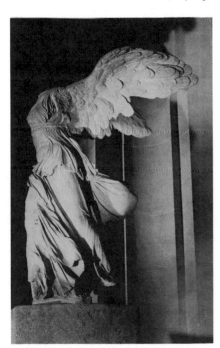

"Nike of Samothrace," c. 190 B.C., Louvre, Paris.

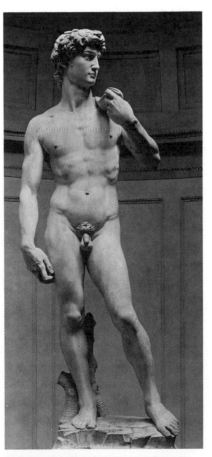

Michelangelo, "David," 1501–4, Galleria dell' Accademia, Florence.

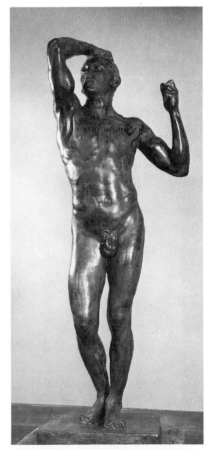

Rodin, "The Age of Bronze," 1876, Minneapolis Institute of Arts.

ARCHITECTURE FIT FOR THE GODS.
Greek culture influenced the art and architecture of every subsequent period of Western civilization, but most especially the Renaissance (when many Classical works were rediscovered) and eighteenth- and nineteenth-century Greek Revival crazes. During the latter period, the vogue for Greek style was so widespread that every museum, art academy, and college proudly displayed reproductions of Greek sculpture. Public buildings, such as courthouses and banks, became pseudo-Greek temples.

Architects intended the brilliant white marble Parthenon to be the ultimate expression of Athens' grandeur. Even in ruins, it crowns the Acropolis. The Parthenon's perfection was due to barely perceptible departures from straight lines. Columns curve slightly inward and the entablature and stepped platform are barely arched. These "refinements," as they were called, bent straight lines to give the illu-

sion of upward thrust and solid support for the central mass. Built without mortar, the Parthenon remained relatively intact until 1687, when a direct rocket hit destroyed its core.

In 1801 Lord Elgin carted off much of the sculpture to the British Museum, where the poet John Keats gazed at the marbles for hours, "like a sick eagle looking at the sky."

ARCHITECTURE FOR THE AGES

Considered one of the most beautiful and influential buildings of all time, the Parthenon indirectly inspired the temple format of Thomas Jefferson's Virginia Capital and Michael Graves's Post-Modern revival of Classical elements like columns and arcades.

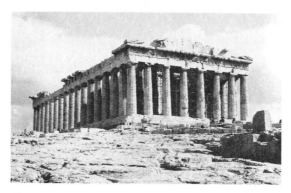

Iktinos and Kallikrates, the Parthenon,
448–432 B.C., Acropolis, Athens.

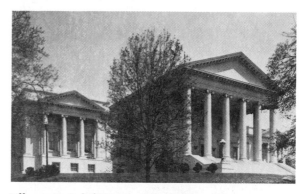

Jefferson, Capitol of Virginia, 1785–92, Richmond, VA.

Graves, Clos Pegase Winery, 1987, Napa Valley, CA.

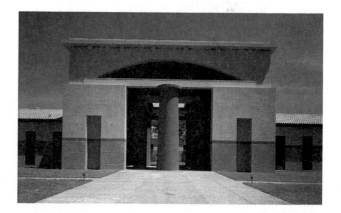

WHO WAS WHO IN ANCIENT GREECE

Ancient Greece is best known for its philosophers (Socrates, Plato, Aristotle), playwrights (Aeschylus, Aristophanes, Euripides, Sophocles), and mathematicians (Euclid, Pythagoras). Some of the leading artists were:

PHIDIAS (500–432 B.C.), most famous Athenian sculptor, overseer of Parthenon statuary, first used drapery to reveal body

POLYKLEITOS (active 450–420 B.C.), rival of Phidias, wrote book on proportion; most celebrated work colossal gold and ivory statue of Hera at Argos

PRAXITELES (active mid-4th century B.C.), Athenian sculptor famous for first entirely nude Aphrodite statue; introduced more sensual, natural concept of physical beauty

GREEK ARCHITECTURE: A PRIMER

Monuments were treated by the Greeks as large sculpture and were built with the same rules of symmetry and ideal proportions. Public rites took place in front of the temple, where elaborate sculpture told the story of the temple's deity. The most common locations for sculpture were the triangular pediments and horizontal frieze. During the Classic period, features on faces were impassive, giving rise to the term Severe Style. Regardless of the violent events depicted, faces showed little expression as in the Temple of Zeus at Olympia, where a woman seemed lost in thought as she, almost incidentally, removed a drunken centaur's hand from her breast.

Sculpted figures on a building's pediment often protruded sharply from their background stone, which was painted red or blue. Even though the backs of figures could not be seen, because of the Greek obsession with completeness and harmony they were nearly finished.

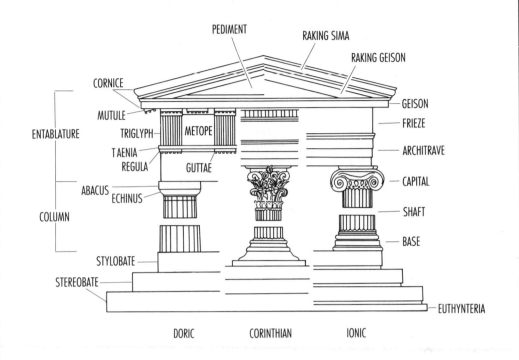

The phrase "Doric order" referred to all the standard components of a Doric temple, typically found on mainland Greece. The "Ionic order" was more widespread in the Greek settlements of Asia Minor and the Aegean. The "Corinthian order," its columns topped by stylized leaves of the acanthus plant, developed much later. It was not widely used on exteriors until Roman times. The curve along the tapering lines of a column was called entasis. In keeping with the Greeks' fixation on harmony, this slight curve conveyed a fluid, rather than rigid, effect. Occasionally, female figures called caryatids replaced fluted columns.

GREEK ART

GOLDEN AGE: 480–430 B.C.

PHILOSOPHY: Moderation in all

MOST FAMOUS WORK: "Winged Victory"

MOST FAMOUS BUILDING: Parthenon

CHARACTERISTIC FORM: Male nude

SIGNATURE CITY: Athens

MAJOR CONTRIBUTIONS: Democracy, individualism, reason

GREEK ART STYLES

GEOMETRIC ART (9th–8th century B.C.), pottery ornamented with geometric banding and friezes of simplified animals, humans

ARCHAIC ART (600–480 B.C.), period includes kouros stone figures and vase painting

KOUROS (nude male youth)/KORE (clothed maiden), earliest (625–480 B.C.) free-standing statues of human figures; frontal stance, left foot forward, clenched fists, and grimace known as "Archaic smile"

SEVERE STYLE, early phase of Classical sculpture characterized by reserved, remote expressions

CLASSICAL ART (480–323 B.C.), peak of Greek art and architecture, idealized figures exemplify order and harmony

HELLENISTIC ART (323–31 B.C.), Greek-derived style, found in Asia Minor, Mesopotamia, Egypt; more melodramatic (as in "Laocoön," 50 B.C.) than Classical style

ROME: THE ORGANIZERS

At its height, the Roman Empire stretched from England to Egypt and from Spain to southern Russia. Because of their exposure to foreign lands, the Romans absorbed elements from older cultures — notably Greece — and then transmitted this cultural mix (Greco-Roman) to all of Western Europe and Northern Africa. Roman art became the building block for the art of all succeeding periods.

At first, awestruck Romans were overwhelmed by the Greek influence. This appetite was so intense that Greek marbles and bronzes arrived by the galleonful to ornament Roman forums. Nero imported 500 bronzes from Delphi alone, and when there were no more originals, Roman artisans made copies. The poet Horace noted the irony: "Conquered Greece," he wrote, "took her rude captor captive."

Later, however, Romans put their own spin on Greek art and philosophy. Having founded the greatest empire the world had ever known, they added managerial talents: organization and efficiency. Roman art is less idealized and intellectual than Classical Greek, more secular and functional. And, where the Greeks shined at innovation, the Romans' forte was administration. Wherever their generals marched, they brought the civilizing influence of law and the practical benefits of roads, bridges, sewers, and aqueducts.

ROMAN ART

PHILOSOPHY: Efficiency, organization, practicality

ART FORMS: Mosaics, realistic wall paintings, idealized civic sculpture

MOST FAMOUS BUILDING: Pantheon

SIGNATURE CITY: Rome

ROLE MODEL: Greece

MAJOR CONTRIBUTIONS: Law, engineering, cement

IS IT GREEK OR IS IT ROMAN?

Greek and Roman art and architecture are often confused. Here's a chart of the major differences.

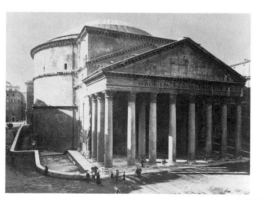

The Pantheon, A.D. 118–125, Rome. *The domed rotunda of the Pantheon illustrates the Roman architects' ability to enclose space.*

Parthenon, 448–432 B.C., Athens. *The Parthenon's triangular pediment and columned portico show classic Greek temple format.*

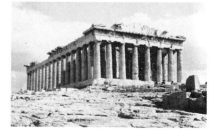

	GREEK	ROMAN
PREFERRED STRUCTURE:	Temples to glorify gods	Civic buildings (baths, forum) to honor Empire
WALLS:	Made of cut stone blocks	Concrete with ornamental facing
TRADEMARK FORMS:	Rectangles, straight lines	Circles, curved lines
SUPPORT SYSTEM:	Post and lintel	Rounded arch, vaults
COLUMN STYLE:	Doric, Ionic	Corinthian
SCULPTURE:	Idealized gods and goddesses	Realistic human beings, idealized officials
PAINTING:	Stylized figures floating in space	Realistic images with perspective
SUBJECT OF ART:	Mythology	Civic leaders, military triumphs

THE LEGACY OF ROME

Roman architects used Greek forms but developed new construction techniques like the arch to span greater distances than the Greek post and lintel system (two vertical posts with a horizontal beam). Concrete allowed more flexible designs, as in the barrel-vaulted roof, and the dome-covered, huge circular areas. Here are some Roman contributions to architecture:

BASILICA, an oblong building with semicircular apses on either end and high clerestory windows, used as meeting place in Roman times and widely imitated in medieval Christian churches.

BARREL VAULT, deep arch forming a half-cylindrical roof

GROIN VAULT, two intersecting barrel vaults at the same height that form a right angle

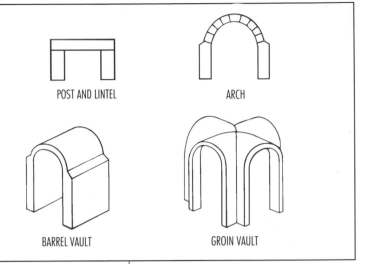

POST AND LINTEL ARCH

BARREL VAULT GROIN VAULT

ROMAN ARCHITECTURE: VAULTING AMBITION.

Besides Roman law, perhaps Rome's most valuable contributions were in the areas of architecture and engineering. Roman builders not only developed the arch, vault, and dome but pioneered the creative use of concrete. These innovations proved revolutionary, allowing Romans for the first time to cover immense interior spaces without inner supports.

Rome became incredibly rich from conquered booty. Nero's palace, the Golden House, with its mile-long portico, was the most opulent residence in antiquity. In the banquet room, perfume sprinkled down on guests from the ceiling. Inside, a domed roof revolved so that visitors could follow the constellations through its central opening.

The Romans loved baths, and the more extravagant, the better. At the enormous Baths of Caracalla (A.D. 215), a capacity crowd of 1,600 bathed in pools of varying water temperatures. An elaborate pipe system stoked by slaves heated steam baths and exercise rooms as well. "We have become so luxurious," observed the writer Seneca, "that we will have nothing but precious stones to walk upon."

ROMAN SCULPTURE: POLITICS AS USUAL.

Although the Romans copied Greek statues wholesale to satisfy the fad for Hellenic art, they gradually developed their own distinctive style. In general, Roman sculpture was more literal. The Romans had always kept wax death masks of ancestors in their homes. These realistic images were completely factual molds of the deceased's features, and this tradition influenced Roman sculptors.

An exception to this tradition was the assembly-line, godlike busts of emperors, politicians, and military leaders in civic buildings throughout Europe, establishing a political presence thousands of miles from Rome. Interestingly, during Rome's decline, when assassination became the preferred means for transfer of power, portrait busts reverted to brutal honesty. An unflattering statue of Caracalla reveals a cruel dictator, and Philip the Arab's portrait shows a suspicious tyrant.

The other principal form of Roman sculpture was narrative relief. Panels of sculpted figures depicting military exploits decorated triumphal arches, under which victorious armies paraded, leading long lines of chained prisoners. The Column of Trajan (A.D. 106–113) was the most ambitious of these efforts. A 650-foot-long relief wound around the column in an unbroken spiral, commemorating mass slaughter in more than 150 scenes.

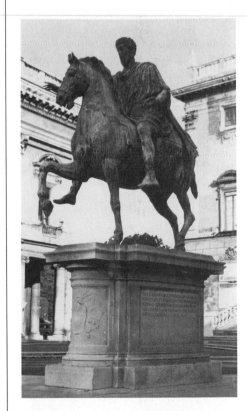

Marcus Aurelius, A.D. 165, Capitoline Hill, Rome. *The Emperor Marcus Aurelius was a Stoic philosopher who detested war. The sculptor represented this gentle, reflective ruler as a superhuman ideal.*

THE COLOSSEUM

With a million people in Rome, many of them poor, emperors distracted the masses from their grievances with large-scale public entertainment. At the Colosseum, which seated 50,000 spectators, for the opening act in A.D. 80, the entire arena was flooded to stage a naval battle reenacted by a cast of 3,000.

Combat between gladiators was popular. Some were armed with shield, sword, and helmet, while others carried only net and trident. Boxers wore leather gloves, their fists clenched around lumps of iron. To guarantee an energetic performance, the combat was to the death.

Slaves carrying whips with lead weights on the lashes drove fleeing men or beasts back into the fray. Up to forty gladiators (if the crowd was in a thumbs-down mood) died per day. In the course of a single day's events, thousands of corpses were dragged off with a metal hook.

Half-time shows featured the execution of criminals, followed by man–wild beast contests. Early "elevators" raised hundreds of starving lions from underground cages to attack unarmed Christians or slaves. Man-versus-bear struggles were also much admired, as were animal hunts starring elephants or rhinoceroses. To celebrate one victory, the Emperor Trajan sacrificed 11,000 lions, leopards, ostriches, and antelopes. To disguise the odor of stables, slaves sprayed clouds of perfume at distinguished spectators and sprinkled red powder on the arena's sand floor to make bloodstains less conspicuous.

Still one of the world's largest buildings in terms of sheer mass, the Colosseum was so efficiently laid out that it inspired present-day stadium design. Each spectator had a seat number corresponding to a certain gate, which allowed smooth crowd flow via miles of corridors and ramps. Three types of columns framed the 161-foot-high structure, using the Doric order at the base, Ionic in the middle, and Corinthian above — the typical design sequence for a multistoried Roman building. The balance of vertical columns and horizontal bands of arches unified the exterior, relating the enormous façade to a more human scale. Sadly, Rome's rich Barberini family later stripped off the stadium's marble facing for their building projects.

Colosseum, A.D. 70–82, Rome.

Pont du Gard, Nîmes, 1st century B.C., France. *Beginning in the 4th century B.C., Romans constructed huge aqueducts to carry water for distances up to 50 miles. These structures were built on continuous gradual declines to transport water by force of gravity. On the Pont du Gard aqueduct, which carried 100 gallons of water a day for each inhabitant of the city, each large arch spanned 82 feet.*

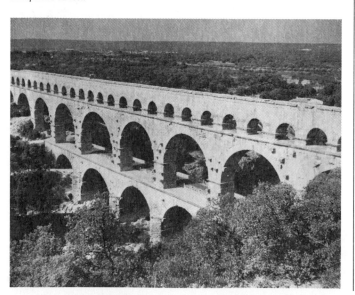

POMPEII: A CITY TURNED TO CARBON

It was 1 P.M. on a summer day when, according to eyewitness Pliny the Younger, Mt. Vesuvius erupted, spewing molten lava and raining ash on the nearby towns of Pompeii and Herculaneum. A black mushroom cloud rose 12 miles over the peak until, by the end of the next day, the villages were covered with 18 feet of ash and pumice. They remained covered — forgotten — for 1,700 years, preserving an incredible hoard of nearly intact artifacts, mosaics, and wall paintings.

Pompeii was a luxurious resort community with a population of 25,000. The scientific excavation that began in the mid-1800s disclosed not only ordinary objects like carbonized loaves of bread, fish, eggs, and nuts (a priest's abandoned lunch) but whole villas in which every wall was painted with realistic still lifes and landscapes. Since the interiors of villas had no windows, only a central atrium opening, ancient Romans painted make-believe windows with elaborate views of fantasy vistas. This style of wall painting ranged from simple imitations of colored marble to trompe l'oeil scenes of complex cityscapes as seen through imaginary windows framed by imaginary painted columns. Artists mastered tricks of perspective and effects of light and shadow that were unknown in world art. Walls glowed with vivid red, tan, and green panels.

Mosaics made of bits of colored stone, glass, or shell (called tesserae) covered floors, walls, and ceilings. Many were as intricate as paintings. In one, fifty tiny cubes composed a one-and-a-half-inch eye. Entrances often included a mosaic of a dog with the words "Cave Canem" (Beware of the Dog).

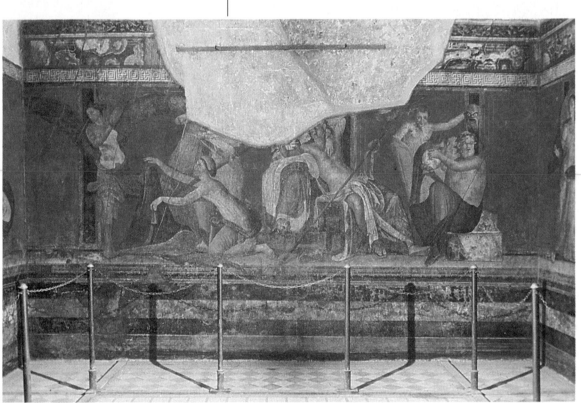

Frieze, Villa of the Mysteries, c. 50 B.C., Pompeii. *A frieze of nearly life-size figures presumably depicted secret Dionysian rites, such as drinking blood of sacrificed beasts.*

PRE-COLUMBIAN ART OF THE AMERICAS: NEW WORLD ART WHEN IT WAS STILL AN OLD WORLD

"Pre-Columbian" refers to the period before Columbus landed in the New World, or before European customs began to influence Native American artisans of North, Central, and South America. Arrowheads from 10,000 B.C. and pottery from 2000 B.C. have been found, evidence of how ancient New World culture actually was. Art was vitally important to tribal society. Objects used in religious rituals, such as carved masks and pipebowls, were thought to be charged with magic. In a life of uncertainty, craftsmen hoped these objects would appease nature and help the tribe survive.

NATIVE AMERICAN ART: A SAMPLING

Pre-Columbian art ranges from the mountains of Peru to the plains of the Midwest to the coast of Alaska. The following were some of the best-known tribal artisans:

NAVAHO: Southwest tribe known for geometric-design rugs colored with herbal and mineral dyes, especially carmine red. Shamans created sand paintings to heal disease, promote fertility, or assure a successful hunt. Still practicing today, Navaho sand painters use natural pigments, like powdered rock in various colors, corn pollen, and charcoal, to produce temporary works on a flat bed of sand.

HOPI: Carved and painted kachina dolls out of cottonwood roots to represent gods and teach religion. Also decorated ceremonial underground kivas in Arizona with elaborate mural paintings of agriculture deities.

KWAKIUTL: Northwest coast tribe that produced totem poles, masks, and decorated houses and canoes. Facial features of masks exaggerated in forceful wood carvings. Mortuary poles and totem poles indicated social status.

ESKIMO: Alaskan tribe that carved masks with moving parts used by shamans; often combined odd materials in surprising ways.

MAYAN: In Guatemala and Mexico, Mayans created enormous temples in stepped-pyramid form. Huge limestone temples were richly carved with relief sculpture and hieroglyphics. Tikal (population 70,000) was largest Mayan site, with highest pyramid reaching 230 feet. Although the Mayans had sophisticated calendar and knowledge of astronomy, civilization withered about A.D. 900.

AZTEC: Capital was Mexico City, the urban center of this large empire. Produced massive statues of gods who demanded regular human sacrifices. Skilled in gold work.

INCAN: Peruvian tribe known for precisely constructed masonry temples and metallurgy; civilization at height when Spaniards arrived.

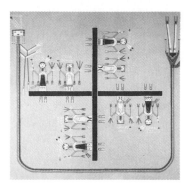

Ceremonial sand painting, 1968, Navaho, National Museum of the American Indian, NY.

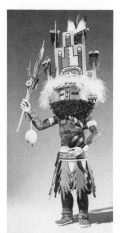

Hopi kachina doll, 1972, National Museum of the American Indian, NY.

Eskimo shaman mask, before 1900, National Museum of the American Indian, NY.

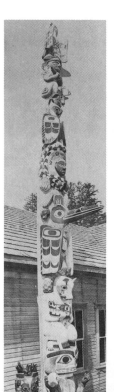

Totem pole, Nootka, 1928 , Smithsonian Institution, Washington, D.C.

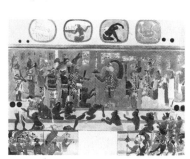

Temple mural, Mayan, A.D. 790–800, Peabody Museum, Harvard.

Gold Figurine of King Tizoc, Aztec, c. 1481–86, Mexican, National Museum of the American Indian, NY.

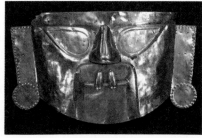

Gold funerary mask, Incan, 12th–14th century, MMA, NY.

MOUND-BUILDERS

Native Americans have always been environmentalists. Their philosophy was based on unity between nature — a maternal force to be loved and respected — and humanity. In the Great Serpent Mound of Ohio, Native Americans constructed an elaborate natural shrine as a setting for their religion. About a quarter-mile long, the burial mound was in the shape of a snake holding an egg in its jaws.

From 2000 B.C., tribes constructed these mounds, each some 100 feet high, from Florida to Wisconsin. More than 10,000 existed in the Ohio Valley alone. Some imitated the shape of a tribe's totem animal, such as an enormous bird with spreading wings. Others were simply shaped like domes, but in each case, the builders hauled millions of tons of earth by hand in baskets, then tamped it down. The volume of the largest mound, near St. Louis, was greater than that of the Great Pyramid. In some cases, inner burial chambers contained archeological treasures, like the body of an aristocrat clothed entirely in pearls.

Mound-builders partly inspired Earthworks, a movement that emerged in the late 1960s to make the land itself a work of art. Robert Smithson's "Spiral Jetty" (now underwater in Great Salt Lake, Utah) is one of the better-known examples of this movement.

"The Great Serpent Mound," 1000 B.C.–A.D. 400, length 1,400', Adams County, Ohio.

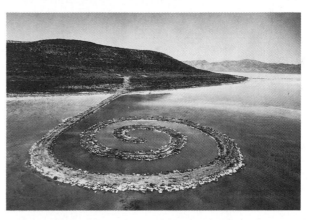

Smithson, "Spiral Jetty," 1970, rock, salt crystals, and earth, coil length 1500', Great Salt Lake, Utah.

Besides their role in important events like initiations, funerals, and festivals, beautiful objects were also prized because Native Americans valued gift-giving. High-quality gifts bestowed prestige on the giver, and artisans excelled in silverwork, basketry, ceramics, weaving, and beadwork. Native Americans were also skilled at wall painting. Their work tended toward the abstract, with stylized pictographs floating almost randomly, as in cave paintings, without foreground or background.

Much Native American art was inspired by visions. The shaman (priest-healer) would reproduce objects the gods communicated to him during a trance. Among the results of drawing on such subconscious impulses were extremely distorted Eskimo masks, among the most original art ever seen.

20TH-CENTURY "TRIBAL" ART

Among the many modern painters influenced by Native American art were Diego Rivera and Jackson Pollock, whose 20th-century works grew out of centuries-old practices.

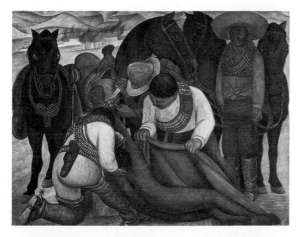

Rivera, "The Liberation of the Peon," 1931, Philadelphia Museum of Art. *The part-Spanish, part-Indian Diego Rivera based his style on Mayan murals, even experimenting with cactus juice as a medium.*

Pollock, "Bird," 1941, MoMA, NY. *After seeing Navaho shamans making sand paintings, Pollock began to use tinted sand and to paint with his canvas on the floor, saying, "On the floor I . . . feel nearer, more a part of the painting, since this way I can walk around it, work from the four sides, and literally be in the painting [like] the Indian sand painters of the West."*

AFRICAN ART: THE FIRST CUBISTS

The main artistic products of tropical Africa were wood carvings, both masks and sculpture in-the-round. In form these objects were angular, off-balance, and distorted. For members of African society, they were sacred objects harboring the life force of an ancestor or nature spirit and had power to cure illnesses or harm enemies. On special occasions the figures and masks were removed from their shrines, washed, anointed with palm oil, and decorated with beads and cloth. In between rituals, the figures were considered so infused with supernatural power they were hidden, and women and children were forbidden to look at them. Although the moist jungle climate rotted many of these wooden objects, those that remain express the emotional intensity their society invested in them.

MASKS. Wooden masks were used in ritual performances with complex musical rhythms, dances, and costumes. For their full impact, they should be thought of in motion, surrounded by colorful garments and the rapid swaying and rustling of raffia skirts and arm fringes.

Masks were intentionally unrealistic: when confronting a supernatural power, the idea was for the performer to conceal his true identity behind this artificial face. For dramatic effect, carvers simplified human features in a series of sharply cut advancing and receding planes.

This freedom from European tradition is what appealed to Pablo Picasso — who became aware of African art around 1905 — and inspired the Cubist movement. Picasso described his reaction to African fetish masks this way: "It came to me that this was very important. . . . These masks were not just pieces of sculpture like the rest. . . . They were magic."

Their influence is evident in Picasso's landmark painting, "Les Demoiselles d'Avignon." (Avignon was the name of a street in Barcelona's red-light district, and the women were intended to depict prostitutes.) The painting was a transition point between Picasso's African-influenced period and pure Cubism. Inspired by the distortions of African carving and in order to show multiple aspects of an object at the same time, Picasso painted the figures in jagged planes.

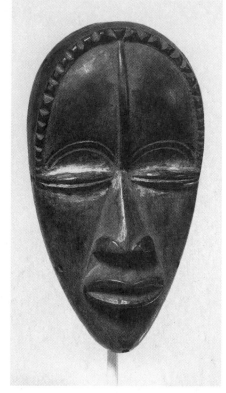

"Kagle" (mask), c. 1775–1825, Dan, Rietberg Museum, Zürich. *African masks were typically lozenge-shaped, with wedge noses and almondlike eyes.*

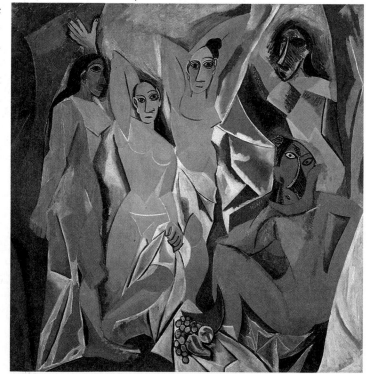

Picasso, "Les Demoiselles d'Avignon," 1907, MoMA, NY. *After seeing African masks, Picasso raced back to his studio to repaint the faces in this picture.*

AFRICAN SCULPTURE.

AFRICAN SCULPTURE. African carvers consistently rejected real-life appearance in favor of vertical forms, tubular shapes, and stretched-out body parts derived from the cylindrical form of trees. Since sculptures were believed to house powerful spirits, these wooden figures could wreak havoc or bestow blessings among the living.

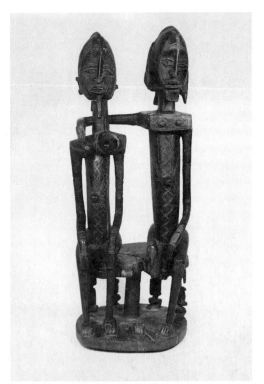

"Couple," n.d., wood, Dogon, Mali, The Barnes Foundation, PA.

THE FAR-FLUNG INFLUENCE OF TRIBAL ART

Beginning with Gauguin's pace-setting appreciation of South Sea islanders, primitive art influenced professional Western artists from the late nineteenth century through the present. The following artists and movements were the most affected by the art of pre-industrial societies:

GAUGUIN: Gauguin went to Tahiti in 1891, seeking an exotic culture unspoiled by civilization. The brilliant colors and simplified anatomy of his island paintings reflect decorative Oceanic art.

FAUVES. Around 1904-8, the Fauves discovered African and South Pacific sculpture. Matisse, Derain, and Vlaminck were key painters who enthusiastically collected African masks.

CUBISTS: Picasso and Braque pioneered this movement based on African tribal sculpture and masks, which fractured reality into overlapping planes. Cubism stimulated developments throughout Europe, leading to the abstraction of Malevich and Mondrian.

SURREALISTS: In the 1920s, antirational artists like Ernst, Miró, Magritte, Giacometti, and Dalí collected Pacific carvings, African masks, and fanciful Eskimo masks.

MEXICAN MURALISTS: José Clemente Orozco, David Siqueiros, and Diego Rivera dominated Mexican art in the 1930s by paying homage to the Mayan and Aztec empires.

MODERNISTS: Sophisticated artists like Modigliani found a freshness and vitality in tribal art missing in conventional art. His paintings of long-necked women resemble African carved figures.

ABSTRACT EXPRESSIONISTS: The impermanence of Navaho sand paintings, destroyed at the end of a rite, influenced Abstract Expressionists to focus on the process of artistic creation rather than the end product.

CONTEMPORARY: Artists as diverse as Jasper Johns, Roy Lichtenstein, Keith Haring, and David Salle have incorporated images of African masks into their work.

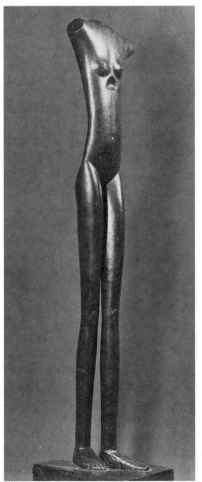

Giacometti, "Walking Woman," 1932–33, collection of Rhode-St.-Genése. *Another Modernist whose work resembles tribal African art is Giacometti, known for his elongated sculptures.*

THE MIDDLE AGES: THE REIGN OF RELIGION

The Middle Ages included the millennium from the fifth to the fifteenth century, roughly from the fall of Rome until the Renaissance. During its initial period, called the Dark Ages, after the death of the Byzantine Emperor Justinian in 565 until the reign of Charlemagne in 800, barbarians destroyed what had taken 3,000 years to build. Yet the Dark Ages were only part of the Middle Ages story. There were many bright spots in art and architecture, from the splendor of the Byzantine court in Constantinople to the majesty of Gothic cathedrals.

Three major shifts occurred that had far-reaching effects on Western civilization:

1. Cultural leadership moved north from the Mediterranean to France, Germany, and the British Isles.
2. Christianity triumphed over paganism and barbarism.
3. Emphasis shifted from the here-and-now to the hereafter, and with it from the body as beautiful to the body as corrupt.

Since the Christian focus was on salvation for a glorious afterlife, interest in realistically representing objects of the world disappeared. Nudes were forbidden, and even images of clothed bodies showed ignorance of anatomy. The Greco-Roman ideals of harmonious proportions and balance between the body and mind ceased to exist. Instead, medieval artisans were interested exclusively in the soul, especially in instructing new believers in church dogma. Art became the servant of the church. Theologians believed church members would come to appreciate divine beauty through material beauty, and lavish mosaics, paintings, and sculpture were the result.

In architecture, this orientation toward the spiritual took the form of lighter, more airy buildings. The mass and bulk of Roman architecture gave way to buildings reflecting the ideal Christian: plain on the outside but glowing with spiritually symbolic mosaics, frescoes, or stained glass inside.

Medieval art was composed of three different styles: Byzantine, Romanesque, and Gothic.

GOLDEN AGE OF BYZANTINE ART

Byzantine refers to eastern Mediterranean art from A.D. 330, when Constantine transferred the seat of the Roman Empire to Byzantium (later called Constantinople) until the city's fall to the Turks in 1453. In the interim, while Rome was overrun by barbarians and declining to a heap of rubble, Byzantium became the center of a brilliant civilization combining early Christian art with the Greek Oriental taste for rich decoration and color. In fact, the complex formality of Byzantine art and architecture doubtless shaped the modern sense of the word "Byzantine."

ART OF THE MIDDLE AGES

Throughout the Middle Ages, in a succession of three styles, art was concerned with religion. The main forms of art and architecture associated with each style were:

	BYZANTINE	ROMANESQUE	GOTHIC
ART	Mosaics, icons	Frescoes, stylized sculpture	Stained glass, more natural sculpture
ARCHITECTURE	Central-dome church	Barrel-vaulted church	Pointed-arch cathedral
EXAMPLE	Hagia Sophia	St. Sernin	Chartres
DATE	532–37	Begun 1080	1194–1260
PLACE	Constantinople, Turkey	Toulouse, France	Chartres, France

ICONS

As gloomy as these images of tortured martyrs were, no discussion of Byzantine art is complete without a look at icons. Icons were small wood-panel paintings, believed to possess supernatural powers. The images of saints or holy persons were typically rigid, frontal poses, often with halos and staring, wide eyes. Icons supposedly had magical properties. According to legend, one wept, another emitted the odor of incense. Ardent believers carried them into battle or wore away their faces by kissing them. So powerful did the cult of icons become that they were banned from 726–843 as a violation of the commandment against idolatry.

Berlinghiero, "Madonna and Child," early 12th century, MMA, NY.

MOSAICS. Some of the world's greatest art, in the form of mosaics, was created during the fifth and sixth centuries in Turkish Byzantium and its Italian capital, Ravenna. Mosaics were intended to publicize the now-official Christian creed, so their subject was generally religion with Christ shown as teacher and all-powerful ruler. Sumptuous grandeur, with halos spotlighting sacred figures and shimmering gold backgrounds, characterized these works.

Human figures were flat, stiff, and symmetrically placed, seeming to float as if hung from pegs. Artisans had no interest in suggesting perspective or volume. Tall, slim human figures with almond-shaped faces, huge eyes, and solemn expressions gazed straight ahead, without the least hint of movement.

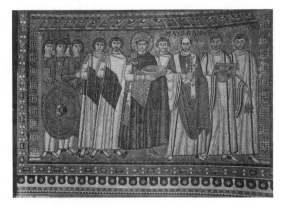

"Justinian and Attendants," c. 547, San Vitale, Ravenna.

"The Battle of Issus," Pompeii, c. 80 B.C., Museo Nazionale, Naples.

Although drawing on the Roman tradition of setting colored cubes, or tesserae, in plaster to form a picture, Byzantine mosaics (above, right) were distinct from Roman (left). Here are the principal variations:

ROMAN MOSAICS	VS.	BYZANTINE MOSAICS
Used opaque marble cubes		Used reflective glass cubes
Pieces had smooth, flat finish		Surfaces left uneven so work sparkled
Colors limited due to use of natural stones		Glowing glass in wide range of colors
Typically found on floor of private homes		Found on walls and ceilings — especially church dome and apse
Subjects were secular, like battles, games		Subjects were religious, like Christ as shepherd
Used minute pieces for realistic detail		Large cubes in stylized designs
Background represented landscape		Background was abstract: sky-blue, then gold

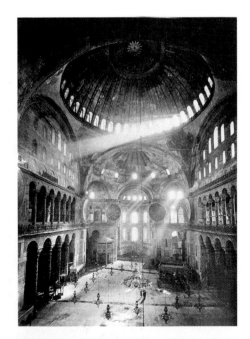

Anthemius of Tralles and Isidorus of Miletus, "Hagia Sophia," Constantinople (Istanbul, Turkey), 532–37. Cathedrals from Venice to Russia were based on this domed structure, a masterpiece of Byzantine architecture.

HAGIA SOPHIA. When Emperor Justinian decided to build a church in Constantinople, the greatest city in the world for 400 years, he wanted to make it as grand as his empire. He assigned the task to two mathematicians, Anthemius of Tralles and Isidorus of Miletus. They obliged his ambition with a completely innovative structure, recognized as a climax in Byzantine architectural style.

The Hagia Sophia (pronounced HAH zhee ah soh FEE ah; the name means "holy wisdom") merged the vast scale of Roman buildings like the Baths of Caracalla with an Eastern mystical atmosphere. Nearly three football fields long, it combined the Roman rectangular basilica layout with a huge central dome. Architects achieved this breakthrough thanks to the Byzantine contribution to engineering — pendentives. For the first time, four arches forming a square (as opposed to round weight-bearing walls, as in the Pantheon) supported a dome. This structural revolution accounted for the lofty, unobstructed interior with its soaring dome.

Forty arched windows encircle the base of the dome, creating the illusion that it rests on a halo of light. This overhead radiance seems to dissolve the walls in divine light, transforming the material into an otherworldly vision. So successful was his creation, that Justinian boasted, "Solomon, I have vanquished thee!"

ROMANESQUE ART: STORIES IN STONE

With the Roman Catholic faith firmly established, a wave of church construction throughout feudal Europe occurred from 1050 to 1200. Builders borrowed elements from Roman architecture, such as rounded arches and columns, giving rise to the term Romanesque for the art and architecture of the period. Yet because Roman buildings were timber-roofed and prone to fires, medieval artisans began to roof churches with stone vaulting. In this system, barrel or groin vaults resting on piers could span large openings with few internal supports or obstructions.

Pilgrimages were in vogue at the time, and church architecture took into account the hordes of tourists visiting shrines of sacred bones, garments, or splinters from the True Cross brought back by the Crusaders. The layout was cruciform, symbolizing the body of Christ on the cross with a long nave transversed by a shorter transept.

Arcades allowed pilgrims to walk around peripheral aisles without disrupting ceremonies for local worshipers in the central nave. At the *chevet* ("pillow" in French), called such because it was conceived as the resting place for Christ's head as he hung on the cross, behind the altar, were semicircular chapels with saints' relics.

The exterior of Romanesque churches was rather plain except for sculptural relief around the main portal. Since most church-goers were illiterate, sculpture taught religious doctrine by telling stories in stone. Sculpture was concentrated in the tympanum, the semicircular space beneath the arch and above the lintel of the central door. Scenes of Christ's ascension to the heavenly throne were popular, as well as grisly Last Judgment dioramas, where demons gobbled hapless souls, while devils strangled or spitted naked bodies of the damned.

Plan of St. Sernin, Toulouse, France. *This typical segmented, Romanesque structure includes multiple semicircular chapels and vaulted square bays.*

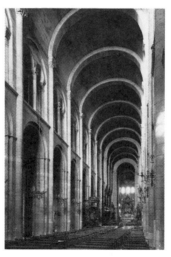

The nave of St. Sernin showing barrel vaults, c. 1080–1120.

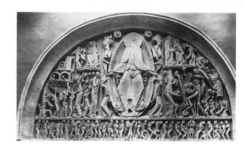

Last Judgment from west tympanum, Autun Cathedral, c.1130–35. *In Romanesque sculpture, realism yielded to moralism. Bodies, distorted to fit the masonry niche, were elongated with expressions of intense emotion.*

GIOTTO: PIONEER PAINTER

Because Italy maintained contact with Byzantine civilization, the art of painting was never abandoned. But at the end of the 13th century, a flowering of technically skilled painting occurred, with masters like Duccio and Simone Martini of Siena and Cimabue and Giotto of Florence breaking with the frozen Byzantine style for softer, more lifelike forms. The frescoes (paintings on damp plaster walls) of Giotto di Bondone (pronounced JOT toe; c.1266–1337) were the first since the Roman period to render human forms suggesting weight and roundness. They marked the advent of what would afterward become painting's central role in Western art.

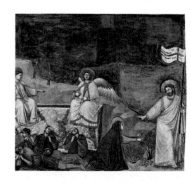

Giotto, "Noli me tangere," *1305, fresco, Arena Chapel, Padua. Giotto painted human figures with a sense of anatomical structure beneath the drapery.*

HOW TO TELL THEM APART

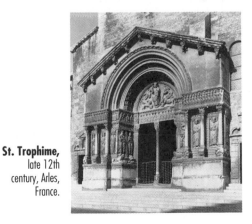

St. Trophime,
late 12th
century, Arles,
France.

Romanesque churches had round arches and stylized sculpture. Gothic cathedrals had pointed arches and more natural sculpture. Keeping Romanesque and Gothic straight means recognizing the distinctive features of each, like the following:

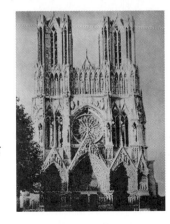

**Reims Cathedral,
west façade,**
c.1220–36, France.

	ROMANESQUE	VS.	GOTHIC
EMPHASIS	horizontal		vertical
ELEVATION	modest height		soaring
LAYOUT	multiple units		unified, unbroken space
MAIN TRAIT	rounded arch		pointed arch
SUPPORT SYSTEM	piers, walls		exterior buttresses
ENGINEERING	barrel & groin vaults		ribbed groin vaults
AMBIANCE	dark, solemn		airy, bright
EXTERIOR	simple, severe		richly decorated with sculpture

ILLUMINATED MANUSCRIPTS. With hordes of pillagers looting and razing cities of the former Roman Empire, monasteries were all that stood between Western Europe and total chaos. Here monks and nuns copied manuscripts, keeping alive both the art of illustration in particular and Western civilization in general.

By this time, the papyrus scroll used from Egypt to Rome was replaced by the vellum (calfskin) or parchment (lambskin) codex, made of separate pages bound at one side. Manuscripts were considered sacred objects containing the word of God. They were decorated lavishly, so their outward beauty would reflect their sublime contents. Covers were made of gold studded with precious and semiprecious gems. Until printing was developed in the fifteenth century, these manuscripts were the only form of books in existence, preserving not only religious teachings but also Classical literature.

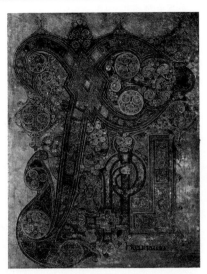

Some of the richest, purely ornamental drawings ever produced are contained in the illuminated gospel called the **Book of Kells** (760–820), collection of Trinity College, Dublin, produced by Irish monks. The text was highly embellished with colorful abstract patterns. Enormous letters, sometimes composed of interlacing whorls and fantastic animal imagery, cover entire pages.

GOTHIC ART: HEIGHT AND LIGHT

The pinnacle of Middle Ages artistic achievement, rivaling the wonders of ancient Greece and Rome, was the Gothic cathedral. In fact, these "stone Bibles" even surpassed Classical architecture in terms of technological daring. From 1200 to 1500, medieval builders erected these intricate structures, with soaring interiors unprecedented in world architecture.

What made the Gothic cathedral possible were two engineering break-throughs: ribbed vaulting and external supports called flying buttresses. Applying such point supports where necessary allowed builders to forgo solid walls pierced by narrow windows for skeletal walls with huge stained glass windows flooding the interior with light. Gothic cathedrals acknowledged no Dark Ages. Their evolution was a continuous expansion of light, until finally walls were so perforated as to be almost mullions framing immense fields of colored, story-telling glass.

In addition to the latticelike quality of Gothic cathedral walls (with an effect like "petrified lace," as the writer William Faulkner said), verticality characterized Gothic architecture. Builders used the pointed arch, which increased both the reality and illusion of greater height. Architects vied for the highest naves (at Amiens, the nave reached an extreme height of 144 feet). When, as often happened, ambition outstripped technical skill and the naves collapsed, church members tirelessly rebuilt them.

Gothic cathedrals were such a symbol of civic pride that an invader's worst insult was to pull down the tower of a conquered town's cathedral. Communal devotion to the buildings was so intense that all segments of the population participated in construction. Lords and ladies, in worshipful silence, worked alongside butchers and masons, dragging carts loaded with stone from quarries. Buildings were so elaborate that construction literally took ages — six centuries for Cologne Cathedral — which explains why some seem a hodge-podge of successive styles.

GOTHIC BUILDING BLOCKS

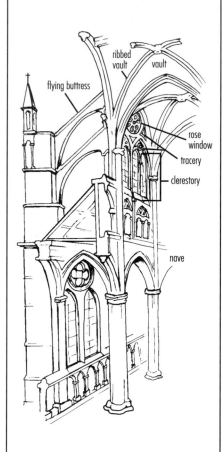

VAULT - arched ceiling

NAVE - main part of church interior

FLYING BUTTRESSES - exterior masonry bridges supporting walls

RIBBED VAULT - molded stone ribs covering seams of groin vaults

CLERESTORY - nave wall lit by windows

ROSE WINDOW - circular window filled with stained glass

TRACERY - stone armature decorating windows

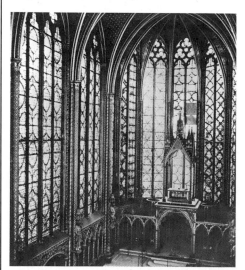

Sainte-Chapelle, 13th century, Paris. *More than three-fourths of the exterior structure is composed of stained glass, filling the interior with rose-violet light.*

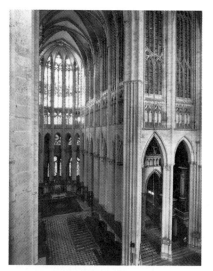

Choir of Beauvais Cathedral, begun 1272. *Beauvais Cathedral's linear design and pointed arches are characteristic of Gothic architecture.*

THE ART OF ARCHITECTURE. Medieval theologians believed a church's beauty would inspire parishioners to meditation and belief. As a result, churches were much more than just assembly halls. They were texts, with volumes of ornaments preaching the path to salvation. The chief forms of inspirational decoration in Gothic cathedrals were sculpture, stained glass, and tapestries.

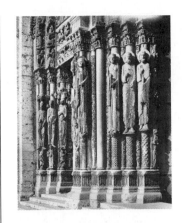

Jamb statues, Royal Portals, Chartres Cathedral, 1145–70.

SCULPTURE: LONG AND LEAN. Cathedral exteriors displayed carved Biblical tales. The Early Gothic sculptures of Chartres (pronounced shartr) and the High Gothic stone figures of Reims (pronounced ranz) Cathedral show the evolution of medieval art.

The Chartres figures of Old Testament kings and queens (1140–50) are pillar people, elongated to fit the narrow columns that house them. Drapery lines are as thin and straight as the bodies, with few traces of naturalism. By the time the jamb figures of Reims were carved, around 1225–90, sculptors for the first time since antiquity approached sculpture in-the-round. These figures are almost detached from their architectural background, standing out from the column on pedestals. After the writings of Aristotle were discovered, the body was no longer despised but viewed as the envelope of the soul, so artists once again depicted flesh naturally.

"The Visitation," jamb statues of west façade, **Reims Cathedral,** c. 1225–90, France. *Sculpture developed from stiff, disproportionately long figures (above) to a more rounded, natural style.*

In "The Visitation," both the Virgin Mary and her kinswoman, Elizabeth, lean primarily on one leg, their upper bodies turned toward each other. The older Elizabeth has a wrinkled face, full of character, and drapery is handled with more imagination than before.

Rose window, Chartres Cathedral, 13th century. *Thousands of pieces of glass, tinted with chemicals like cobalt and manganese, were bound together with strips of lead, which also outlined component figures.*

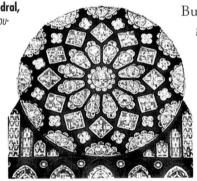

STAINED GLASS. Chartres Cathedral was the visible soul of the Middle Ages. Built to house the veil of the Virgin given to the city by Charlemagne's grandson, Charles the Bald, in 876, it is a multi-media masterpiece. Its stained glass windows, the most intact collection of medieval glass in the world, measure 26,900 feet in total area. Illustrating the Bible, the lives of saints, even traditional crafts of France, the windows are like a gigantic, glowing, illuminated manuscript.

TAPESTRY. Weavers in the Middle Ages created highly refined tapestries, minutely detailed with scenes of contemporary life. Large wool-and-silk hangings, used to cut drafts, decorated stone walls in chateaus and churches. Huge-scale paintings were placed behind the warp (or lengthwise threads) of a loom in order to imitate the design in cloth.

A series of seven tapestries represents the unicorn legend. According to popular belief, the only way to catch this mythical beast was to use a virgin sitting in the forest as bait. The trusting unicorn would go to sleep with his head in her lap and awaken caged. The captured unicorn is chained to a pomegranate tree, a symbol of both fertility and, because it contained many seeds within one fruit, the church. During the Renaissance, the unicorn was linked with courtly love, but in the tapestry's ambiguous depiction both lying down and rearing up, he symbolizes the resurrected Christ.

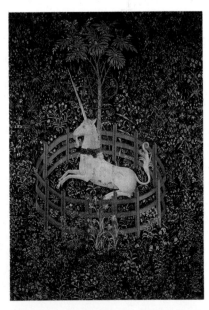

"The Unicorn in Captivity," c. 1500, The Cloisters, MMA, NY.

The Rebirth of Art: Renaissance and Baroque

ALL ROADS LEAD FROM FLORENCE

The Renaissance from the Early Renaissance in Florence and
High Renaissance in Rome and Venice to points North, East, and West

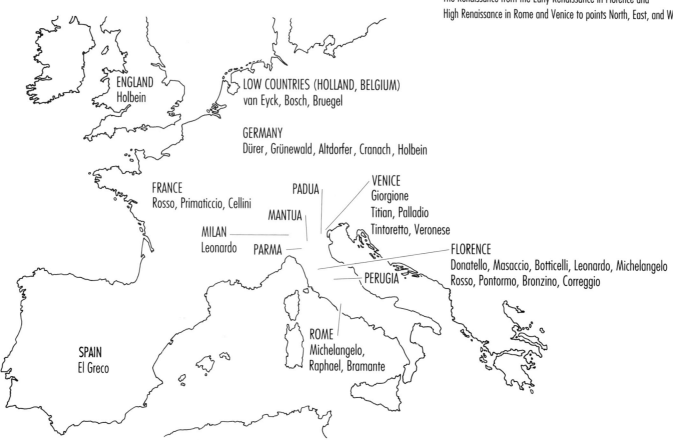

ENGLAND
Holbein

LOW COUNTRIES (HOLLAND, BELGIUM)
van Eyck, Bosch, Bruegel

GERMANY
Dürer, Grünewald, Altdorfer, Cranach, Holbein

FRANCE
Rosso, Primaticcio, Cellini

PADUA

VENICE
Giorgione
Titian, Palladio
Tintoretto, Veronese

MANTUA

MILAN
Leonardo

PARMA

FLORENCE
Donatello, Masaccio, Botticelli, Leonardo, Michelangelo
Rosso, Pontormo, Bronzino, Correggio

PERUGIA

SPAIN
El Greco

ROME
Michelangelo,
Raphael, Bramante

The Middle Ages are so called because they fall between twin peaks of artistic glory: the Classical period and the Renaissance. While art hardly died in the Middle Ages, what was reborn in the Renaissance — and extended in the Baroque period — was lifelike art. A shift in interest from the supernatural to the natural caused this change. The rediscovery of the Greco-Roman tradition helped artists reproduce visual images accurately. Aided by the expansion of scientific knowledge, such as an understanding of anatomy and perspective, painters of the fifteenth through sixteenth centuries went beyond Greece and Rome in technical proficiency.

In the Baroque period of the seventeenth and eighteenth centuries, reverence for Classicism persisted, but everything revved up into overdrive. Ruled by absolute monarchs, the newly centralized states produced theatrical art and architecture of unprecedented grandeur, designed to overwhelm the senses and emotions.

WORLD HISTORY		ART HISTORY
	1400 – 1500	Early Renaissance
	1420s	Perspective discovered
Gutenberg invents printing with movable type	1446 – 50	
Medicis deposed in Florence, art center shifts to Rome	1492	
	1500 – 20	High Renaissance
Renaissance spreads to Northern Europe	1500 – 1600	
	1503 – 6	Leonardo paints "Mona Lisa"
	1508 – 12	Michelangelo frescoes Sistine Chapel ceiling
	1509 – 11	Raphael creates Vatican frescoes
	1510	Giorgione paints first reclining nude
Balboa sights Pacific Ocean	1513	
Luther posts 95 Theses, Reformation begins	1517	
Magellan circumnavigates globe	1520	
	1520 – 1600	Mannerism
Rome sacked by Germans and Spanish	1527	
	1530s	Holbein paints British royalty
Henry VIII of England founds Anglican Church	1534	
	1534 – 41	Michelangelo works on "Last Judgment"
Copernicus announces planets revolve around sun	1543	
Elizabeth I reigns in England	1558 – 1603	
	1577	El Greco goes to Spain
England defeats Spanish Armada	1588	
Edict of Nantes establishes religious tolerance	1598	
	1601	Caravaggio paints "Conversion of St. Paul," Baroque begins
Galileo invents telescope	1609	
King James Bible published	1611	
Harvey discovers circulation of blood	1619	
Pilgrims land at Plymouth	1620	
	1630s	Van Dyck paints aristocracy
	1642	Rembrandt creates "Nightwatch"
	1645	Bernini designs Cornaro Chapel
	1648	Poussin establishes Classical taste, Royal French Academy of Painting and Sculpture founded
Charles I of England beheaded	1649	
	1656	Velázquez paints "Las Meninas"
	1668	Louis XIV orders Versailles enlarged
	1675	Wren designs St. Paul's Cathedral
Newton devises theory of gravity	1687	
Fahrenheit invents mercury thermometer	1714	
	1715	Louis XIV dies, French Rococo begins
Bach completes first Brandenburg Concerto	1720	
	1738	Pompeii and Herculaneum discovered
Catherine the Great rules Russia	1762	
James Watt invents steam engine	1765	
	1768	Reynolds heads Royal Academy
Priestley discovers oxygen	1774	
American colonies declare independence	1776	
	1784 – 85	David launches Neoclassicism
Mozart becomes court musician to Emperor Joseph II	1787	
French Revolution breaks out	1789	

THE RENAISSANCE: THE BEGINNING OF MODERN PAINTING

In the early 1400s, the world woke up. From its beginnings in Florence, Italy, this renaissance, or rebirth, of culture spread to Rome and Venice, then, in 1500, to the rest of Europe (known as the Northern Renaissance): the Netherlands, Germany, France, Spain, and England.

Common elements were the rediscovery of the art and literature of Greece and Rome, the scientific study of the body and the natural world, and the intent to reproduce the forms of nature realistically.

Aided by new technical knowledge like the study of anatomy, artists achieved new heights in portraiture, landscape, and mythological and religious paintings. As skills increased, the prestige of the artist soared, reaching its peak during the High Renaissance (1500–1520) with megastars like Leonardo, Michelangelo, and Raphael.

During the Renaissance, such things as the exploration of new continents and scientific research boosted man's belief in himself, while, at the same time, the Protestant Reformation decreased the sway of the church. As a result, the study of God the Supreme Being was replaced by the study of the human being. From the minutely detailed, realistic portraits of Jan van Eyck, to the emotional intensity of Dürer's woodcuts and engravings, to the contorted bodies and surreal lighting of El Greco, art was the means to explore all facets of life on earth.

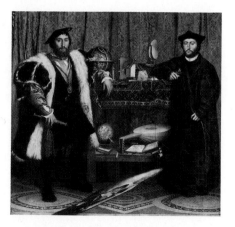

Hans Holbein the Younger, "The French Ambassadors," 1533, NG, London. *This portrait of two "universal men" expressed the versatility of the age. Objects like globes, compasses, sundials, lute, and hymnbook show wide-ranging interests from mathematics to music. Holbein fully exploited all the technical discoveries of the Renaissance: the lessons of composition, anatomy, realistic depiction of the human form through light and dark, lustrous color, and flawless perspective.*

Masaccio, "The Tribute Money," c. 1427, Santa Maria del Carmine, Florence. *Masaccio revolutionized painting through his use of perspective, a consistent source of light, and three-dimensional portrayal of the human figure.*

THE TOP FOUR BREAKTHROUGHS

During the Renaissance, technical innovations and creative discoveries made possible new styles of representing reality. The major breakthroughs were the change from tempera paint on wood panels and fresco on plaster walls to oil on stretched canvas and the use of perspective, giving weight and depth to form; the use of light and shadow, as opposed to simply drawing lines; and pyramidal composition in paintings.

1. OIL ON STRETCHED CANVAS. Oil on canvas became the medium of choice during the Renaissance. With this method, a mineral like lapis lazuli was ground fine, then mixed with turpentine and oil to be applied as oil paint. A greater range of rich colors with smooth gradations of tone permitted painters to represent textures and simulate three-dimensional form.

2. PERSPECTIVE. One of the most significant discoveries in the history of art was the method for creating the illusion of depth on a flat surface called "perspective," which became a foundation of European painting for the next 500 years. Linear perspective created the optical effect of objects receding in the distance through lines that appear to converge at a single point in the picture known as the vanishing point. (In Masaccio's "The Tribute Money," lines converge behind the head of Christ.) Painters also reduced the size of objects and muted colors or blurred detail as objects got farther away.

3. THE USE OF LIGHT AND SHADOW. Chiaroscuro (pronounced key arrow SKEWR o), which means "light/dark" in Italian, referred to the new technique for modeling forms in painting by which lighter parts seemed to emerge from darker areas, producing the illusion of rounded, sculptural relief on a flat surface.

4. PYRAMID CONFIGURATION. Rigid profile portraits and grouping of figures on a horizontal grid in the picture's foreground gave way to a more three-dimensional "pyramid configuration." This symmetrical composition builds to a climax at the center, as in Leonardo's "Mona Lisa," where the focal point is the figure's head.

THE EARLY RENAISSANCE: THE FIRST THREE HALL-OF-FAMERS

The Renaissance was born in Florence. The triumvirate of quattrocento (15th-century) geniuses who invented this new style included the painter Masaccio and sculptor Donatello, who reintroduced naturalism to art, and the painter Botticelli, whose elegant linear figures reached a height of refinement.

MASACCIO. The founder of Early Renaissance painting, which became the cornerstone of European painting for more than six centuries, was Masaccio (pronounced ma SAHT chee oh; 1401–28). Nicknamed "Sloppy Tom" because he neglected his appearance in his pursuit of art, Masaccio was the first since Giotto to paint the human figure not as a linear column, in the Gothic style, but as a real human being. As a Renaissance painter, Vasari said, "Masaccio made his figures stand upon their feet." Other Masaccio innovations were a mastery of perspective and his use of a single, constant source of light casting accurate shadows.

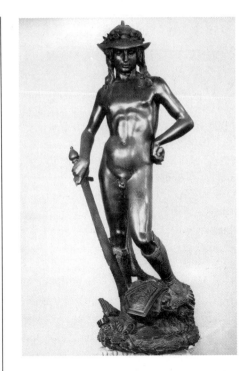

Donatello, "David," c. 1430–32, Museo Nazionale, Florence. *Donatello pioneered the Renaissance style of sculpture with rounded body masses.*

DONATELLO. What Masaccio did for painting, Donatello (1386–1466) did for sculpture. His work recaptured the central discovery of Classical sculpture: contrapposto, or weight concentrated on one leg with the rest of the body relaxed, often turned. Donatello carved figures and draped them realistically with a sense of their underlying skeletal structure.

His "David" was the first life-size, freestanding nude sculpture since the Classical period. The brutal naturalism of "Mary Magdalen" was even more probing, harshly accurate, and "real" than ancient Roman portraits. He carved the aged Magdalen as a gaunt, shriveled hag, with stringy hair and hollowed eyes. Donatello's sculpture was so lifelike, the artist was said to have shouted at it, "Speak, speak, or the plague take you!"

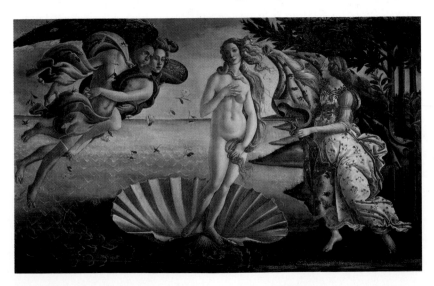

BOTTICELLI. While Donatello and Masaccio laid the groundwork for three-dimensional realism, Botticelli (pronounced bought tee CHEL lee; 1444–1510) was moving in the opposite direction. His decorative linear style and tiptoeing, golden-haired maidens were more a throwback to Byzantine art. Yet his nudes epitomized the Renaissance. "Birth of Venus" marks the rebirth of Classical mythology.

Botticelli, "Birth of Venus," 1482 , Uffizi, Florence. *Botticelli drew undulating lines and figures with long necks, sloping shoulders, and pale, soft bodies.*

THE ITALIAN RENAISSANCE

HEROES OF THE HIGH RENAISSANCE. In the sixteenth century, artistic leadership spread from Florence to Rome and Venice, where giants like Leonardo, Michelangelo, and Raphael created sculpture and paintings with total technical mastery. Their work fused Renaissance discoveries like composition, ideal proportions, and perspective — a culmination referred to as the High Renaissance (1500–1520).

LEONARDO DA VINCI. The term "Renaissance man" has come to mean an omnitalented individual who radiates wisdom. Its prototype was Leonardo (1452–1519), who came nearer to achieving this ideal than anyone before or since.

Leonardo was universally admired for his handsome appearance, intellect, and charm. His "personal beauty could not be exaggerated," a contemporary said of this tall man with long blond hair, "whose every movement was grace itself, and whose abilities were so extraordinary that he could readily solve every difficulty." As if this were not enough, Leonardo could sing "divinely" and "his charming conversation won all hearts."

Leonardo, "Mona Lisa," or "La Gioconda," 1503–6, Louvre, Paris. *The world's most famous portrait embodied all the Renaissance discoveries of perspective, anatomy, and composition.*

An avid mountain climber who delighted in scaling great heights, Leonardo was also fascinated with flight. Whenever he saw caged birds, he paid the owner to set them free. He frequently sketched fluttering wings in his notebooks, where he constantly designed flying contraptions that he eventually built and strapped on himself in hopes of soaring. He once wrote, "I wish to work miracles," an ambition evident in his inventions: a machine to move mountains, a parachute, a helicopter, an armored tank, and a diving bell.

Leonardo did more to create the concept of the artist-genius than anyone else. When he began his campaign, the artist was considered a menial craftsman. By constantly stressing the intellectual aspects of art and creativity, Leonardo transformed the artist's public status into, as he put it, a "Lord and God."

His brilliance had one flaw. The contemporary painter Vasari called Leonardo "capricious and fickle." His curiosity was so omnivorous that distractions constantly lured him from one incomplete project to another. When commissioned to paint an altarpiece, he first had to study tidal movements in the Adriatic, then invent systems to prevent landslides. A priest said Leonardo was so obsessed with his mathematical experiments "that he cannot stand his brushes."

Less than twenty works by Leonardo survive. He died at age 75 in France, where he had been summoned by Francis I for the sole duty of conversing with the king. On his deathbed, said Vasari, Leonardo admitted "he had offended God and mankind by not working at his art as he should have."

MONA LISA

It hung in Napoleon's bedroom until moving to the Louvre in 1804. It caused traffic jams in New York when 1.6 million people jostled to see it in seven weeks. In Tokyo viewers were allowed ten seconds. The object of all this attention was the world's most famous portrait, "Mona Lisa."

Historically, she was nobody special, probably the young wife of a Florentine merchant named Giocondo (the prefix "Mona" was an abbreviation of Madonna, or Mrs.). The portrait set the standard for High Renaissance paintings in many important ways. The use of perspective, with all lines converging on a single vanishing point behind Mona Lisa's head, and triangular composition established the importance of geometry in painting. It diverged from the stiff, profile portraits that had been the norm by displaying the subject in a relaxed, natural, three-quarter pose. For his exact knowledge of anatomy so evident in the Mona Lisa's hands, Leonardo had lived in a hospital, studying skeletons and dissecting more than thirty cadavers.

One of the first easel paintings intended to be framed and hung on a wall, the "Mona Lisa" fully realized the potential of the new oil medium. Instead of proceeding from outlined figures, as painters did before, Leonardo used chiaroscuro to model features through light and shadow. Starting with dark undertones, he built the illusion of three-dimensional features through layers and layers of thin, semi-transparent glazes (Even the Mona Lisa's pupils were composed of successive gauzy washes of pigment). This "sfumato" technique rendered the whole, as Leonardo said, "without lines or borders, in the manner of smoke." His colors ranged from light to dark in a continuous gradation of subtle tones, without crisp separating edges. The forms seemed to emerge from, and melt into, shadows.

And then there's that famous smile. To avoid the solemnity of most formal portraits, Leonardo engaged musicians and jesters to amuse his subject. Although he frequently left his works incomplete because of frustration when his hand could not match his imagination, this work was instantly hailed as a masterpiece, influencing generations of artists. In 1911 an Italian worker, outraged that the supreme achievement of Italian art resided in France, stole the painting from the Louvre to return it to its native soil. "Mona Lisa" was recovered from the patriotic thief's dingy room two years later in Florence.

By 1952 more than 61 versions of the Mona Lisa had been created. From Marcel Duchamp's goateed portrait in 1919 to Andy Warhol's silkscreen series and Jasper Johns's image in 1983, the Mona Lisa is not only the most admired, but also the most reproduced, image in all art.

THE LAST SUPPER

If "Mona Lisa" is Leonardo's most famous portrait, his fresco painting, "The Last Supper," has for five centuries been the world's most revered religious painting. Leonardo declared the artist has two aims: to paint the "man and the intention of his soul." Here he revolutionized art by capturing both, particularly what was going through each figure's mind.

Leonardo immortalized the dramatic moment after Christ announced one of his disciples would betray him, with each reacting emotionally and asking, "Lord, is it I?" Through a range of gesture and expression, Leonardo revealed for the first time in art the fundamental character and psychological state of each apostle. His use of perspective, with all diagonal lines converging on Christ's head, fixed Christ as the apex of the pyramidal composition.

Unfortunately, Leonardo was not temperamentally suited to the demands of traditional fresco painting, which required quick, unerring brushwork instead of accumulated blurred shadings. In "The Last Supper," he experimented with an oil/tempera emulsion of his own invention that failed to bond to the plaster. Even during his lifetime, the mural began to disintegrate. It didn't help that the building was used as a stable and then partly destroyed in World War II. Behind a barricade of sandbags, mildew reduced the fresco to a sad ruin. Today it is being restored square inch by square inch.

Leonardo, "The Last Supper," c. 1495, Santa Maria delle Grazie, Milan.
Leonardo revealed the disciples' character through facial expressions and gestures.

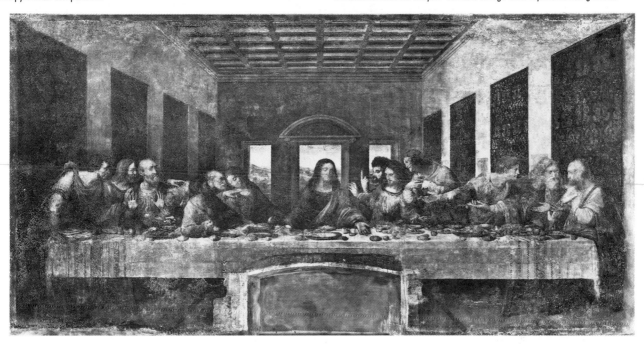

Leonardo, "In the Womb," c. 1510, Royal Collection, Windsor Castle.

The Notebooks

Evidence of Leonardo's fertile imagination lies in the thousands of pages of sketches and ideas in his notebooks. His interests and expertise encompassed anatomy, engineering, astronomy, mathematics, natural history, music, sculpture, architecture, and painting, making him one of the most versatile geniuses ever. Although the notes were unknown to later scientists, Leonardo anticipated many of the major discoveries and inventions of succeeding centuries. He built canals, installed central heating, drained marshes, studied air currents, and invented a printing press, telescope, and portable bombs. From his study of blood vessels, he developed the theory of circulation 100 years before Harvey. He was the first to design a flying machine and first to illustrate the interior workings of the human body. His sketches of the growth of the fetus in the womb were so accurate they could teach embryology to medical students today.

MICHELANGELO: THE DIVINE M. As an infant, Michelangelo (1475–1564) was cared for by a wet nurse whose husband was a stonecutter. The boy grew up absorbed with carving, drawing, and art, even though his family beat him severely to force him into a "respectable" profession. But the Medici prince Lorenzo the Magnificent recognized the boy's talent and, at the age of 15, took Michelangelo to his Florentine court, where the budding artist lived like a son.

Michelangelo did more than anyone to elevate the status of the artist. Believing that creativity was divinely inspired, he broke all rules. Admirers addressed him as the "divine Michelangelo," but the price for his gift was solitude. Michelangelo once asked his rival, the gregarious Raphael, who was always surrounded by courtiers, "Where are you going in such company, as happy as a Monsignor?" Raphael shot back, "Where are you going, all alone like a hangman?"

Michelangelo refused to train apprentices or allow anyone to watch him work. When someone said it was too bad he never married and had heirs, Michelangelo responded, "I've always had only too harassing a wife in this demanding art of mine, and the works I leave behind will be my sons." He was emotional, rough and uncouth, happy only when working or hewing rock at the marble quarry. His wit could be cruel, as when he was asked why the ox in another artist's painting was so much more convincing than other elements. "Every painter," Michelangelo said, "does a good self-portrait."

An architect, sculptor, painter, poet, and engineer, Michelangelo acknowledged no limitations. He once wanted to carve an entire mountain into a colossus. Michelangelo lived until nearly 90, carving until he died. His deathbed words: "I regret that I am dying just as I am beginning to learn the alphabet of my profession."

WHO PAID THE BILLS?

Before there were art galleries and museums, artists depended on the patronage system not only to support themselves but to provide expensive materials for their work. Under the inspired taste of Lorenzo the Magnificent, this resulted in an entire city — Florence — becoming a work of art, as wealthy rulers commissioned lavish buildings and art. Yet, significantly, the word for "patron" is the same in both French and Italian as the word for "boss." With irascible artists like Michelangelo, the tension between being a creator and being told what to create erupted in ugliness. The best example of the strengths and weaknesses of the system was Michelangelo's testy relation to his Medici patrons.

Michelangelo owed his training to Lorenzo de'Medici, but Lorenzo's insensitive son ordered the maestro to sculpt a statue out of snow in the palazzo courtyard. Years later, Medici popes Leo X and Clement VII (the sculptor worked for seven of the thirteen popes who reigned during his lifetime) hired Michelangelo to drop other work and sculpt tomb statues for their relatives. When the stone faces of the deceased bore no resemblance to actual appearance, Michelangelo would brook no interference with his ideal concept, saying that, in 100 years, no one would care what his actual subjects looked like. Unfortunately, the works remain unfinished, for his fickle patrons constantly changed their minds, abruptly cancelling, without explanation and often without pay, projects Michelangelo worked on for years.

Michelangelo's worst taskmaster was Pope Julius II, the "warrior-pope" who was bent on restoring the temporal power of the papacy. Julius had grandiose designs for his own tomb, which he envisioned as the centerpiece of a rebuilt St. Peter's Cathedral. He first commissioned Michelangelo to create forty life-size marble statues to decorate a mammoth two-story structure. The project tormented Michelangelo for forty years as Julius and his relatives gradually whittled down the design and interrupted his progress with distracting assignments. When referring to the commission, Michelangelo darkly called it the "Tragedy of the Tomb."

Michelangelo, "Pietà,"
1498/99–1500, St. Peter's, Rome.
Michelangelo's first masterpiece groups Christ and the Virgin in a pyramidal composition.

THE SCULPTOR. Of all artists, Michelangelo felt the sculptor was most godlike. God created life from clay, and the sculptor unlocked beauty from stone. He described his technique as "liberating the figure from the marble that imprisons it." While other sculptors added pieces of marble to disguise their mistakes, Michelangelo always carved his sculptures from one block. "You could roll them down a mountain and no piece would come off," said a fellow sculptor.

The first work to earn him renown, carved when Michelangelo was 23, was the "Pietà," which means "pity." The pyramidal arrangement derived from Leonardo, with the classic composure of the Virgin's face reflecting the calm, idealized expressions of Greek sculpture. The accurate anatomy of Christ's body is due to Michelangelo's dissection of corpses. When first unveiled, a viewer attributed the work to a more experienced sculptor, unable to believe a young unknown could accomplish such a triumph. When Michelangelo heard, he carved his name on a ribbon across the Virgin's breast, the only work he ever signed.

THE PAINTER: THE SISTINE CHAPEL. A few vines on a blue background — that's all Pope Julius II asked for, to spruce up the barnlike ceiling of the Sistine Chapel. What the artist gave him was more than 340 human figures (10' to 18' tall) representing the origin and fall of man — the most ambitious artistic undertaking of the whole Renaissance. The fact that Michelangelo accomplished such a feat in less than four years, virtually without assistance, was a testimonial to his single-mindedness.

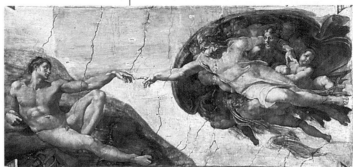

Michelangelo, "The Creation of Adam," detail, 1508–12, Sistine Chapel, Vatican, Rome. *A Zeus-like God transmits the spark of life to Adam. Michelangelo used the male nude to express every human aspiration and emotion.*

Physical conditions alone presented a formidable challenge. Nearly one-half the length of a football field, the ceiling presented 10,000 square feet to be designed, sketched, plastered, and painted. The roof leaked, which made the plaster too damp. The curved shape of the barrel vault divided by cross vaults made Michelangelo's job doubly hard. In addition, he had to work on a seven-story-high scaffold in a cramped and uncomfortable position.

Despite his disdain for painting, which he considered an inferior art, Michelangelo's fresco was a culmination of figure painting, with the figures drawn not from the real world but from a world of his own creation. The nudes, which had never been painted on such a colossal scale, are simply presented, without background or ornament. As in his sculpture, the torsos are more expressive than the faces. His twisted nude forms have a relieflike quality, as if they were carved in colored stone.

Encompassing an entire wall of the Sistine Chapel is the "Last Judgment" fresco Michelangelo finished twenty-nine years after the ceiling. Its mood is strikingly gloomy. Michelangelo depicted Christ not as a merciful Redeemer but as an avenging Judge with such terrifying effect that Pope Paul III fell to his knees when he saw the fresco. "Lord, hold not my sins against me!" the pope cried. Here, too, Michelangelo showed his supreme ability to present human forms in motion, as nearly 400 contorted figures struggled, fought, and tumbled into hell.

Michelangelo, "The Last Judgment," detail, 1541, Sistine Chapel, Rome. *St. Bartholomew, a martyr who was flayed alive, holds up his skin with a grotesque self-portrait of Michelangelo.*

Michelangelo, Campidoglio, 1538–64, Rome. *Michelangelo broke Renaissance rules by designing this piazza with interlocking ovals and variations from right angles.*

THE ARCHITECT. In his later years, Michelangelo devoted himself to architecture, supervising the reconstruction of Rome's St. Peter's Cathedral. Given his lifelong infatuation with the body, it's no wonder Michelangelo believed "the limbs of architecture are derived from the limbs of man." Just as arms and legs flank the trunk of the human form, architectural units, he believed, should be symmetrical, surrounding a central, vertical axis.

The best example of his innovative style was the Capitoline Hill in Rome, the first great Renaissance civic center. The hill had been the symbolic heart of ancient Rome, and the pope wanted to restore it to its ancient grandeur. Two existing buildings already abutted each other at an awkward 80° angle. Michelangelo made an asset of this liability by adding another building at the same angle to flank the central Palace of Senators. He then redesigned the facade of the lateral buildings so they would be identical and left the fourth side open, with a panoramic view toward the Vatican.

Unifying the whole was a statue of Emperor Marcus Aurelius (see p. 17) on a patterned oval pavement. Renaissance architects considered the oval "unstable" and avoided it, but for Michelangelo, measure and proportion were not determined by mathematical formulae but "kept in the eyes."

RAPHAEL. Of the three major figures of the High Renaissance school (Leonardo, Michelangelo, and Raphael), Raphael (pronounced rah fa yell; 1483–1520) would be voted Most Popular. While the other two were revered and their work admired, Raphael was adored. A contemporary of the three men, Vasari, who wrote the first art history, said Raphael was "so gentle and so charitable that even animals loved him."

Raphael's father, a mediocre painter, taught his precocious son the rudiments of painting. By the age of 17, Raphael was rated an independent master. Called to Rome by the pope at age 26 to decorate the Vatican rooms, Raphael completed the frescoes, aided by an army of fifty students, the same year Michelangelo finished the Sistine ceiling. "All he knows," said Michelangelo, "he learned from me."

The rich, handsome, wildly successful Raphael went from triumph to triumph, a star of the brilliant papal court. He was a devoted lady's man, "very amorous," said Vasari, with "secret pleasures beyond all measure." When he caught a fever after a midnight assignation and died on his thirty-seventh birthday, the entire court "plunged into grief."

Raphael's art most completely expressed all the qualities of the High Renaissance. From Leonardo he borrowed pyramidal composition and learned to model faces with light and shadow (chiaroscuro). From Michelangelo, Raphael adapted full-bodied, dynamic figures and the contrapposto pose.

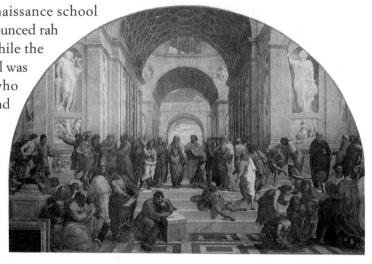

Raphael, "School of Athens," 1510–11, Vatican, Rome. *Raphael's masterpiece embodies the High Renaissance in its balance, sculptural quality, architectural perspective, and fusion of pagan and Christian elements.*

Titian, "Bacchanal of the Adrians," 1518, Prado, Madrid. *This pagan wine party contains the major ingredients of Titian's early style: dazzling contrasting colors, ample female forms, and asymmetric compositions.*

TITIAN: THE FATHER OF MODERN PAINTING. Like his fellow Venetian painters, Titian (pronounced TISH un; 1490?–1576), who dominated the art world in the city for sixty years, used strong colors as his main expressive device. First he covered the surface of the canvas with red for warmth, then he painted both background and figures in vivid hues and toned them down with thirty or forty layers of glazes. Through this painstaking method, he was able to portray any texture completely convincingly, whether polished metal, shiny silk, red-gold hair, or warm flesh. One of the first to abandon wood panels, Titian established oil on canvas as the typical medium.

After his wife died in 1530, Titian's paintings became more muted, almost monochromatic. Extremely prolific until his late 80s, as his sight failed Titian loosened his brushstrokes. At the end they were broad, thickly loaded with paint, and slashing. A pupil reported that Titian "painted more with his fingers than with his brushes."

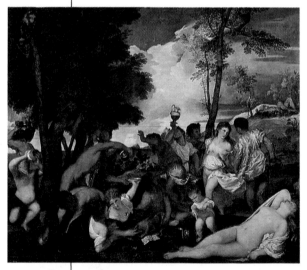

THE VENETIAN SCHOOL

While artists working in Florence and Rome concentrated on sculptural forms and epic themes, Venetian painters were fascinated with color, texture, and mood. Giovanni Bellini (1430–1516) was the first Italian master of the new oil painting technique. Titian's mentor, Bellini was also the first to integrate figure and landscape. Giorgione (1476–1510) aroused emotion through light and color. In his "Tempest," a menacing storm cloud created a sense of gloom and mystery. After Titian — the most famous of Venetian artists — Tintoretto and Veronese continued the large-scale, majestic style of deep coloring and theatricality. In the eighteenth century, the Rococo painter Tiepolo carried on the Venetian tradition, as did Guardi and Canaletto in their atmospheric cityscapes.

ARCHITECTURE IN THE ITALIAN RENAISSANCE. Informed by the same principles of harmonious geometry that underlay painting and sculpture, architecture recovered the magnificence of ancient Rome. The most noted Renaissance architects were Alberti, Brunelleschi, Bramante, and Palladio.

A writer, painter, sculptor, and architect, Alberti (pronounced al BEAR tee; 1404–72) was the Renaissance's major theorist who wrote treatises on painting, sculpture, and architecture. He downplayed art's religious purpose and urged artists to study "sciences" like history, poetry, and mathematics as building blocks. Alberti wrote the first systematic guide to perspective and provided sculptors with rules for ideal human proportions.

Another multifaceted Renaissance man, Brunelleschi (pronounced brew nell LESS kee; 1377–1446) was skilled as a goldsmith, sculptor, mathematician, clock builder, and architect. But he is best known as the father of modern engineering. Not only did he discover mathematical perspective, he also championed the central-plan church design that replaced the medieval basilica. He alone was capable of constructing a dome for the Florence Cathedral, called the Eighth Wonder of the World. His inspiration was to build two shells, each supporting the other, crowned by a lantern stabilizing the whole. In designing the Pazzi Chapel, Brunelleschi used Classical motifs as surface decoration. His design illustrates the revival of Roman forms and Renaissance emphasis on symmetry and regularity.

In 1502, Bramante (pronounced brah MAHN tee; 1444–1514) built the Tempietto ("Little Temple") in Rome on the site where St. Peter was crucified. Although tiny, it was the perfect prototype of the domed central plan church. It expressed the Renaissance ideals of order, simplicity, and harmonious proportions.

Known for his villas and palaces, Palladio (pronounced pah LAY dee oh; 1508–80) was enormously influential in later centuries through his treatise, *Four Books on Architecture*. Neoclassical revivalists like Thomas Jefferson and Christopher Wren, architect of St. Paul's in London, used Palladio's rule book as a guide. The Villa Rotonda incorporated Greek and Roman details like porticos with Ionic columns, a flattened dome like the Pantheon, and rooms arranged symmetrically around a central rotunda.

THE FOUR R'S OF RENAISSANCE ARCHITECTURE

The four R's of Renaissance architecture are Rome, Rules, Reason, and 'Rithmetic.

ROME In keeping with their passion for the classics, Renaissance architects systematically measured Roman ruins to copy their style and proportion. They revived elements like the rounded arch, concrete construction, domed rotunda, portico, barrel vault, and column.

RULES Since architects considered themselves scholars rather than mere builders, they based their work on theories, as expressed in various treatises. Alberti formulated aesthetic rules that were widely followed.

REASON Theories emphasized architecture's rational basis, grounded in science, math, and engineering. Cool reason replaced the mystical approach of the Middle Ages.

'RITHMETIC Architects depended on arithmetic to produce beauty and harmony. A system of ideal proportions related parts of a building to each other in numerical ratios, such as the 2:1 ratio of a nave twice as high as the width of a church. Layouts relied on geometric shapes, especially the circle and square.

Brunelleschi, Pazzi Chapel, 1440–61, Florence.

Bramante, Tempietto, 1444–1514, Rome.

Palladio, Villa Rotonda, begun 1550, Vicenza.

THE NORTHERN RENAISSANCE

In the Netherlands as well as in Florence, new developments in art began about 1420. But what was called the Northern Renaissance was not a rebirth in the Italian sense. Artists in the Netherlands — modern Belgium (then called Flanders) and Holland — lacked Roman ruins to rediscover. Still, their break with the Gothic style produced a brilliant flowering of the arts.

While the Italians looked to Classical antiquity for inspiration, northern Europeans looked to nature. Without Classical sculpture to teach them ideal proportions, they painted reality exactly as it appeared, in a detailed, realistic style. Portraits were such faithful likenesses that Charles VI of France sent a painter to three different royal courts to paint prospective brides, basing his decision solely on the portraits.

This precision was made possible by the new oil medium, which Northern Renaissance painters first perfected. Since oil took longer to dry than tempera, they could blend colors. Subtle variations in light and shade heightened the illusion of three-dimensional form. They also used "atmospheric perspective" — the increasingly hazy appearance of objects farthest from the viewer — to suggest depth.

	As the Renaissance spread north from Italy, it took different forms.	
ITALIAN RENAISSANCE ART	**VS.**	**NORTHERN RENAISSANCE ART**
SPECIALTY:	Ideal beauty	Intense realism
STYLE:	Simplified forms, measured proportions	Lifelike features, unflattering honesty
SUBJECTS:	Religious and mythological scenes	Religious and domestic scenes
FIGURES:	Heroic male nudes	Prosperous citizens, peasants
PORTRAITS:	Formal, reserved	Reveal individual personality
TECHNIQUE:	Fresco, tempera, and oil paintings	Oil paintings on wood panels
EMPHASIS:	Underlying anatomical structure	Visible appearance
BASIS OF ART:	Theory	Observation
COMPOSITION:	Static, balanced	Complex, irregular

THE RENAISSANCE IN THE LOW COUNTRIES

In Holland and Flanders, cities like Bruges, Brussels, Ghent, Louvain, and Haarlem rivaled Florence, Rome, and Venice as centers of artistic excellence. The trademark of these northern European artists was their incredible ability to portray nature realistically, down to the most minute detail.

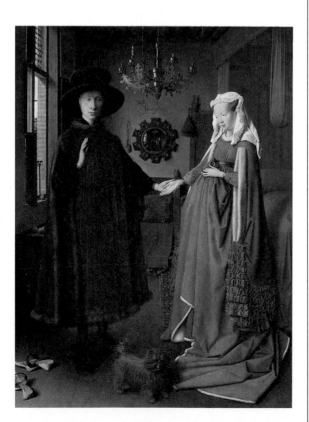

JAN VAN EYCK. Credited with inventing oil painting, the Flemish artist Hubert van Eyck was so idolized for his discovery that his right arm was preserved as a holy relic. His brother, Jan van Eyck (c.1390–1441), about whom more is known, used the new medium to achieve a peak of realism.

Trained as a miniaturist and illuminator of manuscripts, Jan van Eyck painted convincingly the most microscopic details in brilliant, glowing color. One of the first masters of the new art of portrait painting, van Eyck included extreme details like the beginning of stubble on his subject's chin. His "Man in a Red Turban," which may be a self-portrait (1433), was the earliest known painting in which the sitter looked at the spectator. In one of the most celebrated paintings of the Northern Renaissance, "The Arnolfini Wedding," van Eyck captures surface appearance and textures precisely and renders effects of both direct and diffused light.

Van Eyck, "Arnolfini Wedding," 1434, NG, London. *A master of realism, van Eyck recreated the marriage scene, in miniature in the mirror. Virtually every object symbolizes the painting's theme — the sanctity of marriage — with the dog representing fidelity and the cast-off shoes holy ground.*

BOSCH: GARDEN OF THE GROTESQUE. It's not hard to understand why twentieth-century Surrealists claimed Dutch painter Hieronymous Bosch (c. 1450–1516) as their patron saint. The modern artists exploited irrational dream imagery but hardly matched Bosch's bizarre imagination.

Bosch's moralistic paintings suggested inventive torments meted out as punishment for sinners. Grotesque fantasy images — such as hybrid monsters, half-human, half-animal — inhabited his weird, unsettling landscapes. Although modern critics have been unable to decipher his underlying meanings, it seems clear Bosch believed that corrupt mankind, seduced by evil, should suffer calamitous consequences.

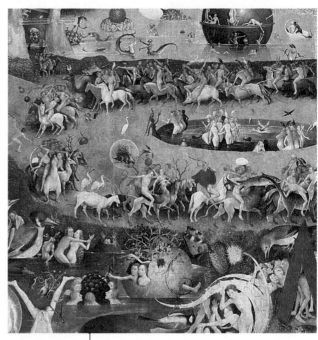

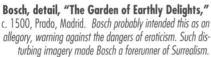

Bosch, detail, "The Garden of Earthly Delights," c. 1500, Prado, Madrid. *Bosch probably intended this as an allegory, warning against the dangers of eroticism. Such disturbing imagery made Bosch a forerunner of Surrealism.*

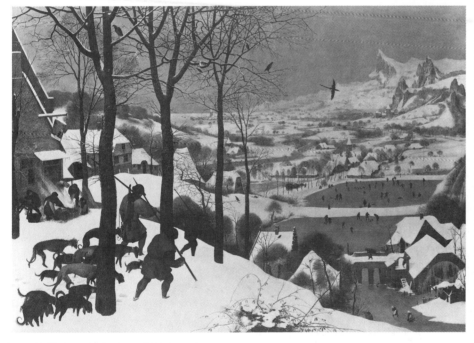

Bruegel, "Hunters in the Snow," 1565, Kunsthistorisches Museum, Vienna. *Bruegel portrayed peasants both honestly and satirically.*

BRUEGEL: PAINTER OF PEASANTS. Flemish painter Pieter Bruegel the Elder (pronounced BROY gull; c.1525–69) was influenced by Bosch's pessimism and satiric approach. Bruegel took peasant life as his subject. In his scenes of humble folk working, feasting, or dancing, the satiric edge always appeared. "The Peasant Wedding," for example, features guests eating and drinking with gluttonous absorption. Besides elevating genre painting (scenes of everyday life) to the stature of high art, Bruegel also illustrated proverbs, such as "The Blind Leading the Blind," with horrific, bestial facial expressions typical of Bosch's Biblical scenes.

Bruegel's most famous painting, "Hunters in the Snow," came from a series depicting man's activities during the months of the year. His preoccupation with peasant life is shown in the exhausted hunters plodding homeward, silhouetted against the snow. Bruegel used atmospheric perspective — from sharp foreground to hazy background — to give the painting depth.

THE GERMAN RENAISSANCE

After lagging behind the innovative Netherlanders, German artists began to lead the Northern School. In the first quarter of the sixteenth century, Germans suddenly assimilated the pictorial advances of their Southern peers Leonardo, Michelangelo, and Raphael. Simultaneous with Italy's peak of artistic creativity was Germany's own High Renaissance, marked by Grünewald's searing religious paintings, Dürer's technically perfect prints, and Holbein's unsurpassed portraits.

***HOLBEIN:* PRINCELY PORTRAITS.** Hans Holbein the Younger (1497–1543), is known as one of the greatest portraitists ever. Like Dürer, he blended the strengths of North and South, linking the German skill with lines and precise realism to the balanced composition, chiaroscuro, sculptural form, and perspective of Italy.

Although born in Germany, Holbein first worked in Basel. When the Reformation decreed church decoration to be "popery" and his commissions disappeared, Holbein sought his fortune in England. His patron, the humanist scholar Erasmus, recommended him to the English cleric Sir Thomas More with the words, "Here [in Switzerland] the arts are out in the cold." Holbein's striking talent won him the position of court painter to Henry VIII, for whom he did portraits of the king and four of his wives.

"The French Ambassadors" (see p. 32) illustrates Holbein's virtuoso technique, with its linear patterning in the Oriental rug and damask curtain, accurate textures of fur and drapery, faultless perspective of the marble floor, sumptuous enameled color, and minute surface realism. The object in the foreground (a distorted skull) and numerous scholarly implements show the Northern penchant for symbolic knickknacks. Holbein depicted faces with the same accuracy as Dürer but with a neutral expression characteristic of Italy rather than the intensity of Dürer's portraits. Holbein's exquisite draftsmanship set the standard for portraits, the most important form of painting in England for the next three centuries.

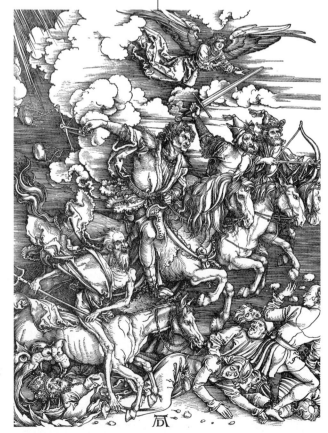

Dürer, "Four Horsemen of the Apocalypse," c. 1497–98, woodcut, MMA, NY. *Dürer used fine, engravinglike lines for shading. In this doomsday vision, the final Four Horsemen — war, pestilence, famine, and death — trample humanity.*

***DÜRER:* GRAPHIC ART.** The first Northern artist to be also a Renaissance man, Albrecht Dürer (pronounced DEWR er; 1471–1528) combined the Northern gift for realism with the breakthroughs of the Italian Renaissance. Called the "Leonardo of the North" for the diversity of his interests, Dürer was fascinated with nature and did accurate botanical studies of plants. Believing art should be based on careful scientific observation, he wrote, "Art stands firmly fixed in nature, and he who can find it there, he has it." This curiosity led, unfortunately, to his demise, as he insisted on tramping through a swamp to see the body of a whale and caught a fatal fever.

Dürer took as his mission the enlightenment of his Northern colleagues about the discoveries of the South. He published treatises on perspective and ideal proportion. He also assumed the mantle of the artist as cultivated gentleman-scholar, raising the artist's stature from mere craftsman to near prince. He was the first to be fascinated with his own image, leaving a series of self-portraits (the earliest done when he was 13). In his "Self-Portrait" of 1500, he painted himself in a Christ-like pose, indicating the exalted status of the artist, not to mention his high opinion of himself.

What assured Dürer's reputation as the greatest artist of the Northern Renaissance was his graphic work. Before Dürer, woodcuts were primitive studies of black and white contrasts. He adapted the form-creating hatching of engraving to the woodcut, achieving a sliding scale of light and shade. Like an engraver, he used dense lines to render differences in texture and tone as subtle as any oil painting. Dürer was the first to use printmaking as a major medium for art.

MAKING PRINTS: THE INVENTION OF GRAPHIC ARTS

One of the most popular (and still affordable) forms of art collecting in recent years has been limited-edition prints, each signed by the artist who oversees the reproduction process. The art of printmaking first flowered during the Northern Renaissance.

WOODCUT

The oldest technique for making prints (long known in China) was the woodcut, which originated in Germany about 1400. In this method, a design was drawn on a smooth block of wood, then the parts to remain white (called "negative space") were cut away, leaving the design standing up in relief. This was then inked and pressed against paper to produce thousands of copies sold for a few pennies each. For the first time, art was accessible to the masses and artists could learn from reproductions of each others' work. Once printing with movable type was developed around the mid-fifteenth century, books illustrated with woodcuts became popular.

Woodcuts reached a peak with Dürer but were gradually replaced by the more flexible and refined method of engraving. In Japan, the colored woodcut was always very popular. In the late nineteenth and early twentieth centuries in Europe, the woodcut enjoyed a revival, with Munch, Gauguin, and the German Expressionists adopting the medium for its jagged intensity.

ENGRAVING

Begun about 1430, engraving was a technique opposite to the woodcut's raised relief. The method was one of several in printmaking known as intaglio (ink transferred from below the surface), where prints are made from lines or crevices in a plate. In engraving, grooves were cut into a metal (usually copper) plate with a steel tool called a burin. Ink was rubbed into the grooves, the surface of the plate wiped clean, and the plate put through a press to transfer the incised design to paper. Forms could be modeled with fine-hatched lines to suggest shading. This technique flowered in the early sixteenth century with Dürer, whose use of the burin was so sophisticated, he could approximate on a copper plate the effects of light and mass achieved by the Dutch in oil and Italians in fresco.

Graphic arts techniques that became popular in later centuries include DRYPOINT, ETCHING, LITHOGRAPHY, and SILKSCREENING (see p. 109).

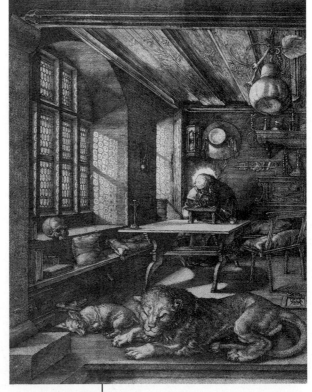

Dürer, "Saint Jerome," 1514, engraving, MMA, NY. *Through straight and curved hatching and crosshatching, Dürer depicted light streaming through bottle-glass windows, casting accurate shadows.*

OTHERS IN THE GERMAN RENAISSANCE

Besides Dürer and Holbein, notable artists were Matthias Grünewald (c. 1480–1528) and Albrecht Altdorfer (1480–1538). Grünewald's masterpiece, "The Eisenheim Altarpiece," shows the horror of the Crucifixion and glory of the Resurrection in a tableau of overwhelming power. Altdorfer, representative of the Danube Style, known for its moody landscapes, is credited with the first pure landscape painting in Western art.

MANNERISM AND THE LATE RENAISSANCE

Between the High Renaissance and the Baroque, from the death of Raphael in 1520 until 1600, art was at an impasse. Michelangelo and Raphael had been called "divino." Kings begged them for the slightest sketch. All problems of representing reality had been solved and art had reached a peak of perfection and harmony. So what now?

The answer: replace harmony with dissonance, reason with emotion, and reality with imagination. In an effort to be original, Late Renaissance, or Mannerist, artists abandoned realism based on observation of nature. Straining after novelty, they exaggerated the ideal beauty represented by Michelangelo and Raphael, seeking instability instead of equilibrium.

The times favored such disorder. Rome had been sacked by the Germans and Spaniards and the church had lost its authority during the Reformation. In the High Renaissance, when times were more stable, picture compositions were symmetrical and weighted toward the center. In the Late Renaissance, compositions were oblique, with a void in the center and figures crowded around — often cut off by — the edge of the frame. It was as if world chaos and loss of a unifying faith ("The center cannot hold," as W. B. Yeats later said) made paintings off-balance and diffuse.

The name "Mannerism" came from the Italian term "di maniera," meaning a work of art done according to an acquired style rather than depicting nature. Mannerist paintings are readily identifiable because their style is so predictable. Figures writhe and twist in unnecessary contrapposto. Bodies are distorted — generally elongated but sometimes grossly muscular. Colors are lurid, heightening the impression of tension, movement, and unreal lighting.

Notable Mannerists were Pontormo and Rosso (see sidebar); Bronzino, whose precious, elegant portraits featured long necks and sloping shoulders; Parmigiano, whose "Madonna with the Long Neck" displayed similar physical distortions; and Benvenuto Cellini, a sculptor and goldsmith known for his arrogant autobiography.

LIFE ON THE EDGE

Mannerists deliberately cultivated eccentricity in their work. Some were equally odd in their private lives. Rosso, who lived with a baboon, was said to have dug up corpses, fascinated with the process of decomposition. His canvases often had a sinister quality, as when he painted St. Anne like a haggard witch. On seeing one of his macabre works, a priest ran from the room shrieking the painter was possessed by the devil.

Pontormo was certifiably mad. A hypochondriac obsessed by fear of death, he lived alone in an especially tall house he had built to isolate himself. His garret room was accessible only by a ladder that he pulled up after himself. His paintings showed this bizarre sensibility. The perspective was irrational and his colors — lavender, coral, puce, poisonous green — unsettling. His figures often looked about wildly, as if sharing their creator's paranoid anxiety.

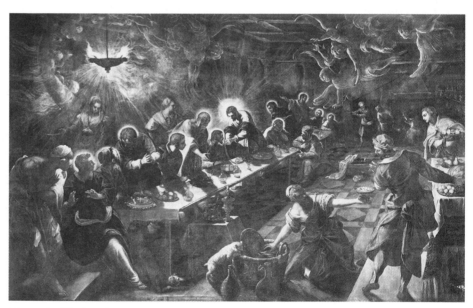

Tintoretto, "The Last Supper," 1594, San Giorgio Maggiore, Venice. *Tintoretto's (1518–94) crowded, dramatic canvases displayed obvious Mannerist traits like a plunging diagonal perspective, making the picture seem off-balance. He used light for emotional effect, from the darkest black to the incandescent light emanating from Christ's head and sketchy, chalk-white angels.*

THE SPANISH RENAISSANCE

The most remarkable figure of the Renaissance working in Spain was the painter El Greco (1541–1614). Born in Crete (then a possession of Venice), he received his first training in the flat, highly patterned Byzantine style. After coming to Venice, he appropriated Titian's vivid color and Tintoretto's dramatic lighting and was also influenced by Michelangelo, Raphael, and the Mannerists in Rome. His real name was Domenikos Theotocopoulos, but he was nicknamed "The Greek" and went to Toledo to work when about age 35.

At the time, Spain was in the grip of a religious frenzy, with the Counter Reformation and Inquisition holding sway. Many of El Greco's surreal, emotionally intense paintings reflected this climate of extreme zealotry.

A supremely self-confident artist, El Greco once said Michelangelo couldn't paint and offered to revamp "The Last Judgment." He also said he detested walking in sunlight because "the daylight blinds the light within." The most striking characteristic of his paintings comes from this inner light. An eerie, unearthly illumination flickers over the canvases, making his style the most original of the Renaissance.

Critics have disputed whether El Greco should be considered a Mannerist; some claim he was too idiosyncratic to be classified. His art manifested certain undeniable Mannerist attributes, such as an unnatural light of uncertain origin and harsh colors like strong pink, acid green, and brilliant yellow and blue. His figures were distorted and elongated — their scale variable — and the compositions full of swirling movement. Like the Mannerists, El Greco — in his religious

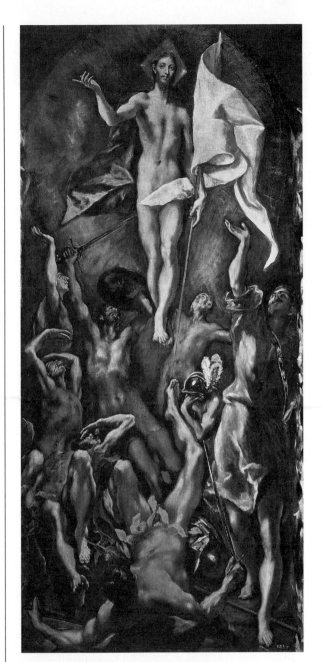

El Greco, "Resurrection," c. 1597–1604, Prado, Madrid. *Many characteristics of El Greco's late, mystical style are evident here: immensely long bodies, harsh light as if from a threatening storm, strong colors, twisted figures, sense of movement, and intense emotionalism.*

paintings although not his portraits — cared little for accurately representing the visual world. He preferred to create an emotion-laden vision of celestial ecstasy.

BEAUTY SECRETS OF THE SPANISH LADIES

Ridiculously elongated hands and slender figures were a hallmark of Mannerism. The fingers in an El Greco painting are characteristically long, thin, and expressive. Spanish ladies of the time so admired refined hands that they tied their hands to the top of the bedstead at night to make them pale and bloodless.

BAROQUE: THE ORNATE AGE

Baroque art (1600–1750) succeeded in marrying the advanced techniques and grand scale of the Renaissance to the emotion, intensity, and drama of Mannerism, thus making the Baroque era the most sumptuous and ornate in the history of art. While the term "baroque" is often used negatively to mean overwrought and ostentatious, the seventeenth century not only produced such exceptional artistic geniuses as Rembrandt and Velázquez but expanded the role of art into everyday life.

Artists now termed as Baroque came to Rome from all of Europe to study the masterpieces of Classical antiquity and the High Renaissance then returned to their homes to give what they learned their own particular cultural spin. Just as seventeenth-century colonists followed the sixteenth-century explorers, so too did these artists build upon past discoveries. While styles ranged from Italian realism to French flamboyance, the most common element throughout was a sensitivity to and absolute mastery of light to achieve maximum emotional impact.

The Baroque era began in Rome around 1600 with Catholic popes financing magnificent cathedrals and grand works to display their faith's triumph after the Counter Reformation and to attract new worshipers by overwhelming them with theatrical, "must-see" architecture. It spread from there to France, where absolute monarchs ruled by divine right and spent sums comparable to the pharaohs to glorify themselves. Palaces became enchanted environments designed to impress visitors with the power and grandeur of the king. Wealth flowing in from the colonies funded the elaborate furnishings, gardens, and art of showplaces like Louis XIV's Versailles. Though just as opulent as religious art, French paintings had nonreligious themes derived from Greek and Roman models, such as Poussin's calm landscapes populated by pagan deities.

In Catholic countries like Flanders, religious art flourished, while in the Protestant lands of northern Europe, such as England and Holland, religious imagery was forbidden. As a result, paintings tended to be still lifes, portraits, landscapes, and scenes from daily life. Patrons of art were not only prosperous merchants eager to show off their affluence but middle-class burghers buying pictures for their homes as well. From Rembrandt's "Nightwatch," characteristic of Northern Baroque art to Rubens's sensuous, highly colored panoramas typical of Catholic Baroque, art of the period had a theatrical, stage-lit exuberance and drama.

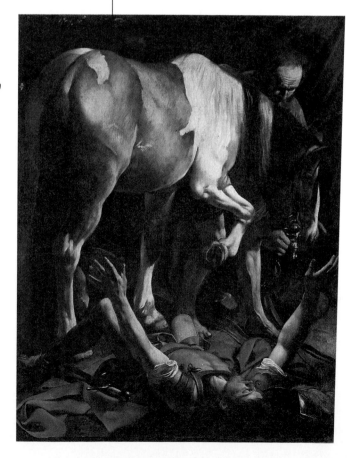

Caravaggio, "The Conversion of St. Paul," c. 1601, Santa Maria del Popolo, Rome. *Although criticized for portraying holy figures as common people, Caravaggio's radical style of sharp light and dark contrasts changed European art.*

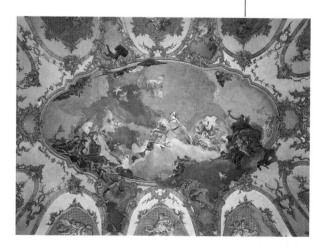

Tiepolo, "Apollo Conducts the Bride, Beatrice, to Babarossa of Burgundy," 1751–52 , Residenz Palace, Würzburg, Germany. *Tiepolo's ceiling fresco of gods and heroes floating heavenward showed the vigorous movement and vivid colors of Baroque art.*

ITALIAN BAROQUE

Artists in Rome pioneered the Baroque style before it spread to the rest of Europe. By this time, art academies had been established to train artists in the techniques developed during the Renaissance. Artists could expertly represent the human body from any angle, portray the most complex perspective, and realistically reproduce almost any appearance. Where Baroque diverged from Renaissance was the emphasis on emotion rather than rationality, dynamism rather than stasis. It was as if Baroque artists took Renaissance figures and set them spinning like tops. Three artists in different media best represent the pinnacle of Italian Baroque: the painter Caravaggio, the sculptor Bernini, and the architect Borromini.

***CARAVAGGIO:* THE SUPERNATURAL MADE REAL.** The most original painter of the seventeenth century, Caravaggio (1571–1610) injected new life into Italian painting after the sterile artificiality of Mannerism. He took realism to new lengths, painting bodies in a thoroughly "down and dirty" style, as opposed to pale, Mannerist phantoms. In so doing, Caravaggio secularized religious art, making saints and miracles seem like ordinary people and everyday events.

Although specializing in large religious works, Caravaggio advocated "direct painting" from nature — often, it seemed, directly from the seamy slums. In "The Calling of St. Matthew," for example, the apostle-to-be sits in a dark pub, surrounded by dandies counting money, when Christ orders him, "Follow Me." A strong diagonal beam of light illuminates the thunderstruck tax-collector's expression and gesture of astonishment.

In "Supper at Emmaus," Caravaggio showed the moment the apostles realized their table companion was the resurrected Christ as an encounter in a wineshop. The disciples, pushing back chairs and throwing open their arms and a bowl of wormy fruit about to topple off the table make the action leap out of the picture frame, enveloping the viewer in the drama. "The Conversion of St. Paul" demonstrates Caravaggio's ability to see afresh a traditional subject. Other painters depicted the Pharisee Saul converted by a voice from heaven with Christ on the heavenly throne surrounded by throngs of angels. Caravaggio showed St. Paul flat on his back, fallen from his horse, which is portrayed in an explicit rear-end view. The hard focus and blinding spotlight

THE FIRST BOHEMIAN ARTIST

If Caravaggio, as has been said, was the first artist intentionally seeking to shock and offend, he certainly succeeded. His contemporaries called him an "evil genius" and the "anti-Christ of painting," while the Victorian writer John Ruskin accused him of "perpetual . . . feeding upon horror and ugliness and filthiness of sin."

Caravaggio's life was as unorthodox as his art. A bohemian and rebel, Caravaggio consorted with the dregs of society. As we know from his lengthy police record, the surly artist was constantly brawling in taverns and streets. After stabbing a man in the groin over a tennis wager, he fled Rome to escape prosecution for murder. In chronic trouble with the law, Caravaggio wandered from city to city and from one lurid scandal to another.

Caravaggio was also disdainful of artistic convention and a very vocal opponent of tradition. When advised to study Classical models and adhere to Renaissance ideals of beauty, he instead hailed a gypsy off the street, preferring to paint this outcast rather than an idealized Greek goddess. Many thought he went too far when, in "Death of the Virgin," he used a drowned corpse as model for the Virgin, irreverently representing the Madonna with bare feet and swollen body, surrounded by grieving commoners. Although the painting was refused by the parish that commissioned it, the Duke of Mantua purchased it on the advice of his court painter, Rubens.

Caravaggio always insisted that back alleys, mean streets, and the unsavory folk he found there were the one true source of art, not rules decreed by others. After a stormy life, this radical talent died at the age of 37.

THE FIRST FEMINIST PAINTER

Caravaggio had many followers, called "i tenebrosi" or "the Caravaggisti," who copied his dark tonality and dramatic lighting in "night pictures." One of the most successful was the Italian Artemisia Gentileschi (1593–1653), the first woman painter to be widely known and appreciated. A precociously gifted artist who traveled widely and lived an eventful, independent life rare for a woman in that time, Gentileschi depicted feminist subjects in Caravaggio's style of brilliantly lighted main players against a plain, dark background.

As a 19-year-old art student, Gentileschi was raped by a fellow pupil and then subjected to a painful and humiliating trial in which she was tortured with thumbscrews to get her to recant. After her attacker was acquitted, Gentileschi devoted herself to painting women who wreak violence against men who have wronged them. In "Judith and Maidservant with the Head of Holofernes," Gentileschi painted the Hebrew heroine (in five different pictures) as an explicit self-portrait. Lit by a candle as the single source of light, the painting reeked with menace and terror, as Judith beheaded the lustful Babylonian general to save Israel.

reveal details like veins on the attendant's legs and rivets on Saul's armor, while inessential elements disappear in the dark background.

Caravaggio's use of perspective brings the viewer into the action, and chiaroscuro engages the emotions while intensifying the scene's impact through dramatic light and dark contrasts. This untraditional, theatrical staging focuses a harsh light from a single source on the subject in the foreground to concentrate the viewer's attention on the power of the event and the subject's response. Because of the shadowy background Caravaggio favored, his style was called "il tenebroso" (in a "dark manner").

Many of Caravaggio's patrons who commissioned altarpieces refused to accept his renditions, considering them vulgar or profane. However, Caravaggio's choice of disreputable, lower-class folk as suitable subjects for religious art expressed the Counter Reformation belief that faith was open to all.

To the contemporary French painter Poussin, known for his peaceful scenes, Caravaggio was a subversive betrayer of the art of painting. To the police, he was a fugitive wanted for murder (see sidebar, p. 47). But to major artists like Rubens, Velázquez, and Rembrandt, he was a daring innovator who taught them how to make religious paintings seem both hyperreal and overwhelmingly immediate.

BERNINI: SCULPTURE IN MOTION.

Gianlorenzo Bernini (1598–1610) was more than the greatest sculptor of the Baroque period. He was also an architect, painter, playwright, composer, and theater designer. A brilliant wit and caricaturist, he wrote comedies and operas when not carving marble as easily as clay. More than any other artist, with his public fountains, religious art, and designs for St. Peter's, he left his mark on the face of Rome.

The son of a sculptor, Bernini carved his remarkable marble "David" when age 25. Unlike Michelangelo's "David" (see p. 13) where the force was pent-up, Bernini's captured the moment of maximum torque, as he wound up to hurl the stone. Biting his lips from strain, Bernini's David conveyed power about to be unleashed, causing any observer standing in front of the statue to almost want to duck. This dynamic, explosive energy epitomized Baroque art and involved the viewer in its motion and emotion by threatening to burst its physical confines.

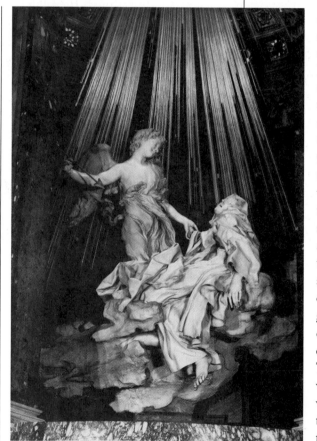

Bernini, "The Ecstasy of St. Theresa," 1645–52, Cornaro Chapel, Santa Maria della Vittoria, Rome. *Bernini fused sculpture, painting, and architecture in a total environment designed to overwhelm the emotions.*

"THE ECSTASY OF ST. THERESA."

Bernini's masterpiece — and the culmination of Baroque style — was "The Ecstasy of St. Theresa." He even designed a whole chapel as a stage set to show it off, including painted balconies on the walls filled with "spectators" sculpted in relief.

St. Theresa reportedly saw visions and heard voices, believing herself to have been pierced by an angel's dart infusing her with divine love. She described the mystical experience in near-erotic terms: "The pain was so great that I screamed aloud; but at the same time I felt such infinite sweetness that I wished the pain to last forever."

Bernini's marble sculpture represented the saint swooning on a cloud, an expression of mingled ecstasy and exhaustion on her face. Since the Counter Reformation Church stressed the value of its members reliving Christ's passion, Bernini tried to induce an intense religious experience in worshipers. He used all the resources of operatic stagecraft, creating a total artistic environment in the chapel. The saint and angel appear to be floating on swirling clouds, while golden rays of light pour down from a vault of heaven painted on the ceiling. The sculptor's virtuosity with textures made the white marble "flesh" seem to quiver with life, while the feathery wings and frothy clouds are equally convincing. The whole altarpiece throbs with emotion, drama, and passion.

ST. PETER'S CATHEDRAL

For most of his life, Bernini worked on commissions for Rome's St. Peter's Cathedral. The focal point of the church's interior was Bernini's bronze canopy-altar (known as a "baldachin") beneath the central dome marking the burial site of St. Peter. Taller than a ten-story building, this extravagant monument features four gigantic, grooved, spiral columns (covered with carved vines, leaves, and bees) that seem to writhe upward like corkscrews. The ensemble, including four colossal bronze angels at the corners of the canopy, is the essence of Baroque style. Its mixture of dazzling colors, forms, and materials produces an overwhelming and theatrical effect of imaginative splendor.

For a climactic spot at the end of the church, Bernini designed the Cathedra Petri, another mixed-media extravaganza to enshrine the modest wooden stool of St. Peter. The sumptuous composition includes four huge bronze figures supporting — almost without touching it — the throne, which is enveloped by flights of angels and billowing clouds. Everything appears to move, bathed in rays of golden light from a stained glass window overhead.

Outside the cathedral, Bernini designed the vast piazza and surrounded it with two curving, covered colonnades supported by rows of four columns abreast. Bernini planned arcades flanking the huge oval space to be like the Church's maternal, embracing arms, welcoming pilgrims to St. Peter's.

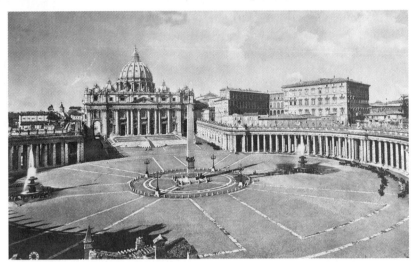

Aerial view of the piazza, St. Peter's Cathedral, Rome.

BORROMINI: DYNAMIC ARCHITECTURE. What Caravaggio did for painting, Francesco Borromini (1599–1667) did for architecture. Just as the painter's spotlighted subjects seem to leap out at the viewer, Borromini's undulating walls create a sense of being strobe-lit. The highly original work of both artists revolutionized their respective fields.

Borromini was a rebellious, emotionally disturbed genius who died by suicide. The son of a mason, he worked first as a stonecutter under Bernini, who later became his arch-rival. But, while Bernini employed up to thirty-nine assistants to execute his hastily sketched designs, the brooding, withdrawn Borromini worked obsessively on the most minute decorative details. He rejected countlesss ideas before saying "questo!" (this one) when he finally settled on a choice.

Even in buildings of modest dimensions, Borromini combined never-before-linked shapes in a startling fashion. The odd juxtaposition of concave and convex surfaces made his walls seem to ripple. Indeed, this quality and his complex floor plans have been compared to the multiple voices of a Bach organ fugue, both designed to produce a mood of exaltation.

Despite the bold elasticity of Borromini's buildings, the structures were unified and cohesive. The scalloped walls of St. Ivo's Church in Rome continuously taper to the top of a fantastic six-lobed dome, with the dome's frame being identical to the shape of the walls below — an organic part of a whole, as opposed to a separate Renaissance dome set upon a supporting block. The variety of curves and counter-curves typical of Borromini's work can be seen in San Carlo alle Quattro Fontane, where the serpentine walls seem in motion.

Borromini, facade, San Carlo alle Quattro Fontane, 1665–67, Rome. *Borromini's trademark was alternating convex and concave surfaces to create the illusion of movement.*

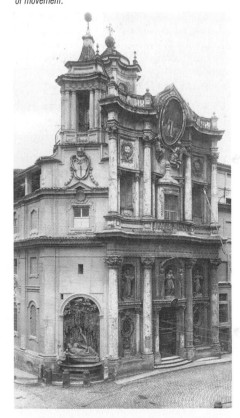

FLEMISH BAROQUE

The southern Netherlands, called Flanders and later Belgium, remained Catholic after the Reformation, which gave artists ample incentive to produce religious paintings. The story of Flemish Baroque painting is really the story of one man, Sir Peter Paul Rubens (1577–1640).

"A prince of painters and a painter of princes," an English ambassador said of Rubens. He led a charmed life, which took him to all the courts of Europe as both painter and diplomat. He was truly a European rather than regional painter, working for rulers of Italy, France, Spain, and England as well as Flanders. As a result, his work perfectly synthesized the styles and concepts of the South and North.

A rare creative genius who had it all, both worldly success and personal happiness, Rubens was outgoing, classically educated, handsome, vigorous, and well traveled. He spoke six languages fluently and had inexhaustible stamina. A visitor to Rubens's studio recalled the maestro painting a picture while listening to Ovid in the original Latin, carrying on a learned conversation, and dictating a letter — all at the same time. As one patron said, "Rubens had so many talents that his knowledge of painting should be considered the least of them."

Energy was the secret of Rubens's life and art. His output of more than 2,000 paintings was comparable only to Picasso's. He was swamped by commissions, which made him both wealthy and renowned. He rose each morning at 4 A.M., and worked nonstop until evening. Still, he needed an army of assistants to keep up with the demand for his work. His studio has been compared to a factory, where Rubens did small color sketches in oil of his conception or outlined a work full-size, to be painted by assistants (which is how van Dyck got his start), then finished by the master himself.

His studio in Antwerp (open to visitors today) still retains the balcony Rubens designed overlooking his work area, where customers could watch him paint huge pictures. One recalled how Rubens stared at a blank panel with arms crossed, then exploded in a flurry of quick brushstrokes covering the entire picture.

RELIGIOUS PAINTING. One painting that created a sensation, establishing Rubens's reputation as Europe's foremost religious painter, was "The Descent from the Cross." It has all the traits of mature Baroque style: theatrical lighting with an ominously dark sky and glaringly spot-lit Christ, curvilinear rhythms leading the eye to the central figure of Christ, and tragic theme eliciting a powerful emotional response. The English painter Sir Joshua Reynolds called the magnificent body of Christ "one of

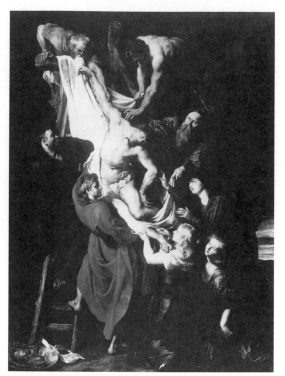

Rubens, "The Descent from the Cross," c. 1612, Antwerp Cathedral. *This painting, full of Baroque curves and dramatic lighting, established Rubens's reputation.*

the finest figures that ever was invented." His drooping head and body falling to the side conveyed the heaviness of death with intense, you-are-there accuracy.

FAT IS BEAUTIFUL. Rubens was probably best known for his full-bodied, sensual nudes. He was happily married to two women (when his first wife died, he married a 16-year-old). Both were his ideal of feminine beauty that he painted again and again: buxom, plump, and smiling with golden hair and luminous skin.

As the art historian Sir Kenneth Clark wrote in *The Nude*, skin represents the most difficult problem for a painter. Rubens's mastery was such, he promised patrons "many beautiful nudes" as a selling point. Whatever the subject, his compositions were always based on massive, rounded human figures, usually in motion. While most painters, because they revered the Classical style, worked from plaster casts or antique sculptures, Rubens preferred to sketch from living models.

HUNTING PICTURES. One characteristic Rubens shared with Hals and Velázquez was that his method of applying paint was in itself expressive. Rubens's surging brushstrokes made his vibrant colors come alive. Nowhere was this more evident than in his hunting pictures, a genre he invented.

MARIE DE'MEDICI SERIES

Rubens's most ambitious project was a sequence of paintings celebrating the life of the queen of France, Marie de'Medici, a silly, willful monarch chiefly remembered for squandering huge sums of money and quarreling incessantly with her spouse (she ruled temporarily after he was assassinated), and for commissioning Rubens to decorate two galleries with pictures immortalizing her "heroic" exploits.

"My talent is such," Rubens wrote, "that no undertaking, however vast in size . . . has ever surpassed my courage." True to his boast, he finished Marie's twenty-one large-scale oils in just three years, virtually without assistance. Even more difficult, however, must have been creating glorious epics out of such inglorious raw material. Here, too, the tactful Rubens was up to the task. He portrayed Marie giving birth to her son (the royal heir before she had him banished) as a solemn nativity scene. His panel on Marie's education featured divinities like Minerva and Apollo tutoring her in music and eloquence.

In "Marie Arrives at Marseilles," the goddess of Fame heralds the queen's landing in France with golden trumpets. Rubens diplomatically omitted Marie's double chin (though in later scenes he did portray her queen-size corpulence) and concentrated instead on three voluptuous assistants to Neptune in the foreground, even lovingly adding beadlike drops of water on their ample buttocks.

Rubens shared the Baroque era's love of pomp, indicated by the painting's exuberant colors, rich costumes, and golden barge. He approached his life and work with vigor. No matter what the subject, he gave his paintings an air of triumph. As Rubens said, "It is not important to live long, but to live well!"

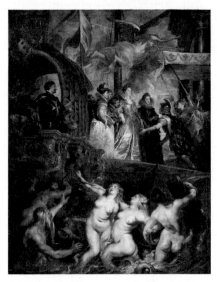

Rubens, "Marie Arrives at Marseilles," 1622–25, Louvre, Paris. *Rubens painted the arrival of the French queen as a sensory extravaganza spilling over with color and opulence.*

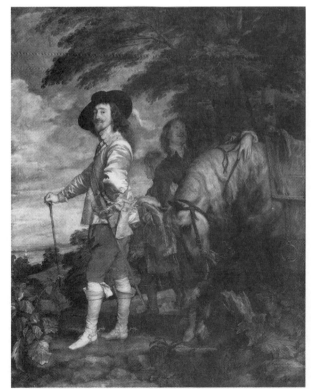

Van Dyck, "Charles I at the Hunt," 1635, Louvre, Paris. *Van Dyck specialized in flattering portraits of elegant aristocrats, posed informally to give the official portrait new liveliness.*

***VAN DYCK:* THE INFORMAL, FORMAL PORTRAIT.** A true child prodigy, Sir Anthony van Dyck (1599–1641) was an accomplished painter when only 16. For a few years he worked with Rubens in Antwerp but, not content to play second fiddle, he struck out on his own, first to Italy and later to England to become court painter to Charles I.

The handsome, vain, fabulously gifted painter was dubbed "il pittore cavalleresco" (painter who gives himself fancy airs) for his snobbish dandyism. He was addicted to high society and dressed ostentatiously, strutting about with a sword and adopting the sunflower as his personal symbol. Van Dyck was a supreme portraitist, establishing a style, noble yet intimate and psychologically penetrating, that influenced three generations of portrait painters.

Van Dyck transformed the frosty, official images of royalty into real human beings. In this new kind of portrait, he posed aristocrats and royals in settings of Classical columns and shimmering curtains to convey their refinement and status. Yet van Dyck's ease of composition and sense of arrested movement, as though the subjects were pausing rather than posing, lent humanity to an otherwise stilted scene.

Another reason for van Dyck's popularity was his ability to flatter his subjects in paint, all becoming slim paragons of perfection, despite eyewitness accounts to the contrary. Charles I was stubby and plain, but in van Dyck's hands, he became a dashing cavalier king, standing on a knoll like a warrior surveying the battlefield beneath the canopy of a tree. One trick van Dyck used to great effect was to paint the ratio of head to body as one to seven, as opposed to the average of one to six. This served to elongate and slenderize his subject's figure.

DUTCH BAROQUE

Though Holland shared its southern border with Flanders, culturally and politically the two countries could not have been more different. While Flanders was dominated by the monarchy and the Catholic Church, Holland, or The Netherlands, was an independent, democratic, Protestant country. Religious art was forbidden in the severe, whitewashed churches and the usual sources of patronage — the church, royal court, and nobility — were gone. The result was a democratizing of art in both subject matter and ownership.

Artists, for the first time, were left to the mercy of the marketplace. Fortunately, the prosperous middle class had a mania for art collecting. One visitor to Amsterdam in 1640 noted, "As For the art off Painting and the affection off the people to Pictures, I think none other goe beeyond them, . . . All in generalle striving to adorne their houses with costly pieces." Demand for paintings was constant. Even butchers, bakers, and blacksmiths bought paintings to decorate their shops.

Such enthusiasm produced a bounty of high-quality art and huge numbers of artists that specialized in specific subjects such as still lifes, seascapes, interiors, or animals. In the seventeenth century, there were more than 500 painters in Holland working in still life alone.

Dutch art flourished from 1610 to 1670. Its style was realistic, its subject matter commonplace. But what made its creators more than just skilled technicians was their ability to capture the play of light on different surfaces and to suggest texture — from matte to luminous — by the way light was absorbed or reflected. Most of these Dutch painters, a fairly conservative crew, are referred to as the Little Dutchmen, to distinguish them from the three great masters, Hals, Rembrandt, and Vermeer, who went beyond technical excellence to true originality.

STILL LIFE. As a genre of painting, the still life began in the post-Reformation Netherlands. Although the form was considered inferior elsewhere, the seventeenth century was the peak period of Dutch still life painting, with artists achieving extraordinary realism in portraying domestic objects. Often still lifes were emblematic, as in

THE STILL LIFE

Dutch still life masters who pioneered the form as a separate genre were interested in how light reflected off different surfaces. Heda's "Still Life" counterpoints the dull gleam of pewter against the sheen of silver or crystal.

In the eighteenth century, the French painter Chardin spread the still life art form to the south by concentrating on humble objects. Nineteenth-century painters like Corot, Courbet, and Manet used still life to examine objects' aesthetic qualities. Cézanne, the Cubists, and the Fauves employed the still life to experiment with structure and color, while Italian painter Morandi concentrated almost exclusively on still lifes. A photo-realist style of trompe l'oeil painting arose in the United States beginning with the Peale brothers' still lifes, followed by the lifelike "deceptions" of Harnett and Peto, up to contemporary painters like Audrey Flack.

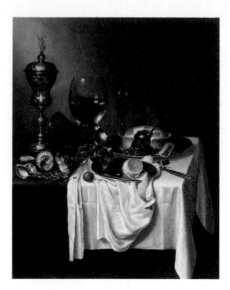

Heda, "Still Life," c.1636, Fine Arts Museums of San Francisco.

"vanitas" paintings, with symbols like a skull or smoking candle representing the transience of all life.

LANDSCAPE. Before the Baroque era, landscape views were little more than background for whatever was going on in the front of the picture. The Dutch established landscape as deserving of its own artistic treatment. In contrast to France, where Poussin and Claude focused on an idealized nature, the great Dutch landscape artists, such as Aelbert Cuyp, Jacob van Ruisdael, and Meindert Hobbema, treated nature realistically, often set against towering clouds in a great sky.

RUISDAEL: "BIG SKY" PAINTINGS. The most versatile landscape artist was Ruisdael (1629–82). Although he painted sharply defined details, he emphasized great open stretches of sky, water, and fields and used dramatic contrasts of light and shadow and threatening clouds to infuse his work with melancholy. This expansiveness and somber mood distinguished him from hundreds of other landscape artists working at the time.

HALS: MASTER OF THE MOMENT.

Frans Hals's (1580–1666) contribution to art was his ability to capture a fleeting expression. Whether his portraits depicted musicians, gypsies, or solid citizens, he brought them to life, often laughing and hoisting a tankard. His trademark was portraits of men and women caught in a moment of rollicking high spirits.

Hals's most famous painting, "The Laughing Cavalier," portrays a sly figure with a smile on his lips, a twinkle in his eyes, and a mustache rakishly upturned. Hals achieved this swashbuckling effect chiefly through his brushstrokes. Before Hals, Dutch realists prided themselves on masking their strokes to disguise the process of painting, thereby heightening a painting's realism. Hals put his own "signature" on his images through slashing, sketchlike brushstrokes.

In this "alla prima," technique, which means "at first" in Italian, the artist applies paint directly to the canvas without an undercoat. The painting is completed with a single application of brushstrokes. Although Hals's strokes were clearly visible at close range, like Rubens's and Velázquez's, they formed coherent images from a distance and perfectly captured the immediacy of the moment. Hals caught his "Jolly Toper" in a freeze-frame of life, with lips parted as if about to speak and hand in mid-gesture.

Hals transformed the stiff convention of group portraiture. In his "Banquet of the Officers of the Saint George Guard Company," he portrayed militiamen not as fighters but feasters at an uproarious banquet. Before Hals, artists traditionally painted group members as in a class picture, lined up like effigies in neat rows. Hals seated them around a table in relaxed poses, interacting naturally, with each facial expression individualized. Although the scene seems impromptu, the composition was a balance of poses and gestures with red-white-and-black linkages. The Baroque diagonals of flags, sashes, and ruffs reinforced the swaggering, boys-night-out feeling.

Hals's outgoing, merry portraits of the 1620s and '30s reveal his gift for enlivening, rather than embalming, a subject. Sadly, at the end of his life, Hals fell from favor. Although he had been a successful portraitist, the love of wine and beer his paintings celebrated spilled over into his personal life. With ten children and a brawling second wife who was often in trouble with the law, Hals, "filled to the gills every evening," as a contemporary wrote, died destitute.

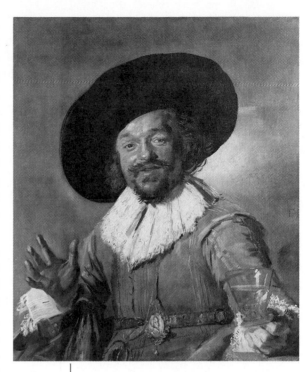

Hals, "The Jolly Toper," 1627, Rijksmuseum, Amsterdam. *Hals used sweeping, fluid brushstrokes to freeze the passing moment in candid portraits of merry tipplers.*

Ruisdael, "Windmill at Wijk-bij-Duurstede," c. 1665, Rijksmuseum, Amsterdam. *Ruisdael's landscapes convey a dramatic mood through the wind-raked sky, mobile clouds, and alternating sun and shadow streaking the low horizon.*

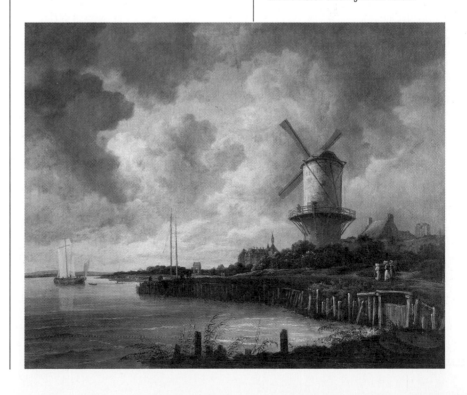

REMBRANDT: THE WORLD FAMOUS. Probably the best-known painter in the Western world is Rembrandt van Rijn (1606–69). During his lifetime, Rembrandt was a wildly successful portrait painter. Today his reputation rests principally on the probing, introspective paintings of his late years, their subtle shadings implying extraordinary emotional depth.

EARLY STYLE. For the first twenty years of his career, Rembrandt's portraits were the height of fashion, and he was deluged with commissions. Although his output was prolific, he was difficult to deal with. "A painting is finished," he said, "when the master feels it is finished." Customers often resorted to bribery to receive their portraits on time. During this prosperous period, Rembrandt also painted Biblical and historical scenes in a Baroque style. These intricately detailed works were lit dramatically, with the figures reacting melodramatically.

LATE STYLE. The year of "The Nightwatch," 1642, marked a turning point in Rembrandt's career. His dearly loved wife died prematurely (they had already lost three children in infancy) and he increasingly abandoned facile portraits with Baroque flourishes for a quieter, deeper style. In his mature phase, Rembrandt's art became less physical, more psychological. He turned to Biblical subjects but treated them with more restraint. A palette of reds and browns came to dominate his paintings, as did solitary figures and a pervasive theme of loneliness. He pushed out the limits of chiaroscuro, using gradations of light and dark to convey mood, character, and emotion.

ETCHING. Rembrandt is considered the most accomplished etcher ever. He handled the needle with such skill and speed, his etchings convey the spontaneity of a sketch. One of his best-known etchings, "Six's Bridge," a landscape, was said to have been done between courses during dinner when a servant dashed to a nearby village to fetch mustard.

Nightwatch. "The Nightwatch," an example of his early style, shows Rembrandt's technical skill with lighting, composition, and color that earned it the reputation as one of the world's greatest masterpieces.

The painting was erroneously believed to be a night scene because of the darkened varnish that coated it. After cleaning, it was evident the scene took place in the day, at the dramatic moment the larger-than-life captain at center gives his militia company its marching orders.

Like Hals, Rembrandt revolutionized the clichéd group portrait from stiff, orderly rows to a lively moment of communal action, giving a sense of hectic activity through Baroque devices of light, movement, and pose. The captain and lieutenant seem on the verge of stepping into the viewer's space, while contrasting light flashes and dark background keep the eye zig-zagging around the picture. The crisscrossing diagonals of pikes, lances, rifles, flag, drum, and staff make the scene appear chaotic, but — since they converge at right angles — they are part of a hidden geometric pattern holding everything together. Color harmonies of yellow in the lieutenant's uniform and girl's dress and red sash and musketeer's uniform also unify the design.

According to legend, since each member of the company had paid equally to have his portrait immortalized, Rembrandt's obscuring some faces appalled the sitters and marked the beginning of his decline from favor. A student of the painter wrote that Rembrandt paid "greater heed to the sweep of his imagination than to the individual portraits he was required to do," yet added that the painting was "so dashing in movement and so powerful" that other paintings beside it seemed "like playing cards."

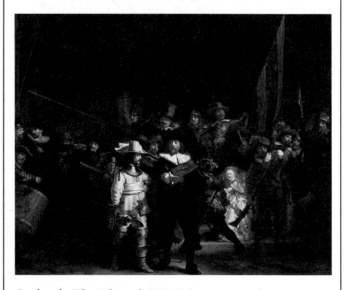

Rembrandt, "The Nightwatch," 1642, Rijksmuseum, Amsterdam.

EARLY STYLE, c. 1622–42	LATE STYLE, c. 1643–69
Used dramatic light/dark contrasts	Used golden-brown tones, subtle shading
Design seemed to burst frame	Static, brooding atmosphere
Scenes featured groups of figures	Scenes simplified with single subject
Based on physical action	Implied psychological reaction
Vigorous, melodramatic tone	Quiet, solemn mood
Highly finished, detailed technique	Painted with broad, thick strokes

PAINTINGS. Rembrandt's technique evolved from attention to minute detail to large-scale subjects given form through broad, thick smudges of paint. His first biographer wrote, "In the last years of his life, he worked so fast that his pictures, when examined from close by, looked as if they had been daubed with a bricklayer's trowel." He almost carved with pigment, laying on heavy impasto "half a finger" thick with a palette knife for light areas and scratching the thick, wet paint with the handle of the brush. This created an uneven surface that reflected and scattered the light, making it sparkle, while the dark areas were thinly glazed to enhance the absorption of light.

Rembrandt's only known comment on art was in a letter, where he wrote that he painted "with the greatest and most deep-seated emotion." The rest of his remarkable contribution to art he left on the canvas.

SELF-PORTRAITS

Rembrandt's nearly 100 self-portraits over the course of forty years were an artistic exploration of his own image that remained unique until van Gogh. The self-portraits ranged from a dewy-eyed youth to an old man stoically facing his own physical decay. In between were brightly lit portraits of the affluent, successful entrepreneur, dressed in furs and gold. Later, the distinctions between light and shadow became less pronounced as he used chiaroscuro to find his inner being.

Comparing an early and late self-portrait shows the change from fine detail to bolder strokes. In the first, done when Rembrandt was about 23, he used Caravaggesque lighting, with one side of the face in deep shadow. He paid as much attention to superficial costume detail (see the rivets on his iron collar) as to character traits. In the later self-portrait, when Rembrandt was 54, the inner man was the focus, conveyed through freer application of paint.

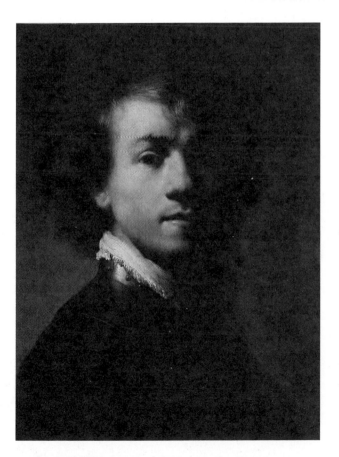

Rembrandt, "Self-Portrait," c.1629–30, Mauritshuis, The Hague.

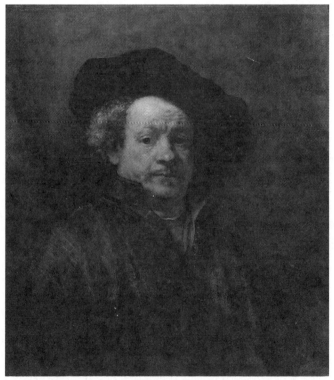

Rembrandt, "Self-Portrait," 1660, MMA, NY.

VERMEER: MASTER OF LIGHT. Called the "Sphinx of Delft" because of the mystery about his life, the painter Johannes Vermeer (1632–75) is now considered second only to Rembrandt among Dutch artists. He remained in his native city of Delft until he died bankrupt at the age of 43, leaving a widow and eleven children. His surviving paintings are few, only thirty-five to forty. Perhaps he never painted more, for no painter until Ingres worked so deliberately.

And no painter except perhaps van Eyck was as skillful as Vermeer in his masterful use of light. While other artists used a gray/green/brown palette, Vermeer's colors were brighter, purer, and glowed with an intensity unknown before.

Besides his handling of color and light, Vermeer's perfectly balanced compositions of rectangular shapes lend serenity and stability to his paintings. A typical canvas portrays a neat, spare room lit from a window on the left and a figure engrossed in a simple domestic task. But what elevates his subjects above the banal is his keen representation of visual reality, colors perfectly true to the eye, and the soft light that fills the room with radiance. His pictures contain no central anecdote, passion, or event. The soft, buttery — almost palpable — light roaming over various surfaces is his true subject.

Vermeer used a "camera obscura" to aid his accuracy in drawing. This was a dark box with a pinhole opening that could project an image of an object or scene to be traced on a sheet of paper. Yet Vermeer did not merely copy the outlines of a projected scene. His handling of paint was also revolutionary. Although in reproduction the brushstrokes appear smooth and detailed, Vermeer often applied paint in dabs and pricks so that the raised surface of a point of paint reflected more light, giving vibrancy and a sense of rough, three-dimensional texture. His technique was close to the pointillism of the Impressionists. One critic described his paint surface as "crushed pearls melted together."

In "The Kitchenmaid," his method of defining forms not by lines but by beads of light was evident, especially around the rim of the milk pitcher, a mosaic of paint daubs. Vermeer was also a master of varying the intensity of color in relation to an object's distance from the light source. The crusty bread picks up the strongest light and reflects it, through precise touches of impasto (or thickly applied paint). Almost too attentive to detail, Vermeer, to avoid monotony on the whitewashed wall, even adds stains, holes, and a nail. The composition is so balanced and cohesive that removing just one of the elements would threaten its sta-

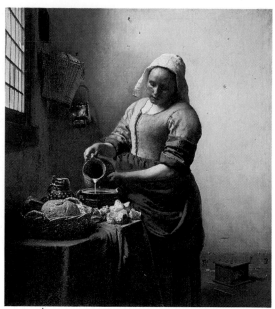

Vermeer, "The Kitchenmaid," c. 1658, Rijksmuseum, Amsterdam. *Vermeer's true subject was light and its effect on color and form.*

bility. Although the painting is devoid of dramatic incident, the maid's utter absorption in her task gives her work an air of majesty. As one critic said of Vermeer, "No Dutch painter ever honored woman as he did."

WHO WERE THE OLD MASTERS?

Besides the group portrait on the Dutch Masters cigar box, is there any agreement on which painters comprise the auction category "Old Masters"? It's actually a flexible concept — rather than an explicit listing — of notable painters from the Renaissance and Baroque periods. The following are some of the main artists sure to top anyone's list of Old Masters.

Bellini	Correggio	Masaccio	Tintoretto
Bosch	Dürer	Michelangelo	Titian
Botticelli	El Greco	Poussin	Van Dyck
Bruegel	Giorgione	Raphael	Van Eyck
Canaletto	Hals	Rembrandt	Velázquez
Caravaggio	Holbein	Reni	Vermeer
Carracci	La Tour	Rubens	Veronese
Claude	Leonardo	Tiepolo	Zurbarán

ENGLISH BAROQUE

The seventeenth century was a period of upheaval in England, with Charles I losing his head, Cromwell destroying church art, and Parliament seizing power. While in literature the 1600s was an era of extraordinary creativity (Shakespeare, Donne, Milton), the visual arts in England lagged far behind. Since religious art was forbidden in Puritan churches and the taste for mythological subjects never caught on, English art was limited almost exclusively to portraits. In the past, England had imported its painters (Holbein and van Dyck). Now, for the first time, it produced three important native artists: Hogarth, Gainsborough, and Reynolds.

HOGARTH: THE ARTIST AS SOCIAL CRITIC.

"I have endeavored to treat my subjects as a dramatic writer; my picture is my stage," wrote the painter/engraver William Hogarth (1697–1764). Influenced by contemporary satirists like Fielding and Swift, Hogarth invented a new genre the comic strip — or a sequence of anecdotal pictures that poked fun at the foibles of the day. The masses bought engravings based on these paintings by the thousands as Hogarth became the first British artist to be widely admired abroad.

Hogarth's lifelong crusade was to overcome England's inferiority complex and worship of continental artists. He criticized the Old Masters as having been "smoked into worth" by time, and thereby rendered nearly indecipherable; he denounced fashionable portrait painters as "face painters." In his portraits, he refused to prettify the subject, believing that irregularities revealed character. Commissions, as a result, were few, which led him to

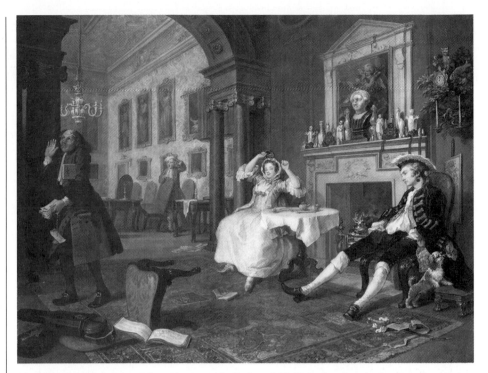

Hogarth, "Breakfast Scene," from Marriage à la Mode, c. 1745, NG, London. *Hogarth is best known for satirical pictures poking fun at English society.*

discover his true calling — satirical prints.

When Hogarth was still a boy, his schoolmaster father had been imprisoned for debt, an experience that permanently marked the painter. In his series The Rake's Progress, Hogarth candidly shows the seamy side of life, exposing the deplorable conditions of debtors' prison and Bedlam hospital for the insane. Hogarth could also be considered the first political cartoonist. He drew his targets from the whole range of society, satirizing with equal aplomb the idle aristocracy, drunken urban working class (a first in visual art), and corrupt politicians.

Hogarth's series Marriage à la Mode ridiculed a nouveau riche bride wed to a dissolute viscount in a marriage arranged to improve the social standing of the former and bank account of the latter. As Hogarth's friend, Henry Fielding, wrote in the comic novel *Tom Jones*, "His

designs were strictly honorable, as the phrase is; that is, to rob a lady of her fortune by way of marriage."

Hogarth used many small touches to suggest the storyline of his paintings. In "Breakfast Scene," a bride coyly admires the groom her father's dowry has purchased, while the dissheveled noble looks gloomy, hung over, or both. The clock, with its hands past noon, suggests a sleepless night of debauchery, further indicated by the cards on the floor, overturned chair, and broken sword. The lace cap in the aristocrat's pocket hints at adultery.

Uncompromising honesty tinged with humor were the hallmarks of Hogarth's art. He once said he would rather have "checked the progress of cruelty than been the author of Raphael's [paintings]."

HOW TO TELL THEM APART

GAINSBOROUGH AND REYNOLDS: PORTRAITS OF THE UPPER CRUST.

Two contemporaneous portrait painters of the era were Thomas Gainsborough (1727–88) and Sir Joshua Reynolds (1723–92). Both were highly successful, painting thousands of elegant, full-length portraits of the British aristocracy. Their works often hang side by side in art galleries, easily confused because of their common subject matter. In many ways, however, they defined the distinction between informal and formal.

Gainsborough, "Mrs. Richard Brinsley Sheridan," c.1785, NG, Washington. *In Gainsborough's fashionable portraits, the sitter posed informally with a landscape background.*

Reynolds, "Jane, Countess of Harrington," 1777, Henry E. Huntington Library and Art Gallery, San Marino, CA. *Reynolds idealized his subjects, converting them to Classical deities.*

GAINSBOROUGH	REYNOLDS
Easy-going, often overdue with commissions (wrote "painting and punctuality mix like oil and vinegar")	Hard-working, careful businessman, complete professional
Naive, spontaneous, exclaimed to sitter: "Madame, is there no end to your nose?"	Consummate gentleman/scholar, at home in most genteel social circles
No intellectual pretensions or ambitions, loved nature, music	Well educated in classics, England's first art theorist
Solo act — didn't use assistants	Employed assistants and drapery painters
Casual poses without posturing	Aimed at "senatorial dignity" in portraits
Natural setting, landscape background	Antique props: urns, pedestals, columns
Sitters in contemporary dress	Sitters in character as goddesses, saints

GAINSBOROUGH: **BACK TO NATURE.** Gainsborough worshiped van Dyck. He learned from the master how to elongate figures to make them seem regal and set them in charmingly negligent poses to make them seem alive. Gainsborough refreshed British art with his loving portrayal of landscape backgrounds. He painted landscapes for his own pleasure, constructing miniature scenes in his studio of broccoli, sponges, and moss to simulate unspoiled nature. These did not sell, so Gainsborough had to content himself with inserting landscape backgrounds in his portraits.

In "Mrs. Richard Brinsley Sheridan," his subject was dressed informally, seated on a rock in a rustic setting (the painter wished to add sheep for a more "pastoral" air). The natural beauty of both the landscape and subject harmonize perfectly. The framing tree at right arcs into the painting to lead the eye back, while the curves of clouds and mid-ground tree, shrubs, hills, and skirt bring the focus back to the sitter's face. This Baroque swirl of encircling eye movement repeats the oval of her face.

The leafy look of Gainsborough's paintings helped establish the concept, taken up in earnest by nineteenth-century painters like Constable, that nature was a worthwhile subject for art.

REYNOLDS: **HOMAGE TO ROME.** Testimony of Reynolds' devotion to the Grand Tradition is that he went deaf from spending too much time in the frosty rooms of the Vatican while sketching the Raphaels that hung there. While on the continent, he also caught a lifelong dose of "forum fever," thereafter littering his portraits with Roman relics and noble poses. His dilemma was that, although he could get rich at "face painting," only history painters were considered poets among artists. Reynolds tried to combine the two genres, finding fault with Gainsborough for painting "with the eye of the painter, not the poet."

Reynolds was a champion of idealizing reality. In separate portraits both he and Gainsborough did of the actress Mrs. Siddons, Gainsborough showed her as a fashionable lady, while Reynolds portrayed her as a Tragic Muse enthroned between symbols of Pity and Terror. He so idolized such masters as Raphael, Michelangelo, Rubens, and Rembrandt he even painted his self-portrait costumed as the latter.

His portraits succeeded in spite of his pedantic self. "Damn him! How various he is!" Gainsborough exclaimed of this artist who could paint imposing military heroes, genteel ladies, and playful children with equal skill. Ironically, in his best portraits Reynolds ignored his own rules. Instead of idealizing what he termed "deficiencies and deformities," he relied on an intimate, direct style to capture the sitter's personality.

THE ROYAL ACADEMY AND THE GRAND MANNER

Modeled on the French Académie Royale, the British Royal Academy of Arts was founded in 1768 with Sir Joshua Reynolds as its first president. In his fifteen "Discourses" over the course of twenty years, Reynolds preached a strict code of rules based on Classicism. Artists were required to uphold the Grand Manner, "the beau idéal of the French," Reynolds said, portraying heroic figures in idealized settings with ancient Roman trappings. The painting of serious, historical scenes was the favored subject. Yet since Reynolds made his living by portraits, he allowed this genre into the official canon, as long as sitters did not wear contemporary clothing. (Nude figures, however, were acceptable.) The idea was to improve upon nature, wiping out any "individual facial peculiarities" and purging the background of "grosser elements of ordinary existence." In his own work, Reynolds imitated Greek and Roman art, often modeling his subjects on gods and goddesses.

For 100 years, the Academy wielded unmatched authority. By the late nineteenth century, however, it was perceived as an anachronism that enshrined mediocrity and opposed progressive art. The novelist George Moore wrote in 1898, "that nearly all artists dislike and despise the Royal Academy is a matter of common knowledge."

BAROQUE ARCHITECTURE: ST. PAUL'S CATHEDRAL. England's main contribution to Baroque architecture was St. Paul's Cathedral, designed by Sir Christopher Wren (1632–1723). In fact, Wren designed more than fifty stone churches in London, a feat necessitated by the Great Fire of London in 1666 that destroyed more than 13,000 houses and eighty-seven churches.

St. Paul's was Wren's masterpiece (indeed, his remains are entombed there), intended to rival Rome's St. Peter's. The project began inauspiciously, since workers were unable to demolish the sturdy pillars of the burned church. When blasting away with gunpowder didn't work, they resorted to a medieval battering ram. After a day of "relentless battering," the last remnants of the old church fell and the new church began to rise — a forty-year undertaking.

Wren was an intellectual prodigy — a mathematician and astronomer praised by Sir Isaac Newton. He used his engineering skills to design the church's dome, second in size only to St. Peter's. Its diameter was 112 feet, and at a height of 365 feet, it was higher than a football field. The lantern and cross atop the dome alone weighed 64,000 tons. How to support such a tremendous load? Wren's pioneering solution was to contruct the dome as a wooden shell covered in thin lead. He could then create a beautiful silhouette on the outside and a high ceiling in the interior with a fraction of the weight. St. Paul's is one of the major churches of the world. As Wren's inscription on his tomb in the great cathedral says, "If you seek a monument, look around you."

Wren, St. Paul's Cathedral, West facade, 1675–1712, London.

BAROQUE

Baroque art throughout Europe tended to be larger than life — full of motion and emotion — like the grandiose religious works produced in Rome. Yet, rather than merely imitating Italian masterpieces, each country developed its own distinctive style and emphasis.

	ITALIAN	FLEMISH	DUTCH	SPANISH	ENGLISH	FRENCH
HEYDAY	1590–1680	1600–40	1630–70	1625–60	1720–90	1670–1715
EMPHASIS	Religious works	Altarpieces	Portraits, Still Lifes, Landscapes	Court Portraits	Portraits of Aristocracy	Classical Landscapes and Decorative Architecture
PATRON	Church	Church, Monarch	People	Monarch	Upper Class	Monarch
STYLE	Dynamic	Florid	Virtuoso	Realistic	Restrained	Pretentious
QUALITIES	Drama, Intensity, Movement	Sensuality	Visual Accuracy, Studies of Light	Dignity	Elegance	Order and Ornament

SPANISH BAROQUE

Spain's major gift to world art was Diego Velázquez (1599–1660). Extraordinarily precocious, while still in his teens he painted pictures demonstrating total technical mastery. At the age of 18, he qualified as a master painter. On a visit to Madrid, Velázquez did a portrait so perfect in execution it attracted the king's attention. His first painting of Philip IV pleased the monarch so much he declared from then on only Velázquez would do his portrait. At the age of 24, Velázquez became the country's most esteemed painter and would spend more than thirty years portraying the royal court.

Like Holbein's, Velázquez's royal portraits were masterpieces of visual realism, but the Spaniard's methods were the opposite of Holbein's linear precision. No outlines are visible in his portraits; he created forms with fluid brushstrokes and by applying spots of light and color, a precursor of Impressionism.

Velázquez differed from most Baroque artists in the simplicity and earthiness of his work. He never forgot his teacher's advice: "Go to nature for everything." As a result, he never succumbed to the pompous style of strewing allegorical symbols and Classical bric-a-brac about his paintings. Instead, he depicted the world as it appeared to his eyes. Velázquez's early paintings portrayed even holy or mythological figures as real people, drawn against a neutral background.

Whether portraying the king or a court dwarf, Velázquez presented his subjects with dignity and, in all cases, factuality. His approach humanized the stiff, formal court portrait tradition by setting models in more natural poses without fussy accessories. Although a virtuoso in technique, Velázquez preferred understatement to ostentation and

WORLD'S GREATEST PAINTING

In a 1985 poll of artists and critics, Velázquez's "Las Meninas" ("The Maids of Honor") was voted, by a considerable margin, "the world's greatest painting." Picasso paid it homage by doing a series of forty-four variations on the work. Velázquez took seriously Leonardo's dictate, "the mirror is our master," and tried to approximate what he saw as closely as possible, often working years on a canvas.

The painting was ostensibly a royal portrait of the five-year-old princess Margarita, attended by her ladies in waiting and two dwarfs. With the diverse additional portraits, it is also like a group painting of the subject: "Visitors to the Artist's Studio." In the middle ground is a mirrored reflection of the king and queen, in the background a full-length portrait of a court official on the steps.

Critics have speculated Velázquez was playing with the idea of the ambiguity of images, including many versions of portraiture, even on the left a self-portrait of himself in the act of reproducing this very scene from a mirror. His skill was such that all the images seem equally convincing, whether indirect (mirrored reflections and paintings of paintings) or "direct" portraits.

"Las Meninas" shows Velázquez's constant concern with design and composition. Although the figures seem informally grouped, the composition actually consists of a carefully balanced series of overlapping triangles. He used only the lower half of the canvas for portraits and filled the space above with a range of light and shadow to produce the illusion of space. Firm verticals and horizontals keep the viewer's eye from getting lost in the room. In 1650, a connoisseur of art said of Velázquez's work that, while all the rest was art, this alone was truth.

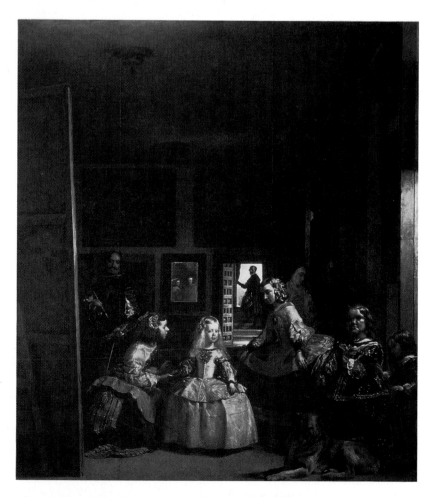

Velázquez, "Las Meninas," 1656, Prado, Madrid. *Velázquez created forms through color and light rather than through lines, achieving startlingly real images of the human figure.*

realism to idealism.

On his friend Rubens's advice Velázquez visited Rome to study Renaissance and Classic masters in the Vatican collection. While there, he painted perhaps his finest portrait, "Pope Innocent X." The sitter's sharp glance was so lifelike — almost predatory—the pope declared it "troppo vero" (too truthful).

Although Velázquez is considered a master of realism, he achieved his effects with loose brushstrokes that, when scrutinized at close range, seem to melt into blurred daubs of paint. As the contemporary Spanish writer on art Antonio Palomino said, "One cannot understand it if standing too close, but from a distance, it is a miracle!"

To accomplish this "miracle," Velázquez dabbed quick touches of paint with which to suggest reflected light. An Italian painter exclaimed of his work, "It is made of nothing, but there it is!"

THE TOP 10

In 1985, a panel of art experts for the *Illustrated London News* judged "Las Meninas" as "by far the greatest work of art by a human being." The following is a list of the winners and how they placed:

1. Velázquez "Las Meninas"
2. Vermeer "View of Delft"
3. Giorgione "The Tempest"
4. Botticelli "La Primavera"
5. Francesca "The Resurrection"
6. El Greco "The Burial of the Count Orgaz"
7. Giotto "The Lamentation"
8. Grünewald "The Isenheim Altarpiece"
9. Picasso "Guernica"
10. Rembrandt "The Return of the Prodigal Son"

THE VELAZQUEZ ARTISTIC TREE

Because Spain was artistically isolated, Velázquez's work was not widely known until the nineteenth century. Then, his brilliant brushwork, which captured the visual world with an almost hyperrealism, inspired painters seeking to break free of the academic straitjacket. The tree shows some prominent artists directly influenced by Velázquez.

BACON — hallucinatory "Head Surrounded by Sides of Beef" showed his obsession with Velázquez's "Pope Innocent X."

WHISTLER — used dark, full-length figures on neutral ground, reduced content to essential expressive forms.

SARGENT — influenced by technique, color, casual arrangement of multigroup figures.

MANET — considered Velázquez's method totally new, said "I have found in him . . . my ideal of painting."

GOYA — learned subtle gradations of color, glowing highlights.

VELÁZQUEZ

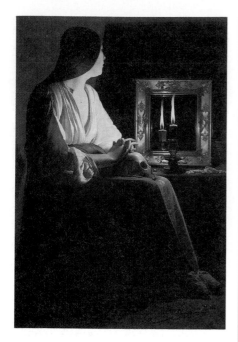

La Tour, "The Penitent Magdalen," c.1638–43, MMA, NY. *The first important French painter of the seventeenth century was Georges de La Tour, who specialized in candlelit night scenes derived from Caravaggio. Here he pictured Mary Magdalen at the moment of her conversion, her face illuminated by a bright flame amid almost total darkness. La Tour simplified all forms to near-geometric abstraction so the light appeared to fall smoothly without refraction. This drew the observer into the circle of light to share the mood of inner stillness and intimacy. As one critic said of La Tour, "A candle has conquered the enormous night."*

FRENCH BAROQUE

In the seventeenth century, France was the most powerful country in Europe, and Louis XIV tapped the finest talents to glorify his monarchy with a palace of unparalleled splendor. With the coming of Versailles, France replaced Rome as the center of European art (a distinction it retained until World War II), even as it modeled its art on Roman relics.

***POUSSIN:* MASTER OF COMPOSITION.** The most famous French painter of the seventeenth century, Nicolas Poussin (pronounced poo SAHN; 1594–1665), worked not in France but in Rome. Passionately interested in antiquity, he based his paintings on ancient Roman myths, history, and Greek sculpture. The widespread influence of Poussin's work revived this ancient style, which became the dominant artistic influence for the next 200 years.

Poussin took Classical rationalism so seriously that, when Louis XIII summoned him to Paris to paint a Louvre ceiling fresco, he refused to conform to the prevailing code of soaring saints. People don't fly through the air, he insisted with faultless logic, thus losing the commission and returning to his beloved Roman ruins.

Left to his own devices, Poussin chose to paint in what he called "la maniera magnifica" (the grand manner). Or, as he put it, "The first requirement, fundamental to all others, is that the subject and the narrative be grandiose, such as battles, heroic actions, and religious themes." The artist must shun "low" subjects. Those who didn't avoid everyday life (like Caravaggio, whom he detested) "find refuge in [base subjects], because of the feebleness of their talents."

Poussin's work exerted enormous influence on the course of French (and, therefore, world) art for the next two centuries because all artists were trained in "Poussinism," an institutionalized Classicism.

***CLAUDE:* NATURE AS IDEAL.** After Poussin, the best known French Baroque painter was Claude Lorrain (1600–82), known simply as Claude. Like Poussin, Claude was drawn to Italy, where he painted idyllic scenes of the Italian countryside. Where the two differed was in their inspiration, for Claude was inspired less by Classical forms than by nature itself and the serene light of dawn and dusk that unified his canvases.

Claude lived for extended periods among shepherds, sketching trees, hills, and romantic ruins of the Italian *campagna* in the early morning or late afternoon. His paintings were typically arranged with dark, majestic trees forming a partial arch that framed a radiant countryside view and intensified the central light. Claude had no interest in the tiny human figures that inhabited his countrysides; their only purpose was to establish scale for the natural elements. Indeed, he paid other artists to paint them for him.

Poussin, "Burial of Phocion," 1648, Louvre, Paris. *Poussin's balanced, orderly scenes shaped Western art for 200 years.*

VERSAILLES: PALACE OF POMP. The pinnacle of Baroque opulence was the magnificent château of Versailles, transformed from a modest hunting lodge to the largest palace in the world. It was a tribute to the ambition of one man, King Louis XIV (1638–1715), who aspired, it was said, "beyond the sumptuous to the stupendous." "L'état c'est moi" (I am the state), said the absolute monarch known as the "Sun King." Surrounded by an entourage of 2,000 nobles and 18,000 soldiers and servants, Louis created a total environment of ostentatious luxury, designed to impress visitors with the splendor of both France and his royal self.

Versailles' hundreds of rooms were adorned with crystal chandeliers, multicolored marble, solid-silver furniture, and crimson velvet hangings embroidered in gold. The king himself, covered in gold, diamonds, and feathers, received important guests seated on a nine-foot, canopied silver throne. His royal rising (*lever*) and retiring (*coucher*) were attended by flocks of courtiers in formal rituals as important to the court as the rising and setting of the sun. Four hundred ninety-eight people were required merely to present the king with a meal. "We are not like private people," said the king. "We belong entirely to the public."

Visual impact took precedence over creature comforts in the palace. The vast marble floors made the interior so frigid, water froze in basins, while the thousands of candles illuminating soirées made summer events stiflingly hot. Despite such drawbacks, Louis XIV hosted fêtes like jousting tournaments, banquets, and Molière comedies. The ballroom was garlanded with flowers. Outdoor trees were illuminated with thousands of pots of candles and hung with oranges from Portugal or currants from Holland. As La Fontaine said, "Palaces turned into gardens and gardens into palaces."

The grounds contained a private zoo with elephants, flamingos, and ostriches, a Chinese carousel turned by servants pumping away underground, and gondolas on the mile-long Grand Canal. The Versailles court lived in unmatched luxury amid opulent furnishings and artworks, most of which qualify as decorative rather than fine art.

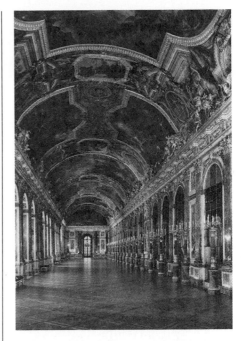

Le Brun & Hardouin-Mansart, Hall of Mirrors, Versailles, c. 1680. *This 240-foot-long gallery was lined with massive silver furniture (later melted down to finance a war). With seventeen floor-to-ceiling windows and mirrors reflecting the sun, this gallery impressed one visitor as "an avenue of light."*

Le Nôtre, Parterre du Midi, 1669–85, Versailles. *The symmetrical patterns of Versailles' park and gardens restructured nature on a vast scale.*

GARDENING ON A GRAND SCALE

The vastness of Versailles' interior was dwarfed by extensive gardens designed by André Le Nôtre. In place of marshes and forests, he imposed a mathematically exact scheme of gardens, lawns, and groves of trees. "The symmetry, always the symmetry," Louis XIV's mistress Madame de Maintenon complained. To avoid the monotony of geometric patterns, Le Nôtre emphasized water — both in motion, as in the gold-covered Fountain of Apollo, and in large reflecting pools. His scheme required so much water that Louis XIV assigned 30,000 troops in a failed attempt to divert the River Eure from 40 miles away.

ROCOCO

Rococo was born in Paris, where it coincided with the reign of Louis XV (1723–74). By 1760, it was considered outmoded in France but was in vogue until the end of the century for luxurious castles and churches throughout Germany, Austria, and Central Europe. Rococo was primarily a form of interior decoration, the name deriving from the "rocaille" motif of shellwork and pebbles ornamenting grottoes and fountains.

In some ways, the Rococo style looks like the word itself. The decorative arts were the special display ground for its curvilinear, delicate ornamentation. Floors were inlaid in complicated patterns of wood veneer, furniture was richly carved and decorated with Gobelin upholstery and inlays of ivory and tortoiseshell. Clothing, silverwork, and china were also overwrought with curlicues as well as flowers, shells, and leaves. Even carriage designers avoided straight lines for carved swirls and scrolls, and horses wore immense plumes and bejeweled harnesses. Rococo art was as decorative and nonfunctional as the effete aristocracy that embraced it.

PAINTING PICNICS IN THE PARK. After Louis XIV died in 1715, the aristocracy abandoned Versailles for Paris, where the salons of their ornate townhouses epitomized the new Rococo style. The nobility lived a frivolous existence devoted to pleasure, reflected in a characteristic painting, the "fête galante," an outdoor romp peopled by elegantly attired young lovers. The paintings of Antoine Watteau (1684–1721), François Boucher (1703–70), and Jean–Honoré Fragonard (1732–1806) signaled this shift in French art and society from the serious and grandiose to the frothy and superficial.

In Watteau's "Pilgrimage to Cythera," romantic couples frolic on an enchanted isle of eternal youth and love. Boucher also painted gorgeously dressed shepherds and shepherdesses amid feathery trees, fleecy clouds, and docile lambs. Boucher's style was artificial in the extreme; he refused to paint from life, saying nature was "too green and badly lit." His pretty pink nudes in seductive poses earned him great success among the decadent aristocracy. Fragonard's party paintings were also frilly and light-hearted. In his best known, "The Swing," a young girl on a swing flirtatiously kicks off a satin slipper, while an admirer below peeks up her lacy petticoats.

WOMAN'S DAY

The pre-French-Revolution eighteenth century was a period when women dominated European courts. Madame de Pompadour was virtual ruler of France, Maria Theresa reigned in Austria, and Elizabeth and Catherine were monarchs of Russia. Female artists, too, made their mark, the most notable being two portrait painters to Queen Marie-Antoinette, ELISABETH VIGÉE-LEBRUN (1755–1842) and ADÉLAIDE LABILLE-GUIARD (1749–1803). The Venetian painter ROSALBA CARRIERA's (1675–1757) fashionable portraits pioneered the use of pastels (chalklike crayons later used by the Impressionists).

Watteau, "Pilgrimage to Cythera," 1717, Louvre, Paris. *Watteau idealized his delicate fantasy landscapes, inhabited by graceful aristocrats engaged in amorous flirtation, with fuzzy color and hazy atmosphere.*

ROCOCO ART

MOOD:
Playful, superficial, alive with energy

INTERIOR DÉCOR:
Gilded woodwork, painted panels,
enormous wall mirrors

SHAPES:
Sinuous S- and C-curves, arabesques,
ribbonlike scrolls

STYLE:
Light, graceful, delicate

COLORS:
White, silver, gold, light pinks, blues, greens

FRENCH BUZZWORDS:
la grâce (elegance), *le goût* (refined taste)

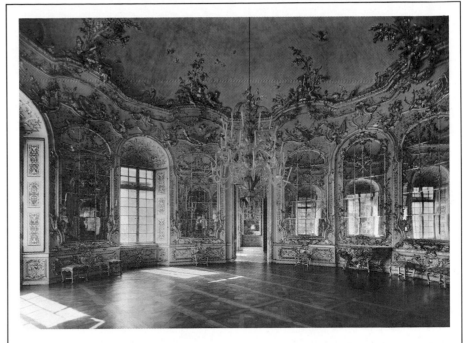

Cuvilliés, Mirror Room, 1734–39, Amalienburg, Germany. *The best example of a Rococo interior, the Mirror Room was designed by François de Cuvilliés (1698–1768), who was originally hired as a court dwarf. This "maison de plaisance," or pleasure house, is profusely but delicately decorated. A series of arched mirrors, doors, and windows is surrounded by carved plants, cornucopias, animals, and musical instruments — all silver-gilt on a cool-blue background. The rising and sinking curves of the ornamentation make this a tour de force of Rococo style.*

Gaudí, Casa Milà, 1907, Barcelona. *Although Rococo love of artifice was alien to the Spanish architect Antonio Gaudí (1852–1926), his work incorporated sinuous, Rococo curves. Gaudí's work grew out of Art Nouveau and was based on his desire to jettison tradition and assume the random forms of nature. In its avoidance of straight lines and rippling effect — with windows shaped like lily pads — this apartment house is heir to the Rococo.*

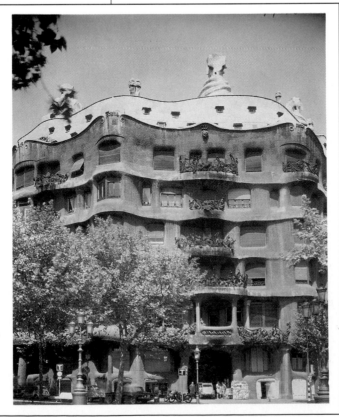

ROCOCO ARCHITECTURE: INTERIOR DECORATING. In eighteenth-century France, the exteriors of buildings continued to be Baroque, gradually giving way to Neoclassical. But inside private townhouses of Paris and the churches and palaces of Germany, Austria, Prague, and Warsaw, fanciful Rococo ornamentation ran wild.

The Nineteenth Century: Birth of the "Isms"

For Western civilization the nineteenth century was an age of upheaval. The church lost its grip, monarchies toppled, and new democracies suffered growing pains. In short, tradition lost its luster and the future was up for grabs. Unfamiliar forces like industrialization and urbanization made cities bulge with masses of dissatisfied poor. The fast pace of scientific progress and the ills of unrestrained capitalism caused more confusion.

The art world of the 1800s seethed with factions, each overreacting to the other. Instead of one style dominating for centuries, as in the Renaissance and Baroque eras, movements and countermovements sprang up like crocuses in spring. What had been eras became "isms," each representing a trend in art. For most of the century, three major styles competed with one another: Neoclassicism, Romanticism, and Realism. Toward the end of the century, a blur of schools — Impressionism, Post-Impressionism, Art Nouveau, and Symbolism — came and went in quick succession.

WORLD HISTORY		ART HISTORY
Louisiana Purchase	1803	
Fulton invents steamboat	1807	
Bolivár leads South American revolution	1811	
Napoleon defeated at Waterloo	1815	
Beethoven completes 9th Symphony	1823	
First railroad built in England	1825	
Queen Victoria crowned	1837	Daguerre invents photography
	1841	Collapsible tin tubes patented for oil paint
Marx and Engels issue *Communist Manifesto*, Gold discovered in California	1848	
	1855	Courbet's Pavilion of Realism
Flaubert writes *Madame Bovary*	1856 – 57	
Mendel begins genetic experiments	1857	
First oil well drilled, Darwin publishes *Origin of Species*	1859	
Steel developed	1860	Snapshot photography developed
U.S. Civil War breaks out	1861	
Lincoln abolishes slavery	1863	Salon des Refusés launches modern art
Suez Canal built	1869	
Prussians besiege Paris	1871	
	1873	First color photos appear
	1874	Impressionists hold first group show
Custer defeated at Little Big Horn, Bell patents telephone	1876	
Edison invents electric light	1879	
	1880	Van Gogh begins painting career
Population of Paris hits 2,200,000	1881	
	1883	Monet settles at Giverny
First motorcar built	1885	First Chicago skyscraper built
	1886	Impressionists hold last group show
	1888	Portable Kodak camera perfected
Hitler born	1889	Eiffel Tower built
	1890	Monet's first haystacks series
	1891	Gauguin goes to Tahiti
	1892	Rodin sculpts Balzac
	1893	Art Nouveau spreads
Dreyfus trial begins	1894	Monet finishes Rouen Cathedral series
Freud develops psychoanalysis	1895	Vollard shows Cézanne paintings, Lumière Brothers introduce movies
Curies discover radium	1898	

NEOCLASSICISM: ROMAN FEVER

From about 1780 to 1820, Neoclassic art reflected, in the words of Edgar Allan Poe, "the glory that was Greece, /And the grandeur that was Rome." This revival of austere Classicism in painting, sculpture, architecture, and furniture was a clear reaction against the ornate Rococo style. The eighteenth century had been the Age of Enlightenment, when philosophers preached the gospel of reason and logic. This faith in logic led to the orderliness and "ennobling" virtues of Neoclassical art.

The trendsetter was Jacques-Louis David (pronounced Dah VEED; 1748–1825), a French painter and democrat who imitated Greek and Roman art to inspire the new French republic. As the German writer Goethe put it, "the demand now is for heroism and civic virtues." "Politically correct" art was serious, illustrating tales from ancient history or mythology rather than frivolous Rococo party scenes. As if society had overdosed on sweets, principle replaced pleasure and paintings underscored the moral message of patriotism.

NEOCLASSICISM

VALUES:
Order, solemnity

TONE:
Calm, rational

SUBJECTS:
Greek and Roman history, mythology

TECHNIQUE:
Stressed drawing with lines, not color; no trace of brushstrokes

ROLE OF ART:
Morally uplifting, inspirational

FOUNDER:
David

In 1738, archeology-mania swept Europe, as excavations at Pompeii and Herculaneum offered the first glimpse of well-preserved ancient art. The faddish insistence on Greek and Roman role models sometimes became ridiculous, as when David's followers, the "primitifs," took the idea of living the Greek Way literally. They not only strolled about in short tunics, they also bathed nude in the Seine, fancying themselves to be Greek athletes. When novelist Stendhal viewed the nude "Roman" warriors in David's painting "Intervention of the Sabine Women," he was skeptical. "The most ordinary common sense," he wrote, "tells us that the legs of those soldiers would soon be covered in blood and that it was absurd to go naked into battle at any time in history."

The marble frieze statuary brought from Athens' Parthenon to London by Lord Elgin further whetted the public appetite for the ancient world. "Glories of the brain" and "Grecian grandeur" is how the poet John Keats described the marbles. Leaders of art schools and of the French and British Royal Academies were solidly behind the Neoclassic movement and preached that reason, not emotion, should dictate art. They emphasized drawing and line, which appealed to the intellect, rather than color, which excited the senses.

The hallmark of the Neoclassical style was severe, precisely drawn figures, which appeared in the foreground without the illusion of depth, as in Roman relief sculpture. Brushwork was smooth, so the surface of the painting seemed polished, and compositions were simple to avoid Rococo melodrama. Backgrounds generally included Roman touches like arches or columns, and symmetry and straight lines replaced irregular curves. This movement differed from Poussin's Classicism of a century earlier in that Neoclassical figures were less waxen and ballet-like, more naturalistic and solid.

Ancient ruins also inspired architecture. Clones of Greek and Roman temples multiplied from Russia to America. The portico of Paris's Pantheon, with Corinthian columns and dome, copied the Roman style exactly. In Berlin, the Brandenburg gate was a replica of the entrance to Athens' Acropolis, topped by a Roman chariot. And Thomas Jefferson, while serving as ambassador to France, admired the Roman temple Maison Carrée in Nîmes, "as a lover gazes at his mistress." He renovated his home, Monticello, in the Neoclassical style.

FRENCH NEOCLASSICISM

DAVID: PAINTING THE PAST. It was on a trip to Rome, when he first saw Classical art, that David had his breakthrough vision. He said he felt as if he "had been operated on for cataract." He avidly drew hands, eyes, ears, and feet from every antique sculpture he encountered, saying, "I want to work in a pure Greek style." Before long, David's disciples were throwing bread pellets at Watteau's "Pilgrimage to Cythera," to show their contempt for what they felt was "artificial" art.

In "Oath of the Horatii," three brothers swear to defeat their enemies or die for Rome, illustrating the new mood of self-sacrifice instead of self-indulgence. Just as the French Revolution overthrew the decadent royals, this painting marked a new age of stoicism. David demonstrated the difference between old and new through contrasting the men's straight, rigid contours with the curved, soft shapes of the women. Even the painting's composition underscored its firm resolve. David arranged each figure like a statue, spot-lit against a plain background of Roman arches. To assure historical accuracy, he dressed dummies in Roman costumes and made Roman helmets that he could then copy.

David, a friend of the radical Robespierre, was an ardent supporter of the Revolution and voted to guillotine King Louis XVI. His art was propaganda for the republic, intended to "electrify," he said, and "plant the seeds of glory and devotion to the fatherland." His portrait of a slain leader, "Death of Marat," is his masterpiece. Marat, a close friend of David, was a radical revolutionary stabbed to death by a counterrevolutionary in his bath. (Before the Revolution, while hiding from the police in the Paris sewers, Marat had contracted psoriasis and had to work in a medicated bath, using a packing box for a desk.) Right after the murder, David

rushed to the scene to record it. Although the background is coldly blank, David's painting emphasized the box, bloodstained towel, and knife, which, as actual objects, were worshiped by the public as holy relics. David portrays Marat like a saint in a pose similar to Christ's in Michelangelo's "Pietà."

When Robespierre was guillotined, David went to jail. But instead of losing his head, the adaptable painter became head of Napoleon's art program. From the taut compositions of his revolutionary period, he turned to pomp and pageantry in his paintings of the little emperor's exploits, such as "Coronation of Napoleon and Josephine." Although his colors became brighter, David stuck to the advice he gave his pupils, "Never let your brushstrokes show." His paintings have a tight, glossy finish, smooth as enamel. For three decades, David's art was the official model for what French art, and by extension, European art, was supposed to be.

David, "Oath of the Horatii," 1784, Louvre, Paris. *David's "Oath of the Horatii" marked the death of Rococo and birth of Neoclassical art, which should, David said, "contribute forcefully to the education of the public."*

David, "Death of Marat," 1793, Musées Royaux des Beaux-Arts de Belgique, Brussels. *David painted the slain revolutionary hero like a modern-day Christ.*

INGRES: ART'S FINEST DRAFTSMAN.

Following David, the first half of nineteenth-century art was a contest between two French painters: Jean Auguste Dominique Ingres (pronounced ANN gruh; 1780–1867), champion of Neoclassicism, and Eugène Delacroix (pronounced duh la KRWAH; 1798–1863), ardent defender of Romanticism. Ingres came naturally to Neoclassicism, for he was the star pupil of David.

An infant prodigy, at the age of 11 Ingres attended art school and

Ingres, "Portrait of the Princesse de Broglie," 1853, MMA, NY. *Ingres's clear, precise forms, idealized beauty, and balanced composition sum up the Neoclassical style.*

at 17 was a member of David's studio. The young disciple never let his brushstrokes show, saying paint should be as smooth "as the skin of an onion." Ingres, however, went even further than his master in devotion to the ancients. In his early work, he took Greek vase paintings as his model and drew flat, linear figures that critics condemned as "primitive" and "Gothic."

Then Delacroix and Géricault burst on the scene, championing emotion and color rather than intellect and draftsmanship as the basis of art. Against the "barbarism" of these "destroyers" of art, Ingres became the spokesman of the conservative wing, advocating the old-time virtue of technical skill. "Drawing is the probity of art," was his manifesto. He cautioned against using strong, warm colors for visual impact, saying they were "antihistorical."

The battle sank into name calling, with Ingres labeling Rubens, the hero of the Romantics, "that Flemish meat merchant." He considered Delacroix the "devil incarnate." When Delacroix left the Salon after hanging a painting, Ingres remarked, "Open the windows. I smell sulfur." In turn, the Romantics called the paintings of

Ingres and his school "tinted drawings."

Ironically, this arch-defender of the Neoclassic faith sometimes strayed from his devout principles. True, Ingres was an impeccable draftsman whose intricate line influenced Picasso, Matisse, and Degas (who remembered Ingres's advice to "draw many lines"). But Ingres's female nudes were far from the Greek or Renaissance ideal. The languid pose of his "Grande Odalisque" was more Mannerist than Renaissance. Although identified with controlled, academic art, Ingres was attracted to exotic, erotic subjects like the harem girl in "Odalisque." Critics attacked the painting for its small head and abnormally long back. "She has three vertebrae too many," said one. "No bone, no muscle, no life," said another. Ingres undoubtedly elongated the limbs to increase her sensual elegance.

Ingres preached logic, yet the romantic poet Baudelaire noted that Ingres's finest works were "the product of a deeply sensuous nature." Indeed, Ingres was a master of female nudes. Throughout his career, he painted bathers, rendering the porcelain beauty of their flesh in a softer style than David's.

In "Portrait of the Princesse de Broglie," Ingres paid his usual fastidious attention to crisp drapery, soft ribbons, fine hair, and delicate flesh, without a trace of brushwork. The color has an enamellike polish and the folds of the costume fall in precise, linear rhythm. Ingres is chiefly remembered as one of the supreme portraitists of all time, able to capture physical appearance with photographic accuracy.

Ingres, "La Grande Odalisque," 1814, Louvre, Paris. *This portrait shows Ingres's trademarks of polished skin surface and simple forms contoured by lines, in contrast to the irregular drapery.*

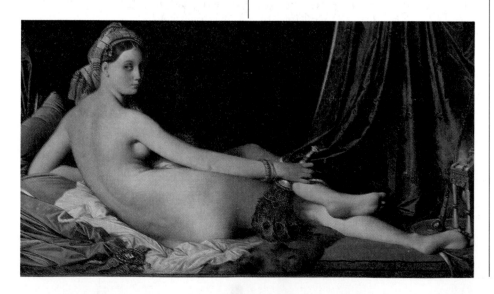

ODALISQUE

The reclining, or recumbent, female nude, often called Odalisque after the Turkish word for a harem girl, is a recurrent figure throughout Western art. Here is how some artists have given their individual twist to a traditional subject.

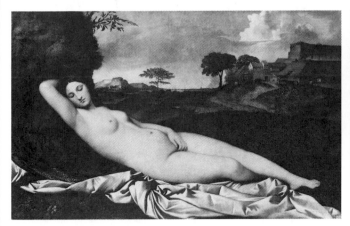

Giorgione, "Sleeping Venus" (the Dresden Venus), c. 1510, Staatliche Kunst-sammlungen, Dresden. *The first known recumbent female nude as an art subject was by the Venetian Giorgione, a Renaissance painter about whom little is known. He probably painted "Sleeping Venus" in 1510, the year of his early death from the plague. Titian was said to have finished the work, adding the Arcadian landscape and drapery. Traits associated with this popular genre of painting are a simple setting, relaxed pose propped on pillows, and the absence of a story. Giorgione was handsome and amorous, a keen lover of female beauty, yet he portrays his Venus as a figure of innocence, unaware of being observed.*

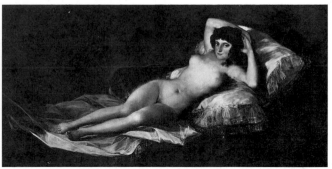

Goya, "The Nude Maja," 1796–98, Prado, Madrid. *Goya was denounced during the Inquisition for this "obscene," updated version featuring full frontal nudity. The title means "nude coquette," and Goya's blatantly erotic image caused a furor in prudish Spanish society. His friend and patron, the aristocratic but very unconventional Countess of Alba, is believed to be the model. A clothed replica of the figure, in an identical pose but very hastily sketched, also exists. It is said that Goya painted it when the Count was on his way home, to justify all the time the painter had spent in the Countess' company. Goya was probably inspired by Velázquez's "Rokeby Venus," a recumbent nude seen from the back. Although an outraged suffragette slashed Velázquez's "Venus," Goya's nude is much more seductive, with her soft, smooth flesh contrasted to the crisp brushwork of satin sheet and lace ruffles.*

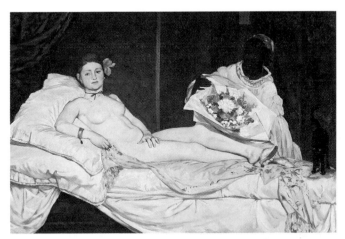

Manet, "Olympia," 1863, Musée d'Orsay, Paris. *Manet's "Olympia" also caused a public outcry. With her bold, appraising stare and individualized features, this was obviously no idealized goddess but a real person. One critic called her a "female gorilla." Others attacked Manet's nonacademic technique: "The least beautiful woman has bones, muscles, skin, and some form of color. Here there is nothing." "The shadows are indicated," another wrote, "by large smears of blacking." Most considered the painting's sexuality immoral: "Art sunk so low does not even deserve reproach."*

Huge crowds flocked to the Salon to see what the fuss was about. After the canvas was physically attacked, it was hung out of reach, high above a doorway. One viewer complained, "You scarcely knew what you were looking at — a parcel of nude flesh or a bundle of laundry." Manet became the acknowledged leader of the avant-garde because of "Olympia's" succès de scandale.

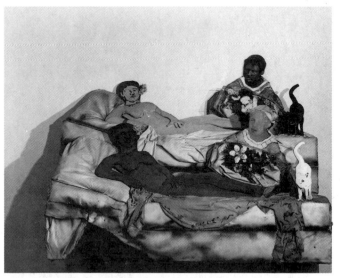

Rivers, "I Like Olympia in Blackface," 1970, Centre Pompidou, Paris. *New York painter Larry Rivers, born in 1923, was a member of the generation following Abstract Expressionism that challenged abstract art's dismissal of realism and developed Pop art. Rivers combined the free, vigorous brushstrokes of Abstract Expressionism with subject matter from diverse sources ranging from advertising to fine art. Color, not subject matter, according to Rivers, "is what has meaning." His version of Manet's "Odalisque" gives a fresh face to a centuries-old concept.*

AMERICAN NEOCLASSICISM

The founding of the American republic coincided with the popularity of Neoclassicism. Since the ancient Roman republic seemed an apt model, the new country clothed itself in the garb of the old. It adopted Roman symbols and terms like "Senate" and "Capitol" (originally a hill in ancient Rome). For a century, official buildings in Washington were Neoclassic knock-offs.

The fact that Neoclassic became *the* style was mostly due to Thomas Jefferson, an amateur architect. He built the University of Virginia as a learning lab of Classicism. The ensemble included a Pantheon-like Rotunda and pavilions in Roman temple forms. Jefferson used Doric, Ionic, and Corinthian orders to demonstrate the various styles of architecture to students.

In sculpture, antique figures in an idealized, Classical style were also the rage. One of the most acclaimed works of the nineteenth century was Hiram Powers's "Greek Slave" (1843), a marble statue of a naked girl in chains that won international fame. Horatio Greenough applied Neoclassical doctrines less successfully. The practical American public laughed at his statue of a bewigged George Washington with a nude torso and Roman sandals.

The first American-born painter to win international acclaim was Benjamin West (1738–1820), whose work summed up the Neoclassic style. He was so famous for battle scenes that he became president of the British Royal Academy and was buried in St. Paul's Cathedral. West spent his entire career in England, and his London studio was a mandatory stop for visiting American painters.

"The Peale Family," 1770–1773, New-York Historical Society.

Peale: The Leonardo of the New World. *Charles Willson Peale (1741–1827) was a model Enlightenment man. A scientist as well as artist who was unfailingly curious and energetic, his list of skills and interests rivaled Leonardo's. He came to painting through craftsmanship and was a saddler, watchmaker, silversmith, and upholsterer before becoming the most fashionable portraitist in the colonies. Peale was also a Revolutionary war soldier, politician, and ingenious inventor. He conceived a new type of spectacles, porcelain false teeth, a steam bath, and a stove that consumed its own smoke. He was also first to excavate a mastodon skeleton, which he exhibited in the natural history museum he founded in Philadelphia with more than 100,000 objects. His list of firsts included the first art gallery in the colonies and the first art school.*

Peale was the father of seventeen children. He named them after painters and they obliged him by becoming artists, like the portraitist Rembrandt, still-life painter Raphaelle, and artist/naturalist Titian. "The Peale Family" includes nine family members and their faithful nurse (standing with hands folded). Peale himself stoops at left holding his palette. He titled the painting on the easel "Concordia Animae" (Harmony of Souls), indicating the painting's theme.

The composition emphasizes the essential unity of the group. Although they are divided into two camps, all are linked by contact of hand or shoulder except the nurse. The figures slightly overlap, with the scattered fruit also binding the two halves. Peale suggests a visual tie by the painter's brother seated at left sketching his mother and her grandchild at right. This type of picture, or "conversation piece," was popular in eighteenth- and early-nineteenth-century painting. It represents perfectly the ideal of e pluribus unum.

Peale's most famous work is "The Staircase Group," a life-size trompe l'oeil portrait of his two sons climbing stairs with a real step at the bottom and door jamb as a frame. Peale painted the scene so convincingly that George Washington reportedly tipped his hat to the boys.

At the age of 86, the inexhaustible Peale was known to whoop down hills riding one of the first bicycles. He finally succumbed to overexertion while searching for a fourth wife.

BEGINNINGS OF AMERICAN ART. The fact that a talented American had to pursue his craft in England was due to the backward state of the arts. Most colonists were farmers, preoccupied with survival and more interested in utility than beauty. They were from working-class stock, hardly the type to commission works of art. The influence of Puritanism with its prejudice against "graven images" meant that the church would not be a patron. There were no large buildings to adorn or great wealth to buy luxury items. Silver and furnishings showed fine craftsmanship and Federal architecture was handsome. But sculpture was practically unknown except for graveyard statuary.

The first American painters were generally self-taught portrait or sign painters. Their work was flat, sharply outlined, and lacking in focal point. Portraiture was, not surprisingly, the most sought-after art form, since politics stressed respect for the individual. Itinerant limners, as early painters were called, painted faceless single or group portraits in the winter and, in spring, sought customers and filled in the blanks.

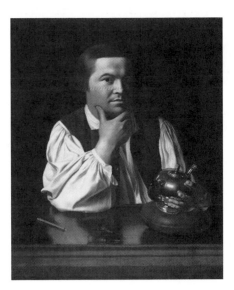

Copley, "Portrait of Paul Revere," c. 1768–70, Museum of Fine Arts, Boston. *Copley's portraits of Boston society offered sharp glimpses into his subjects' personalities.*

COPLEY: **THE FIRST GREAT AMERICAN PAINTER.** Painting in America was considered a "useful trade like that of a Carpenter or shoe maker, not as one of the most noble Arts in the world," complained America's first painter of note, John Singleton Copley (pronounced COPP lee; 1738–1815). Despite this disrespect, the Bostonian taught himself the profession by studying anatomy books and reproductions of paintings. In his teens, he set up as a portrait painter and, by the age of 20, completely outstripped any native artist. He was the first colonial to have a work exhibited abroad. With Copley, art in America grew up.

Copley had an astonishing ability to record reality accurately. His subjects had real bulk, and he brilliantly simulated reflected light on various textures. Copley also portrayed his sitter's personality with penetrating observation. Eliminating the columns and red curtains used to dress up portraits, he concentrated on the fleeting expressions and gestures that reveal character. Although he painted his well-to-do clients' costumes in detail, he focused on the individuality of their faces, where each wrinkle suggested character.

PAINTING THE CHARACTER OF THE COLONIES. Copley's portrayal of his friend, a shirt-sleeved Paul Revere, was an innovation for its time, when a portrait never pictured manual labor. Yet Copley posed the silversmith holding a teapot he had made, his tools in clear sight. Revere had not yet taken the midnight ride that Longfellow set to verse but was already a leading opponent of British rule. His shrewd, uncompromising gaze and the informal setting without courtly trappings summed up the Revolution's call for independence.

STUART: **THE FIRST DISTINCTIVE AMERICAN STYLE.** Gilbert Stuart (1755–1828) was America's other great painter of the Neoclassic period. Stuart refused to follow established recipes for painting flesh, saying he would not bow to any master, but "find out what nature is for myself, and see her with my own eyes." He used all the colors to approximate flesh but without blending, which he believed made skin look muddy, like saddle leather. Something of a pre-Impressionist, Stuart made skin seem luminous, almost transparent, through quick brushstrokes rather than layered glazes. Each stroke shone through the others like blood through skin, giving a pearly brilliance to his faces. Flesh, Stuart said, is "like no other substance under heaven. It has all the gaiety of a silk mercer's shop without its gaudiness and gloss, and all the soberness of old mahogany without its sadness."

Stuart was the equivalent of court painter for the new republic. His contribution was in simplifying portraiture, discarding togas and passing gestures to emphasize timeless aspects. Stuart painted faces with such accuracy that Benjamin West said Stuart "nails the face to the canvas."

Stuart, "George Washington," (The Athenaeum Portrait), 1796, Museum of Fine Arts, Boston. *Stuart's portraits of George Washington demonstrate how the painter went beyond the European tradition. By stripping away all nonessentials (the background was never completed), Stuart implies that greatness springs only from individual character. The portrait omits Washington's smallpox scars but hints at his endurance in the firm line of his mouth. Some have questioned whether the tightly clamped lips indicated not the fortitude to survive Valley Forge but the general's uncomfortable wooden teeth.*

In any event, this image has become the most famous American portrait of all time. A victim of his own success, Stuart came to hate the job of duplicating the likeness, which he called his "hundred dollar bills." Now this national icon stares from its niche on the one-dollar bill.

GOYA: MAN WITHOUT AN "ISM"

The paintings of the Spanish artist Francisco de Goya (1746–1828) fit no category. His work was indebted only to the realism of Velázquez, the insight of Rembrandt, and, as he said, to "nature." Goya was a lifelong rebel. A libertarian fiercely opposed to tyranny of all sorts, the Spanish artist began as a semi-Rococo designer of amusing scenes for tapestries. Then he became painter to Charles IV of Spain, whose court was notorious for corruption and repression. Goya's observation of royal viciousness and the church's fanaticism turned him into a bitter satirist and misanthrope.

His work was subjective like the nineteenth-century Romantics', yet Goya is hailed as the first modern painter. His nightmarish visions exposing the evil of human nature and his original technique of slashing brushstrokes made him a forerunner of anguished twentieth-century art.

Goya's "Family of Charles IV" is a court painting like no other. The stout, red-faced king, loaded with medals, appears piggish; the sharp-eyed trio at left (including an old lady with a birthmark) seems downright predatory; and the queen insipidly vacant. Critics have marveled at the stupidity of the thirteen family members of three generations for not having realized how blatantly Goya exposed their pomposity. One critic termed the group a "grocer and his family who have just won the big lottery prize." The painting was the artist's homage to Velázquez's "Las Meninas" (see p. 60). Goya — like his predecessor — placed himself at left behind a canvas, recording impassively the parade of royal arrogance.

ART OF SOCIAL PROTEST. Goya was equally blunt in revealing the vices of church and state. His disgust with humanity followed a near-fatal illness in 1792 that left him totally deaf. During his recovery, isolated from society, he began to paint demons of his inner fantasy world, the start of a preoccupation with bizarre, grotesque creatures in his mature work.

A master graphic artist, Goya's sixty-five etchings, "The Disasters of War" from 1810–14, are frank exposés of atrocities committed by both the French and Spanish armies during the invasion of Spain. With gory precision, he reduced scenes of barbarous torture to their horrifying basics. His gaze at human cruelty was unflinching: castrations, dismemberments, beheaded civilians impaled on bare trees, dehumanized soldiers staring indifferently at lynched corpses.

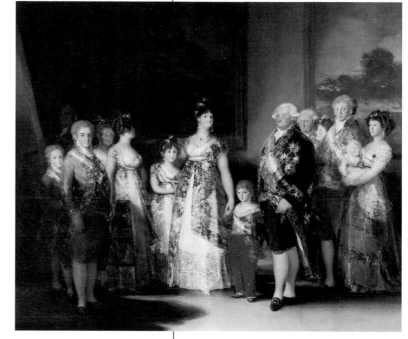

Goya, "Family of Charles IV," 1800, Prado, Madrid. *The Spanish monarchy was so vain and imbecilic they failed to notice that Goya portrayed them in all their ostentation.*

"The Third of May, 1808" is Goya's response to the slaughter of 5,000 Spanish civilians. The executions were reprisal for a revolt against the French army in which the Spaniards were condemned without regard to guilt or innocence. Those possessing a penknife or scissors ("bearing arms") were marched before the firing squad in group lots.

The painting has the immediacy of photojournalism. Goya visited the scene and made sketches, and yet his departures from realism give it additional

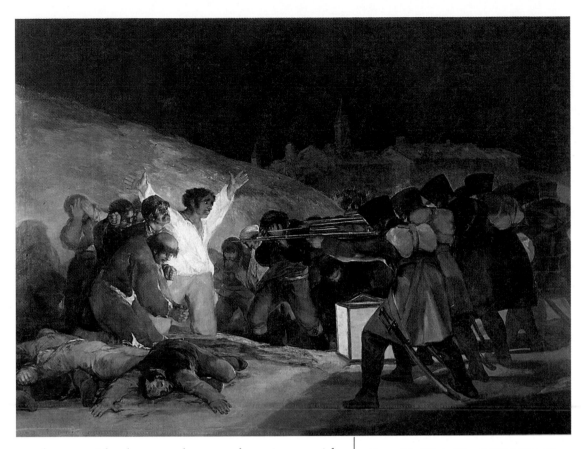

power. He lit the nocturnal scene with a lamp on the ground, casting a garish light. In the rear, the church is dark, as if the light of all humanity had been extinguished. Bloody carcasses project toward the viewer, with a line of victims stretching off in the distance. The immediate victims are the center of interest, with a white-shirted man throwing wide his arms in a defiant but helpless gesture recalling the crucified Christ. The acid shades and absence of color harmony underscore the event's violence.

In other paintings of that time, warfare was always presented as a glorious pageant and soldiers as heroes. Goya contrasted the victims' faces and despairing gestures with the faceless, automatonlike figures of the firing squad. Although deafness cut Goya off from humanity, he passionately communicates his strong feelings about the brutality and dehumanization of war.

LATE STYLE: BLACK PAINTINGS. Goya became obsessed with depicting the suffering caused by the political intrigue and decadence of the Spanish court and church. He disguised his repulsion with satire, however, such as in the disturbing "black paintings" he did on the walls of his villa, Quinta del Sordo (house of the deaf). The fourteen large murals in black, brown, and gray of 1820–22 present appalling monsters engaged in sinister acts. "Saturn Devouring His Children" portrays a voracious giant with glaring, lunatic eyes stuffing his son's torn, headless body into his maw. Goya's technique was as radical as his vision. At one point he executed frescoes with sponges, but his satiric paintings were done with broad, ferocious brushstrokes as blazing as the events portrayed.

Goya died in France, in self-imposed exile. He was the father of 20 children but left no followers. His genius was too unique and his sympathies too intense to duplicate.

ROMANTICISM:
THE POWER OF PASSION

[handwritten note: Live fast / Die young / Leave a beautiful corpse]

"Feeling is all!" the German writer Goethe proclaimed, a credo that sums up Romantic art. Rebelling against the Neoclassic period's <u>Age of Reason</u>, the Romantic era of 1800–50 was the <u>Age of Sensibility</u>. Both writers and artists chose emotion and intuition over rational objectivity. As the German Romantic landscape painter Caspar David Friedrich wrote, "The artist should paint not only what he sees before him, but also what he sees in him." Romantics pursued their passions full-throttle. Living intensely rather than wisely had its price. Romantic poets and composers like Byron, Keats, Shelley, Chopin, and Schubert all died young.

<u>Romanticism</u> got its name from a revived interest in <u>medieval tales</u> called <u>romances</u>. "Gothic" horror stories combining elements of the macabre and <u>occult were in vogue</u> (it was during this period that Mary Shelley wrote *Frankenstein*), as was Gothic Revival architecture, seen in the towers and turrets of London's Houses of Parliament. The "in" decorating look was arms and armor. Sir Walter Scott built a pseudo-Gothic castle, as did the novelist Horace Walpole, where he could, he said, "gaze on Gothic toys through Gothic glass."

Another mark of Romanticism was its cult of nature worship. Painters like Turner and Constable lifted the status of landscape painting by giving natural scenes heroic overtones. Both man and nature were seen as touched by the supernatural, and one could tap this inner divinity, so the Romantic gospel went, by relying on instinct.

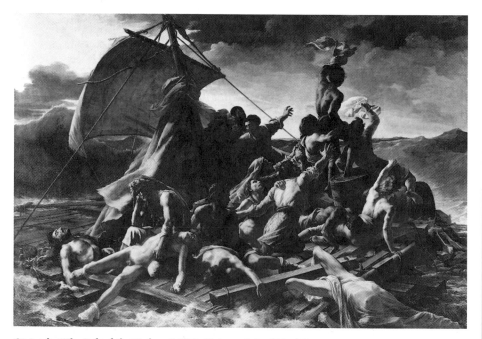

Géricault, "The Raft of the Medusa," 1818–19, Louvre, Paris. *Géricault inaugurated Romanticism with this canvas contrasting images of extreme hope and despair.*

ROMANTICISM

VALUES:
Intuition, Emotion, Imagination

INSPIRATION: Medieval and Baroque eras, Middle and Far East

TONE: Subjective, spontaneous, nonconformist

COLOR: Unrestrained; deep, rich shades

SUBJECTS: Legends, exotica, nature, violence

GENRES: Narratives of heroic struggle, landscapes, wild animals

TECHNIQUE: Quick brushstrokes, strong light-and-shade contrasts

COMPOSITION: Use of diagonal

FRENCH ROMANTICISM

GÉRICAULT. Théodore Géricault (pronounced JHAY ree coe; 1791–1824) launched Romanticism with one painting, "The Raft of the Medusa." He based the huge (16' x 23½') canvas on a contemporary event, a shipwreck that caused a political scandal. A government ship, the *Medusa*, carrying French colonists to Senegal sank off the west coast of Africa due to the incompetence of the captain, a political appointee. The captain and crew were first to evacuate and took over the lifeboats, towing a makeshift raft piled with 149 passengers. Eventually they cut the towrope, leaving the immigrants to drift under the equatorial sun for twelve days without food or water, suffering unspeakable torments. Only fifteen lived.

Géricault investigated the story like a reporter, interviewing survivors to hear their grisly tales of starvation, madness, and cannibalism. He did his utmost to be authentic, studying putrid bodies in the

morgue and sketching decapitated heads of guillotine victims and faces of lunatics in an asylum. He built a model raft in his studio and, like an actor immersing himself in a role, even lashed himself to the mast of a small boat in a storm.

This extraordinary preparation accounts for the painting's grim detail. But Géricault's romantic spirit is at the root of its epic drama. The straining, contorted body language of the nude passengers says everything about the struggle for survival, a theme that obsessed the artist.

Because of the graphic treatment of a macabre subject and the political implications of the government's incompetence, the painting created a huge sensation. Romantic passion was, for the first time, visible in extremis, capturing not some idealized form from the past but contemporary reality. The painting's fame broke the stranglehold of the Classical Academy. From this time, French art was to stress emotion rather than intellect.

In his private life, Géricault was also an archetypal Romantic. Like the fiery poet Lord Byron who died the same year, "safety last" could have been his motto. He had no concern for his own well-being and dedicated himself to a life of passion and defending the downtrodden. His teacher called Géricault a madman, and the Louvre banned him for brawling in the Grande Galerie. Fascinated with horses, Géricault died at the age of 32 after a series of riding accidents.

Although he exhibited only three paintings publicly in his decade-long, meteoric career, Géricault left an indelible mark. His energetic handling of paint and rousing scenes of titanic struggle kicked off the Romantic era in French art.

DELACROIX: PAINTER OF PASSION.

Eugène Delacroix became leader of the Romantic movement after Géricault's death. A moody, solitary man, he always ran a slight fever. Delacroix believed the artist should feel the agony of creation and, like his friend the composer Frederic Chopin, he was consumed by the flame of genius. "The real man is the savage," he confided to his journal. As the Romantic poet Baudelaire put it, Delacroix was "passionately in love with passion."

Delacroix chose his subjects from literature or from stirring topical events. Instead of the Neoclassic style of antique calm, violence charged his exotic images. Delacroix painted an early work, "Massacre at Chios," as soon as he heard the news of Turks slaughtering Christians on the island of Chios. Although purists called it a "massacre of painting," spectators wept when they saw the pitiful babe clutching its dead mother's breast.

OUT OF AFRICA.
In 1832, a visit to Morocco changed Delacroix's life. He infiltrated a harem and made hundreds of sketches. Delacroix was fascinated by the colorful costumes and characters, like throwbacks to a flamboyant past. "The Greeks and Romans are here," he wrote, "within my reach." For the next thirty years, he stuck to lush colors, swirling curves, and animals like lions, tigers, and horses knotted in combat.

"The Death of Sardanapalus" shows Delacroix's attraction to violence. Delacroix based the painting on Byron's verses of the Assyrian emperor Sardanapalus, who, faced with military defeat, ordered his possessions destroyed before immolating himself on a funeral pyre. Delacroix portrays the shocking instant when servants execute the king's harem girls and horses. It is an extravaganza of writhing bodies against a flaming red background. The intense hues, vivid light/dark contrasts, and turbulent forms in broad brushstrokes are a virtual manifesto of Romanticism.

Delacroix, "Death of Sardanapalus," 1827, Louvre, Paris. *Fascinated by physical and emotional excess, Delacroix portrays a wild, writhing scene as an emperor's concubines are murdered.*

NEOCLASSICISM VS. ROMANTICISM

For twenty-five years Delacroix and Ingres led rival schools whose squabbling dominated the Paris art scene. Their two paintings of the virtuoso violinist Paganini demonstrate the different outlooks and techniques of the Neoclassic and Romantic movements.

Ingres was a talented violinist himself and knew Paganini personally, yet his version of the maestro is an objective, formal portrait of the public man. With photographic accuracy, his crisp, precise lines duplicate exactly Paganini's physical appearance. This is a rational man, totally in control.

Delacroix defines the musician's form through color and energetic, fluid brushwork, as opposed to lines. Unlike Ingres's ramrod-straight figure, Delacroix's Paganini is curved like a violin, carried away by the ecstasy of performance. Eyes closed, foot almost tapping, Delacroix's painting is a figure of passionate abandon. This is the inner man in the throes of emotion.

Ingres,"Paganini," 1819, Louvre, Paris.

Delacroix,"Paganini," c. 1832, Phillips Collection, Washington, DC.

CONTRIBUTIONS. Delacroix liberated painting from the Classical concept of color as a tint applied over forms defined by line drawing. Under his hand, color — especially vibrating adjacent tones — became the indispensable means to model forms, a discovery extended by van Gogh, Renoir, Degas, Seurat, and Cézanne. The admiring van Gogh remarked, in fact, that "only Rembrandt and Delacroix could paint the face of Christ."

Delacroix did not attempt to reproduce reality precisely but aimed at capturing its essence. He established the right of a painter to defy tradition and paint as he liked. Goya, who had been similarly idiosyncratic, saw Delacroix's work when the Spaniard was an old man and heartily approved.

Delacroix, whose output was enormous, claimed he had enough compositions for two lifetimes and projects to last 400 years. He painted at a fever-pitch, furiously attacking the whole canvas at once, saying that, "If you are not skillful enough to sketch a man falling out of a window during the time it takes him to get from the fifth story to the ground, then you will never be able to produce monumental work." A friend eulogized Delacroix as a painter "who had a sun in his head and storms in his heart; who for 40 years played upon the keyboard of human passions."

THE ARTIST'S PALETTE

The Machine Age — in full swing by the nineteenth century — brought improved materials that affected the way artists painted. For one thing, a wider range of colors was available. Before, artists used earth colors because most pigments came from minerals in the earth. Now chemical pigments were invented that could approximate a greater variety of the colors in nature. Emerald green, cobalt blue, and artificial ultramarine were a few of the pigments discovered.

The burden of laboriously preparing colors shifted from the artist to professional tradesmen. Part of every artist's training had been how to grind paint by hand and mix it with linseed oil to create oil paint. Now machines ground pigments that were mixed with poppy oil as a binder and sold to artists in jars. With the poppy oil, the paint retained the mark of the brush more, for a textured effect as in van Gogh's paintings. For the Impressionist generation, in fact, the visible sign of brushwork represented an artist's individual signature.

With these innovations, chiaroscuro, or the multilayered, subtle gradations of color to suggest three-dimensional volume, gradually became obsolete. No longer did artists — as they had since Leonardo's time — indicate shadows by thin, transparent washes of dark color and highlights by thick, opaque clots of light pigment. Painters represented both light and shade in opaque colors applied with a loaded brush. Instead of successive layers of paint, each applied after the preceding one had dried, the rapid, sketchlike alla prima style took over by 1850, allowing artists to produce an entire work at a single sitting.

The biggest change resulted from the invention of the collapsible tin tube for paint in 1840, which made the artist's studio portable. By the 1880s, the Impressionists chose to paint outdoors using the new bright colors, so they could heed Corot's maxim, "Never lose the first impression which has moved you."

ENGLISH ROMANTICISM

Two English painters, born only a year apart, did more than anyone to establish landscape painting as a major genre. Yet stylistically J.M.W. Turner and John Constable could not have been further apart. Constable made nature his subject, while for Turner the subject was color. Constable painted placid scenes of the actual countryside, while Turner's turbulent storms existed mainly in his imagination.

CONSTABLE: FIELD AND STREAM. What William Wordsworth's poems did for England's Lake District, John Constable's (1776–1837) landscapes did for East Anglia, now known as Constable country, on the east coast of England. Both romanticized boyhood rambles through moors and meadows as the subject for poetry and art.

Constable's work was not well received during his lifetime. His father, a prosperous miller, bitterly opposed Constable being a "lowly" painter, and Constable did not sell a painting until he was 39. Members of the Academy called his work, now considered bold and innovative, "coarse" and "rough."

In turn, Constable looked down on conventional landscape painters who based their work on tradition rather than what they actually saw. He said others were always "running after pictures and seeking the truth at second hand." Constable, in contrast, never went abroad and learned only from close observation of nature in his native Suffolk. His views of the English countryside are serene, untroubled, and gentle: "the sound of water escaping from mill-dams," he wrote, "willows, old rotten planks, slimy posts, and brickwork — I love such things. These scenes made me a painter."

As a boy, Constable had learned to "read" the sky while setting the sails on his father's windmills, and as a man he applied this interest in meteorology to his painting. He often went "skying" — sketching cloud formations as source material for paintings. The sky, he believed, was "the key note, . . . and the <u>chief organ of sentiment</u>" in a painting. This love of clouds and sun and shadow led him to make the <u>first oil sketches ever</u> painted outdoors, starting in 1802, thus anticipating the Impressionists' open-air methods (though Constable executed the final finished paintings — "six-footers," he called them — in his studio).

Constable believed landscapes should be based on observation. His rural scenes reflect an intense love of nature, but he insisted they were not idealized: "imagination never did, and never can, produce works that are to stand by comparison with realities," he wrote.

Because of his devotion to actual appearances, Constable rebelled against the coffee-colored tones then in vogue for landscapes, correctly insisting they were actually the result of darkened varnish on Old Master paintings. When a friend claimed Poussin's original tints were the brownish color of a violin, Constable responded by putting a violin on the grass to demonstrate the difference.

Constable simulated the shimmer of light on surfaces by tiny dabs of color stippled with white. (Many found these white highlights incomprehensible, calling them "Constable's snow.") He put tiny red dots on leaves to energize the green, hoping the vibrations between complementary hues would convey an impression of movement like the flux of nature.

Constable, "The Hay Wain," 1821, NG, London. *Constable portrays the farmer with his hay wagon (or "wain") as an integral part of the landscape, emphasizing Constable's mystical feeling of man being at one with nature. Critics found this landscape so lifelike one exclaimed, "The very dew is on the ground!"*

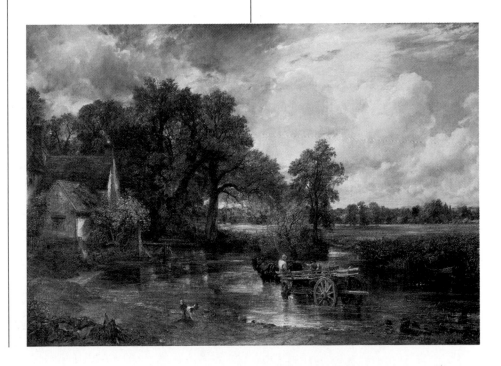

TURNER: A TURN TOWARDS ABSTRACTION. Like Constable, J.M.W. Turner (1775–1851) began painting bucolic landscapes with a smooth, detailed technique. Also like Constable, he later experimented with more radical techniques and evolved a highly original style that influenced later generations of artists. The two painters differed, however, in Turner's love of the dramatic, of subjects like fires and storms. Turner painted nature in the raw.

The child of a poor London barber, Turner skipped school to sketch his father's customers. By the age of 12 he was selling his watercolors and at 15 had exhibited at the Royal Academy. His calm, familiar, rural scenes were an immediate hit with the public and made him a financial success. Once Turner began to travel to the continent, he became fascinated by the wilder aspects of nature and evolved his distinct style. He aimed to evoke awe in his viewers and shifted his subject from calm countrysides to Alpine peaks, flaming sunsets, and the theme of man's struggle against the elements.

Turner's style gradually became more abstract as he attempted to make color alone inspire feeling. The foremost colorist of his day, Turner was the first to abandon brown or buff priming for a white undercoat, which made the final painting more brilliant. He neutralized deep tones by adding white and left light tones like yellow undiluted for greater luminosity. People said he put the sun itself into his paintings.

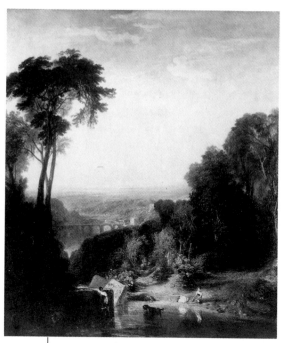

Turner, "Crossing the Brook," 1815, Tate Gallery, London. *Although Turner became the most original landscape artist, his early work was a tame imitation of traditional techniques and content.*

"Rain, Steam, and Speed — The Great Western Railway" is a typical late painting in which Turner eliminated detail to concentrate on the essential form of a locomotive speeding over a bridge toward the viewer. This was one of the first paintings of a steam train, which had been invented only twenty years before. In it Turner tried to express the idea of speed, air, and mist through veils of blue and gold pigment. Turner supposedly researched the painting by sticking his head out of a train window for ten minutes during a storm. Critics jeered at the work when it appeared for its lack of realism. Constable meant to criticize Turner's mature work when he called it "golden visions" and said, "He seems to paint with tinted steam, so evanescent and airy."

At the end of his life, just before exhibiting his nearly abstract paintings, Turner painted in people and added titles to make them more comprehensible to the public. Violently attacked, these canvases were considered unfinished and indistinguishable from each other. One critic accused Turner of thinking "that in order to be poetical it is necessary to be almost unintelligible." Although Turner never considered himself an abstract painter, paintings discovered after his death contain no recognizable subject whatsoever, just swirling masses of radiant color. His discovery of the power of pigment had an enormous influence on the course of modern art. Turner pushed the medium of paint to its expressive limit. His last works anticipate modern art in which paint itself is the only subject.

Turner became increasingly reclusive in his later years, hiding from acquaintances and living under an assumed name. He turned down handsome prices and hoarded his best paintings, selling only those he considered secondrate. On his deathbed, the story goes, Turner asked to be taken to the window so he could die gazing at the sunset.

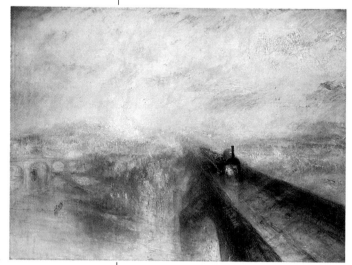

Turner, "Rain, Steam, and Speed — The Great Western Railway," 1844, NG, London. *This painting of a steam locomotive demonstrates the shimmering light and pearly atmospheric glow of Turner's near-abstract, late work, in which he implies rather than depicts a subject.*

AMERICAN ROMANTICISM

Romantic painting in America encompassed two subjects: nature and the natural man. The former included landscapes and the latter were genre paintings of common people in ordinary activities. In both, the subjects were seen through rose-colored glasses, like the seven dwarfs' "hi-ho, hi-ho" version of working in a mine. Forests were always picture-postcard perfect, and happy settlers without exception were cheerful at work or play.

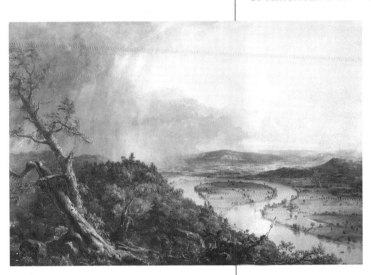

Cole, "The Oxbow (The Connecticut River Near Northampton)," 1836, MMA, NY. *Leader of the Hudson River School, Cole emphasized the grandeur and immensity of America's landscape.*

THE AMERICAN LANDSCAPE: AH, WILDERNESS. Before 1825, Americans considered nature menacing. The first thing colonial settlers did was burn or hack down vast tracts of virgin woods to make clearings for fields and villages. They admired nature only when it was tamed in plantations and gardens. After 1830 a shift occurred. America's natural wonders became a bragging point equal to Chartres or the Colosseum. As tides of settlers poured westward, pushing back frontiers, the wilderness became a symbol of America's unspoiled national character.

This shift in sentiment affected art. American writers like Emerson and Thoreau preached that God inhabited nature, which dignified landscapes as a portrait of the face of God. Suddenly the clichéd formula art of London, Paris, and Rome, which had before guided American painting, was obsolete. The grandeur of the American continent became the artist's inspiration.

The Hudson River School was America's first native school of painting. Its members, Thomas Cole, Asher B. Durand, John F. Kensett, and Thomas Doughty, delivered visual sermons on the glories of nature. They were the first to concentrate exclusively on landscapes, which replaced portraits as the focus of American art. Their patriotic scenes of the Hudson River area conveyed a mood of worshipful wonder. They combined realistic detail with idealized composition in a new form of romantic realism. Typically, the scenes were on a large scale with sweeping panoramic horizons that seemed to radiate beyond the painting's borders, suggesting America's unlimited future.

***COLE:* HUDSON RIVER SCHOOL LEADER.** Thomas Cole (1801–48) was the founder of the Hudson River School of Romantic landscapes. Cole, a self-taught artist, lived on a bluff overlooking the Hudson River. An outdoor enthusiast, he rambled on foot throughout the area in the spring, summer, and fall, scaling peaks to make pencil sketches of untouched natural scenes. During the winter, after his memory of particular locales had faded to a fuzzy afterglow, he portrayed the essential mood of a place in oil paintings. Cole's finished work — a combination of real and ideal— reflects this working method. He presents foreground in minute detail and blurs distant vistas to suggest the infinite American landscape.

In "The Oxbow," Cole faithfully reproduced rocks, juicy vegetation, a gnarled tree, and his folding chair and umbrella. The blond panorama of the Connecticut River Valley and receding hills seems to stretch forever. The painting depicts the moment just after a thunderstorm, when the foliage, freshened by a cloudburst, glistens in a theatrical light.

Cole's work expressed the proud belief that America was a primeval paradise, a fresh start for humanity. For the optimistic Hudson River School, communion with nature was a religious experience that cleansed the soul as surely as rainfall renewed the landscape. As Cole wrote in his diary before painting this picture, "I would not live where tempests never come, for they bring beauty in their train." America may have lacked picturesque ancient ruins, but its lush river valleys and awesome chasms and cascades were subject enough for the Hudson River School.

ARTIST-EXPLORERS: BIERSTADT AND CHURCH. The genera-
tion of painters after the Hudson River School tackled
more far-flung landscapes. Frederic Edwin Church
(1826–1900) and Albert Bierstadt (1830–1902) were the
Lewis and Clark of painting — "intrepid limners" they
were called — as they sketched the savage beauty of
nature from the lush vegetation of the tropics to the ice-
bergs of the Arctic.

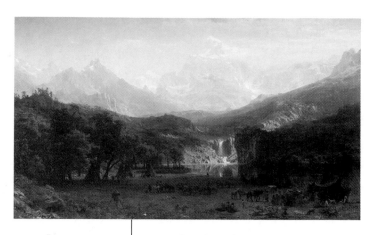

Bierstadt, "The Rocky Mountains," 1863, MMA,
NY. *Bierdstadt captured the adventurous frontier spirit as
well as the concept of the noble savage in harmony with
nature.*

Bierstadt specialized in sweeping views of thrilling
natural wonders. His career coincided with the westward
movement begun by the forty-niners and their wagon
trains. At the age of 29, Bierstadt joined a survey team
mapping a westward route. Face to face with the Rocky
Mountains, he found his personal mother lode: sketching the overwhelming
vistas of the mountains. When he returned to his New York studio, he sur-
rounded himself with photographs, sketches, Indian artifacts, and animal tro-
phies and began to paint the views of the American West that made him world
famous.

"The Rocky Mountains" is one
of Bierstadt's typical images of the
West as a Garden of Eden. He
employed his usual compositional
devices of a highly detailed fore-
ground (the peaceful encampment of
Shoshone Indians) and distant soar-
ing mountains pierced by a shaft of
sunlight. His paintings were like a
commercial for westward expansion,
as if that were America's Manifest
Destiny.

THE P. T. BARNUM OF AMERICAN ART

Bierstadt's paintings were as vast in scale as the scenes he depicted — wall-sized canvases as big as a 9'x12' rug. A running
joke was that his next subject would be "all outdoors" and that he had built a château near the widest part of the Hudson River
so he would have room to turn his canvases. Bierstadt had a flair for showmanship. He not only sold paintings for $25,000 each
(an enormous sum then), he charged 25 cents admission when he exhibited a work. Crowds lined up for the theatrical display of
his paintings, which were flanked by potted plants and velvet draperies. The artist thoughtfully supplied magnifying glasses to
scrutinize details of the polished scene, and although an entire painting might have a Paul Bunyan–like scale, on close inspection,
one could see minute petals of individual wildflowers.

GENRE PAINTING: THE AMERICAN DREAM IN ACTION

Genre painting also gained respect in the first half of the nineteenth century.
No longer placed on painting's lowest rung, these scenes of the common peo-
ple engaged in everyday activity were enormously popular.

Bingham, "Fur Traders Descending the Missouri,"
1845, MMA, NY. *In this classic "genre" painting, Bingham
romanticizes the settling of the Wild West.*

BINGHAM: SON OF THE PIONEERS. The first important painter of the
West was George Caleb Bingham (1811–79), known for his
scenes of frontier life. Criticized in the East for uncouth subjects
like riverboatmen playing cards, fishing, and chewing tobacco, he
saw himself as a social historian immortalizing pioneer life.

Unlike many other artists who took the wilderness as a sub-
ject, Bingham was part of the life he portrayed. He spent his
childhood on a hard-scrabble farm in Missouri and was appren-
ticed to a cabinetmaker before trying his hand at sign painting.
He taught himself to paint with a how-to manual and homemade
pigments, then took off down the Missouri and Mississippi rivers
painting portraits. Bingham was soon acclaimed for celebrating
the march west and the activities of the frontier. To Bingham, the
commonplace was grand and bargemen at a hoedown were just as
noble as ancient heroes in battle.

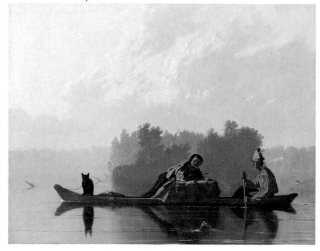

REALISM

During the first half of the nineteenth century, as artistic wars between Neoclassicism and Romanticism raged, Realism, a force that would dominate art for the second half of the century, slowly began to emerge. With the first grindings of the Machine Age, Neoclassicism's anachronisms and Romanticism's escapism would prove to be no match for Realism's hard edge.

In a sense, Realism had always been a part of Western art. During the Renaissance, artists overcame all technical limitations and represented nature with photographic accuracy. From van Eyck to Vermeer to Velázquez, artists approximated visual reality with consummate skill. But before Realism, artists in the nineteenth century modified their subjects by idealizing or sensationalizing them. The "new" Realism insisted on precise imitation of visual perceptions without alteration. Realism's subject matter was also totally different. Artists limited themselves to facts of the modern world as they personally experienced them; only what they could see or touch was considered real. Gods, goddesses, and heroes of antiquity were out. Peasants and the urban working class were in. In everything from color to subject matter, Realism brought a sense of muted sobriety to art.

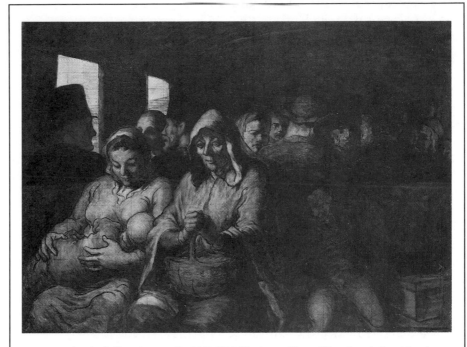

Daumier, "The Third-Class Carriage," c. 1862, MMA, NY. *A spiritual heir to William Hogarth, Honoré Daumier (1808–79) drew savagely satirical caricatures that punctured the pomposity of Royalists, Bonapartists, and politicians. King Louis Philippe jailed Daumier for his cartoon of the king swallowing "bags of gold extorted from the people." Still Daumier continued his attacks. "The Third-Class Carriage" portrayed working-class passengers as dignified, despite being crammed together like lemmings. This was the earliest pictorial representation of the dehumanizing effect of modern transportation.*

ROSA BONHEUR (1822–99) *was the nineteenth century's leading painter of animals. Her pictures of sheep, cows, tigers, and wolves reflected her passion for the animal kingdom. When someone reproached her saying, "You are not fond of society," the French artist replied, "That depends on what you mean by society. I am never tired of my brute friends." Her home in Paris was a menagerie of goats, peacocks, chickens, even a steer, wandering in and out of the studio. When she painted outdoors, dogs lay about her in a circle.*

Bonheur's lifelike images reflected her thorough research. For "The Horse Fair," Bonheur sketched at the Paris horse market for a year and a half, disguised as a man in order to be inconspicuous. To gain an accurate knowledge of anatomy, she worked in a slaughterhouse, "wading," as she said, "in pools of blood." Bonheur was as fiercely independent as the lions she painted. She lived with a female friend, cut her hair short like a man's, smoked cigarettes even though doing so was scandalous, and obtained a police permit to wear trousers. A courageous and colorful character, she was one of the first advocates of women's rights.

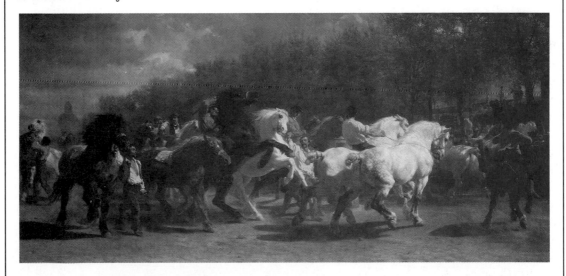

Bonheur, "The Horse Fair," 1853–55, MMA, NY.

FRENCH REALISM

COURBET. The father of the Realist movement was Gustave Courbet (pronounced Koor BAY; 1819–77). A man of great pragmatism, he defied the conventional taste for history paintings and poetic subjects, insisting that "painting is essentially a concrete art and must be applied to real and existing things." When asked to paint angels, he replied, "I have never seen angels. Show me an angel and I will paint one."

His credo was "everything that does not appear on the retina is outside the domain of painting," As a result, Courbet limited himself to subjects close to home, like "Burial at Ornans" a 22-foot-long canvas portraying a provincial funeral in bleak earth tones. Never before had a scene of plain folk been painted in the epic size reserved for grandiose history paintings. Critics howled that it was hopelessly vulgar.

When an art jury refused to exhibit what Courbet considered his most important work, "Interior of My Studio," the painter built his own exhibition hall (actually a shed) called the "Pavilion of Realism" — the first one-man show ever. There was nothing restrained about Courbet. He loudly defended the working class and was jailed for six months for tearing down a Napoleonic monument. He detested the theatricality of Academic art; his drab figures at everyday tasks expressed what Baudelaire termed the "heroism of modern life."

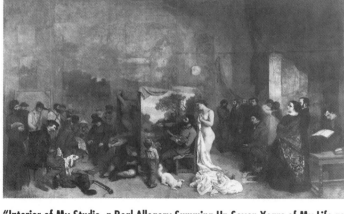

Courbet, "Interior of My Studio, a Real Allegory Summing Up Seven Years of My Life as an Artist," 1854–55, Musée d'Orsay, Paris. *Courbet portrays the two spheres of influence that affected his art. At left are the ordinary people that are his subjects, and at right, representatives of the Paris art world. The focal point is a self-portrait of the artist. His pivotal position between the two worlds implied that the artist was something of a go-between, linking the real world to the art world.*

THE BARBIZON SCHOOL: REALISTIC FRENCH COUNTRYSIDES. Influenced by Constable, who painted actual scenes rather than imagined ones, a group of landscape painters known as the Barbizon School brought the same freshness to French art. Beginning in the 1830s, they painted outdoors near the town of Barbizon. The most famous names associated with this school were Millet and Corot.

COROT: MISTY TREES. Jean-Baptiste-Camille Corot (pronounced Kore ROH; 1796–1875) was taught "to reproduce as scrupulously as possible what I saw in front of me." He brought a natural, objective style to landscape painting, capturing the quality of a particular place at a particular moment. Corot used a limited palette of pearly, silvery tones with olive green, and soft, wispy strokes. The nearly monochromatic landscapes of his later years were so popular they have become some of the most widely forged paintings in the world, giving rise to the comment, "Corot painted 3,000 paintings, of which 6,000 are in America."

Peasant Portraits. *Jean-François Millet (pronounced Mee LAY; 1814–75) is forever linked to portrayals of rural laborers plowing, sowing seed, and harvesting. Born to a peasant family, he once said he desired "to make the trivial serve to express the sublime." Before, peasants were invariably portrayed as doltish. Millet gave them a sturdy dignity.*

Corot, "Ville d'Avray," 1870, MMA, NY. *Barbizon painters like Corot painted directly from nature.*

Millet, "The Sower," c. 1850, Museum of Fine Arts, Boston.

AMERICAN REALISM

HOMER. "He is a genuine painter," novelist Henry James said of Winslow Homer (1836–1910). "To see, and to reproduce what he sees, is his only care." A self-taught artist, Homer steered clear of outside influence and theory, basing his work on direct observation of nature. "When I have selected the thing carefully," he said of his method, "I paint it exactly as it appears." His skill made him the major American marine painter and watercolorist of all time.

First apprenticed to a lithographer, Homer became a successful illustrator for popular magazines. His drawings of idyllic farm scenes and girls playing croquet kept him steadily employed. As a Civil War artist, he produced illustrations of camp life. At the age of 27, he began — without instruction — to paint in oils. Homer's friends thought his total indifference to European art was "almost ludicrous," but Homer insisted on inventing himself. "If a man wants to be an artist," he said, "he should never look at paintings."

CRASHING WAVES AND STORMY SEAS. In the 1880s Homer retreated to Maine where he began to paint the raging sea. In shipwreck paintings like "The Gulf Stream" and "The Life Line," man-against-the-elements became a recurrent theme. Later Homer dropped human figures from his sea paintings altogether and simply portrayed high winds driving blue-green waves against boulders under gray skies. He sometimes waited days for just the right light, dashing out at midnight to paint moonlight on the waves. His ability to portray harsh, stormy weather, to the point where you can almost feel the icy spray, remains unmatched.

At the age of 38 Homer struck out in a new direction. Watercolors had long been used by artists in preparatory studies, but Homer was the first to display his watercolors as finished works and thereby installed the form as a major medium. His marine watercolors are luminous and brightly colored, with patches of white paper left radiant like the glaring tropical sun. In the hands of other painters, watercolors often looked anemic, but in Homer's bold style, they had the authority of oils.

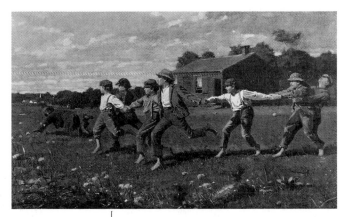

Homer, "Snap the Whip," 1872, MMA, NY. *Homer brought a new realism to genre painting, presenting exuberant images of rural America.*

WATERCOLOR

Invented by ancient Egyptians and used by Renaissance artist Dürer to tint ink drawings, the watercolor came into its own in the mid-nineteenth century as a vehicle for painting English landscapes. Used before primarily for sketches, the watercolor was finally recognized as a technique with its own potential.

Although most beginning artists start with watercolor because the clean-up and materials (brush, paint box, paper, and water) are simple, it is actually a very demanding medium. Its significant characteristics are the fluidity and transparency of the paint, which allows the white background to show through. Artists who have used watercolor with special skill are Cézanne, Sargent, Dufy, Grosz, Klee, and especially Winslow Homer and John Marin.

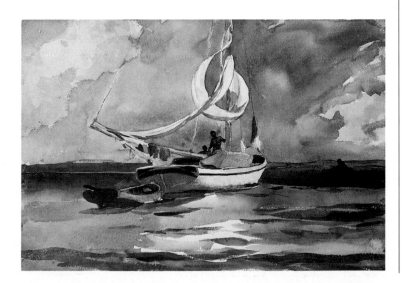

Homer, "Sloop, Nassau," 1899, MMA, NY. *Homer was America's premier marine painter and watercolorist, fascinated by the power and energy of the sea.*

***EAKINS:* THE ANATOMIST.** Thomas Eakins (pronounced AY kins; 1844–1916) was such an uncompromising realist that when he decided to paint a crucifixion, he strapped his model to a cross. His first concern, he maintained, whether painting a religious picture or, more commonly, portraits and Philadelphia scenes, was to get the anatomy right.

Eakins approached his profession logically and systematically, mastering the necessary technical skills in progressive stages. To learn anatomy, he dissected cadavers and became so knowledgeable on the subject he lectured to medical students. He plotted out the perspective of his paintings with mathematical precision, laying out the structure in grids by mechanical drawing. He was as straightforward as artists came. "I hate affectation," he wrote. "I am learning to make solid, heavy work."

RADICAL TEACHING METHOD. As director of the Pennsylvania Academy, Eakins revolutionized art instruction. The accepted practice was to draw from plaster casts of ancient sculpture. Eakins detested such second-hand learning: "The Greeks did not study the antique," he said. "Nature is just as varied and just as beautiful in our day as she was in the time of Phidias." He required students to draw the nude from life, studying its motion and anatomy. The idea was ahead of its time: when he insisted on a class of both men and women drawing from what a newspaper called "the absolute nude," Eakins was fired in disgrace. Indeed, many of Eakins' attitudes were ahead of their time. When professional careers were closed to women and blacks, he encouraged them to study art. One of his pupils, Henry O. Tanner (1859–1937), became the first important black painter and the most successful black American artist before Romare Bearden and Jacob Lawrence.

PORTRAITS. From the late 1870s on, Eakins painted mostly portraits. Each captured the essence of the individual, yet because he never flattered a sitter, many customers refused the commissioned works. "The negative response was often brutally discourteous and disagreeable," wrote his biographer. Of those accepted, an inordinate number — probably 10 percent — were destroyed. Today Eakins is considered America's finest nineteenth-century painter and, in the opinion of many, the greatest painter America has produced.

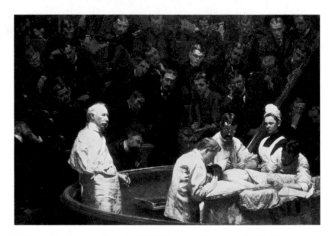

STARK REALISM. *Eakins depicts an actual breast-cancer operation by the surgeon Dr. Agnew, who lectures to medical students. Critics considered Eakins's "anatomy lessons" a "degradation of art" and denounced him as a "butcher" for his graphic portrayals. The Pennsylvania Academy refused to display the painting at its exhibition, but for Eakins, clinical fact made the painting all the more truthful.*

Eakins, "The Agnew Clinic," 1889, University of Pennsylvania, Philadelphia.

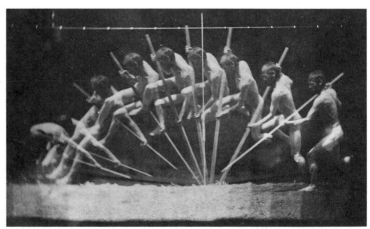

Eakins, "Pole-Vaulter: Multiple Exposure Photograph of George Reynolds," 1884–85, MMA, NY. *Eakins was a pioneer in the new technique of photography. Anticipating the invention of the movie camera, he, with Eadweard Muybridge, was first to take rapid, multiple exposures. Eakins used photo sequences of a man running or hurling a javelin to analyze the anatomy of movement.*

WHISTLER: ART FOR ART'S SAKE. James Abbott McNeill Whistler (1834–1903) was one of the most controversial artists of the nineteenth century and a leading theoretician of the Art for Art's Sake doctrine. Before a painting is anything else, Whistler maintained, it is, first and foremost, a blank surface covered with colors in varying patterns. His portraits, landscapes, and night pictures were less representations of a subject than experiments in decorative design. He intended no moral uplift in his paintings, saying, "Art should be independent of all claptrap." This radical notion that a design exists in and of itself, not to describe a subject or tell a story, would later change the course of Western art, just as his paintings were precursors of modern abstraction.

Whistler's life was as unconventional as his art. Born in Lowell, Massachusetts, he spent much of his childhood in St. Petersburg, Russia, which he claimed as his birthplace. "I shall be born when and where I want, and I do not choose to be born in Lowell," he said. After flunking out of West Point for a "deficiency in chemistry," Whistler bounced around without a profession until reading in *La Vie de bohème* of the wild life of Parisian art students. At the age of 21 he sailed for Europe, never to return to America.

Whistler played the bohemian to the hilt, flaunting his relationship with his red-haired model/mistress and parading conspicuously about London in foppish dress. With his lavish life-style, he was frequently in debt. He pawned his jacket for an iced tea on a hot day, and once, after a meal, announced, "I have just eaten my washstand." Given to public tantrums, Whistler upbraided the

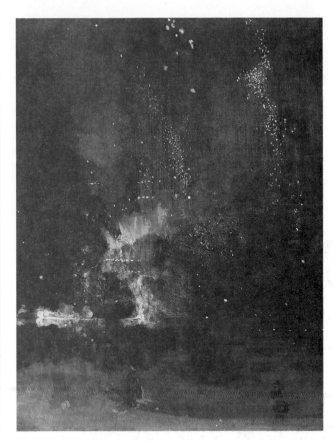

Whistler, "Nocturne in Black and Gold: The Falling Rocket," 1875, Detroit Institute of Arts. *This painting of fireworks in the night sky foreshadowed abstraction.*

"Philistines" who failed to appreciate his work. His insulting diatribes to the press prompted Degas's warning, "My friend, you behave as if you had no talent."

One notorious dispute shocked all of London. When Whistler exhibited "Nocturne in Black and Gold: The Falling Rocket," the influential critic John Ruskin denounced it as an affront to art and likened it to "flinging a pot of paint in the public's face." Outraged, Whistler sued for libel. In the widely publicized trial, he testified with caustic wit. When asked to justify a fee of 200 guineas for what Ruskin maintained was a "slovenly" painting executed in a maximum of two days, Whistler said its price was based on "the knowledge of a lifetime." He explained the painting's lack of identifiable objects: "I have meant to divest the picture from any outside anecdotal sort of interest. . . . It is an arrangement of line, form, and color first."

Whistler's most famous work, "Arrangement in Gray and Black No.1," is universally and incorrectly known as "Whistler's Mother." The artist believed the identity of the sitter was irrelevant to the painting, calling it an "arrangement" of forms. Whistler seemed to be heeding the advice of his friend French poet Mallarmé to "paint not the thing, but the effect that it produces."

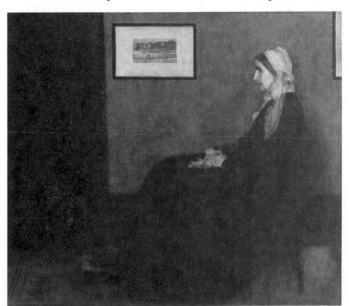

Whistler, "Arrangement in Gray and Black No. 1," 1872, Musée d'Orsay, Paris. *Whistler's strong sense of pattern and design made him insist that this painting was about shapes and colors, not his mother.*

SARGENT: PORTRAITS OF HIGH SOCIETY. The last great literal portrait painter (before the camera made such art less in demand) was John Singer Sargent (1856–1925). Truly an international artist, he was described as "an American born in Italy, educated in France, who looks like a German, speaks like an Englishman, and paints like a Spaniard." Although he painted with Monet at Giverny, Sargent modeled himself after the Spanish painter Velázquez, the acknowledged master of visual realism.

Sargent's childhood was rootless, as his American parents flitted from one hotel to another all over the Continent. By 19 Sargent had begun formal art training in Paris and by the age of 25 he was already a sensation — though not the kind he had hoped for. The work which was to have cemented his reputation created a scandal instead. Sargent painted a bold, full-length portrait of a famous Parisian beauty, posed in a deeply cut gown, her strap dangling immodestly off her shoulder

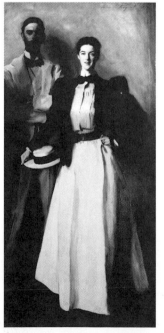

Sargent, "Mr. and Mrs. I. N. Phelps Stokes," 1897, MMA, NY. *Sargent painted portraits of high society in an elegant, elongated style.*

EARLY PHOTO-REALISM

Harnett, "Still Life – Violin and Music," 1888, MMA, NY.

William Michael Harnett (1848–92) was the most emulated American still life painter of his generation. His microscopically accurate paintings of ordinary objects (called "deceptions") were so convincing, they literally "fooled the eye" (the meaning of the term "trompe l'oeil"). Spectators had to be fenced off to keep them from wearing away the paint by touching. While academic painters exhibited their prettified nudes in the Paris Salon, Harnett's work hung in saloons. In fact, a Harnett trompe l'oeil made one pub so famous, people lined up to gape at the painting. Regulars routinely won bets with customers who insisted the painted objects were real. Harnett was nearly arrested by Treasury agents who considered his pictures of currency to be counterfeiting.

"Still Life—Violin and Music," is a tour de force of realism. Through the use of shadows (the sheet music and calling card are shown with edges bent, the door stands ajar), Harnett simulates a wide range of depth. The objects are arranged with geometrical precision. Vertical axes (the bow, wood slats, and metal latch) intersect horizontal lines defined by hinges and wood frame. The slightest rearranging of any object would upset the composition's careful balance.

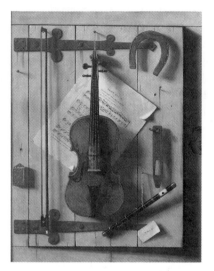

(he later painted over the strap, restoring it to propriety). Although he called the painting "Madame X," everyone recognized the subject, and, with her shocking lavender makeup, she became the laughing stock of Paris. Her mother demanded that he withdraw the work from view. Shocked by the response, Sargent left Paris for London, where he vowed to abandon frankness for flattery in all future portraits.

Sargent had a gift for posing his prosperous subjects naturally to bring them to life. When asked if he sought to represent the inner person behind the veil, Sargent replied, "If there was a veil, I should paint the veil. I can only paint what I see."

THE SOCIAL REGISTER. Witty, urbane, and perfectly at ease among the upper crust, Sargent could pick his subjects and name his price. He excelled at the "portrait d'apparat," or portrait of a person — usually

rich and powerful — in his or her home setting. Although he concentrated on the full-length figure, his portraits included opulent accessories like Ming vases, yards of satin, red velvet draperies, and gleaming gold.

In "Mr. and Mrs. I. N. Phelps Stokes," Sargent intended to portray only Mrs. Stokes in a van Dyck pose with a huge dog at her side. Unfortunately, no Doberman was available, so he sketchily substituted her husband, whose vague, shadowy face indicates he was clearly an afterthought. Sargent lavished more care on the crisply drawn female figure, her face radiant with intelligence and charm. The sharp folds of her starched skirt serve to elongate her height and exaggerate her slenderness in Sargent's clean, linear design. Such elegant paintings in the tradition of Gainsborough and Reynolds made Sargent a huge success on both sides of the Atlantic.

ARCHITECTURE FOR THE INDUSTRIAL AGE

For much of the nineteenth century, revival styles like pseudo-Greek or Roman temples and updated Gothic castles dominated architecture. When the Industrial Revolution made new materials like cast-iron supports available, architects at first disguised them in Neoclassical Corinthian columns. Only in purely utilitarian structures like suspension bridges, railroad sheds, and factories was cast iron used without ornament. Gradually, however, an awareness grew that new materials and engineering methods demanded a new style as practical as the Age of Realism itself.

The Crystal Palace (1850–51), housing the first World's Fair in London, demonstrated the aesthetic possibilities of a cast-iron framework. Joseph Paxton (1801–65), an engineer who specialized in greenhouses, designed the iron-and-glass structure as a huge conservatory covering 21 acres and enclosing mature trees already on the site. Because machines stamped out cast-iron elements in prefabricated shapes, construction was a snap. In an astonishing six months, workers put the building together like a giant erector set. A barrel-vaulted transept of multiple panes of glass in an iron skeleton ran the length of the building. Interior space, flooded with light, seemed infinite, the structure itself almost weightless.

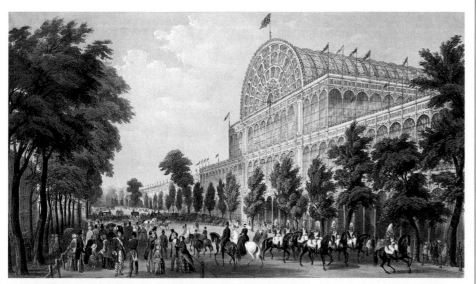

Paxton, The Crystal Palace, 1850–51, (destroyed by fire, 1935), Guildhall Library, London. *The Crystal Palace was the first iron-and-glass structure built on such a huge scale that showed industrial materials were both functional and beautiful.*

Use of cast iron spread after mid-century, permitting buildings to be bigger, more economical, and fire-resistant. Many buildings with cast iron facades still stand in New York's SoHo district, and the United States Capitol dome was constructed of cast-iron in 1850–65. After 1860, when steel was available, vast spaces could be enclosed speedily. The invention of the elevator allowed buildings to grow vertically as well as horizontally, preparing for the advent of the skyscraper.

The greatest marvel of engineering and construction of the age was the Eiffel Tower. Built as the central feature of the 1889 Paris Exhibition, at 984 feet it was the world's tallest structure. The Tower consisted of 7,300 tons of iron and steel connected by 2.5 million rivets. It became a daring symbol of the modern industrial era.

ARTS AND CRAFTS. *Countering the growing prestige of Industrialism was the Arts and Crafts Movement led by British author and designer William Morris (1834–96). Throughout Europe and America, the Arts and Crafts Movement of the late nineteenth century influenced decorative arts from wallpaper and textiles to book design. The group advocated a return to the handicraft tradition of art "made by the people, and for the people, as a happiness to the maker and the user." Morris succeeded temporarily in reviving quality in design and craftsmanship, which was threatened with extinction by mass production. He did not, however, achieve his goal of art for the masses. Handmade objects were simply too expensive.*

The Arts and Crafts Movement was influenced by the Pre-Raphaelite Brotherhood, an earlier English art group formed in 1848 to restore art to the "purity" of Italian art before Raphael. It included the painters W. H. Hunt, J. E. Millais, and D. G. Rossetti.

Morris, "Cray" chintz, *1884, Victoria & Albert Museum, London.*

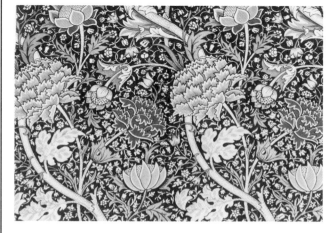

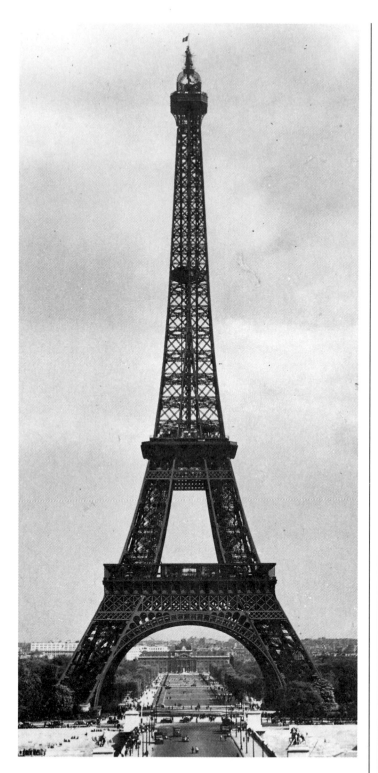

Eiffel, Eiffel Tower, 1889, Paris. *A triumph of modern engineering, the Eiffel Tower flaunted its iron-and-steel skeleton, devoid of allusions to past architectural styles.*

ART NOUVEAU

Art Nouveau, which flourished between 1890 and World War I, was an international ornamental style opposed to the sterility of the Industrial Age. Art Nouveau relied upon twining, flowering forms to counter the unaesthetic look of machine-made products. Whether called Jugendstil (Youth Style) in Germany, Modernista in Spain, Sezessionstil in Austria, Stile Liberty in Italy, or Style Moderne in France, Art Nouveau was easily recognizable by its sinuous lines and tendrillike curves. It was used to maximum effectiveness in the architecture of Antonio Gaudí (see p. 65) and the Belgian Victor Horta, and in interior design of the period in general. Art Nouveau's trademark water lily shape exerted a pervasive influence on the applied arts such as wrought-iron work, jewelry, glass, and typography.

BEARDSLEY: AESTHETIC DECADENCE. Aubrey Beardsley (1872–98) was an illustrator whose curvilinear drawings ideally reflect Art Nouveau design. Beardsley's black-and-white illustrations for his friend Oscar Wilde's *Salome* caused a sensation when the book was published. In one illustration, Salome kisses the severed head of John the Baptist, whose dripping blood forms a stem. The drawing's perverse eroticism typified fin-de-siècle decadence. Beardsley eliminated shading in his graphic art, contrasting black and white patterns in flowing, organic motifs.

Beardsley, "Salome," 1892, Princeton University Library. *Beardsley used Art Nouveau's sinuous, curving lines based on plant forms.*

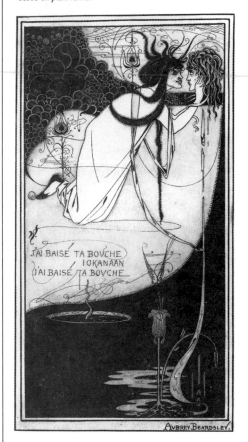

TIFFANY: GLASS MENAGERIE. The epitome of Art Nouveau's creeping-vine motif was the glasswork of American Louis Comfort Tiffany (1848–1933). Tiffany's lamps cascaded with stained-glass wisteria, his vases blossomed into lotuses, and his stained-glass windows dripped clusters of grapes. Whatever the object, all Tiffany designs were bowers of willowy leaves and petals in gleaming colors.

Son of the founder of New York's Tiffany's jewelers, Tiffany studied painting, then designed stained-glass windows for churches. When he replaced martyrs and saints with poppies and peacocks, his work became immensely popular. In the floral, landscaped windows celebrating nature's profusion, Tiffany created some of the most innovative glasswork ever.

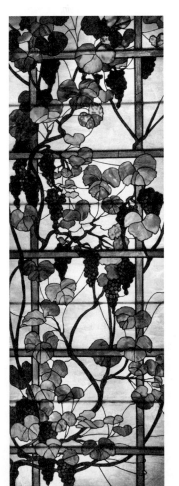

Tiffany studios, "Grape Vine," 1905, MMA, NY. *Tiffany's Art Nouveau works in stained glass reflected his two passions: nature and color.*

BIRTH OF PHOTOGRAPHY

In the early nineteenth century scientific discoveries in optics and chemistry converged to produce a new art form: photography. In 1826 French chemist Nicéphore Niépce (1765–1833) made the first surviving photographic image, a view of the courtyard outside his home. To obtain the hazy image, Niépce exposed a polished pewter plate for eight hours.

His collaborator, Louis-J.-M. Daguerre (1789–1851), invented a more practical process of photography in 1837. His first picture, "Still Life," was a brilliantly detailed view of a corner of his studio, exposed for 10 to 15 minutes. In 1839 Daguerre inadvertently took the earliest known photograph of a human being. His picture of a Parisian boulevard known to have been crowded with rushing pedestrians is eerily empty of life, except for a man having his shoes shined — the only human being who stood still long enough for his image to register during the long exposure.

An Englishman, William Henry Fox Talbot (1800–77), further improved the process of photography with his invention of calotypes, or the photo negative, announced in 1839. He had begun experimenting by pressing leaves, feathers, and pieces of lace against prepared paper that was exposed to sunlight. His later prints of projected images were blurred compared to the sharp daguerreotypes, but were achieved with paper negatives and paper prints.

Other advances soon followed. In 1851 a process called wet-plate reduced exposure time to seconds and produced prints almost as precise as Daguerre's. Then the tintype was invented, with an image on a thin metal plate instead of delicate glass. Next the dry-plate liberated the photographer from dashing into the darkroom immediately. Not only would the image keep longer before developing, the speed of exposure was so fast the photographer no longer needed a tripod. By 1858, instant photography replaced the daguerreotype. In the 1880s, portable hand-held cameras and roll film took over.

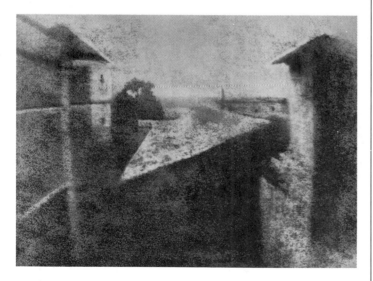

Niépce, "View from His Window at Gras," 1826, Gernsheim Collection, University of Texas at Austin. *This is the first surviving photograph, exposed for eight hours.*

Daguerre, "A Portrait of Charles L. Smith," 1843, International Museum of Photography at George Eastman House, Rochester, NY. *Daguerre invented a practical method of photography.*

Fox Talbot, "Sailing Craft," c. 1844, Science Museum, London. *Fox Talbot developed paper negatives and prints.*

TYPES OF POPULAR PHOTOGRAPHY

TRAVEL PHOTOGRAPHY. Professional photographers swarmed to wayward locales to document far-off wonders and feed the public's appetite for the exotic. Suddenly the pyramids and sphinxes of Egypt, Old Faithful erupting, Niagara Falls, and the Grand Canyon were accessible to armchair travelers. These first mobile shutterbugs surmounted formidable difficulties, lugging heavy equipment and fragile plates up Alpine peaks, working under broiling sun, and then in the stifling gloom of portable darkrooms. Blackened fingers, clothes corroded by silver nitrate, and often great physical danger could not daunt the early pioneers of photography.

WAR PHOTOGRAPHY AND MATTHEW BRADY. In more than 7,000 negatives, Matthew Brady (1823–96) brought home the horrors of the Civil War. "A spirit in my feet said go, and I went," he explained. In addition to his spirit, he had to take along a wagonload of equipment. Troops called his darkroom on wheels the "Whatsit" wagon. It often became the target of enemy fire as Brady crouched inside processing glass plates while battles raged around him. Since it took three minutes to make an impression on a plate, Brady was confined to pictures of soldiers posing in camp, battlefields, and corpses in trenches. His photos of skeletons with canteens still slung around them recorded the grim reality of war with a heretofore-unknown authenticity and inspired Lincoln's Gettysburg Address.

At Bull Run, Brady was almost killed and was lost for three days. Still wearing his long linen duster, straw hat, and a borrowed sword, a gaunt and hungry Brady straggled into Washington. After loading up on new supplies, he rushed back to the front.

O'Sullivan, "Canyon de Chelly, Arizona," 1867, International Museum of Photography at George Eastman House, Rochester NY. *Travel photographs of the American West convinced Eastern legislators to establish the first national parks.*

Brady, "Ambulance Wagons and Drivers at Harewood Hospital," 1863, Library of Congress, Washington, DC. *Civil War photographer Brady's authentic pictures demonstrated the new medium's claim to be a "mirror with a memory."*

DOCUMENTARY PHOTOGRAPHY. Jacob Riis (1849–1914) was a New York police reporter who had direct experience with the violence of sordid city slums. After flash gunpowder (the equivalent of a modern flashbulb) was invented, he had the element of surprise on his side and invaded robbers' hangouts, sweatshops, and squalid tenements to document appalling conditions on Manhattan's Lower East Side. Riis published the shocking details in newspaper exposés and a book, *How the Other Half Lives* (1890). His graphic images led to the first legislation to reform housing codes and labor laws.

Riis, "Street Arabs in the Area of Mulberry Street," c. 1889, Jacob A. Riis Collection, Museum of the City of New York. *Muckraking photojournalist Riis documented unsavory living and working conditions among the urban poor, as in this shot of homeless children.*

PORTRAIT PHOTOGRAPHY. Nadar (1820–1910), a French caricaturist, began to photograph the leading artistic figures of Paris in 1853. His portraits of luminaries like George Sand, Corot, Daumier, and Sarah Bernhardt were more than just stiff documentary portraits. He conceived, posed, and lighted the figures to highlight their character traits. For instance, in his photograph of Bernhardt, the archetypal tragic actress, he posed her swathed in a dramatic sweep of drapery. Nadar was among the first to use electric light for photographs and invented aerial photography, hovering above Paris in a hot air balloon. He built one of the largest balloons in the world, Le Géant ("the giant"), and was once swept away to Germany and dragged 25 miles over rough terrain before he could halt the runaway craft.

Nadar, "Sarah Bernhardt," 1859, International Museum of Photography at George Eastman House, Rochester, NY. *Nadar photographed Paris's leading lights like the famed actress.*

Cameron, "Call, I follow; I follow; let me die," c. 1867, Royal Photographic Society, Bath. *Cameron was the first to shoot pictures out of focus in order to convey atmosphere.*

ART PHOTOGRAPHY. Julia Margaret Cameron (1815–79) wanted to capture nothing less than ideal beauty. When given a camera at the age of 48, she began making portraits of famous Victorians who also happened to be her friends: Tennyson, Carlyle, Browning, Darwin, and Longfellow. Cameron excelled at defining personality in intense portraits and said, "When I have had such men before my camera my whole soul has endeavored to do its duty towards them in recording faithfully the greatness of the inner as well as the features of the outer man. The photograph thus taken has been almost the embodiment of a prayer." She was first to have lenses specially built for a soft-focus effect in her allegorical and often overly sentimental genre pictures.

EARLY PORTRAIT PHOTOGRAPHY

It's no wonder our ancestors look stiff and grim in early daguerreotypes, given the pain involved in capturing an image. To take the first photo portraits, Samuel F. B. Morse made his wife and daughter sit dead still for twenty minutes on the roof of a building in glaring light with their eyes closed (he later painted in the eyes). Most photographers had special chairs called "immobilizers," which clamped the sitters' heads in a vise hidden from the camera's sight, to make sure their subjects held still. One victim described the ordeal, recalling that he sat "for eight minutes, with the strong sunlight shining on his face and tears trickling down his cheeks while . . . the operator promenaded the room with watch in hand, calling out the time every five seconds." Despite the discomfort, daguerreotypes were wildly popular. Emperor Napoleon III even halted his march to war in front of a studio to have his portrait taken.

PHOTOGRAPHY'S IMPACT ON PAINTING

When the French romantic painter Delaroche, known for his painstakingly detailed scenes, heard of the first photograph, he proclaimed, "From this day, painting is dead!" The art of painting miniature portraits was immediately doomed, replaced by the ubiquitous daguerreotypes which could be ready in fifteen minutes for $12\frac{1}{2}$ cents. The Fauve painter Vlaminck spoke for fearful painters when he said, "We hate everything that has to do with the photograph."

Other artists viewed photographs as helpful adjuncts. Delacroix used them as studies for hard-to-hold poses, saying, "Let a man of genius make use of the Daguerreotype as it should be used, and he will raise himself to a height that we do not know." His bitter rival, Ingres, denied that photographs could ever be fine art but also used them as portrait studies, admiring "their exactitude that I would like to achieve." His portraits have a silvery style similar to daguerreotypes.

Soon many painters saw the advantage of using photographs for portraits instead of interminable sittings. After artists had reproduced the camera likeness, the subject had only to sit for final color touch-ups. Bierstadt found photos useful models for his panoramic landscapes, while Courbet and Manet also used them. Degas's frozen-action shots helped him devise unusual poses and unconventional compositions. Within three generations after the invention of photography, painters abandoned the image for abstraction.

Gradually photographers began to insist their craft was more than a trade of snapping portraits or groundwork for painting but a fine art in itself. As the writer Lamartine put it, photography was "more than an art, it is a solar phenomenon, where the artist collaborates with the sun." The camera excelled at reproducing images realistically, but photographers aspired to imitate painting. To compete with the artist's imagination, "art photographers" began to shoot images slightly out of focus, retouch negatives, add paint to prints, superimpose negatives, and otherwise manipulate the mechanically produced images. A new art form for the post-Industrial-Revolution world was born.

IMPRESSIONISM:
LET THERE BE COLOR AND LIGHT

The movement known as Impressionism marked the first total artistic revolution since the Renaissance. Born in France in the early 1860s, in its purest form it lasted only until 1886, but it nevertheless determined the course of most art that followed. Impressionism radically departed from tradition by rejecting Renaissance perspective, balanced composition, idealized figures, and chiaroscuro. Instead, the Impressionists represented immediate visual sensations through color and light.

Their main goal was to present an "impression," or the initial sensory perceptions recorded by an artist in a brief glimpse. They built on Leonardo's observation that a person's face and clothes appear green when walking through a sunlit field. Color, they discovered, is not an intrinsic, permanent characteristic of an object but changes constantly according to the effects of light, reflection, or weather on the object's surface.

To meet the challenge of portraying such fleeting qualities of light, they created a distinctive short, choppy brushstroke. These brightly colored spots formed a mosaic of irregular daubs throbbing with energy like the pulsebeat of life or the shimmer of light on water. At close range, the Impressionists' daubs of pure color side by side looked unintelligible, causing critics to charge they "fired paint at the canvas with a pistol." At a distance, however, the eye fused separate streaks of blue and yellow, for instance, into green, making each hue seem more intense than if mixed on a palette. Even their painted shadows were not gray or black (the absence of color which they abhorred) but composed of many colors.

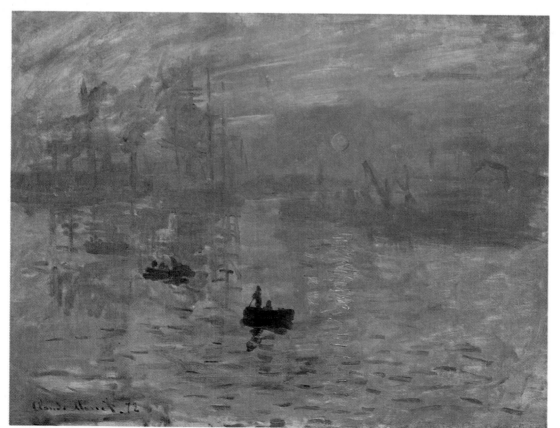

Monet, "Impression: Sunrise," 1872, Musée Marmottan, Paris. *In 1874 Degas, Sisley, Pissarro, Morisot, Renoir, and Monet, among others, mounted their first group exhibition, which included "Impression: Sunrise." This painting earned the group the name "Impressionists," coined by a critic as a derogatory slur on the "unfinished" nature of the work. (The term "impression" had before been used to denote a rapid, sketchlike treatment or first intuitive response to a subject.) Here Monet's blobs and streaks of color indicating ripples and boats at dawn were the finished painting. The name stuck.*

HOW TO TELL THEM APART

It doesn't help that Manet's and Monet's names are almost identical or that the whole group often painted the same scenes in virtually indistinguishable canvases. First impressions can be deceiving, however. Basic differences are just as striking as the similarities.

Monet, "Rouen Cathedral," 1892—94, Museum of Fine Arts, Boston.

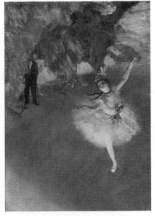

Renoir, "Le Moulin de la Galette," 1876, Musée d'Orsay, Paris.

Manet, "Bar at the Folies-Bergère," 1882, Courtauld Institute, London.

Degas, "Prima Ballerina," c. 1876, Musée d'Orsay, Paris.

ARTIST	MANET	MONET	RENOIR	DEGAS
SUBJECTS	Updated Old Masters themes, painted contemporary scenes with hard edge	Landscapes, waterfront scenes, series on field of poppies, cliffs, haystacks, poplars, Rouen Cathedral; late work: near-abstract water lilies	Voluptuous, peach-skinned female nudes, café society, children, flowers	Pastel portraits of human figure in stop-action pose; ballerinas, horse races, café society, laundresses, circus; late work: nudes bathing
COLORS	Dark patches against light, used black as accent; early: somber; late: colorful	Sunny hues, pure primary colors dabbed side by side (shadows were complementary colors dabbed side by side)	Rich reds, primary colors, detested black — used blue instead	Gaudy hues side by side for vibrancy; early: soft pastel; late: broad smears of acid-colored pastels
STYLE	Simplified forms with minimal modeling, flat color patches outlined in black	Dissolved form of subject into light and atmosphere, soft edges, classic Impressionist look	Early: quick brushstrokes, blurred figures blended into hazy background; late: more Classical style, solidly formed nudes	Offbeat angles with figures cropped at edge of canvas, asymmetrical composition with void at center
ADVICE	Not much of a theorist but did say artist "simply seeks to be himself and no one else"	"Try to forget what objects you have before you, a tree, a house, a field or whatever. Merely think, here is a little square of blue, here an oblong of pink, here a streak of yellow, and paint it just as it looks to you."	"Paint with joy, with the same joy that you would make love to a woman."	"Even when working from nature, one has to compose."

LANDMARK PAINTINGS IN ART HISTORY

Certain paintings altered the course of Western art, signaling a profound shift from one style to the next. These seminal works not only kicked off a revolution in how painters saw art, they changed the way people thought about the world.

Each of these groundbreaking paintings seemed radical in its day. Most provoked howls of outrage from conservatives. Now, however, they've become part of yesterday's tradition that new artists defy in even more controversial gestures of independence. "All profoundly original art, " said critic Clement Greenberg, "looks ugly at first."

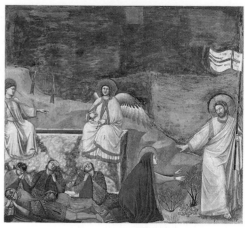

Giotto, "Noli me tangere," 1305–6, Arena Chapel, Padua. *Giotto founded the Western tradition in painting when he broke away from stylized, Byzantine figures for a more three-dimensional style and convincing sense of space. Giotto's natural style, coupled with the Renaissance mastery of anatomy and perspective, was the cornerstone of Western art until the twentieth century.*

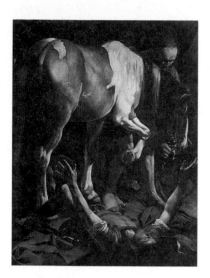

Caravaggio, "Conversion of St. Paul," c. 1601, Santa Maria del Popolo, Rome. *In his strongly lit, realistically painted figures, Caravaggio rejected Renaissance-idealized beauty and Mannerist artificiality. He introduced everyday reality into art, engaging the viewer's emotions through thrusting compositions and dramatic shadows. Although Caravaggio worked only twelve years, he revolutionized Western painting, portraying old subjects in completely new ways and ushering in the theatrical Baroque Age.*

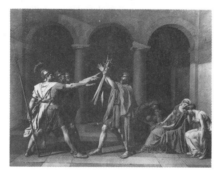

David, "Oath of the Horatii," 1784, Louvre, Paris. *David's austere, taut composition marked the end of fluffy, frivolous Rococo art. Henceforth, Neoclassical art, with its revival of interest in antiquity and morality and its rational sense of order, dominated.*

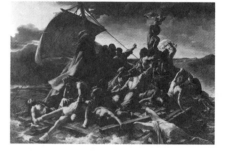

Géricault, "The Raft of the Medusa," 1818–19, Louvre, Paris. *Géricault rejected stiff, intellectualized art for passionate, subjective topics and technique. By treating a contemporary event (a shipwreck) with epic grandeur, he ushered in a new concept of what constitutes art. Instead of academic history painting, Romantic art could portray individual emotional concerns.*

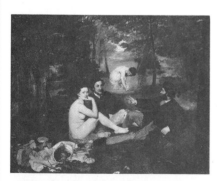

Manet, "Le Déjeuner sur l'herbe," 1863, Musée d'Orsay, Paris. *Manet shattered tradition by painting female nudes as contemporary human beings, not idealized goddesses, and by abandoning academic chiaroscuro for bold light-dark contrasts. By repudiating the allegorical Salon style, he brought painting into the modern world of real life.*

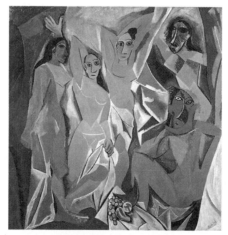

Picasso, "Les Desmoiselles d'Avignon," 1907, MoMA, NY. *In this transitional painting on the brink of Cubism, Picasso exploded traditional ideas of beauty, perspective, anatomy, and color. He replaced the appearance-based style that had reigned since the Renaissance with an intellectual structure that existed only in his mind — the most important turning point in the development of no-holds-barred Contemporary art.*

Pollock, "Number 1, 1950 (Lavender Mist)," 1950, NG, Washington, DC. *Around 1947 Pollock abandoned paint brushes and easel painting, putting his canvas on the floor and pouring paint without premeditation. This process, prompted by the subconscious and incorporating chance effects, created an all-over pattern of lines and drips that eliminated accepted ideas of composition like focal point, background, and foreground. Pollock's breakthrough gave unprecedented freedom to artists and moved the avant-garde capital from Paris to New York.*

THE MOVEMENT.

Impressionism arose around 1862 when Renoir, Monet, Bazille, and Sisley were students in the same Parisian studio. Exceptionally close-knit because of their common interest in painting nature out-of-doors, they took excursions together to paint with the Barbizon artists. When urged by a teacher to draw from antique casts, the young rebels dropped formal course work. "Let's get out of here," Monet said. "The place is unhealthy." They claimed Manet as their hero, not for his style but for his independence. Rejected by the gatekeepers of officialdom, in 1874 the Impressionists decided to show their work as a group — the first of eight cooperative shows.

Their work differed drastically from the norm both in approach and technique. Painting from start to finish in the open air was their modus operandi; the usual method of sketching outside, then carefully finishing a work in the studio was, for them, a heresy. Their use of light and color rather than meticulously drawn form as guiding principles was also considered shocking. This new work had no discernible narrative content; it didn't rehash history but portrayed instead a slice of contemporary life or a flash snapshot of

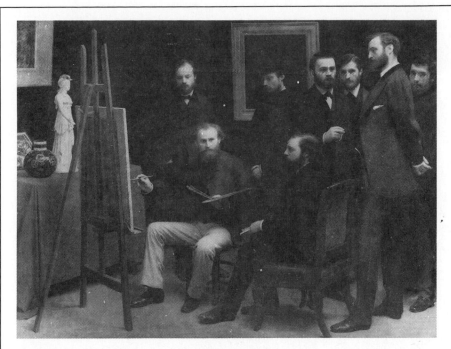

Fantin-Latour, "L'Atelier des Batignolles," 1870, Musée d'Orsay, Paris.

Manet's Gang. *The still life painter Fantin-Latour celebrated Manet's role as leader of French avant-garde artists with this group portrait at Manet's studio, or "atelier." Manet is at the easel with the German painter Scholderer standing behind and writer Astru seated for his portrait. On the right (from left) are Renoir, Zolu, Edmond Maitre, Bazille, and Monet. The word "Batignolles" in the title refers to a section of Montmartre in Paris where the Impressionist painters gathered to debate art. Since they painted only during daylight hours, in the evenings they met at the Café Guerbois. Manet presided over this group of renegade painters Degas, Cézanne, Sisley, Renoir, Fantin-Latour, Bazille, Pissarro, and Monet, known as "Manet's gang." Monet recalled, "From [these evenings] we emerged with a firmer will, with our thoughts clearer and more distinct." 1869 was the turning point. Renoir and Monet then worked side by side outdoors with their portable easels and traveling paint boxes. They established the new technique while capturing the fleeting effects of sunlight on the waters of the Seine.*

FIRST IMPRESSIONISM

PERIOD: 1862–86

ORIGINAL CAST: Manet, Monet, Renoir, Degas, Pissarro, Sisley, Morisot, Cassatt

SUBJECTS: Outdoors, seaside, Parisian streets and cafés

PURPOSE: To portray immediate visual sensations of a scene

nature. And how unkempt the Impressionist version of nature appeared! Landscapes were supposed to be artificially arranged à la Claude with harmoniously balanced hills and lakes. Composition for the Impressionists seemed nonexistent, so overloaded was one side of the canvas, with figures chopped off by the picture frame.

The work was considered so seditious that a cartoon showed a pregnant woman barred from entering the Impressionist exhibit, lest her exposure to such "filth" injure her unborn child. A newspaper solemnly recounted how a man, driven insane by the paintings, rushed out to bite innocent bystanders. The art critics were even

crueler. One claimed Renoir's "Nude in the Sun" made the model's flesh look putrid. They called Monet's dark daubs "tongue lickings" and pronounced his technique "slapdash." Not until the 1880s were Impressionist painters accepted and acclaimed.

CONTRIBUTIONS.

After Impressionism, painting would never again be the same. Twentieth-century painters either extended their practice or reacted against it. By defying convention, these rebels established the artist's right to experiment with personal style. Most of all, they let the light of nature and modern life blaze through the shadowy traditions of centuries.

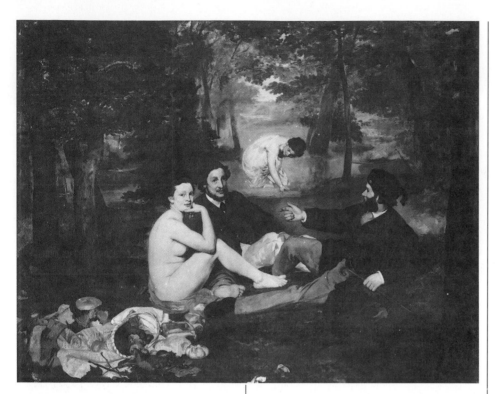

Manet, "Le Déjeuner sur l'herbe," 1863, Musée d'Orsay, Paris. *Manet painted flat areas of color — a radical break with traditional chiaroscuro.*

MANET: PIONEER OF THE MODERN.

Edouard Manet(1832–83) is often called the Father of Modern Art. A reluctant martyr to the avant-garde who wanted nothing more than the official recognition he was denied, Manet is difficult to classify.

Although he painted alongside Renoir and Monet, who hailed him as their leader, he never exhibited with the Impressionists. Classically trained, he saw himself in the tradition of the great masters whose motifs he often borrowed. Yet critics vilified his work, labeling it a "practical joke . . . a shameful, open sore."

What outraged the public and made Manet a hero to young rebels was his translating the Great Tradition into modern terms. Manet stripped away idealizing mythology to portray modern life candidly. He also eliminated the subtle glazing and detailed polish of academic technique. His sketchy brushwork gave his pictures an unfinished look, making his images appear flat and hard.

Art history credits Manet with launching "the revolution of the color patch." With this new technique, Manet suggested form through broad, flat areas (or patches) of color. Almost as if consciously declining to compete with the camera's realism, he refused to simulate three-dimensionality through modeling forms with lines or gradations of color. His stencillike images were purposely shallow and simplified. In place of halftones to suggest volume, he used starkly contrasting light tones against dark.

This radical shift in technique forced people to look anew at the picture surface. Ever since the Renaissance, artists regarded the framed painting as a window to look *through*, in order to see a painted scene "receding" in the distance. With Manet's minimized modeling and perspective, he insisted his viewers look *at* the picture surface itself — a flat plane covered with painted shapes.

"Déjeuner sur l'herbe," or "Luncheon on the Grass," is the painting that stigmatized Manet as "a danger" to public morality. Shown at the Salon des Refusés in 1863 (an exhibition composed of canvases rejected by the official Salon), "Déjeuner" offended on both moral and aesthetic grounds. Portraying a naked woman and two clothed men picnicking was considered indecent because Manet failed to idealize the nude. Her contemporary look, direct gaze, and the fact that she resembled no pagan deity scandalized viewers, for whom nudity was acceptable only if disguised in Classical trappings.

Actually, Manet firmly grounded the work in the Renaissance tradition, basing the painting on both Giorgione's "Concert Champêtre" and an engraving after a Raphael design. The painting was also an

updating of the traditional "fête galante" painting where decorative aristocrats lolled in misty parks. In addition, Manet used traditional elements like the triangular grouping of figures, the still life arrangement in the left foreground, the goddesslike figure bathing at rear, and receding perspective for the illusion of depth.

He tried to make the public see what Baudelaire called the "epic" side of "actual life," or "how grand we are in our neckties and varnished boots!" Yet because Manet recast these conventions in realistic modern dress, the work aroused an unprecedented firestorm of hostility.

Two years later, in 1865, Manet's "Olympia" (see p. 71) caused an even greater stir. Crowds lined up 20 feet deep — held at bay by hefty guards — to gawk at what has been called "the first modern nude," a courtesan frankly confronting the spectator. Again Manet drew on precedent, using Titian's "Venus of Urbino" as model, but this time he substituted a prostitute for a goddess. The novelist Zola praised Manet for his modernity, calling Manet "a child of the century." To the conservative majority, however, Manet's matter-of-fact presentation of a real, unclothed human being was merely vulgar.

Academic artists who exhibited to great acclaim in the annual Salon often portrayed nudes, but only as Classical deities. Their technique also differed from Manet's sketchy style. At the time, painters charged by the hour. The more meticulously they worked on a painting, putting in endless detail and a high degree of finish, the higher the sale price. Although Manet worked hard on his paintings, often repainting them many times until satisfied, he was scorned as crudely incompetent for his "shortcuts" in applying paint with broad strokes.

LATE STYLE. In the 1870s, Manet's brushwork became even freer and looser. As he began to accompany Monet and Renoir on painting trips along the Seine, his work became indistinguishable from Impressionism. Manet's late masterpiece, "A Bar at the Folies-Bergère," shows how completely he absorbed Impressionist principles. He expressed, as Matisse observed, "only what immediately touched his senses." Far more important than the cabaret bar or barmaid, the subject of the painting is the painter's sensory impressions rendered through color.

Manet excelled at giving vital, visual form to the boulevards and cafés of contemporary Paris. Alone among the Impressionists, he faced the political upheavals of his day. When starving masses rioted, other Impressionists fled to the countryside to paint flowers, but Manet rushed to the scene to record the drama of class struggle. He never blinked at reality or compromised his highly original vision. By liberating his work from artistic convention, he earned Renoir's accolade: "Manet was a whole new era of painting."

THE SALON

What was this all-important Salon that dictated style in French painting for 200 years? Established in 1667 by the French Academy, the Salon was an annual art show named for the room, or Salon, in the Louvre where it was originally held. Not just the officially sanctioned art fair, the Salon was the only public art exhibition in Paris. As such, jurors wielded supreme power in standardizing taste. Since they were members of the arch-conservative Academy, jurors spurned works by innovative artists and perpetuated the stranglehold of history painting on French art.

In 1863, jurors rejected 3,000 of 5,000 paintings submitted. Calling the unacceptable work "a serious danger for society," the Salon was obviously hostile to bold art. The resulting outcry came to the attention of Emperor Napoleon III, who ordered the refused works exhibited in a pavilion dubbed the Salon des Refusés. Huge crowds viewed works by artists like Manet, Cézanne, and Pissarro.

The exhibit was a notorious succès de scandale (due mostly to Manet's epochal "Déjeuner sur l'herbe"). Art historians date the beginning of modern painting from this point. By the 1880s, the prestige of the Salon declined steadily, as artists like the Impressionists staged their own shows. Art dealers too began to play a more important role in displaying nonmainstream art.

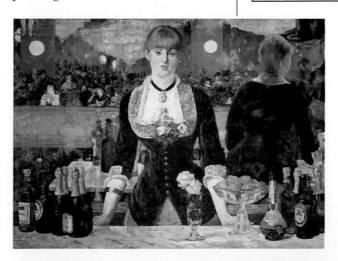

Manet, "A Bar at the Folies-Bergère," 1882, Courtauld Institute, London. *Manet used Impressionist techniques of flickering light and color.*

THE ART DEALER

Undoubtedly, some enterprising merchants made a killing exporting galleon-loads of Athenian art to Rome during Nero's shopping spree. But the first written evidence of the art dealer's profession comes from Renaissance art historian Vasari. He described how a Madonna painting by Andrea del Sarto "fetched for the merchants four times as much as they had paid for it" when resold to Francis I of France. During the seventeenth century the French Royal Academy forbade painters to sell their own work, forcing them to rely on commercial middlemen, and the art dealer became indispensable. Watteau even died in the arms of his dealer.

In the nineteenth century, merchants became patrons when visionary Parisian dealers like Durand-Ruel, Père Tanguy, and Ambroise Vollard bought works by artists the Salon rejected — "outcasts" like Monet, Renoir, van Gogh, Gauguin, Cézanne, and Picasso. In New York in the 1940s, Peggy Guggenheim provided a similar cushion for innovators like Duchamp, Ernst, and Pollock at her Art of This Century Gallery. The most savvy contemporary dealer is Leo Castelli, who transformed the '60s art world when he promoted Pop artists like Rauschenberg, Johns, Lichtenstein, and Warhol, then later championed Minimalists and Conceptual artists.

MONET: LIGHT = COLOR. Claude Monet (1840–1926) once said he wished he had been born blind and then gained his sight so he could, without preconceptions, truly paint what he saw. As it was, revelation came at age 18 when he began to paint out-of-doors. "Suddenly a veil was torn away," he said. "My destiny as a painter opened out to me."

Monet began as a commercial artist and caricaturist but after roaming the coast of Normandy painting sunlit, water-drenched scenes, he became a leading exponent of recording nature directly to convey his immediate impression of a given moment. After studying landscapes by Constable and Turner in London, Monet contributed "Impression: Sunrise" to the first Impressionist exhibit in 1874, which summed up the new movement's theme and gave it its name forevermore. For the next half-century, while others of the original group evolved their own variations on the theme, Monet remained true to the credo that light is color.

His dedication had its price. Like Renoir, during the 1860s and '70s, Monet suffered appalling poverty, pawning his possessions for paint. In 1869 a visitor reported that Monet was desperate: "completely starved, his wings clipped." He only survived because Renoir brought him bread from his own table. In 1875 he begged his friends for financial assistance, writing Zola, "We haven't a single sou in the house, not even anything to keep the pot boiling today." Monet pleaded with collectors to take his canvases at any price and burned 200 paintings rather than let them fall into his creditors' hands. By 1886, things were different. At the Impressionists' first New York exhibit, Monet was an established success and could afford to build a special studio to house his huge canvases.

OBSESSION. Monet's unwavering devotion to Impressionist ideals entailed physical as well as economic hardship. He was so obsessed with accurately portraying fugitive conditions of light that the outdoors became his studio. Regardless of weather, he hauled thirty canvases to the field to record haystacks, replacing one canvas with the next as the light changed. In winter he planted his easel in the snow and waded through ice floes in hip boots,

CATHEDRAL SERIES

In the 1890s Monet fixed on the idea of painting the same subject under different lighting conditions at different seasons to show how color constantly changes according to the sun's position. His series of haystacks, poplars, water lilies, and the Rouen Cathedral show how light and weather conditions define both form and color. In the cathedral sequence of more than thirty canvases, the Gothic stone building, dependent on fleeting atmospheric effects recorded from dawn to twilight, virtually dissolves. At left in glaring daylight the cathedral appears bleached out. At right, the projecting stone catches the fading yellow light, with flaming orange concavities and shadows in complementary blue.

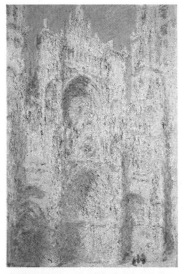

Monet, "Rouen Cathedral, West Facade, Sunlight," 1894, NG, Washington, DC.

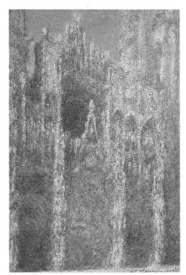

Monet, "Rouen Cathedral, Sunset," 1892–94, Museum of Fine Arts, Boston.

waiting patiently for just the right slant of light on the Seine. Once, when he painted on the beach during a storm, he was swept under by a wave.

Monet loved the water, once remarking that he wished to be buried in a buoy, and painted the sea frequently. He even converted a flat-bottomed boat, fitted out with grooves to hold his canvases, into a floating studio where he painted stacks of pictures from dawn till dusk. A visitor recalled: "In one of his Poplars the effect lasted only seven minutes, or until the sunlight left a certain leaf, when he took out the next canvas and worked on that."

Monet's lifelong fervor for open-air painting appeared as early as 1866 when he painted "Women in the Garden." Although the canvas was more than eight feet high, he was determined to paint it entirely outside and had a trench dug to hold the bottom of the canvas. He then raised and lowered the painting on pulleys as he worked on different levels. When the painter Courbet visited, he was astonished that Monet threw down his paint brush, refusing to paint even background leaves when the sun went behind a cloud.

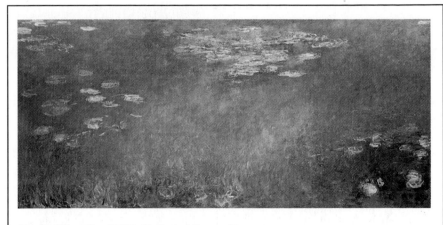

Monet, "Waterlilies," 1919–26, Cleveland Museum of Art.

GIVERNY. *When Monet went to live in Giverny, 40 miles from Paris, in 1883, it was hardly what it would become — a living canvas he called "my most beautiful masterpiece." At first he just planted a few flowers to provide still life subjects for rainy days. In 1890 Monet began to improve the garden, planting wisteria, weeping willows, and bamboo to create "a virgin forest of highly hued blossoms." Each day a gardener removed weeds and insects from the pond and clipped lily pads to keep the surface reflective. He even "bathed" the water lilies daily to increase their lustre. "Aside from painting and gardening," Monet said, "I am good for nothing."*

Each interest fed the other until, after 1911, the garden became his sole subject. Monet gradually expanded the size of the pond and the scale of his paintings, placing canvases 6 feet high and 14 feet long side by side in triptychs. When cataracts blurred his vision, Monet's painted water lilies became hazier and finally indistinguishable from the water and reflections. He had invented a new kind of painting that foreshadowed abstraction. "The essence of the motif is the mirror of water whose appearance alters at every moment, thanks to the patches of sky which are reflected in it, and which give it light and movement," he said.

Monet's compulsion to paint was so extreme he described himself as an animal endlessly turning a millstone. During his vigil at his first wife's deathbed, instead of mourning, he could not refrain from painting, recording blue, gray, and yellow streaks on her face as the pallor of death replaced the flush of life.

TECHNIQUE. Monet's style consisted of applying to the canvas small dabs of pigment corresponding to his immediate visual observations. Instead of the conventional gradations of tone, he placed vibrating spots of different colors side by side. In an effect called "optical mixing," these "broken colors" blended at a distance. To represent shadows, instead of black Monet added the complementary (or opposite) color to the hue of the object casting a shadow.

In the 1880s, Monet changed his handling of pigment. Rather than many specks of paint, he lengthened his brushstrokes into sinuous sweeps of color. In his hundreds of water lily paintings of 1900–26, Monet eliminated outlines and contours until form and line almost disappeared in interwoven brushstrokes. Vibrant colors melt into each other just as flowers blend into water and foliage. No image is the central focus, perspective ceases to exist, and reflections and reality merge in a hazy mist of swirling color. In these near-abstractions foreshadowing twentieth-century art, paint alone representing a moment of experience in light became Monet's subject.

Vision, for Monet, was supreme. He painted his colorful visions until his death at 86. "Monet is only an eye," Cézanne said. "But what an eye."

RENOIR: LOVE, LUST, AND LAUGHTER. "Renoir," a contemporary writer said, "is perhaps the only painter who never produced a sad painting." Pierre-Auguste Renoir (1841–1919) believed, "A picture must be an amiable thing, joyous and pretty — yes, pretty! There are enough troublesome things in life without inventing others."

Renoir came by the prettiness naturally, for he began by painting flowers on porcelain. Even through years of struggle when he was "so poor," as Bazille said, "that he used to pick up empty paint tubes and still squeeze something out of them," Renoir kept his cheerful optimism. This joie de vivre makes him perhaps the most beloved, and accessible, painter ever. Renoir's subjects were invariably crowd pleasers: beautiful women (often nude), flowers, pretty children, sunny outdoor scenes full of people and fun. He rooted his art in actual experience, convinced, as he said, that "Life was a perpetual holiday."

"Le Moulin de la Galette" (the name of a popular outdoor café) bursts with gaiety. Like Monet, who often painted the same subject at Renoir's side, Renoir fragmented form into glowing patches of light applied as short brushstrokes of distinct colors. The absence of outline, with form suggested by highlights, and dappled light are other Impressionist features, as was his refusal to use black. "It's not a color," he said, believing black punched a hole in the canvas. (He painted shadows and coats dark blue.) By snipping off figures at the edge of the canvas, he implied the scene expanded beyond the frame and engaged the viewer. His subjects seem unposed — momentarily caught in the flux of living.

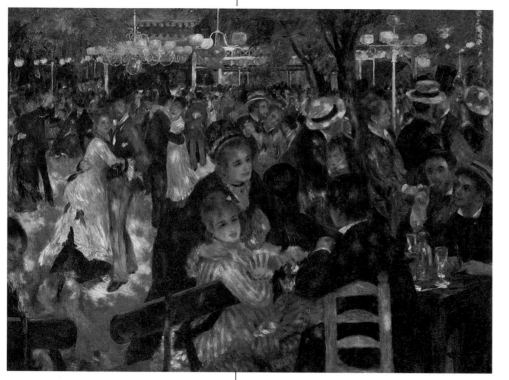

Renoir, "Le Moulin de la Galette," 1876, Musée d'Orsay, Paris. *Renoir specialized in human figures bathed in light and color, expressing the everyday joys of life. "The earth as the paradise of the gods, that is what I want to paint," he said.*

Renoir's brother described the painter's research for the picture as far from onerous: "When he painted the Moulin de la Galette he settled down to it for six months, wedded to this whole world which so enchanted him, and for which models in poses were not good enough. Immersing himself in this whirlpool of pleasure-seeking, he captured the hectic moment with dazzling vivacity."

As his Impressionist works gained success, however, Renoir became discontent with the style, saying in 1881, "[I] had traveled as far as Impressionism could take me." He rejected the insubstantiability of the Impressionist method and looked for a more organized, structured technique. After studying Renaissance masters, Renoir turned away from contemporary scenes toward universal subjects, particularly nudes in classical poses.

NUDES. Renoir's favorite eighteenth-century artists were the painters of pretty women, Boucher and Fragonard. Where Fragonard boasted he painted with his bottom, Renoir claimed to paint with his maleness. A lusty, enthusiastic

man, Renoir delighted in his portrayal of sensuous, rosy, ample nude women whom he described in amorous terms: "I consider my nude finished when I feel like smacking her bottom."

Hot red is the dominant color in his paintings of nudes, for he took great care to approximate healthy flesh tones. "I want a red to be loud, to ring like a bell; if it doesn't turn out that way, I put on more reds or other colors until I get it," he explained. "I look at a nude; there are myriads of tiny tints. I must find the ones that will make the flesh on my canvas live and quiver."

Renoir wanted to express more than just vitality and fertility, however, with his earth-mother nudes. He paid new attention to design and outlined forms distinctly in his "manière aigre" (sharp style). He posed the nudes in crisp arrangements according to Classical prototypes, as Venuses and nymphs, and eliminated background detail for a sense of timeless grandeur. "I like painting best when it looks eternal without boasting about it," he said, "an everyday eternity, revealed on the street corner: a servant-girl pausing a moment as she scours a saucepan, and becoming a Juno on Olympus."

After 1903 Renoir, afflicted with severe arthritis, lived on the Riviera. Confined to a wheelchair, his hands paralyzed, he painted with a brush strapped to his wrist. Despite what his dealer called the "torture" of this "sad state," Renoir displayed "the same good disposition and the same happiness when he [could] paint." Sadly, Renoir's diminishing artistic control is evident in his late nudes, where the buxom, ruddy-cheeked females are swollen, grossly exaggerated, and intensely colored. More important than skill for the painter, Renoir thought, was that "one should be able to see that he loves to caress his canvas."

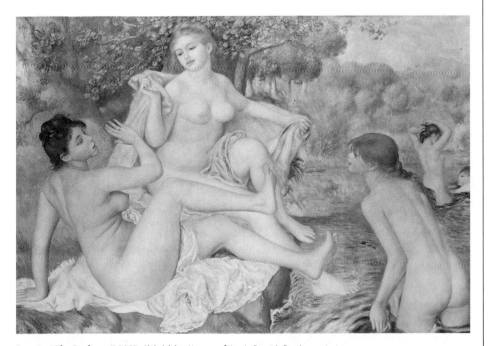

Renoir, "The Bathers," 1887, Philadelphia Museum of Art. *In Renoir's Post-Impressionist period, he painted sensuous nudes as solid, carefully defined forms.*

WHILE PARIS BURNED . . .

Ironically, while the Impressionists churned out their upbeat canvases full of light, Paris endured some of its darkest, most desperate days. In 1870–71 during the Franco-Prussian War, France suffered one humiliating defeat after another. German troops besieged Paris, devastated the city by shelling, and prevented all supplies from entering. Citizens resorted to eating rats and animals from the zoo and stripped parks of trees for fuel. Thirty-six thousand people starved to death.

Although Manet, Degas, Bazille (who died in the fighting), and Renoir served in the Army (Renoir without seeing action), Sisley, Pissarro, and Monet fled to England to escape the draft. The only blood that ever appeared in Pissarro's work was when Prussians turned his studio into a slaughterhouse, using his 1,500 painted canvases as aprons while butchering hogs.

After France's ignominious defeat, Parisian republicans set up a reform government, the Commune, brutally repressed by French troops. Civil war broke out. During this fierce resistance, 30,000 were executed. Meanwhile, the Impressionists decamped — except Manet, who produced lithographs protesting the suppression of the Commune. In rural retreats they painted dazzling landscapes, blithely oblivious to the civic upheavals they considered an unwelcome intrusion into their artistic activities.

DEGAS: THE RELUCTANT IMPRESSIONIST. "Art is not a sport," said Edgar Degas (1834–1917), explaining why he detested painting out-of-doors. Yet, despite this basic difference from the Impressionists, he was counted a charter member of the group through friendship, his commitment to contemporary subject matter, and his opposition to official academic painting.

Distinct from the others, Degas had zero interest in landscape painting and no concern for the effects of changing atmosphere and light. His subjects were limited: racetracks, circuses, opera, café scenes, women at work, nudes bathing, and — above all — ballerinas. Thoroughly trained in academic art, Degas idolized Ingres, who advised him, "Draw lines, young man, many lines, from memory or from nature; it is this way that you will become a good painter." Degas's emphasis on linear drawing and composition, as well as the three-dimensional depth and firm contours of his pictures, set him apart from the Impressionists, as did his preference for artificial light.

Degas shared with Monet, Manet, and Renoir, however, an interest in scenes that appeared unplanned and spontaneous, as if capturing a split-second glimpse of the world. For Degas, this haphazard appearance was carefully contrived. "No art was ever less spontaneous than mine," he said. "A picture is an artificial work, outside nature. It calls for as much cunning as the commission of a crime."

AT THE BARRE. Degas's specialty was the human figure in a moment of arrested motion. His hundreds of paintings, drawings, and pastels of ballerinas show his compulsion to portray casual moments of action. The unconventional poses catch the dancers off-guard while scratching, yawning, or adjusting their slippers. This "unposed," snapshot effect derived from Degas's interest in photography, which froze subjects in awkward movements.

His eccentric compositions reflect the influence of Japanese prints, which placed figures informally off-center, sometimes cropped by the edge of the frame. Degas represented dancers, onstage or at rehearsal, from oblique angles with lighting often originating below as if from footlights. He typically clusters figures to one side with large empty areas of floor space exposed. In "Prima Ballerina," (see p. 97), the stage is viewed from above, as if the spectator were in an upper box. The off-center composition and steeply tilted floor are characteristic of Degas's bold, unexpected designs.

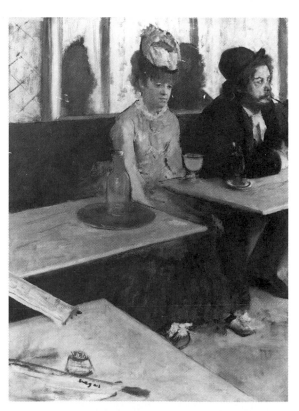

Degas, "The Glass of Absinthe," 1876, Musée d'Orsay, Paris. *Degas's "slice of life" shows the lonely downside of modern urban life.*

AT THE BAR. Degas's "Glass of Absinthe" shows a similar overloading of the figures to one side, balanced by the diagonal zigzag of empty tables drawing the reader into the picture. Although the painting has the abrupt, realistic quality of a snapshot and presents contemporary life unadorned, the effect was painstakingly contrived. Degas refused to prettify his subject, shown with brutal honesty seated before a glass of absinthe. "Art cannot be done with the intention of pleasing," he said.

NUDES. After 1886, Degas focused on pictures of women bathing, seen, he said, as if "through a keyhole," denoting the unposed quality of the works. As with dancers and subjects in the cafés, he did not idealize the figures. "I show them deprived of their airs and affectations, reduced to the level of animals cleaning themselves," he said. This innovation — to portray nudes unaware of observation, engaged in strictly utilitarian acts like toweling dry or combing their hair — gives nakedness for the first time a practical function in a picture.

To avoid stereotyped poses, Degas directed his models to move freely about the studio. He later fabricated a pose from memory, to convey a private but thoroughly natural attitude. "It is all very well to copy what you see, but it is better to draw only what you still see in your memory," he said. "Then you reproduce only what has struck you, that is to say, the essentials." Surprisingly, for one who portrayed the nude so intimately, his pictures emit no sensual warmth. When asked why his women were ugly, Degas replied, "Women in general are ugly."

PASTELS: A FIRST. As Degas's eyesight began to fail in the 1870s, he switched from oil to pastel, a powdered pigment in stick form like chalk. Pastels allowed him to draw and color at the same time, and he developed a highly original style, giving new strength to the medium. Degas was first to exhibit pastels as finished works rather than sketches and the only painter to produce a large body of major work in the medium.

As his eyes weakened, Degas's colors intensified and he simplified his compositions. In the late pastels, he loosened his handling of pigment, which exploded in free, vigorous strokes with bright colors slapped together to enhance the impact of both. He outlined forms decisively, filling them in with patches of pure color. As always, the pictures of nudes seem casually arranged, but the underlying structure was firmly composed and daring.

SCULPTURE. "A blind man's art" is what Degas called sculpture. Nearly blind, he relied on his sense of touch to model wax figurines of dancers and horses, which were cast in bronze after his death. Renoir considered them superior to Rodin's sculpture in their sense of movement — always Degas's first concern.

Degas, "The Little 14-Year-Old Dancer," 1879–81, cast in 1922, MMA, NY. *Degas sculpted this figure in wax when his eyesight was failing and he had to create by touch.*

SUPPORTING CAST

Besides the four major Impressionist artists, other notable painters working in the style were Cassatt, Morisot, and Pissarro.

CASSATT. Although he hated to admit a woman could draw so well, when Degas first saw Mary Cassatt's (pronounced Cah SAT; 1845–1926) work, he said, "There is a person who feels as I do." Soon after they became lifelong friends, and Cassatt began to exhibit with the Impressionists. "I had already recognized who were my true masters. I admired Manet, Courbet, and Degas," she said. "I hated conventional art. I began to live."

Cassatt also hated social conventions that forbade women from pursuing a profession. Born to a wealthy Pennsylvania family, she left the United States as soon as possible to study art in Europe before settling in Paris. "How wild I am to get to work, my fingers fairly itch," she said. It wasn't so simple, however, for Victorian women. Since they were not permitted to be alone with any man except a relation, Cassatt's only male subjects were her father, brothers, and Degas (she destroyed that canvas). Her trademark images were portraits of mothers with children.

Inspired by Japanese prints, Cassatt adopted — in oil, pastels, and prints — their brightly colored, flat images and sharp designs. A gifted draftsman, like Degas she crisply and precisely outlined her figures and composed tautly calculated designs. Her figures typically dominate the picture space, crammed close to the surface, but are surrounded by expressive space, for Cassatt exploited the visual power of space between objects. She used the Impressionist palette of vivid hues, pale tints, golden light, and shadows tinged with color.

In her mother-and-child pictures (modern icons of maternity like Picasso's and Henry Moore's), the figures gesture realistically. In protective poses with faces close together, they touch, caress, and embrace.

Keenly aware of restraints imposed on all women, Cassatt became both a socialist and supporter of women's suffrage. "After all give me France," she said. "Women do not have to fight for recognition here if they do serious work." As Gauguin observed, "Mary Cassatt has charm, but she also has force."

Cassatt, "Young Mother Sewing," c. 1893, MMA, NY. *In Cassatt's trademark mother-and-child images, she adopted elements from Japanese prints like strong linear patterning and flat forms in high-keyed color.*

PRINT COLLECTING

A print is made by creating a design on a hard surface like wood, metal, or stone, which is then inked and pressed against paper to transfer the image. Relief cutting, as in Dürer's Renaissance woodcuts, was the earliest method for duplicating images. Then Rembrandt achieved subtle effects with drypoint, but until the late 1800s most artists concentrated on one-of-a-kind artworks rather than multiples.

In the 1870s what had been mainly a commercial process for duplicating pictures was revitalized by painter-engravers like Pissarro, Toulouse-Lautrec, Bonnard, and Munch. Before, artists had colored etchings (printed in ink of one color) by hand. When the Impressionists saw Japanese color woodblock prints using inks of different colors, they began applying this technique in drypoint prints (Cassatt) and color lithographs (Lautrec). Color prints became the rage in France in the 1890s, and the limited-edition color print was born. For the most part, the public did not consider prints a collectible artistic endeavor until the 1960s when galleries specializing in prints opened with works created for the medium. A boom in sales, exhibits, and connoisseurship occurred as Contemporary artists tried their hands at over-sized prints that rivaled the scale of canvases, at a fraction of the cost to collectors.

MORISOT. Berthe Morisot (1841–95), the great-granddaughter of Fragonard, was both intelligent and independent. Early on she rejected her stuffy drawing master to paint out-of-doors with Corot. While copying a Rubens in the Louvre, she met Manet, who was to become the chief influence on her work. She, in turn, persuaded him to try open-air painting and brighter colors. Since women were not allowed in life classes to

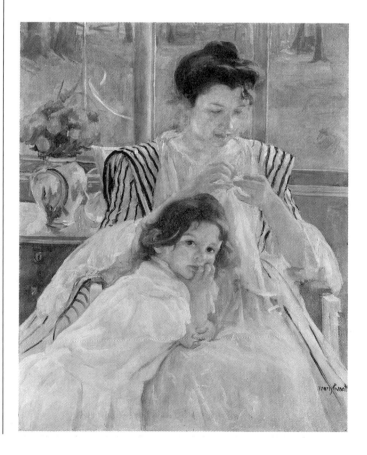

draw from the model, Morisot painted domestic scenes and women and children (her husband, Manet's younger brother, Eugène, was the only man she painted). Yet she was treated as an equal of the other Impressionists and came in for her share of condemnation at their first show. "Lunatic" critics called her, adding, "She manages to convey a certain feminine grace despite her outbursts of delirium." Morisot only laughed. In 1875, her works fetched higher prices than her male colleagues'.

Like them, Morisot used no outlines, just touches of color to indicate form and volume, but her style was even freer than the other Impressionists'. Her vigorous brushstrokes flew across the canvas in all directions. She also shared the Impressionist goal of portraying personal visual experience. Her paintings were heavily autobiographical, often dealing with her daughter, Julie. "She lived her painting," as the poet Paul Valéry said, "and painted her life."

PISSARRO. Camille Pissarro (1830–1903) was the father figure and peacemaker of the Impressionist group. A kindly anarchist, he took artists like Cézanne and Gauguin under his wing. "Do not define too closely the out-

line of things," he advised. "It is the brushstrokes of the right value and color which should produce the drawing."

Pissarro excelled at reproducing an outdoor scene exactly with bright colors and patchy brushstrokes. "One must be humble in front of nature," he said. Besides rural landscapes, he is known for bustling Parisian street scenes, as if viewed from a second-story window, filled with people and carriages rendered as spots of color.

In 1890–92 Pissarro flirted briefly with the pointillism of Seurat and Signac, carefully arranging small dots of color to convey form. A patient teacher, Pissarro instructed Cézanne in how to control form through color and diagonal brushstrokes. "Humble and colossal," Cézanne called his mentor.

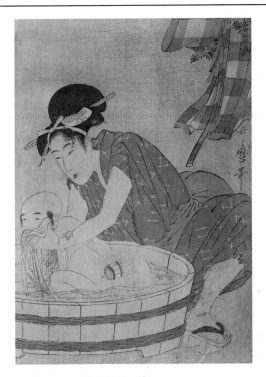

Kitagawa Utamaro (1753–1806), "Woman Bathing Her Baby in Tub," MMA, NY.

JAPANESE WOODBLOCK PRINTS

In the 1860s Japanese color woodblock prints, known as ukiyo-e prints, were first imported into France, where they became an important influence away from the European tradition of painting. "Ukiyo," which means "floating world," referred to the red-light district of Japanese cities, where all social classes mingled in the pleasure-seeking round of theaters, restaurants, and brothels. The prints' informal glimpses of contemporary life reinforced the Impressionists' preference for modern subjects.

Artists like Degas, Manet, Cassatt, Whistler, and Gauguin also appropriated Japanese techniques, the first non-Western art to have a major impact in Europe. They imitated the flat, brightly colored, sharply outlined images and expressive, often contrasting, linear patterns. The Impressionists borrowed the prints' unusual, and often high, point of view of looking down on a scene, the lack of single-point perspective, and the off-center composition. Figures jut out of the picture frame, as if cropped haphazardly, and slanting lines lead the eye into the picture.

MORE DEVELOPMENTS IN GRAPHIC ARTS

When we left off (see p. 43), Renaissance artists were using woodcuts and engravings to produce multiple prints. Since then other techniques make possible the widespread reproduction of an artist's work.

DRYPOINT AND ETCHING. In drypoint, a design is scratched into a copperplate with a fine steel needle, which permits soft atmospheric effects. In etching, indentations on a plate are submerged in an acid bath so that only the lines appear in the print.

LITHOGRAPH. In the lithograph, the artist draws on a limestone slab with a greasy crayon. Water is applied, which adheres to the stone's nongreasy surfaces, and then greasy ink is rolled on, which sticks only where there is no water. A sheet of paper is then applied to the slab in a lithographic press to reproduce the image.

SILK SCREEN PRINTS. The newest graphic art is silk screen printing or serigraphy, developed in the United States most obviously by Andy Warhol. He attached a stencil to a screen of silk stretched on a frame, then forced ink through the stencil with a rubber squeegee. The image produced was flat and unshaded, appearing commercial and mechanical — the effect Warhol desired.

RODIN: FIRST MODERN SCULPTOR

According to the twentieth-century sculptor Brancusi, "In the nineteenth century, the situation of sculpture was desperate. Rodin arrived and transformed everything." In fact, sculpture had declined into little more than decorative public monuments. Auguste Rodin (1840–1917) singlehandedly revived sculpture as a medium worthy of an original artist.

As a young sculptor, Rodin was rejected three times by the École des Beaux-Arts. The rejection probably saved him from rigid academic formulas, as he developed his own innovative style based on the live model. A trip to Italy where Rodin studied the work of Donatello and Michelangelo marked his turning point. Michelangelo's "Bound Slave" inspired Rodin's first major, full-sized work, "The Age of Bronze." It also aroused the first major controversy in a career beset by public misunderstanding. The statue's extreme naturalism — a definitive break with the current idealizing style — so astonished critics that they accused Rodin of making it from life casts. Rodin defended the nude's realism, saying, "I obey nature in everything, and I never pretend to command her."

As compensation for maligning Rodin's reputation, he was granted the commission for a large (18'x12') sculptured portal in 1880. Based on Dante's "Inferno," the project, called the Gates of Hell, occupied Rodin until the end of his life. Although he never completed the doors, Rodin spun off many of the nearly 200 writhing figures in separate full-size sculptures, such as "The Thinker" and "The Kiss." Heavily influenced by Michelangelo's "Last Judgment," the anguished figures on the Gates tumble headlong, the intense emotion heightened by the expressive power of the human body.

To arrive at dramatic poses revealing inner feelings, Rodin refused to use professional models frozen in stock postures. "They have stuffed the antique," Rodin said of Neoclassical sculpture based on ancient Greek statuary. For Rodin, official art was too distant from real life. He hired can-can dancers to stroll about the studio assuming unusual, spontaneous poses. Compulsively modeling in clay, he followed them to capture their every movement.

The body in motion was Rodin's means of expressing emotion. "I have always endeavored," he said, "to express the inner feelings by the mobility of the muscles." Once his wife charged into the studio in a fit of anger, stomping around the room yelling. Rodin modeled her enraged face without looking at the clay. "Thank you, my dear," he said at the end of the tirade. "That was excellent."

This emphasis on personal experience as the source of art differed drastically from academic art but fit perfectly the Impressionists' focus on responding directly to the modern world. Rodin revolutionized

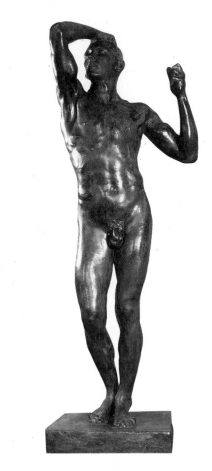

Rodin, "The Age of Bronze," 1876, Minneapolis Institute of Arts. *Rodin revitalized sculpture by abandoning the Classical tradition to present a realistic, rather than stylized, nude.*

MORE THAN RODIN'S MODEL

Stunningly beautiful and extremely talented, French sculptor Camille Claudel (1864–1943) became Rodin's model, lover, and collaborator when she was 19 and he 43. Claudel excelled at anatomy, so she contributed the hands and feet to Rodin's works. She wanted control of more than hands and feet, however. She wanted Rodin's heart. They quarreled fiercely, with frequent ruptures. Sexually insatiable, Rodin made no secret of his lust for his models. His liaisons were incessant and open. He even propositioned rich society ladies who paid him 40,000 francs each for portrait busts. After a fifteen-year stormy relationship, Claudel broke with Rodin.

Rodin acknowledged her gifts: "I have shown her where to find gold, but the gold she has found is really her own," but talent wasn't enough. As his career prospered and hers faltered, she became more bitter until her brother committed her to an asylum where she spent the last forty years of her life.

sculpture just as his Impressionist contemporaries did painting.

Rodin's greatest triumph was also his most savagely criticized work: a ten-foot-tall statue of the French writer Balzac. "I should like to do something out of the ordinary," he said with modest understatement when he began the monument. The result, unveiled in 1898 as a plaster sculpture, was so "out of the ordinary" that the public, critics, and his patrons were overwhelmingly hostile.

The statue bore little resemblance to Balzac, who, in fact, had an unpreposessing, stout build. Rodin wrapped him in a flowing robe, with most of the author's body indefinite except his grossly exaggerated mane of hair, projecting eyebrows, and recessed eyes. "I sought in 'Balzac' . . . to render in sculpture what was not photographic. My principle is to imitate not only form but also life." His radical design made no attempt to reproduce the great writer's actual features. What Rodin portrayed was the act of creativity itself, using drastic simplification and distortion to make the head seem to erupt from the massive body. It was "the face of an element," the writer Lamartine said; "the sum of my whole life," Rodin called it.

"Artistically insufficient" and "a colossal fetus," his patrons howled. Others compared "Balzac" to a penguin, a sack of coal, and a shapeless larva. "A monstrous thing, ogre, devil and deformity in one," wrote an American journalist. Rodin defended his conception as "a really heroic Balzac who . . . boils over with passion. . . . Nothing I have ever done satisfied me so much, because nothing cost me so much, nothing sums up so profoundly what I believe to be the secret law of my art."

His secret law was incompletion — or the power of suggestion — as an aesthetic principle. Rodin rescued sculpture from mechanical reproduction with his rugged, "unfinished" surfaces and suppression of detail.

CONTRIBUTIONS. By 1900 Rodin was acknowledged as the world's greatest living sculptor. Critics hailed him for the very qualities they had once denounced: portraying psychological complexity and making sculpture a vehicle for personal expression. Brancusi called Rodin's "Balzac," which brought sculpture to the brink of abstraction, "the incontestable point of departure for modern sculpture."

Rodin, "Balzac," 1897, Musée Rodin, Paris. *Rodin dispensed with literal accuracy in portraying the French writer, relying on an intuitive, summary approach that distorted anatomy to express the concept of genius.*

POST-IMPRESSIONISM

Post-Impressionism, like Impressionism, was a French phenomenon that included the French artists Seurat, Gauguin, Cézanne, Toulouse-Lautrec and the Dutchman van Gogh, who did his major work in France. Their careers spanned 1880–1905, after Impressionism had triumphed over academic art. The Post-Impressionists' styles derived from their forerunners' breakthroughs. Instead of the "brown gravy" of historical painting done in feebly lit studios, their canvases shone with rainbow-bright color patches. Yet the Post-Impressionists were dissatisfied with Impressionism. They wanted art to be more substantial, not dedicated wholly to capturing a passing moment, which often resulted in paintings that seemed slapdash and unplanned.

Their response to this problem split the group into two camps, much like the Neoclassical and Romantic factions earlier in the century. Seurat and Cézanne concentrated on formal, near-scientific design — Seurat with his dot theory and Cézanne with his color planes. Gauguin, van Gogh, and Lautrec, like latter-day Romantics, emphasized expressing their emotions and sensations through color and light. Twentieth-century art, with its extremes of individual styles from Cubism to Surrealism, grew out of these two trends.

Van Gogh, "The Starry Night," 1889, MoMA, NY. *Van Gogh expressed his emotional reaction to a scene through color.*

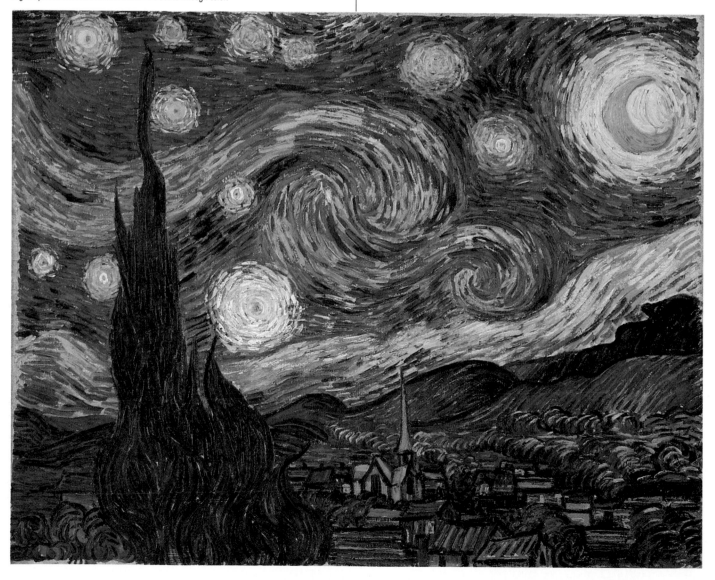

THE POST-IMPRESSIONIST ROUNDUP

To keep the major Post-Impressionists straight, here are their identifying characteristics.

ARTIST	SEURAT	TOULOUSE-LAUTREC	CEZANNE	GAUGUIN	VAN GOGH
SUBJECTS	Leisure activities in Paris	Cabaret nightlife	Still lifes with fruit, landscapes of Mont Ste-Victoire, L'Estaque	Tahiti natives, peasants in Brittany	Self-portraits, flowers, landscapes, still lifes
SIGNATURE	Bright colors in tiny dots (pointillism)	First art posters used for publicity	Proto-Cubist stress on geometric structure	Exotic primitivism	Agitated, swirling brushstrokes
MOODS	Scientific, logical	Decadent, hectic	Analytical, stable	Symbolic, mysterious	Passionate, vibrant
CONCERNS	System of optical blending in eye of beholder	Fin-de-siècle malaise	Underlying permanent order	Brilliant color to express emotion	Emotional reaction to subject through color, brushwork
HALLMARKS	Grainy surface, stylized figures in halo of light ("irradiation"); flat; precise design	Sketchy drawing, empty center, and cutoff figures at edges; eerie, indoor lighting and off-key colors, caricatures, masklike features	Balanced design; flat, squarish patches of color in graduated tones; simple geometric shapes	Simplified forms in unnatural colors, strong outlines in rhythmic patterns	Thick impasto in choppy strokes or wavy ribbons; simple forms in pure, bright colors; curling rhythms suggesting movement
BRUSH-STROKE					

SEURAT: POINT COUNTERPOINT. Degas nicknamed Georges Seurat (1859–91) "the notary" because the younger painter always wore a top hat and dark suit with precisely pressed trousers. Seurat was just as meticulous in his art. "They see poetry in what I have done," Seurat once said. "No, I apply my method, and that is all there is to it."

His quasiscientific "method" is known as "pointillism." It consisted of applying confetti-sized dots of pure, unmixed color over the whole canvas. Seurat theorized that complementary (or opposite) colors, set side by side, would mix in the viewer's eye with greater luminosity than if mixed on the painter's palette. The whole was supposed to fuse together, like a mosaic, from a distance, but actually the individual specks never completely merge, giving a grainy, scintillating effect to the surface of the canvas.

Because Seurat's system was so labor-intensive, he finished only seven large paintings in his decade-long career. His most celebrated work, "A Sunday on La Grande Jatte" — so famous it inspired Stephen Sondheim's Broadway musical *Sunday in the Park with George* — took him two years and forty preliminary color studies. Seurat kept the bright, unmixed colors of the Impressionists and their holiday, open-air themes, but he added a stable design based on geometric shapes and rigorously calculated patterns.

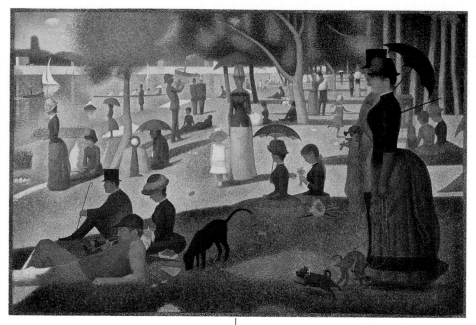

Seurat, "A Sunday on La Grande Jatte," 1884–86, Art Institute of Chicago. *Seurat developed the pointillist technique of using small dots of pure color.*

METHOD PAINTING. After 1886, Seurat decided to systematize other elements of painting. He used color and lines like engineer's tools, assigning certain emotions to different colors and shapes to elicit predictable responses in the spectator. For Seurat, warm colors (the orange-red family) connoted action and gaiety, as did lines moving upward. Dark, cool colors (blue-green) and descending lines evoked sadness, while middle tones, or a balance of warm and cool colors, and lateral lines conveyed calm and stasis.

Seurat's last painting, "Le Cirque" (circus), conveys a mood of frenetic activity. The acid yellow and orange colors and upward-curving lines of the performers contrast jarringly with the muted spectators ranged horizontally in static rows. Seurat suppressed detail to give the scene a simplified poster style like the artificiality of the entertainment world.

Seurat died at the age of 31, three days after exhibiting the painting in an unfinished state. His mother hung "Le Cirque" over his deathbed. He was such a radical individualist that he never sought followers, saying, "The more numerous we are, the less originality we have." Yet when he died, Pissarro wrote, "You can conceive the grief of all those who followed him or were interested in his artistic researches. It is a great loss for art."

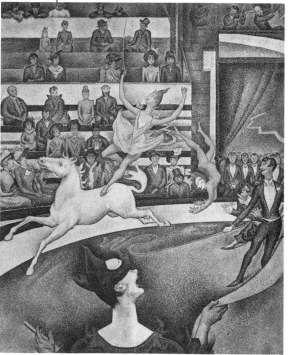

Seurat, "Le Cirque," 1891, Musée d'Orsay, Paris. *Seurat believed he could precisely stimulate emotions in his viewers by combining certain lines and colors.*

TOULOUSE-LAUTREC: POSTERS OF PARIS.

Toulouse-Lautrec's work was so similar to Degas's in style and content that he might almost be taken for a mini-Degas. Lautrec made his own sizable contributions, however, in lithography and poster art, two media he virtually invented. Although Degas, resentful of being ripped-off, was known for his sarcastic putdowns of Lautrec, he accorded him Impressionism's ultimate accolade, saying at a Lautrec exhibition, "Well, Lautrec, it's clear you're one of us."

The art of the two men was indeed similar. Henri de Toulouse-Lautrec (1864–1901) drew his subjects, like Degas, from contemporary life: Parisian theaters, dance halls, and circuses. Both artists also specialized in portraying movement and private moments through slice-of-life glimpses with abrupt, photographic cropping. The novel, asymmetric compositions of both derived from their mutual admiration of Japanese prints.

"Only the figure counts," Lautrec said. "Landscape is, and should always be, only an adjunct." Virtually all of Lautrec's paintings are of figures in interior night scenes lit somewhat arbitrarily by glaring, artificial light. His primary interests were the demimonde actors, entertainers, acrobats, and prostitutes, whom he caricatured to highlight their essential attributes.

Lautrec also caricatured his own deformed appearance in bitter self-portraits. Born to France's most blueblood family — the 1,000-year-old Counts of Toulouse — Lautrec was a self-imposed exile from high society due to a childhood tragedy. As a teenager, he broke both legs, which atrophied, giving him a five-foot stature with a child's short legs, the powerful torso of a man, and a grossly disproportionate head. As a teenage invalid, Lautrec abandoned his love of riding and shooting for his interest in art, although his teacher pronounced his early drawings "simply awful."

The adult Lautrec led a life of notorious dissipation. Alcoholic and syphilitic, he consorted with bohemians and social outcasts. For his series of paintings of bored prostitutes lounging around dreary bordellos, he lived in a brothel for a time.

Lautrec's most original contribution was in the realm of the graphic arts, for he singlehandedly made the new form of lithography and the poster respectable media for major art. Beginning about 1890, he designed posters of bold visual simplicity, which "took possession of the streets," as everyone agreed when they first appeared.

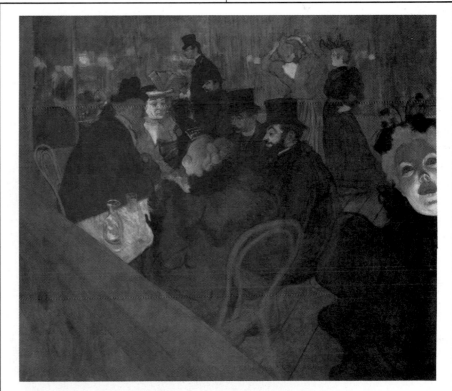

Toulouse-Lautrec, "At the Moulin Rouge," 1892, Art Institute of Chicago.

NIGHT LIFE. Lautrec's chronicle of Parisian nightlife — seen, he said, from "elbow height" — *perfectly captures the malaise and decadence of the fin-de-siècle period. He uses harsh lighting and dissonant colors to convey the era's surface gaiety and underlying melancholy. Lautrec went every night to the music hall to paint and even included himself (the short bearded figure at rear), along with a host of grotesque individualized portraits.*

CÉZANNE: THE PLANE TRUTH.

In 1874, a critic dismissed Paul Cézanne (1839–1906) as "no more than a kind of madman, with the fit on him, painting the fantasies of delirium tremens." By 1914, "the Christopher Columbus of a new continent of form," was how another critic hailed him. In the intervening forty years, Cézanne ignored both howls and hails, painting every day, not to win "the admiration of fools," he said, but "to try to perfect what I do for the joy of reaching greater knowledge and truth."

Although he began by exhibiting with the Impressionists (after being rejected by the École des Beaux-Arts and the Salon) and was tutored in open-air painting by Pissarro, Cézanne was too much of a loner to join any group. Encouraged to come to Paris from his native Aix-en-Provence by the novelist Zola, a childhood friend, Cézanne always felt alien in the city. Even among the Impressionists he was considered beyond the pale. Manet called him a "farceur" (a joke); Degas thought he was a wild man because of his provincial accent, comical clothes, and unorthodox painting style.

The public denounced Cézanne's paintings with a vengeance: coarse, degenerate, incompetent were some of the milder opinions. At the first Impressionist exhibit in 1874, sneering crowds were loudest around Cézanne's paintings, doubling up with laughter and hooting that his canvas was "one of those weird things evolved by hashish."

Stung by ridicule, Cézanne retreated to Aix in 1886 and devoted himself tirelessly to his art. Obscure until his first one-man show in 1895, after which he was revered as a "Sage" by the younger generation of artists, Cézanne gained a reputation as an unapproachable hermit, almost an ogre. In the face of pervasive mockery and misunderstanding of his work, he continued what he called his "research" with gloomy intensity. Cézanne described his "one and only goal" as "to render, whatever our power or temperament in the presence of nature may be, the likeness of what we see, forgetting everything that has appeared before our day."

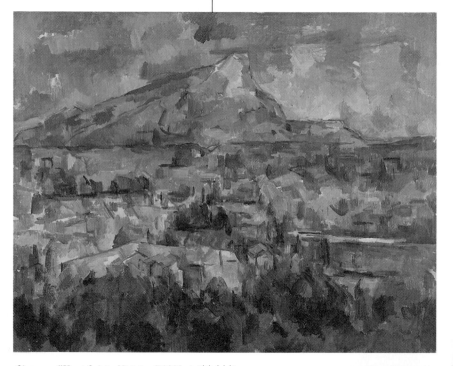

Cézanne, "Mont Sainte-Victoire," 1902–4, Philadelphia Museum of Art. *Unlike Monet's series of canvases on one subject, Cézanne's many renditions of this mountain do not vary according to season or time of day.*

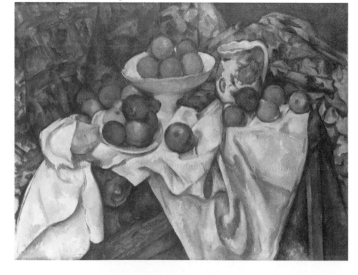

Cézanne, "Still Life with Apples and Oranges," 1895–1900, Musée d'Orsay, Paris. *Cézanne wanted to express inner form, which he perceived as orderly geometric shapes, through outer form.*

What made Cézanne's art so radical in his day and appreciated in ours was his new take on surface appearances. Instead of imitating reality as it appeared to the eye, Cézanne penetrated to its underlying geometry. "Reproduce nature in terms of the cylinder and the sphere and the cone," he advised in a famous dictum. By this he meant to simplify particular objects into near-abstract forms fundamental to all reality. "The painter possesses an eye and a brain," Cézanne said. "The two must work together."

MONT SAINTE-VICTOIRE. In "Mont Sainte-Victoire," a landscape he painted more than thirty times, Cézanne portrayed the scene like a geodesic pyramid, defining surface appearance through colored planes. To create an illusion of depth, he placed cool colors like blue, which seem to recede, at rear and warm colors like red, which seem to advance, in front.

Cézanne believed that beneath shifting appearances was an essential, unchanging armature. By making this permanent geometry visible, Cézanne hoped "to make of Impressionism," he said, "something solid and durable, like the art of the museums, to carve out the underlying structure of things." His innovative technique, applied to favorite themes of portraits, landscapes, and still lifes, was to portray visual reality refracted into a mosaic of multiple facets, as though reflected in a diamond.

STILL LIFES. Once nicknamed "Flowers and Fruit," Cézanne was as systematic in his still lifes as in landscapes. A visitor described how Cézanne set up a still life: "Cézanne arranged the fruit, contrasting the tones one against another, making complementaries vibrate, the greens

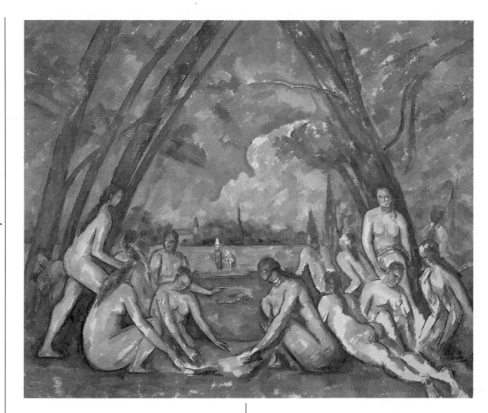

Cézanne, "Large Bathers," 1906, Philadelphia Museum of Art. *Cézanne's late nudes with their stiff, geometric forms, were a precursor to Cubism.*

against the reds, the yellows against the blues, tilting, turning, balancing the fruit as he wanted it to be. . . . One guessed that it was a feast to the eye for him." He painted and repainted so compulsively, fruit invariably rotted and had to be replaced by wax models.

NUDES. "The culmination of art is figure painting," Cézanne said, and, in his last ten years, he was obsessed with the theme of nude bathers in an outdoor setting. Because of his extreme slowness in execution, his shyness, and a fear of his prudish neighbors' suspicions, Cézanne did not work from live models. Instead he tacked up reproductions of paintings by Rubens and El Greco and drew on his own imagination rather than observation. The result — in a series of canvases — is

abstracted figures as immobile as his still lifes.

Cézanne was unaffected when, in the last years of his life, recognition finally came. He continued to work just as doggedly in isolation, until the day he died. Modern artists now consider him an oracle who invented his own fusion of the real and abstract. "The greatest source of Cubism," the sculptor Jacques Lipchitz said, "was unquestionably . . . the late works of Cézanne." Like Giotto, who pioneered realistic representation, Cézanne initiated a major — though opposite — shift in art history. Cézanne liberated art from reproducing reality by reducing reality to its basic components.

GAUGUIN: "LIFE IS COLOR." "The man who came from far and who will go far" is what van Gogh called his friend Paul Gauguin (1848–1903). Both were true. Gauguin had lived in Peru as a child, spent six years before the mast as a young man sailing to exotic ports, and — before he was through — counted the South Seas islands as home.

In another sense, Gauguin had come from a vocation as far removed as the moon from the artist's life. For more than a decade, he was a prosperous Parisian stockbroker, a middle-class father of five who took up Sunday painting in 1873 and exhibited a thoroughly conventional picture in the Salon. By 1883, Gauguin had ditched his family for his new love — art — and jettisoned traditional painting for what he called "savage instinct." Not long after, the former financial wizard painted his Paris apartment chrome yellow, with the Tahitian words for "Here One Loves" over the door, and paraded the boulevards with a monkey on his shoulder and an outlandishly dressed Javanese girl on his arm.

It was obvious from the beginning Gauguin's life would be extraordinary. As an extremely gifted child always carving wood, a neighbor had predicted of him, "He'll be a great sculptor." At the age of nine Gauguin saw a picture of a hobo and ran away from home, yearning to amble down country roads with a bundle tied to a stick. "The boy is either a genius or a fool," his headmaster concluded.

When Gauguin became a full-time painter at 35, he headed for Pont-Aven in Brittany, a backward province on the French coast where, he said, "I find the primitive and the savage." He proceeded, as he said, "to restore painting to its sources," meaning to primal emotion and

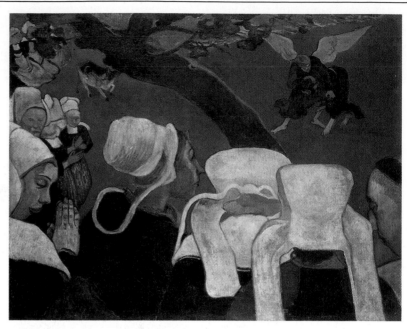

Gauguin, "Vision after the Sermon, or Jacob Wrestling with an Angel," 1888, National Gallery of Scotland, Edinburgh. *Gauguin followed his own advice, "Don't copy too much from nature. Art is an abstraction." He stylized the Breton women witnessing a supernatural vision to make them symbols of faith. He painted the ground red, separating the "real" world of the women in the foreground from the "imaginary" world of Jacob wrestling with the angel by the diagonal tree painted blue.*

imagination. In the process, Gauguin transformed art. His version of the crucifixion, "Yellow Christ," shows Christ (with Gauguin's own face) completely yellow, with the cross planted in Brittany surrounded by orange-colored trees. He used neither perspective nor chiaroscuro (which he dismissed as "hostile to color"). Young avant-garde painters (especially the group later known as the Nabis, including Vuillard and Bonnard) flocked to Pont-Aven to observe the master's startling use of color. "A meter of green is greener than a centimeter if you wish to express greenness," he told them, recommending this full approach to life as well: "Eat well, kiss well, work ditto and you'll die happy."

The public was slow to recognize his merit, and Gauguin found himself without tobacco for his pipe, sometimes going for three days without food. His painting "Breton Village in the Snow" was hung

upside down as "Niagara Falls" and sold for only seven francs. "It isn't difficult to make art," he noted ruefully. "The whole trouble is in selling it." Yet, he wrote his wife, safely ensconced with her bourgeois relatives in Denmark, "The more trouble I have the stronger I seem to grow." A visitor also noted, "He gave the strong impression of one who had sacrificed everything to art though half-knowing he would never profit from it." Often without money for materials — in Tahiti he was reduced to spreading thin paint on coarse sacking — Gauguin kept his wit. "It is true," he said, "suffering stimulates genius. It is as well not to have too much of it; otherwise it merely kills one."

What kept him going, and kept him on the move, was his "terrible longing for the unknown," as he said, "which made me commit many madnesses." This quest led him to devise a totally new method

of painting based not on his perception of reality but his conception of it. He refused to reproduce surface appearances, instead transforming colors and distorting shapes to convey his emotional response to a scene. "Life is color," Gauguin said. "A painter can do what he likes as long as it's not stupid."

"The dream caught sight of," is how he summed up what he was after in art, "something far stronger than anything material." Portraying his dreams was the essence of Gauguin's nonnaturalistic art: "A strong feeling can be translated at once," he said. "Dream over it and seek the most simple form for it." The painter Maurice Denis acknowledged Gauguin's pioneering discoveries: "Gauguin freed us from all the restraints which the idea of copying nature had placed upon us."

Seeking pure sensation untainted by "sick" civilization, Gauguin spent his last ten years in the South Seas, where he felt, as he wrote, "Free at last, without worrying about money and able to love, sing and die." He lived in a native hut with a 13-year-old Tahitian mistress, turning out vividly hued, symbolic paintings, wood sculpture, and woodcuts. Shortly before his death at age 56 in the Marquesas Islands, Gauguin remained the unrepentant individual: "It is true I know very little but I prefer the little that comes from myself," he wrote. "And who knows whether this little, taken up by others, won't become something great?"

Gauguin's contributions taken up and extended by others include flattening forms, using intensified color arbitrarily for emotional impact, and — above all — presenting his subjective response to reality. Gauguin's South Seas paintings demonstrate these tendencies. "Ia Orana Maria" (native dialect for "I hail thee, Mary") portrays the Annunciation, radically reinterpreted. Gauguin retained the angel's greeting to the Virgin and halos for Mary and Jesus. Everything else he recast in Tahitian terms, except the composition, adapted from a Javanese bas-relief. The simplified figures, the firm outlines in rhythmic patterns, the symbolism drawn from primitive and Far Eastern sources, the rich colors — especially lilac, pink and lemon —expressed the vitality that non-European culture embodied for Gauguin.

"I wanted to establish the right to dare everything," Gauguin said just before his death. "The public owes me nothing . . . but the painters who today profit from this liberty owe me something." He dared to portray an internal reality, and those who profited were Expressionists like Munch, Symbolists like Redon, Fauves like Matisse, Cubists like Picasso, and a whole slew of abstract artists. It's no wonder Gauguin is among the founders of modern art.

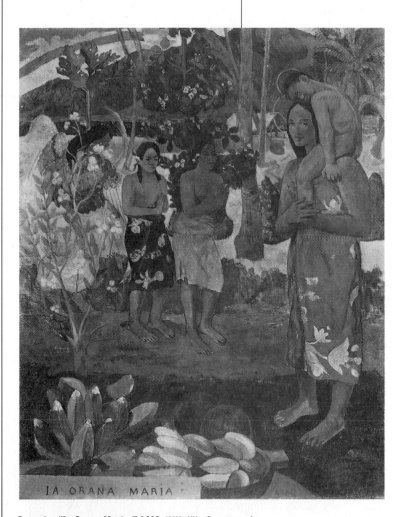

Gauguin, "Ia Orana Maria," 1892, MMA, NY. *Gauguin used flat planes, abstracted figures, and bright colors in his best-known paintings of Tahitian natives.*

VINCENT AND PAUL

Ever since they first met in Paris, van Gogh was positive he had found a kindred spirit in Gauguin. While Gauguin painted in Brittany surrounded by disciples, the Dutchman bombarded him with letters begging him to come to the South of France where they would work side by side. Van Gogh rented a small house, painted it bright yellow, and decorated a room with sunflower paintings for Gauguin. When the idolized Gauguin arrived in 1888, van Gogh was ecstatic. They painted, debated art passionately, drank, and caroused at brothels together. Gauguin brought routine to van Gogh's life, cleaning the house from top to bottom and cooking all their meals. "He seemed to catch a glimpse of all that was in him and from this sprang that whole series of sun after sun in full sunlight," Gauguin later wrote about van Gogh's masterful work during their two months together.

But bliss was not eternal. When van Gogh saw the portrait Gauguin painted of him, he said, "Yes, it's me all right, but me mad." The words proved prophetic. Later, they argued at a café and van Gogh threatened Gauguin with a straight razor. Gauguin stared him down, until van Gogh slunk away. That night, van Gogh sliced off his left ear lobe, wrapped it in a handkerchief, and presented it to a prostitute. Gauguin took the first train north. Van Gogh was thoroughly ashamed of himself. They continued to communicate by letter, and shortly before committing suicide, van Gogh referred to Gauguin as his "dear master." For his part, Gauguin later wrote, "When Gauguin says 'Vincent,' his voice is soft."

Gauguin sensed something special about their brief sojourn together. "Though the public had no idea of it," he wrote, "two men were doing a tremendous job there, useful to both. Perhaps to others too? Some things bear fruit."

VAN GOGH: **PORTRAIT OF THE SUFFERING ARTIST.** "Love what you love," was Dutch painter Vincent van Gogh's (1853–90) artistic credo. During a brief, ten-year career, van Gogh produced sun-scorched landscapes and brooding self-portraits.

Born in Holland, van Gogh was obsessed with religion and social service. A misfit who failed at one vocation after another, at age 27 he asked himself, "There is something inside me that could be useful, but what is it?" He determined to fulfill his "mission" to humanity through art, consoling the unfortunate through realistic portrayals of working-class life.

In 1886, when van Gogh discovered Impressionism in Paris, his work underwent a total metamorphosis. He switched from dark to bright colors and from social realist themes to light-drenched, outdoor scenes. He was still a humanitarian — at one point he proposed selling his sunflower paintings for 40¢ each to brighten the walls of workers' homes — but he changed from, as he said, trying "to express the poetry hidden in [peasants]" to portraying the healing power of nature. "These canvases will tell you what I cannot say in words," he wrote, "the health and fortifying power that I see in the country."

Even though van Gogh adopted the broken brushstroke and bright complementary colors of the Impressionists, his art was always original. He had a horror of academic technique, claiming he wanted "to paint incorrectly so that my untruth becomes more truthful than

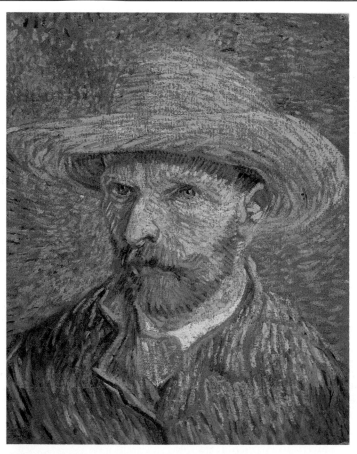

Van Gogh, "Self-Portrait with a Straw Hat," 1887, MMA, NY.

the literal truth." Van Gogh soon based his whole practice on the unorthodox use of color "to suggest any emotion of an ardent temperament." Like his hero Gauguin, van Gogh disdained realism.

Many have interpreted the distorted forms and violent, contrasting colors of van Gogh's canvases as evidence of mental imbalance. The shy, awkward painter (self-described as a "shaggy dog") was subject to overwhelming spells of loneliness, pain, and emotional collapse. Alternately depressed and hyperactive, he threw himself into painting with a therapeutic frenzy, producing 800 paintings and as many drawings in ten years. He painted all day — without stopping to eat — at white-hot speed and then continued painting into the night with candles stuck to his hat brim. He considered his work "the lightning rod for my sanity," his tenuous hold on a productive life.

Van Gogh has come to be the prototype of the suffering genius who gives himself totally to his art. "I have risked my life for my work," he said, " and my mind has half foundered." His life was bitterly unhappy. Van Gogh was thwarted in winning recognition for his work and only sold one painting during his lifetime. He was similarly unfortunate in love. Rejected by several women, when a Dutch spinster finally accepted him, her parents forbade the match and she poisoned herself.

Art became van Gogh's only refuge. In the south of France, "I let myself go," he said, "paint what I see and how I feel and hang the rules!" From 1888–90, at Arles, at the sanitorium at Saint-Rémy, and finally at Auvers under the care of Dr. Gachet, van Gogh, although deeply disturbed and prey to hallucinations, turned out one masterpiece after another, an output unmatched in the history of art. Inspired by nature, he painted cypresses, blossoming fruit trees, flowers, and wheatfields charged with his favorite color, yellow.

It was while he was a patient in the Saint-Rémy asylum that van Gogh produced "Starry Night" (see p. 112). He was painting in a "dumb fury" during this period, staying up three nights in a row to paint because, as he wrote, "The night is more alive and more richly colored than the day." Yet, though

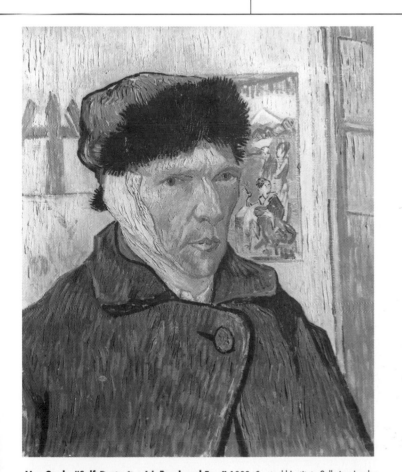

Van Gogh, "Self-Portrait with Bandaged Ear," 1889, Courtauld Institute Galleries, London.

SELF-PORTRAITS

Van Gogh did nearly forty self-portraits in oil, more than any artist except his fellow Dutchman Rembrandt. His aim in portraits was to capture the essence of human life so vividly that 100 years later, the portraits would seem like "apparitions." In his self-portraits the artist's presence seems so intense one has the impression of a tormented spirit haunting the canvas.

"Self-Portrait with a Straw Hat" reflects the Impressionist influence. Van Gogh said he wanted "to paint men and women with something of the eternal which the halo used to symbolize." The whirlpool of brushstrokes encircling his head has that effect.

The later "Self-Portrait with Bandaged Ear," done two weeks after his disastrous quarrrel with Gauguin and self-mutilation, shows van Gogh's unflinching self-revelation. Using very few colors, van Gogh concentrates all agony in the eyes. "I prefer painting people's eyes to cathedrals," he wrote, "for there is something in the eyes that is not in the cathedral."

in a fever of productivity, "I wonder when I'll get my starry night done," he wrote, " a picture that haunts me always."

The picture conveys surging movement through curving brush-work, and the stars and moon seem to explode with energy. "What I am doing is not by accident," van Gogh wrote, "but because of real inten-tion and purpose." For all the dynamic force of "Starry Night," the composition is carefully bal-anced. The upward thrusting cypresses echo the vertical steeple, each cutting across curving, lateral lines of hill and sky. In both cases, the vertical forms act as brakes, counterforces to prevent the eye from traveling out of the picture. The dark cypresses also offset the bright moon in the opposite corner for a balanced effect. The forms of the objects determine the rhythmic

Van Gogh, "Crows over Cornfield," 1890, National Museum of Van Gogh, Amsterdam. *Shortly before he died, van Gogh painted this last picture, describing it as "vast stretches of corn under troubled skies . . . I did not need to go out of my way to express sadness and the extreme of loneliness." The dark, lowering sky and menacing crows forcefully embody his looming troubles.*

flow of brushstrokes, so that the overall effect is of expressive unity rather than chaos.

In van Gogh's last seventy days, he painted seventy canvases. Although under constant strain, he was at the peak of his powers tech-nically, in full control of his simpli-fied forms, zones of bright color without shadow, and expressive brushwork. "Every time I look at his pictures I find something new," his physician, Dr. Gachet, said. "He's more than a great painter, he's a philosopher."

Yet van Gogh was often despondent at his lack of prospects and dependence on his brother for financial support. "Until my pic-tures sell I am powerless to help," he wrote, "but the day will come when it will be seen that they are worth more than the price of the colors they are painted with, and of my life which in general is pretty barren." In 1990 van Gogh's "Por-trait of Dr. Gachet" sold at auction for $82.5 million, a record price for a work of art.

After receiving a letter from his brother complaining of financial

worries, and fearful of being a bur-den, van Gogh ended his last letter with the words, "What's the use?" walked into a field with a pistol, and shot himself. He died two days later. Briefly conscious before dying, he uttered his final thought, "Who would believe that life could be so sad?"

At his funeral, between sobs, Dr. Gachet eulogized van Gogh: "He was an honest man and a great artist. He had only two aims: humanity and art. It was the art that will ensure his survival." Van Gogh had said, "I would rather die of pas-sion than boredom." He had specu-lated on the prospects of immortali-ty: "A painter must paint. Perhaps there will be something else after that."

VINCENT AND THEO

Vincent and his younger brother Théo, an art dealer in Paris, had a close, though difficult, life-long friendship. When it became obvious Vincent could never support himself in a conventional pro-fession (he tried art gallery assistant, teacher, and missionary), Théo became his sole financial support, allowing Vincent to paint full-time. Throughout his life Vincent poured out his despair and ambitions in letters to Théo. These have become the essential source of information about the artist's life and work. When Vincent killed himself, Théo rushed to his side. Heartbroken, he wrote their mother, "He was so my own, own brother." Théo soon went mad himself and, with-in five months of Vincent's suicide, died.

EARLY EXPRESSIONISM

***MUNCH:* THE MIND CRACKING.** The greatest Norwegian painter and an important inspiration for the German Expressionist movement was Edvard Munch (pronounced Moonk; 1863–1944). Although he spent time in Paris where he learned from Impressionist and Post-Impressionist art, Munch's most productive period was 1892–1908 in Berlin. There he produced paintings, etchings, lithographs, and woodcuts that expressed modern anguish with unequaled power.

Munch was always an outsider, brooding and melancholy, who called his paintings his "children" ("I have nobody else," he said). His neuroses sprang from a traumatic childhood: his mother and eldest sister died of consumption when he was young, leaving him to be raised by a fanatically religious father. Even as an adult, Munch was so afraid of his father that he ordered "Puberty," his first nude painting, to be covered at an Oslo exhibit his father attended.

"Illness, madness, and death were the black angels that kept watch over my cradle," Munch wrote of his painful youth. Treated for depression at a sanatorium, Munch realized his psychological problems were a catalyst for his art. "I would not cast off my illness," he said, "for there is much in my art that I owe to it."

Munch specialized in portraying extreme emotions like jealousy, sexual desire, and loneliness. He aimed to induce a strong reaction in his viewers, saying, "I want to paint pictures that will make people take off their hats in awe, the way they do in church."

His most famous work, "The Scream," represents the intolerable fear of losing one's mind. Every line in the painting heaves with agitation, setting up turbulent rhythms with no relief for the eye. "Above the blue-black fjord," Munch wrote of "The Scream," "hung the clouds, red as blood, red as tongues of fire." Today the painting has become so famous it is practically a cliché for high anxiety, but when Munch first exhibited the painting, it caused such an uproar, the exhibit was closed.

Although Munch often went for months without painting, once he began a work, he painted in a frenzy. The easel rattled as he attacked the canvas with violent brushstrokes. After one bout of nonstop work, heavy drinking, and a disastrous love affair, Munch suffered a nervous breakdown. Afterwards determined to put aside his tormented themes, his work became more optimistic but less moving. Munch was a forerunner of Expressionism, a style that portrayed emotions through distorting form and color.

Munch, "The Scream," 1893, National Gallery, Oslo. *Munch is known for his emotionally charged images of fear, isolation, and anxiety that greatly influenced the German Expressionists.*

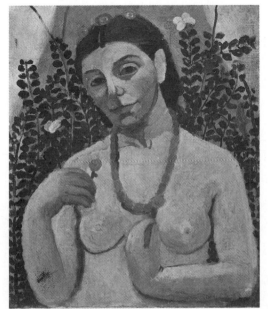

*An important precursor of Expressionism was German-born **Paula Modersohn-Becker** (1876–1907), who, working in isolation, developed a completely modern style. Searching for, as she said, "great simplicity of form," she concentrated on single figures: wide-eyed, often nude, self-portraits and portraits of peasants. In a brief career, cut short by her death from childbirth, she executed groundbreaking images of great intensity.*

Modersohn-Becker, "Self-Portrait," 1906, Öffentliche Kunstsammlung, Kunstmuseum, Basel.

SYMBOLISM

The forerunner of Surrealism, Symbolism was an artistic and literary movement that thrived in the last decade of the nineteenth century. Poets like Mallarmé and Rimbaud and painters like Odilon Redon and Gustave Moreau dis-carded the visible world of surface appearances for the inner world of fantasy. Rimbaud even advocated that the artist ought to be deranged to penetrate to the deeper truth beneath surface feelings.

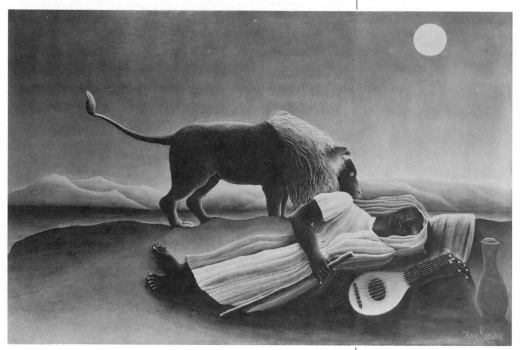

Rousseau, "The Sleeping Gypsy," 1897, MoMA, NY. *Rousseau was a self-taught painter of primitive, haunting landscapes, who was considered a forerunner of Surrealism.*

ROUSSEAU: JUNGLES OF THE IMAGINATION.

When an admirer told Henri Rousseau (1844–1910) his work was as beautiful as Giotto's, he asked, "Who's Giotto?" Rousseau, also known as Le Douanier because he had been a toll collector, was as naïve as his paintings.

This French Grandma Moses was an untrained hobby painter when, confident of his ability, he quit his job at age 40 to paint full-time. "We are the two great painters of the age," he told Picasso. "You paint in the 'Egyptian' style, I in the modern." Picasso and the French avant-garde circle hailed Rousseau as "the godfather of twentieth-century painting," but one cannot be sure of Picasso's sincerity, since the professional artists who took up with Rousseau delighted in playing practical jokes on their vain, gullible colleague.

Actually, Rousseau believed his fantastic, childlike landscapes — full of strange, lurking animals and tree-sized flowers — were realistic paintings in the academic style. He studied plants and animals at the Paris zoo, but his technical limitations were clear. He minutely detailed the lush, stylized foliage and meticulously finished the painting's surface so that no brushstrokes were visible. Still, his figures were flat and the scale, proportion, and perspective were skewed. Despite — or perhaps because of — these "flaws," his stiff jungle scenes have an air of mystery and otherwordliness to them.

A simple man, Rousseau sang loudly while he worked to keep his spirits up, but sometimes frightened himself with his bizarre imaginings. Once he had to open a window and stop work until he regained his composure. A visitor saw him painting with a wreath of leaves around his thumb. When asked why, Rousseau answered, "One must study nature."

PARTY ANIMAL

Although the public derided his work, Parisian painters recognized Rousseau as a true, if somewhat dull-witted, original. Picasso hosted a banquet in his honor, decorating his studio with vines to make it look like one of Rousseau's jungles. He even set up a "throne" for Rousseau, consisting of a chair on a packing crate surrounded by flags, lanterns, and a banner proclaiming "Homage to Rousseau."

Rousseau, ensconced on the dais, stoically endured a lantern dripping wax on his head until it formed a pyramid like a dunce's cap. When the lantern caught fire, the artists easily convinced the gullible Rousseau it was a sign of divine favor. While the party swirled about him, Rousseau — who accepted the "tribute" with straight-faced gravity, even writing Picasso a thank you note — dozed off, snoring gently.

REDON: FANTASTICAL FLOWERS.

Another French painter who, like Rousseau, would later inspire the Surrealists was Odilon Redon (pronounced Ruh DON; 1840–1916). After drawing a subject accurately, "I am driven as in torment," Redon once said, "to create something imaginary." The creatures of Redon's imagination were even more bizarre than Rousseau's: macabre insects, amoeboid monsters like his noseless cyclops, plants with human heads, and a hot-air balloon that is simultaneously an eyeball.

"My originality consists in making improbable beings live," Redon said, "by putting . . . the logic of the visible at the service of the invisible." Influenced by the disturbing poetry of Poe and Baudelaire, Redon created works that evoke a hallucinatory world.

Since he was dealing with the unseen world, Redon's technique focused on suggesting rather than describing his subject. He relied on radiant color and line to inform his erotic, perverse visions.

In "Orpheus" Redon used iridescent color to evoke a magical netherworld. The painting alludes to the mythological musician — his floating, dismembered head is seen in profile beside a fragment of his lyre — who has lost his love, Eurydice. Redon's canvases sparkled with glowing color — especially the clusters of strange flowers that were his signature.

RYDER: SUBJECTIVE SEASCAPES.

The American Symbolist painter Albert Pinkham Ryder (1847–1917) was another fan of Edgar Allan Poe who, like Redon, painted pictures from his imagination and used simplified forms and yellowish light to create works of haunting intensity.

One of the most original artists of his day, Ryder was the stereotypical hermit artist, who, in his last years, refused to even go out during the day because he felt sunlight would sear his eyes. He lived alone in downtown New York amid incredible squalor. Totally indifferent to his surroundings, Ryder piled his studio waist-high with dusty papers, milk bottles, ashes, and dead mice in traps. He slept on the floor to avoid bedbugs and, when a caller knocked, it took 15 minutes to clear a path to the door. The artist "must live to paint," he said, "and not paint to live." Amid the dirt and disorder, Ryder painted a dream world that contorted reality.

Ryder looked to nature for inspiration, closely observing the sea and sky, but his paintings were intentionally short on detail to create the mystical feeling he sought. "What avails a storm cloud accurate in color," he asked, "if the storm is not within?" In "Death on a Pale Horse," his most famous painting, a menacing cobra uncoils in the foreground as a spectral figure holding a scythe gallops across a barren landscape. Although the image is drawn from Ryder's private demons, it evokes a primordial shudder.

Sadly, Ryder was as indifferent to his art materials as he was to his life-style. He worked in fits and often slapped ill-prepared paint (even candle grease) onto a wet undercoating. As a result, all 150 of his canvases are severely cracked.

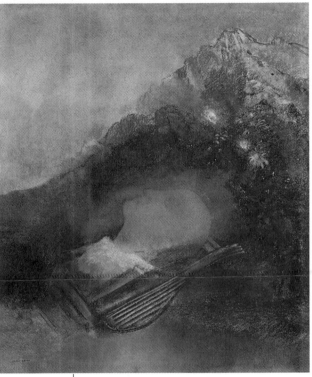

Redon, "Orpheus," 1913, Cleveland Museum of Art. *Redon is known for delicate, opalescent flowers, ghostlike profiles, and mystical apparitions.*

THE BIRTH OF MODERN ARCHITECTURE

Near the turn of the century, architecture branched out into several directions. The Neoclassical tradition continued to dominate public buildings like banks, libraries, and city halls. Architects for these civic projects studied at the École des Beaux-Arts, a prestigious but conservative art school in Paris. The "Beaux-Arts" style of domes and arches seemed out of place on the bustling streets of modern metropolises. These mock Greek or Roman buildings were like a leftover stage set from *Spartacus*.

At the same time, new materials, new technology, and new needs were drastically changing the profession of architecture, and an entirely different form of building began to emerge. Architects were called upon to design structures that had never before existed: suspension bridges, grain elevators, train sheds, factories, warehouses, and high-rise office buildings. The exorbitant cost of urban real estate made maximum use of small space imperative, and the invention of the elevator — perfected in the 1880s — made soaring skyscrapers possible. Cheap steel allowed builders to rely on a strong inner cage for support instead of the traditional masonry walls and stone columns. Architects found themselves being virtually forced by modern function to break free of ancient Greek and Roman prototypes.

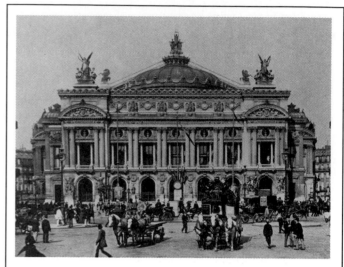

Charles Garnier, Opera House, 1875, Paris. *The Beaux-Arts Opera House was the epitome of the reactionary style modern architects rejected. With its paired Corinthian columns, profusion of sculpture, and ostentatious ornament, it was the biggest and showiest theater in the world.*

Hector Guimard, Entrance to the Métro, c. 1900, Paris. *This wrought-iron entrance to the Paris Métro, or subway, shows the curling, organic, plantlike style of Art Nouveau that began to replace popular Neoclassical revival styles around the turn of the century. Twenty or so of sculptor Guimard's serpentine entrances still beautify the Métro.*

American midwestern architect Louis Sullivan's credo of "form follows function" became the rallying cry of the day. The new designs were to express a building's commercial purpose, without any overlay of historical ornament. It was somehow fitting that the first new school of architecture to emerge in centuries was born in Chicago, "Stormy, husky, brawling, /City of the Big Shoulders," as poet Carl Sandburg would later call it. Chicago was a city without a past, a city of new immigrants that seemed to be making itself up as it went along.

Chicago was also the site of the 1893 World's Fair, a huge exposition of pavilions designed to show off America's industrial might. Ironically — and sadly — the Fair's buildings, temporary plaster structures, were designed by East Coast traditionalists like Richard Morris Hunt and the firm of McKim, Mead & White in a Neo-Roman style totally out of sync with Chicago's gritty reality. Dubbed the "White City," the expo (except for Sullivan's Transportation Building) showed not the slightest trace of originality. The Fair's Neoclassicism crowned the Beaux-Arts style as king and set public architecture back for several decades. Meanwhile, the metacenter of modern design would later shift to New York where truly innovative architecture appeared in new structures like the Brooklyn Bridge, finished in 1883, and the first skyscraper, New York City's Equitable Building (1871).

SULLIVAN: THE FIRST MODERN ARCHITECT. Louis Sullivan (1856–1924) virtually invented the skyscraper and, in the process, put Chicago on the cultural map. With his partner Dankmar Adler, Sullivan designed the Chicago Auditorium that opened in 1889. On opening night, dazzled by the sumptuous building, President William Henry Harrison turned to his vice-president and said, "New York surrenders, eh?"

Sullivan and Chicago were made for each other. As a boy of 12, he had wandered the streets of Boston commenting on buildings that "spoke" to him: "Some said vile things," he wrote, "some said prudent things, some said pompous things, but none said noble things." A short stint at the École des Beaux-Arts convinced him that Classicism was dead weight and a radical new approach was necessary. "It can [be done]," he wrote, "and it shall be. No one has — I will!" With this resolution, he breezed into Chicago where, despite a financial depression, "there was a stir — an energy that made [me] tingle to be in the game," he wrote.

Sullivan saw immediately that the new vertical towers demanded a wholly new aesthetic. The tall office building "must be every inch a proud and soaring thing," he said, "rising in sheer exultation that from bottom to top it is a unit without a single dissenting line." One of the earliest to use the steel frame, Sullivan insisted that this inner grid be "given authentic recognition and expression." The exterior of his designs always echoed, not only the building's function, but its interior skeleton.

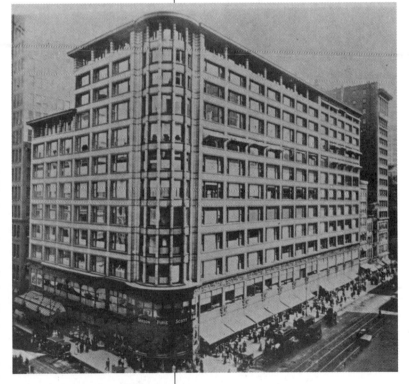

Sullivan, Carson-Pirie-Scott Department Store, 1899-1904, Library of Congress. *Louis Sullivan is considered the father of modern American architecture.*

Chicago's Carson-Pirie-Scott department store was Sullivan's revolutionary metropolitan image. Its gridlike appearance reflects its rectangular steel framework, and the sweeping horizontal bands of windows parallel the street. The stark geometric simplicity of this twelve-story building heralded the beginning of modern architecture in America.

Just because Sullivan rejected antique styles did not mean he avoided decorative elements. "Ornament, when creative, spontaneous," he wrote, "is a perfume." But just as he called for new architecture to match new technology, he wished surface decoration to be fresh and inventive. Although the top ten stories of Carson-Pirie-Scott are sleek, with bare terra-cotta sheathing, the bottom two floors, at eye level, are richly decorated with coiling cast-iron ribbons in an Art Nouveau pattern. The twisting tendrils, designed by Sullivan, interlace around the building to provide visual interest and relief from the building's unadorned bulk.

Like most visionaries, Sullivan was not appreciated as much in his day as in ours. His graceful commercial structures were considered inferior to opulent Beaux-Arts knock-'em-dead buildings like the Paris Opera House. It took Sullivan's prize pupil, Frank Lloyd Wright, to bring many of the master's ideas to fruition.

The Twentieth Century: Modern Art

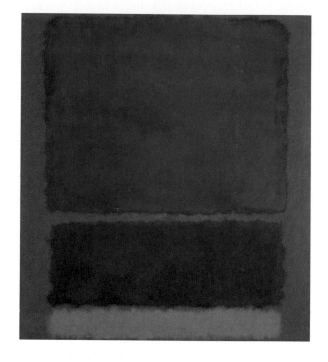

"Beauty must be convulsive or cease to be," said Surrealist spokesman André Breton. In the twentieth century, art was aggressively convulsive, with styles replacing each other as fast as hemlines changed in the fashion world. Throughout this dizzying parade, one theme was constant: art concerned itself less with exterior visual reality and more with interior vision. As Picasso put it, the artist paints "not what you see, but what you know is there."

Twentieth-century art provided the sharpest break with the past in the whole evolution of Western art. It took to an extreme what Courbet and Manet began in the nineteenth century — portraying contemporary life rather than historical events. Twentieth-century art not only declared all subjects fair game, it also liberated form (as in Cubism) from traditional rules and freed color (in Fauvism) from accurately representing an object. Modern artists defied convention with a vengeance, heeding Gauguin's demand for "a breaking of all the old windows, even if we cut our fingers on the glass."

At the core of this philosophy of rejecting the past, called Modernism, was a relentless quest for radical freedom of expression. Released from the need to please a patron, the artist stressed private concerns, experiences, and imagination as the sole source of art. Art gradually moved away from any pretense of rendering nature toward pure abstraction, where form, line, and color dominate.

During the first half of the century, the School of Paris reigned supreme. Whether or not artists of a particular trend lived in Paris, most movements emanated from France. Until World War II the City of Light shined as the brightest beacon of modern art. Fauvism, Cubism, and Surrealism originated there. In the 1950s the New York School of Abstract Expressionism dethroned the School of Paris. The forefront of innovation shifted for the first time to the United States, where Action Painter Jackson Pollock, as his colleague Willem de Kooning said, "busted our idea of a picture all to hell."

WORLD HISTORY		ART HISTORY
Wrights fly airplane	1903	
Einstein announces relativity theory	1905	First Fauve exhibit, Die Brücke founded, Stieglitz opens 291 Gallery
Earthquake shakes San Francisco	1906	
	1907	Brancusi carves first abstract sculpture
	1908	Picasso & Braque found Cubism
	1908–13	Ash Can painters introduce realism
Peary reaches North Pole	1909	
	1910	Kandinsky paints first abstract canvas, Futurists issue Manifesto
	1911	Der Blaue Reiter formed
Henry Ford develops assembly line	1913	Armory Show shakes up American art
World War I declared	1914	
	1916	Dada begins
Lenin leads Russian Revolution	1917	De Stijl founded
	1918	Bauhaus formed
	1920s	Mexican muralists active
U.S. women win vote	1920	Soviets suppress Constructivism
Hitler writes *Mein Kampf*	1924	Surrealists issue Manifesto
Lindbergh flies solo across Atlantic	1927	
Fleming discovers penicillin	1928	
Stock Market crashes	1929	
	1930s	American Scene painters popular, Social Realists paint political art
FDR becomes President	1933	
Spanish Civil War begins	1936	
Commercial television begins	1939	
U.S. enters World War II	1941	
First digital computer developed	1944	
Hiroshima hit with atom bomb	1945	Dubuffet coins term "L'Art Brut"
Mahatma Gandhi assassinated, Israel founded	1948	
People's Republic of China founded	1949	
Oral contraceptive invented	1950	Abstract Expressionism recognized
	1952	Harold Rosenberg coins term "Action Painting," Frankenthaler invents stain painting
DNA structure discovered, Mt. Everest scaled	1953	
Supreme Court outlaws segregation	1954	
Salk invents polio vaccine	1955	
Elvis sings rock 'n' roll	1956	Wright builds Guggenheim
Soviets launch Sputnik	1957	

FAUVISM: EXPLODING COLOR

"Fauvism isn't everything," Matisse remarked, "only the beginning of everything." In duration, Fauvism was only a blip on the screen of world art, lasting from 1904 to 1908. As the first major avant-garde art movement of the twentieth century, however, it kicked off the modern era with a bang.

The 1905 Paris exhibit that introduced Fauvism was one of those crucial moments in art history that forever changed the way we look at the world. Before, the sky was blue and grass was green. But in canvases by Fauve artists like Matisse, Vlaminck, Derain, Dufy, Braque, and Rouault, the sky was mustard-yellow, trees tomato-red, and faces pea-green. It was as if gremlins seized the color knob on the tv and all the hues went berserk.

Public response was hostile. The group got its name from a critic who called them "wild beasts" (fauves). Others termed the work "raving madness," "a universe of ugliness," and "the naive and brutal efforts of a child playing with its paintbox." A visitor to the exhibit recalled how spectators reacted with "shrieks of laughter . . . lurching hysterically in and out of the galleries."

What made critics consider the Fauves "all a little mad" was their use of color without reference to actual appearance. Far from crazy, however, they were in earnest about experimenting with new ways to express their emotional response to a scene (generally landscapes or seascapes painted outdoors).

The Fauves' radical departure from tradition originated when they saw — and were deeply impressed by — retrospectives on van Gogh, Gauguin, and Cézanne from 1901 to 1906. Vlaminck told of encountering van Gogh's work: "I was so moved, I wanted to cry with joy and despair. On that day I loved van Gogh more than my own father." Matisse had already experimented with transforming traditional subjects, as in a male figure he painted pure blue. But, after meeting Vlaminck and Derain at the van Gogh show, he visited their joint studio and saw their clashing colors and bold distortions of form. "I couldn't sleep last night," Matisse wrote the next day. The movement, which never called itself a movement although its practitioners worked together and shared common goals, was born with Matisse as its spokesman.

Another influence on the Fauves' refusal to imitate nature was their discovery of non-European tribal arts, which were to play a formative role in modern art. Derain, Vlaminck, and Matisse were among the first to collect African masks. The art of the South Seas, popularized by Gauguin, and Central and South American artifacts also led them away from the Renaissance tradition and toward freer, more individual ways of communicating emotion.

FAUVISM

LOCALE: France

PERIOD: 1904–8

NOTABLES: Matisse, Derain, Vlaminck, Dufy, Rouault, Braque

HALLMARKS: Intense, bright, clashing colors
Distorted forms and perspective
Vigorous brushstrokes
Flat, linear patterns
Bare canvas as part of overall design

TRANSLATION: Wild beast

DRUNK ON COLOR. The Fauves shared an intoxication with exaggerated, vibrant color. They liberated color from its traditional role of describing an object to expressing feelings instead. After pushing sizzling color to the extreme of non-representation, the Fauves became increasingly interested in Cézanne's emphasis on underlying structure, which gave rise to the next revolution in art: Cubism.

Braque, only very temporarily a Fauve, went on to do his best work as founder, with Picasso, of Cubism. For others, like Derain, Dufy, and Vlaminck, their brief Fauve fling represented their finest work. Of the Fauves, only Matisse continued to explore the potential of pure color as he went on reducing forms to their simplest signs. Although Fauvism was short-lived, it was highly influential, especially on German Expressionism.

By 1908, the Fauves had taken the style to its blazing limit. Burnout was inevitable. Braque explained its demise, saying, "You can't remain forever in a state of paroxysm."

VLAMINCK: TO KNOW EXCESS. Maurice de Vlaminck (1876–1958) "painted," according to one critic, "as other men throw bombs." Vlaminck did everything in extreme. When he ate lamb, he ate a whole leg; when he went cycling, he rode 150 miles in one day; when he told the story of an uneventful train derailment, he embellished it with tales of bodies littering the landscape and blood on the tracks.

Physically a big man who was extremely sure of himself, Vlaminck in his life and art was the wildest beast in the Fauve jungle. He taught boxing, played the violin in seedy cafés, and wrote soft-core porno novels. A self-taught artist, he bragged that he never set foot in the Louvre. Overwhelmed by the 1901 van Gogh show, Vlaminck, with his friend Derain, started squeezing paint on the canvas straight from the tube, smearing the bold colors thickly with a palette knife. He placed daubs of clashing colors side by side to intensify their effect, making his exuberant landscapes seem to vibrate with motion. A favorite subject was the bridge at Chatou, the Paris suburb where he lived, portrayed at a sharp tilt with thick, expressive brushwork.

DERAIN: FIREWORKS. André Derain (pronounced duh REN; 1880–1954) was the quintessential Fauve. He reduced his brushstrokes to Morse code: dots and dashes of burning, primary colors exploding, he said, like "charges of dynamite."

Derain pioneered strong color as an expressive end in itself. His bold, directional brushstrokes eliminated lines and the distinction between light and shade. In his harbor and beach scenes, the differing strokes — from choppy to flowing — give a sense of movement to sky and water.

For the first two decades of the twentieth century, Derain was at the avant-garde hub, a creator of Fauvism and an early Cubist. He later turned to the Old Masters for inspiration and his work became dry and academic. The sculptor Giacometti visited Derain, who had clearly outlived his fame, on his deathbed. When asked if he wanted anything, Derain replied, "A bicycle and a piece of blue sky."

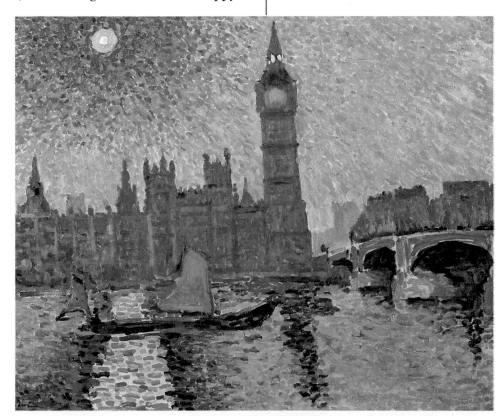

Derain, "Big Ben," 1905, Troyes, Private collection. *Derain applied bright, clashing colors with expressive brushstrokes to distort reality — the identifying marks of Fauvism.*

***DUFY:* FAUVE'S ANIMATOR.** It's been said one can hear tinkling champagne glasses when looking at Raoul Dufy's (pronounced Doo FEE; 1877–1953) pictures. His cheerful canvases of garden parties, concerts, horse races, regattas, and beach scenes on the coast of Normandy are undeniably fashionable. Yet Dufy was more than a mere entertainer and chronicler of the rich. His drawing was so fluid, his colors so vivacious, that he never failed to animate a scene with charm.

Everything came easily to Dufy. As a student at the École des Beaux-Arts, he found drawing with his right hand too facile, so he switched to the left, which he eventually came to prefer. Passionate about music, he closed his eyes while listening to an orchestra and visualized colors like the crimson and rose that saturate his paintings.

Although Expressionism (distorting an object's actual appearance to relay an artist's emotional response) is usually associated with violent, perverse subjects, Dufy proved it could be jovial. He used intense colors that have nothing to do with an object's appearance but everything to do with his own outlook. When accused of neglecting natural appearance in his painting, he said, "Nature, my dear sir, is only a hypothesis." Dufy's pleasure-soaked paintings of the life of leisure were immensely popular and helped win acceptance for his fellow Fauves.

***ROUAULT:* STAINED GLASS PAINTINGS.** Georges Rouault (pronounced Roo OH; 1871–1958) worked with the Fauves briefly and shared with them technical traits like expressive brushwork and glowing color. Yet, while the other Fauves painted urbane, joyous canvases, his were filled with pain and suffering.

A devout Catholic, Rouault's lifelong concern was to redeem humanity through exposing evil. In his early work, he concentrated on condemning prostitutes and corrupt judges with savage, slashing brushstrokes. Later he portrayed sad circus clowns and finally, after 1918, virtually all his work was on religious subjects, especially the tragic face of Christ. Rouault's "passion," he believed, was best "mirrored upon a human face."

As a youth, Rouault apprenticed with a stained glass maker and repaired medieval cathedral windows. The heavy, black lines compartmentalizing bodies into richly colored segments in his mature oils have the feel of stained glass. Rouault's simplified bodies have a powerful, expressive function, to communicate his religious faith.

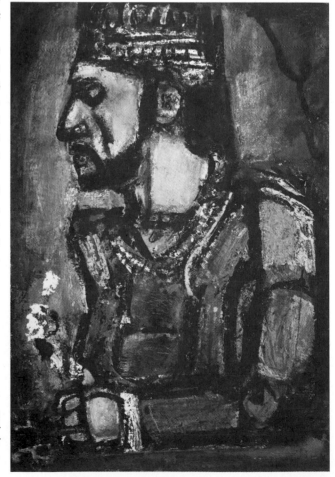

Rouault, "The Old King," 1916–37, Carnegie Museum of Art, Pittsburgh. *This figure of an aging Biblical king shows Rouault's trademark blocks of deep color bordered by massive black lines like stained glass.*

FIRE SALE

Georges Rouault's relationship with his dealer, the famed avant-garde champion Ambroise Vollard, was not exactly tension free. Rouault had too many overly ambitious (namely, unfinished) projects in progress at once. Vollard, whom Cézanne called a "slave driver," was always nagging him for finished work to sell.

Once Rouault nearly burned alive. Dressed as Santa Claus to amuse his children, the cotton padding in his costume caught fire from candles on the Christmas tree. His hands were seriously burned, a clear setback to his work. Vollard, ever the taskmaster, was unsympathetic. "You've been through fire!" he said. "Your painting will be all the more beautiful." But after Vollard's death, to show how little he cared for money, Rouault burned several hundred unfinished canvases in a factory furnace.

TWENTIETH-CENTURY SCULPTURE: A NEW LOOK

Sculpture soon caught up with the current of antirealism that swept twentieth-century painting.

BRANCUSI: THE EGG AND I. The greatest Modernist sculptor was Rumanian artist Constantin Brancusi (1876–1957), who shaved away detail almost to the vanishing point. "Since the Gothic, European sculpture had become overgrown with moss, weeds — all sorts of surface excrescences which completely concealed shape," British sculptor Henry Moore said. "It has been Brancusi's mission to get rid of this undergrowth and to make us once more shape-conscious."

Brancusi saw reality in terms of a few basic, universal shapes: the egg, the smooth pebble, and the blade of grass. Whatever the subject, from 1910 he simplified its form — in wood, marble, or metal — into these elemental shapes. "Simplicity is not an end in art," Brancusi said. "but one arrives at simplicity in spite of oneself in drawing nearer to the reality in things."

Brancusi showed his independent spirit early. He left home at age 11 to work as a shepherd and wood-carver. He then made his way from Bucharest to Paris on foot. When he arrived in France in 1904, he was offered a job as assistant to Rodin, the reigning king of sculpture. Brancusi refused, saying, "No other tree can grow in the shadow of an oak."

Brancusi was first to abandon the accepted practice of letting professional stonecutters do the actual carving of a sculpture. In 1907 he began carving stone directly, saying his hands followed where the material led. Sculptor Jacques Lipchitz, whose studio was below Brancusi's, recalled a constant tapping like a dripping faucet that kept him awake. It was Brancusi, continually chipping away until he reached an absolute bedrock image. "Create like a god, command like a king, work like a slave," Brancusi said.

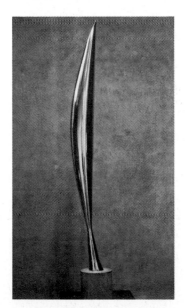

Brancusi, "Bird in Space," c. 1927, MoMA, NY. *This work represents not an actual bird but the concept of flight. "What is real is not the external form," Brancusi insisted, "but the essence of things." Although Brancusi's sculptures abandoned recognizable images entirely, he drew his themes from nature before reducing them to the most concentrated, elemental kernel.*

BRASS TAX

When "Bird in Space" was brought to the U.S. for a Brancusi show, a customs inspector refused to exempt it from duty as a sculpture. He insisted it in no way resembled a bird and was, therefore, not a work of art but a hunk of metal to be taxed as raw material. Another official had less trouble with the sculptor's work. When a Brancusi sculpture was denounced in Paris as obscene and a policeman came to haul it away, the gendarme offered this appraisal: "I see nothing indecent; this looks like a snail."

MODIGLIANI: THE PRIVILEGE OF GENIUS

Italian artist Amedeo Modigliani (1884–1920) is known primarily for paintings of reclining nudes. All the figures have long, thin necks, sloping shoulders, tilted heads with small mouths, long noses, and blank slits for eyes. In addition to his originality in painting, Modigliani was brash in both sculpture and zest for life.

Too handsome for his own good, Modi (as he was called) plunged into the bohemian life in Paris. Although poor as a pauper, he dressed to the hilt, with flying red scarf and loud corduroy suit. When the mood struck, he was wont to strip off his clothes, shouting to astounded café patrons, "Look at me! Don't I look like a god?" With his friend painter Maurice Utrillo, Modi caroused all night in bars, chanting poetry, swilling down cheap wine and absinthe, and smoking hashish. Together they made airplanes out of banknotes and sailed them over trees. He treated his mistress abominably. Once, in a violent rage, he threw her out the window. "People like us have different rights from other people because we have different needs which put us . . . above their morality," he wrote.

Modi painted portraits for a few francs to buy drink, but poverty was a real handicap when it came to sculpture. For wood to carve, he stole railway ties. Modi never cared for modeling in clay. "Too much mud," he said, so he pried up stone blocks from street beds at night. Like his neighbor, Brancusi, Modi carved simplified figures that radiate primeval power. "Your real duty is to save your dream," Modi said. After drinking all night and selling the suit he was wearing to buy more wine, he caught pneumonia in the bitter cold of dawn. Modigliani died at the age of 35.

TWIN TITANS OF THE TWENTIETH CENTURY: MATISSE AND PICASSO

If the first fifty years of twentieth-century art were reduced to two painters, they would be Picasso and Matisse, the "North and the South Pole" of art, in Picasso's words. These two prolific French artists were indeed opposite points on the compass for all Modernist explorers. Each inspired a different form of revolt against realism, one of shape, the other of color. Picasso, in Cubism, broke up forms to recombine them in new ways. Matisse, not to describe form but to express feeling, launched a chromatic revolution.

MATISSE: IN LIVING COLOR. "You speak the language of color," the aging Renoir told Henri Matisse (1869–1954). From the time Matisse pioneered jellybean-bright Fauve landscapes until the brilliant cutouts of his old age, Matisse believed, "Color was not given to us in order that we should imitate Nature," he said, but "so that we can express our own emotions."

Reaction against his early experiments was so violent, Matisse would not let his wife attend his groundbreaking 1905 exhibit. When an outraged viewer insisted, "It's not a woman; it is a painting," Matisse said that was exactly his idea: "Above all, I did not create a woman, I made a picture." This was the basic premise of twentieth-century painting: art does not represent, but reconstructs, reality. Or, as the Cubist painter Braque put it, "It is a mistake to imitate what one wants to create."

ART OF OMISSION. "You were born to simplify painting," Matisse's teacher, Gustave Moreau, told his pupil. It was as if Matisse put the overblown Salon style on a diet, stripping it down to bare bones. Throughout his long career, working 12 to 14 hours a day, seven days a week, Matisse sought to eliminate nonessentials and retain only a subject's most fundamental qualities. "Condensation of sensations . . . constitutes a picture," is how Matisse explained his technique. His preliminary sketches evolved from complex to simple, from particular to general, as one after the other he pared away extraneous details. A minimalist before the term existed, Matisse perfectly evoked sensual nudes in line drawings with barely a dozen strokes.

"FEEL-GOOD PAINTINGS." Matisse lived in trying times. Countless strikes, uprisings, assassinations, and two world wars exploded around him. Yet his paintings with titles like "Joie de vivre" blithely ignored all social or political controversy. Matisse had "sun in his belly," Picasso said of his chief rival whose charming scenes shine with the radiant light of the Mediterranean coast. Matisse's typical subjects almost persuade the viewer that paradise exists on earth: tables laden with tropical fruit, flowers, and drink; views out sunny windows; and female nudes languorously reclining.

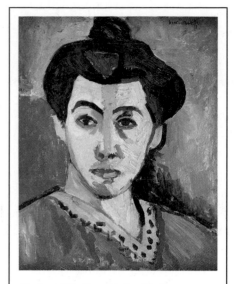

Matisse, "The Green Stripe (Madame Matisse)," 1905, Statens Museum für Kunst, Copenhagen. *Matisse used color to transform a conventional subject into a vibrating, original design. Energizing the face, the unexpected streak allows the head to compete with the assertive background. Matisse stressed surface pattern, placing equal emphasis on foreground and background, and on objects and the space around them. "No point is more important than any other," he said, abandoning shadow and perspective for a flat, ornamental, "overall" effect.*

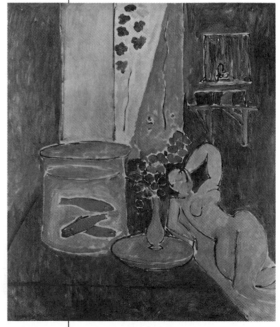

Matisse, "Goldfish and Sculpture," 1911, MoMA, NY. *One of the most influential modern painters, Matisse expressed the joy of life through powerful colors and simplified shapes.*

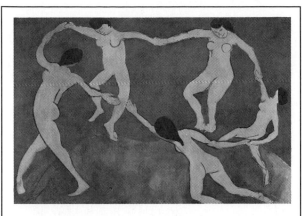

Matisse, "Dance" (first version), 1909, MoMA, NY. *Matisse used deliberately simplified forms and only three colors to portray the essence of joyful movement. The intensified colors ("The bluest of blues for the sky," he said, "the greenest of greens for the earth") were so vivacious, Matisse was startled when rays of sunlight striking the painting made it seem to quiver.*

Matisse believed painting should not only be beautiful but should bring pleasure to the viewer. He was master of the sinuously curved line called an "arabesque." "What I dream of is an art of balance, of purity and serenity devoid of troubling or depressing subject matter," he said — an art comfortable as an armchair after a hard day's work.

Matisse came late to painting, having trained to be a lawyer to please his bourgeois father. While he was recovering from an appendectomy, his mother brought him a box of paints and a how-to book, and the world lost an attorney and gained an artist. "It was as if I had been called," he remembered. "Henceforth I did not lead my life. It led me."

Matisse left for Paris to study art, with his father shouting, "You'll starve!" as the train pulled out of the station. He gained notoriety as leader of the Fauves' 1905 show. In 1917 Matisse began to spend winters on the French Riviera — first in Nice, then in Vence, where he donated a chapel of his own design that is one of the most moving religious buildings in Europe. Matisse was not a believer. His view of an afterlife was a celestial studio "where I would paint frescoes." He had, however, what he described as "a religious feeling towards life." After local nuns nursed him through a serious illness in the 1940s, the grateful Matisse devoted himself to every detail of the chapel.

THE ULTIMATE PAPER CUTOUTS. In his last years, Matisse was bedridden. Although arthritic, by fastening a charcoal stick to a bamboo fishing pole he was able to sketch huge figures on the ceiling above his bed. But his favorite activity was to cut fanciful shapes out of brightly colored paper to be glued into large-scale collages. These cutouts are the most joyous creations of any painter's old age and injected wider scope and freedom into his art.

In "Les Bêtes de la Mer" ("Beasts of the Sea"), Matisse uses symbolic shapes to imply coral, surf, and sea plants and animals. The dissonant colors produce visual excitement and energy. Indeed, his colors were so bright his doctor advised him to wear dark glasses when working on the cutouts. From floor to ceiling the vivid shapes covered his bedroom walls. "Now that I don't often get up," he said, "I've made myself a little garden to go for a walk in." The vivid collages were his most original work, the culmination of a lifetime of simplifying and intensifying art. The only difference between his earlier paintings and the cutouts, he said, was that "I have attained a form filtered to its essentials."

Matisse's constant refrain was "Exactitude is not truth." A subject's "inherent" truth — "the only truth that matters," according to Matisse — differed from outward appearance. To find this core truth meant searching for an irreducible "sign" to represent an object. The fact that the "sign" seemed childishly simple was part of Matisse's success: "I have worked for years in order that people might say, 'It seems so easy to do!'"

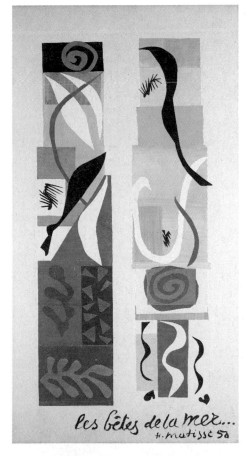

Matisse, "Les Bêtes de la Mer," 1950, NG, Washington, DC. *In Matisse's collaged paper cutouts, his characteristic elements of suggestive forms and dazzling color for emotional impact are evident.*

***PICASSO:* THE KING OF MODERN ART.** "When I was a child, my mother said to me, 'If you become a soldier, you'll be a general. If you become a monk, you'll end up as the Pope,'" Pablo Picasso (1881–1973) told his mistress Françoise Gilot. "Instead," he added, "I became a painter and wound up as Picasso."

For half a century, Picasso led the forces of artistic innovation, shocking the world by introducing a new style and then moving on as soon as his unorthodoxy became accepted. His most significant contribution — aided by Braque — was inventing Cubism, the major revolution of twentieth-century art. Until the age of 91 Picasso remained vital and versatile. Probably the most prolific Western artist ever, Picasso produced an estimated 50,000 works.

Picasso could draw before he could talk. His first words at age two were "pencil, pencil," as he beggged for a drawing tool. Born in Spain the son of a mediocre painter, by his mid-teens Picasso had mastered the art of drawing with photographic accuracy. When he visited an exhibit of children's art in 1946, he remarked at that age he could draw like Raphael, but "it took me many years to learn how to draw like these children."

Although Picasso worked in a number of distinctive styles, his art was always autobiographical. "The paintings," he said, "are the pages of my diary." Walking through the chronological sequence of work in Paris's Musée Picasso is like wandering the corridors of his love life. Women were his chief source of inspiration.

BLUE PERIOD. Picasso's first original style grew out of his down-and-out years as an impoverished artist. The Blue Period of 1901–4 is so called because of the cool indigo and cobalt blue shades Picasso used. The paintings, obsessed with scrawny blind beggars and derelicts, literally project the "blues" that seized Picasso during this period, when he had to burn his sketches for fuel. Working without recognition, he elongated the limbs of his bony figures until they looked like starved El Grecos.

ROSE PERIOD. As soon as Picasso settled full-time in Paris (he spent his working career in France) and met his first love, Fernande Olivier, his depression vanished. He began to use delicate pinks and earth colors to paint circus performers like harlequins and acrobats. The paintings of this Rose, or Circus, Period (1905–6) are sentimental and romantic.

Picasso, "The Blindman's Meal," 1903, MMA, NY.
Picasso's melancholy "Blue Period" paintings portray thin, suffering beggars and tramps.

Picasso, "Portrait of Ambroise Vollard," 1915, MMA, NY.

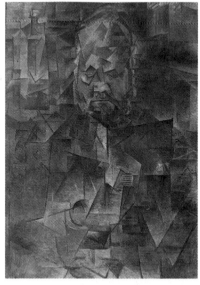

Picasso, "Portrait of Ambroise Vollard," 1910, Pushkin State Museum of Fine Arts, Moscow.

VOLLARD CUBED. *"I have no idea whether I'm a great painter," Picasso said, "but I am a great draftsman." Although he could draw likenesses as precisely as Ingres, he chose to invent new forms rather than perpetuate the old. In the Analytic Cubist portrait of Vollard, Picasso broke the subject into a crystallike structure of interlocking facets in subdued colors.*

ANATOMY OF A MASTERPIECE

During the Spanish Civil War, fascist dictator Francisco Franco hired the Nazi Lüftwaffe to destroy the small Basque town of Guernica. For three hours warplanes dropped bombs, slaughtering 2,000 civilians, wounding thousands more, and razing the undefended town. The Spaniard Picasso, filled with patriotic rage, created the 25-foot-wide by 11-foot-high mural in one month. It is considered the most powerful indictment ever of the horrors of war. "Painting is not done to decorate apartments," Picasso said. "It is an instrument of war for attack and defense against the enemy."

Picasso incorporated certain design elements to create a powerful effect of anguish. He used a black-white-gray palette to emphasize hopelessness and purposely distorted figures to evoke violence. The jagged lines and shattered planes of Cubism denote terror and confusion, while a pyramid format holds the composition together. Some of Picasso's symbols, like the slain fighter with a broken sword implying defeat, are not hard to decipher. Picasso's only explanation of his symbols was: "The bull is not fascism, but it is brutality and darkness. . . . The horse represents the people."

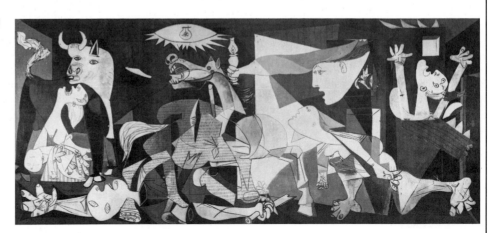

Picasso, "Guernica," 1937, Reina Sofía Art Center, Madrid.

"NEGRO" PERIOD. Picasso discovered the power of abstracted African masks around 1907, incorporating their motifs into his art. In the same year he produced the breakthrough painting "Desmoiselles d'Avignon," one of the few works that singlehandedly altered the course of art.

HARBINGER OF CUBISM: "LES DESMOISELLES D'AVIGNON." Called the first truly twentieth-century painting, "Desmoiselles" (see p. 22) effectively ended the nearly 500-year reign of Renaissance-ruled Western art. The most radical shift since works by Giotto and Masaccio, it shattered every precept of artistic convention. Picasso's five nudes are hazy on anatomy, with lop-sided eyes, deformed ears, and dislocated limbs. Picasso also fractured the laws of perspective, breaking up space into jagged planes without orderly recession — even presenting the eye of one figure from a frontal view and face in profile. Picasso smashed bodies to bits and reassembled them as faceted planes that one critic compared to a "field of broken glass."

The aggressive ugliness of the women repelled visitors to Picasso's studio. Matisse thought the painting a hoax and Braque, shaken, said, "It is like drinking kerosene in order to spit fire." The modern writer Gertrude Stein, Picasso's friend and patron (whose own portrait by Picasso was less than flattering, although she admitted, "For me, it is I") defended his daring: "Every masterpiece has come into the world with a dose of ugli-ness in it. This ugliness is a sign of the creator's struggle to say something new."

"I paint what I know," Picasso said, "not what I see." Inspired by Cézanne's geometric patterns, Picasso broke reality into shards representing multiple views of an object seen from front, rear, and back simultaneously.

SCULPTURE. Picasso shook up sculpture as thoroughly as he did painting. In 1912 his "Guitar" sheet metal assemblage completely broke with traditional methods of carving or modeling marble or clay. One of the first to use found objects, Picasso transformed the unlikeliest materials into sculpture, as in his "Head of a Bull" composed of a bicycle seat and handlebars.

DIVERSITY. After World War I, Picasso experimented with widely differing styles, drawing faithful likenesses one day and violently distorted figures the next. "To copy others is necessary," Picasso believed, "but to copy oneself is pathetic." With such miscellaneous talents and interests, there could be no smooth sequence of "early," "middle," and "late" styles.

A restless explorer constantly re-inventing the shape of art, Picasso summed up his career in the words: "I love discovering things." As his friend Gertrude Stein put it, "He alone among painters did not set himself the problem of expressing truths which all the world can see, but the truth which only he can see."

CUBISM

One of the major turning points in twentieth-century art, Cubism lasted in pure form only from 1908 to 1914. The style got its name from Matisse's dismissal of a Cubist landscape by Georges Braque as nothing but "little cubes." Although the four "true" Cubists — Picasso, Braque, Gris, and Léger — broke objects into a multitude of pieces that were not actually cubes, the name stuck. Cubism liberated art by establishing, in Cubist painter Fernand Léger's words, that "art consists of inventing and not copying."

ANALYTIC CUBISM. The first of two phases of Cubism was called "Analytic" because it analyzed the form of objects by shattering them into fragments spread out on the canvas. Picasso's "Ambroise Vollard" (see p. 136) is a quintessential work of Analytical Cubism. Picasso and Braque worked in a nearly monochrome palette, using only brown, green, and later gray in order to analyze form without the distraction of bright colors.

SYNTHETIC CUBISM. Braque and Picasso invented a new art form, called collage (from the French word "coller," to glue). From 1912 to 1914, joined by Spanish painter Juan Gris, they incorporated stenciled lettering and paper scraps into their paintings. Braque's "Mandolin" dismantles the stringed instrument only to reassemble, or "synthesize," its essential structural lines in corrugated cardboard and newsprint.

Besides Braque and Picasso, Juan Gris (pronounced Grease; 1887–1927) contributed significantly to Synthetic Cubism. From 1909, Fernand Léger (pronounced Lay ZJEH; 1881–1955) added curved

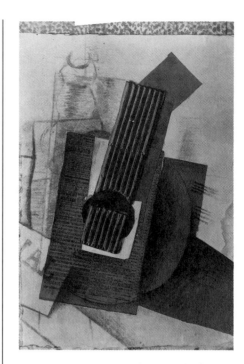

Braque, "Mandolin," 1914, Ulmer Museum, Ulm, Germany. *Coinventor of Cubism with Picasso, Braque collaborated in the development of collage during the Synthetic Cubist phase.*

forms to the angular Cubist vocabulary. Because his shapes tended to be tubular, he was inevitably dubbed a "Tubist." He is most noted for his urban, industrial landscapes full of polished, metallic shapes, robotic humanoids, and hard-edged mechanical gears.

The teasing quality of all Cubist art springs from its ambivalence between representation and abstraction. On the brink of dissolving an object into its component parts, hints of it flicker in and out of consciousness. Based on the world of appearances, Cubism delivers a multi-faceted fly's-eye view of reality. "It's not a reality you can take in your hand. It's more like a perfume," Picasso said. "The scent is everywhere but you don't quite know where it comes from."

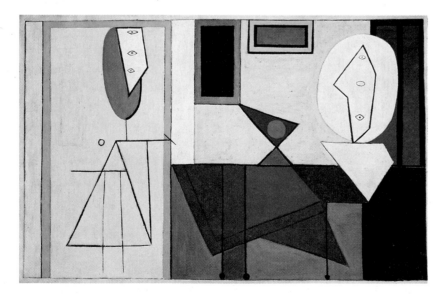

Picasso, "The Studio," 1928, MoMA, NY.

SYNTHETIC CUBISM *employs strong colors and decorative shapes. At left the painter holds a brush indicated by a small diagonal line at the end of a horizontal "arm." His oval "head" contains three vertical eyes, perhaps suggesting the painter's superior vision. A floating circle is all that remains of the artist's palette. His subject, a still life of fruit bowl and bust on a table with red tablecloth, also consists of geometric shapes. What holds the tautly constructed composition together are repeated (and precisely related) vertical, horizontal, and diagonal lines.*

MODERNISM OUTSIDE OF FRANCE

During the decade after the birth of Cubism, the world witnessed astounding changes. Technology zoomed ahead at breakneck speed, transforming the world from agrarian to industrial, from rural to urban. Against a backdrop of World War I, Europe erupted in political chaos. Finally the Russian revolution of 1917 called for the destruction of everything from the old regime. Artists searched for new forms to express this upheaval. Three movements — Futurism in Italy, Constructivism in Russia, and Precisionism in the United States — adapted the forms of Cubism to redefine the nature of art.

FUTURISM

KINETIC ART. Futurism began in 1909 as a literary movement when the Italian poet F. T. Marinetti issued its manifesto. Marinetti, a hyperactive self-promoter nicknamed "The Caffeine of Europe," challenged artists to show "courage, audacity, and revolt" and to celebrate "a new beauty, the beauty of speed."

BOCCIONI: **POETRY IN MOTION.** Marinetti found an ally in the ambitious, aggressive painter Umberto Boccioni (1882–1916), who urged painters to forsake art of the past for the "miracles of contemporary life," which he defined as railroads, ocean liners, and airplanes. The bossy Boccioni, labeled by a friend "Napoleon come back to life," refused to study academic art: "I want to paint the new, the fruit of our industrial age."

FASTER THAN A SPEEDING BULLET. The key to Futurist art, practiced by Giacomo Balla, Carlo Carrà, Luigi Russolo, and Gino Severini in addition to Boccioni, was movement. The painters combined bright Fauve colors with fractured Cubist planes to express propulsion. In his most famous painting, "The City Rises," Boccioni portrayed workers and horses bristling like porcupines with his trademark "lines of force" radiating from each figure to imply velocity. He tried to capture not just a freeze-frame "still" of one instant but a cinematic sensation of flux.

Although Futurist art was fairly well received, the members' public demonstrations caused an uproar. To provoke the passive public, Futurists climbed the bell tower of Venice's St. Mark's. As churchgoers exited, they bombarded them with outrageous slogans blasted through loudspeakers: "Burn the museums! Drain the canals of Venice! Burn the gondolas, rocking chairs for idiots! Kill the moonlight!" The rebels measured their success by the amount of abuse in the form of insults, rotten fruit, and spoiled spaghetti the crowd hurled back at them.

Boccioni's most famous work is "Unique Forms of Continuity in Space." The charging figure is an answer to Marinetti's belief that "a roaring racing car that seems to run on shrapnel is more beautiful than the Victory of Samothrace." Boccioni's Futuro-Cubist Nike (see p. 13 for original) slices through space trailing flamelike flaps. "I am obsessed these days by sculpture," Boccioni wrote. "I think I can achieve a complete revival of this mummified art." After making good on his boast, he died in a riding accident at age 34. Boccioni and Marinetti founded a movement based on speed. With the death of its leading artist, Boccioni, Futurism died fast.

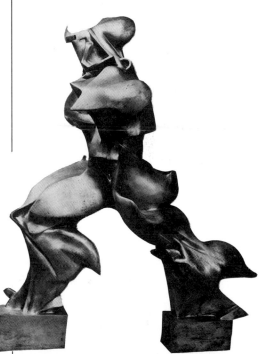

Boccioni, "Unique Forms of Continuity in Space," 1913, MoMA, NY. *Boccioni celebrated the power and dynamism of modern life in this Futurist sculpture of a striding figure.*

CONSTRUCTIVISM: SEEING RED.

Around 1914 the Russian avant-garde flourished with artists, called Constructivists, like Vladimir Tatlin, Liubov Popova, Kasimir Malevich, El Lissitzky, Alexander Rodchenko, Naum Gabo, and Antoine Pevsner. From Cubism the Constructivists borrowed broken shapes. From Futurism they adopted multiple overlapping images to express agitated modern life. These artists pushed art from representational to abstract.

Then the 1917 revolution converted Russian society from a feudal state to a "people's republic." Lenin tolerated the avant-garde. He thought they could teach the illiterate public his new ideology through developing novel visual styles. For a brief time, before Stalin cracked down and forbade "elitist" easel painting, Russia's most adventurous artists led a social, as well as artistic, revolution. They wanted to strip art, like the state, of petty bourgeois anachronisms. They tried to remake art, as well as society, from scratch.

THREE MODERNIST MOVEMENTS			
	FUTURISM	CONSTRUCTIVISM	PRECISIONISM
PERIOD:	1909–18	1913–32	1915–30
LOCALE:	Italy	Russia	United States
ARTISTS:	Boccioni, Balla, Severini, Carrà, Russolo	Tatlin, Malevich, Popova, Rodchenko, Lissitzky, Gabo, Pevsner	Sheeler, Demuth, O'Keeffe
FEATURES:	lines of force representing movement and modern life	geometric art reflecting modern technology	sleek urban and industrial forms

Tatlin, "Model for the Monument for the 3rd International," 1920. Recreated in 1968 for exhibition at the Moderna Museet, Stockholm. *Tatlin planned this revolving tower as a symbol of the momentum and unlimited potential of the Soviet Union.*

About 1914 Tatlin (pronounced TAT lahn; 1885–1953) originated Russian geometric art. He called this abstract art, which was intended to reflect modern technology, "Constructivism" because its aim was "to construct" art, not create it. The style prescribed using industrial materials like glass, metal, and plastic in three-dimensional works. Tatlin's most famous work was a monument to celebrate the Bolshevik revolution. Intended to be 1,300 feet tall, or 300 feet higher than the Eiffel Tower, the monument was planned for the center of Moscow. Since steel was scarce, his idea remained only a model, but it clearly would have been the most astonishing "construct" ever. Tilted like the leaning Tower of Pisa, the openwork structure of glass and iron was based on a continual spiral to denote humanity's upward progress.

Tatlin's rival, Malevich (pronounced MAL uh vich; 1878–1935), also pioneered abstract geometric art. His squares floating on a white background and finally his white-on-white paintings simplified art more radically than ever before. Malevich wanted "to free art from the burden of the object." He tried to make his shapes and colors as pure as musical notes, without reference to any recognizable object. Popova (1889–1924) added glowing color to Analytic Cubism.

These artists believed they could build a technological utopia through their designs. But around 1924 the dream ended brutally. The Communist Party declared art must be functional, an art for the masses, preferably propagandistic. Stalin sent nonconforming artists to labor camps and locked away their Modernist works in cellars. The flowering of Russian invention and optimism lasted only a brief "Prague spring."

PRECISIONISM: MODERNISM IN AMERICA.

In 1907 when Picasso was effectively burying the Renaissance with "Les Desmoiselles d'Avignon," American art was planted solidly in the past. Only a group of painters known as The Eight, or the Ashcan School (see p. 154) dared shake up convention by portraying real-life subjects of the Big City rather than maidens on unicorns in moonlight. Another group of American artists, the Precisionists, was concerned not just with new subject matter like the Ashcan School but with new attitudes toward form. The leading figures of this movement, which flourished in the 1920s, were the painters Charles Sheeler (1883–1965), Charles Demuth (1883–1935), and Georgia O'Keeffe (1887–1986).

The Precisionists straddled the borderline between representation and abstraction. They simplified forms to an extreme of spare geometry, using clean-edged rectangles to indicate soaring skyscrapers and factories. Sheeler's "River Rouge Plant" praises the severe, engineered beauty of an automobile factory, while Demuth's "My Egypt" portrays grain elevators with the epic grandeur of ancient pyramids.

O'KEEFFE: AN AMERICAN ORIGINAL. One of the most free-thinking artists to bring American art out of its cultural backwater and into the Modernist mainstream was Georgia O'Keeffe. "I decided that I wasn't going to spend my life doing what had already been done," she said and proceeded to do what no one had done before. O'Keeffe is best known for her huge blowups of single flowers like irises and calla lilies. O'Keeffe told why she magnified flowers: "Nobody has seen a flower — really — it is so small — we haven't time — and to see takes time. . . . I'll paint it big and they will be surprised into taking time to look at it." O'Keeffe evoked nature without explicitly describing it and approached the brink of abstraction. "I found that I could say things with color and shapes that I couldn't say in any other way — things that I had no words for," she said in 1923.

Six years later, entranced by bare desert landscapes, O'Keeffe went to New Mexico. She painted outdoors, day and night, sleeping in a tent and wearing gloves to work on frigid days. Sometimes the wind raged so fiercely it blew the coffee out of her cup and swept away her easel. She specialized in broad, simple forms to portray red sunsets, black rocks, and rippling cliffs. In the West O'Keeffe further pared down her art, literally to the bare bones, in a series of skull and pelvic bone pictures. Her bleached-bone paintings portray austere, curvilinear forms to express, she said, "the wideness and wonder of the world."

In her nineties, despite failing eyesight, O'Keeffe tackled a new art form: pottery. At 90 she explained her success: "It takes more than talent. It takes a kind of nerve . . . a kind of nerve and a lot of hard, hard work."

STIEGLITZ AND O'KEEFFE

In 1916, Alfred Stieglitz was a famous New York photographer whose Photo-Secession Gallery (also called 291 after its Fifth Avenue address) was the hub of avant-garde activity in New York. Georgia O'Keeffe was then a 28-year-old art teacher. "Finally a woman on paper," Stieglitz supposedly declared when he saw her work. In 1917 he mounted her first public show, and they became lovers. Stieglitz documented every line of O'Keeffe's body in nearly 500 photographs. Some are so sexually graphic, they have yet to be shown. The intimate nude studies caused curiosity-seekers to flock to her shows. She was the most celebrated woman artist in America.

After their marriage the couple set a new standard for sexual liberty. Each blatantly pursued numerous extramarital affairs, Georgia O'Keeffe with both men and women. An FBI file described her as an ultraliberal security risk. In their work, O'Keeffe and Stieglitz were also risk-takers. He championed the latest trends in the arts and took landmark photographs. She was a pioneer of artistic liberty who once said, "Art is a wicked thing. It is what we are."

O'Keeffe, "City Night," 1926, Minneapolis Institute of Arts. *O'Keeffe reduces skyscrapers to polished, streamlined forms like architectural drawings.*

EXPRESSIONISM:
THE FINE ART OF FEELING

In Germany, a group known as the Expressionists insisted art should express the artist's feelings rather than images of the real world. From 1905–30 Expressionism, the use of distorted, exaggerated forms and colors for emotional impact, dominated German art.

This subjective trend, which is the foundation of much twentieth-century art, began with van Gogh, Gauguin, and Munch in the late nineteenth century and continued with Belgian painter James Ensor (1860–1949) and Austrian painters Gustave Klimt (1862–1918), Egon Schiele (1890–1918), and Oskar Kokoschka (1886–1980). But it was in Germany, with two separate groups called Die Brücke and Der Blaue Reiter, that Expressionism reached maturity.

***DIE BRÜCKE:* BRIDGING THE GAP.** Founded in 1905 by Ernst Ludwig Kirchner (1880–1938), Die Brücke (pronounced dee BROOCK eh) was the earliest German group to seize the avant-garde spirit. The name means "bridge"; its members believed their work would be a bridge to the future. "To attract all revolutionary and fermenting elements," its credo claimed, "that is the purpose implied in the name 'Brücke.'" The group demanded "freedom of life and action against established and older forces." Until Die Brücke dissolved in 1913, the artists lived and worked communally, first in Dresden then in Berlin, producing intense, anguished pictures with harshly distorted forms and clashing colors. "He who renders his inner convictions as he knows he must, and does so with spontaneity and sincerity, is one of us," Kirchner proclaimed.

The major contribution of the Expressionists was a revival of the graphic arts, especially the woodcut. With dramatic black-and-white contrasts, crude forms, and jagged lines, woodcuts perfectly expressed the sickness of the soul that was a major subject of Expressionist art.

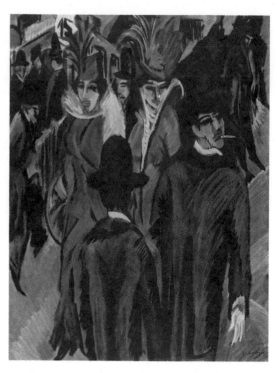

Kirchner, "Berlin Street Scene," 1913, Brücke Museum, Berlin. *Kirchner distorted figures into grotesque, jagged forms to portray their inner corruption.*

THE HORROR OF WAR

Kollwitz, "Infant Mortality," 1925, Library of Congress, Washington, DC.

Käthe Kollwitz (1867–1945) focused on pacifist subjects and the suffering of the poor. Like the later German Expressionist Max Beckmann, she was Expressionist in technique but concerned more with social protest than inner exploration. A master printmaker in etchings, lithographs, and woodcuts, Kollwitz used stark forms and harsh lines to express the tragic loss in war's aftermath. "Infant Mortality" evokes a mother's despair at her baby's death, through the woodcut's intense blackness.

***KIRCHNER:* LIFE IS A CABARET.** Kirchner (pronounced KEAR kner) summed up the movement: "My goal was always to express emotion and experience with large and simple forms and clear colors." His series of street scenes and cabaret dancers display the brutal angularity linked with Expressionism. After World War I his style became even more frenzied and morbid until, haunted by the rise of Nazism, he committed suicide.

***NOLDE:* UNMASKING THE DEMON WITHIN.** The painter Emil Nolde (pronounced NOHL day; 1867–1956) is an example of how Expressionists borrowed from tribal and oceanic art to revitalize decadent Western culture. Nolde saw in primitive art the vigor his age lacked. Like the Belgian painter Ensor, Nolde gave his human figures hideous, masklike faces to suggest a deformed spirit. He used garish colors, coarse forms, and ghoulish figures to communicate the evil of prewar Germany. Nolde was so intent on forcefully expressing the ugliness around him that he threw away his brushes and wiped thick blotches of pigment on the canvas with rags. His paintings were so shocking, mothers threatened unruly children, "If you don't behave, Nolde will come and get you, and smear you all over his canvas."

***DER BLAUE REITER:* COLOR ALONE.** The second, more loosely organized vanguard group of the German Expressionists was called the Blue Rider (pronounced dehr BLAH way RIGHT er in German), after a painting by its leader Wassily Kandinsky (1866–1944). Founded in Munich around 1911, this group's most oustanding artists were Kandinsky and Swiss painter Paul Klee (1879–1940). Although the movement disintegrated with the outbreak of World War I in 1914, it had a lasting effect because of Kandinsky's breakthrough to pure abstraction.

Kandinsky, "Improvisation 31 (Sea Battle)," *1913, NG, Washington, DC. Kandinsky painted the first abstract canvases in which shape and color, not subject, are the expressive factors.*

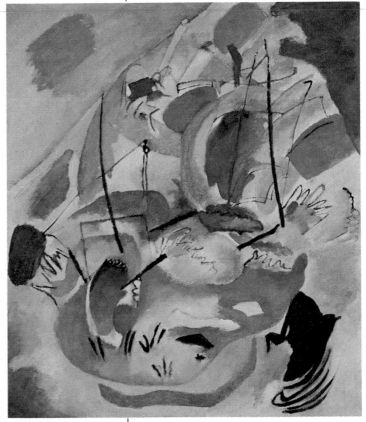

***KANDINSKY:* INVENTOR OF ABSTRACT ART.** The Russian painter Kandinsky was first to abandon any reference to recognizable reality in his work. He came to this revolutionary discovery by accident. Around 1910, when he returned at twilight to his studio, he recalled, "I was suddenly confronted by a picture of indescribable and incandescent loveliness. Bewildered I stopped; staring at it. The painting lacked all subject, depicted no identifiable object and was entirely composed of bright color-patches. Finally I approached closer and, only then, recognized it for what it was — my own painting, standing on its side on the easel."

This insight — that color could convey emotion irrespective of content — spurred Kandinsky to take the bold step of discarding realism altogether. He experimented with two types of paintings: "Compositions," in which he consciously arranged geometric shapes, and "Improvisations," where he exerted no conscious control over the paint he applied spontaneously. With rainbow-bright colors and loose brushwork, Kandinsky created completely nonobjective paintings with titles like "Composition No. 2," as abstract as his canvases.

***KLEE:* CHILD'S PLAY.** "Color has got me," Klee (pronounced clay) exclaimed on a trip to North Africa when he was 24, "I and color are one." Throughout his career, color and line were the elements by which Klee expressed his offbeat outlook on life. He once declared, "Were I a god, I would found an order whose banner consisted of tears doing a gay dance."

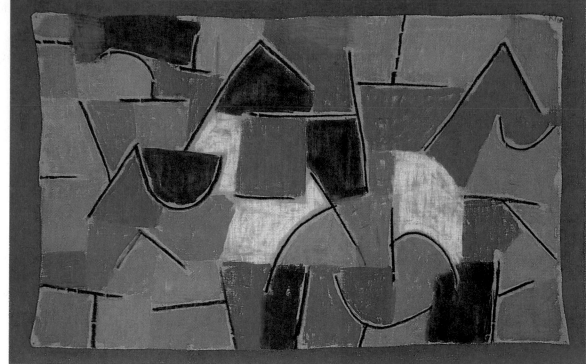

Klee's work, like Matisse's, is deceptively simple, and for both this was the desired effect. Klee consciously imitated the dreamlike magic of children's art by reducing his forms to direct shapes full of ambiguity. "I want to be as though newborn," he wrote, "to be almost primitive." Klee mistrusted rationality, which he felt simply got in the way and could even be destructive. In search of a deeper truth, he compared his art to the root system of a tree, which, nourished by subterranean imagery, "collects what comes from the depth and passes it on."

The respect for inner vision made Klee study archaic signs such as hex symbols, hieroglyphics, and cave markings, which he felt held some primitive power to evoke nonverbal meanings. His later paintings use rune-like ideograms to encode his reaction to the world. "Blue Night" divides the sky into patchwork planes of cool to warm color, bounded by mysterious lines. The lines could mark constellation patterns or represent some forgotten alphabet. They illustrate Klee's belief that "art does not reproduce the visible, it makes visible."

Klee, "Blue Night," 1923, Öffentliche Kunstsammlung, Kunstmuseum, Basel. *Klee went beyond realism in humorous, childlike paintings designed to plumb the depths of the subconscious.*

HITLER'S ART SHOW

First the Nazis banned jazz from the airwaves, then they burned books by Hemingway, Thomas Mann, and Helen Keller. "Where books are burned, people are burned," warned the writer Heinrich Heine. Artists felt the atmosphere of terror and oppression acutely, causing painter George Grosz to flee Germany in 1933. "I left because of Hitler," Grosz said of the frustrated artist become dictator. "He is a painter too, you know, and there didn't seem to be room for both of us in Germany."

Those modern artists who stayed saw their works confiscated and, in 1937, exhibited as objects of ridicule. Hitler and his propaganda minister, Joseph Goebbels, organized a show of what they called "Degenerate" art (Entartete Kunst), consisting of masterpieces by the century's most brilliant artists: Picasso, Matisse, and Expressionists like Kandinsky, Klee, Nolde, Kirchner, Kokoschka, and Beckmann.

The object was to discredit any work that betrayed Hitler's master race ideology; in short, anything that smacked of dangerous free-thinking. Nazi leaders considered Modernist art so threatening they prohibited children from the show and hired actors to roam the halls loudly criticizing modern art as the work of lunatics. They scrawled derogatory slurs on the walls beside the paintings, which were grouped into categories like "Insults to German Womanhood" and "Nature as Seen by Sick Minds." Price tags displayed how much public museums had paid for the works with signs: "Taxpayer, you should know how your money was spent." Despite the effort to suppress "offensive" modern art, with an estimated three million in attendance, the exhibit may have been one of the biggest successes ever.

MONDRIAN: HARMONY OF OPPOSITES

While German Expressionists wallowed in angst, a Dutch group of Modernists led by painter Piet Mondrian (pronounced MOWN dree ahn; 1872–1944) tried, from 1917 to 1931, to eliminate emotion from art. Called De Stijl (pronounced duh STEHL), which means "The Style," this movement of artists and architects advocated a severe art of pure geometry.

Mondrian came from a neat, Calvinist country where the severe landscape of interlocking canals and ruler-straight roads often looked mechanically laid out. During the chaos of World War I he concluded, "Nature is a damned wretched affair." Mondrian decided to jettison "natural," messy art for a new style called Neo-Plasticism. The goal: to create a precise, mechanical order lacking in the natural world.

LINING UP. Mondrian based his style on lines and rectangles. Theorizing that straight lines do not exist in nature, he decided to use straight lines exclusively to create an art of harmony and order — qualities conspicuously missing from the wartorn world. When De Stijl was transferred to architecture, it would supposedly bring all chaotic forces into line, achieving a balance of opposites as in the Cross.

For Mondrian, vertical lines represented vitality and horizontal lines tranquility. Where the two lines crossed in a right angle was the point of "dynamic equilibrium." In his trademark paintings, Mondrian restricted himself to black lines forming rectangles. He used only the primary colors of red, blue, and yellow and three noncolors: white, black, and gray. By carefully calculating the placement of these elements, Mondrian counterpointed

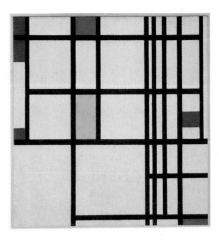

Mondrian, "Composition in Red, Blue, and Yellow," 1920, MoMA, NY. *One of the most important proponents of abstract act, Mondrian painted geometric designs in limited colors.*

competing rhythms to achieve a "balance of unequal but equivalent oppositions." Although his grid paintings look similar, each one is precisely — and differently — calibrated.

The major contribution of De Stijl to art was its drive toward absolute abstraction, without any reference whatsoever to objects in nature. "Art systematically eliminates," Mondrian said, "the world of nature and man." He wanted art to be as mathematical as possible, a blueprint for an organized life.

A control freak, Mondrian even transformed his own environment into one of his paintings. He covered his studio walls with rectangles in primary colors or gray, white, and black. Although the studio was as sparsely furnished as a monk's cell, he kept an artificial tulip in a vase, its leaves painted white (since he had banned the color green). He painted all furniture white or black and his record player bright red.

Mondrian was important in the history of art for opposing the cult of subjective feeling. By the 1950s his easily identifiable style was so famous that for many it became a symbol of modern art.

BRANCHING OUT

Mondrian arrived at his mature style through progressively simplifying natural forms. In a famous series of tree paintings done in Paris in 1911—12 under the influence of Cubism, his advance from description to abstraction is clear. In both paintings shown, the motif is a bare-branched tree. In the earlier painting at left, the image of spreading branches and thick trunk is discernible, while in the later work, Mondrian dissolves the tree in a web of lines until it is virtually unrecognizable. The space between the lines becomes as important as the lines themselves to balance the painting. It was a short, but significant, step from the second painting to making lines and the spaces between them the sole subject of his work.

Mondrian, "Gray Tree," 1912, Haags Gemeentemuseum, The Hague.

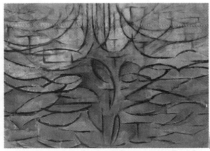

Mondrian, "Flowering Apple Tree," 1912, Haags Gemeentemuseum, The Hague.

MODERNIST ARCHITECTURE: GEOMETRY TO LIVE IN

Before the twentieth century, "prestige" architecture always meant rehashing the past. Victorian homes were bulky and complicated, with turrets and carved gingerbread. The new International Style of the 1920s, so called because it transcended national boundaries, changed all that. For these architects, science and industry were almost a religion. Their streamlined designs gave form to the Machine Age by rejecting all historical ornament. It was like shedding a Victorian bathing costume, complete with bloomers, parasol, and ruffled cap, for a string bikini.

***GROPIUS:* BAUHAUS DESIGN.** Walter Gropius (pronounced GROW pee us; 1883–1969), director of Germany's influential Bauhaus school of design, probably had more indirect influence on the look of modern cities than any single man. He was mentor to generations of architects who radically changed the look of metropolises everywhere. Gropius conceived buildings totally in terms of twentieth-century technology, with no reference to the past. The Bauhaus buildings he constructed are simple glass boxes, which became a worldwide cliché.

"Architecture is a collective art," Gropius believed, urging his Bauhaus colleagues to collaborate like medieval cathedral-builders. The architecture he envisioned obliterated individual personality in favor of designs that could be mass-produced. In a debased form, Gropius knock-offs became the anonymous, high-rise buildings in every city from Topeka to Tokyo.

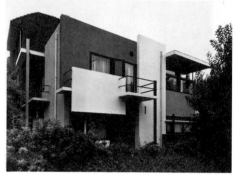

Rietveld, Schroeder House, 1924, Utrecht. *Rietveld used only primary colors with black, white, and gray to design this International Style house of flat planes and straight lines like a Mondrian painting.*

THE INTERNATIONAL STYLE

GOAL: High-tech, clean design

ENEMIES: Ornament, historical reference

HOUSE: Machine for living

STYLE: Glass and steel boxes

FAVORITE SUBJECT: Geometry

CULMINATION: Seagram Building

QUOTE: Mies van der Rohe, while strolling the Chicago lakeshore surveying his work: "Well, they will know we were here."

***MIES:* LESS IS MORE.** Gropius's most famous colleague was German architect Mies (rhymes with "please") van der Rohe (1886–1969). Son of a stonemason, Mies designed bare towers with glass curtain walls. His materials like steel frame and plate glass determined the form of his structures. New York's Seagram Building (1956–58) is a monument to purity, its straight lines expressing perfectly the famous Miesian dictum: "Less is more."

Mies is equally famous for another saying: "God dwells in the details." In the Seagram Building, despite its thirty-eight-story scale, he showed his superb craftsmanship by custom-designing details like lettering on lobby mailboxes. "A beautiful lady with hidden corsets," American architect Louis Kahn called the Seagram Building. Although it seems light and simple structurally, its bronze sheathing covers a skeleton of steel.

***LE CORBUSIER:* A MACHINE FOR LIVING.** The third International Style pioneer was Swiss architect Le Corbusier (1887–1965), known for defining a house as "a machine for living." From the 1920s through the forties, Le Corbusier designed homes to resemble the machines he so admired and Cubist art he formerly painted. His clean, precise, boxy houses had machine-planed surfaces and ribbonlike strips of windows. They illustrate the International Style trademark of flow — with interior and exterior mingling in an open floor plan.

FRANK LLOYD WRIGHT. "Not only do I intend to be the greatest architect who has yet lived," Frank Lloyd Wright (1867–1959) once said, "but the greatest architect of all time." He may well have achieved his ambition, for this American architect designed some of the most original and beautiful structures in history. Among Wright's gifts to the American home are cathedral ceilings, built-in furniture and lighting fixtures, casement windows, carports, the massive fireplace, and split-level ranches. His most far-reaching contributions were busting wide open boxy floor plans and designing site-specific buildings that seem to grow naturally out of their location.

GO WITH THE FLOW. Wright drew layouts with continuity in mind, so that walls, ceilings, and floors flow seamlessly just as rooms merge with each other and the outside environment. He wanted "no posts, no columns" because "the new reality," he said, "is space instead of matter." The International Style architects borrowed this concept of flowing space from Wright, as well as his clean-cut rectangular shapes radiating from a central core (often a massive hearth).

Wright differed from the International Style in his insistence on natural forms and materials and his respect for the environment. In fact, his early "Prairie Houses" designed for the Midwest got their name because of their low-slung, horizontal lines that hug the flat land and blend with the natural setting.

Wright's style is impossible to categorize, for he skipped from Japanese to Aztec to purely imaginative motifs, as inspiration and whim dictated. Opposed to the worship of technology, Wright celebrated the individual. Claiming the prerogative of genius, he insisted on designing every last detail of his work. He created stained glass windows, dishes, fabrics, furniture, rugs, drapes — he even designed gowns for one client's wife.

Unfortunately, some of his designs were too abstract for, quite

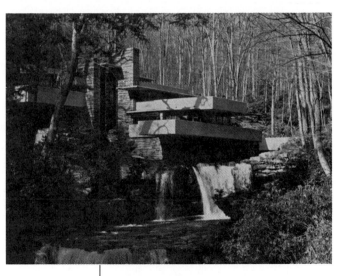

Wright, "Fallingwater" (Kaufmann House), 1936, Bear Run, Pennsylvania. *Illustrating Wright's "organic architecture," this house seems to sprout out of living rock. Built mostly of rough stone, the house's form echoes the native rock ledges. Cantilevered terraces hover over a rushing waterfall. The house's irregular spaces flow as easily as water, illustrating Wright's adage: "No house should ever be on any hill or on anything. It should be of the hill, belonging to it, so hill and house should live together and each be happier for the other."*

literally, comfort. Executives of the Wright-designed Price Tower said his chairs "make you feel like you are about to fall on your face." Wright himself admitted, "I have been black and blue in some spot, almost all my life from too intimate contact with my own furniture."

A GENIUS IN HIS OWN MIND

The only thing Frank Lloyd Wright, child of the Midwest prairie, remembered about elementary school was building with blocks. At age 18, with innovative Chicago architect Louis Sullivan, Wright was building for real. "When Sullivan and I came to architecture it had been sleeping a hundred years," Wright boasted. "We woke it up." An implacable foe of imported European styles, Wright preached the need for a new, native architecture. His signature became the low-slung, uniquely American, single-family home.

Wright's life was as precedent-shattering as his buildings. The "master," as he called himself, enjoyed outraging the public. His seventy-year career was punctuated by one tabloid headline after another: bankruptcies, scandalous divorces, and three marriages. In 1909 he deserted his wife and six children for an affair in Europe with a client's wife. During a bitter courtroom battle, Wright named himself when asked to identify the world's best architect. He later explained, "I was under oath, wasn't I?"

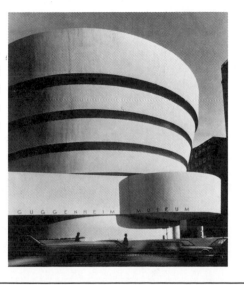

Wright, Guggenheim Museum, 1959, NY. *The most radical of his buildings, the Guggenheim substitutes curves for right angles, making the whole a giant abstract sculpture.*

DADA AND SURREALISM: ART BETWEEN THE WARS

DADA: A WORLD GONE GAGA. Founded in neutral Zurich in 1916 by a group of refugees from World War I, the Dada movement got its name from a nonsense word. Throughout its brief lifespan of seven years, Dada often seemed nonsensical, but it had a no-nonsense aim. It protested the madness of war. In this first global conflict, billed as "the war to end all wars," tens of thousands died in trenches daily to gain a few scorched yards before being driven back by counterattacks. Ten million people were slaughtered or maimed. It's no wonder Dadaist artists felt they could no longer trust reason and the establishment. Their alternative was to overthrow all authority and cultivate absurdity.

Dada was an international attitude that spread from Zurich to France, Germany, and the United States. Its main strategy was to denounce and shock. A typical Dada evening included several poets declaiming nonsense verse simultaneously in different languages with others yapping like dogs. Orators hurled insults at the audience, while absurdly costumed dancers flapped about the stage and a young girl in communion dress recited obscene poetry.

Dadaists had a more serious purpose than merely to shock. They hoped to awaken the imagination. "We spoke of Dada as a crusade that would win back the promised land of the Creative," said Alsatian painter Jean Arp, a founder of Dada.

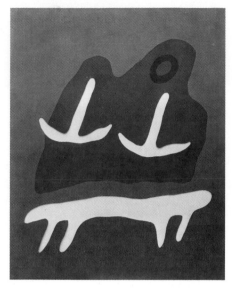

Arp, "Mountain, Table, Anchors, Navel," 1925, MoMA, NY. *Arp shared the Dada faith in accident, creating "free" forms by chance.*

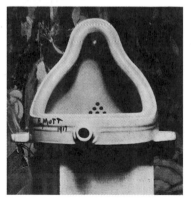

Duchamp, "Fountain," 1917 Photograph by Alfred Stieglitz, Philadelphia Museum of Art.

DUCHAMP: THE "DADA" OF SURREALISM

French artist Marcel Duchamp (pronounced doo SHAHN 1887–1968) was one of the most influential figures in modern art. A prime mover of both Dada and Surrealism, he also inspired diverse movements from Pop to Conceptualism. Duchamp became a legend without actually producing much art. Although his "Nude Descending a Staircase" (see p. 150) was notorious, Duchamp abandoned painting at the height of his celebrity. "I was interested in ideas — not merely in visual products," he said. "I wanted to put painting once again at the service of the mind."

For Duchamp, conceiving a work of art was more important than the finished work. In 1913 he invented a new form of art called "readymades" by mounting a bicycle wheel on a kitchen stool. His most controversial readymade was a porcelain urinal he signed R. Mutt. Duchamp defended the unconventional objet d'art, saying, "Whether Mr. Mutt with his own hand made the fountain or not has no importance. He CHOSE it [he] created a new thought for that object." Duchamp's readymades opened the floodgates for art that was purely imaginary rather than merely "retinal" (interpreting the visual world). He changed the concept of what constitutes art.

ARP: GAME OF CHANCE. In his work, Arp (1887–1966) exploited the irrational. He discovered the principle of random collage by accident, when he tore up a drawing and threw the pieces on the floor. Admiring the haphazard pattern the scraps formed, Arp began to make "chance" collages. "We declared that everything that comes into being or is made by man is art," said Arp. He constantly experimented to evolve new forms. His characteristic works include playful, egglike shapes that suggest living creatures. Arp stated his aim: "To teach man what he had forgotten: to dream with his eyes open."

SCHWITTERS: A MATTER OF MERZ. German collagist Kurt Schwitters (1887–1948) also subverted accepted concepts. When asked, "What is art?" he replied, "What isn't?" Schwitters cruised the streets of Hanover scouring gutters for discarded junk like bus tickets, buttons, and shreds of paper. He then combined this refuse into assemblages he called "merz." Arp and Schwitters used these "nonart" materials instead of oil on canvas "to avoid any reminder of the paintings which seemed to us to be characteristic of a pretentious, self-satisfied world," Arp said.

By 1922, Dada — admittedly "against everything, even Dada"— dissolved into anarchy. Its contribution was to make art less an intellectual exercise and more a foray into the unpredictable.

SURREALISM: POWER OF THE UNCONSCIOUS.

Two years later a direct offspring of Dada, Surrealism, was born. Surrealism, which flourished in Europe and America during the twenties and thirties, began as a literary movement, fostered by its godfather, poet André Breton. It grew out of Freudian free-association and dream analysis. Poets and, later, painters experimented with automatism — a form of creating without conscious control — to tap unconscious imagery. Surrealism, which implies going beyond realism, deliberately courted the bizarre and the irrational to express buried truths unreachable by logic.

Surrealism took two forms. Some artists, like Spanish painter Joan Miró and German artist Max Ernst, practiced improvised art, distancing themselves as much as possible from conscious control. Others, like the Spaniard Salvador Dalí and Belgian painter René Magritte, used scrupulously realistic techniques to present hallucinatory scenes that defy common sense.

MIRO: THE JOY OF PAINTING.

"Miró may rank," said Surrealist guru André Breton, "as the most surrealist of us all." Joan Miró (1893–1983) consistently tried to banish reason and loose the unconscious. Working spontaneously, he moved the brush over the canvas drawing squiggles in a trancelike state or slapped on paint in a creative frenzy intensified by hunger, since he could afford only one meal a day. His goal, he said, was "to express with precision all the golden sparks the soul gives off."

Miró invented unique biomorphic signs for natural objects like the sun, moon, and animals. Over the years these forms were progressively simplified into shorthand pic-

DARK SHADOWS

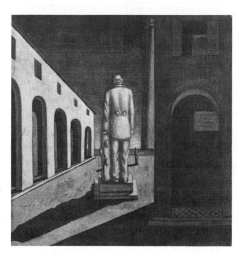

De Chirico, "The Mystery and Melancholy of a Street," 1914, Öffentliche Kunstsammlung, Kunstmuseum, Basel. *Hailed by the Surrealists as their precursor, Italian painter Giorgio De Chirico (pronounced KEY ree coh; 1888–1978) was painting nightmare fantasies fifteen years before Surrealism existed. Drawing on irrational childhood fears, De Chirico is known for his eerie cityscapes with empty arcades, raking light, and ominous shadows. The skewed perspective and nearly deserted squares inhabited by tiny, depersonalized figures project menace. In fact, with these paintings as his best evidence, De Chirico was exempted from military service as mentally unstable. On an early self-portrait he inscribed, "What shall I love if not the enigma?"*

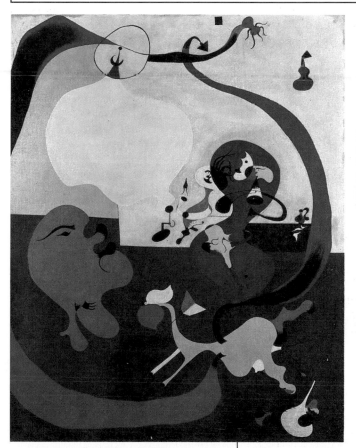

Miró, "Dutch Interior II," c. 1920, Guggenheim collection, Venice. *Miró improvised geometric shapes and biomorphic forms in playful dream imagery.*

tograms of geometric shapes and amoebalike blobs — a mixture of fact and fantasy. "Miró could not put a dot on a sheet of paper without hitting square on the target," the Surrealist sculptor Giacometti said.

Miró's semiabstract shapes, although stylized, always playfully alluded to real objects. Brilliantly colored and whimsical, they seem like cartoons from another planet. "What really counts is to strip the soul naked," Miró said. "Painting or poetry is made as one makes love — a total embrace, prudence thrown to the winds, nothing held back."

ERNST: MOTHER OF MADNESS. Both a Dadaist and Surrealist, Max Ernst (1891–1976) best exemplifies how Surrealists employed ambiguous titles. With labels like "The Preparation of Glue from Bones" and "The Little Tear Gland That Says Tic Tac," Ernst tried to jolt the viewer to mental attention. In one of his most well-known works, "Two Children Threatened by a Nightingale" (1924), the title induces a shocked double-take. Although it seems straight out of a Hitchcock scenario, Ernst said the picture derived from his pet cockatoo's death when he was a child and that for years he suffered from "a dangerous confusion between birds and humans."

Ernst referred to himself as "the male mother of methodical madness." He first experienced hallucinations when he saw fevered visions during a bout of childhood measles. He found he could induce similar near-psychotic episodes (and adapt them in art) by staring fixedly until his mind wandered into some psychic netherworld. With so many unusual inner sights to see, it's not surprising Ernst described his favorite pastime as "looking." Ernst invented "frottage," a new method for generating surprising imagery. He placed a sheet of paper over rough surfaces like wood planks and rubbed with a soft pencil. He then elaborated on these patterns to produce fantastic, sometimes monstrous, imagery.

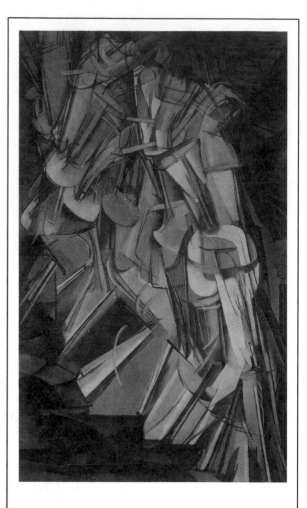

Duchamp, "Nude Descending a Staircase, No. 2," 1912, Philadelphia Museum of Art.

CHAGALL

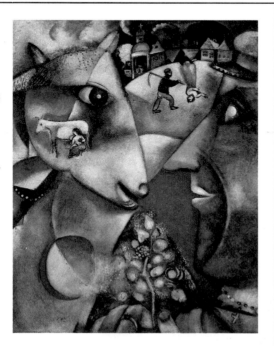

Chagall, "I and the Village," c. 1911, MoMA, NY. *French painter Marc Chagall (1887–1985) was inspired by two sources of imagery: the Jewish life and folklore of his Russian childhood and the Bible. Although his imaginative fantasies were hailed as a precursor to Surrealism, Chagall insisted he painted actual memories, not irrational dreams.*

THE GREATEST SHOW ON EARTH

The most significant art show in American history, called the Armory Show because it took place in New York's 69th Regiment Armory building, burst the bubble of American provincialism in 1913. It included works by the most controversial modern masters of Europe. Americans were clearly unprepared for Matisse's bold colors, Picasso's fractured forms, and Duchamp's Dadaist spirit. "Nude Descending a Staircase" was the show's runaway sensation. A portrait of a nude in overlapping stages of movement, it came to symbolize the essence of modern art. An "explosion in a shingle factory," one journalist dubbed it.

Unprecedented ridicule, hostility, and indignation greeted the show, called "pathological" by the New York Times. Critics lampooned the artists as "bomb-throwers, lunatics, depravers," calling the room of Cubist paintings a "Chamber of Horrors." Public officials demanded the show be shut down to safeguard public morals.

The show had two major, lasting effects. On the positive side, American artists learned of the artistic revolution happening in Paris studios an ocean away. "Progressive" art became a force to be reckoned with, modern galleries sprang up, and artists experimented with abstract forms. The downside was that the American public initially perceived modern art as a bad joke, even a fraud — a perception which partially continues today.

DALÍ: PAINTING PARANOIA. The painter who based his technique, which he called "critical paranoia," on exploiting his own neuroses was Salvador Dalí (1904–89). When Dalí came to Paris in 1928 and joined the Surrealists, he had plenty of obsessions to draw on. He was terrified of insects, of crossing streets, of trains, boats, and airplanes, of taking the Métro — even of buying shoes because he couldn't bear to expose his feet in public. He laughed hysterically and uncontrollably and carried a piece of driftwood at all times to ward off evil spirits. "The only difference between a madman and myself," Dalí said, "is that I am not mad."

With so rich a lode of irrational fears fueling his art, Dalí placed a canvas beside his bed, staring at it before sleep and recording what he called "hand-painted dream photographs" when he awoke. He claimed he cultivated paranoid delusions deliberately to make himself a "medium" for the irrational, but that he could snap back to control at will.

Dalí differed from Ernst and Miró in that, instead of inventing new forms to symbolize the unconscious, he represented his hallucinations with meticulous realism. His draftsmanship is so skilled it almost has a miniaturist's precision, but he distorted objects grotesquely and placed them in unreal dream landscapes. When Dalí attended a costume party where everyone came "as their dreams," Dalí dressed as a rotting corpse. This recurrent nightmare often appeared in his work. His most famous, "The Persistence of Memory," shows limp watches and a strange lump of indefinable flesh. Although metallic, the watches appear to be decomposing. A fly and cluster of jewellike ants swarm over them. "With the coming of Dalí, it is perhaps the first time that the mental windows have been opened really wide," Breton said, "so that one can feel oneself gliding up toward the wild sky's trap."

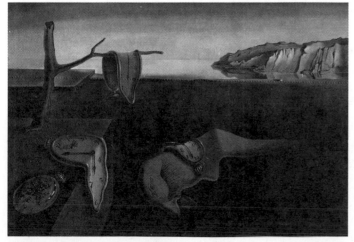

Dalí, "The Persistence of Memory," 1931, MoMA, NY. *Dalí used the techniques of realism for a surreal effect by distorting familiar objects and placing them in a hallucinatory context.*

Magritte, "The False Mirror," 1928, MoMA, NY. *Magritte gave ordinary objects an irrational twist by juxtaposing elements of the absurd.*

MAGRITTE: DREAM VISIONS. René Magritte (pronounced Mah GREET; 1898–1967), like Dalí, painted disturbing, illogical images with startling clarity. Magritte began as a commercial artist designing wall paper and fashion ads. In his Surrealist work, he used this mastery of realism to defy logic. He placed everyday objects in incongruous settings and transformed them into electric shocks, such as the flood of bowler-hatted gentlemen falling like raindrops or a piece of fried ham on a plate that is also an eyeball. These disturbing juxtapositions of familiar sights in unnatural contexts compel a new vision of reality beyond logic.

DALÍ: OFF THE DEEP END

An inventive self-promoter, Dalí became Mr. Surrealism more through publicity gimmicks than art. Who else but Dalí would lecture at the Sorbonne with his foot in a pail of milk or give a press conference with a boiled lobster on his head? "If you play at genius," Dalí said, "you become one."

At the 1936 London Surrealist exhibit, Dalí made a striking entrance with two white Russian wolfhounds. Wearing a diving suit topped by a Mercedes Benz radiator cap, Dalí began to lecture. Since the suit was bolted shut, no one could hear him. The seal was also nearly air tight, and Dalí began to gasp for breath, flailing his arms and begging the audience to extricate him. The spectators — thrilled with this exhibition of asphyxiation — applauded wildly until someone finally popped his lid off. All agreed the performance had been highly convincing.

PHOTOGRAPHY COMES OF AGE

In the Victorian era, photographers responded to critics who said their work was not art by imitating academic painting. Through darkroom gimmickry, they produced prettified, soft-focus scenes. Around the turn of the century, the tide of Modernism influenced avant-garde photographers to express their personal views of the world. They shook off their inferiority complex and concentrated on taut compositions and pure form.

Atget, "Luxembourg, Fontaine Corpeaux," 1901–2, MoMA, NY. *Atget was one of the first to record everyday objects as mysterious and evocative.*

MAN RAY (1890–1977). A charter Dada and Surrealist artist was American photographer/painter Man Ray. One of the most inventive photographers of his day, he developed a technique around 1921 he called "rayographs." In this method, he placed objects on photo-sensitive paper, then exposed it to light. The mischievous result resembled Cubist collages.

ATGET (1857–1927). Hailed by Surrealists as a forefather, Eugène Atget was really the father of modern photography. Surrealists like Man Ray (and his colleague, photographer Berenice Abbott) rescued Atget from oblivion, finding a kindred spirit in his mysterious, concentrated images that have De Chirico's deadpan quirkiness. Atget never considered himself an "art" photographer but a chronicler of Paris — its residents and street life. He took straightforward photos of subjects like iron grillwork, shop windows, and fountains. Like Duchamp with

Man Ray, "Rayograph 1928," 1928, MoMA, NY. *Surrealist Man Ray experimented to transcend surface realism and created this witty photo-assemblage of string, cotton, and strips of paper.*

his readymades, Atget raised the mundane to the magical. Through his clean, uncluttered style and eye for the telling detail, Atget charged his most commonplace images with significance. His arresting scenes often look haunted. The bold reduction to essentials lends a hyperclarity that makes the ordinary seem extraordinary.

CARTIER-BRESSON (b. 1908). French photographer Henri Cartier-Bresson began as a Cubist painter before turning to photography in 1932. His great contribution to photojournalism is his ability to capture what he calls the "decisive moment." More than just recording, Cartier-Bresson snaps the most intense instant of action or emotion to reveal an event's inner meaning. "There is one moment at which the elements in motion are in balance," he said. "Photography must seize upon this moment." Many Cartier-Bresson photographs have a Surrealist element of the unexpected. His odd juxtapositions within the camera frame make reality seem unreal. Some of his images are so startling they seem to be the result of pure chance, but Cartier-Bresson's odd croppings were carefully composed.

Cartier-Bresson, "Children Playing in Ruins," 1933, Magnum, NY. *A genius of timing, Cartier-Bresson captures the peak moment when movement crystalizes to convey many levels of meaning or the essence of a character.*

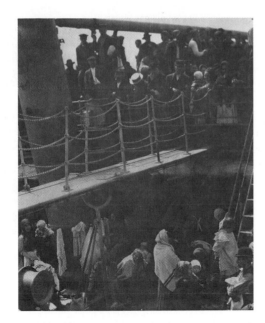

Stieglitz, "The Steerage," 1907, MoMA, NY. *The diagonal gangway splits the scene into upper and lower classes, using composition and lighting to make a point about society.*

STIEGLITZ (1864–1946). Besides championing modern art at his 291 Gallery (named for its Fifth Avenue address), Stieglitz revolutionized camera work by stressing "straight," unretouched photography. He urged progressive photographers not to mimic painting or resort to lens and lighting tricks but to exploit the direct honesty of their medium.

Stieglitz's classic shot, "The Steerage," represents the first time a documentary photo reached the level of conscious art in America. Stieglitz was on the first-class deck of an ocean liner when he saw, he later said, "a picture of shapes and underlying that the feeling I had about life." The geometric shapes and composition tell the human story. The diagonal gangway cleaves the scene visually into upper (upper-class passengers, mostly in the dark, who seem formal and faceless) and lower levels (the steerage, or cheapest fares, composed of poor immigrant families, with strong light spotlighting their humanity). "Photography is my passion," Stieglitz said, "the search for truth my obsession."

WESTON (1886–1958). Edward Weston started as a commercial photographer shooting romantic Hollywood portraits of starlets. In the 1920s he gave up darkroom gimmicks for stark images of nudes, sand dunes, and vegetables. Weston brought out the strong sensuality of simple shapes like peppers, while reducing other forms, like a palm tree trunk, to semiabstract simplicity. From immediate foreground to deep distance, detail is sharp. He tried, he said, to get the quality of a subject "rendered with the utmost exactness: stone is hard, bark is rough, flesh is alive."

Weston, "Leeks," 1927, Center for Creative Photography, Tucson, AZ. *This closeup of leeks shows how expressive pure form can be when arranged in a powerful, simple composition.*

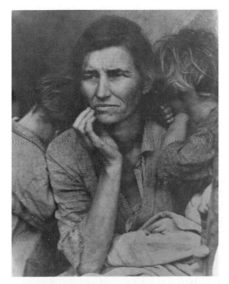

Lange, "Migrant Mother, California," 1936, Library of Congress. *Lange's documentary photos of the poor brought social problems to the attention of a wide audience.*

LANGE (1895–1965). After the 1929 stock market crash, photographers focused on the suffering caused by the Depression. Dorothea Lange followed the homeless who had been tractored off their Dust Bowl farms. Her compassion helped her capture poignant moments that tell about human lives and feelings. Her field notes for the unposed, uncropped "Migrant Mother" read: "Camped on the edge of a pea field where the crop had failed in a freeze. The tires had just been sold from the car to buy food. She was 32 years old with seven children." The dignity and total honesty of Lange's photographs shocked Americans into recognizing the plight of the poor. As photo historian Robert J. Doherty wrote, "This small, shy, insecure woman had a strong sense of justice which sparked a silent fury that came to light in the strong emotion of her photographs. With a camera in her hand, she became a giant."

AMERICAN ART: 1908–40

While artists elsewhere moved increasingly toward abstraction, American painters kept alive the realist tradition and portrayed American life with utmost fidelity.

ASHCAN SCHOOL: TRASHY TALES. "Guts! Guts! Life! Life! That's my technique!" said painter George Luks. "I can paint with a shoestring dipped in pitch and lard." The prudish American public did not, however, consider "guts" and contemporary urban life suitable for art. They dismissed such "raw" scenes of real people shopping and carousing as fit only for the ash can. This insult gave the name to a group of American painters who bashed the stuffy art monopoly with the same gusto that Theodore Roosevelt busted trusts.

SLOAN: **STREET LIFE.** John Sloan (1871–1951) — like other Ashcanners Luks, William Glackens, and Everett Shinn — started as a newspaper sketch-artist. He was accustomed to racing to a fire or train derailment to record the scene in a straightforward but dramatic fashion. A slapdash, you-are-there approach, using broad brushstrokes to capture the tumult and verve of city life, characterizes his mature work. Because Sloan insisted on painting "low-life" subjects, his work didn't sell until he was past 40. Sloan was such an ardent advocate of the masses that he ran for state office in 1908 as a Socialist but was defeated. Despite setbacks, Sloan remained convinced that art should be down-to-earth, rooted in daily life. "It is not necessary to paint the American flag to be an American painter," Sloan said. "As if you didn't see the American scene every-time you opened your eyes."

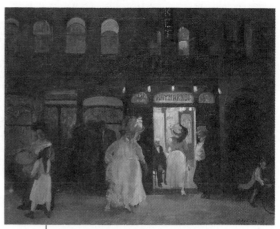

Sloan, "Haymarket," c. 1907, Brooklyn Museum. *Ashcan School painters injected realism into American art by taking ordinary people as their subject.*

FIRST ABSTRACT AMERICAN ART

Marin, "Lower Manhattan (Composition Derived from Top of the Woolworth Building)," 1922, MoMA, NY. *At the same time as the Ashcan painters, another group of American artists also championed casting off tradition. But they took a radical approach to form rather than subject and helped American art catch up with Modernism. This first wave of abstract painters in the U.S. included Marsden Hartley, Max Weber, Georgia O'Keeffe, Arthur Dove, Stuart Davis, and John Marin. The dominant force in the 1920s toward abstraction was John Marin (1870–1953). He is often called the greatest watercolorist ever. A perfectionist, Marin compared painting to golf: the fewer strokes the better. His views of skyscrapers, broken into cubistic planes and angles, explode with vitality, proving that watercolor need not be synonymous with washed-out landscapes.*

ASHCAN SCHOOL, OR THE EIGHT

LOCALE:
New York City, 1908–13

BEST-KNOWN ARTISTS:
Henri, Sloan, Bellows

STYLE:
Realistic, sketchlike

SUBJECT:
Urban grit and vigor

WHY CONDEMNED:
"Sordid," low-life subjects

WHY PRAISED:
First uniquely American art

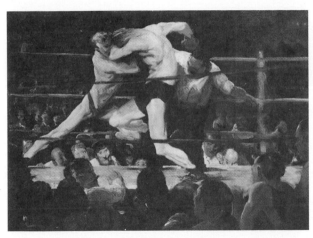

BELLOWS: BOXING. George Bellows (1882–1925) is perhaps the only artist who gave up stealing bases for painting faces. Although he sacrificed a career as a professional baseball player, as a painter he translated the vigor and exuberance of sport into art. "Stag at Sharkey's" shows the dynamic energy that marked both the subject and style of the Ashcan School. Bellows portrayed the pulsating life of New York docks, gutters, and bars with a heroic vitality. "The ideal artist is the superman," Bellows proclaimed. Sadly, with macho stoicism, he ignored stomach cramps until his appendix ruptured and he died at age 42.

Bellows, "Stag at Sharkey's," 1909, Cleveland Museum of Art.
Bellows captured the dynamism of the city that the Ashcan painters glorified.

ART AS ACTIVISM: AMERICAN SCENE AND SOCIAL REALISM. During the Depression, realism took two forms. The American Scene School, or Regionalism, enshrined Midwest values as the essence of American character. "American art," said painter Edward Hopper, "should be weaned from its French mother." Meanwhile, Social Realism exalted the struggles of the working class. Both trends portrayed simple folk, reacted against the growing prestige of abstract art, and tried to stir up either pride or protest during a decade of national trouble.

AMERICAN SCENE: CORNY AS KANSAS IN AUGUST. Those known as "American Scene" painters, Thomas Hart Benton, John Steuart Curry, and Grant Wood, took life on the plains as their subject, elevating its inhabitants to heroic stature. In WPA murals produced during the Depression, they romanticized the can-do pioneer spirit in an attempt to inspire optimism in a time of despair.

BENTON: AMERICAN HEROES. Thomas Hart Benton (1889–1975), leader of the American Scene, believed hometown reality should inspire art. Benton consciously rejected European styles he had briefly absorbed during a trip to Paris. "I wallowed in every cockeyed ism that came along," he said, "and it took me ten years to get all that modernist dirt out of my system." Once he purged himself of foreign influence, Benton produced sinuous paintings of Americans at work and play that idealized the American past.

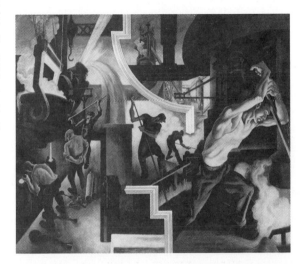

Benton, "Steel," 1930, collection of Equitable-Art Advisory, NY. *Benton glorified American workers as muscular, powerful figures.*

MOUNT RUSHMORE

At the same time that American Scene painters idealized legendary exploits like Paul Revere's ride or George Washington's encounter with a cherry tree, an ambitious project transformed an entire mountain wall into the ultimate patriotic monument. At Mount Rushmore, South Dakota, jackhammers and dynamite blasted four 1,300-foot-high presidents' faces (of Washington, Jefferson, Lincoln, and Theodore Roosevelt, each with 20-foot-long noses) into a cliff. Its $1.5-million cost was a mountain of money during the Depression. Gutzon Borglum, the sculptor, defended the price, saying, "Call up Cheops and ask him how much his pyramid in Egypt cost and what he paid the creator. It was inferior to Mount Rushmore."

WOOD: GOTHIC GARGOYLES. Grant Wood (1892–1942) adopted the most primitive style among American Scene realists. His greatest inspiration, he said, came when he was milking a cow, but he produced his homages to the heartland from a Connecticut studio. His reverence for country life drove him to chronicle the people and landscape of his native Iowa in almost obsessive detail. "American Gothic" is Wood's most famous work, modeled on his sister and dentist. When it appeared, Iowans feared he was mocking their homespun looks. "To me," Wood insisted, "they are basically good and solid people." He elongated their faces almost to the point of caricature, he said, "to go with this American Gothic house." Once the uproar subsided, the picture, along with "Whistler's Mother," became one of the most popular paintings in America.

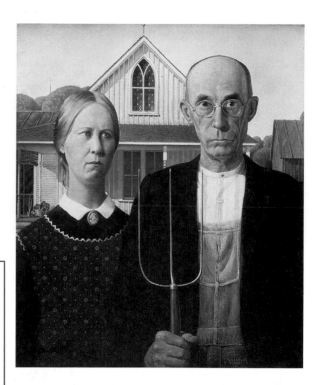

Wood, "American Gothic," 1930, Art Institute of Chicago. *American Scene painters like Wood portrayed simple country folk in a realistic style.*

ONLY THE LONELY

EDWARD HOPPER *(1882–1967) was out of sync with the home-of-the-free-and-the-brave, booster spirit of American realism. In his meticulously described paintings of American vernacular architecture — storefronts, diners, gas stations — he expressed one theme:*

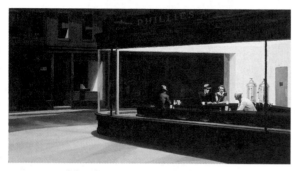

Hopper, "Nighthawks," 1942, Art Institute of Chicago.

loneliness. While Ashcan School pictures vibrate with energy and American Scene canvases drip Apple Pie patriotism, Hopper's work seems drained of energy and hope. Others waved the flag; Hopper showed the void behind the hoopla. Hopper took his cue from writer Theodore Dreiser, who observed, "It was wonderful to discover America but it would have been even more wonderful to lose it." His scenes are cold and empty, as bleak as the Depression. His scathing look at small-town life illustrates Sinclair Lewis's Main Street, where "dullness is made God."

SOCIAL REALISM. With one quarter of the labor force unemployed, banks bankrupt, and the Midwest Bread Basket turned into a Dust Bowl, the Depression-era United States was on the skids. A group of artists like Ben Shahn, Reginald Marsh, and Jacob Lawrence used art to highlight injustice and motivate reform. In Mexico and the U.S., Latino artists (José Orozco, David Siqueiros, and Diego Rivera — see p. 21) produced vast murals celebrating the working class. Deeply committed to social change, these painters attacked evils of capitalism in a semi-realistic style that exaggerated features, color, and scale for emotional impact.

AMERICA'S GREATEST BLACK ARTIST

ROMARE BEARDEN *(1912–1988) began as a Social Realist in Harlem during the 1930s. Aspiring, he said, "to paint the life of my people as I know it," he portrayed card games on the street and children taking piano lessons in New York as well as roosters, washtubs, and voodoo women from his North Carolina childhood. In 1964 he found his mature style: photocollage. Picasso had told him in the 1950s, "You've got to tell a lie to get to a stronger truth." Bearden began to express the collective history of the African-American experience through a patchwork of photographed figures. The combined snippets create a jazzy hybrid larger than its parts.*

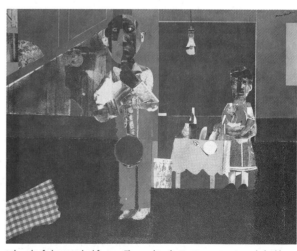

Bearden, "The Woodshed," 1970, MMA, NY.

SOCIAL PROTEST ART

Although Hogarth originated the form, socially conscious paintings were few before the nineteenth century. Artists were generally interested in grander themes and besides, political statements didn't look good hanging on the wall. Some who challenged the status quo were:

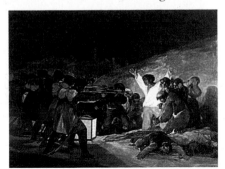

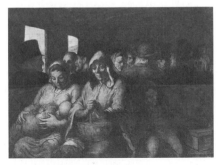

HONORÉ DAUMIER, in "Rue Transnonain, April 15, 1834," portrayed a heap of civilian bodies executed by state troops. Here he implies the deadening effect of Machine Age transportation.

FRANCISCO GOYA, scathingly denounced man's follies in paintings like "The Third of May, 1808," part of a series entitled The Disasters of War.

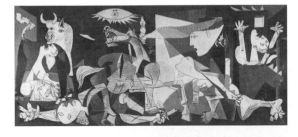

JACOB RIIS, a pioneering photojournalist, exposed scandalous conditions like homelessness among immigrants.

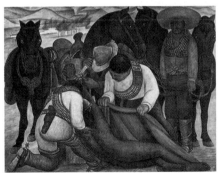

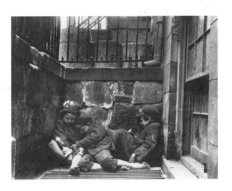

PABLO PICASSO, attacked the destructiveness and cruelty of war in works like "Guernica."

DIEGO RIVERA, portrayed an executed Mexican peasant as Christ being taken from the cross.

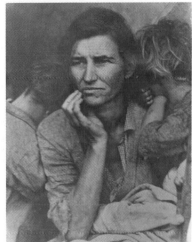

ANSELM KIEFER, used fiery imagery to protest the horror of the Holocaust.

DOROTHEA LANGE, highlighted poverty among the dispossessed during the Depression.

ABSTRACT EXPRESSIONISM

With Abstract Expressionism, for the first time, the metacenter of what was happening in world art shifted to American shores. And a "happening" is largely what Abstract Expressionism was all about, encompassing as "art" not just the product of artistic creation but the active process of creating it.

Also called "action painting" and the New York School, Abstract Expressionism stressed energy, action, kineticism, and freneticism. It used much of what had been defined as art as little more than a point of departure. Indeed, Abstract Expressionism is to conventional artistic technique what jazz is to 4/4 time. While one might look at a painting of Jackson Pollock or Franz Kline and say, "I don't get it," that would be like criticizing jazz great Charlie Parker for not following a tune.

Abstract Expressionism began to take form in the late 1940s and early '50s partially as a reaction to a war that devastated two continents, destroyed 16 million people, and left in its wake a world out of whack. When the Surrealists arrived in America during World War II, the new generation of American painters discovered from them the art of anarchy. But where Dada and Surrealism revolted against logic, the Americans took "automatism" one step further, relying on instinct to shape works of art that were not only irrational but were, at their core, unpremeditated accidents.

Pioneered by such artists as Arshile Gorky, Hans Hofmann, and Jackson Pollock, the Abstract Expressionists liberated themselves from geometric abstraction and the need to suggest recognizable images. Giving free rein to impulse and chance, the impassioned act of painting became an absolute value in itself.

No one better epitomized this wildly subconscious approach than Pollock. Labeled "Jack the Dripper" by *Time* magazine, Pollock made a revolutionary breakthrough by abandoning the paintbrush altogether, sloshing, pouring — and dripping — commercial paints onto a vast roll of canvas on the floor of his studio/barn. With Herculean ambition, he also abandoned the easel format for a monumental, murallike scale. The image of Pollock is of a man possessed — possessed by his own subconscious — as he flung and slung skeins of paint in an all over configuration, throwing out in the process such conventional artistic considerations as foreground, background, focal point, and perspective like so many empty paint cans.

The resulting highly improvisational canvases by Pollock and friends not only stole Europe's position as Keeper of the Cultural Flame, it expanded the very definition of what was thought to be "Art." No longer was art required to imitate tame visual appearance; the energy and emotion of Abstract Expressionism smashed conventions and laid the groundwork for much of what was to follow.

ABSTRACT EXPRESSIONISM

PERIOD: Late 1940s, early '50s

LOCALE: New York, East Hampton

AIM: Express inner life through art

TECHNIQUE: Free application of paint, no reference to visual reality

THEORY: Image not result of preconceived idea, but of creative process

WHAT IS "ART"?

For centuries, a debate has raged over what art is. A lot of what is called art is so outlandish, it stretches the credulity and sabotages one's appreciation of it. Here are some attempts by a number of people to define art.

Proto-abstractionist Arthur Dove (before 1920): "[Art] is the form that the idea takes in the imagination rather than the form as it exists outside."

Expressionist Oskar Kokoschka (1936): "[Art is] an attempt to repeat the miracle that the simplest peasant girl is capable of at any time, that of magically producing life out of nothing."

Realist Ben Shahn (1967): "[Art is] the discovery of images during work, the recognition of shapes and forms that emerge and awaken a response in us."

Or, as Pop artist Andy Warhol said when asked if his six-hour-long film of a man sleeping was art: "Well, first of all, it was made by an artist, and second, that would come out art."

ACTION PAINTING

Critic Harold Rosenberg first used the term "action painting" to explain the Abstract Expressionist working method when he wrote: "the canvas began to appear . . . as an arena in which to act. . . . What was to go on the canvas was not a picture but an event." According to theory, the painter improvises an image as he goes along. The resulting painting records a moment in the artist's life.

The best known, most widely appreciated Abstract Expressionists are:

ARSHILE GORKY (1904–48) pioneered "automatic" painting in the U.S. Called "a Geiger counter of art" by de Kooning, Gorky typified the development of American vanguard artists as he shifted from Cubism to Surrealism, then broke free of European models. The Armenian-American painter freely brushed washes of glowing color inside clearly outlined biomorphic shapes. He favored oval splotches of flowing primary colors like yellow and red, reminding some of runny eggs. Children fled in terror from this 6'3" painter, habitually dressed in black from head to toe like Count Dracula. After a series of setbacks — losing his wife, his health, and his work in a fire — Gorky hung himself in a woodshed. His scrawled message: "Goodbye my 'Loveds."

Gorky, "Water of the Flowery Mill," 1944, MMA, NY.

JACKSON POLLOCK (1912–56) conveyed what he called "energy made visible" in his mural-sized, abstract paintings that embodied his psychic state at the moment of their creation. "New needs demand new techniques," he said, throwing out easel, palette, paintbrushes, and artistic convention to pour and fling commercial paints on a roll of unprimed canvas spread on his barn floor. The resulting "drip" paintings, begun in 1947, are a dense network of fluid, interlacing lines. Like the expanding universe after the Big Bang, the sweeping threads of black, white, and silver paint seem to surge in complex visual rhythms, offering no center of interest or sense of boundary. Pollock's unique contribution was to express emotion through abstraction. "In him," said critic Clement Greenberg, "we had truth."

Pollock, "No. 1, 1950 (Lavender Mist)," NG, Washington, DC.

PAINT HARD, LIVE HARD

Jackson Pollock attacking the keys of a grand piano with an ice pick. Pollock shattering a table full of glasses, then fingering the shards to drip blood in designs on the tabletop. Pollock pounding a table so ferociously that a box of matches burst into flames. Burning with intensity, Pollock convinced a generation of artists that art comes from within rather than without. His loutish behavior is legendary. He brawled in bars, urinated in potted plants, ripped doors off their hinges, and died drunk in a car crash at the age of 44.

Regardless of how turbulent his personal life or how unstructured his canvases, Pollock's art was anything but mindless. "NO CHAOS DAMN IT," he once wired a critic who failed to see how a canvas squirted with ink-filled basting syringes could be art.

When Hans Hofmann first visited Pollock's studio he was startled by the absence of any models or sketches. "Do you work from nature?" he asked. Pollock replied, "I am nature."

WILLEM DE KOONING (b. 1904), the Old Master of Abstract Expressionism, came to the U.S. from Holland as a stowaway. With his solid background in academic painting and an ability to draw like Ingres, he worked in a realistic style until 1948, when he developed his mature style of slashing brushstrokes. Unlike his colleagues, de Kooning kept his interest in the human figure and is known for a series of "Woman" paintings (which he compared to the Venus of Willendorf). These frontal images appear to both dissolve into and emerge out of fiercely brushed paint. His canvases look raw and unfinished, but de Kooning constantly reworked them in his trademark yellow, pink, and buff colors.

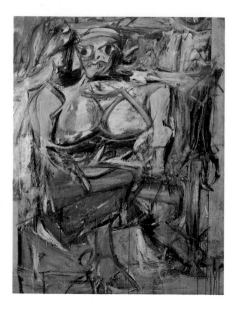

de Kooning, "Woman I," 1950–52, MoMA, NY.

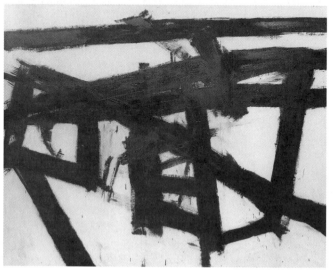

Kline, "Mahoning," 1956, Whitney, NY.

FRANZ KLINE (1910–62) was converted to abstraction after viewing his normal-sized sketches blown up on a wall with a slide projector. He was overwhelmed by the power of these giant black brushstrokes against a stark white background, and began to paint black enamel bars using a housepainter's brush on huge, white canvases. Kline derived his massive linear forms from industrial shapes like trains and girders. "The final test of a painting," he said, "is: does the painter's emotion come across?"

BLACK MOUNTAIN COLLEGE

The hands-down winner among all-star art schools was the experimental Black Mountain College in North Carolina during its brief heyday of 1933–57. Its staff and alumni were like a Who's Who of the American avant-garde, including painters Albers, Shahn, de Kooning, Kline, Motherwell, composer John Cage, dancer Merce Cunningham, architect Buckminster Fuller, and poets Charles Olson and Robert Creeley. It was at Black Mountain that Rauschenberg first conceived his object-plus-canvas composites. One morning Rauschenberg was stunned by a canvas he had been working on the night before. He called fellow student Cy Twombly to see what had happened. Trapped in the thick black paint was a white butterfly. The "combine" was born.

HANS HOFMANN (1880–1966) was an early advocate of freely splashed pigment. A highly influential teacher, he influenced a generation of disciples with his "push-pull" (repulsion/attraction of certain colors) theory. One of the first to experiment with pouring paint, the German-American painter is known for rectangles of high-keyed, contrasting colors that seem to collide.

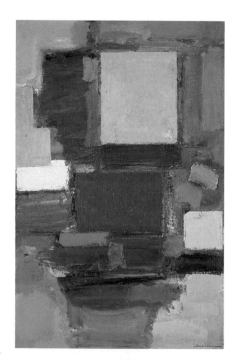

Hofmann, "The Gate," 1960, Guggenheim, NY.

CLYFFORD STILL (1904–80) was as intense and jagged as his paintings. A pioneer of nearly monochromatic painting, Still troweled on uneven shapes of paint with a palette knife. His early work consisted of vertical, ragged areas of color in earth tones. Later he used brighter colors but always with a "ripped curtain" pattern lacking any central focus.

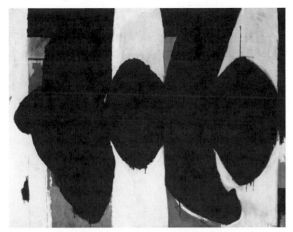

Motherwell, "Elegy to the Spanish Republic, No. 34," 1953–54, Albright-Knox Art Gallery, Buffalo.

Still, "Untitled," 1946, MMA, NY.

ROBERT MOTHERWELL (1915–91) was the wealthy intellectual of the group. After studying philosophy at Harvard and Stanford, he took up abstract painting inspired by European Modernism. Motherwell is known for the more than 100 paintings he called "elegies" for the doomed Spanish Republic. These works feature oval shapes wedged between irregular, vertical bands in black, white, and brown.

Other lesser-known but not necessarily less-important Abstract Expressionists are: Adolph Gottlieb (1903–74), best known for stylized "burst" paintings in which circular forms float above exploding masses of paint. James Brooks (1906–92) invented stain painting (painting on unprimed, absorbent canvas which gives a "fuzzy" effect). William Baziotes (1912–63) portrayed an imaginary underwater world. Ad Reinhardt (1913–67) combined Mondrian with Abstract Expressionism into geometric abstractions, and later did the famous "black-on-black" paintings. Bradley Walker Tomlin (1899–1953) is known for calligraphic strokes like bird scratchings. Philip Guston (1913–80) thickly overlapped brushstrokes in a crosshatching of luminous colors. He became a figurative artist in later years. Lee Krasner (1911–84), Pollock's wife, suggested human forms without literally depicting them. Ibram Lassaw (b. 1913), one of the first Americans to make abstract sculpture, in 1950 welded open grids and latticed metal sculpture. Esteban Vicente (b. 1903) uses an air compressor to spray luminous colors in abstract paintings.

JOAN MITCHELL

A second generation member of the Abstract Expressionist group who still keeps the flame alive is Chicagoan Joan Mitchell (b. 1926). Her scribbly, darting brushstrokes on a plain white field are abstract versions of landscapes in gold, yellow, and blue. Although the loose brushstrokes seem quickly applied, as if the whole painting were produced in a blaze of improvisation, Mitchell insists, "The idea of 'action painting' is a joke. There's no 'action' here. I paint a little. Then I sit and I look at the painting, sometimes for hours. Eventually the painting tells me what to do."

FEDERAL ART PROJECT

During the darkest days of the Depression, President Roosevelt put 10,000 artists to work. "Hell! They've got to eat just like other people," said FDR's aide Harry Hopkins. In the most ambitious program of government art patronage ever, the U.S. Treasury doled out $23.86 a week to artists like Thomas Hart Benton, John Steuart Curry, Ben Shahn, Isamu Noguchi, and Arshile Gorky and Jackson Pollock who would become known as Abstract Expressionists. During the program's tenure of 1935–43, these artists — many young and unknown — produced one work every two months, for a total of 100,000 easel paintings, 8,000 sculptures, and more than 4,000 murals for public buildings. The subsidy allowed a generation of artists the luxury of experimenting with new styles. Painter Stuart Davis traced "the birth of American art" to the Federal Art Project. Its support catalyzed a burst of innovation and catapulted New York to the forefront of advanced art.

FIGURAL EXPRESSIONISM: NOT JUST A PRETTY FACE

Reacting against the prevailing trend of complete abstraction, a few postwar painters kept figurative painting alive. They began, however, with the Modernist principle that art must express a truth beyond surface appearance. These painters retained the figure only to bend it to their will.

DUBUFFET: BRUTE STRENGTH. While art leadership shifted from Paris to New York, Jean Dubuffet (1901–85) made his mark as the most original Continental artist by completely overthrowing European tradition. To "replace Western art with that of the jungle, the lavatory, the mental institution" is how Dubuffet described his aim. He invented a new term for this new art: "L'Art Brut" (pronounced Lar BROOT), which means raw or crude art.

Dubuffet believed art as practiced for centuries had run out of steam. It was dry and lifeless compared to the compelling images he discovered scrawled in graffiti or turned out by people on the margins of society, like mental patients and criminals. "It was my intention to reveal," he said, "that it is exactly those things [others] thought ugly, those things which they forgot to look at, which are in fact very marvelous."

For Dubuffet, only amateurs could tap the imagination without self-censorship. Professional art was, he thought, "miserable and most depressing." Art by social outcasts is "art at its purest and crudest, springing solely from its maker's knack of invention and not, as always in cultured art, from his power of aping others."

OUTSIDER ART. Like Dubuffet's L'Art Brut, Outsider Art, or work outside the mainstream of professional art, is produced by self-taught, inwardly driven artists. Their work includes not only entire environments like Simon Rodia's Watts Towers in Los Angeles, but paintings and sculptures of outrageous inventiveness.

Outsider art encompasses work by the insane and criminals as well as by unschooled artists. Often its practitioners are obsessively committed to their work, using whatever means and materials are at hand, such as cast-off metal and roots or stumps of trees. Swiss mental patient Adolf Wolfli, for example, was unstoppable, compulsively covering any surface in reach with dense drawings. North Carolina artist Jimmie Lee Sudduth paints with mud and sugar water from plastic bags of thirty-six different colors of dirt. When he can't find exactly the right earth-tone he needs, Sudduth mixes up a batch of rose petals for red or wild turnip greens for — what else? — green. "I don't like to use paint too much," he says.

Dubuffet, "The Cow with the Subtile Nose," 1954, MoMA, NY. *Dubuffet's work represented, he said, the "values of savagery." Throwing out conventional oil-on-canvas, Dubuffet used new materials as well as a new mindset. He incorporated mud, ashes, banana peels, butterfly wings, and chicken droppings into his paintings. With these, he mixed oil, cement, asphalt, or putty to build up a thick paste, then scratched deliberately primitive designs into the thick surface.*

Hampton, "Throne of the Third Heaven of the Nation's Millennium General Assembly," c. 1950–64, National Museum of American Art, Washington, DC. *A janitor who created this work in his spare time in a garage, James Hampton intended the gold-and-silver-foil-covered structure as a throne for the Messiah.*

BACON: THE POPE OF PAINT. London artist Francis Bacon (1909–92), a descendant of the Elizabethan Sir Francis Bacon, was known for his twisted, horrifying figures that look like melting monsters. First widely seen in 1945, the images were "so unrelievedly awful" said art critic John Russell, "that the mind shut with a snap at the sight of them." Bacon painted human figures as freakish half-human, half-beast embryos, with snouts for noses, bloody eye sockets, mouths with no heads, and feet that dissolved into puddles. At the same time as the eye recoils from the image, Bacon's handling of paint is so seductively beautiful, it's hard to look away.

A self-taught painter, Bacon consciously searched for forms that would have a visceral impact on viewers' emotions. He believed photography eliminated the artist's need to report reality. He hoped his deformed portraits would leave "a

PARADISE GARDEN: A SHRINE OF OUTSIDER ART

"A man of visions" is how painter Howard Finster (b. 1916) signs his work. He had his first vision at age three in a tomato patch. An apparition of his sister, recently deceased from rabies, appeared announcing he would be a man of visions. Since then, he's had thousands of visions, some of the Biblical sort like bands of angels, others more futuristic like spaceships.

For forty-five years, Finster preached as a fundamentalist minister, then one day he got paint on his finger and a face told him to paint sacred art. Finster filled in a two-and-a-half-acre swamp in Summerville, Georgia, to create an environment of evangelism he calls Paradise Garden. He paved the walkways with bits of colored glass, rhinestones, mirror fragments, marbles, and rusty tools. He made a 20-foot-high structure called Bicycle Tower of discarded bike frames, lawn mowers, and wheels. What others call junk is a jewel to Finster. "Lots of people said I was crazy," he admitted. "Noah couldn't get any support on the ark because it looked crazy to people."

trail of the human presence," he said, "as the snail leaves its slime." To suggest the truth, he distorted it. "Fact leaves its ghost," he said. Typically, Bacon placed figures in realistic settings and glaring light but smudged and twisted them. "I get nearer," he said, "by going farther away."

BODY LANGUAGE. Bacon never worked from live models, although he did many portraits of friends based on memory or photos. "Who can I tear to pieces," he asked, "if not my friends?" Often he drew inspiration from color plates of hideous wounds or disfiguring diseases, which accounts for the impression of flayed flesh his images convey. Themes of war, dictators, and meat appear frequently in his work, as do images of tubular furniture, a red rug, window shades with dangling cords, an umbrella, a rabid dog, and a bloodied human figure on a bed.

An eccentric who spent his time painting, gambling, drinking, or curled up in a fetal position daydreaming, Bacon called his work "exhilarated despair." Although museum curators admired his work, Bacon was aware it appalled most collectors. He imagined new acquaintances thinking, "Ha! Slaughterhouses!" when they met him. He never toned down his style, admitting, "Whoever heard of anyone buying a picture of mine because he liked it?"

Bacon, "Head Surrounded by Sides of Beef," 1954, Art Institute of Chicago. *Bacon was fascinated with Velázquez's portrait of Pope Innocent X and did a series of grotesque versions, sometimes with the pope shrieking amid blurred shafts of spectral paint. Bacon reworked the Velázquez portrait in many studies but insists he never saw the original. The screaming pope is hemmed in by luminescent sides of meat, suggesting Bacon's belief that "we are all carcasses."*

A WOMAN'S LIFE

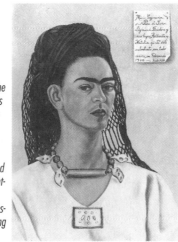

Kahlo, "Self-Portrait," 1940, Private collection. *The work of Mexican painter Frida Kahlo (1907–54) was shocking in its candor. The bulk of her 200 paintings were fantasized self-portraits, dealing with subjects seldom treated in Western art: childbirth, miscarriage, abortion, and menstruation. She delighted in role-playing and wore colorful Mexican costumes, basing her painting style on indigenous folk art and Roman Catholic devotional images. An invalid who had thirty-two operations in twenty-six years, she had a red leather boot encrusted with Chinese gold trim and bells made for her wooden leg after her leg was amputated so she could "dance her joy."*

At her first one-woman show, Kahlo's doctor said she was too ill to attend, so she had herself carried in on a stretcher as part of the exhibit. Kahlo died soon after. When they pushed her body into the oven to be cremated, the intense heat snapped her corpse up to a sitting position. Her hair blazed in a ring of fire around her head. She looked, painter David Siqueiros said, as if she were smiling in the center of a sunflower.

POSTWAR SCULPTURE

Postwar sculptors worked with new materials like scrap metal, new techniques like welding, and new forms like assemblage and mobiles. Although abstraction was their dominant mode, the chief feature of their art was experimentation.

MOORE: ENGLAND'S MOST FAMOUS SCULPTOR. Henry Moore (1898–1986) clearly built on the biomorphic shapes of Surrealists Jean Arp and Joan Miró. He also based his work on natural forms like shells, pebbles, and bones. Subjects that preoccupied him throughout his career were the reclining figure, mother and child, and family. Although he minimized surface detail and greatly simplified forms, Moore's large, open shapes are semi-naturalistic, perforated by holes that are as important as the solid parts of his works.

Moore, "Reclining Mother and Child," 1960–61, Walker Art Center, Minneapolis. *Moore did stylized single and grouped figures with characteristic hollows.*

To discover evocative forms, Moore studied artifacts like Anglo-Saxon, Sumerian, and pre-Columbian objects as well as nature. He aimed not for beauty but power of expression. "Truth to the material" was another principle. Whether he worked in wood, stone, or bronze, Moore respected his medium. His figures seem to emerge out of their materials, his designs harmonized with natural textures and streaks.

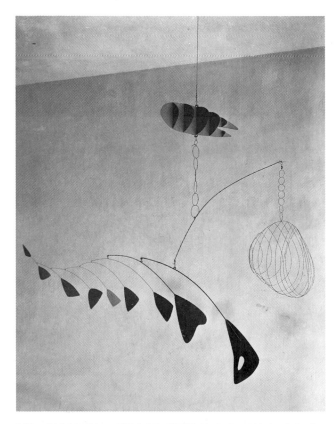

Calder, "Lobster Trap and Fish Tale," 1939, MoMA, NY. *Calder knocked sculpture off its feet by inventing the mobile, which combines spontaneity and playfulness.*

CALDER: DEFYING GRAVITY. "The least one can expect of sculpture," Dalí said, "is that it stand still." American artist Alexander Calder (1898–1976) disagreed and invented a new art form: sculpture in motion. Dubuffet named Calder's floating sculpture "mobiles."

Calder got the idea when he visited Mondrian's studio and admired the colored rectangles covering the walls. He wanted to make, he said, "moving Mondrians." In 1932 Calder succeeded by suspending discs of sheet metal painted black, white, and primary colors from wires and rods. Since the barest wind set them dancing, the result was a constantly shifting set of shapes that Calder called "four-dimensional drawings." In "Lobster Trap and Fish Tale," the forms swim in space, realigning themselves with the slightest breath of air. In 1953 Calder invented what Jean Arp dubbed "stabiles," or nonmoving steel structures whose intersecting planes spring from the ground on tiny points.

Calder intended his work to delight and surprise. While sculpture was traditionally heavy and massive, his was airy and open. He was as unpredictable as his work. A friend once discovered him working in his studio with a clothespin and piece of cotton clamped on his nose because he had a cold and wouldn't stop to wipe. When asked by an earnest visitor how he knew that a piece was finished, "When the dinner bell rings," was Calder's reply.

SMITH: MAN OF STEEL. The most important sculptor associated with the New York School was David Smith (1906–65). "When I begin a sculpture I am not always sure how it is going to end," he said. Smith invited chance and surprise to enter the process of creation, believing that sculpture should pose a question, not offer a solution.

"Now steel, that's a natural thing for me," Smith, the descendant of a blacksmith, admitted. He called his work site Terminal Iron Works because it was more a machine shop than an artist's studio. Smith learned his craft on a Studebaker auto assembly line where he picked up welding and riveting skills. Untrained in sculpture, he fused machined metal parts into open, linear designs. Smith is best known for his Cubi series of balanced stainless steel cubes and cylinders. Cantilevered into space, the squares and rectangles seem momentarily poised but on the brink of collapse. Although semiabstract, they often suggest the human form.

After Smith's death in a car crash, his friend Robert Motherwell eulogized him, "Oh David, you were as delicate as Vivaldi and as strong as a Mack truck."

Smith, "Cubi X," 1963, MoMA, NY. *Smith was among the first to use welding in sculpting his geometric compositions.*

BOURGEOIS: THE LONELY CROWD. While Calder and Smith pioneered new forms in metal, French-American sculptor Louise Bourgeois (b. 1912) did ground-breaking work in carved wood. Her first exhibition in 1949 included constructions of six-foot-tall wooden posts that were thin like asparagus. She clustered several tapering columns together and often painted them black because, she said, "the world is in mourning."

The relation — or its lack — between individuals had long been Bourgeois' preoccupation. She titled a sculpture "One and Others," saying, "This is the soil from which all my work grows."

As a girl Bourgeois studied geometry at the Sorbonne, finding refuge from her fears and anxieties in mathematical precision. When she took up art with Cubist painter Léger, she worked hard to be mathematically correct. "You don't have to be so rigid and precise," Léger told her. "You can push geometry around a bit."

Bourgeois, "Quarantania, I," 1948–53, MoMA, NY. *Bourgeois is known for her carved wood ensembles.*

NEVELSON: BEYOND THE WALL. "I didn't want it to be sculpture and I didn't want it to be painting," said American sculptor Louise Nevelson (1900–88) of her work. "I wanted something else. I wanted an essence." The "essence" Nevelson created is a novel art form. Her characteristic "sculptured walls" consist of cubicles crammed full of carpenter's cast-offs: newel posts, balusters, finials, and pieces of molding. She painted an entire 11-foot-high wooden wall, composed of many boxy compartments, one color: usually flat black, later white or gold. "I have given shadow a form," said Nevelson.

As a child newly arrived from Russia, in Rockland, Maine, where her father ran a lumber yard, Nevelson was always sure of her artistic calling. "My life had a blueprint from the beginning, and that is the reason that I don't need to make blueprints or drawings for my sculpture. What I am saying is that I did not become anything. I was an artist." Through years without recognition, "the only thing that kept me going," Nevelson said, "was that I wouldn't be appeased."

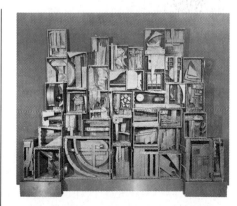

Nevelson, "Sky Cathedral," 1958, Albright-Knox Art Gallery, Buffalo. *A pioneer of environmental sculpture, Nevelson made wall-sized collages of discarded wood scraps.*

COLOR FIELD

In the late 1940s and early '50s a few New York School painters spun off a variation on Action Painting where vast expanses, or "fields" of color became the focus. "Color Field" painting was invariably abstract, and canvases were huge, almost mural-size.

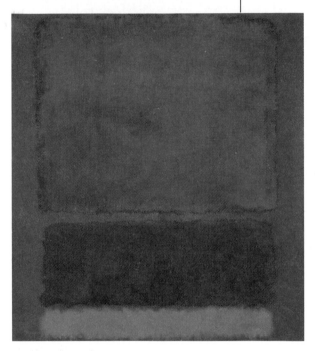

Rothko, "Blue, Orange, Red," 1961, Hirshhorn Museum and Sculpture Garden, Smithsonian Institution, Washington, DC. *Rothko painted bars of color that seem to dissolve into each other.*

IVY LEAGUE MATERIAL

In the early '60s, Mark Rothko proposed to donate a triptych and two large murals to Harvard University. Then-president of Harvard, Nathan Pusey, who had only the faintest knowledge of abstract art, arrived at Rothko's studio one morning to inspect the gift. The stocky Rothko, dressed like a disreputable housepainter, poured his guest a shot of whiskey in a paint-smeared glass. Pusey stared at "miles" of Rothko rectangles like dominoes minus the spots. Rothko stared at Pusey. "Well, what do you think of them?" Rothko finally asked. Uncertain of a suitable reply, Pusey said, "Rather sad." Rothko's face lit up: Pusey was "right on the beam."

ROTHKO: BLURRED RECTANGLES. "There are some painters who want to tell all," said Russian-American Mark Rothko (1903–70), "but I feel it is more shrewd to tell little." While Rothko told little, he suggested volumes in his eight-foot-high paintings consisting of two or three soft-edged, stacked rectangles.

Interested in the relation between one color and another, Rothko built up large patches of pigment that seem to hover within their color fields. Erasing all evidence of brushstrokes, he also eliminated recognizable subject matter. In a joint statement with painter Adolf Gottlieb, Rothko wrote, "We favor the simple expression of the complex thought." As his paintings became simpler, they became larger. "A large picture is an immediate transaction," Rothko said, "it takes you into it."

As Rothko slipped into depression and alcoholism, his paintings lost their hushed, calm aura, becoming dark and melancholy. His murals for the St. Thomas University chapel in Houston are black, brown, and eggplant purple. A year later, he took his life.

Newman, "Day One," 1951–52, Whitney, NY. *Newman is known for monochromatic fields of color relieved by a contrasting stripe.*

NEWMAN: ZIP STRIPS. Barnett Newman (1905–70) was the most radical abstractionist of the New York School. He gave up texture, brushwork, drawing, shading, and perspective for flat fields of pure color sliced by one or two off-center stripes ("zips," he called them). While Abstract Expressionist paintings seem to explode with energy, Newman's are condensed, relying wholly on the evocative power of color.

An intellectual who wrestled with profound philosophic and religious issues, Newman tried to find innovative visual equivalents for his mystical concerns, as in his Stations of the Cross series at Washington's National Gallery of Art. The colossal scale of his canvases (one painting is 17 feet wide) was indispensable to his meaning. "Scale equals feeling," Newman said. To him the "void" relieved only by a stripe looked sublime, full of light, meaning, and "the chaos of ecstasy."

FRANKENTHALER: STAIN PAINTING. When New York painter Helen Frankenthaler (b. 1928) first saw Jackson Pollock's black-and-white work, she was stunned. "It was as if I suddenly went to a foreign country but didn't know the language," she said, "but was eager to live there . . . and master the language." Soon after, she visited Pollock's studio and learned his pouring technique. In 1952 she combined two sources of inspiration: Pollock's methods and John Marin's watercolors. With oil thinned to the consistency of watercolor and unprimed sailcloth tacked to the floor, she poured paint from coffee cans, guiding its flow with sponges and wipers.

The unique stain paintings that resulted exist at the crossroads between chance and control. "I think accidents are lucky," Frankenthaler said, "only if you know how to use them." Frankenthaler's colorful shapes float like swollen calligraphy. Because the thin washes of pigment soak into the canvas rather than rest on top of it, the white fabric shines through, irradiating the color with light like stained glass. Denser zones contrast vividly against the open, expansive field of lush color.

LOUIS: VEILS AND VARIATIONS. American artist Morris Louis (1912–62) discovered his style when he saw what Frankenthaler was doing. Her work, he said, was "a bridge between Pollock and what was possible." Morris perfected the spontaneous-but-composed method of staining canvas. He poured diluted acrylic paint, tilting his unprimed canvas to guide the flow into several characteristic forms: veils, stripes, and florals. By relying solely on the directed fall of paint, Louis produced paintings without a single brushstroke. With the "handwriting" of the painter gone, his works communicated purely through color.

A Louis trademark was the "veil" painting: overlapping fans of color produced by pouring pigment down vertically placed canvases. He also created "floral" patterns of smoky color that flare out in scallops. His "stripes" run from top to bottom in multicolored canals of color. Louis experimented with leaving a huge empty space in the middle of his canvases, framed by diagonal bands of color at the corners. The central white space, more than a negative void, packs a positive punch.

Frankenthaler, "The Bay," 1963, Detroit Institute of Arts. *Frankenthaler developed stain painting because, she said, the paint "cried out to be soaked, not resting" on top of the canvas.*

NEWMAN'S PASSION

Barnett Newman painted a fourteen-work series (1958–66) on unprimed canvas using only black and white paints. The austere pictures, each composed of a couple of stripes, indicate the fourteen stages of Christ's Passion from trial to entombment. When attending a formal dinner at New York's Plaza Hotel, Newman, dignified in his tuxedo and monocle, spotted a priest and asked, "Have you seen my Stations of the Cross paintings? I showed them at the Vatican, and the Pope told me I had brought Christianity into the twentieth century." The painter Lee Krasner, for whom art was the one true religion, snapped, "For Christ's sake, Barney, isn't that a little pretentious?"

Louis, "Point of Tranquility," 1959–60, Hirshhorn Museum and Sculpture Garden, Smithsonian Institution, Washington, DC. *Louis poured paint in several distinct patterns that resemble veils, stripes, or floral designs.*

The Twentieth Century and Beyond: Contemporary Art

The problem with assessing Contemporary art is that it's still alive and growing. History has yet to tell the tale of who will fade from memory and who prevail. What is clear, however, is that movements have come and gone since 1960 at a brisk clip. A common thread linking them is their opposition to Abstract Expressionism. It's as if the shadow cast by Jackson Pollock loomed so large that future offshoots had to hack down the tree to find their own spot in the sun. Hard Edge painters and Minimalist sculptors annihilated Action Painting's cult of personality by creating machinelike forms. Pop artists embraced commercial imagery, and Conceptualists pared the idea of a hand-wrought art object to ground zero, where art existed in the mind more than on canvas. All these movements centered in New York, where it began to seem as if painting was terminally passé.

Then around 1980 Europe seized the spotlight. German and Italian painters known as Neo-Expressionists returned figure painting and recognizable images to the mainstream, infusing their intense, emotional canvases with autobiographical and social concerns. In Post-Modern art of the next generation, everything was up for grabs. Allowable forms, materials, media, and content were expanded to such a degree that nothing seemed off limits, and artists grappled with the challenge of being truly original rather than merely novel. As the twentieth century draws to a close, art is more international, with no geographical area dominating, and more diverse than ever before. After a century of experimentation, the legacy is wide-open freedom.

WORLD HISTORY		ART HISTORY
	1959	"Street Photography" in vogue
Kennedy elected President	1960	Stella exhibits shaped "Hard Edge" canvases,
		Yves Klein makes paintings with nude women as "brushes"
First man orbits earth, Berlin Wall erected, Birth control pills available	1961	
	1962	First Pop art exhibit
John F. Kennedy assassinated	1963	
Civil Rights Act passed, Beatles win fame	1964	Op Art begins
	1965	Minimalism recognized
Cultural Revolution begins in China	1966	Venturi publishes theory of Post-Modern architecture
Students demonstrate against Vietnam War	1967	Conceptual Art developed
Robert Kennedy, Martin Luther King, Jr., assassinated	1968	Earth Art documented, Process Art exhibited
Armstrong walks on moon, Woodstock festival held	1969	Judy Chicago founds feminist art program
First Earth Day launches environmental movement	1970	
	1972	Photo-Realism shown
Women win abortion rights	1973	Auction escalates art prices
Nixon resigns	1974	
	1975	Graffiti art exhibited
	1976	Performance Art shown
	1977	Beaubourg opens in Paris, Blockbuster King Tut show tours
	1978	I. M. Pei's East Wing opens at National Gallery of Art
MTV debuts	1981	Neo-Expressionism exhibited
AIDS identified	1982	Post-Modern architecture recognized
Gorbachev begins reform	1985	
Challenger explodes, Chernobyl nuclear reactor erupts	1986	Installations become trend
Stock market crashes	1987	
Exxon Valdez oil spills, Democracy crushed in China, Berlin Wall opens	1989	Senator Jesse Helms attacks "obscene" art
Desert Storm defeats Iraq	1991	

HARD EDGE

Around 1948, Abstract Expressionism burst on the scene with fierce emotionalism, impulsiveness, and signature brushstrokes. The painters of ten years later defined themselves as everything Abstract Expressionists were not. It was as if they took to heart Minimalist painter Ad Reinhardt's slogan, "a cleaner New York is up to you." Hard Edge painters cleaned up the act of Action Painters.

Hard Edge took the Expressionism out of Abstract Expressionism. What it offered instead of spontaneous, subjective abstraction was calculated, impersonal abstraction. Hard Edge painting uses sharply contoured, simple forms. The paintings are precise and cool, as if made by machines. It took even further the Modernist tendency to view the artwork as an independent object rather than a view of reality or the painter's psyche. In Hard Edge, the painted surface is nothing more than a pigment-covered area bordered by canvas stretchers. Frank Stella summed it up best: "What you see is what you see."

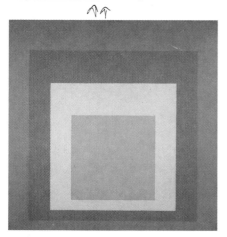

Albers, "Homage to the Square: 'Ascending,'" 1953, Whitney, NY. *A color theorist, Albers demonstrated the effect of one color on another. Here the bottom and side bands of gray and blue rectangles appear darker than the upper bands, even though the shades are uniform throughout.*

ALBERS: THE SQUARE SQUARED. The patron saint of Hard Edge painting was German-American painter and color theorist Josef Albers (1888–1976). After teaching at the Bauhaus, Albers came to the United States and taught a course called "Effect Making" at the experimental Black Mountain College in North Carolina. Throughout Albers's long career as a teacher, his obsession was one color's effect on another or, as he said, "how colors influence and change each other: that the same color, for instance, — with different grounds or neighbors — looks different."

At Albers's first class he asked the students, "Vich of you children can draw a straight line?" Facing the blackboard, Albers then walked sideways, dragging a piece of chalk across the board until he produced a perfectly level line ten feet long. Soon thereafter he set his pupils to mastering nearly impossible technical tasks like drawing letters and numbers backward with a pencil gripped between their toes. He taught technical control, not freedom.

Albers's own work reflected such extreme discipline. From the 1950s he concentrated on variations of the most neutral, stable form he could find: the square. His Homage to the Square series consists of superimposed squares of subtly varied hues, a textbook demonstration of how colors interact. Albers wanted his viewer to be aware of "an exciting discrepancy between physical fact and psychic effect of color" — the optical illusion of color.

NOLAND: ON TARGET. Kenneth Noland (b. 1924), an American pupil of Albers, learned his color lessons well. But instead of squares, he first specialized in concentric circles. By confining himself to the circle (called his "target" paintings, begun in 1958), Noland established the center of the canvas (the "bull's eye") as a structuring device, forcing the viewer to focus on other formal elements. "With structural considerations eliminated," he said, "I could concentrate on color."

By the mid-'60s, Noland moved on to another trademark shape: immense, brightly colored chevrons. In traditional composition, forms cohere around a central focal point, but in Noland's, the wing-shaped chevrons seem to fly off toward the canvas edge. Noland also defied tradition by breaking the picture's rectangular format. A pioneer of the shaped canvas, he used diamonds, triangles, and irregular shapes.

Noland attempted to erase his personal identity from his canvases by the use of controlled designs, intense colors, and geometric compositions he called "self-cancelling," rather than "self-declaring." Instead of screaming "Look at me!" to draw attention to an artist's inner vision as

Noland, "Bend Sinister," 1964, Hirshhorn Museum and Sculpture Garden, Smithsonian Institution, Washington, DC. *Noland divided space with sharply defined shapes and colors to evoke calculated visual sensations.*

in Abstract Expressionism, up-front Hard Edge paintings quietly state, "Look for yourself." It was not about interior angst, only exterior surface.

KELLY: PERFORMING MASSES. More than a brush, the tools of the Hard Edge painter's trade are quick-drying acrylic paint and masking tape for clear, crisp outlines. American artist Ellsworth Kelly (b. 1923) outlined his shapes so sharply, they looked like razor cuts. Yet he claimed, "I'm not interested in edges. . . . I want the masses to perform."

And perform they do. Kelly combines giant, simple shapes so they almost oscillate. The viewer is hard put to say which is forefront and which is background. In some of his paintings, a large shape seems barely confined within the canvas, while in others the image seems to continue outside the picture frame. In both cases, Kelly sets up a fluctuating tension between static/dynamic and closed/open forms. In "Blue, Red, Green," the cut-off, irregular blue ellipse slices across a green rectangle like a water hazard on a putt-putt course. The green form seems both a flat plane and a slightly receding background.

Kelly also used shaped canvases in irregular, geometric, and curved formats. He typically combined two bold, intense colors and basic shapes in mural-sized canvases.

Kelly, "Blue, Red, Green," 1962–63, MMA, NY. *Hard Edge painters used simple forms and limited colors in precise, impersonal designs.*

STELLA: MECHANICAL DRAWING. One of the most original of contemporary American artists is Frank Stella (b. 1936). Stella insists on the painting as a self-sufficient object. "All I want anyone to get out of my paintings, and all I ever get out of them," Stella said, "is the fact that you can see the whole idea without any confusion."

Stella first established his identity with a series of black-striped paintings consisting of sooty pinstripes separated by narrow white bands. Breaking the rectangle with shaped canvases was a way for him to overcome the illusion that a painting is a window into illusionistic space. Instead of traditional easel paintings that told a story, made a "statement," or presented a metaphor for something else, Stella said his painting was a "flat surface with paint on it — nothing more."

Stella deliberately sacrificed personal handling, using commercial house paint and metallic paint. In his large-scale "protractor" series of paintings based on intersecting protractor arcs in fluorescent colors, he based both the shape of the canvas and design on a mechanical drawing tool. From the 1960s through the '80s, in series after series, Stella determined his composition by such mechanical means, using rulers, T-squares, and French-curve templates to sketch on graph paper. In the '70s, Stella entered what he called his "baroque phase" and developed a new, 3-D format straddling the border between painting and sculpture.

Stella, "Star of Persia II," 1967, Hirshhorn Museum and Sculpture Garden, Smithsonian Institution, Washington, DC. *Stella emphasizes the painting as an independent object in his canvases fusing design and shape.*

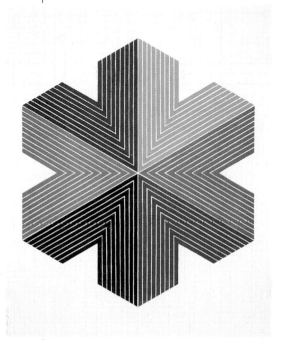

PRE-POP ART

For an art movement that began so far outside the mainstream, Abstract Expressionism entrenched itself surprisingly fast. Within ten years, its founders and its style seemed overbearingly trite. Wannabe Action Painters, in shameless imitation, were splashing gallons of paint, cashing in on what rapidly became a standardized schtick. Innovative young painters of the mid-fifties rebelled against these faux abstractions. "It was not an act of hostility," said Jasper Johns, explaining why he chose a different path from Pollock. "It was an act of self-definition."

As Robert Rauschenberg, Johns's co-leader in the breakaway, said, "I had decided that ideas are not real estate. There's enough room to move in that you don't have to stand in the same place or imitate. Everyone was doing de Kooning, Newman, Reinhardt. There were only two artists that didn't copy other artists: Jasper Johns and I." In a quintessential act of defiance, Rauschenberg in 1953 produced a work of art by erasing a de Kooning drawing. This off-with-their-heads gesture symbolized how the movement Rauschenberg and Johns began wiped out Abstraction's dominance of world art.

RAUSCHENBERG: FORM EQUALS FACT.
Rauschenberg (b.1925) was the postwar artist most responsible for liberating the artist from a compulsion to record his own emotions. A recycler of throwaways before salvage was chic, Rauschenberg invented a hybrid form of art, half-painting and half-sculpture, he called "combines." After combing New York streets for junk, or sculpture-waiting-to-be-discovered in his opinion, Rauschenberg attached eccentric materials like rusted traffic signs, frayed shirt cuffs, and a stuffed eagle to his expressionistically painted canvases. "A pair of socks is no less suitable to make a painting with," he said, than oil and canvas. "I wanted the images to still have the feeling of the outside world rather than cultivate the incest of studio life."

In a famous statement that explains his appropriation of found objects, Rauschenberg said, "Painting relates to both art and life. . . . I try to act in the gap between the two." Acting in the gap meant nothing was off-limits. "A picture," he said, "is more like the real world when it's made out of the real world." In this equal-opportunity approach, Rauschenberg resembles his mentor, avant-garde composer John Cage, who made music out of silence (actually, the sounds of the restless audience). When once complimented on a composition, Cage stared out the window, saying, "I just can't believe that I am better than anything out there."

MERGERS AND ACQUISITIONS. "Multiplicity, variety, and inclusion" Rauschenberg called the themes of his art. During forty prolific years he has merged Dada's radical questioning of accepted practice with an energetic, Abstract Expressionist brushstroke and Surrealist faith in accident. In the process, he acquired his own distinct style based on risk-taking. "If art isn't a surprise," Rauschenberg has said, "it's nothing."

An example of his openness to possibility occurred one May morning when Rauschenberg woke up inspired to paint but had no money for canvas. Surveying his bedroom, he seized an old quilt and tacked it and his pillow to the stretcher before splashing them with paint. Although shocked Italian officials refused to display the work that resulted ("Bed"), Rauschenberg considered it "one of the friendliest pictures I've ever painted. My fear has always been that someone would want to crawl into it." He habitually bought discount paint without labels at a hardware store. He never knew what color he would use until he pried off the lid. "It's the sport of making something I haven't seen before," he said. "If I know what I'm going to do, I don't do it."

During the '80s, Rauschenberg launched a self-funded crusade called ROCI (pronounced Rocky, after his pet turtle) — Rauschenberg Overseas Culture Interchange — to promote peace through art.

Rauschenberg, "Monogram," 1955–56, Moderna Museet, Stockholm. *In this "combine," Rauschenberg mounted a stuffed angora goat wearing an automobile tire on a collaged canvas base to prove that all materials are equally worthy of art.*

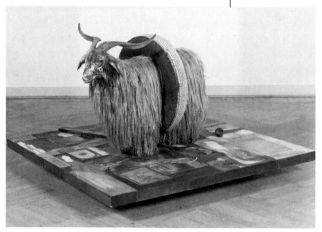

JOHNS: ZEN MASTER OF AMERICAN ART.

The opposite of Rauschenberg's passionate, Jack Daniels-swilling welcome of chaos is the cool calculation of Jasper Johns (b. 1930). "Jasper Johns was Ingres, whereas Rauschenberg was Delacroix," according to their longtime dealer Leo Castelli. Yet the two swapped ideas when both had studios in the same New York loft building from 1955 to 1960. Both returned recognizable imagery to art. They even collaborated on window displays for Tiffany and Bonwit Teller. One Tiffany window featured fake potatoes, real dirt, and real diamonds. Like a Johns painting, it combined artifice and reality that glittered with unexpected gems.

SEEING, NOT JUST LOOKING.

For Johns, as for Duchamp, art was an intellectual exercise. During the '50s and '60s he chose familiar two-dimensional objects like flags, targets, and maps as subjects, "things the mind already knows," he said, which "gave me room to work on other levels." In "Three Flags," each successive, stacked canvas of decreasing size realistically portrays a familiar object. At the same time, with its richly textured surface of encaustic (pigment mixed with wax), it is also patently artificial. By contrasting the flag's impersonal structure to his personal artistic handwriting, Johns gave a new identity to an object which, as with O'Keeffe's flowers, is routinely seen but "not looked at, not examined."

Speaking of Leo Castelli's success, de Kooning once said, "He could even sell beer cans," which prompted one of Johns's most provocative works: "Painted Bronze" (1960), two cylinders cast in bronze with painted trompe l'oeil Ballantine Ale labels. Here were disposable beer cans transformed, like

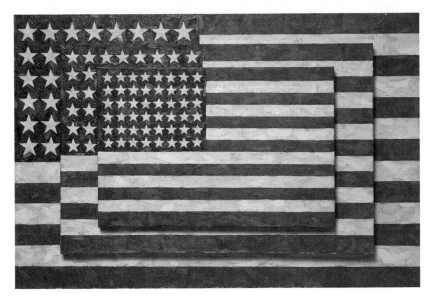

Johns, "Three Flags," 1958, Whitney, NY. *Johns, with Rauschenberg, was first to rebel against Abstract Expressionism by returning recognizable imagery to art.*

bronzed baby shoes, into permanent trophies. Johns challenged the viewer: Are they ale cans or sculpture? Reality or art? "I was concerned with the invisibility those images had acquired," Johns said, "and the idea of knowing an image rather than just seeing it out of the corner of your eye."

His art is a study of ambiguity and metamorphosis. Johns sometimes covered the canvas with cross-hatching traditionally used by draftsmen to indicate depth but for Johns a flat surface pattern. "Take an object. Do something to it. Do

something else to it," was Johns's credo. His art is intentionally oblique, cool, and detached yet open to multiple interpretations.

In 1985, acknowledged as one of the most esteemed living artists, Johns began to make his paintings more personal. He introduced a figure (a shadowy self-portrait) in Four Seasons, a series exploring the passage of time. Although this work has clear autobiographical implications, as usual, Johns's symbols puzzle more than illuminate.

HAPPENINGS

As part of the Pop scene, artists like Allan Kaprow and Jim Dine staged happenings, designed to take art off the canvas and into life.

Robert Rauschenberg rented thirty large desert turtles for one happening, "Spring Training." The turtles roamed a darkened stage with flashlights strapped to their backs, sending light flashing in all directions, while Rauschenberg, clad in jockey shorts, traipsed around wiggling his toes and fingers. Then he and a friend toted each other around like logs. For the climax, Rauschenberg, in a white dinner jacket and on stilts, poured water into a bucket of dry ice harnessed to his waist. Clouds of vapor coiled around him, a finale he later pronounced "too dramatic." Afterward, returning the turtles in a taxi, Rauschenberg praised their performance. "But the turtles turned out to be real troupers, didn't they? They were saving it all for the performance. They don't have very much, so they saved it."

POP ART

Once Rauschenberg and Johns reintroduced recognizable imagery, the stage was set in the early 1960s for artists to draw their subjects directly from popular ("pop") culture. With a resounding WHAAM! Roy Lichtenstein's comics-derived paintings took direct aim at the abstract art of the '50s. Besides Lichtenstein, artists like Andy Warhol, Claes Oldenburg, and James Rosenquist, who all had commercial art backgrounds, based their work on images from Times Square neon signs, the mass media, and advertising.

This return to pictorial subject matter was hardly a return to art tradition. Pop art made icons of the crassest consumer items like hamburgers, toilets, lawnmowers, lipstick tubes, mounds of orange-colored spaghetti, and celebrities like Elvis Presley. "There is no reason not to consider the world," Rauschenberg said, "as one large painting." Pop artists also made art impersonal, reproducing Coke bottles or Brillo boxes in a slick, anonymous style. With playful wit, the new art popped the pomposity of Action Painting.

Pop artists blazed into superstardom in 1962 like comets in a Marvel comic. Pop was easy to like. Its shiny colors, snappy designs — often blown up to heroic size — and mechanical quality gave it a glossy familiarity. Pop became as much an overnight marketing phenomenon as a new artistic movement. Collectors compared the skyrocketing prices of their acquisitions to IBM stock. Meanwhile, galleries chock full of passé Abstract Expressionist inventory were out of the action. One jealously posted a sign next to an exhibit of Warhol soup cans: "Get the real thing for 29 cents."

For architect Philip Johnson, a Pop collector, the art was more than monetarily enriching. "What Pop art has done for me is to make the world a pleasanter place to live in," he said. "I look at things with an entirely different eye — at Coney Island, at billboards, at Coca-Cola bottles. One of the duties of art is to make you look at the world with pleasure. Pop art is the only movement in this century that has tried to do it."

LICHTENSTEIN: COMIC STRIP IMAGERY

Since 1962, American Pop artist Roy Lichtenstein (pronounced LICK ten stine; b. 1923) has parodied the mindless violence and sexless romance of comic strips to reveal the inanity of American culture. Lichtenstein said he painted war comics and tawdry romance melodramas because "it was hard to get a painting that was despicable enough so that no one would hang it. Everyone was hanging everything. It was almost acceptable to hang a dripping paint rag. [But] the one thing everyone hated was commercial art. Apparently they didn't hate that enough either."

Lichtenstein, "Whaam!" 1963, Tate Gallery, London. Lichtenstein's trademark style borrows comic book techniques as well as subjects. Using bright primary colors with black and white, he outlines simplified forms, incorporating mechanical printer's (benday) dots and stereotyped imagery. By enlarging pulp magazine panels to billboard size, Lichtenstein slaps the viewer in the face with their triviality.

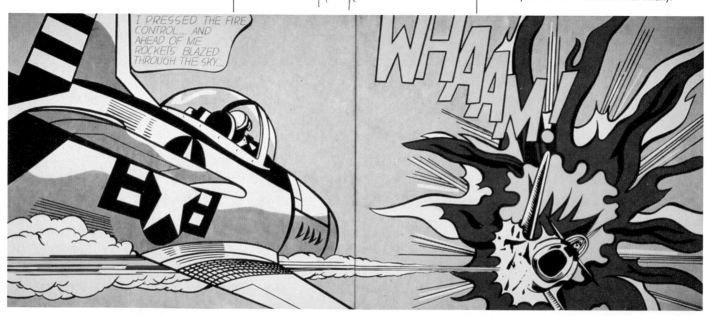

WARHOL: THE POPE OF POP. People who have never been inside an art museum know American painter Andy Warhol (1930–87). Warhol picked his subjects off supermarket shelves and from the front pages of the tabloids. He would then mass-produce images like Marilyn or Campbell's Soup cans in assembly-line fashion, repeating them by silkscreen duplication. These well-known images pushed art out of the museum and into the mainstream.

"Once you begin to see Pop," Warhol said, "you can't see America in the same way." Not only did Warhol force the public to reexamine their everyday surroundings, he made a point about the loss of identity in industrial society. "The reason I'm painting this way is that I want to be a machine," he said. Warhol delighted in deadpan, outrageous statements: "I think it would be terrific if everyone looked alike," he said, and, "I want everybody to think alike. I think everybody should be a machine." Just when critics concluded his platinum fright wig, pale makeup, and dark glasses concealed an incisive social commentator, Warhol punctured their balloons: "If you want to know all about Andy Warhol, just look at the surface of my paintings and films and me, and there I am. There's nothing behind it."

Warhol began as a very successful shoe illustrator for print ads. He lived with his mother in New York with twenty-five cats. Then in 1960 Warhol made acrylic paintings of Superman, Batman, and Dick Tracy. From 1962–65 he added the famous soup cans, Coke bottles, dollar signs, celebrity portraits, and catastrophe scenes straight out of the *National Inquirer*. A natural self-promoter, Warhol made himself into a media sensation. He installed his retinue at a downtown studio called The Factory.

From 1963–68 Warhol made more than sixty films which reached new depths of banality. One silent film, "Sleep," runs six hours, capturing every non-nuance of a man sleeping. "I like boring things," Warhol said.

Although Warhol works are instantly recognizable, he opposed the concept of art as a handmade object expressing the personality of the artist. In his multiple images, endlessly repeated as in saturation advertising, Warhol brought art to the masses by making art out of daily life. If art reflects the soul of a society, Warhol's legacy is to make us see American life as depersonalized and repetitive. "Andy showed the horror of our time as resolutely as Goya in his time," said contemporary painter Julian Schnabel.

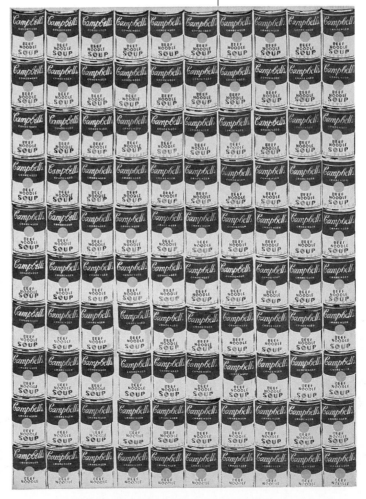

Warhol, "100 Cans of Campbell's Soup," 1962, Albright-Knox Art Gallery, Buffalo. *Best known for his serial images of consumer items in a hard-edged graphic style, Warhol wanted a machinelike art without social comment or emotion.*

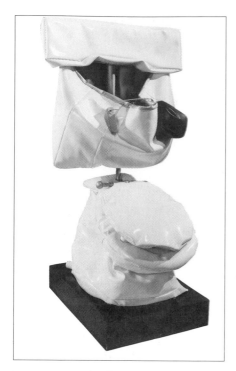

Oldenburg, "Soft Toilet," 1966, Whitney, NY. *By transforming commonplace objects, Oldenburg hoped to make the viewer appreciate their qualities as design objects.*

OLDENBURG: METAMORPHOSIS.

Involved from 1959 to 1965 with Happenings, an early form of performance art, American sculptor Claes Oldenburg (b.1929) developed three-dimensional, large-scale blowups of familiar objects. "I want people to get accustomed to recognize the power of objects," Oldenburg said. Ordinary objects, he believes, "contain a functional contemporary magic," but we have lost any appreciation of this because we focus on their uses.

Oldenburg magnified the scale of objects like clothespins, baseball bats, and lipstick tubes to the epic size of Times Square billboards. He also altered their composition, constructing a typewriter out of soft vinyl, clothespin out of steel, or icepack out of painted canvas stuffed with kapok.

Oldenburg's soft sculptures are like 3-D versions of Dalí's limp watches. His magnifications and transmogrifications "give the object back its power," he said, by disorienting viewers and shocking them out of their torpor. "Soft Toilet," for instance, turns all expectations topsy-turvy. What should be hard is soft and sagging, what should be sanitary looks unhygienic. "Gravity is my favorite form-creator," Oldenburg said.

Besides his soft sculpture, Oldenburg is also known for his proposed civic monuments, most of which exist only as witty sketches. He has suggested replacing standard memorials like soldiers and cannons with colossal enlargements of everyday items like spoons, cigarette butts, or peeled bananas. For the Thames River in London, Oldenburg proposed huge toilet bowl floats to rise and fall with the tides.

Like James Rosenquist, who painted billboards before becoming a Pop artist, Oldenburg was interested in the power of scale as a property in art. "I alter to unfold the object," Oldenburg said, to make us "see," perhaps for the first time, an object we look at every day.

OP ART

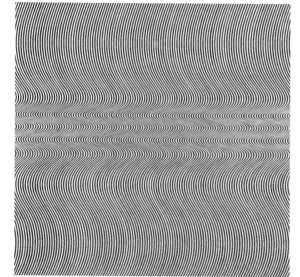

Riley, "Current," 1964, MoMA, NY.
"Op," or "optical" art, was developed in the mid-'60s by English painter Bridget Riley, French-Hungarian Victor Vasarély, and the Americans Richard Anuszkiewicz and Lawrence Poons. It combined color and abstract patterns to produce optical illusions of pulsating movement.

CASTING CALL

Segal, "Walk/Don't Walk," 1976, Whitney, NY. *Around 1960 American sculptor George Segal (b.1924) created a new art form: plaster casts of figures set in actual environments. By wrapping surgical bandages around living people, he created eerily lifelike, stark white sculptures. Although cast from the living image, Segal's molded people are ghostly and depersonalized. Often in a group, as on a bus, they project loneliness and alienation. Segal's joyless sculpture is to Pop what Hopper's grim pictures are to upbeat American Scene paintings. Like the Pop artists, however, Segal fuses reality with unreality to intensify the impact of ordinary experience.*

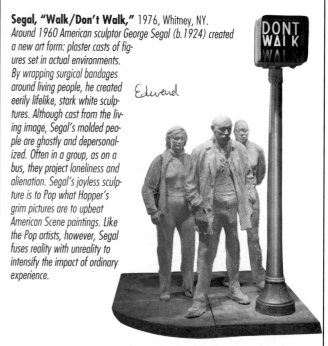

MINIMALISM: THE COOL SCHOOL

The inevitable conclusion of the modern artist's urge to reduce art to basics was Minimalism. Although monochrome canvases by painters like Robert Ryman, Brice Marden, Robert Mangold, and Agnes Martin are called Minimalist, it is primarily a school of sculpture. The founding fathers are all American sculptors like Donald Judd, who defined Minimalism as "getting rid of the things that people used to think were essential to art."

SOLID GEOMETRY. Minimalists, like Hard Edge painters, eradicated the individual's handprint, as well as any emotion, image, or message. To attain such a "pure," anonymous effect, they used prefab materials in simple geometric shapes like metal boxes or bricks.

Minimalism was a reaction against both the swagger of Abstract Expressionism and vulgarity of Pop. After they jettisoned both personality and consumerism, what Minimalists had left were cold, mechanical forms for the viewers to make of them what they would. Metal shelves attached to a gallery wall, panes of glass on a gallery floor, a plank leaning against a wall are all Minimalist art. The ultimate Minimalist exhibit was French artist Yves Klein's show of nothing at all, just a freshly whitewashed gallery containing no object or painting (two patrons even bought nonexistent canvases — Klein demanded payment in gold). "Compared to them," art dealer Leo Castelli said, "Mondrian is an expressionist painter."

For these sculptors, minimum form ensured maximum intensity. By paring away "distractions" like detail, imagery, and narrative — i.e., everything — they forced the viewer to pay undiluted attention to what's left. "Simplicity of shape does not necessarily equate," said Robert Morris, "with simplicity of experience."

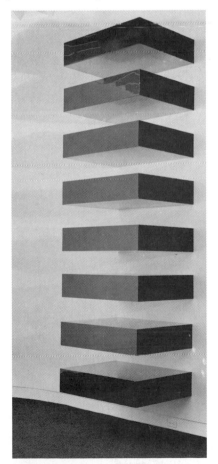

Judd, "Untitled," 1969, Norton Simon Museum of Art, Pasadena, CA. *Minimalism is art reduced to the absolute minimum, totally abstract and commercially manufactured, without reference to the artist's emotions, personality, or any recognizable image.*

MINIMALISM

LOCALE: U.S. in 1960s–70s

FORM: Abstract, geometric modules

LOOK: Clean, bare, simple

TECHNIQUE: Machine-made

MEANING: You be the judge

A MINI-ROUNDUP OF THE MOST PROMINENT MINIMALISTS

DONALD JUDD (b. 1928) makes machine-made stainless-steel, Plexiglas, and plywood boxes arranged in horizontal or vertical rows on walls. "A shape, a volume, a color, a surface is something in itself," he said.

CARL ANDRE (b. 1935) went to the opposite extreme from traditional vertical, figurative sculpture on a pedestal. Instead, he arranged bricks, cement blocks, and flat slabs on the floor in a horizontal configuration, as in his 29-foot-long row of bricks on the ground.

DAN FLAVIN (b. 1933) sculpts with light, attaching fluorescent tubes to the wall in stark geometric designs giving off fields of color. Hint: Look at the light, not at the tubes.

SOL LEWITT (b. 1928) creates simple forms in series like white or black cubes, either open or closed. Although he later added primary colors, LeWitt stresses that art should "engage the mind rather than the eye or emotions."

ROBERT MORRIS (b. 1931) is known for large-scale, hard-edged geometric sculptures like big, blocky right angles. "Unitary forms do not reduce relationships," he said. "They order them." Morris also does antiform sculpture in soft, hanging material like felt. The pieces droop on the wall, sculpted by gravity.

RICHARD SERRA (b. 1939) became infamous for his huge metal sculpture "Tilted Arc," which aroused such hatred in a public square in New York that it was removed in 1989. Serra's entry for the 1991 Carnegie International art show consisted of two black rectangles, each hanging on a different wall, one placed high and the other near the floor.

CONCEPTUAL ART: INVISIBLE VISUAL ART

"Painting is dead," the art world proclaimed in the late 1960s and early '70s. Not just painting — sculpture, too, in the opinion of a group called Conceptual Artists. "Actual works of art are little more than historical curiosities," said Joseph Kosuth. This didn't mean that Art was dead. This development was just part of a trend called "dematerialization of the art object." In simple terms: if a creative idea is fundamental to art, then producing an actual object provoked by that idea is superfluous. Art resides in the core concept, not the practical work. Minimalists scrubbed their art clean of image, personality, emotion, message, and handcrafting. Conceptualists went a step further and eliminated the art object altogether. "The idea itself, even if not made visual, is as much a work of art as any finished product," said sculptor Sol Le Witt, who gave the movement its name.

Conceptual Artists include Germans Joseph Beuys (1921–86), Hanne Darboven, and Hans Haacke; Americans Le Witt, Kosuth, John Baldessari, Jenny Holzer, Bruce Nauman, Chris Burden, Jonathan Borofsky; and Bulgarian-American Christo. In fact, Conceptual Artists do create works, but they barely resemble traditional art. The label is an umbrella term covering diverse movements — anything that is neither painting nor sculpture, which emphasizes the artist's thinking, not his manipulation of materials.

Any action or thought can be considered Conceptual Art. Japanese-American artist On Kawara, for instance, has painted a date on a small gray panel each day since January 25, 1966, and exhibits randomly selected dates. Les Levine ran a Canadian kosher restaurant as an artwork. Morgan O'Hara obsessively records how she spends each moment of her life. John Baldessari placed the letters C-A-L-I-F-O-R-N-I-A at different locations around the state. It's all Conceptual Art, as long as the idea rather than the art object is paramount. Here are some of its forms.

PROCESS ART. While Minimalist sculptors went about assembling prefab parts, Robert Morris decided that the process of creating art was more important than the finished piece. Like existentialism — but also taking a page from the Abstract Expressionists — the artist discovers meaning by doing. Walter De Maria in 1961 described a Process Art project: "I have been thinking about an art yard I would like to build. It would be sort of a big hole in the ground. Actually, it wouldn't be a hole to begin with. That would have to be dug. The digging of the hole would be part of the art."

ENVIRONMENTAL ART. Conceptual Artists frequently do their thing far from museums and galleries. Earth-

MEDIA IS THE MESSAGE

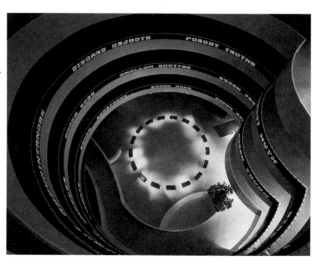

Holzer, "Selections," 1989, Solomon R. Guggenheim, NY. *A subset of Conceptual Art since the 1970s is media art. American artist Jenny Holzer (b.1950) uses mass media like billboards to push art out of the museum and into public spaces. She began by posting small, anonymous stickers with ambiguous, fortune-cookie epigrams like "MONEY CREATES TASTE" on garbage can lids and parking meters. Then she graduated to 20' x 40' electronic signs flashing from Las Vegas to Times Square. From impersonal electric ribbon signs and banal sayings, she constructs a form of emotional theater to combat public apathy toward most art.*

CONVERSATIONS WITH A COYOTE

Much of the public's you-call-that-art? skepticism has been in direct response to the extremism of some contemporary art. But for the generation that emerged in the late '60s, art could be made out of absolutely any event, idea, or material. One artist telephoned instructions to museum workers, who put together a work of art the "artist" had not seen or touched. Joseph Beuys held a weeklong conversation with a coyote. Vito Acconci crushed live cockroaches on his belly, and Piero Manzoni canned his own excrement to display at a New York gallery. Kim Jones earned the name "Mudman" by roaming SoHo streets wearing nothing but a loin cloth and mud. Julian Schnabel drags a tarp behind his jeep to weather it, then whacks the canvas with a tablecloth soaked in paint to create an image.

works artists like Robert Smithson (see p. 21) devised vast projects requiring bulldozers moving tons of earth. Wrap artist Christo (b. 1935) specializes in temporarily wrapping bridges and buildings — even one million square feet of Australian coast — in plastic. In 1983 he surrounded eleven islands in Florida's Biscayne Bay with pink polypropylene tutus.

PERFORMANCE ART. A staged event involving the artist talking, singing, or dancing, Performance Art requires artists to use their bodies in front of an audience. Joseph Beuys walked around a Düsseldorf gallery performing "How to Explain Pictures to a Dead Hare" (1965). His face covered in gold leaf and honey, he explained various paintings to a dead rabbit cradled in his arms. In his 1972 "Seedbed" performance, Vito Acconci masturbated for six hours under a ramp at the Sonnabend gallery, broadcasting his moans and groans on loudspeakers.

INSTALLATIONS. Room-size exhibitions crammed with a conglomeration of disparate objects like words, videos, photos, and ordinary objects like beer cans comment on topical political issues like AIDS. Although the objects seem unrelated, the viewer is intended to enter the environment ignorant and emerge enlightened about some pressing social theme the artist has revealed.

Jonathan Borofsky turned the Paula Cooper Gallery into a studio by drawing on walls and inviting visitors to play ping-pong on a black-and-white painted table. A four-foot stack of paper scrawled with numbers from zero to 2,687,585 stood on the floor (Borofsky undertook to count to infinity). Hundreds of copies of an antilittering handbill littered the floor. (The artist's mother started picking them up before the opening until someone stopped her, explaining that the idea was to have them underfoot.)

DANGER ZONE

California performance artist/sculptor Chris Burden, called "the Evel Knievel of the avant-garde," makes his displays a life-or-death affair to take art out of elitism into the real world of looming danger. To "explore" violence, he had a friend shoot him in the arm while guests at a Los Angeles gallery watched. In "Doorway to Heaven" (1973), Burden grounded two live electric wires on his bare chest, recording the aura of sparks in a striking photograph. A Viennese group went too far when they smeared sheep blood and entrails on participants and crucified them upside down in a gallery. One died from self-mutilation.

PROCESS NOT PRODUCT

Haacke, "Condensation Cube," 1963–65, John Weber Gallery, NY.

Hans Haacke (b.1936), a left-wing artist who works in the United States, concentrates on the act of making a work rather than the work itself. In "Poll of MoMA Visitors" (1970), he gathered museum-goers' opinions on the Vietnam War. From 1963 he constructed transparent boxes containing fluids that fluctuate with temperature and air pressure. Incorporating the behavior of wind, air, and water into his work, Haacke's "collaborator" became the surrounding "climate," which varied from hour to hour.

CONTEMPORARY ARCHITECTURE

In the 1970s and '80s designers traded in Miesian-inspired Barcelona benches and Breuer chairs (honestly, they were never very comfortable) for Adirondack benches and Shaker rockers. A consensus formed that Bauhaus-inspired Modernism was, as one critic said, "polished death." International Style buildings based on the grid and glass skin had multiplied so widely, they were the House Style of corporate headquarters throughout the world. Critics denounced their anonymity and hungered for passion and personality.

Modernism seemed like a dead end, and Post-Modernism arose as its alternative. In place of T-square-straight, antiseptic forms, the new architecture used curvilinear, complex shapes. Post-Modernism resurrected color, ornament, and historical touches like the dome, arch, and vault. While one particular style has not yet jelled, architects today experiment with a variety of novel forms with an almost Baroque flair. What is clear about Post-Modern architecture is its pluralism.

Johnson and Burgee, Pennzoil Place, 1976, Houston. *Initially an advocate of the International Style, Johnson later designed buildings that broke from the white box format and added historical references.*

PEI: THE LAST MODERNIST. I. M. Pei (pronounced PAY; b. 1917) became the International Style's leading exponent in the postwar period. Pei's buildings declare their identity as abstract objects first, then as refined monuments. Frequently triangular in shape with an oversized Henry Moore sculpture out front, they are monochromatic and severe like Minimalist sculpture.

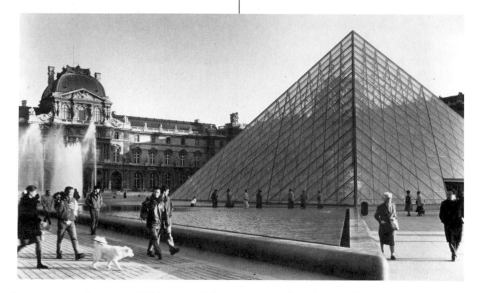

Pei, Entrance to the Louvre, 1989, Paris. *Pei's buildings use simple, uncluttered, geometric forms.*

JOHNSON: THE TURNING POINT. For the first half of his career, American architect Philip Johnson (b. 1906) was apprentice to his master Mies van der Rohe's International Style. In 1956, they collaborated on the landmark Park Avenue Seagram Building (at 53rd Street). In 1949, Johnson built the penultimate glass box, Glass House, in New Canaan, Connecticut, where sheets of glass comprise the whole exterior. He had reached the maximum of minimum: pure, clean, abstract — all qualities of "The International Style" that he also championed in an influential book of the same title.

In the mid-'70s, Johnson sniffed a change in the air and seized the Post-Modern banner. Pennzoil Place in Houston (1976) looks like a gigantic Minimalist sculpture but diverges from the bland, rectangular anonymity of the International Style in its daring shape and dark color. It consists of two towers separated by a ten-foot slot, joined at the bottom by a glass wedge housing a lobby. Johnson tapered the roof to a rakish 45-degree angle. Johnson's P.P.G. Place in Pittsburgh is a Post-Modern masterpiece with its Gothic tower and turrets — like the Houses of Parliament executed in sleek, mirrored glass. The "Chippendale skyscraper" that Johnson and partner John Burgee designed for AT&T recalls Brunelleschi's fifteenth-century Pazzi Chapel in its arch-and-colonnaded base. Its broken pediment top is like an eighteenth-century grandfather clock. Thanks to Johnson, it became chic to quote from the past. As Johnson told his students, "You cannot not know history."

BEAUBOURG: CONTEMPORARY CULTURE PAR EXCELLENCE. A building that fits no category except maybe futuro-fantasy is the Centre Pompidou, known as the Beaubourg, in Paris. If Johnson's Pennzoil resembles Minimalist sculpture, the Beaubourg is a Dada funfest. Dedicated to putting Paris back at the helm of contemporary art, the Beaubourg houses labs and display spaces dedicated to modern art, industrial design, avant-garde (especially computer-generated) music, and film. After the Eiffel Tower, it's the most popular attraction in Paris.

The building wears its technology on its sleeve, with all service functions turned inside out. Heating and cooling ducts, stairs, elevators, escalator, water and gas pipes crisscross the exterior steel skeleton. Color is a vital element, with components color-coded according to function: red for ramps and conveyances that move people, green for water, blue for air conditioning, and yellow for electrical wiring. Could anyone but Parisians make plumbing so stylish?

Its designers sought to create a radically new kind of building for an institution that goes far beyond ho-hum museum activities. Anyone wandering into the corridor where composers push buttons to create music of squawks and bleeps knows right away he's entered a new French Revolution. The public plaza outside throbs with performers juggling, singing, miming, and breathing fire. "If the hallowed, cultlike calm of the traditional museum has been lost, so much the better," said then-director Pontus Hulten. "We are moving toward a society where art will play a great role, which is why this museum is open to disciplines that were once excluded by museums. . . ."

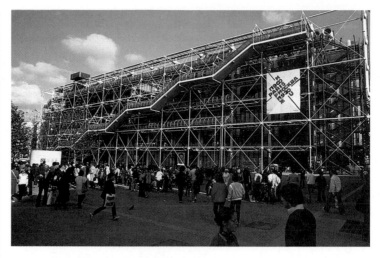

Piano and Rogers, Centre Pompidou, 1977, Paris. *This building celebrates technology by putting beams, ductwork, pipes, and corridors on the outside.*

GRAVES: THE TRIUMPH OF POST-MODERNISM. A Post-Modern American architect for whom color is a central component is Michael Graves (b. 1934). Instead of basing color on technical function as at the Beaubourg, Graves keys it to nature: to earth, foliage, and sky. "My color sense is very childlike," Graves said. "I don't want to upset the code." Graves uses "representational" color, sheathing the base of buildings in earth hues like terra-cotta and dark green, graduating to sky tones above, like an azure-blue soffit.

In the late 1970s Graves converted to Post-Modernism and mixed Classical elements and fantasy (he designed the new Mickey Mouse–inspired Disney headquarters). Now he dots his multicolored facades with architectural flashbacks ranging from Beaux-Arts Classicism to Egyptian revival to streamlined Modernism. In his Portland Public Services Building (1983), dubbed "The Temple," Graves divided the tower into three separate sections suggesting the base, shaft, and capital of a Classical column.

Dramatic entrances are a Graves trademark. Instead of the interior/exterior free flow of Modernism, he amplifies the passage between public and private, outside and inside. A typical device is the "voided keystone." Where a traditional arch has a keystone at its apex, Graves places a window, heightening the drama of the central portal as focal point.

Graves, Clos Pegase Winery, 1987, CA. *Graves reintroduced color and historical detail to architecture.*

GEHRY: CALIFORNIA DREAMIN'. The most provocative Post-Modern architect working today is indisputably Frank O. Gehry (b. 1929). Canadian born, Gehry put himself through architecture school by working as a truck driver. Now he works out of Los Angeles, a pioneer of what he has called "cheapskate architecture." Gehry buildings are instantly identifiable for their use of unpretentious, industrial materials like plywood, chain-link fencing, corrugated cardboard, and cinderblock. Why? "I had a lot of poor clients," Gehry said.

An experimental urge also entered his calculations. When he saw the Minimalist sculpture of Carl Andre and Donald Judd, made of firebricks and plywood, Gehry said he got interested in "the idea that you could make art out of anything." He also liked the informal air these "anti-aesthetic" materials gave a design.

Gehry has also designed Post-Modern buildings that express their purpose through form. His Loyola Law School in Los Angeles (1985) has sleek columns and spaces that echo the stoa (columned pavilion) and agora (open meeting area) of ancient Greece, the birthplace of Western law. The California Aerospace Museum bursts with dynamism in jutting angles that suggest flight.

A quirky individual who tries to insinuate a fishlike form into every building, Gehry's work is as unique as his outlook. "I am trying to respond to a particular time," he said, "because I don't think you can escape."

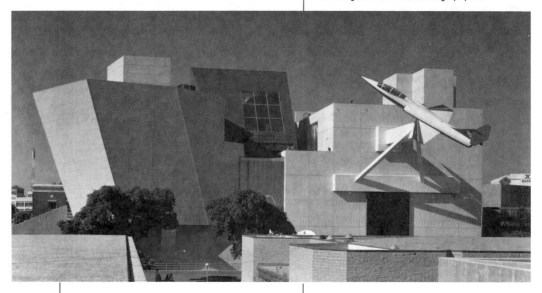

Gehry & Associates, California Aerospace Museum, 1984, Los Angeles. *Gehry's forms seem on the verge of lift-off in this design that reflects the building's purpose.*

VENTURI: LESS IS A BORE. If Frank Gehry is the wild man of Post-Modernism, American architect Robert Venturi (b. 1925) is Everyman. The leading theoretician of Post-Modernism, Venturi demolished Mies's famous "less is more" with his counterattack: "less is a bore." In several influential books like *Learning from Las Vegas* he argued that architecture should accept not only historical styles but respect "dumb and ordinary" vernacular buildings. As Venturi put it, "Main Street is almost all right."

Venturi practices what he preaches. He believes architecture should accommodate a multiplicity of styles, so in one structure (a vacation lodge in Vail, Colorado) he combined sources as diverse as the Swiss chalet, Palladio, Art Nouveau, and the International Style of Le Corbusier. More than anyone, he is credited with inventing the jaunty pluralism of Post-Modern architecture.

In Guild House, a home for retirees in Philadelphia, Venturi deliberately made the design unassuming and unpretentious. He used Pop poster-style lettering and crowned the arch that serves as focal point with a television antenna. The brick building puts on no airs, makes no big statement, and blends in thoroughly with its undistinguished neighbors. Critics have faulted this intentional banality. "Don't take it so hard," his partner John Rauch told Venturi when they lost another commission. "You're only a failure. I'm an assistant failure."

Recently Venturi has completed major projects, such as buildings for the Princeton University campus faced with a red-and-white checkerboard motif like the Purina Dog Chow logo. His Sainsbury Wing of London's National Gallery (1991) is a collection of irreverent historical allusions, and his colorful Seattle Art Museum (1991) has the same playful quality.

AN ARCHITECTURAL SURVEY

Throughout the book, references to the evolution of architecture appear. Page 39 covered Renaissance architecture, for instance, and page 146 dealt with the International Style. Here's a quick rundown of major names in the history of Western architecture.

BIRTH OF ARCHITECTURE

STONEHENGE — most famous megalithic monument used for ritual purposes, c. 2000 B.C.

ZIGGURAT — stepped, mudbrick temple designed as meeting place for man and gods in Sumer, c. 2100 B.C.

PYRAMID — gigantic monument for dead pharaoh; first named architect, Imhotep, built stepped pyramid for Egyptian King Zoser, c. 2780 B.C.

PARTHENON — Iktinos and Phidias perfected Greek Doric temple style, 447–432 B.C.

PANTHEON — best example of Roman monumental architecture, fully exploited arch, vaults, dome, concrete, c. A.D. 118–28

BYZANTINE — Anthemius of Tralles and Isidore of Miletus supported dome of Hagia Sophia by pendentives to allow flood of light, 532–37

ROMANESQUE — church style with massive piers and towers, round-topped arches like St. Sernin, begun c. 1080

GOTHIC — vault supported by flying buttresses, strong vertical orientation and pointed arches like Chartres Cathedral, 1194–1260

RENAISSANCE AND BAROQUE

BRUNELLESCHI (1377–1446) — first great Italian Renaissance architect, rediscovered Classical forms and simplicity

ALBERTI (1404–72) — formulated architectural theory based on rules of proportion

BRAMANTE (1444–1514) — High Renaissance architect who redesigned St. Peter's Cathedral

MICHELANGELO (1475–1564) — remodeled Capitoline Hill in Rome

PALLADIO (1508–80) — arch-and-column compositions of symmetrical villas copied around world

BERNINI (1598–1680) — designed Roman churches, chapels, fountains for theatrical effect

BORROMINI (1599–1667) — used curves and countercurves, rich surface decoration

CUVILLIÉS (1695–1768) — designed extravagant Rococo rooms based on mirrors, gilt, profusely carved stucco

NINETEENTH CENTURY

JEFFERSON (1743–1826) — revived Classical/Palladian style in neo-temples

EIFFEL (1823–1923) — devised namesake tower in 1889 as triumph of engineering and industrial materials

SULLIVAN (1856–1924) — developed modern architecture with form-follows-function concept

GAUDI (1852–1926) — Spanish Art Nouveau architect based fluid, linear style on organic forms

TWENTIETH CENTURY

WRIGHT (1869–1959) — American innovator who pioneered "organic" buildings with flowing lines

GROPIUS (1883–1969) — led Bauhaus trend toward functionalism

MIES VAN DER ROHE (1886–1969) — perfected simple, unornamented skyscraper with glass curtain walls

LE CORBUSIER (1887–1965) — shifted from sleek, International Style buildings to sculptural fantasies

JOHNSON (b. 1906) — evolved from International Style to Post-Modernism

PEI (b. 1917) — stark, geometric buildings like abstract sculpture

GEHRY (b. 1929) — "Deconstructivist" architect whose buildings of disconnected parts have unfinished, semipunk look

GRAVES (b. 1934) — introduced color and historical references into modern design

VENTURI (b. 1925) — leading theoretician for diversity in architecture

PHOTOGRAPHY: WHAT'S NEW

"Straight," undoctored photography, as championed by Alfred Stieglitz, retained its advocates until World War II, then gradually gave way to a more subjective use of the medium. In the new, introspective style, rather than just presenting objective information in documentary form, the camera expressed feelings and manipulated reality to create fantasies and symbols. Photojournalist W. Eugene Smith, in his moving portraits of Japanese children crippled by mercury poisoning, used pictures to comment on society with what he termed "reasoned passion." Rather than a single trend or movement, the most important trait of contemporary photography is diversity. The following photographers represent some of the types of photography being practiced from late Modernism through Post-Modernism.

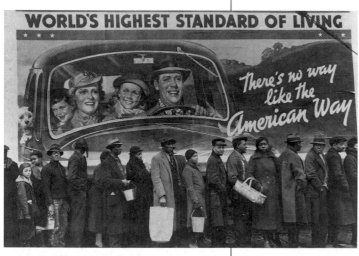

Bourke-White, "At the Time of the Louisville Flood," 1937, collection of the George Arents Research Library, Syracuse University, NY. *Bourke-White's broad, poster like style shows the unemployed on a breadline during the Depression, ironically revealing the gap between the American dream and reality.*

ABBOTT: "THE PAST JOSTLING THE PRESENT." American photographer Berenice Abbott (1898–1991) began her career in the heroic age of photography, when it was first established as an art form. She produced a series of New York street scenes in the 1930s for which she is best known. In her Modernist photographic style, Abbott framed compositions dynamically, shooting up or down at dizzying angles to capture the city's vitality. She wanted to show the "spirit of the metropolis," while remaining true to its essential fact, its hurrying tempo," to evoke "the past jostling the present."

BOURKE-WHITE: THE PHOTO-ESSAY. When Henry Luce hired American photographer Margaret Bourke-White (1904–71) for *Fortune* magazine, he taught her that pictures had to be both beautiful and factual. In her obsessive drive for the perfectly composed photograph, she never forgot to include the essential truth of a situation. Bourke-White shot classic photo-essays that brought the reality of American and Soviet industry and the Depression home to millions of readers. An aggressive, fearless reporter, she flew in planes and dangled from cranes to get exactly the right shot. Her colleague Alfred Eisenstaedt said she had "the ideal attitude" for a photojournalist:

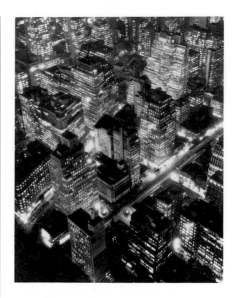

Abbott, "Nightview, NY," 1932, Commerce Graphics Ltd., Inc. *Shot from atop the Empire State Building, this panorama conveys the energy and romance of the city.*

"At the peak of her distinguished career," she "was willing and eager as any beginner on a first assignment. She would get up at daybreak to photograph a bread crumb, if necessary." "Sometimes I could murder someone who gets in my way when I'm taking a picture," Bourke-White said. "I become irrational. There is only one moment when a picture is there, and an instant later it is gone — gone forever."

In World War II and the Korean War, Bourke-White, heeding war photographer Robert Capa's advice: "If your pictures are no good, you aren't close enough," faced danger on the front lines. She unflinchingly recorded the dazed faces of survivors when Buchenwald was liberated. Her work for *Life* magazine both popularized the photo-essay and opened the way for women to compete with male journalists, proving women were physically and technically capable of such a demanding task.

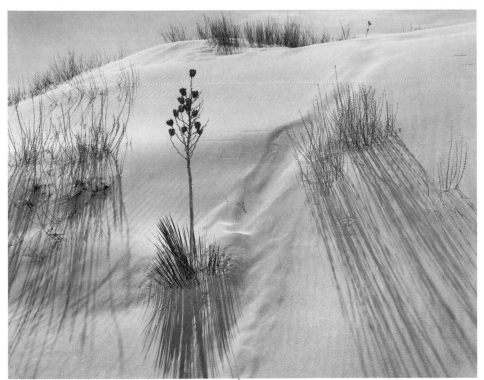

Adams, "Sand Dunes, White Sands National Monument, N.M.," c. 1942, Courtesy of Trustees for Ansel Adams Trust, NY. *A master of landscape photography, Adams was legendary for his technical skill, as seen in this balanced, controlled picture composed with precise clarity.*

***ADAMS:* THE AMERICAN WEST.** When he was 14, Ansel Adams (1902–84) took his first picture with a Brownie box camera of mountain peaks in the Yosemite Valley. For the next six decades, he took pictures of Yosemite, each a technically perfect rendition of unspoiled nature. "Big country — space for heart and imagination," he described it. The preeminent photographer of the American West, Adams never grew bored with these scenes. A conservationist and mountaineer, he loved the wilderness intensely and believed "a great photograph is a full expression of what one feels."

With Stieglitz, Weston, and Paul Strand, Adams was a leading advocate of "straight" photography. Avoiding tricky camera angles, he previsualized his final image in a large-format view camera. This allowed him to capture the scene with rich texture, meticulous detail, and an infinite tonal range from light to dark. Above all, the quality of light infuses Adams's scenes with drama. Shades vary from clear white to inky black, dividing his photographs into distinct zones. Trained as a pianist, Adams brought the same technical control to photography and achieved virtuoso prints that shine with clarity. A photograph, he believed, is "an instrument of love and revelation."

STREET PHOTOGRAPHY. In the '60s, with the rise of Pop art and Venturi's stress on vernacular architecture, a new style of photography arose called "snapshot aesthetic." Professionals deliberately framed casual, unposed photos resembling amateur efforts in order to banish traces of artifice. In this head-on approach, "street photographers" like Diane Arbus, Robert Frank, Bruce Davidson, Garry Winogrand, Lee Friedlander, and Joel Meyerowitz documented the "social landscape" of cities.

Arbus, known for her images of "freaks"— transvestites, hermaphrodites, giants, and dwarfs—brought the most harrowing eye to this task. Yet she approached these marginal people without prejudging them. What seems most bizarre in her work are the shots of "normal" people, fixed in unrehearsed poses that transform them into grotesques. In one picture of a mother and child, the mother's fingers seem to be squeezing the life out of her son, who drools a river of spittle and glares at the camera. In a 1972 retrospective at the Museum of Modern Art, Arbus's images made her subjects look so ugly that viewers spit on the pictures.

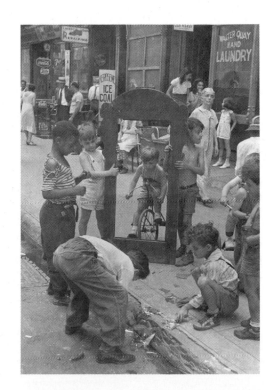

Levitt, "New York (Broken Mirror)," 1942, Laurence Miller Gallery, NY. *Helen Levitt's straightforward style shows both the complexity and humanity of the best "street photography."*

UELSMANN: FANTASYLAND. An American photographer who exploits the bizarre in a totally different vein than Arbus is Jerry N. Uelsmann (b. 1934). Uelsmann sandwiches half a dozen or more negatives superimposed on one another into one print. He combines these images seamlessly to make a totally unreal scene out of real objects. "The mind knows more than the eye and camera can see," he has said. Early in his career, Uelsmann portrayed women as fertility figures, with their nude bodies growing out of grass, embedded in rocks, or floating over the ocean. His work succeeds best when he transmutes ordinary objects into uncanny, startling symbols to bring out what he calls "an innermost world of mystery, enigma, and insight."

Uelsmann, "Navigation without Numbers," 1971, Courtesy of the artist. *Uelsmann layers different negatives to produce a photomontage that restores magic to photography.*

Baldessari, "The Story of One Who Set Out to Study Fear," 1982, Sonnabend Collection, NY.

Conceptual artist John Baldessari is considered a pioneer of Post-Modernism. This narrative photo sequence shows the Contemporary tendency to combine images with text.

PHOTO-REALISM

Also known as Hyper-Realism, Photo-Realism thrived in the United States from the mid-'60s to mid-'70s. Influenced by Pop art, it reproduced photographs in painting with such fidelity one critic called it "Leica-ism." To achieve near-exact likenesses, artists projected photo slides on canvas and used commercial art tools like the airbrush. Their painted reproductions of reality are so detailed, the work rivals fifteenth-century master Jan van Eyck's. Despite this surface factualness, however, Photo-Realists differ from their predecessors. Post-Modern realism adopts the flattened effect of a camera image and treats objects as elements in an abstract composition.

HANSON: PHOTO-REAL SCULPTURE

If you ask a museum guard a question and he doesn't respond, don't be upset. It could be the "guard" is a Duane Hanson statue. Hanson's life-size works, dressed in real clothes, are so lifelike they make wax museum replicas seem abstract.

From plaster casts of real people, Hanson constructs tinted fiberglass models, which he outfits with wigs, glasses, and jewelry so they're nearly indistinguishable from the real thing. His "Tourists" (1970) portrays an elderly man in plaid bermuda shorts and flowered shirt, festooned with camera, tripod, and film cannisters. His wife sports a tacky scarf, gold sandals, and tight polyester pants. On the street, viewers would ignore such tourists, but they stare with fascination at this familiar species in a gallery.

Most Photo-Realists specialize in one subject. Richard Estes does highly reflective city windows. Audrey Flack paints symbolic still lifes, Malcolm Morley portrayed travelers on cruise ships during his Photo-Realist phase, and Chuck Close paints large-scale mug shots.

ESTES: WINDOWS ON THE WORLD.
Richard Estes (b. 1936) goes the camera one better. His sharp-focus street scenes have even more depth of field and precise long-distance detail than a camera could ever capture. Estes projects a photo on a canvas and paints over it in a procedure similar to that other master of realism, Vermeer, with his camera obscura. But where Vermeer's subject was light, Estes specializes in reflections. His luminous plateglass windows contain a labyrinth of layered images. The paintings portray a clear, glossy world but, at the same time, a world of distortions and ambiguity.

Another Photo-Realist who paints reflections in shop windows is Don Eddy (b. 1944). Eddy airbrushed gaudy designs on surfboards and hotrod cars as a California teenager, then worked as a photographer. His technicolor paintings fuse the two skills, highlighting precise details with hyperclarity.

FLACK: POST-MODERN STILL LIFES.
Audrey Flack (b. 1931) also borrows a trick from Dutch Renaissance artists: the "vanitas" painting, or still life with objects symbolizing the brevity of life. Yet Flack's paintings deal with twentieth-century issues like feminism. Each object is an allegory for women's role in the modern world — like the queen chess piece in "Queen" — versatile, powerful, but ultimately subordinate.

Close, "Fanny/Fingerpainting," *1985, Pace Gallery, NY. Working from photos, Close builds remarkable likenesses from a variety of tiny marks.*

CLOSE: CLOSE-UP.
Since 1967, Chuck Close (b. 1940) has painted gigantic passport photos of his friends' faces. With dazzling technique, he produces detailed portraits that — seen from a distance — look uncannily like giant blown-up photographs. Yet up close, the viewer becomes aware of the process of representing the image, for Close often paints with unorthodox means, such as building an image out of his own inked fingerprints. This gives an impression of fluctuation. Like Seurat's pointillist technique, the many small dots forming the image flicker back and forth in the spectator's mind. One moment, it's a spitting image of a person, the next it's an animated pattern of spots.

NEO-EXPRESSIONISM

The Minimalists in 1975 wrote obituaries for painting, insisting the future belonged to video, performance art, and Conceptual Art — things like ball bearings scattered on the floor. Well, like Mark Twain's death, the Demise of Painting was greatly exaggerated. In the eighties painting was back with a bang. And not zero-content, no-color painting but painting that bashes you over the head like heavy metal music.

The new movement was born in Germany and reached a climax of international esteem in the 1980s. It was termed Neo-Expressionism because it revived the angular distortions and strong emotional content of German Expressionism. Neo-Expressionism brought back such banished features as recognizable content, historical reference, subjectivity, and social comment. It resurrected imagery, the easel painting, carved or cast sculpture, and the violent, personalized brushstroke. Bricks on the floor or shelves on a wall weren't going to cut it any more. Where art of the '70s was cool as ice, art of the '80s was hot, hot, hot. The leaders were Germans like Anselm Kiefer, Gerhard Richter, Sigmar Polke, and Georg Baselitz and Italians like Francesco Clemente, Sandro Chia (pronounced KEY ah), and Enzo Cucchi. Neo-Expressionism marked the rebirth of Europe as an art force to be reckoned with.

Kiefer, "To the Unknown Painter," 1983, Carnegie Museum of Art, Pittsburgh. *Kiefer uses thick, dark paint to represent charred earth, evoking the horror of the Holocaust.*

***KIEFER:* SCORCHED EARTH.** Called by art critic Robert Hughes "the best painter of his generation on either side of the Atlantic," Anselm Kiefer (b. 1945) became an '80s star due to the new taste for narrative art. The subject he deals with provokes a strong response: German and Jewish history from ancient times through the Holocaust. Kiefer represents his central motif — charred earth — through thick, dark paint mixed with sand and straw. Kiefer showed an early fascination with Nazi atrocities. As a young artist doing Conceptual work, he took photos of himself in Nazi regalia giving the Sieg Heil salute. "I do not identify with Nero or Hitler," he explained, "but I have to re-enact what they did just a little bit in order to understand the madness."

The means Kiefer chooses to portray fascism are unorthodox. Besides sand and straw, his paintings are collages of acrylic paint, tar, epoxy, copper wire, melted and hardened lead, and ceramic shards.

BEUYS:
GURU OF NEO-EXPRESSIONISM

The father-figure of Neo-Expressionism was Joseph Beuys (1921–86). As a teacher and artist, Beuys taught a generation of young German artists to reexamine their history without illusion. Beuys was a radical in both art and politics. A member of the left-wing Green party who believed everyone was an artist, Beuys wanted to regenerate humanity. He shifted attention from art as an object to the artist as activist. He created a mythic persona for himself, spouting his revolutionary credo to young followers and the press with religious fervor.

Part of Beuys's heroic status derived from his war experience. As a Lüftwaffe pilot he crashed in the Crimea (the hat he always wore hid scars). Tartar nomads cared for him, wrapping him in felt and fat to keep him warm in subzero temperatures. Beuys used these materials in his work, as well as industrial substances. At his Guggenheim show, Beuys exhibited a large tub of pork fat; he often heaped piles of felt and stacks of iron, copper, or lead as art displays. Beuys was also a performance artist who staged irrational spectacles like chatting with a dead rabbit. Like Germany's postwar Economic Miracle, Beuys re-energized German art.

Clemente, "Francesco Clemente Pinxit," 1981, Virginia Museum of Fine Arts, Richmond. *Clemente distorts the body to express irrational fears and fantasies.*

***CLEMENTE:* BODY LANGUAGE.** Another European who employs the Expressionist mode successfully is Francesco Clemente (b. 1952). In various media (watercolor, pastel, fresco, and oil), Clemente portrays nightmarish, hallucinatory states of mind through images of fragmentary body parts. "I'm interested in the body as a conductor between what we show on the outside and what we feel within," Clemente said.

Clemente's portraits uncover more than the naked human body. They suggest repressed urges and fantasies that both repel and fascinate. His faces are typically distorted with psychic strain, à la Munch, and rendered in unnatural color. In one painting, a pair of feet exudes a brown substance resembling blood, feces, and mud.

***BASELITZ:* THE WORLD TURNED UPSIDE DOWN.** Painter-sculptor Georg Baselitz (b. 1938) led, with Beuys, the revival of German Expressionism. A controversial artist, since 1969 he has portrayed figures upside down to show his disdain for convention.

Like Kiefer, Baselitz deals with World War II and its aftermath. In the '60s he painted despondent pilots and pink, gangrenous feet. As a child Baselitz witnessed the firebombing of Dresden in 1945, which inspired a major work, "45." The piece consists of twenty large paintings of women's faces (upside down) on wood. The faces are purposely distorted, looking like terrified Raggedy Ann dolls with their pink skin and red hair. Transcending the comic effect is Baselitz's violently scarred wood. With chisel, chainsaw, and wood plane he attacked the images, making them look under fire. Violent vortexes of slashes and gouges spin out from the faces as if victims of strafing.

***BASQUIAT:* THE WILD CHILD.** Jean-Michel Basquiat (pronounced BAHS kee aht; 1960–88) died at age 28 of a drug overdose. The enfant terrible of '80s art, he lived, painted, and died hard.

A high school dropout and self-taught painter, Basquiat first made his mark around 1980 in downtown New York scrawling graffiti slogans on walls. As part of a two-man team known as SAMO (for "same old shit"), he left anonymous social observations like: "riding around in Daddy's convertible with trust fund money" and "SAMO as an antidote to nouveau-wavo bullshit." In 1981 Basquiat, of mixed Haitian and Puerto Rican descent, turned to painting and was instantly taken up by the art world. His intense, frenetic canvases, crammed with graffiti lettering and cartoonish figures, made him a Neo-Expressionist superstar.

Basquiat's street-smart work conveys the fierce energy and jazzy spontaneity of rap music. He collaborated with his friend and mentor, Andy Warhol, for a few years before Warhol's death in 1987. Basquiat, with his fast-track personality and self-destructive life-style, had the fifteen minutes of fame Warhol predicted. He was both a legend and a casualty of the superheated '80s art scene.

THE NEW BREED: POST-MODERN ART

Art in the '90s is as diverse as the post–Cold War world. With nations changing their stripes as rapidly as a chameleon on plaid, art too is in a state of flux. Yet certain attitudes recur with enough frequency to note as significant. For example, art in the '90s is nothing if not political. Text-heavy installations exhort viewers to consider issues like the AIDS epidemic, environmental problems, homelessness, racism, sex, and violence. The materials and formats of art are as varied as the subjects, with alternative art forms, like performance art and hybrid genres like photo-derived art, multiplying. Post-Modernists may declare that Modernism's rejection of reality is obsolete, but the process of re-inventing art continues unabated.

APPROPRIATION ART: THE ART OF RECYCLING.
A key Modernist concept undermined by '80s art was the idea of the art object as a hand-made original. This magnum opus was supposed to be a culminating statement, the product of an artist's gradual progress. Forget progress, said the Post-Modernists, for whom "new" did not automatically equate with "improved." The future of art lay in the past more than in the individual imagination.

Artists began to appropriate images from diverse sources, as Pop artists had done, but drew on art history and mythology as well as the mass media. They combined pre-existing images with their own (as in the work of Julian Schnabel and David Salle) or presented the appropriated images as their own (Louise Lawler's montages of famous art works, Mike Bidlo's obvious forgeries of masterpieces, and Sherrie Levine's photographs of Edward Weston photographs). Jeff Koons recast kitsch images like an inflatable bunny in stainless steel. By retreading familiar ground, Appropriation Artists sought to annex both the power of the original image and reveal its manipulative force as propaganda.

Schnabel, "Hope," 1982, Whitney, NY. *Schnabel layers different images and objects, showing how Appropriation Art recycles pre-existing elements into new statements.*

PHOTOGRAPHY-DERIVED ART: RERUNS.
A form of Appropriation Art uses photographic images in unexpected combinations to re-interpret history and comment on socio-political issues. Relying on mechanical reproduction rather than handmade imagery, this new hybrid art form fragments, layers, and juxtaposes photographed images (as in the torn, yellowed photo-assemblages of Doug and Mike Starn, known as the Starn Twins) to change their context and meaning.

KRUGER: BILLBOARD BARRAGE.
New Jersey-born Barbara Kruger (b. 1945) splices cropped photographic images with text in an impassioned, punchy, feminist art. Kruger's aggressive polemics use a mock-advertising graphic style of blown-up images with confrontational messages that assault the viewer. "I want to speak and hear impertinent questions and rude comments," Kruger said. "I want to be on the side of surprise and against the certainties of pictures and property."

Kruger, "Untitled (What big muscles you have!)," 1986, Centre Pompidou, Paris. *Kruger's jolting combination of language and image speaks out on political issues like censorship, abortion, domestic violence, and bigotry.*

Sherman, "Untitled #228," 1990, Metro Pictures, NY. *Sherman photographs herself as characters based on Old Master portraits.*

SHERMAN: COSTUME MELODRAMAS.

American artist Cindy Sherman (b. 1954) specializes in fabricated self-portraits in which she dresses up like Hollywood or Old Master stereotypes and photographs herself. In the 1970s she "starred" in imaginary black-and-white movie stills based on '50s film noir clichés. The sham images of terrified, wide-eyed ingenues often implied sex and violence as well as the limitations of traditional female roles — always the victim, never the victor.

Her '80s work shifted to large-scale color prints in which she masqueraded as both male and female characters derived from art masterpieces. Yet, though she closely resembled a Holbein monk, Fragonard courtesan, or van Eyck matron, the re-creations were deliberately artificial, emphasizing obvious bits of fakery like false noses, wigs, or latex bosom. Although the sham self-portraits seem like narcissistic role-playing, they are "pictures of emotions personified," Sherman insisted, "not of me." Her stated goal: "I'm trying to make other people recognize something of themselves rather than me."

LONGO: THE CITY AS CINEMA.

American artist Robert Longo (b. 1953) calls himself "the anti-Christ of media, coming back at the culture that created me." A leading image-appropriator, he transforms commercial and cinematic images into high-impact, billboard-sized paintings that project the menace and violence of the city at night. Longo's huge, powerful, mixed-media works seethe with intensity, using high-contrast, mass-media style to manipulate audience response. "I want the viewer to look at something that is both beautiful and horrifying," Longo said. "I am looking for a positive force in negative imagery."

Longo, "Cindy," 1984, Whitney, NY. *Longo draws on cinematic and commercial imagery to project a sense of menacing urban life.*

NARRATIVE ART: STORY TIME. Art in the '80s saw the rebirth of the painting as an accessible form of storytelling. Mark Tansey's monochrome canvases portrayed an imaginary version of history, such as the occupation of SoHo by German troops (a sly dig at the takeover of art by German Neo-Expressionists). Faith Ringgold combines text and imagery in her patchwork quilts recounting the life of black women. Sue Coe's feminist paintings memorialize events like "Woman Walks into Bar — Is Raped by 4 Men on the Pool Table — While 20 Men Watch." Leon Golub's overtly political paintings protest war and the abuse of power. For Golub, art is not comfortable or pleasurable but unsettling: "The work should have an edge." Others who use recognizable imagery to convey autobiographical concerns are David Hockney (with his California pools, palms, and photomontages), Jennifer Bartlett (who explores multiple facets of a scene in serial images), Susan Rothenberg (in her feathery paintings of dancers), and Elizabeth Murray (who fragments domestic objects into mysterious, detonated puzzles).

FISCHL: SUBURBAN PSYCHODRAMA.

New York painter Eric Fischl (b. 1948) burst into notoriety with "Sleepwalker" in 1979, a painting in which a surly teenage boy masturbated in a backyard wading pool. Critics hailed his disturbing images as exposés of the failure of the American dream. Like John Cheever short stories, on the surface his paintings portrayed ordinary suburbanites, but their subtext reeked loneliness, desperation, and dread. Sexually loaded, Fischl's images of middle-class life have "What's wrong with this picture?" undertones. The stories alluded to on canvas require viewer participation to resolve their ambiguities.

After envisioning Levittown as Gomorrah, Fischl turned to exotic locales, setting his lushly painted scenes in the Caribbean, Morocco, India, and the Riviera. Despite the mock-travelogue gloss, the same danger and enigma lurk. "The new paintings are about me in the world; the other was about the world in me," Fischl said. "They're equally terrifying."

"A Visit To/A Visit From/The Island," for instance, contrasts indolent, affluent tourists basking in ignorance of the violent world that threatens the black working class. What links the two halves of the diptych is the storm cloud gathering over the frolicking white vacationers, a storm that brings death to the vulnerable natives. In Fischl's words: "I try to create the effect of something unsaid."

Fischl, "A Visit To/A Visit From/The Island," 1983, Whitney, NY. *Fischl's narrative paintings — psychologically tense and emotionally complex — require viewer participation to decipher their meaning.*

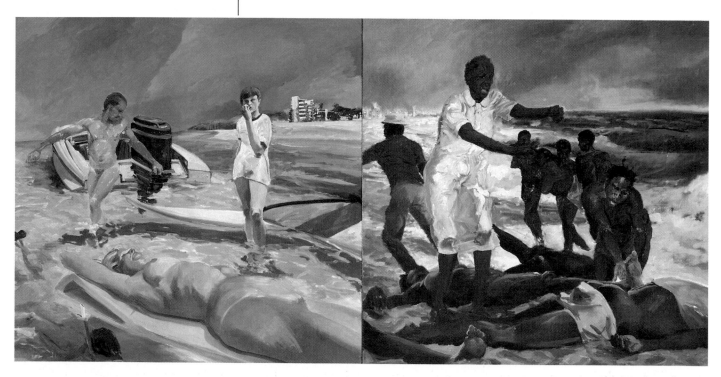

GRAFFITI ART. Based on the Italian word for "scratch," graffiti are scribbled words or doodles on walls. Even found in ancient Egyptian tombs, graffiti first appeared in the artist's studio with American painter Cy Twombly, Frenchman Jean Dubuffet, and the Spaniard Antoni Tàpies. Real graffiti art is an art of the streets. Armed with felt-tip markers and aerosol spray cans, in the 1970s and '80s hundreds of graffiti "bombers" made their mark on the urban scene, often covering entire subway cars in New York with cartoon-derived words and images.

POLITICAL ART. In art of the '80s and '90s, words are often as important as images, and tirades of text confront gallery-goers. Much purely visual art has an overtly feminist slant, as in Mary Kelly's work. Judy Chicago's "The Dinner Party" (1979) installation includes a "table" and place settings representing great women of history. Performance artists like Laurie Anderson, Karen Finley, and Eric Bogosian also speak out against sexism, racism, and economic injustice in mixed-media, theatrical monologues. In her performance piece "The Black Sheep," Finley shrieked her outrage against the white, male power structure. Stripped to her underpants and smeared with chocolate simulating excrement, Finley used her body as a symbol of women's degradation.

POST-MODERN SCULPTURE. Oil on canvas may have made a comeback in painting, but the only thing certain about Contemporary sculpture is that the figure on a pedestal is long gone — probably for good. Several trends are evident, however, such as the use of a wide range of materials, from dolls to furniture to

GRAFFITI GRAPHICS. The first professionally-trained artist to use the graffiti style was New Yorker Keith Haring (1958–90). Although he was frequently arrested for defacing public property, commuters soon began to appreciate Haring's trademark images scrawled in subways: the "radiant baby," barking dog, zapping spaceships, and winged television set. "Everything I ever dreamed I could accomplish in art was accomplished the first day I drew in the subways and the people accepted it," he said. When Haring died of AIDS, graffiti art, which had rapidly become commericalized, was finished as a force in art.

Haring, "Untitled," 1982, Courtesy of Keith Haring estate.

industrial products. Mario Merz, leader of Italy's Arte Povera (pronounced AR tay po VAIR uh, which means "poor art") movement, uses rubber, newspapers, bales of hay, and neon tubing in his igloo-shaped works.

Reflecting the era's infatuation with speed and technology, other sculptors use machine parts to incorporate movement into their work. Mark di Suvero, a former crane operator, welds steel girders into abstract kinetic forms that gyrate like lumbering mastodons.

Both the American John Chamberlain and French sculptor César found gold in auto junkyards. They twisted demolition derby debris like warped fenders and squashed cars into macabre metal forms, as arresting as a roadside pileup.

Installations are in vogue, ranging from Chilean artist Alfredo Jaar's (b. 1956) pleas for justice in the Third World to American Judy Pfaff's fantasy environments like colorful underwater gardens.

Semiabstract sculpture that refers to recognizable objects is alive in the hands of black American Martin Puryear (b. 1941) and American Nancy Graves (b. 1940). Graves's painted, cast bronze pieces are playful explosions of oddly grafted forms like lavender and orange palmetto leaves pinwheeling into the air. Puryear is known for his virtuoso handling of wood.

Figurative art is eerily evocative in the work of American Kiki Smith (b. 1954), who bases her sculpture on the human body, "our primary vehicle," she said, "for experiencing our lives." Soon after the death of her father, Abstract Expressionist artist Tony Smith, Kiki produced a piece both disturbing and consoling: an algae-coated wax hand floating in a mason jar of dark green water. A certified Emergency Medical Technician, Smith presents the body as a frail clinical specimen and, at the same time, a resilient spiritual vessel.

WHAT'S HAPPENING NOW. Art in the '90s, like life in the '90s, reflects the unsettled twilight of the twentieth-century. It offers questions more than answers, challenges more than certainty. As Contemporary painter Mark Tansey put it, "A painted picture is a vehicle. You can sit in your driveway and take it apart or you can get in it and go somewhere." Art so far in the '90s ranges from figurative to abstract, funky to "serious," handmade to mechanically produced. Some of the Up-and-Comers on the scene today, and the style that put them on the map, are:

ROBERT ARNESON — California artist who founded Funk Art with intentionally vulgar ceramic busts

ASHLEY BICKERTON (b. 1959) — known for abstract wall sculptures, thickly encrusted with paint

ROSS BLECKNER (b. 1949) — paints large-scale abstractions with subtle variations in color and pattern

CHRISTIAN BOLTANSKI — French Conceptual artist specializing in installations

JONATHAN BOROFSKY (b. 1942) — creates large, mixed-media installations of painting, sculpture, text, video, and found objects

SOPHIE CALLE — French artist known for narrative photo-sequences

JIM DINE — paints Pop images like tools, robes, hearts

ROBERT GOBER (b. 1954) — explores flesh and the body in sculptures made of wax and human hair

GROUP MATERIAL AND GRAN FURY (includes David Wojnarowicz, 1954–92) — two activist artists' collectives dealing with issues relating to AIDS

GUERRILLA GIRLS — left-wing artists' collective that produces posters protesting censorship, sexism (example: Mona Lisa with fig leaf covering mouth)

REBECCA HORN — combines moving mechanical parts in feminist installations

JÖRG IMMENDORFF — German Neo-Expressionist obsessed with socio-political issues

ALEX KATZ — radically stylizes imagery in clean, figurative paintings

MIKE KELLEY (b. 1954) — signature work: bedraggled stuffed animals and dolls

BRUCE NAUMAN (b. 1941) — Conceptual artist known for wax-cast heads and video installations

NAM JUNE PAIK — "father" of video art

ANTOINE PREDOCK (b. 1937) — quirky New Mexico architect who reveres landscape and site

TIM ROLLINS (b. 1955) and K.O.S. (Kids of Survival) — collaboration between artist and South Bronx teenagers who paint on pages of books

RICHARD PRINCE (b. 1949) — Appropriation artist who invented "re-photography," or making photographs of photographs; also does silk screen paintings of cartoons

LUCAS SAMARAS (b. 1936) — creates surreal images by altering photographs

NANCY SPERO (b. 1926) — feminist artist who layers visual images and written language

DOUG AND MIKE STARN (the Starn Twins, b. 1961) — manipulate, deface, recombine photographs

PAT STEIR (b. 1940) — known for abstract streams of paint inspired by waterfalls

PHILIP TAAFFE (b. 1955) — does abstract paintings composed of Byzantine patterns

CARRIE MAE WEEMS (b. 1953) — combines oddly lit, blurred black-and-white photos with text (example: "I sided with men so long I forgot women had a side.")

TERRY WINTERS (b. 1949) — paints organic forms in earthy colors

INDEX

Page numbers in *italics* refer to illustrations.

Every Day a Holiday

Celebrating Children's Literature throughout the Year

Elizabeth A. Raum

School Library Media Series, No. 21

The Scarecrow Press, Inc.
Lanham, Maryland, and London
2001

SCARECROW PRESS, INC.

Published in the United States of America
by Scarecrow Press, Inc.
4720 Boston Way, Lanham, Maryland 20706
www.scarecrowpress.com

4 Pleydell Gardens, Folkestone
Kent CT20 2DN, England

British Library Cataloguing-in-Publication Information Available

Library of Congress Cataloging-in-Publication Data

Raum, Elizabeth A., 1949–
 Every day a holiday : celebrating children's literature throughout the year / Elizabeth A. Raum
 p. cm — (School library media series ; no. 21)
 Includes bibliographical references and index.
 ISBN: 0-8108-4043-X (alk. paper)
 1. Children—Books and reading—Bibliography. 2. Holidays—Bibliography. 3. Special events—Bibliography. 4. Children's literature—Bibliography. I. Title. II. Series.

Z1037 .R27 2001
028.1'62—dc21 2001031051

For Mom and Dad—who make every day special

Contents

Acknowledgments

Credit for this book is shared with

The Curriculum Center, Reference Department, and Interlibrary Loan staff of the Carl B. Ylvisaker Library, Concordia College, Moorhead, Minnesota.

Joel Dahlin and Ryan Weber at free-clip-art.net who generously granted permission to use the clip art that decorates this book.

Carol Krabbenhoft who formatted the manuscript with the greatest care and expertise.

Richard Raum, my husband, who supported and encouraged this work.

Introduction

Is Every Day a Holiday?

Every day is a good day for reading, and every day, in one way or another, is a special day. Pairing books with special events provides a focus for story time and may help children develop creative connections between reading and the world around them. This book is designed for teachers, librarians, daycare workers, youth leaders, parents, and everyone who cares about children and wants to enrich children's lives with books.

Holidays

As I began researching material for this book, I was amazed to discover the thousands of intriguing holidays that are celebrated throughout the world. I simply couldn't include them all, but I have tried to represent a wide range of cultural, religious, and legal holidays, special events, and wacky celebrations. Holidays don't come neatly packaged, one to a day, so I had to make choices. Those choices were made on the basis of the following questions:

- Is the holiday one that can be explained to and appreciated by children?
- Will learning about this holiday enrich children's lives?
- Does the holiday contain unique elements that make it different from others already included in this collection?
- Are there children's books that complement this holiday?

Holidays marked with an asterisk (*) actually occur on one specific date only. (*January 17, Benjamin Franklin's Birthday* is such a holiday.)

Other holidays vary from year to year. This is true for many religious celebrations, particularly those based on a lunar or solar calendar, e.g. *Chinese New Year, Diwali,* or *Ramadan.* For these holidays, I have projected exact dates ten years ahead when possible. Many legal holidays vary slightly from year to year, and I have provided the rule when possible. Some holiday dates, however, are determined by particular groups on a year-to-year basis and a long-range forecast is not possible. *The National Tractor Pull* is such an event. Other holidays, usually those sponsored by a particular organization, last an entire month. For example, *January is Bath Safety Month.* Some holidays exist only in our hearts and may be celebrated whenever the time seems right. *Snow Day* or *Yard Sale Saturday* are such days.

The holiday reference books that I used in planning this are listed as General Holiday Resources in the Resource Guide in the back of this book. I used hundreds of additional sources, both web-based and print resources, to verify holidays and to locate additional information about the celebrations.

Children's Books

After I researched the holidays, I began matching each holiday with quality children's literature. The Resource Guide at the end of this book includes a complete listing of suggested children's books. The children's literature bibliographies that I used in matching books and holidays are also listed in the Resource Guide at the back of this book.

For some holidays, there are dozens of children's books available to support the holiday. If the connection is more creative, I have provided a brief explanation. While some of the books are recent, others are, unfortunately, no longer in print. Nevertheless, I have included these older titles knowing that many will still be available in libraries or in personal collections.

All of the books included in this collection are picture books or illustrated nonfiction books. However, the holidays are not all limited to the interests of the preschool or early elementary school child. Some holidays and the suggested books are clearly designed for younger children (e.g. *February 14—Ferris Wheel Day* or *April 11—National Garden Week*). Other holidays and books will appeal to older elementary or middle school children (e.g. *June 11—Cataclysmos Day* or *March 23—Pakistan Day*). As always, it is essential that you, as group facilitator, read the story and formulate discussion questions prior to sharing the book with children.

Activities

Adults who read to children are usually comfortable and gifted in leading book discussions. I have not included discussion questions, but have assumed that you will follow each reading with questions and discussion. The suggested activities included in this book are designed to extend and enhance the holiday celebration. Certainly many of you will devise their own activities tailored to your region, your group, and your own interests. The activities I've listed in this book are merely starting points as you begin to explore a topic.

I hope that this collection of holidays and children's books brings you and the children with whom you spend your special days, many months of happy celebrations.

*January 1 New Year's Day

 Since prehistoric times, people have celebrated the beginning of each new year. In ancient times, the new year was often celebrated with the coming of spring or even summer. The seasons of the year were used to mark the passage of time.

The Romans were the first to use January 1 as the beginning of the new year. In 45 B.C. Julius Caesar devised a new calendar with the help of an Egyptian astronomer, Sosigenes of Alexandria. This calendar set January 1 as New Year's Day and included a leap year day every four years. This early calendar was filled with errors. For example, 46 B.C. is called the Year of Confusion because it had 445 days and fifteen months. Eventually, however, the calendar was adjusted to match the seasons. Today we use the Gregorian calendar, which was developed in 1582 under the rule of Pope Gregory XII.

Many of the New Year customs that we observe today derive from ancient beliefs. Noise making on New Year's Eve is a tradition borrowed from ancient Babylon and India. The loud noises were originally intended to drive out the old year and to get rid of evil spirits before the arrival of the new year. In many cultures, people fired off guns or cannons to frighten off demons. Today fireworks serve as a reminder of these ancient beliefs. Other peoples greet the new year with the pleasant chime of church bells.

Featured Book

January Rides the Wind: A Book of Months, by Charlotte F. Otten; illus. by Todd L. W. Doney. Lothrop, Lee & Shepard, 1997.

Each month is described in a short verse. Vivid poetic images present activities typical in rural settings.

Additional Book

Little Sister and the Month Brothers, retold by Beatrice Schenk DeRegniers; illus. by Margot Tomes. Sebury, 1976.

Activities

1. Draw images representative of the months. Use the drawings to create a calendar for classroom use.
2. Create your own verses to describe typical activities in your neighborhood during the different months.
3. Research New Year's traditions throughout the world.

*January 2 Georgia Ratification Day

The first known European to travel to Georgia was Spanish explorer Hernando De Soto, who came looking for gold. It was the English, however, who established major settlements in the area. In November of 1732 James Oglethorpe and 120 settlers left England for Georgia aboard the ship *Anne*. They established the first town, Savannah, in February of 1733. The settlers suffered during the first hot Southern summer. Luckily a group of Jewish settlers arrived, bringing with them Dr. Samuel Nunes, who cured many

of the sick. The English and Jewish settlers were joined by German-speaking Protestants called Salzburgers. Other settlers from Scotland arrived soon after.

As time went on, settlers from Georgia joined with others in the thirteen colonies to oppose the British. When American leaders created the United States Constitution in 1787, Georgia was among the first to approve the constitution, making it our fourth state, on January 2, 1788.

Featured Book

Georgia Music, by Helen V. Griffith; illus. by James Stevenson. Greenwillow, 1986.

A young girl and her grandfather find joy in the Georgia countryside during a summer visit. After lunch, they listen to the music created by the bumblebees, crickets, and grasshoppers that inhabit the garden. In the evenings, grandfather makes music on his harmonica, and at night they go to sleep listening to the music of the katydids, the tree frogs, and the birds.

Additional Books

Wild Wild Sunflower Child Anna, by Nancy White Carlstrom; illus. by Jerry Pinkney. Aladdin, 1991.

This gentle poem about a child's joy at spending the day outdoors among the grass, flowers, ants, and beetles will evoke images reminiscent of Georgia.

Bo Rabbit Smart for True: Folktales from the Gullah, retold by Priscilla Jaquith; illus. by Ed Young. Philomel, 1981.

Many of these folk tales, which have been told in Georgia for years, trace their origins to India and Africa. (See "Notes" at the back of the book.)

Activities

1. Play the song "Georgia on My Mind." Do the music or the words create an impression of Georgia? How does this compare to the Georgia music in the story?
2. Create your own Georgia music. Assign students parts (cricket chirpers, bumblebee buzzers, tree-frog trillers, bird twitterers), and reread the story with sound effects.

*January 3 Drinking Straw Anniversary

On January 3, 1888, Marvin Stone patented the spiral winding process which allowed for the manufacture of the first paper drinking straw. Prior to this time, natural rye grass straws were the only alternative for beverage drinkers. Stone created the process by winding strips of paper around a pencil and gluing it together. Straws were wound by hand until 1906, when a machine was developed which could wind straws. Eventually this invention led to a variety of other possibilities for the spiral winding process. January 3 is a great day to celebrate inventiveness and creativity.

Featured Book

Andrew Henry's Meadow, by Doris Burn. Coward-McCann, 1965.

Andrew Henry is an inventive boy whose family does not always appreciate the way he turns the house upside down with his inventions. One day he leaves home for a distant meadow where he creates a unique village of special houses for himself and his friends.

Additional Book

Herbert Binns & The Flying Tricycle, by Caroline Castle and Peter Weevers. Dial, 1986.

Activity

Draw or describe a fantastic invention of your own.

January 4 Letter Writing Week

Universal Letter Writing Week, celebrated during the first seven days in January, is sponsored by the International Society of Friendship and Good Will whose members reside in 189 different countries. The society encourages its members to use both English and the international language, Esperanto, to communicate by letter with friends all over the world. The society feels that early January is a good time to think of and write to friends worldwide.

Featured Books

Dear Peter Rabbit, by Alma Flor Ada; illus. by Leslie Tryon. Atheneum, 1994.

This book is a veritable feast of letter writing as various fairy tale characters, including Goldilocks, Peter Rabbit, and the Three Pigs, exchange letters.

Dear Mr. Blueberry, by Simon James. Margaret K. McElderry, 1991.

Emily and her teacher, Mr. Blueberry, exchange letters about the whale that Emily believes lives in her backyard pond.

Additional Books

Dear Bear, by Joanna Harrison. Carolrhoda, 1994.

The Jolly Postman, by Janet Ahlbert. Little Brown, 1986.

Love Letters, by Arnold Adoff; illus. by Lisa Desimini. Blue Sky, 1997.

Post Card Passages, by Susan Joyce; illus. by Doug DuBosque. Peel, 1994.

Stringbean's Trip to the Shining Sea, by Vera B. Williams and Jennifer Williams. Greenwillow, 1988.

Activity

Write letters to family members; another class in your school, town, state, or even in a different country; the principal, mayor, governor, or president; people living in a local nursing home.

*January 5 La Befana

In Italian folklore, the three wise men met an old woman, Befana, who was busy cleaning her house. She asked where they were going and when they told her that they were going to see the new Messiah, she asked if they would wait until she finished her chores so she could go along. They declined to wait; after all, their business was urgent. They encouraged her to visit the newborn king as soon as she finished her cleaning.

When she finally set out to find Jesus, it was too late. Ever since that time, Befana has been wandering all over the world in search of the baby Jesus. She climbs down chimneys on the evening of January 5, Epiphany Eve, bringing gifts to children just as the wise men brought gifts to the infant Jesus. A similar tale developed in Russia with stories about an old woman called Baboushka.

The next day, January 6, is known as Epiphany or Twelfth Night. It marks the visit of the three kings to Bethlehem and the last of the twelve days of Christmas.

Featured Books

The Legend of Old Befana, by Tomie De Paola. Harcourt Brace Jovanovich, 1980.

Befana, by Anne Rockwell. Atheneum, 1974.

Both stories briefly retell the legend of Befana. De Paola's bright, bold illustrations contrast with Rockwell's pencil drawings. Each of the books focuses on different details of the Befana legend.

Activities

1. Compare and contrast the two versions of the La Befana legend.
2. Create skits based on the story.
3. Consider various Christmas legends. How does the story of La Befana compare with the story of St. Nicholas? Chart the differences.

*January 6 National Smith Day

Smith is the most common surname in the English-speaking world. Approximately 1,282,500 Smiths live in the United States. All people named Smith, including such variations as Goldsmith and Koopersmith, are invited to celebrate on National Smith Day.

January 6 was chosen as Smith Day to honor Captain John Smith who was born in England on January 6, 1580. He later became the leader of the English colonists who settled at Jamestown, Virginia, in 1607. Another famous Smith, Jedediah Strong Smith, was born in Bainbridge, New York, on January 6, 1799. As one of the first explorers of the American west, Jedediah Smith helped to develop the Oregon Trail. He claimed to be the first American to reach California by land and to travel from San Diego up the West Coast to the Canadian border. He was killed by Comanche Indians on the Sante Fe Trail in present-day Kansas on May 27, 1831.

Celebrate National Smith Day by reading books written or illustrated by Smiths. There are dozens.

Featured Books

Chester the Out-of-Work Dog, by Marilyn Singer; illus. by Cat Bowman Smith. Henry Holt, 1992.

Clay Boy, retold by Mirra Ginsburg; illus. by Jos. A. Smith. Greenwillow, 1997.

Ho for a Hat! by William Jay Smith; illus. by Lynn Munsinger. Little Brown, 1989.

Laughing Time: Collection Nonsense, by William Jay Smith; illus. by Fernando Krahn. Farrar, Straus & Giroux, 1990.

My Grandma's Chair, by Maggie Smith. Lothrop, Lee & Shepard 1992.

The Stinky Cheese Man and Other Fairly Stupid Tales, by Jon Scieszka & Lane Smith. Viking, 1992.

Twenty-Six Rabbits Run Riot, by Clara Lockhart Smith. Little Brown, 1990.

Activities

1. Use the local telephone directory to find out how many Smiths live in your town or city. What other names are common in your area?
2. Use a reference book (e.g. encyclopedia, biographical dictionary) to identify other famous Smiths.

*January 7 Balloon Ascension Day

On January 7, 1785, Jean-Pierre Blanchard, a Frenchman, and Dr. John Jeffries, a doctor from Boston, successfully crossed the English Channel from Dover, England, to Calais, France, by balloon. They landed in a forest near the coast. Before landing, however, they had thrown virtually everything in the balloon overboard to avoid landing in the cold channel waters. Eight years later, on January 9, 1793, Blanchard made the first manned balloon ascent in the United States at Philadelphia, Pennsylvania. President George Washington attended. On January 7, balloonists often exhibit balloons, blimps, or other flying crafts.

Featured Book

Three in a Balloon, by Sarah Wilson. Scholastic, 1990.

In September 1783 the first hot air balloon made its ascent in France with three animals aboard: a sheep, a duck, and a rooster. Wilson imagines the trip that the three farm animals took over the French countryside. Her soft, watercolor illustrations support the text with humor and warmth.

Additional Book

Hot-Air Henry, by Mary Calhoun; illus. by Erick Ingraham. Morrow, 1982.

Activities

1. Hot air balloons often have unique, colorful designs and shapes. Find pictures of some fanciful balloons, and then design a hot air balloon that expresses your special interests.
2. Imagine a hot air balloon ride over your neighborhood. What would you see? If you could go anywhere in a hot air balloon, where would you go? Why?

January 8 Snow Day

At least once a winter, children throughout the northern United States expect a Snow Day. While it probably won't fall on January 8, this is a good day to celebrate the possibility that some day soon school will be cancelled because of icy roads, blowing snow, or drifts too high to jump over.

Featured Book

Snow Day, by Moira Fain. New York: Walker, 1996.

A snow day saves the day for Maggie Murphy who hadn't finished her homework. Maggie is delighted with the reprieve, but is less thrilled to have her teacher, Sister Agatha Ann join Maggie and her friends on the sledding hill.

Additional Books

Snow Day, by Betsy Maestro; illus. by Giulio Maestro. Scholastic, 1989.

When the big snow arrives, all the snow moving equipment in town helps to clear the roads so that life can resume as normal.

Snowshoe Thompson, by Nancy Smiler Levinson; illus. by Joan Sandin. HarperCollins, 1992.

Even on the snowiest days, Snowshoe Thompson braved the weather to deliver mail to people in the northern California mountains. This story is based on the life of John Thompson, a Norwegian immigrant, who used skis to make sure that the mail got through.

Activities

1. Imagine that the radio announcer has just declared, "Snow Day." What will you do?
2. Write a short poem of your own describing a powerful storm.

*January 9 Connecticut Admission Day

By the 1600s, about sixteen different Indian groups lived in the area we now call Connecticut. Their life changed drastically in 1614 when a Dutch explorer named Adriaen Block arrived in Connecticut. The colony grew quickly as Dutch and English colonists arrived to build towns. By the 1700s Connecticut was the third largest colony with almost 26,000 colonists. On January 9, 1788, Connecticut approved the Constitution making it the fifth state in the United States.

Today Connecticut is home to more than three million people. The United States Coast Guard Academy, located in New London, Connecticut, trains young men and women to guard the coasts and help with sea rescue.

Featured Book

Ferryboat, by Betsy and Guilio Maestro. Thomas Y. Crowell, 1986.

This simple picture book describes the ferry crossing between the towns of Chester and Hadlyme, Connecticut. The ferry began operation in 1769, even before Connecticut achieved statehood, and it continues to make its journey today.

Additional Book

Little Toot, by Hardie Gramatky. Putnam, 1939.

This classic storybook tells the story of the "cutest, silliest little tugboat you ever saw." While not specifically set in Connecticut, *Little Toot* evokes images of East Coast shipping operations.

Activity

Design your own boats—ferryboats, tugboats, sailboats, rowboats, or big ocean liners.

January 10 National Clean Off Your Desk Day

 An international consulting firm in Washington, D.C., promotes the second Monday in January as a time for workers to make their desks neater. The company executives believe that if your desk is neat you will be a more productive worker.

Featured Book

The Perfectly Orderly H-O-U-S-E, by Ellen Kindt McKenzie: illus. by Megan Lloyd. New York: Henry Holt, 1994.

"There was an Old Woman who lived in a small bit of a house." She never threw anything away. After all, she might need it some day. When she ran out of room, she convinced her brother to build her a "perfectly orderly house" where each of the twenty-six rooms housed items beginning with a different letter of the alphabet. Eventually, she decided that her original house, now nearly empty, was just right.

Additional Book

"Mrs. Pig Gets Cross," from *Mrs. Pig Gets Cross and Other Stories,* by Mary Rayner. Dutton, 1987.

Activities

1. Clean your desk.
2. Look at your school library's organization plan. How are picture books organized? What scheme is used to organize nonfiction books? Why don't libraries use the alphabetical system for nonfiction?

January 11 Bath Safety Month

January is National Bath Safety Month. This event is sponsored by Homecare America, a healthcare products company. January 11 is a good day to think about bath and bathtub safety. According to the United States government, over 163,286 seek emergency room treatment each year for injuries associated with bathtubs and showers. About one hundred children under the age of five drown each year in the bathtub. While the following bathtub stories are fun, bathtub safety is a serious concern.

Featured Book

No More Water in the Tub! by Tedd Arnold. Dial, 1995.

William's bath turns into a wild adventure when his brother Walter allows the bath to overflow.

Additional Books

The Tub People, by Pam Conrad; illus. by Richard Egielski. Harper & Row, 1989.

King Bidgood's in the Bathtub, by Audrey Wood; illus. by Don Wood. Harcourt Brace Jovanovich, 1985.

Activities

1. Create a bath safety poster to share with local day care centers.
2. Make a mural of silly bath safety rules. Then follow-up with a list of those rules that we should take seriously.

*January 12 National Handwriting Day

On January 12, 1737, John Hancock was born in Braintree, Massachusetts. Hancock's birth date moved to January 23 when the Georgian calendar was adopted. He became a prominent merchant in Massachusetts, and when the colonies declared independence from England, Hancock became one of the leaders of the provincial assembly. Eventually he was chosen president of the Continental Congress. On July 4, 1776, John Hancock signed the original copy of the Declaration of Independence. On August 2, he and fifty-six others signed the declaration again after it had been transcribed onto parchment. Hancock's remains the most prominent signature. Today a signature is often referred to as a "John Hancock." National Handwriting Day is celebrated on John Hancock's birthday and is intended to encourage legible handwriting.

Featured Book

Will You Sign Here, John Hancock? by Jean Fritz; illus. by Trina Schart Hyman. Coward, McCann & Geoghegan, 1976.

While a bit long for a read-aloud, you might choose to read brief sections which focus on Hancock's famous signature on the Declaration of Independence.

Additional Books

Muggie Maggie, by Beverly Cleary; illus. by Kay Life. Morrow, 1990.

Maggie's cursive writing is untidy. Although she had originally looked forward to learning cursive writing with the rest of her third grade class, her embarrassment over her first attempts upset her so much that she wants to give up on cursive altogether. Chapter 2 of this brief novel will make a good read-aloud and will serve to open a discussion of penmanship.

Activities

1. Practice creating a fancy signature of your own.
2. Examine a copy of the Declaration of Independence and have each student choose one of the signers as a focus for a brief research project.

*January 13 Silvesterkläuse

This New Year's celebration originated in Switzerland in 1582 and is still celebrated in Urnäsch, Switzerland, on both January 1 (the Gregorian New Year) and January 13 (the Julian New Year). Masked and costumed men ski or walk from house to house singing a wordless yodel as a way to wish local families a prosperous new year. The traditional costumes represent three very different groups: the beautiful, the ugly, and the ordinary. The costumed men especially enjoy going to rural farmhouses where they are greeted with a welcoming drink by the farmer and his wife.

Featured Book

Ski Pup, by Don Freeman. Viking, 1963.

Hugo, a Saint Bernard pup living in the Swiss Alps, plays the hero when he rescues Tino, a young skier who is separated from his ski class.

Additional Books

Cross-Country Cat, by Mary Calhoun; illus. by Erick Ingraham. Morrow, 1979.

Buford the Little Bighorn, by Bill Peet. Houghton Mifflin, 1967.

While neither of these stories takes place in Switzerland, skiing plays a major role in the story of a cat who travels on cross-country skis and a little bighorn sheep who escapes from hunters by joining the downhill skiers.

Activities

1. Decorate colorful cutouts of downhill skiers. Assemble all the skiers on a bulletin board covered in snow-white paper. Hide a dog, a cat, or a bighorn sheep among the skiers in the finished display.
2. Videotape a few minutes of a downhill ski race or a ski jumping contest. Develop a list of descriptive words that capture the excitement of the race.

January 14 Penguin Hatching Season

January is an exciting time on the Antarctic Peninsula! It's penguin hatching season.

In October, the penguins migrated to their rookeries and met their mates. They spent time gathering stones which they piled up to create a nest for the eggs they will produce. The female laid one egg, then waited for one to four days before laying another. It will take about thirty-seven days before the eggs hatch.

In most penguin species, the female incubates the eggs for about two weeks, and then she turns the nest over to the male while she goes to sea to eat krill, which are small, shrimplike crustaceans. Once she has regained the weight she lost during the previous weeks, she returns to the nest where both parents take turns watching over the eggs.

The chick uses an egg tooth to break through the egg's shell. It can take twenty-four to forty-eight hours for the chick to hatch. The egg tooth falls off a day or two after hatching. The baby penguin is covered in a fluffy coat of down feathers. For the first three weeks one parent guards the chicks constantly while the other goes for food. By the time they reach three weeks of age, the chicks are left on their own while the parents get food. The chicks don't go to sea until they are about nine weeks old. They know instinctively how to swim and catch food. Once they go to sea, hatching season is over, and the Antarctic becomes quieter as colder weather sets in.

Featured Book

Antarctic Antics: A Book of Penguin Poems, by Judy Sierra, illus. by Jose Aruego & Ariane Dewey. Gulliver Books, 1998.

This collection of ten poems is so easy to read that most first and second graders will be able to read along with just a little help.

Additional Books

Cuddly Dudley, by Jez Alborough. Candlewick, 1993.

I Like It When, by Mary Murphy. Red Wagon Preschool Book, 1997.

Penguin Pete, by Marcus Pfister. North-South Books, 1987.

Splash! A Penguin Counting Book, by Jonathon Chester and Kirsty Melville. Tricycle Press, 1997

Activities

1. Draw pictures of penguins at play (either real or imagined).
2. Gather penguin facts from several reference books and create a bulletin board display.

January 15 Martin Luther King's Birthday

In Atlanta, Georgia, on January 15, 1929, Martin Luther King, Jr. was born. He dedicated his life to ending the injustices of racism and guiding people, both black and white, to learn to live together peacefully. His peaceful revolution helped turn the tide of racism in this country and guarantee equal treatment of all peoples under the law. Martin Luther King, Jr. was assassinated on April 4, 1968, in Memphis, Tennessee.

Just four days after King was assassinated, Representative John Conyers of Michigan submitted the first legislation to make King's birthday a national holiday. By 1970, petitions with more than six million signatures had been submitted to Congress. Others, including the Southern Christian Leadership Conference kept pressure on Congress to create a federal holiday honoring King. Finally, in 1983, President Reagan signed legislation decreeing the third Monday in January as Martin Luther King, Jr. Day. It was

the first new federal holiday since 1948 (when Memorial Day was created) and the only American holiday besides George Washington's birthday designed to honor a particular individual. It was first celebrated as a national holiday in 1986.

Featured Book

Happy Birthday, Martin Luther King, by Jean Marzollo; illus. by J. Brian Pinkney. Scholastic, 1993.

This picture book tells in simple, easy to understand language the story of Martin Luther King's life. King's essential message is retained even though the events of his life are greatly telescoped.

Additional Books

A Picture Book of Martin Luther King, Jr., by David A. Adler; illus. by Robert Casilla. Holiday House, 1989.

Martin Luther King, by Rosemary L. Bray; illus. by Malcah Zeldis. Greenwillow, 1995.

Activities

1. Different states and cities celebrate Martin Luther King, Jr. Day in different ways. Think of a creative way to celebrate the holiday which honors Dr. King's ideal of peace and equality for everyone.
2. Design a poster which helps others in your school or community share in Martin Luther King, Jr.'s dream of a world without hate, prejudice, or violence.

*January 16 National Nothing Day

This day was created in 1973 by newspaperman Harold Pullman Coffin who felt that Americans should have one day when they can just sit around without celebrating anything in particular. Over the years people have noted this day with amusement and have celebrated the fact that nothing particular happened on this day. However, a careful review of history shows that, indeed, several important events did actually occur on this date. Therefore, it's a good day to celebrate the fact that just when we think nothing at all is happening, there is an amazing world of adventure at our fingertips!

Featured Books

And to Think That I Saw It on Mulberry Street, by Dr. Seuss. Vanguard Press, 1937.

Nothing Ever Happens on 90th Street, by Roni Schotter; illus. by Kyrsten Brooker. Orchard, 1997.

In both books, keen observers realize that the apparent "nothing" that happens can become something special in the hands of a gifted storyteller.

Activities

1. Do nothing. Discuss what happens when you try to do nothing.
2. Spend a day or part of a day writing down all the "nothing" that happens in your neighborhood. Turn it into a "Mulberry Street" or "90th Street" story.

*January 17 Benjamin Franklin's Birthday

Benjamin Franklin was born in Boston, Massachusetts on January 17, 1706. One of our most honored patriots, Franklin was a publisher. He also founded the first Circulating Library and the Union Fire Company, was appointed postmaster of Philadelphia, proposed the creation of the University of Pennsylvania, and began a series of scientific experiments leading to various inventions. In 1775 he served as a delegate to the Continental Congress. He signed the Declaration of Independence and negotiated a number of important treaties between the United States, and France and Great Britain. Sayings from his book, *Poor Richards Almanack*, are still in use today

Featured Book

The Hatmaker's Sign: A Story of Benjamin Franklin, retold by Candace Fleming; illus. by Robert Andrew Parker. Orchard, 1998.

Thomas Jefferson felt discouraged when members of the Continental Congress began correcting the *Declaration of Independence*. Benjamin Franklin, sensing Jefferson's anger and embarrassment, took the younger man aside and told him the story of the hatmaker's sign. This account is based on a story from *The Papers of Thomas Jefferson*, Jefferson's autobiography.

Additional Books

The Many Lives of Benjamin Franklin, by Aliki. Simon & Schuster, 1977.

Even though it presents only a sketch of the life of Franklin, this simple retelling with cartoon-like drawings, will serve as a fine introduction to the life of Benjamin Franklin for young children.

What's the Big Idea, Ben Franklin? by Jean Fritz; illus. by Margot Tomes. Coward, McCann & Geoghegan, 1976.

This forty page biography is interesting enough that older children will enjoy it as a read-aloud or a read-alone. Fritz has included fascinating facts from Franklin's life without losing his major accomplishments amid these interesting sidelights.

Activity

Discuss some of the sayings from *Poor Richard's Almanack*:
"A true friend is the best possession."
"A bird in the hand is worth two in the bush."
"If your head is wax don't walk in the sun."
"A quarrelsome man has no good neighbors."
"Don't throw stones at the neighbors if your own windows are glass."

*January 18 Pooh Day

Alan Alexander Milne was born on January 18, 1882 in London, England. Milne first made his living as a freelance journalist and later wrote novels and poems for children. He married in 1913 and in 1920 had a son named Christopher Robin. Little Christopher was given a stuffed bear on his first birthday, a bear almost as big as the boy, whom he called, "Winnie-the-Pooh. Various other toy animals joined the fam-

ily, and by the time Christopher was three, his father had begun writing stories about Christopher Robin and his stuffed animals. Winnie-the-Pooh is still popular today, and characters like Pooh, Piglet, Roo, Eeyore, and Tigger are available in book, video, and toy versions throughout the world.

Featured Books

The House at Pooh Corner: Stories of Winnie-the-Pooh, by A. A. Milne. Dutton, 1928.

Winnie-the-Pooh, by A. A. Milne. Dutton, 1926.

Activities

1. Listen to *Return to Pooh Corner* sung and arranged by Kenny Loggins. Sony Music Entertainment, 1994; or *Return to Pooh Corner* sung by Jim Salstrom. Moulin D'Or Recordings, 1996.
2. Read almost any chapter of the listed Milne books. These chapters are actually short stories which will be quite clear to children who are familiar with the Pooh characters.

*January 19 *Timqat (Timkat)*

Ethiopian Christians celebrate the birth of Jesus, which they call Ganna, on January 7. *Timqat*, held on January 19, celebrates the baptism of Jesus in the Jordan River. Children are given new clothes for this holiday, and the adults wash their garments so that everyone is dressed in white when they assemble at their churches at sunset. They form a procession with the *tabot*, a replica of the holy ark in which the ancient Israelites placed the Tablets of the Law, the first five books of the Old Testament. Ethiopians believe that the original Ark of the Convenant was not lost, but is preserved in the Cathedral of Axum in Ethiopia. The *tabot* is taken to a local lake or pond or stream where it is placed in a tent. The people go home for supper and then return to the site of the *tabot* where they will participate in spirited singing and dancing all night. At two o'clock in the morning, the priests perform mass. At dawn the clergy bless the water and renew the baptismal vows of anyone who wishes, and then they process back to the church where the *tabot* is normally stored. The day is concluded with feasting. Young men and women often find their mates during this spirited festival.

Timqat is a good day to read some Ethiopian folktales.

Featured Books

Fire on the Mountain, by Jane Kurtz; illus. by E. B. Lewis. Simon & Schuster, 1994.

This traditional tale shows the courage and devotion of a young Ethiopian shepherd boy who must spend a night alone on the cold mountaintop. He manages to outfox the rich master and gain enough money to buy his own cows, and therefore his independence.

The Lion's Whiskers: An Ethiopian Folktale, by Nancy Raines Day; illus. by Ann Grifalconi. Scholastic, 1995.

This tale from the Amhara people, traditional rulers of Ethiopia, tells of a woman who must pluck three whiskers from an old lion in order to gain the love and respect of her stepson.

Additional Books

Pulling the Lion's Tail, by Jane Kurtz; illus. by Floyd Cooper. Simon & Schuster, 1995.

Only a Pigeon, by Jane and Christopher Kurtz; illus. by E. B. Lewis. Simon & Schuster, 1997.

Activities

1. Learn more about Ethiopia by consulting encyclopedias, almanacs, and atlases in your library.
2. Draw your own version of an incident from the story

*January 20 Inauguration Day

Adopted in 1933, the 20th Amendment to the Constitution specifies that the President will be inaugurated on January 20 of the year following the election. Prior to that time, the President's term of office began on March 4. President Franklin Delano Roosevelt was the first to have a January 20 inauguration. If January 20 falls on a Sunday, the oath is taken privately with the public ceremonies following on Monday. Inauguration ceremonies traditionally begin at noon when the Chief Justice of the Supreme Court administers the oath of office to the President. The President repeats: "I do solemnly swear that I will faithfully execute the office of the President of the United States, and will, to the best of my ability, preserve, protect and defend the Constitution of the United States." The new president then delivers an inaugural address. George Washington's 135 word address at his second inauguration was the shortest; William Henry Harrison's one-hour-forty-five minute speech was the longest. Weather permitting, the inauguration is held on the grounds of the Capitol, and is followed by a parade. Later in the evening, an inaugural ball is held at the White House. Additional inauguration parties take place at other Washington locations to accommodate the many invited guests.

Featured Book

A Big Cheese for the White House: The True Tale of a Tremendous Cheddar, by Candace Fleming; illus. by S. D. Schindler. DK, 1999.

In 1801, the town of Chesire, Massachusetts, made a big cheese for President Jefferson who has been unable to get excellent cheeses for his table.

Additional Book

Arthur Meets the President, by Marc Brown. Little Brown, 1991.

When Arthur's essay wins a national contest, he visits the White House and meets the president.

Activities

1. Discuss the question—If your town was to give the president an appropriate gift, what would that gift be and why?
2. Imagine you have entered the same contest as Arthur. How would you answer the question, "How I Can Help Make America Great?"

January 21 National Soup Month

National Soup Month, sponsored by the Campbell Soup Company, is celebrated throughout the month of January. The cold January weather and a cup of warm soup seem like natural partners.

Featured Book

Dumpling Soup, by Jama Kim Rattigan; illus. by Lillian Hsu-Flanders. Little Brown, 1991.

Dumpling soup is a tradition for Marisa's family who lives in Hawaii. All of her relatives, who come from Korea, Japan, China, and Hawaii, join together for a new year's celebration and a delicious family meal with many ethnic foods.

Additional Books

Mean Soup, by Betsy Everitt. Harcourt Brace Jovanovich, 1992.

Alphabet Soup, by Mirko Gabler. Henry Holt, 1992.

Stone Soup, by Marcia Brown. Charles Scribner's Sons, 1974.

Activities

1. Pretend that your class is going to make and sell dumpling soup or mean soup or alphabet soup or stone soup. Design an appropriate soup label.
2. Look at the food pyramid. Where would soup be on the pyramid? Look at some soup labels. Is soup healthy? Why or why not?
3. Write a memory of a special family party or holiday meal.

January 22 National Book Month

The National Book Foundation has declared the entire month of January as National Book Month. Libraries and bookstores often sponsor special events, such as author visits or book discussions, during National Book Month.

Featured Book

Edward and the Pirates, by David McPhail. Little Brown, 1997.

Edward's love of books lands him in the middle of a pirate adventure.

Additional Books

The Girl Who Hated Books, by Manjusha Pawagi; illus. by Leanne Franson. Beyond Words Publishing, 1999.

The Character in The Book, by Kaethe Zemach. HarperCollins, 1998.

Activities

1. Visit the library and select books for pleasure reading.

2. Have a book discussion. Join several friends in reading the same book and then spend some time talking about the book's ideas.
3. Read to a friend, perhaps someone too young to read or someone in a nursing home who would enjoy having a reader.
4. Begin a memory book of your own. Write brief description of favorite relatives, neighbors, or friends.

*January 23 National Pie Day

The American Pie Council has proclaimed January 23 as National Pie Day. The American Pie Council is "dedicated to preserving America's love affair with pies." The familiar phrase, "as American as apple pie," reminds us that Americans consider pie baking and pie eating part of their heritage. The American Pie Council sponsors the National Pie Championships and publishes a newsletter *The Pie Times*. A warm pie is a special treat on this cold January day.

Featured Book

How to Make an Apple Pie and See the World, by Marjorie Priceman. Alfred A. Knopf, 1994.

In order to find the ingredients to make an apple pie, a young girl must travel the world.

Additional Book

James Bear's Pie, by Jim Latimer; illus. by Betsy Franco-Feeney. Charles Scribner's Sons, 1992.

Activities

1. Bake and share a pie.
2. Hold a pie sale and give the proceeds to your favorite charity.
3. Have each student bring in a pie recipe and put them together into a pie recipe book as a gift for moms, grandmas, or a favorite neighbor.
4. Hold a paper pie contest by turning paper circles into scrumptious looking paper pies.

January 24 Chinese New Year

In China, the New Year celebration is also called the Spring Festival. It is a time for reunion and for renewal. This Buddhist festival is the most widely celebrated festival throughout China. Chinese communities throughout the world celebrate Chinese New Year. It is a time when old debts must be paid, and the house must be thoroughly cleaned. Food for the holidays, including a large fish cooked whole and dumplings, is prepared ahead of time so that there is plenty of time to relax and enjoy the festivities. Children often receive presents from their parents: a bowl of sweets from their mother and a coin or two wrapped in red paper from their father. Families gather on the eve of the New Year to feast and visit. They continue feasting and visiting with family the next day. This is a happy celebration with lots of time spent wishing friends and neighbors well in the year ahead. New Year parades feature people,

dressed in large lion or dragon masks and costumes, dancing through the streets. Firecrackers add to the excitement.

2001	2/12	2006	1/29
2002	2/1	2007	2/18
2003	1/22	2008	2/7
2004	1/22	2009	1/26
2005	2/9	2010	2/14

Featured Books

Lion Dancer: Ernie Wan's Chinese New Year, by Kate Waters and Madeline Slovenzlow. Scholastic, 1990.

Moy Moy, by Leo Politi. Charles Scribner's Sons, 1960

Both stories follow Chinese American children through the celebration of the Chinese New Year. The lion dance is a prominent part of both celebrations.

Activities

1. Create a modified Chinese New Year parade with Chinese music and a parade around the room.
2. Distribute fortune cookies and have each person share the fortune inside.
3. Make dragon masks.

January 25 Up-Helly-Aa

This holiday celebrated on the last Tuesday in January in the Shetlands, marks the end of the month-long Yule celebration. Various interpretations exist. Some people claim that Up-Helly-Aa signifies the ending of the holy days; others say it celebrates the end of winter. Whatever the intent, this holiday reflects the Scandinavian influence in the northern British Isles. The capital city of Lerwick hosts hoards of costumed and masked jokesters organized into ten man squads. They drag a thirty-foot model of a Viking longship, mounted on wheels, to the city center. When they arrive at the center, the 500 or more men toss their lighted torches onto the ship so that it is consumed by a glorious blaze of fire. The revelers then visit restaurants and bars where they eat, dance, and give humorous speeches. The costumes depict historical persons and events; Viking costumes are a favorite.

Viking sagas are a great match for this holiday which celebrates Viking adventures.

Featured Books

Elfwyn's Saga, by David Wisniewski. Lothrop, Lee & Shepard, 1990.

Because of a curse placed on Anlaf and all his family by Gorm the Grim, Anlaf's tiny daughter is born blind. The Hidden Folk visit special favor on the little girl which provides her with special grace, knowledge, and insight. When Gorm creates an even worse threat for Anlaf's people, young Elwyn's lack of sight enables her to save the entire clan.

Leif's Saga: A Viking Tale, by Jonathon Hunt. Simon & Schuster, 1990.

Asgrim tells his young daughter Sigrid of the exploits of Leif Eriksson who sails from Greenland to North America in the eleventh century.

Activities

1. Using drawings from the story and pictures in reference sources, draw and decorate Viking ships and/or helmets using Norse designs.
2. Trace the route of the Vikings from Norway to the Shetland Islands to Greenland and on to North America.

*January 26 Michigan Admission Day

Michigan became the twenty-sixth state on January 26, 1837. The people of Michigan had actually drawn up a state constitution and elected Stevens T. Mason as their first governor on October 5, 1835, but a dispute between Michigan and Ohio delayed statehood.

Today Michigan is an industrial state known for its automobile manufacturing. Mining and farming are also important to Michigan's economy. Michigan's forests and lakes attract over 22 million tourists a year. Michigan has more than 11,000 lakes and is surrounded by four of the Great Lakes. The Great Lakes divide the state into two parts, the Lower Peninsula, where all of Michigan's larger cities are located and the Upper Peninsula, a less populated, forested area sometimes called the Land of Hiawatha because it is described in the famous poem by Henry Wadsworth Longfellow. When European explorers first arrived in Michigan, the state was inhabited by about 15,000 Native Americans, most of whom spoke the Algonquian language. These included the Chippewa, Menomminee, the Ottawa, the Potawatomi, and the Miami tribes. The area around present-day Detroit, was home to the Wyandot tribe which spoke the Iroquois language.

Featured Books

Hiawatha, by Henry Wadsworth Longfellow; illus. by Susan Jeffers. Dutton, 1983.

Hiawatha's Childhood, by Henry Wadsworth Longfellow; illus. by Errol Le Cain. Farrar, Straus & Giroux, 1984.

Both books present excerpts from Longfellow's epic poem which focus on the childhood of Hiawatha. Longfellow wrote the poem in 1855. He combined myths, legends, and first-person accounts to create a fictional biography of a courageous Indian chief. He added a rhythm and richness of language that made the poem an immediate popular success, one that has endured over the years. Both of these versions are visually stunning interpretations.

Activities

1. Copy the text of the poem and have the group read it chorally or assign different verses to several readers and read it serially.
2. Try memorizing a few lines of the poem to recite the next day. Poetry recitation was a common way for students to learn in the late nineteenth and early twentieth century.

*January 27 Birthday of Wolfgang Amadeus Mozart

On January 27, 1756, Wolfgang Amadeus Mozart was born in Salzburg, Austria. Many consider Mozart to be the greatest composer who ever lived. By the age of three, he showed a keen interest in musical instruments. He began taking formal lessons at age four. Around the time he turned five, Mozart composed his first piece. With his sister Nannerl he performed throughout Europe, amazing royal audiences in many countries. He also met and worked with another famous composer, Johann Christian Bach.

Mozart was a child prodigy, but unlike many prodigies, his genius continued throughout his life. Before his death in 1791 at the age of thirty-five, Mozart composed over 600 pieces of music, including twenty operas, fifty-five concert arias, seventeen sacred masses, forty-eight symphonies, 103 minuets. Among his most well-known pieces are *The Magic Flute*, an opera, and *Eine Kleine Nachtmusik*, written for string quartet.

Featured Books

Mozart Tonight, by Julie Downing. Bradbury, 1991.

Mozart: Scenes from the Childhood of the Great Composer, by Catherine Brighton. Doubleday, 1990.

Both books accurately recount events in Mozart's young life. The illustrations give readers a flavor of life in Europe during the 1700s, as well as an appreciation for the various highlights of Mozart's childhood.

Activity

Listen to some of Mozart's music. There are several new recordings especially designed for children. However, almost any work by Mozart is appropriate for young listeners.

*January 28 Rwanda Democracy Day

Rwanda is located in the east-central part of Africa. On January 28, 1962, the people of Rwanda gained independence after forty-three years of rule by Belgium. Although it lies near the Equator, Rwanda is a mountainous country with a cool, pleasant climate. It is, however, one of the most crowded African nations with a population of over 8 million. Elephants, antelopes, hippopotamuses, crocodiles, leopards, and wild boars make their home in Rwanda.

Sadly, Rwanda is divided by warring factions of the Hutus, who make up 90 percent of the nation's people, and Tutsis, who are the traditional leaders, but number less than 9 percent of the population. Massacre and disease have wiped out thousands of people, and peace seems but a distant dream to the children of Rwanda.

French and Kinyarwanda are the official languages of Rwanda. Kinyarwanda is one of several Bantu languages that are spoken by over 180 million Africans. The Bantu were among the original settlers of Rwanda and they established a great central African kingdom.

The tales below both come from the Bantu.

Featured Book

The Name of the Tree: A Bantu Folktale, retold by Celia Barker Lottridge; illus. by Ian Wallace. Margaret K. McElderry, 1989.

The hungry animals find a very tall tree filled with delicious fruit, but they must learn the name of the tree before they can eat of the fruit. The gazelle and the elephant fail in their attempt to learn and remember the tree's name, but a young tortoise follows his great-great-great-grandmother's advice and saves the day.

Additional Book

"Sebgugugu the Glutton: A Bantu Tale" in *Behind the Back of the Mountain: Black Folktales from Southern Africa*, retold by Verna Aardema; illus. by Leo and Diane Dillon. Dial, 1973.

Activity

Study a map of Africa. Locate Rwanda and the surrounding countries. Try memorizing the nations of Africa. What method could you use to remember their names?

*January 29 Kansas Day

Kansas, known as the Sunflower State, joined the Union on January 29, 1861, making it the thirty-fourth state. Kansas supplies much of the nation's wheat and has been called the *Breadbasket of America*. Three major plains, the Dissected Till Plains, the Southeastern Plains, and the Great Plains, give Kansas its gentle rolling prairies and fertile soils. The weather changes suddenly, and sometime violently, in Kansas causing blizzards, thunderstorms, and tornadoes. Although modern day Kansas has several big cities including Lawrence, Topeka and Wichita, it is also a state of small towns and farming communities.

Featured Books

Climbing Kansas Mountains, by George Shannon; illus. by Thomas B. Allen. Bradbury, 1993.

When Sam's dad suggests that they "climb a Kansas mountain," Sam thinks his dad is joking. After all, there are no mountains in Kansas. But Dad has a surprise in store when he takes Sam to the top of a grain elevator and they are able to look out over the flat Kansas countryside.

Going West, by Jean Van Leeuwen; illus. by Thomas B. Allen. Dial, 1992.

Allen, who lived in Lawrence, Kansas, at the time he illustrated both of these books, evokes images of the Kansas prairie. Van Leeuwen's story of a pioneer family crossing the prairie portrays both the hardships and the rewards of the early settlers.

Activities

1. Locate a topographical map of the United States. What other states share a topography similar to that of Kansas? Which are the most mountainous states?

2. Find Kansas on a map. Use the distance scale and calculate how long it would take to cross Kansas by car (assuming sixty mph); by plane (assuming 600 mph); by covered wagon drawn by oxen (assuming seven miles per day).

January 30 Oatmeal Month

January is designated as Oatmeal Month. The Quaker Oats Company, which sponsors Oatmeal Month, suggests that people should "celebrate oatmeal, a low-fat, sodium-free, whole grain that, when eaten daily as a part of a diet that is low in saturated fat and cholesterol, may help reduce the risk of heart disease."

Featured Book

Goldilocks and the Three Bears, retold by Tony Ross. Macmillan, 1985.

Porridge, or oatmeal, plays an important role in this familiar fairy tale.

Additional Book

Gregory, the Terrible Eater, by Mitchell Sharmat; illus. by Jose Aruego and Ariane Dewey. Four Winds, 1980.

Activities

1. Eat oatmeal. Choices include hot oatmeal, granola, granola bars, or oatmeal cookies.
2. Create a healthy breakfast bulletin board with pictures and descriptions of healthy breakfast foods.

*January 31 Jackie Robinson's Birthday

Jackie Robinson was the first African American to play major league baseball. Robinson was born on January 31, 1919 in Cairo, Georgia. He played four sports at the University of California at Los Angeles. He began his baseball career with the Negro American League's Kansas City Monarchs in 1945. He joined the Brooklyn Dodgers, a New York City team, in 1947 as the first player to move from the Negro leagues to major league baseball. Although he began his career as a first baseman, Robinson became famous as a second baseman. He had an outstanding hitting record and was known as a superb runner and base stealer. In 1947 he was named Rookie of the Year. In 1949 he was named the National League's Most Valuable Player. Jackie Robinson was elected to the National Baseball Hall of Fame in 1962.

Featured Book

Teammates, by Peter Golenbock, illus. by Paul Bacon. Gulliver Books, 1990.

Golenbock tells the story of the close friendship between Jackie Robinson and Dodger shortstop, Pee Wee Reese. This book provides the social and cultural background to help children understand the extent of the discrimination faced by Robinson and other African Americans during the early years of the twentieth century.

Additional Books

A Picture Book about Jackie Robinson, by David Adler; illus. by Robert Casilla. Holiday House, 1994.

Jackie Robinson: He was the First, by David Adler; illus. by Robert Casilla. Holiday House, 1994.

The Story of Jackie Robinson: Bravest Man in Baseball, by Margaret Davidson. Dell, 1988.

Jackie Robinson Breaks the Color Line, by Andrew Santella. Children's Press, 1996.

Activities

1. Who is your favorite sports hero? Why?
2. Women also faced a difficult time gaining acceptance as athletes. Make a list of well-known women athletes, African American athletes, and Hispanic athletes. List each person's sport beside the name.

*February 1 Robinson Crusoe Day

On February 1, 1709, Alexander Selkirk was rescued after four years alone on an uninhabited island in the South Pacific. Selkirk had an argument with his captain in 1704 and had requested to be put ashore. The story of Selkirk's four years on the island became the basis for Daniel DeFoe's famous survival story, Robinson Crusoe, published in 1719.

Today's island adventures are purely imaginary. These storybook characters visit islands and partake of fantastic adventures. A cold February day is a good day to dream of faraway tropical islands. . . .

Featured Books

The Cinder-Eyed Cats, by Eric Rohmann. Crown, 1997.

Hey Al, by Arthur Yorinks; illus. by Richard Egielski. Farrar, Straus & Giroux, 1986.

The Water Shell, by Gretchen Schields. Gulliver Books, 1995.

Activity

Imagine your own island adventure. Write a description of the island. What adventure awaits you there? Work singly or in groups. Each person or group can create a fantastic adventure to share with others.

*February 2 Candlemas

Candlemas is a religious celebration of the presentation of the infant Jesus at the temple in Jerusalem. According to the New Testament gospel, Simeon held the baby in his arms and said, "Light to lighten the Gentiles." Candlemas is celebrated in Christian communities throughout the world and often features a procession of candles. In Austria, there is a blessing of the candles in the church and then each family carries home a blessed candle which they may light during times of danger or illness, or during times of special joy. In many South American countries, Candlemas features colorful parades through city streets. On the shores of Lake Titicaca in the Bolivian village of Copacabana and the Peruvian town of Puno and the surrounding areas, colorful pageants feature parades with costumed native dancers. In Bolivia, Inca Indians act out a drama based on Pizarro's conquest of the Andes. The celebrations combine the gods of native religions with a ceremony which honors the Virgin Mary.

In Great Britain, the badger comes out to test the weather on Candlemas in keeping with the old rhyme:

> "If Candlemas Day be dry and fair,
> The half of winter's to come and mair.
> If Candlemas Day be wet and foul,
> The half of winter's gone at Yule."

In France, it is the bear who tests the weather, and in the United States the groundhog comes out of the ground. If he sees his shadow, there'll be six more weeks of bad weather. In the United States, Candlemas is called Groundhog Day.

Featured Books

Gretchen Groundhog, It's Your Day! by Abby Levine; illus. by Nancy Cote. Whitman, 1998.

It's Groundhog Day! by Steven Kroll; illus. by Jeni Bassett. Holiday House, 1987.

Will Spring Be Early or Will Spring Be Late? by Crockett Johnson. Thomas Y. Crowell, 1959.

Activity

Read the newspaper's weather report, watch the television weather, or listen to weather news on radio to learn what the groundhog's actions reveal about the coming of spring.

February 3 *Mame-maki*

Mame-maki, which is also called the Bean Throwing Festival, is a Shinto holiday celebrated at all major temples throughout Japan on the last day of winter. According to the lunar calendar, the last day of winter usually occurs in early February. Temple priests or local celebrities, such as sumo wrestlers or actors, toss beans by the handful at the crowds gathered outside. Children and their mothers and grandmothers gather the beans, shouting, "*Fuku wa uchi, oni wa soto,*" which means "in with the good luck, out with the devils." To insure good luck, some people go home and eat the number of beans equal to their age.

Featured Book

Tasty Baby Belly Buttons, by Judy Sierra; illus. by Meilo So. Alfred A. Knopf, 1999.

The favorite treat for the Japanese giants, the oni, are children's belly buttons. One day, a childless couple finds a perfect baby girl inside a melon. As she gets older, she sets out on a special mission to rescue the babies from the oni. This silly story seems to reflect the happy mood of the Bean Throwing Festival.

Additional Book

Plenty to Watch, by Mitsu & Taro Yashima. Viking, 1954.

Activity

In honor of *Mame-maki* distribute to each child a number of beans equal to her/his age (green beans or jellybeans). Before eating them, be sure to say "*Fuku wa uchi, oni wa soto*" which, roughly translated, means "good luck."

*February 4 Sri Lanka Independence Day

Sri Lanka is a beautiful island country located in the Indian Ocean about twenty miles off the southeast coast of India. Although there are several different ethnic groups who live on Sri Lanka, about 74 percent of the population are the Sinhalese. They are Buddhists and speak a language called Sinhala. Another large group, the Tamils, speak Tamil and are Hindus. Most of the people are farmers and live in traditional mud houses with thatched roofs. Rice is the chief food, often served with curry dishes. Tea is a favorite drink.

Until 1948, Ceylon was a British colony. On February 4, 1948, Ceylon gained its independence. In 1972, Ceylon changed its name to Sri Lanka, which means "Blessed Isle." Sri Lankans celebrate Independence Day with parades, special worship services, national games, and folk singing and dancing.

Featured Book

The Umbrella Thief, by Sybil Wettasinghe; illus. by Cathy Hirano. Kane Miller, 1987.

This contemporary folktale tells the story of a Sri Lankan, Kiri Mama, who returns to his village with a new invention—an umbrella. As each of the umbrellas he brings back to the village disappears, Kiri Mama devises a plan to catch the thief.

Additional Book

Foolish Rabbit's Big Mistake, by Rafe Martin; illus. by Ed Young. Putnam, 1985.

This traditional Jataka tale has been told throughout Asia for nearly 2500 years. Jataka tales are stories of one of the Buddha's earlier births. *Foolish Rabbit's Big Mistake* may remind listeners of the story of Henny-Penny or Chicken-Little.

Activities

1. Locate Sri Lanka on a map and do some fact finding to learn more about this lovely island.
2. Folktales are designed to teach. What is the lesson contained in today's folktale? Can you think of other familiar tales with the same moral?

*February 5 Weatherperson's Day

John Jeffries, born on February 5, 1744, was a Boston physician who kept detailed observations of the weather. He also participated with Jean-Pierre Blanchard in the first balloon flight across the English Channel in 1785 (see January 7). February 5 is designated as Weatherperson's Day in honor of Jeffries. February 5 is an excellent day to honor modern-day meteorologists and to read stories about the weather.

Featured Books

Bartholomew and the Oobleck, by Dr. Seuss. Random House, 1949.

When the King gets tired of rain, sunshine, fog, and snow, he summons the royal magicians to create a new kind of weather: oobleck.

Cloudy with a Chance of Meatballs, by Judi Barrett; illus. by Ron Barrett. Atheneum, 1978.

As Grandpa tells the story, the only weather in Chewandswallow comes three times a day as breakfast, lunch, and dinner.

Activities

1. Write your own zany weather story. Imagine the strangest sorts of storms and describe the consequences.

2. Listen to the weather on radio or TV or read the newspaper weather report. Compare the forecasts and the actual weather. Is your weatherperson usually right? Try predicting the next day's weather yourself based on your knowledge of weather patterns and your intuition.

Note: There are dozens of stories related to real weather. Find them listed by type of weather (e.g. tornado, rain, etc.) in your library's catalog.

*February 6 Massachusetts Admission Day

On February 6, 1788, Massachusetts ratified the United States Constitution to become our sixth state. Massachusetts, known as the Bay State, played a vital role in the history of this country. Some believe that the Viking explorer, Leif Eriksson may have visited Massachusetts as early as the year 1000 A.D. The Pilgrims arrived in Massachusetts in 1620 and many events surrounding the Revolutionary War took place in Massachusetts.

Today, Massachusetts is the third most densely populated state in the nation. Boston, located on the Atlantic Ocean, is its largest city. Massachusetts is well known for its excellent colleges and museums, its fishing industry, and its manufacturing. Most of the cranberries grown in the United States are grown in Massachusetts.

Featured Book

The Wild Horses of Sweetbriar, by Natalie Kinsey-Warnock; illus. by Ted Rand. Cobblehill, 1990.

A seven-year-old girl watches the wild horses prance on her coastal island. When winter comes, she fears for their lives as the hard winter deprives them of their food. The story is based on a true incident that took place off the coast of Massachusetts in 1895.

Additional Books

The Adventures of Obadiah, by Brinton Turkle. Viking, 1972.

Thy Friend, Obadiah, by Brinton Turkle. Viking, 1969.

Obadiah, a small Quaker boy living on Massachusetts's Nantucket Island, enjoys adventure at a sheep shearing in the first book and with a sea gull that follows him around Nantucket in the second. Both books recreate the life and times of early Massachusetts life.

George the Drummer Boy, by Nathaniel Benchley; illus. by Don Bolognese. Harper & Row, 1977.

Sam the Minuteman, by Nathaniel Benchley; illus. by Arnold Lobel. Harper & Row, 1969.

Both stories recall the battle between the British soldiers and the Massachusetts Minutemen in Lexington, Massachusetts, that marked the beginning of the American Revolution.

Activity

Make a list of the ways in which daily life differs today from life in early Massachusetts as depicted in these stories.

February 7 Lantern Day

The culminating event of Chinese New Year is the Lantern Festival. There is some evidence that this festival was originally held to usher in spring with its increasingly warm and bright days. Two thousand years later, the cities and towns of China glow with the light of thousands of colorful paper lanterns. The lanterns are crafted in the shape of fish, animals, people, household objects, plants, and so on. People enjoy walking through the towns admiring the lanterns and eating traditional rice dumplings called *yuanxiao*. Some festivals include parades with people walking on stilts and performing lion dances. The lion dance, also associated with the first night of the Chinese New Year, features two people wearing an elaborate lion costume and dancing through the street.

2001	2/7	2006	2/12
2002	2/26	2007	3/4
2003	2/15	2008	2/21
2004	2/5	2009	2/12
2005	2/23	2010	2/28

Featured Book

Why Rat Comes First: A Story of the Chinese Zodiac, retold by Clara Yen; illus. by Hideo C. Yoshida. Children's Press, 1991.

This clever story provides one explanation for how the Chinese years got their names.

Additional Books

The Blue Bird, by Fiona French. Henry Z. Walck, 1972.

Beautiful Warrior: The Legend of the Nun's Kung Fu, by Emily Arnold McCully. Scholastic, 1998.

Activities

1. Use the list in the back of *Why Rat Comes First* to find out what animal represents the year you were born.
2. Invite a Chinese American to come to class to discuss the Chinese New Year celebration.

*February 8 Boy Scouts Day

The American Boy Scouts were founded on February 8, 1910, by William D. Boyce, an American publisher who learned about the British Boy Scouts while spending time in London. The British Boy Scouts were founded a few years earlier by Robert S. S. Baden-Powell, a hero of the British Calvary. His 1908 book, *Scouting for Boys*, was a great success. Another organization, the Sons of Daniel Boone already existed in the United States and eventually merged with the Boy Scouts. Boy Scouts celebrate February as Boy Scout Month and have special dinners and ceremonies that honor outstanding Scouts.

Boy Scouts Day is a good time to read about the kinds of wildlife adventures that Boy Scouts enjoy.

Featured Book

The Biggest Bear, by Lynd Ward. Houghton Mifflin, 1952.

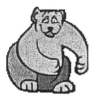

Johnny Orchard, a country boy of long ago, goes into the woods to look for the biggest bear. Instead he finds a hungry bear cub which he raises until bear grows so big that Johnny must find the bear a new home.

Additional Books

Pioneer Bear, by Joan Sandin. Random House, 1995.

The Call of the Wolves, by Jim Murphy; illus. by Mark Alan Weatherby. Scholastic, 1989.

Activities

1. If you have scouts (boys or girls) in your group, ask them to share their experiences with the class.
2. Has anyone in the group had a wilderness adventure? Swap wilderness stories.

February 9 Library Lovers' Month

Celebrate libraries. The Friends and Foundations of California Libraries promote February as Library Lovers' Month and suggest that library supporters create a celebration in honor of their libraries. Anytime is a good time to celebrate libraries, so spend some time on February 9 reading about children who found special treasures at the library.

Featured Books

Tomás and the Library Lady, by Pat Mora; illus. by Raul Colón. Alfred A. Knopf. 1997.

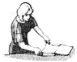

This charming story is based on the life of Tomás Rivera, the son of migrant farm workers, who was encouraged to read by a librarian in Iowa. Rivera went on to become a writer and leader in the field of education.

Red Light, Green Light, Mama and Me, by Cari Best; illus. by Niki Daly. Orchard, 1995.

Lizzie takes the train downtown to spend the day with her mama at the downtown public library.

Activities

1. Design a cover for your favorite book.
2. Cut pennant shapes from construction paper and use crayons or markers to create pennants promoting your favorite books. Display the pennants on a bulletin board.
3. Visit the library and check out a book.

February 10 Black History Month

Black History Month began as Negro History Week in 1926 at the initiative of Dr. Carter G. Woodson, who is considered the "Father of Black History." The purpose of the original celebration was to emphasize the ways in which African Americans influenced history. The first Negro History Week included

community speaker forums, lectures on history, and school plays and programs portraying African American heroes. During the 1976 Bicentennial, the celebration was expanded to the entire month of February. The focus of this month-long celebration is to honor those African Americans who have contributed to our nation's history and progress in various fields: as scientists, inventors, artists, politicians, educators, religious leaders, and so on.

Featured Book

Jewels, by Belinda Rochelle; illus. by Cornelius Van Wright and Ying-Hwa Hu. Dutton, 1998.

When Belinda spends the summer with her great-grandparents, she loves to hear the stories they share about their own family history which so richly parallels the African American experience.

Additional Books

I Have Heard of a Land, by Joyce Carol Thomas; illus. by Floyd Cooper. Joanna Cotler Books, 1998.

On the Day I Was Born, by Debbi Chocolate; illus. by Melodye Rosales. Scholastic, 1995.

Sister Anne's Hands, by Marybeth Lorbiecki; illus. by K. Wendy Popp. Dial, 1998.

Activity

Create a list of famous African Americans and assign students to discover a few facts about each. Share these facts in a newsletter, on a bulletin board, or in a brochure celebrating Black History Month.

February 11 Compass Cup Cow Race

Mt. Compass Oval in South Australia is the site of a race among ten cows each February. Local farmers bid on chances to ride a cow in the race. Because cows are not trained for riding, the race is actually a meander in whatever direction each cow chooses. Other events in this festival include hay-bale stacking, rubber-boot marathon (contestants "race" in water-filled rubber boots), a contest to see how many people can fit into an outhouse, and a cow-dung tossing contest. It's a day of fun in this rural town twenty-seven miles south of Adelaide. The Compass Cow Race is held the second Sunday in February. Consider this a day to enjoy silly cow stories.

Featured Books

The Cow Who Wouldn't Come Down, by Paul Brett Johnson. Orchard, 1993.

The Cows Are Going to Paris, by David Kirby & Allen Woodman; illus. by Chris S. Demarest. Caroline House, 1991.

George Washington's Cows, by David Small. Farrar, Straus & Giroux, 1994.

Metropolitan Cow, by Jim Eagan. Houghton Mifflin, 1996.

Minnie and Moo Go Dancing, by Denys Cazet. DK, 1998.

All of the above books feature silly cows doing things that cows don't normally do.

Activity

Imagine cows in some other improbable situations: spending the day in your classroom, playing hop-scotch or basketball, vacationing with the family. Write brief, one or two paragraph descriptions of what happens to your own silly cows.

*February 12 Lincoln's Birthday

Abraham Lincoln was one of the most beloved presidents of the United States. He was born on February 12, 1809, and died by assassination on April 15, 1865. Students will be familiar with many of the events in Lincoln's life, but his birthday is the perfect occasion to revisit the life of Abraham Lincoln and the legends surrounding him.

Featured Book

A. Lincoln and Me, by Louise Borden; illus. by Ted Lewin. Scholastic, 1999.

A young boy who shares Abraham Lincoln's birthday talks enthusiastically about the things that he and Abraham Lincoln have in common.

Additional Books

Honest Abe, by Edith Kunhardt; illus. by Malah Zeldis. Greenwillow, 1993.

A Picture Book of Abraham Lincoln, by David A. Adler; illus. by John & Alexandra Wallner. Holiday House, 1989.

Activities

1. If Abraham Lincoln were alive today, what questions would you ask him about his life and times? Can you find any of these answers using reference books in the library?
2. Create a timeline of the important events in Abraham Lincoln's life. Include some of the events happening in the United States at that time.
3. List the special qualities that people admire about Abraham Lincoln. Do we still admire these traits in our leaders today? Would you expect different qualities in a modern president?

February 13 National Wild Bird Feeding Month

The National Bird Feeding Society recognizes February as National Wild Bird Feeding Month. February is one of the most difficult months for wild birds in the United States. Snow and cold make it hard for them to find the seeds and harmful insects that they usually eat. Everyone is encouraged to provide food, water, and shelter to birds to help support them during the winter months.

Featured Book

Counting is for the Birds, by Frank Mazzola, Jr. Charlesbridge, 1997.

This beautifully illustrated book identifies ten species of wild birds that come to a feeder. The rhyming text is supplemented by details about the feeding preferences of the various birds.

Additional Books

The Birds Beauty Contest, by Joachim Voigts. Gamsberg, 1992.

The House I'll Build for the Wrens, by Shirley Neitzel; illus. by Nancy Winslow Parker. Morrow, 1997.

Activities

1. Build a simple feeder for wild birds or scatter birdseed on the ground (away from cats) for the birds in your neighborhood. Check your library's shelves for books about building bird feeders. Dean T. Spaulding's *Feeding Our Featured Friends* (Lerner, 1997) or *Bird Feeders and Shelters You Can Make* by Ted S. Pettit (Putnam, 1970) provides ideas and directions.
2. Go on a winter bird walk. Be sure and bring some bird food along with you. How many birds can you see? Can your hear them?

*February 14 Ferris Wheel Day

On February 14, 1859, George Washington Gale Ferris was born in Galesburg, Illinois. Ferris, an engineer and inventor, is best known as the inventor of the Ferris wheel. He his giant wheel developed for the Chicago Exposition in 1893. Ferris's wheel was 250 feet in diameter, and each of its thirty-six cabs could hold sixty people. On opening day, June 21, 1893, a forty-piece band squeezed into one of the cars to play for the first few rides. For fifty cents, thousands enjoyed a twenty-minute ride. George Washington Gale Ferris was not the first to invent a Ferris wheel, but his was the first giant wheel.

Smaller wheels had been used for entertainment for centuries. On May 17, 1620, an English traveler in Turkey reported seeing a ride for children in which the children sat in little seats hung on a turning wheel. Such wheels were called "pleasure wheels" and were used in England by 1728. These first wheels were hand turned and made of wood. The first metal wheel was created in the 1880s in Indiana by the Concerman Brothers. Although pleasure wheels have become larger and more complex over the years, they continue to bring enjoyment to people throughout the world.

Featured Book

Fair! by Ted Lewin. Lothrop, Lee & Shepard, 1997.

In words and pictures this book takes readers from the empty fairground through the set-up and excitement of a small town fair.

Additional Book

Night at the Fair, by Donald Crews. Greenwillow, 1997.

Very few words are needed to guide the viewer through these fair scenes which will remind readers of the fairs they have attended.

Activity

Use a compass to draw a large circle and then create your own spectacular Ferris wheel.

*February 15 Galileo Day

On February 15, 1564, Galileo Galilei was born in Pisa, Italy. During Galileo's childhood, his family moved to Florence and his father decided that Galileo should become a medical doctor. He attended the University of Pisa and studied medicine and philosophy. However, mathematics interested him far more than medicine. After university, he returned to Florence where he worked as a mathematics tutor, and where he invented a hydrostatic balance, an instrument to determine the specific gravity of objects.

In 1609 he built his first telescope and was able to determine that the theories of Aristotle and Ptolemy were false. In 1610 he discovered the four moons of Jupiter. His continued studies of astronomy led him to support Copernicus's theory that the planets revolve around the sun. Galileo developed several theories related to the movement of the earth, the laws of pendulums, and the laws of freely falling bodies. Galileo's impact on mathematics and astronomy changed the way that people thought about the universe.

Featured Book

Starry Messenger: A Book Depicting the Life of a Famous Scientist, Mathematician, Astronomer, Philosopher, Physicist Galileo Galilei, by Peter Sís. Farrar, Straus & Giroux, 1996.

With lyrical language and fascinating illustrations Sís tells the story of the great astronomer's life.

Additional Books

Galileo, by Leonard Everett Fisher. Macmillan, 1992.

Galileo and the Universe, by Steve Parker. HarperCollins, 1992.

Activities

1. Visit a planetarium.
2. Take a walk at night to study the stars. Use a star guide to identify which planets and stars are visible in your part of the country.
3. Study pendulums. How do they work? What functions do pendulums serve?

*February 16 Heart 2 Heart Day

Heart 2 Heart Day, started by Bill Gurvitch, honors the sharing of feelings with someone else. It came out of a writing project which developed diaries, scrapbooks, and friendship books for children. In a diary, the writer shares feelings privately. On Heart 2 Heart Day everyone can share their ideas openly with someone else.

Featured Book

My Mama Had a Dancing Heart, by Libba Moore Gray; illus. by Raul Colon. Orchard, 1995.

Mama shares her love of life and dancing with her young daughter.

Additional Books in Which Dance Brings People Together

Dancing with Dziadaiu, by Susan Campbell Bartoletti; illus. by Annika Nelson. Harcourt Brace, 1997.

Dancing with the Indians, by Angela Shelf Medearis; illus. by Samuel Byrd. Holiday House, 1991.

Song and Dance Man, by Karen Ackerman; illus. by Stephen Gammell. Alfred A. Knopf, 1988.

Activities

1. Host a square dance or a folk dance. See how dancing together brings people closer.
2. Think about a time when your family got together for a celebration. Were there Heart 2 Heart moments when memories were shared and ideas exchanged?

*February 17 PTA Day

The National Parent-Teacher Association, the PTA, was founded on February 17, 1897, by Mary Grinnell Mears. The PTA is the largest volunteer child advocacy organization in the United States. Today the PTA has more than 6 million members who work together to ensure the health, welfare, and education of children. Local PTAs celebrate PTA Day, also called Founder's Day, by honoring a local advocate for children, creating PTA displays, holding special PTA meetings, or sharing scoops of ice cream with students at a special party.

PTA Day is a wonderful time to honor teachers or parent volunteers. The following books are just a few of the many books available which tell stories of helpful teachers.

Featured Books

Lilly's Purple Plastic Purse, by Kevin Henkes. Greenwillow, 1996.

Ruby the Copycat, by Peggy Rathmann. Scholastic, 1991.

The Teeny Tiny Teacher, by Stephanie Calmenson; illus. by Denis Roche. Scholastic, 1998.

Thank You, Mr. Falker, by Patricia Polacco. Philomel, 1998.

Where Does the Teacher Live? By Paula Kurzband Feder; illus. by Lillian Hoban. Dutton, 1979.

Activity

Do something special for a teacher or a parent volunteer.

*February 18 Gambian Independence Day

This national holiday in Gambia recognizes February 18, 1965, as the day when Gambia gained its independence from Great Britain. Five years later, on April 24, 1970, Gambia became a republic. Gambia, which is surrounded by the West African country of Senegal, is one of the smallest independent countries in Africa. It borders the Atlantic Ocean and lies along the banks of the Gambian River. Gambia is a poor country with little fertile soil and no valuable minerals. Farmers in Gambia grow tropical fruit and

peanuts. Only about one-third of the children in Gambia attend school. Gambian children enjoy a rich story-telling tradition.

Featured Books

The Singing Man: Adapted from a West African Folktale, retold by Angela Shelf Medearis; illus. by Terea Shaffer. Holiday House, 1994.

The Story of Lightning & Thunder, by Ashley Bryan. Maxwell Macmillan International, 1993.

Why Mosquitoes Buzz in People's Ears: A West African Tale, retold by Verna Aardema; illus. by Leo and Diane Dillon. Dial, 1975.

Activities

1. Locate Gambia on a world map. Have each student gather a few facts about this West African country using atlases, encyclopedias, almanacs, and nonfiction books. Spend time sharing this information.
2. Using the book *A Taste of West Africa* by Colin Harris (New York: Thomson Learning, 1994), make and eat a West African treat. Bananas and peanuts are typical Gambian foods.

February 19 President's Day

The third Monday in February is the day on which we honor all former presidents of the United States. Originally there were separate celebrations for Abraham Lincoln's birthday on February 12 and for George Washington's birthday on February 22. The Monday Holiday Law of 1971 moved the date for Washington's birthday to the third Monday and in doing so removed some of the special significance of that occasion. George Washington was born on February 11, 1732, under the old Julian calendar. When the Gregorian calendar was adopted, his birthday moved to February 22, 1732. In 1832, the 100th anniversary of Washington's birthday, many communities celebrated Washington's birthday with the firing of cannons, speeches, the ringing of church bells, grand balls, or military parades. Many communities still celebrate Washington's birthday with special events. This is a good day to give special honor to our first president, George Washington.

Featured Book

George Washington's Breakfast, by Jean Fritz; illus. by Paul Galdone. Coward-McCann, 1969.

George W. Allen shares his birthday with George Washington. He wants to know all about George Washington and goes on a research adventure to discover what George Washington ate for breakfast.

Additional Books

Buttons for General Washington, by Peter and Connie Roop; illus. by Peter Hanson. Carolrhoda, 1986.

Phoebe and the General, by Judith Berry Griffin; illus. by Margot Tomes. Coward, McCann & Geoghegan, 1977.

Both books retell true stories of young people who act as spies during the Revolutionary War to help George Washington's effort to defeat the British.

Activity

Using the materials in the story, make a list of facts about President Washington. Add to the list by doing your own research. What additional facts can you find about George Washington's life and presidency?

HOODIE-HOO HOODIE-HOO HOODIE-HOO

*February 20 Hoodie-Hoo Day

At exactly noon, everyone in the Northern Hemisphere is encouraged to go outdoors and yell "hoodie-hoo" to chase away winter. Spring is only one month away!

Featured Book

North Country Spring, by Reeve Lindbergh; illus. by Liz Sivertson. Houghton Mifflin, 1997.

Lindbergh's gentle verses and Sivertson's paintings capture the end-of-winter, beginning-of-spring feelings of the land and the creatures that inhabit it.

Additional Book

Blackberry Ramble, by Thacher Hurd. Crown, 1989.

Activity

Sometime around the noon hour, go outside and shout, "hoodie-hoo." Over the next days and weeks, note the signs that spring is one its way.

February 21 National Cherry Month

The Cherry Marketing Institute has declared February National Cherry Month. They suggest that the ruby-red color of cherries is appropriate to the celebration of Valentine's Day or Presidents' Day. Cherries were brought to America by early European settlers. The first cherry orchard was planted in northern Michigan in the mid-1800s by Peter Dougherty, a Presbyterian missionary. At about the same time, Henderson Lewelling established cherry orchards in western Oregon by transporting cherry seedlings over the Oregon Trail. Today 75 percent of all tart cherries, used in pies, are produced in the Great Lakes region. One cherry tree can produce enough cherries for twenty-eight pies. 70 percent of the sweet cherries are produced in the western states. These cherries are ready for eating just as they are, or they can be preserved as maraschino cherries.

Featured Book

Cherries and Cherry Pits, by Vera B. Williams. Greenwillow, 1986.

It seems that everywhere Bidemmi turns, she finds cherries and cherry pits.

Additional Book

Frannie's Fruits, by Leslie Kimmelman; illus. by Petra Mathers. Harper & Row, 1989.

The Potato Man, by Megan McDonald; illus. by Ted Lewin. Orchard, 1991.

Activities

1. Sample cherries—both fresh and canned maraschino cherries—or share a piece of cherry pie.
2. Draw all sorts of fruit and vegetables for a bulletin board on healthy eating.

February 22 Children's Dental Health Month

February has been declared National Children's Dental Health Month by the American Dental Association. The first observance of Children's Dental Health Day began on February 8, 1949. In 1955 it became a weeklong event, and in 1981 the entire month of February was declared Children's Dental Health Month. Dentists throughout the country visit schools and appear in the media to talk about the importance of good dental care. About half of all school-age children enter school with no cavities thanks to good dental care. Others aren't so fortunate. Contact local dentists for additional information.

Featured Book

Parts, by Tedd Arnold. Dial, 1997.

Humorous verse and illustrations tell the story of a little boy who thinks he is coming apart when he finds hairs in his comb, fuzz in his belly button, and a loose tooth.

Additional Books

Dr. DeSoto, by William Steig. Farrar, Straus & Giroux, 1982.

Grandpa's Teeth, by Rod Clement. HarperCollins, 1998.

Activities

1. Invite a dentist or a dental assistant to class to discuss the importance of good dental care.
2. Create posters reminding everyone of the importance of brushing their teeth after eating.
3. Write public service announcements about dental health. You might present these over a school public address system or create a videotape to share with others.

February 23 Whale Festival

Festivals to watch migrating whales are held in Mendocino, Fort Bragg, and Gualala, California, on the northern coast during late February and March. A Festival of Whales held in Dana Point, California, features whale watches, art shows, children's activities, musical performances, and eating and drinking. The festivals last for several days as the whales make their way past the California coast on their way north. The gray whales migrate over 10,000 miles each year from the warm shores of western Mexico to the cold northern waters of Alaska and Siberia.

Featured Books

The Whales' Song, by Dyan Sheldon; illus. by Gary Blythe. Dial, 1991.

Grandmother tells Lilly how she watched the singing whales migrate when she was a girl.

A Symphony of Whales, by Steve Schuch; illus. by Peter Sylvada. Harcourt Brace, 1999.

This beautifully illustrated book retells the story of nearly three thousand beluga whales trapped in the waters off Siberia during the winter of 1984-85. A fictional child, Glashka, alerts her village and participates in the rescue effort.

Activities

1. Listen to classical music while drawing pictures of whales gliding through the ocean, caught in the ice, or surfacing in the sea.
2. Learn more about whales by reading nonfiction books and encyclopedia entries.

*February 24 Estonian Independence Day

This national holiday celebrates Estonia's declaration of independence from Russian rule on February 24, 1918. The day is celebrated with speeches, patriotic parades, and concerts featuring Estonian music. Folk songs are especially important to this celebration. Estonia's freedom from Russia was short-lived and Estonians returned to Russian rule for another seventy-five years. Estonia has a long history of domination by other countries—Germany, Denmark, Sweden, Poland, and Russia. Originally, most Estonians were related to the Finns and were farmers. Today, many Russians live in Estonia, and the country is known for its manufacturing and mining. About 70 percent of Estonia's people now live in cities or towns. In 1991, Estonia regained its independence.

Featured Book

Elinda Who Danced in the Sky: An Estonian Folktale, adapted by Lynn Moroney; illus. by Veg Reisberg. Children's Press, 1990.

This gentle story tells of Elinda who watches over the birds and guides their migration. When she reaches marriageable age, the North Star, the Moon, and the Sun all propose marriage. Elinda turns them all down. Then she meets Prince Borealis, Lord of the Northern Lights. Although they never marry, Elinda, with her wedding veil called the Milky Way, can sometimes be spotted dancing across the winter sky with Prince Borealis.

Additional Book

The Sea Wedding & Other Stories from Estonia, by Peggy Hoffman and Selve Maas; illus. by Inese Jansons. Dillon, 1978.

These twelve tales from Estonia are told in a manner that will appeal to older children and reveal the nature of the Estonian countryside and of Estonian customs.

Activity

Locate Estonia on a map. Notice its relationship to Finland, as well as to the countries which have ruled Estonia during its long history.

===

*February 25 Kuwait National Day

Kuwait is a tiny Arab nation located at the northern end of the Persian Gulf. Much of its land is desert, which in 1946 was recognized as one of the richest petroleum deposits in the world. Only two to six inches of rain falls each year in Kuwait making it one of the hottest, driest countries in the world. Kuwait's National Day celebrates the accession of Sheikh Saad' Abdallah as-Salim Sabah (1895-1965). His descendants ruled Kuwait until August of 1990 when Iraq invaded Kuwait. Today Kuwait is again ruled by Crown Prince Sheik Saad al Abdullah who serves as the prime minister. The official language is Arabic, and Islam is the official religion. Celebrate Kuwait's National Day by reading some Middle Eastern tales.

Featured Book

The Three Princes: A Tale from the Middle East, retold by Eric A. Kimmel; illus. by Leonard Everett Fisher. Holiday House, 1994.

Three princes seek the hand of a lovely princess. Each sets out to find something that the princess will judge the "greatest wonder." One returns with a crystal ball, another with a magic carpet, and the third with an orange. The princess must judge which is greatest.

Additional Book

Hosni the Dreamer: An Arabian Tale, by Ehud Ben-Ezer; illus. by Uri Shulevitz. Farrar, Straus & Giroux, 1997.

Activites

1. Locate Kuwait on a map of the world. Find out more about this fascinating country and create a bulletin board fact display.
2. Invite someone who immigrated from Kuwait to speak to your group.
3. Discuss these folktales. Can you think of similar tales from other countries?

===

February 26 Ayyami-I-Ha

The days from February 26 through March 1 serve as "intercalary" days which adjust the Baha'i calendar to remain in line with the earth's solar orbit. These special days are dedicated to charitable acts: gift giving, celebration, and hospitality. The fast days of the nineteenth month will follow. The Baha'i faith is one of the world's newest religions. It developed from Islamic roots and is practiced primarily in the Middle East. The Baha'i faith teaches respect for all religions which share in the revelation of one God. This religion calls for an end to prejudice based on race, sex, religion, ethnic heritage, or nationality.

Featured Books Which Celebrate Gift Giving

Giving, by Shirley Hughes. Candelwick, 1993.

A small girl spends her day giving gifts to those she loves.

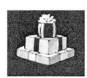

Gifts, by JoEllen Bogart and Barbara Reid. Scholastic, 1994.

When Grandma travels throughout the world, she brings home unique and wonderful gifts from distant and exotic places.

Activities

1. Create a list of gifts that cost nothing, but mean a lot.
2. Make a gift for someone in your life: a drawing, a poem, a story, a song.

*February 27 Dominican Republic Independence Day

The Dominican Republic is a beautiful Caribbean country located in the West Indies. It covers the eastern two-thirds of the island of Hispaniola. Haiti covers the western portion of the island. About half of the people of the Dominican Republic are farmers who raise sugar cane, avocados, bananas, oranges, and various other crops. Much of the manufacturing in the Dominican Republic is related to agriculture or mining.

On December 6, 1492, Christopher Columbus landed on the island. Once Columbus and his men reported that they had found gold, thousands of Spanish colonists moved to Hispaniola and founded the city which is now Santo Domingo. A treaty in 1697 required the Spanish to turn the western part of the island, now Haiti, over to France, and fighting between the two areas erupted as the native Haitians overturned the French and moved on to take over the area that is now the Dominican Republic. For many decades, the area was contested, and the Dominican Republic was either under Haitian or Spanish rule. On February 27, 1844, the Dominican Republic gained independence from the Haitians. However, it was 1966 before the last foreign troops left the island for good. February 27 is a public holiday in the Dominican Republic. It is celebrated with parades and political rallies.

Featured Book

My Two Worlds, by Ginger Gordon; photos by Martha Cooper. Clarion, 1993.

Kirsy Rodrigues, a second-grader in New York City, contrasts her daily life in New York with that of her relatives in the Dominican Republic.

Additional Book

Island Baby, by Holly Keller. Scholastic, 1992.

While not specifically set in the Dominican Republic, this gentle story of a small boy and his pop's bird hospital evokes images of life on a Caribbean island.

Activities

1. Find out more about the Dominican Republic by using maps and reference books to learn about the plants, animals, and people who live there.
2. Create your own *My Two Worlds* story by contrasting two places which are important in your life. These might be two different countries, states, or towns; or they might be two different settings in the same area such as school and home.

*February 28 Kalevala Day

This national holiday in Finland honors the poet Elias Lonnrot who published Finland's epic poem, the "Kalevala," in 1835. Until that time, little had been written in the Finish language.

The stories in the Kalevala were told for centuries around campfires, at festivals, and on hunting and fishing expeditions. Lonnrot, a doctor, gathered the songs together in written form. He began his work with these lines:

> "Now the cold told a tale to me
> The rain dictated poems
> Another tale the winds brought
> The birds added words
> The treetops speeches. . . ."

These stories are still told today. Parades and concerts are held in Finland on February 28 each year to honor Lonnrot.

Featured Book

Louhi: Witch of North Farm, retold by Toni De Gerez; illus. by Barbara Cooney. Viking Kestrel, 1986.

The mischievous witch, Louhi, has stolen the sun and the moon and locked them away. All is darkness until Vainamoinen, the Great Knower, tricks her into returning light to Finland.

Additional Books

Heroes of the Kalevala, Finland's Saga by Babette Deutsch. Julian Messner, 1940.

Tales from a Finnish Tupa, by James Cloyd Bowman and Margery Bianco; trans. by Aili Kolehmainen. Albert Whitman, 1936.

Both books are collections of Finnish tales. There are few illustrations, but older children will enjoy listening to these magical tales.

Activity

Locate Finland on the world map. How do you think Finland's location influences the stories of the Kalevala?

*February 29 Leap Day

Every fourth year an adjustment is made to the calendar by adding an "intercalary" or leap day in order to bring our calendar into line with the earth's orbit. (The earth actually takes 365 days, five hours, and forty-eight minutes to circle the sun.) 2000 was a leap year. The next will be 2004. Non-leap day years, called common years, have fifty-two weeks and one day. On leap year, there are fifty-two weeks and two days. An old tradition allowed women to propose to men during leap year. If the man refused, he had to pay a forfeit. Because of this tradition, Leap Day was sometimes called Bachelors' Day. This tradition is based on a law passed in Scotland on Leap Day in 1288 that made it legal for women to propose to men.

Leap Day babies are rare. Only one out of 1461 babies are born on Leap Day. There are approximately 200,000 people in the United States who claim Leap Day as their birthdays. Worldwide, the number is about four million. Let's celebrate babies today, because all babies, Leap Day babies as well as those not born on Leap Day, are special!

Books about Babies for Very Young Children

Daisy Thinks She is a Baby, by Lisa Kopper. Alfred A. Knopf, 1994.

I'm a Baby You're a Baby, by Lisa Kopper. Viking, 1995.

"More More More" Said the Baby: 3 Love Stories, by Vera B. Williams. Greenwillow, 1990.

So Much, by Trish Cooke; illus. by Helen Oxenbury. Candlewick, 1994.

When I Was Little: A Four-Year-Old's Memoir of Her Youth, by Jamie Lee Curtis; illus. by Laura Cornell. HarperCollins, 1993.

Books about Babies for Slightly Older Children

The Rainbabies, by Laura Krauss Melmed; illus. by Jim LaMarche. Lothrop, Lee & Shepard, 1992.

What Baby Wants, by Phyllis Root; illus. by Jill Bartow. Candlewick, 1998.

Will You Mind the Baby, Davy? by Brigitte Weninger; illus. by Eve Tharlet; trans. by Rosemary Lanning. North-South Books, 1997.

Activity

Share memories of being a baby. How was life different then?

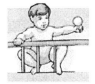

March

***March 1 Nebraska Statehood Day**

On March 1, 1867, Nebraska became the thirty-seventh state. At that time, Nebraska was on the western border of the United States, but now it is in the heartland, a Great Plains state, with a lively agricultural economy. Cattle, pigs, and turkeys are all raised in Nebraska. Cowboys patrol the vast cattle herds of western Nebraska. Corn, hay, oats, and wheat grow in Nebraska's fertile soil.

Nebraska was originally included in the Louisiana Purchase and was among the lands explored by Lewis and Clark. Many Indian tribes, including the Missouri, Omaha, Oto, Pawnee, Cheyenne, and the Sioux lived in what is now Nebraska. Most were wandering tribes who built no permanent homes. However, when the white settlers began arriving in large numbers in 1863 and 1864, some tribes were driven north to Minnesota. Others resettled in Oklahoma. The Oregon Trail proved to be an important route for travelers going west. Many of them settled in Nebraska.

Today's books focus on those settlers who traveled the Oregon Trail or other trails westward across Nebraska.

Featured Book

Dandelions, by Eve Bunting; illus. by Gred Shed. Harcourt Brace, 1995.

As Zoe and her family travel across Nebraska territory, Zoe tries to find a way to make Mama happy.

Additional Book

West by Covered Wagon: Retracing the Pioneer Trails, by Dorothy Hinshaw Patent; photos by William Muñoz. Walker, 1995.

Activities

1. Why did a simple dandelion mean so much to Zoe's mother? If you left home on a journey to a new territory, what would you miss most? Describe it in a picture, poem or paragraph.
2. Locate Nebraska on a map. Find information on the Oregon Trail or other trails West. Where did the route go? How did the Oregon Trail affect the settlement of Nebraska?

***March 2 Read Across America Day**

In 1997 a task force from the National Education Association adopted March 2 as Read Across America Day in an attempt to "get kids excited about reading." They selected March 2 to honor Dr. Seuss who was born on that day in 1904. Dr. Seuss, whose real name was Theodor Seuss Geisel, was the author of many "I Can Read" books. These easy-to-read books have helped millions of children begin reading. In the year 2000, the National Education Association estimates that 23 million children participated in Read Across America activities. Reading events take place in schools, homes, and workplaces and are supported by educators, parents, politicians, and concerned citizens everywhere.

If your school does not participate in Read Across America Day, contact your local branch of the National Education Association for further information. Encourage reading and honor Dr. Seuss by reading some of his books. His first children's book was *And to Think That I Saw It on Mulberry Street* published in 1937. He also wrote under the name of Theo. LeSeig. Additional Seuss books are listed below:

The Cat in the Hat.
The Eye Book.
The 500 Hats of Bartholomew Cubbins.
The Foot Book.
Green Eggs and Ham.
Horton Hatches the Egg.
How the Grinch Stole Christmas.
If I Ran the Zoo.
McElligot's Pool.
On Beyond Zebra.

Activities

1. Have older students read to younger ones.
2. Have younger students read to elderly neighbors or nursing home residents.
3. Ask business people to read to your group. Select books appropriate to their professions.
4. Stage a choral reading of one of the Seuss books.
5. Create bookmarks which promote reading.

*March 3 *Hinamatsuri* (Dolls Day)

On this day in Japan, girls display their doll (*hina*) collections. These collections usually consist of ten to fifteen dolls that are treasured family heirlooms. Once owned by mothers or grandmothers, these dolls are carefully arranged on special shelves. They wear special dresses and antique costumes which cannot be removed; these are not dolls that are played with but are for display only. Young girls dress up in their best clothes and invite their friends into their homes to admire the dolls. They may host a tea party for friends and dolls.

Hinamatsuri is a good day to read about and celebrate dolls around the world.

Featured Book

Elizabeti's Doll, by Stephanie Stuve-Bodeen; illus. by Christy Hale. Lee & Low, 1998.

Elizabeti, a small Tanzanian girl, enjoys her new baby brother, but wishes for a baby of her own. Elizabeti chooses a rock, which she names Eva, to be her own special baby. The rock doll goes everywhere with Elizabeti. Elizabeti doesn't realize how much she cares for her rock doll until she loses Eva among the fire stones.

Additional Books

The Chalk Doll, by Charlotte Pomerantz; illus. by Frane Lessac. Scholastic, 1989.

Nettie Jo's Friends, by Pat McKissack; illus. by Scott Cook. Alfred A. Knopf, 1989.

Activities

1. Make paper dolls or rock dolls. Be creative in painting and dressing the doll.
2. Have each child bring a doll from home and make a display of favorite dolls and stuffed animals.

*March 4 Vermont Statehood and Sugaring Time

March 4 is a good time to celebrate two important events connected with Vermont. On March 4, 1791, Vermont became the fourteenth state to join the union. Until that time, Vermont was an independent republic which had won its freedom from the British when Ethan Allen and the Green Mountain Boys captured Fort Ticonderoga. Vermont's colorful history and scenic countryside attract many tourists from around the country.

Early March also marks the beginning of Sugaring Time. For a few weeks when the nights are still below freezing, but the days are warm, the sap runs freely from the maple trees. Local syrup farmers must tap the maple trees with small metal spigots, collect the sap, and then boil it down until it attains just the right flavor and texture. Sugaring is hard work. It takes about forty gallons of maple sap to make one gallon of maple syrup. Vermont leads the country in the production of maple syrup.

March 4 is a good time to read stories of Vermont and Vermonters.

Featured Books

Snowflake Bently, by Jacqueline Briggs Martin; illus. by Mary Azarian. Houghton Mifflin, 1998.

This Caldecott Award winner tells the story of a self-taught Vermont scientist who photographed and studied snowflakes.

The Wonderful Hay Tumble, by Kathleen McKinley Harris; illus. by Dick Gackenback. Morrow, 1988.

This joyful story recalls the problem of a young farmer whose farm, high on a Vermont hilltop, is a hopeless pile of rocks until a wonderful hay tumble transforms it.

Activities

1. Purchase some real Vermont maple syrup and some maple-flavored syrup. Look at the list of ingredients on each bottle and then taste each. What are the differences? Consider production, cost, and flavor.
2. Hold a pancake breakfast. Plan the menu, select the recipes, and purchase the ingredients. Select a place and time, create an invitation list, and make invitations (perhaps in the shape of maple leaves or pancakes). Prepare the food and enjoy! This might be a social event or a fund-raiser.

March 5 Feast of Excited Insects or *Kyongchip*

Kyongchip or the Feast of Excited Insects, held sometime around March 5, marks the beginning of spring in Korea. The insects awake from winter hibernation indicating the change of season. Farmers

begin sowing rice or wheat in their fields. Families take bouquets of flowers to the graves of their ancestors in the hope that their crops will be bountiful. March 5 is a good time to read silly stories of excitable insects.

Featured Book

Two Bad Ants, by Chris Van Allsburg. Houghton Mifflin, 1988.

Two bad ants have no idea how dangerous life is outside their colony until they go out on their own.

Additional Books

The Giant Jam Sandwich, by John Vernon Lord; verses by Janet Burroway. Houghton Mifflin, 1972.

The Very Hungry Caterpillar, by Eric Carle. Philomel, 1969.

Activities

1. Try to imagine what the world might look like to an ant or a bee or a caterpillar. Draw a picture of you or your home as seen by an insect.
2. Korean farmers welcome insects as a sign of a good harvest. Think of ways that insects make our lives better. You may need to do some research focusing on particular insects.

*March 6 Alamo Day

On March 6, 1836, the Alamo, an abandoned Spanish mission, fell to defeat in the brief war of Texas independence. Stephen Austin, known as the father of Texas, initially brought 300 settlers to Texas in 1821. At that time, Texas became part of Mexico. Increasing numbers of Americans moved into the territory, and by October 1835 the Texans were fighting for independence. As the Mexican leader Santa Anna arrived in San Antonio with 4,000 troops to contain the rebellion, the 150 Texas defenders fled to the old Alamo mission. They held out until March 6 when Santa Anna took the fort and killed the Texas rebels. Davy Crockett and James Bowie were among those who died that day. "Remember the Alamo" became the battle cry of the Texans who won independence on April 21, 1836. Remember Texas today and the brave Texans who fought at the Alamo by reading about Davy Crockett in fact and tall tales.

Factual Account of Davy Crockett

A Picture Book of Davy Crockett, by David A. Adler; illus. by John & Alexandra Wallner. Holiday House, 1995.

Tall Tale Accounts of Davy Crockett

"Davy Crockett," in *American Tall Tales*, by Mary Pope Osborne; illus. by Michael McCurdy. Alfred A. Knopf, 1991; 3-13.

"Davy Crockett Teaches the Steamboat a Leetle Patriotism," *Big Men, Big Country: A Collection of American Tall Tales*, by Paul Robert Walker; illus. by James Bernardin. Harcourt Brace Jovanovich, 1993; 15-21.

The Narrow Escapes of Davy Crockett, by Ariane Dewey. Greenwillow, 1990.

Sally Ann Thunder Whirlwind Crockett: A Tall Tale, retold by Steven Kellogg. Morrow, 1995.

Activities

1. Why do you think that Davy Crockett, who was a real historical figure, became the subject of so many tall tales? Can you think of other real people whose extraordinary abilities would make them good subjects for tall tales?
2. Go to the library and select more tall tales to read and enjoy.
3. Try your hand at writing a tall tale. You might use your tall tale to invent an extraordinary adventure in the life of a real person.

*March 7 Monopoly Invented

On Marcy 7, 1933, the game of Monopoly was played for the first time. Charles B. Darrow of Germantown, Pennsylvania, invented the game, and when it was rejected by Parker Brothers, he produced it himself. He and a printer friend sold 5,000 handmade sets to a Philadelphia department store and it sold quickly. Today, over 200 million games have been sold in eighty countries and the game is produced in twenty-six languages throughout the world. The longest game in history lasted seventy straight days, and the longest game played in a bathtub lasted ninety-nine hours!

Featured Book

Jumanji, by Chris Van Allsburg. Houghton Mifflin, 1981.

Two children left alone for an afternoon find a mysterious game. Once they begin playing, one adventure follows another until they are on the verge of disaster.

Additional Book

Last Licks: A Spaldeen Story, by Cari Best; illus. by Diane Palmisciano. DK, 1998.

Activity

It's a good day to play Monopoly or another board game. If you are particularly creative, create your own game. Who knows—it might be the next Monopoly!

*March 8 International Woman's Day

This holiday began in the United States to honor the March 8, 1857, revolt of women in New York City's garment industry. It was proclaimed a holiday in 1910 and is celebrated today in many countries throughout the world, including Great Britain, China, Afghanistan, and the former Soviet Union countries. In the kingdom of Nepal, Woman's Day is called *Tij* Day and is celebrated exclusively by women. In Mauritanis, Woman's Day is a day when women are freed from work and may spend the day relaxing. International Woman's Day is a day to honor working women.

Featured Book

Saturday at the New You, by Barbara E. Barber; illus. by Anna Rich. Lee & Low, 1994.

A young girl's favorite day of the week is Saturday when she can help Momma at her beauty parlor, The New You.

Additional Books

A Chair for My Mother, by Vera B. Williams. Greenwillow, 1982.

My Working Mom, by Peter Glassman; illus. by Tedd Arnold. Morrow, 1994.

Activity

Honor the working women (remembering stay-at-home moms work, too) in your family by creating thank-you pictures or notes, offering to help with the chores, making a gift, or preparing a special treat.

March 9 Iditarod Sled Dog Race

The longest and toughest sled dog race in the world begins in Anchorage, Alaska, on March 5 and continues until the racers reach Nome about ten days later. The racers must cross two mountain ranges, 150 miles of frozen Yukon River, and deal with bears, wolves, and other creatures along the trail. The race is held on the historic trail used by a team of mushers who brought medicine from Anchorage to Nome to fight a diphtheria epidemic. A big party is held at the finish line in Nome.

Featured Book

Akiak: A Tale from the Iditarod, by Robert J. Blake. Philomel, 1997.

Akiak, a sled dog who is injured during the race, refuses to give up despite being disqualified.

Additional Books

Dogteam, by Gary Paulsen; illus. by Ruth Wright Paulsen. Delacorte, 1993.

Mush! Across Alaska in the World's Longest Sled-Dog Race, by Patricia Seibert; illus. by Jan Davey Ellis. Millbrook, 1992.

Activities

1. On a map of Alaska trace the route that the original team of mushers might have followed to get to Nome from Anchorage.
2. Do some research to discover what animals the mushers might encounter along the Iditarod Trail.

March 10 Sweetwater Rattlesnake Roundup

There are several rattlesnake roundups in Texas, but the one in Sweetwater, held the second weekend in March, is advertised as the biggest. It began in 1958 as a way to eliminate some of the rattlesnakes bothering the livestock in the area. Each year about 12,000 pounds of Western Diamondback Rattlesnakes are caught. The venom milked from the snakes is used as an antidote for snakebite and for medical research. The skins are used to make belts and boots. The

roundup includes snake-handling demonstrations, snake milking, and prizes for the biggest and heaviest snakes. Miss Snake Charmer is elected and there is a rattlesnake-eating contest. Over 4,000 pounds of snake meat is eaten each year.

Featured Books

Snake Alley Band, by Elizabeth Nygaard; illus. by Betsy Lewin. Doubleday, 1998.

Young Snake falls asleep in the woods far from the other snakes of the snake band. When he wakes, he discovers a variety of other creatures eager to join a band. The new Snake Alley Band sounds even better than the all snake group.

Armadillo Rodeo, by Jan Brett. Putnam, 1995.

Bo, a young Texas armadillo, mistakes Harmony Jean's new red rodeo boots for a playful armadillo and follows Harmony Jean to the rodeo.

Activities

1. There are 2700 species of living snakes. Have each child choose one and gather some interesting facts. Create a snake fact bulletin board.
2. In addition to rattlesnakes and armadillos, what other creatures live in Texas? Research and find out.
3. Create your own animal-sound band.

*March 11 Blizzard of 1888

The most famous blizzard in U.S. history lasted thirty-six hours and devastated the northeastern United States. The snow in New York City's Herald Square measured thirty feet deep due to drifting. All transportation, except via sleigh or snowshoes, stopped, the stock exchanges closed, and communications were cut off. In fact, some telegraph messages from New York City to Boston were transmitted through England. Four hundred people died as a result of this blizzard and property loss of $25 million occurred because fire fighters could not get through the snow to put out blazes. Stories from the storm became legends. For example, a New York City shoe salesman claimed to have sold 1,200 pairs of rubber boots following the blizzard.

Featured Books

Flying Over Brooklyn, by Myron Uhlberg; illus. by Gerald Fitzgerald. Peachtree, 1999.

A small boy imagines flying over a snow-covered Brooklyn and admiring the city's many sights covered with snow. An author's note provides information on the 1947 blizzard which covered the city with 25.8 inches of snow.

Blizzards! By Lorraine Jean Hopping; illus. by Jody Wheeler. Scholastic, 1998.

Chapter 1 describes the blizzards of 1888 and their effects on North and South Dakota and on New York City.

Additional Book

Brave Irene, by William Steig. Farrar, Straus & Giroux, 1986.

Activities

1. Begin a weather chart recording the temperature and precipitation in your area for the next month.
2. Share stories of major storms which you have experienced.
3. Ask older people you know, parents, grandparents, or neighbors, about the storms that they remember from their childhood. What makes a storm memorable?

*March 12 Girl Scout Day

On March 12, 1912, Mrs. Juliette Gordon Low founded the Girls Scouts in America. At first they were called Girl Guides after a similar organization in England. By 1915, however, they were renamed Girl Scouts and continue to this day to promote good citizenship, social activities, and appreciation of the outdoors for girls ages five to seventeen. Celebrate Girl Scout Day by reading about girls who enjoy nature.

Featured Book

Fox Song, by Joseph Bruchac; illus. by Paul Morin. Philomel, 1993.

Jamie experiences the joys of nature from her Abenaki Indian grandmother as they explore the New England countryside together.

Additional Book

The Cabin Key, by Gloria Rand; illus. by Ted Rand. Harcourt Brace, 1994.

Activity

Take a winter nature walk. Be as quiet as possible. Focus on the sights, sounds, and smells surrounding you. When you return inside, jot down your observations and share them with others. What surprised you?

March 13 Umbrella Month

With spring rains comes the need for one of our most useful inventions—the umbrella. From ancient times to today umbrellas have been used as sunshades. Such umbrellas are called parasols. However, in the 1700s heavy umbrellas made of wood and oilcloth were used in Europe to protect people from rain. Today umbrellas come in all shapes, sizes, and colors. Some even fold small enough to fit in a pocket. March is Umbrella Month. Read about rainy days and the ingenious umbrella.

Featured Books

In the Rain with Baby Duck, by Amy Hest; illus. by Jill Barton. Candlewick, 1995.

Baby Duck hates the rain until her understanding Grampa finds her a pair of red rubber boots and an umbrella which turns a rainy day into an adventure. This story will be especially appealing for younger children.

Roger's Umbrella, by Honest Dan'l Pinkwater; illus. by James Marshall. Dutton, 1982.

Roger's umbrella seems to cause more problems than it solves. Each outing is a wild adventure.

Additional Books

Umbrella, by Taro Yashima. Viking, 1969.

What If It Never Stops Raining? by Nancy Carlson. Viking, 1992.

Activities

1. Take a walk in the rain.
2. Create a list of good rainy day activities.

March 14 Tornado Season

Tornadoes are one of the most fascinating weather phenomena and also one of the most destructive. About 75 percent of tornadoes occur between March and July. Most of the world's tornadoes form in the midwestern United States, particularly in an area called Tornado Alley, which includes parts of the states of Kansas, Missouri, Oklahoma, and Texas. Between six hundred to seven hundred tornadoes are reported every year in the United States, with one in four occurring in the late afternoon. Tornado warning systems alert people in threatened areas to go to safe areas, and school children in some areas of the Midwest regularly participate in tornado drills.

Featured Nonfiction Book

Tornadoes, by Peter Murray. Child's World, 1996.

This photographic essay provides a child's eye view of an approaching tornado. The photographs provide an amazing glimpse of the power of tornadoes.

Featured Fiction Books

One Lucky Girl, by George Ella Lyon; illus. by Irene Trivas. DK, 2000.

The Strongest Man This Side of Cremona, by Georgia Graham. Red Deer, 1998.

Activities

1. Do you live in a tornado area? If so, March 14 is a good day to review tornado safety procedures.
2. Experiment with a tornado. A number of science experiment books will provide directions on how to create tornadoes in a jar. One such book is *How the Weather Works: 100 Ways Parents and Kids Can Share the Secrets of the Atmosphere*, by Michael Allaby. Pleasantville, N. Y.: Reader's Digest, 1995.

*March 15 Maine Admission Day

Maine, the most easterly of all the states, joined the Union on March 15, 1820, as the twenty-third state. Although not one of the original thirteen states, Maine was the site of England's first northern colony. In 1607 the Popham colony was founded. The harsh Maine winter and difficulties with the Indians drove the English home in 1608. Among the first inhabitants of Maine were the Algonquian, Passamoquoddy, Penobscot, and Kennebec Indians.

Maine is known as the Pine Tree State. Forests cover much of the state and lumbering is an important industry. Maine is one of the top producers of potatoes. Corn, hay, blueberries, and apples are also grown in Maine. Maine's long, rugged coastline attracts many tourists and provides a rich fishing ground. Ninety percent of the country's lobsters come from Maine. Cod, flounder, tuna, and soft-shell clams are also harvested in Maine.

Featured Book

Island Boy, by Barbara Cooney, Viking Kestrel, 1988.

Tibbetts Island, off the coast of Maine, has always been home to Matthais, the youngest of the Tibbetts children. The story follows Matthais as he grows up on the island, leaves the island in search of adventure as a seaman, and eventually returns to the island to raise his own family. When his grandson, also named Matthais, talks of leaving the island for adventure, Matthais comments, "It is good to see the world beyond the bay. Then you will know where your heart lies."

Additional Books

Blueberries for Sal, by Robert McCloskey, Viking, 1948.

One Morning in Maine, by Robert McCloskey. Viking, 1952.

Winter Barn, by Peter Parnall. Macmillan, 1986.

Activities

1. Find Maine on a map. Using the story as a guide, compare the activities which take place in these stories about Maine with activities common in your state today. How many of the activities are unique to Maine or northern New England? How many are unique to the time in which the story takes place? Can you imagine these adventures taking place today?
2. Maine is special to the characters in these stories. What makes a place special? Share some memories that focus around a certain place you lived or visited.
3. Imagine that you live on an island. How does island life differ from life on the mainland?

March 16 Music in Our Schools Month

Sponsored by the National Association for Music Education, Music in Our Schools Month is a time to appreciate the special benefits of music education. Learning to appreciate all kinds of music—jazz, country, pop, classical, and world music—is important to our intellectual development. It's also lots of fun. March is a good time to appreciate the magical ways in which music enriches our lives.

In addition to the books listed below, there are dozens of beautifully illustrated books based on the words of familiar childhood songs.

Featured Book

Moses Goes to a Concert, by Isaac Millman. Farrar, Straus & Giroux, 1998.

Moses and his classmates, all deaf, attend a concert. Even though they cannot hear as others do, they enjoy the event and meet the orchestra's percussionist who is also deaf.

Additional Book

Mole Music, by David McPhail. Henry Holt, 1999.

Activities

1. Ask children to share their musical talent by singing or playing an instrument for the group.
2. Listen to great music together. Draw pictures of whatever enters your mind as you listen to the music.
3. Attend a concert.

*March 17 St. Patrick's Day

St. Patrick is the patron saint of Ireland, born about 390 A.D. in Britain and died around 461 A.D. His father and grandfather were devout Christians, but when Patrick was sixteen he was captured by pagan Irishmen and sold into slavery. After six years he gained his freedom and returned home to Roman Britain to train for the priesthood. Eventually he returned to Ireland as a bishop in 432 A.D. to undertake missionary duties.

St. Patrick's Day is celebrated throughout Ireland with worship services. People may wear the shamrock, a symbol of St. Patrick who used its three-part leaves to teach about the Holy Trinity. People in Ireland greet friends with the words, "May the blessings of St. Patrick be with you."

American celebrations of St. Patrick's Day tend to be much rowdier than those in Ireland. Boston's St. Patrick's Day parade dates back to 1737 and New York's to 1762. The drinking of green beer and the wearing of green derbies or green carnations is a tradition in Irish American communities.

Featured Book

The Leprechaun in the Basement, by Kathy Tucker; illus. by John Sandford. Whitman, 1999.

On St. Patrick's Day Michael McKeever discovers that a leprechaun lives in the basement. Although he refuses to share his pot of gold, the leprechaun does bring luck to Michael and his family.

Additional Books

Seeing Is Believing, by Elizabeth Shub; illus. by Rachel Isadora. Greenwillow, 1979.

The Leprechaun's Story, by Richard Kennedy; illus. by Marcia Sewall. Dutton, 1979.

Activities

1. List all the ways you are lucky.
2. Tell a story about a time that good luck came your way.

March 18 Marzenna Day

Along the Vistula River in Poland, Marzenna Day, held the Saturday or Sunday nearest March 21, welcomes spring. Villagers, dressed in colorful costumes, carry a Marzenna to the river and throw her in. The Marzenna is a straw doll that is about three or four feet tall and dressed in rags, a hat, and lots of ribbons. The act of throwing the Marzenna into the river not only says goodbye to winter, but acts out an old tale about a girl who was saved by a young man just as she was about to be sacrificed to the gods of storms and floods. The people celebrate the start of spring with singing and dancing.

Featured Book

The Nine Crying Dolls: A Story from Poland, retold by Anne Pellowski; illus. by Charles Mikolyacak. Philomel, 1980.

When baby Antolek won't stop crying, an old grandmother suggests that the mother make nine rag dolls and pass them along. The crying would leave with the dolls. The result is an epidemic of crying babies!

Additional Book

The Littlest Matryoshka, by Corinne Demas Bliss; illus. by Kathryn Brown. Hyperion, 1999.

A set of nesting dolls travels from Russia to the United States where the littlest one is lost in the snow. Although this story focuses on Russian nesting dolls, such dolls are also popular in Poland (see the note at the back of the book).

Activity

Design a Marzenna. Using a simple paper cutout, give the doll a face and clothing and then, if possible, toss the doll into a stream as a way of saying goodbye to winter and of celebrating the beginning of spring.

March 19 Canberra Day

The city of Canberra, Australia's capital, was founded on March 12, 1913. It was a totally planned city built about 200 miles southwest of Sydney. The city includes a giant ornamental pond, Lake Burley Griffin, which was built in a depression on a vast, dusty plain. Canberra Day is celebrated on the third Monday in March. A ten day celebration precedes Canberra Day. The festival includes an opera, a "street bed" derby (wheeled beds are raced through the streets), balloon rides, and other community events.

Celebrate Canberra Day with fanciful stories of some of Australia's amazing animals.

Featured Books

The Biggest Frog in Australia, by Susan L. Roth. Simon & Schuster, 1996.

One Woolly Wombat, by Rod Trinca and Kerry Argent; illus. by Kerry Argent. Kane Miller, 1985.

Possum Magic, by Mem Fox; illus. by Julie Vivas. Omnibus, 1983.

Activities

1. Make a list of all the Australian animals mentioned in the story. Work in groups to learn more about the animals. Create a drawing and an informational paragraph for each one.
2. Make a list of the Australian animals mentioned in the story and then create a similar list of the animals which would be mentioned in a story about your hometown.
3. Locate Australia on a map of the world. How would you get there from home? How long would the trip take?

*March 20 National Agriculture Day

March 20, the first day of spring, is also National Agriculture Day. Sponsored by the Agriculture Council of America and many state agriculture councils, National Agriculture Day honors our nation's farmers and farm families. March 20 is a good day to read about farms and farmers.

Featured Book

Amelia's Road, by Linda Jacobs Altman; illus. by Enrique O. Sanchez. Lee & Low, 1993.

Amelia Luisa Martinez is the child of migrant workers. She yearns for a place to call home, but the family is always following the crops. Amelia discovers that home is always with her.

Additional Books

Little Farm by the Sea, by Kay Chorao. Henry Holt, 1998.

Yonder, by Tony Johnston; illus. by Lloyd Bloom. Dial, 1988.

Activities

1. Research the kinds of farms located in your area. Bring a food item made of locally grown ingredients to class.
2. Invite a local farmer to visit and talk about his/her work.
3. How has farming in your state changed over the years? Visit with older people who lived on farms of the past and compare their experiences with that of farming today.
4. Chart what you eat for a day. Which food items are produced in the United States? Which are imported from other countries?

March 21 The Vernal Equinox

On two days each year, the sun is directly above the earth's equator. On March 20 or 21, the vernal equinox signals the beginning of spring in the Northern Hemisphere. On September 22 or 23 the autumnal equinox heralds the beginning of autumn in the North. In the Southern Hemisphere, the seasons are reversed. During the equinox, the days and nights are of approximately equal length.

March 21 is a day to celebrate the coming of spring.

Featured Book

When Spring Comes, by Natalie Kinsey-Warnock; illus. by Stacey Schuett. Dutton, 1993.

A young girl imagines all of the things that she will do when spring comes to her northern home.

Additional Books

In the Moonlight, Waiting, by Carol Carrick; illus. by Donald Carrick. Clarion, 1990.

Activities

1. List some of the activities that you look forward to, now that spring has come.
2. Draw a picture of some of the spring activities that you enjoy.

March 22 National Peanut Month

The National Peanut Council has proclaimed March as National Peanut Month. According to the Peanut Council, Americans consume more than six pounds of peanuts and items containing peanuts each year. Peanuts are a good source of protein and contain many essential vitamins and minerals. It is important to note, however, that some individuals are severely allergic to peanuts and should not eat peanuts or any product containing peanuts. Doctors recommend that if there is a history of allergies in the family, children under the age of three should not be given peanuts in any form.

Featured Book

A Weed Is a Flower: The Life of George Washington Carver, by Aliki. Simon & Schuster, 1985.

Watercolor illustrations highlight the important events and accomplishments in the life of George Washington Carver.

Additional Books

A Pocketful of Goobers: A Story About George Washington Carver, by Barbara Mitchell; illus. by Peter E. Hanson. Carolrhoda, 1986.

George Washington Carver: The Peanut Scientist, by Patricia and Frederick McKissack. Enslow, 1991.

Activities

1. Make and enjoy peanut butter snacks.
2. Taste-test a variety of peanuts: salted, dry-roasted, honey-roasted, etc. Survey friends and family about their favorites and tally the results.

*March 23 Pakistan Day

In the early 1900s India, Pakistan, and Bangladesh were one nation under British rule. It was an uneasy alliance, however, as there were religious conflicts between the Hindu and Muslim populations. On March 23, 1940, the Muslim League proposed that a separate republic be formed for the Muslim population. The suggested name was Pakistan which means *land of the pure* in Urdu. On August 14, 1947, Pakistan became an independent dominion in the British Commonwealth of Nations. On March 23, 1956, Pakistan became a republic. This date, which is still celebrated with parades and fairs, is also known as Republic Day.

Featured Book

The Gifts of Wali Dad: A Tale of India and Pakistan, retold by Aaron Shepard; illus. by Daniel San Souci. Atheneum, 1995.

When the poor, but generous, Wali Dad gave away some gold coins, he set in motion a gift-giving extravaganza that looked as if it would never end. This folktale of unknown origin reflects strong Islamic and Zorastrian influences.

Additional Book

Nadia's Hands, by Karen English; illus. by Jonathan Weiner. Boyds Mill, 1999.

Although this story takes place in the United States, it focuses on Nadia's experiences as a flower girl in a traditional Pakistani wedding.

Activities

1. Locate Pakistan on the world map. Using reference sources to find a few facts about this Muslim nation in South Asia.
2. Invite a Pakistani-American to class to talk about the customs and culture of Pakistan.

*March 24 Philippines Independence Day

In 1901 the United States set up a colonial government in the Philippines as a result of a treaty signed with Spain at the conclusion of the Spanish-American War. On March 24, 1934, United States President Franklin D. Roosevelt signed a bill granting independence to the Philippines. Although the independence bill was signed in 1934, the Philippines did not gain complete independence until July 4, 1946. Today the Philippines is a country composed of more than 7,000 islands in the southwest Pacific Ocean. Fewer than half of the islands have names, and only 900 are actually inhabited. There are about sixty-six million Filipinos. Both Filipino and English are the official languages.

Featured Books

Pedro and the Monkey, by Robert D. San Souci; illus. by Michael Hays. Morrow, 1996.

This trickster tale from the Philippines tells of a young Filipino farmer, Pedro, who traps a magic monkey. In return for his freedom, the monkey arranges for Pedro to marry the daughter of a wealthy landowner.

A Crocodile's Tale: A Philippine Folk Story, by Jose and Ariane Aruego. Charles Scribner's Sons, 1972.

In this trickster tale, a crocodile threatens to eat Juan even though Juan saved the crocodile's life.

Activities

1. Locate a map of the Philippines. How many of the 7,000 islands are visible on the map? Identify the largest island, Luzon, and its capital city of Manila. What other facts can you learn from studying the map?
2. Use reference books, nonfiction books, and a magazine index to find pictures of the Philippines. What do the pictures tell you about life on a Pacific island?

*March 25 Greek Independence Day

Greece's recorded history dates from about 3000 B.C., but modern Greek history begins around 1300 A.D. when the Ottoman Empire, centered in Turkey, gradually took over the area now Greece. For centuries the Greeks were under Turkish authority. On March 25, 1821, Greece declared its independence after nearly 400 years of Turkish rule and began a war with Turkey that lasted for eight years. In 1829 Turkey finally recognized Greece's independence and withdrew from the country.

Over the years, Greece expanded to its current size. Approximately ten million people live in Greece, a small country that borders on the Mediterranean Sea. About 30 percent of the people live in the capital city, Athens. Greece is a popular tourist destination, and people are particularly attracted to its ancient ruins. On March 25, church services and parades are held to celebrate Greek Independence Day.

Greek Independence Day is a good day to celebrate the rich mythological heritage that we have received from the ancient Greeks.

Featured Book

King Midas and the Golden Touch, retold and illus. by Charlotte Craft and K. Y. Craft. Morrow, 1999.

Beautifully illustrated, this version of the Midas myth is based on Nathaniel Hawthorne's retelling.

Additional Books

The Midas Touch, retold by Jan Mark; illus. by Juan Wijngaard. Candlewick, 1999.

Jacob Lawrence Aesop's Fables. University of Washington Press, 1997.

Activities

1. Read two or more versions of the Midas myth or Aesop's Fables. Compare and contrast them.

2. Try rewriting a Greek myth or fable using a modern setting. What would be different? Would the moral or lesson still be appropriate?

*March 26 Robert Frost Day

Robert Frost, born in San Francisco on March 26, 1874, became the most popular American poet of his time. In 1885, Frost moved with his family to New England where he spent the rest of his life. He attended Harvard College, but never earned a college degree. He worked as a farmer, a schoolteacher, and an editor, but his life's work was poetry. His poems reflect themes common to rural New England life, particularly that of Vermont and New Hampshire. His poetry won many prizes, including the Pulitzer Prize, and national recognition. Frost died in 1963.

Featured Books

Birches, by Robert Frost; illus. by Ed Young. Henry Holt, 1988.

Stopping by Woods on a Snowy Evening, by Robert Frost; illus. by Susan Jeffers. Dutton, 1978.

You Come Too: Favorite Poems for Young Readers, by Robert Frost; illus. by Thomas W. Nason. Henry Holt, 1959.

The first two picture books each present a single Frost poem vividly illustrated. The third book is a collection of several Frost poems accessible to young readers.

Activities

1. Read two or three Frost poems. How are they alike? What common themes or settings do they share?
2. Select a Frost poem and do your own illustration.
3. Try writing a few verses of your own based on a scene from nature.

March 27 National Craft Month

The Hobby Industry Association, with over 4,000 members representing the craft and hobby industry, sponsors March as National Craft Month. A 1998 survey by the Hobby Industry Association revealed that most people use their craft projects for gifts, personal use, home decorating or holiday decorating. Seven out of ten households surveyed said that at least one household member had participated in craft or hobby activities during the past year. Art or drawing, home décor, paper cutting, and paper crafts were most frequently mentioned by people taking the survey. Dozens of craft books have been written for children which provide directions for simple projects.

March 27 is a good day to read about people who have crafted items which continue to have meaning through the years.

Featured Book

Something from Nothing, by Phoebe Gilman. Scholastic, 1992.

In this Jewish folktale, Joseph's baby blanket is transformed into ever smaller items until it seems as if there is nothing left.

Additional Books

Hands, Lois Ehlert. Harcourt Brace Jovanovich, 1997.

The Josefina Story Quilt, by Eleanor Coerr; illus. by Bruce Degen. Harper & Row, 1986.

Sam Johnson and the Blue Ribbon Quilt, by Lisa Ernst Campbell. Lothrop, Lee & Shepard, 1983.

Activities

1. Find a how-to book in the library, follow the directions, and create a special gift for someone you know.
2. Bring a quilter or woodworker or other crafter to class for a demonstration.
3. Invite parents to bring handcrafted items that have become family heirlooms to class to share with students.

*March 28 Teacher's Day

Czechoslovakian Jan Amos Komensky, born on this day in 1592, was the first person to write an illustrated textbook for children. His pocket-sized book was used to teach children Latin words. Komensky also believed in compulsory education for all children. This holiday in Czechoslovakia is called Teacher's Day and celebrates Komensky's contribution to education. Children may bring flowers or gifts to their teachers. It is also a day for special educational lectures and activities.

Teacher's Day is a good day to read stories from Czechoslovakia.

Featured Book

The Three Golden Keys, by Peter Sis. Doubleday, 1994.

An adventurer traveling by hot-air balloon lands in the city of Prague and must solve the mystery of the city.

Additional Book

The Golem, by David Wisniewski. Clarion, 1996.

A clay giant comes to life and helps a rabbi care for the Jews of Prague during the wars in the 1500s.

Activities

1. Discuss the story you read. What does it reveal about life in Prague and the Czech people? Do you think you would like to live there? Why or why not?
2. Locate the Czech Republic on a map. Find out more about this area of Europe.

March 29 National Noodle Month

According to the National Pasta Association consumption of noodles, in all their various forms, increases by as much as 20 percent during the months of January, February, and March. They have chosen to celebrate pasta by naming March as National Noodle Month. According to legend, German bakers in the thirteenth century created shapes from dough and called them *nudels*. *Nudels* in the shape of birds, or stars, or other familiar symbols were baked and served as bread. Present day noodles come in a wide variety of shapes including alphabets, rotini, angel hair, capellini, manicotti, bow ties, shells, and regular spaghetti. March 29 is a fine day to read spaghetti adventures.

Featured Book

Strega Nona: An Old Tale, retold by Tomie DePaola. Prentice-Hall, 1975.

This story from Italian folklore presents Strega Nona, a "grandma witch" in the town of Calabria, who leaves Big Anthony alone to watch her magic pasta pot with amusing results.

Additional Books

More Spaghetti, I Say! by Rita Golden Gelman; illus. by Jack Kent. Scholastic, 1977.

Spaghetti and Meatballs for All! A Mathematical Story, by Marilyn Burns; illus. by Debbie Tilley. Scholastic, 1997.

The Spaghetti Party, by Doris Orgel; illus. by Julie Durrell. Bantam, 1995.

Activities

1. Hold a spaghetti (or noodle) party. It might be a potluck with everyone bringing a different kind of noodle dish.
2. Go to a grocery store and note all the different kinds of noodles. Why are there so many?
3. Use noodles in a craft project. (You'll find lots of suggestions for noodle crafts in books at your local library.)

*March 30 Doctor's Day

On this day, Americans honor their physicians. On March 30, 1842, Dr. Crawford W. Long first used anesthesia on a patient during surgery to remove a tumor from his neck. The official flower of Doctor's Day is a red carnation.

Featured Books

Stick Out Your Tongue! Jokes about Doctors and Patients, by Peter and Connie Roop; illus. by Joan Hanson. Lerner, 1986.

Doctor Rabbit's Foundling, by Jan Wahl; illus. by Cyndy Szekeres. Random House, 1977.

Activities

1. Make a Doctor's Day bulletin board to honor local doctors by making red carnations from construction paper, assembling them on a bulletin board, and listing the names of local doctors.
2. Invite a doctor to class to talk about preventive health care.

*March 31 Oranges and Lemons Day

At St. Clement Danes church in London, children celebrate this festival which takes its name from the old nursery rhyme: "Oranges and lemons, say the bells of St. Clement's." The church, founded by Danish merchants, is located on the banks of the Thames. Its wharf was a natural entry point for fruit, which may be the origin of the rhyme. In 1920, the church installed a carillon which rings out the tune of the nursery rhyme. On March 31 it rang for the first time. Children of the nearby primary school read the lessons and recite the rhyme on March 31 and are rewarded by a gift of an orange and lemon. Tables outside the church are piled high with the fruit each March 31.

Featured Book

The Bells of London, by Ashley Wolff. Dodd, Mead & Company, 1985.

Ashley Wolff recalls the rhyme about oranges and lemons in this brief, but beautifully illustrated text.

Additional Books That Feature Traditional English Folktales

The Green Mist, retold and illus. by Marcia Sewall. Houghton Mifflin, 1999.

Harald and the Great Stag, by Donald Carrick. Clarion, 1988.

The Hobyahs, retold by Robert D. San Souci; illus. by Alexi Natchev. Doubleday, 1994.

Lazy Jack, by Vivian French; illus. by Russell Ayto. Candlewick, 1995.

Activity

1. Eat an orange or drink orange juice or lemonade as you listen to the stories.
2. See how many nursery rhymes you can recite by memory.

April

*April 1 April Fool's Day

This is the day for playing practical jokes on people. April Fool's Day is celebrated throughout North America and Europe. Some scholars speculate that the custom began when the calendar was changed in 1582 and the date of the year's beginning moved from March 25 to January. Anyone who forgot was an April fool. In France, April 1 is called *"poisson d'Avril."* Children tape paper fish to each other's backs and yell, "April fish!" Some French people exchange fish-shaped chocolates on this unique holiday.

Featured Book

All of Our Noses Are Here and Other Noodle Tales retold by Alvin Schwartz; illus. by Karen Ann Weinhaus. Harper & Row, 1985.

This collection makes great April Fool's Day reading because these noodle tales feature people who are kind and loving, but not very bright!

Additional Books

April Fool by Mary Blount Christian; illus. by Diane Dawson. Macmillan, 1981.

The April Fool by Alice Schertle; illus. by Emily Arnold McCully. Lothrop, Lee & Shepard, 1981.

Activities

1. Make fish out of paper and try to tape them to one another's backs. The trick, of course, is to do so without the other realizing what you are up to.
2. Plan a group April Fool trick on a teacher, school administrator, another class, or family members. Be sure that it is something that everyone will find funny and that will be harmless. (A good rule is: How would you feel if this trick were played on you?) See how creative you can be.

*April 2 International Children's Book Day

The International Board on Books for Young People (IBBY) sponsors a worldwide celebration of children's books. April 2 is the birthday of Hans Christian Andersen, the Danish author of some of our most beloved fairy tales. Children are encouraged to adopt pen pals from foreign countries and to write or illustrate their own stories. The Hans Christian Andersen medal is awarded every two years to recognize an author or illustrator of children's books who has made a distinguished contribution to children's literature.

Read any of the hundreds of versions of Hans Christian Andersen's fairy tales. These include:

The Emperor's New Clothes	*The Shoemaker and His Wife*
The Little Match Girl	*The Steadfast Tin Soldier*
The Little Mermaid	*Thumbelina*
The Nightingale	*The Ugly Duckling*
The Princess and the Pea	

Activities

1. Compare various versions of the fairy tales. How have different illustrators interpreted Andersen's stories?
2. Retell one of the stories as if it took place today in your community.

*April 3 Pony Express Day

On April 3, 1860, the Pony Express began mail delivery service between St. Joseph, Missouri, and Sacramento, California. By using a system of men riding fast ponies between relay stations ten miles apart, pony-expressed mail got from Missouri to California in ten days or less. This was the fastest mail service of the time. Prior to the Pony Express, mail had to be shipped by boat or stage coach and could take three weeks or longer to reach its destination. The Pony Express often carried mail more than 200 miles a day. In its height the Pony Express employed 400 fast horses and eighty riders. Because riders rode both day and night in all kinds of weather and through dangerous territory, the Pony Express took on romantic connotations. Despite its lasting reputation, the Pony Express lasted for only two years and ultimately lost $100,000 in operating costs.

Featured Books

The First Ride: Blazing the Trail for the Pony Express, by Jacqueline Geis. Hambleton-Hill, 1994.

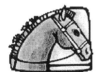 *Pony Express!* by Steven Kroll; illus. by Dan Andreasen. Scholastic, 1996.

The Pony Express, by Peter Anderson. Children's Press, 1996.

They're Off! The Story of the Pony Express, by Cheryl Harness. Simon & Schuster, 1996.

Activity

1. Research the routes used by the Pony Express and mark them on a map of the United States. Mark other routes used to take mail from Missouri to California in the 1860s.
2. Compare mail delivery today with mail delivery in the 1860s.

April 4 Golden Rule Week

The International Society of Friendship and Good Will sponsors Golden Rule Week during the first seven days of April. The society believes that everyone should follow the Golden Rule to help make the world a better place to live in. According to the society, the following quotations represent the Golden Rule in several of the world's great religions:

Buddhist:	"In five ways can a man minister to his friends and family—by generosity, courtesy, and benevolence, by treating them as he treats himself, and by being as good as his word."
Christian:	"Do unto others as you would have them do unto you."
Jewish:	"What is hurtful to yourself, do not to your fellow man."
Sikh:	"As thou deemest thyself so deem others. Then shalt thou become a partner in heaven."
Hindu:	"Do not to others, which if done to thee, would cause thee pain."

Taoist: "Regard your neighbor's gain as your own gain and regard your neighbor's loss as your own loss."

Featured Books

Brothers: A Hebrew Legend, retold by Florence B. Freedman; illus. by Robert Andrew Parker. Harper & Row, 1985.

Difficult times make two brothers, who live on adjacent farms, aware of the joys of kindness and good will.

Additional Books

The Full Belly Bowl, by Jim Aylesworth; illus. by Wendy Halperin. Atheneum, 1999.

The Woodcutter's Duck, by Krystyna Turska, Macmillan, 1972.

Boots and His Brothers: A Norwegian Tale, retold by Eric A. Kimmel; illus. by Kimberly Bulcken Root. Holiday House, 1992.

Activity

Perform an act of kindness.

April 5 National Poetry Month

April is National Poetry Month. Sponsored by the Academy of American Poets, this annual celebration is designed to honor American poets and to encourage all Americans to enjoy and value poetry. There is a wealth of poetry written especially for children. Poetry inspires, amuses, informs, and enriches our lives. The books listed below are only a sampling of the excellent poetry anthologies designed for children. In addition to poetry collections, there are numerous picture book versions of individual poems.

Featured Books

The Beauty of the Beast: Poems from the Animal Kingdom, selected by Jack Prelutsky; illus. by Meilo So. Alfred A. Knopf, 1997.

The Children's Book of Poems, Prayers and Meditations, compiled by Liz Attenborough; various illustrators. Element, 1998.

The Random House Book of Poetry for Children: A Treasury of 572 Poems for Today's Child, selected by Jack Prelutsky; illus. by Arnold Lobel. Random House, 1983.

Side by Side: Poems to Read Together, selected by Lee Bennett Hopkins; illus. by Hilary Knight. Simon & Schuster, 1988.

Sing a Song of Popcorn: Every Child's Book of Poems, selected by Beatrice Schenk de Regneirs, *et al.*; various illustrators. Scholastic, 1988.

Talking Like the Rain: A Read-to-Me Book of Poems, selected by X. J. Kennedy and Dorothy M. Kennedy; illus. by Jane Dyer. Little Brown, 1992.

Activities

1. Choose a poem and memorize it for presentation to your class.
2. Try writing your own poem. Share it with others.

*April 6 North Pole Day

The North Pole was discovered on April 6, 1909. Robert E. Peary led the expedition. Matthew A. Henson, Peary's assistant, and four Eskimo guides named Coqueeh, Ootah, Eginwah, and Seegloo, accompanied Peary. Peary and Henson had tried to reach the Pole beginning in 1886. When they finally arrived on April 6, 1909, they were exhausted from traveling eighteen to twenty hours a day. Henson actually reached the Pole first, and Peary arrived forty-five minutes later. The men spent thirty hours at the North Pole before heading back. Several other explorers also claimed to be the first to reach the North Pole, but in 1911, the National Geographic Society authenticated Peary's claim that his party was, indeed, the first to reach the North Pole.

Several biographies of both Peary and Henson are available. Select excerpts for reading aloud.

Featured Book

Matthew Henson and Robert Peary: The Race for the North Pole, by Laurie Rozakis; illus. by Tom Foty. Blackbirch, 1994.

Both Henson's and Peary's contributions to this exploration are highlighted in this accurate account.

Additional Books

Peary Reaches the North Pole, by Gordon Charleston. Dillon, 1993.

Arctic Explorer: The Story of Matthew Henson, by Jeri Ferris. Carolrhoda, 1989.

Activity

Locate the North Pole on the globe. Why was it so difficult to reach? What obstacles stood in the way of its discovery?

*April 7 World Health Day

On April 7, 1948, the United Nations formed the World Health Organization to coordinate international health programs throughout the world. The celebration on April 7 recognizes the founding of the World Health Organization and encourages people throughout the world to focus on a particular issue related to world health. The elimination of small pox was a major achievement of the World Health Organization. Over the years, good nutrition, elimination of specific diseases, heart health, and oral health have all been addressed during World Health Day celebrations.

Featured Books

The Greatest Table: A Banquet to Fight Against Hunger, by Michael J. Rosen; various illustrators. Harcourt Brace, 1994.

This feast of illustrations by some of the best illustrators in children's literature calls attention to the need to share our wealth of food with the hungry worldwide.

It Takes a Village, by Jane Cowen-Fletcher. Scholastic, 1993.

When Yemi is charged with the care of her little brother Kokou, she finds that the entire village is ready to help. This story takes place in Benin, but the message transcends a single country or continent.

Activities

1. Discuss ways in which the world can serve as a village to help those who suffer from hunger or disease on World Health Day.
2. Find out how your community is helping others with issues of health and nutrition.
3. Plan a week's worth of healthy meals.
4. Create a poster urging everyone to practice good health habits.

April 8 Children's Day in Florida

The second Tuesday in April is a legal holiday in Florida called Children's Day. Florida is a state with many attractions for children including ocean beaches and marine animals, Disney World, the John F. Kennedy Space Center, and a variety of other theme parks. Over five million tourists come to Florida each year to take advantage of its many attractions.

 Florida is the southernmost state in the United States and is called the *Sunshine State*. In addition to its ocean beaches, Florida has swamps filled with amazing creatures including alligators. Oranges, grapefruits, and other exotic fruits are among Florida's major exports. Florida is also a leading producer of honey.

Featured Book

My Family Vacation, by Dayal Kaur Khalsa. Clarkson N. Potter, 1988.

May's family leaves the cold weather at home for a vacation in Florida. The family experiences some of the vacation activities available in Florida.

Additional Books

Because of its warmth and beauty, many older Americans retire to Florida. Children's Day in Florida is a good day to read stories of children and their grandparents.

July, by James Stevenson. Greenwillow, 1990.

When I Am Old with You, by Angela Johnson; illus. by David Soman. Orchard, 1990.

Activities

1. Have you ever been to Florida? Share your impressions of the *Sunshine State*.

2. Where would you like to go on vacation? What would you like to see and do? Draw a picture of the sights and write a brief paragraph: I wish I could travel to. . . .

3. Do some research on Florida. Which of its many attractions would you most like to see? Consider such things as a visit to a swamp, a day on the ocean beach, or a chance to watch a rocket-launch at the space center.

4. Do you spend time with your grandparents? What special things have your grandparents taught you?

April 9 National Week of the Ocean

The second full week in April is celebrated as National Week of the Ocean. This week is a good time to focus on our relationship to the world's oceans. Believe it or not, oceans cover 70 percent of the earth's surface. There are over 25,000 species of fish in the oceans. National Week of the Ocean is a time to appreciate our oceans by studying them and learning to use them wisely. Of course, oceans provide us with many kinds of fun: swimming, fishing, whale watching, and enjoying the beaches they create.

Featured Book

Not the Piano, Mrs. Medley! by Evan Leine; illus. by S. D. Schindler. Watts, 1991.

Mrs. Medley and pals pack nearly everything for a trip to the beach except for the one thing they are sure to need.

Additional Books

The Storm, by Anne Rockwell; illus. by Robert Sauber. Hyperion, 1994.

Moonbathing, by Liz Rosenberg; illus. by Stephen Lambert. Harcourt Brace Jovanovich, 1996.

Activities

1. If you live near the ocean, go for a shore walk. Observe the ocean. Care for the earth by picking up litter along the way.

2. Study the ocean. Read about oceans and the many creatures that inhabit them.

*April 10 Humane Day

On April 10, 1866, the Society for the Prevention of Cruelty to Animals was founded. The purpose of the society is to make life kinder for animals. This day is a good day to read about pets and to think about proper care and treatment of all the animals in our lives. There are dozens of books about pets, particularly about cats and dogs.

Featured Books

Arthur's Pet Business, by Marc Brown. Joy Street, 1990.

Arthur is determined to prove he is responsible enough to have a puppy.

A Bag Full of Pups, by Dick Gackenbach. Clarion, 1981.

Mr. Mullins has twelve pups to give away. Everyone has a special use for the puppy except for one small boy who simply wants a pup to play with.

Activities

1. Do something special for your pet today.
2. Make posters encouraging others to treat pets kindly.
3. Invite someone from the local animal shelter to speak with your group about the shelter's work and about the responsibilities of pet ownership.
4. Create a list of essential aspects of pet ownership.

April 11 National Garden Week

National Garden Week, celebrated during the second week in April, is designed to honor all those who beautify their homes and communities by planting gardens. It is sponsored by the National Garden Bureau. April 11 is a fine time to think about gardens and to read about some of the gardens created in children's books.

Featured Book

Flower Garden, by Eve Bunting; illus. by Kathryn Hewitt. Scholastic, 1994.

A young girl and her father prepare a beautiful flower garden as a birthday surprise for her mother.

Additional Books

City Green, by DyAnne DiSalvo-Ryan. Morrow, 1994.

Sunflower Sal, by Janet S. Anderson; illus. by Elizabeth Johns. Albert Whitman, 1997.

Surprise Garden, by Zoe Hall; illus. by Shari Halpern. Scholastic, 1996.

Activities

1. Plant some flowers around your school or neighborhood.
2. Help an elderly neighbor plant flowers or weed a garden.
3. Create a window planter or flower box.

April 12 Colombian National Beauty Contest for Burros

This beauty contest in Santa Antero, Columbia, is a highlight of Holy Week festivities (see April 15 for dates). The contestants are real burros dressed up in women's dresses and bonnets. They parade in front of the enthusiastic crowds dressed in formal gowns, as well as in swimsuits. The winner is the most beautiful and the prize is retirement from normal burro labors. In addition to the beauty contest, there are folk dances, musical events, and art exhibitions. The nearby Caribbean beaches provide swimming and sunbathing.

Featured Books

Sylvester and the Magic Pebble, by William Steig. Windmill, 1969.

Sylvester the donkey finds a magic pebble, and when he is in danger, he asks it to turn him into a rock.

The Bremen Town Musicians, retold by Janet Stevens. Holiday House, 1992.

In this Brothers Grimm tale, an old donkey, a dog, cat, and rooster set out for the town of Bremen to become musicians.

Activity

Imagine a beauty contest for a particular kind of animal based on the Beauty Contest for Burros. Draw a picture of the event or create a list of criteria for judging the contest.

*April 13 Metropolitan Museum of Art Anniversary

On April 13, 1870, the Metropolitan Museum of Art opened its doors for the first time. This world-class art museum, located in New York City, contains over two million works of art from all over the world. Even if you can't visit the Metropolitan Museum, there are thousands of other art galleries and museums awaiting visitors.

April 13 is a great day to read about art museums and the great art they contain. Today's featured books contain imaginative treatments of art in museums. There are many other books about museum visits, painters, and art. Many art museums have published books based on works on display. The staff of the Metropolitan Museum of Art has published nearly a dozen books for young people since 1982.

Featured Books

Ella's Trip to the Museum, by Elaine Clayton. Crown, 1996.

The Gentleman and the Kitchen Maid, by Diane Stanley; illus. by Dennis Nolan. Dial, 1994.

The Girl with a Watering Can; by Ewa Zadrzynska; illus. by Arnold Skolnick. Chameleon Books, 1990.

Activities

1. Visit an art museum.
2. Create your own imaginative story based on a famous work of art.
3. Read a biography of a famous artist and look at prints of the artist's work.

*April 14 Pan American Day

The Organization of American States was founded on April 14, 1890. The purpose of this organization is to strengthen peace and security in the Western Hemisphere by promoting understanding between countries. Membership includes: Argentina, Bolivia, Brazil, Chile, Colombia, Costa Rica, Cuba, Dominican Republic, Ecuador, El Salvador, Guatemala, Haiti, Honduras, Mexico, Nicaragua, Panama, Paraguay, Peru, the United States, Uruguay, and Venezuela. The first celebration of Pan American Day

took place in 1931, and the holiday has been recognized by presidential proclamation every year since 1948. In Washington, D.C., international students gather at the House of the Americas to perform folk songs and dances. School children may study the various cultures of the Americas.

Featured Book

Saturday Sancocho, by Leyla Torres. Farrar, Straus & Giroux, 1995.

Maria Lili, who lives in an unidentified South American country, loves her grandmother's *sancocho*. When she finds that there is no money to buy the ingredients, she helps her grandmother barter eggs for the ingredients. Picture and story reveal various aspects of South American life.

Additional Books

Coconut Kind of Day: Island Poems, by Lynn Joseph; illus. by Sandra Speidel. Lothrop, Lee & Shepard, 1990.

Señor Cat's Romance and Other Favorite Stories from Latin America, by Lúcia M. González; illus. by Lulu Delacre. Scholastic, 1997.

Activities

1. Make *sancocho*. The recipe is included in the book, *Saturday Sancocho*.
2. Compare life in Latin America, as revealed in these books, with life in your own neighborhood.

April 15 Easter

Christians around the world celebrate Easter on the first Sunday after the first full moon after the twenty-first day of March. Easter is traditionally considered a spring holiday and many of the traditions surrounding Easter—bunnies, eggs, flowers—celebrate the end of winter and the coming of the growing season. For Christians, however, Easter is more than a spring festival. It is the highest holy day of the year and celebrates the resurrection of Jesus Christ, who was killed on a Friday and rose from the dead three days later on a Sunday.

2001	4/15	2006	4/16
2002	3/31	2007	4/8
2003	4/20	2008	3/23
2004	4/11	2009	4/12
2005	3/27	2010	4/4

The following books are illustrated retellings of the Easter story for children:

The Easter Story, by Brian Wildsmith. Alfred A. Knopf, 1993.

Peter's First Easter, by Walter Wangerin, Jr.; illus. by Timothy Ladwig. Zondervan, 1999.

The following books are fictional tales centered on the Easter holiday:

The Tale of the Three Trees: A Traditional Folktale, by Angela Elwell Hunt; illus. by Tim Jonke. Lion, 1989.

This inspirational tale tells of three trees that are surprised by the part they play in the original Easter story.

Chicken Sunday, by Patricia Polacco. Philomel, 1992.

Rechenka's Eggs, by Patricia Polacco. Philomel, 1988.

Both stories relate joyful events that happen around Easter. While they are not explicitly religious, like *The Tale of Three Trees*, they convey the mood of the Easter celebration.

Activities

1. Invite a pastor or active Christian adult to explain the events surrounding Easter and what they mean to Christians.
2. Decorate Easter eggs.
3. Create Easter bonnets using paper plates as the base and gluing or drawing on decorations or create drawings of fantastic Easter bonnets.

April 16 National Coin Week

The third week in April is National Coin Week sponsored by the American Numismatic Association to celebrate the history of numismatics and promote coin collecting. The ANA was founded in 1891 to promote the study of coins, paper money, tokens, and medals. Collectors gather at various events to trade and sell items and to learn more about the history and science of coins and money.

Featured Book

The Gold Coin, by Alma Flor Ada; illus. by Neil Waldman. Atheneum, 1991.

Juan, a thief, follows an old woman in hopes of stealing her gold coin. As the day goes on, however, he develops a new attitude toward the woman and her coin.

Additional Book

Arthur and the Golden Guinea, by Jean Berwick. Golden Gate Junior Books, 1963.

Activities

1. Invite a coin collector to speak with your group.
2. Collect pennies for a worthy cause. Once you combine all the pennies in a jar, have a contest to guess how much they are worth.
3. Design a medal commemorating a special event in your school or neighborhood.

April 17 National Science and Technology Week

The third full week in April is National Science and Technology Week. This week is sponsored by the National Science Foundation in an effort to make everyone aware of the impact of science and technology on our daily life. Celebrate National Science and Technology Week by reading about people who made scientific discoveries that changed the way we view the world.

Featured Books

The Librarian Who Measured the Earth; by Kathryn Lasky; illus. by Kevin Hawkes. Little Brown, 1994.

Rare Treasure: Mary Anning and Her Remarkable Discoveries, by Don Brown. Houghton Mifflin, 1999.

Activity

Working in groups, select a science experiment from the large number of science fair or science experiment books available. Do the experiment and then present your findings to your class or group.

*April 18 Paul Revere Night

On April 18, 1775, Paul Revere made his famous ride through the Massachusetts countryside to warn that the British were on their way to Concord where the American colonists had stored their weapons. Paul Revere was a silversmith and one of the patriots who had spoken against the English king and British rule of the colonies. He volunteered to alert the troops when the British left Boston and to tell them by which route the British soldiers were traveling. His friend, Robert Newman, stood in the Old North Church tower to watch the army's movement. He signaled the message to Paul Revere and other riders who sped away to carry their vital message.

This famous moment in American history has been memorialized by poet Henry Wadsworth Longfellow who wrote "Paul Revere's Ride" in 1861. There are several picture versions which introduce the poem to children.

Featured Books

Paul Revere's Ride, by Henry Wadsworth Longfellow; illus. by Paul Galdone. Thomas Y. Crowell, 1963.

Paul Revere's Ride, by Henry Wadsworth Longfellow; illus. by Ted Rand. Dutton, 1990.

Paul Revere's Ride, by Henry Wadsworth Longfellow; illus. by Nancy Winslow Parker. Greenwillow, 1985.

Activities

1. Copy the text of the poem and have students read it together chorally.
2. Assign different verses to several students and have students read the poem serially.

3. Ask each student to try memorizing a few lines and to recite them for the class the next day. Remind them that poetry recitation was a common way that students learned in the late nineteenth and early twentieth century.

April 19 National Humor Month

The Carmel Institute of Humor sponsors National Humor Month in April just for the fun of it. Recent scientific studies prove the old saying that *laughter is the best medicine*. April 19 is a good day to laugh and enjoy yourself.

A sample of the humorous books available for children include:

Bark, George, by Jules Feiffer. HarperCollins, 1999.

Buttons, by Brock Cole. Farrar, Straus & Giroux, 2000.

Dinorella: A Prehistoric Fairy Tale, by Pamela Duncan; illus. by Henry Cole. Hyperion, 1997.

Farmer Palmer's Wagon Ride, by William Steig. Farrar, Straus & Giroux, 1992.

Parents in the Pigpen, Pigs in the Tub, by Amy Ehrlich; illus. by Steven Kellogg. Dial, 1992.

Play Ball, Amelia Bedelia, by Peggy Parish; illus. by Wallace Tripp. HarperCollins, 1996.

Silly Sally, by Audrey Wood. Harcourt Brace, 1992.

Activities

1. Go to the library and find a joke book. Choose one joke, practice telling it, and then share it with your class or group.
2. Listen to a recording of an old radio comedy.
3. Invite older relatives and neighbors to tell the funniest thing that happened to them when they were children.

April 20 Storm Day/Flood Day

April showers may bring May flowers, but they also bring overflowing rivers and flooded streets. April is often a month when floods roar through the streets, bringing with them destruction. Floods are a time when people often gather to comfort and support one another. Volunteers may help sandbag threatened areas or clean up the after flood mess. April 28 is a good day to remember people and towns dealing with flooding problems.

Featured Book

Come a Tide, by George Ella Lyon; illus. by Stephen Gammell. Orchard, 1990.

March snows and April rains combine to create major flooding in a series of small Kentucky communities.

Additional Book

Flood! by Mary Calhoun; illus. by Erick Ingraham. Morrow, 1997.

Activities

1. Read the newspaper and watch the news to find out if and where flooding is occurring.
2. Think about what is important to you. If a flood forced you to abandon your house, what would you save? Why? How would you save that important item?

*April 21 Kindergarten Day

The first kindergarten was established by Friedrich Fröbel who was born on April 21, 1782. Fröbel established the first kindergarten in 1837 in Blankenburg, Germany. The word *kindergarten* comes from two German words that mean *garden of children*. One of Fröbel's students, Margaretha Meyer Schurz, began the first kindergarten in the United States in Watertown, Wisconsin, in 1856. Initially, her school was a German-speaking school in her home. It soon expanded into a small vacant building. The first English-speaking kindergarten was begun in Boston in 1860 by Elizabeth P. Peabody. By the 1890s over 30,000 children attended kindergarten, and most major cities included kindergartens in their school systems. Today, almost all children between the ages of five and six attend kindergarten.

Featured Books

Mrs. Bindergarten Gets Ready for Kindergarten, by Joseph Slate; illus. by Ashley Wolff. Dutton, 1996.

Look Out Kindergarten, Here I Come! by Nancy Carlson. Viking, 1999.

Vera's First Day of School, by Vera Rosenberry. Henry Holt, 1999.

Activities

1. Kindergartners might want to make a list of all the things they like about kindergarten.
2. Older children might adopt a kindergartner for the day and spend some time reading, going for a walk, or playing a game with the younger student.
3. Older students might write a memory from their own kindergarten days.

*April 22 Brazil Discovery Day

April 22 is called Discovery Day in Brazil. Although native groups, the Guarani and the Tupinamba, had been living in the area for centuries, Pedro Alvarez Cabral was the first European explorer to visit the area. By a 1494 treaty, South America was divided between Spain and Portugal. Portugal claimed what is now Brazil. On April 22, 1500, Peder Alvarez Cabral took possession for Portugal.

As a result of this early Portuguese claim, Portuguese is still the official language of Brazil. Present day Brazil is the largest country of South America in both area and population. It has a varied landscape which includes the world's largest tropical rain forest. The Amazon region covers over half of the country. The western part of this region is hot and humid, and gets over 160 inches of rain per year. In the eastern half, the rain decreases to between forty and eighty inches. Due to such unfavorable weather,

only about 7 percent of Brazil's people live in the rain forest area. The rain forests are amazingly lush. They have over 40,000 varieties of plants, and 1,500 kinds of birds. Monkeys, snakes, and numerous insects and reptiles inhabit this fascinating region.

Featured Books

Amazon Boy, by Ted Lewin. Simon & Schuster, 1993.

Paulo and his father take an overnight steamer down the Amazon River to the city of Belem. Along the way they see many sites typical of Brazilian rural and urban life.

The Great Kapok Tree: A Tale of the Amazon Rain Forest, by Lynne Cherry. Harcourt Brace Jovanovich, 1990.

Beautiful illustrations of the rain forest and its animals enhance this story of forest animals who convince a sleeping woodcutter to spare the enormous kapok tree in which they live.

Activities

1. On a map of South America, locate Brazil. Trace the route of the Amazon River. Where does it begin? Where does it meet the sea?
2. Learn more about the rain forest. What animals dwell there? How big an area does the rain forest cover?
3. Listen to some Brazilian music.

* April 23 Saint George's Day

Not many facts are known about Saint George, the patron saint of England. There are, however, lots of legends about his exploits. We do know that he came from Cappadocia, and that a church was founded in his name in Hauran, east of Jordan, in 514 A.D. He was adopted by the English during the Crusades, and became, by popular demand, the patron saint of England in about 1344 A.D. His most famous adventure, the slaying of a dragon to protect a young maiden, is often recalled in song and story. According to an old tradition, people often wear a red rose in his honor on April 23, St. George's Festival Day.

Featured Books

Saint George and the Dragon, retold by Geraldine McCaughrean; illus. by Nicki Palin. Doubleday, 1989.

Saint George and the Dragon: A Golden Legend, retold by Margaret Hodges; illus. by Trina Schart Hyman. Little Brown, 1984.

Activities

1. Make red roses to wear in Saint George's honor.
2. The lives of saints were often depicted in stained-glass windows. Using colored paper or markers, create a stained-glass window with a cutout of Saint George or a dragon in its center.

*April 24 South Africa's First Democratic Elections

On April 24, 1994, South Africa held democratic elections which allowed people of all races to have a vote. This election, which lasted for three days, marked the end of the struggle against apartheid, the system of racial separation that had been the rule in South Africa for decades. Under the apartheid system, Black Africans were unable to own businesses, attend the schools of their choice, or participate in the government. Many Black Africans, including Nelson Mandela, spent years in prison for anti-apartheid activities. Mandela was elected president of South Africa in the 1994 election. During the three days of the election, over nineteen million people voted, some waiting in line for hours for the privilege of casting their vote. On April 27 South Africa awoke to a new president, a new flag, and a new life for all its citizens.

Featured Book

The Day Gogo Went to Vote: South Africa April 1994, by Elinor Batezat Sisulu; illus. by Sharon Wilson. Little Brown, 1996.

Young Thembi and her family are astounded when Gogo, who is so old that she hasn't left the house in years, announces that she will go to the polls to vote in South Africa's election.

Additional Books about South Africa

Jamela's Dress, by Niki Daly. Farrar, Straus & Giroux, 1999.

Over the Green Hills, by Rachel Isadora. Greenwillow, 1992.

Activities

1. Discuss the importance of participating in elections. Why did people in South Africa struggle for this privilege? Look back at American history. Did the United States face similar challenges?
2. Hold an election in your group or classroom.
3. Invite an elected official to speak with your group about the election process.

April 25 National Turn Off the TV Week

National Turn Off the TV Week takes place during the last week of April each year to encourage children and their families to turn off the TV in order to promote "healthier lives and communities." The TV Turnoff Network believes that it is important to redirect our activities from television viewing to more creative, productive and healthy activities. They want to get beyond the discussion of television program content to focus on those activities displaced by too much television viewing.

Featured Book

Mouse TV, by Matt Novak. Orchard, 1994.

When the TV stops working, the mouse family discovers a variety of new and more engaging activities.

Additional Book

TV Dinner, by Betsy Everitt. Harcourt Brace, 1994.

Activities

1. Turn off the TV. Keep a log of the activities you do instead of watching television.
2. Create posters advertising National Turn Off the TV Week. Emphasize the many entertainment possibilities available in your community.

*April 26 Audubon Day

On April 26, 1785, John James Audubon was born in Haiti. Audubon, who trained as an artist in Paris, struggled to make a living as a painter. He gave drawing lessons, played the flute or violin at dances, and worked in a general store. In 1820 he took a boat ride down the Mississippi River and drew pictures of the birds he observed. He published his paintings in a book called *Birds of America*. After his death, George Bird Grinnell, a student of Audubon, organized the Audubon Society to study and protect birds. The organization still exists and continues to promote bird study and preservation.

Audubon Day is a good day to read stories and poems about birds.

Featured Book

The Language of the Doves, by Rosemary Wells; illus. by Greg Shed. Dial, 1996.

In World War I Italy, Grandfather raised and trained doves who carried coded messages between the troops. He tells Julietta the story of the doves on her sixth birthday.

Additional Books

Bird Watch, by Jane Yolen; illus. by Ted Lewin. Philomel, 1990.

Days of the Blackbird: A Tale of Northern Italy, by Tomie De Paolo. Putnam, 1997.

Activities

1. Go bird-watching. Take along a bird identification book and record the kinds of birds you see.
2. Feed the birds in your neighborhood with seeds or bread crumbs.
3. Find a copy of Audubon's *The Birds of America*. Enjoy looking at the illustrations.

April 27 National Arbor Day

The first Arbor Day was celebrated in the United States on April 10, 1872, when one million trees were planted in Nebraska. This special day is set aside to honor trees, often with tree-planting ceremonies. States celebrate Arbor Day on various dates throughout the spring. This holiday is also celebrated in Canada and Israel.

Featured Books

Meeting Trees, by Scott Russell Sanders; illus. by Robert Hynes. National Geographic Society, 1996.

A boy and his father go for a nature walk together and play a tree identification game.

My Mother Talks to Trees, by Doris Gove; illus. by Marilynn H. Mallory. Peachtree, 1999.

The mother in this story talks to trees "out loud and right in public." Although she is embarrassed at first, the daughter eventually learns to share her mother's fascination with trees.

The Never-Ending Greenness, by Neil Waldman. Morrow, 1997.

Based on the true story of the return to Israel of Jewish people after World War II, this is the tale of a small boy and his mother who planted a tree, the first of many, in their new land.

Activities

1. Plant a tree at your school, in your neighborhood, or in your yard. Care for it and watch it grow.
2. Identify the trees in your neighborhood. Use a tree identification guide to help you with the project.
3. Make posters reminding people to recycle paper products.

*April 28 Maryland Statehood Day

Maryland became the seventh state to join the Union on April 28, 1788. It was first explored by Captain John Smith in 1608, and settlers began arriving soon after. Originally, it began as a place for Roman Catholics to enjoy religious freedom. By 1649, however, the Maryland settlers had passed laws guaranteeing religious toleration for people of all faiths. It was the first colony to do so.

Maryland was a slave state, but it remained with the Union during the Civil War. Many Civil War battles were fought there. Harriet Tubman, the most famous leader of the Underground Railroad, which guided hundreds of slaves to freedom, was born in Maryland.

Maryland is a Mid-Atlantic state divided into two parts by the Chesapeake Bay. Maryland has a large fishing industry. Maryland restaurants are famous for their crab dishes. Crab cakes are a favorite food available throughout the state; even the vendors at Baltimore Oriole baseball games serve crab cakes to hungry spectators.

Featured Book

Aunt Flossie's Hats (and Crab Cakes Later), by Elizabeth Fitzgerald Howard; illus. by James Ransome. Clarion, 1991.

As two sisters visit their great-aunt, Flossie, on Sundays and play with her hat collection, Flossie tells them about the story beyond the hats.

Additional Books

Clara and the Bookwagon, by Nancy Smiler Levinson; illus. by Carolyn Croll. HarperCollins, 1988.

Clara, a Maryland farm girl, dreams about the world beyond her farm, but she has no school or books to help her. She is delighted when a black book-wagon comes down the road bringing with it the world of books. (The state of Maryland developed the first bookmobiles.)

Train to Lulu's, by Elizabeth Fitzgerald Howard; illus. by Robert Casilla. Bradbury, 1988.

Two young sisters take a train trip by themselves from Boston to Baltimore.

Activities

1. Gather a collection of old hats. Make up stories to go with each.
2. Arrange to tour the public library's bookmobile. Ask one of the bookmobile librarians to talk about her job.
3. If you were to take a train trip from your home to Baltimore, through which states would you travel?

*April 29 National Puppetry Day

The Puppeteers of America sponsor National Puppetry Day on April 29. This is a day to celebrate the art of puppetry and to recognize the gift of joy that puppeteers bring to their audiences.

Featured Book

Pinocchio, by Carol Colodi; illus. by Ed Young. Putnam, 1996.

This abridged version retains the sense of the original and is enhanced with exciting new illustrations.

Additional Books

Nellie: A Cat on Her Own, by Natalie Babbitt. Farrar, Straus & Giroux, 1989.

Louie, by Ezra Jack Keats. Greenwillow, 1975.

Activities

1. Go to a puppet show or demonstration.
2. Make puppets.
3. Put on a puppet play for younger children or older adults.

*April 30 National Honesty Day

Since 1992, author M. Hirsh Goldberg has designated April 30 as National Honesty Day. He feels that April begins with a day of foolishness and trickery. On the fifteenth, taxes are due, and people may be tempted to lie about their earnings. Therefore, it is appropriate to use the last day of April as a time to strive for honesty. Goldberg, author of *The Book of Lies: Schemes, Scams, Fakes, and Frauds That Have Changed the Course of History and Affect Our Daily Lives*, chooses April 30 to recognize truth-tellers with his "Honest Abe Awards." April 30 is a good day to talk about the value of honesty.

Featured Book

The Honest-to-Goodness Truth, by Patricia C. McKissack; illus. by Giselle Potter. Atheneum, 2000.

Libby knows that it is important to tell the truth, but needs to learn that telling the whole truth, the honest-to-goodness truth can sometimes cause more harm than good.

Additional Books

The Boy Who Cried Wolf, by Tony Ross. Dial, 1985.

Matilda Who Told Such Dreadful Lies . . , by Hilaire Belloc; illus. by Posy Simmonds. Alfred A. Knopf, 1991.

Activities

1. Discuss the value of honesty. Why is honesty important?
2. Look at several issues of the newspaper. Find articles dealing with the issue of honesty and dishonesty. Are your surprised by the number of articles? Why or why not?
3. Have each member of the group write three sentences: one true, the other two false. See if you can guess which is which. Be sure that the "lies" are not intended to cause hurt, but are silly and fun.

*May 1 Mother Goose Day

The Mother Goose Society of Melrose Park, Pennsylvania, founded Mother Goose Day on May 1 in 1987. It continues to be a day set aside to appreciate Mother Goose rhymes. The society's motto is "Either alone or in sharing, read childhood nursery favorites and feel the warmth of Mother Goose's embrace."

Choose any one of the wonderful versions of Mother Goose rhymes available.

Featured Books

Lavender's Blue: A Book of Nursery Rhymes, compiled by Kathleen Lines; illus. by Harold Jones. Oxford, 1954.

Mama Goose: A New Mother Goose, collected by Liz Rosenberg; illus. by Janet Street. Philomel, 1994.

Mother Goose, compiled by Eulalie Osgood Grover; illus. by Frederick Richardson. Volland, 1915.

Mother Goose: A Canadian Sampler, compiled by Celia Barker Lottridge. Groundwood, 1994.

Mother Goose: If Wishes Were Horses and Other Rhymes, by Susan Jeffers. Dutton, 1979.

The Mother Goose Treasury, by Raymond Briggs. Coward-McCann, 1966.

My Very First Mother Goose, edited by Iona Opie; illus. by Rosemary Wells. Candlewick, 1996.

The Real Mother Goose, illus. by Blanche Fisher Wright. Rand McNally, 1916.

Sylvia Long's Mother Goose, by Sylvia Long. Chronicle, 1999.

Activities

1. Compare several of these books. Notice differences based on the publication date, depiction of certain characters, etc.
2. Act out a Mother Goose rhyme.
3. See how many Mother Goose rhymes members of your group know by heart.

May 2 Older Americans Month

Every year since 1963, a presidential proclamation has been issued declaring that May is a special time to recognize our older citizens. The celebration began in 1963 as Senior Citizens Month. In 1974 the name was changed to Older Americans Month. May is a good time to show appreciation to older Americans and to read stories about grandparents and older friends and neighbors.

Featured Book

Grandaddy's Highway, by Harriet Diller; illus. by Henri Sorensen. Boyds Mills, 1993.

Maggie joins her grandaddy for a truck trip across the country on Highway 30 West.

Additional Books

Miss Fannie's Hat, by Jan Karon; illus. by Toni Goffe. Augsburg, 1998.

The Worry Stone, by Marianna Dengler; illus. by Sibyl Graber Gerig. Rising Moon, 1996.

Activities

1. Visit a nursing home and do something nice for the residents in recognition of Older Americans Month. You might prepare a program, bring homemade goodies, or spend time visiting with the people living there.
2. Take time to visit, telephone, or send a card to a grandparent.
3. Help an older person in your neighborhood with spring yard work or household errands.

*May 3 Polish Constitution Day

In 1791 Poland's first constitution was adopted. This holiday, called *Swieto Trzeciego Maja*, recognizes this attempt to preserve Poland's independence. During the 1500s the Polish empire covered a large part of central and eastern Europe including Belarus and the Ukraine. In 1572, Polish power declined and a series of wars left Poland under the rule of foreign powers until 1791. Unfortunately, the constitution of 1791 was soon discarded as the country was divided among the Russians and the Prussians (modern-day Germany). Poland once again became free of foreign rule in 1951 when it adopted a new constitution. Constitution Day is a good day to read folktales which celebrate Poland's rich cultural heritage.

Featured Book

Strudel, Strudel, Strudel, by Steve Sanfield; illus. by Emily Lisker. Orchard, 1995.

The people of Chelm have several odd rules. This silly folktale explains why "a teacher may not live on the top of a hill," or "own a trunk," or "eat apple strudel."

Additional Book

The Woodcutter's Duck by Krystyna Turska. Macmillan, 1972.

Activity

Invite a Polish American to class to talk about Polish culture, music, dance, foods, etc.

*May 4 Space Day

Space Day is a galaxy-wide celebration of the achievements and opportunities to observe and explore space. Students all over the world will focus on space by studying past achievements, listening to experts in astronomy, and visiting space centers or observatories. Marvelous nonfiction books about space, many with spectacular photographs, are available for children. Less well-known are the poetry collections about space. Celebrate Space Day by reading poems about outer space.

Featured Books

Blast Off! Poems about Space, selected by Lee Bennett Hopkins; illus. by Melissa Sweet. HarperCollins, 1995.

Space Songs, by Myra Livingston Cohn; illus. by Leonard Everett Fisher. Holiday, 1988.

Star Walk, selected by Seymour Simon. Morrow, 1995.

Activities

1. Visit an observatory or invite a local astronomer to talk about stars.
2. Have a stargazing walk in the evening or spend the entire night sleeping under the stars.
3. Create models of the solar system.
4. Build (and fly) model rockets.
5. Create posters advertising trips to faraway planets or stars.
6. Make a timeline of space exploration—and carry it into the next century and beyond.

May 5 Cinco de Mayo

Cinco de Mayo, observed in Mexico and in Mexican communities in the United States, commemorates the Battle of Puebla on May 5, 1862, when Mexican troops defeated invading French forces. The celebration includes parades, patriotic speeches, bullfights, picnics, beauty contests, and fireworks. In the town of Puebla, eleven miles from Mexico City, events include a mock battle in which participants use fruit as ammunition.

Celebrate *Cinco de Mayo* by reading folktales of Mexico.

Featured Books

Musicians of the Sun, by Gerald McDermott. Simon & Schuster, 1997.

The Tale of Rabbit and Coyote, by Tony Johnston; illus. by Tomie De Paola. Putnam, 1994.

The Woman Who Outshone the Sun, by Alejandro Cruz Martínez; illus. by Fernando Olivera. Scholastic, 1991.

Activities

1. Plan a Mexican party. Prepare foods from Mexico (tacos, nachos, etc.), listen to Mexican music, and play Mexican games.
2. Invite someone who has lived in Mexico to visit with your group and to explain *Cinco de Mayo* and other Mexican customs.
3. Learn some Spanish phrases, particularly greetings like "*hola*" (which means "hello") and "*adios*" (which means "goodbye").

May 6 Jazz Fest

Jazz lovers from throughout the world gather in New Orleans, Louisiana, during the last weekend in April and the first weekend in May to celebrate jazz. Six stages feature jazz groups, as well as Cajun and zydeco music, rhythm and blues, cowboy songs, African music, and much more. New Orleans's many jazz clubs are also busy with festival goers, as are the many great restaurants throughout the city. Traditional Louisiana foods are served at the festival site, and local crafts people display their wares.

Featured Book

Duke Ellington, by Andrea Davis Pinkney; illus. by Brian Pinkney. Hyperion, 1997.

This brief, illustrated biography of Duke Ellington celebrates the life of this accomplished composer and bandleader. The notes at the back of the book provide background on the relationships between jazz and other musical styles.

Additional Books

Ben's Trumpet, by Rachel Isadora. Greenwillow, 1979.

Mysterious Thelonious, by Chris Raschka. Orchard, 1997.

(This book should be read in rhythm using the placement of the words on the page as tones for the best effect.)

Rum-A-Tum-Tum, by Angela Shelf Medearis; illus. by James E. Ransome. Holiday House, 1997.

Activity

Listen to jazz (Duke Ellington, Thelonious Monk, or others). Try to feel the music. If you want to move to the music or dance, give in to that urge.

May 7 Be Kind to Animals Week

Sponsored by the American Humane Association, Be Kind to Animals Week is held the first full week in May each year. This same week is also celebrated by the American Veterinary Medical Association as National Pet Week. Both events honor the kindness of those who take good care of the animals in their lives.

Featured Book

Daddy, Could I Have an Elephant? by Jake Wolf; illus. by Marylin Hafnew. Greenwillow, 1996.

Tony wants a big animal for a pet, but eventually realizes that a puppy would be a far better choice.

Additional Books

Can I Keep Him? by Steven Kellogg. Dial, 1971.

"Mine Will," Said John, by Helen Griffith; illus. by Joseph A. Smith. Greenwillow, 1992.

Activities

1. Invite a spokesperson from the local humane association to speak with your group about this important work.
2. Arrange for your group to visit a veterinary clinic or to speak with a veterinarian about animal care.
3. Do something nice for your pet.
4. Hold a pet show.

*May 8 No Socks Day

The Wellness Permission League sponsors No Socks Day on May 8. The League suggests that by giving up wearing socks for one day, we create less laundry, which helps the environment, and our feet will enjoy the freedom.

Featured Book

Shoes, by Elizabeth Winthrop; illus. by William Joyce. Harper & Row, 1986.

After looking at all kinds of shoes, the author concludes that the best shoes are no shoes at all.

Additional Books

The Foot Book, by Dr. Seuss. Random House, 1968.

Fox in Socks, by Dr. Seuss. Random House, 1965.

Activity

Take off your shoes and wiggle your toes. Go barefoot.

May 9 International Bluegrass Month

May is International Bluegrass Month. Bluegrass music has its origins in the melodies brought to Appalachia from Ireland and England. However, Bill Monroe is considered the father of American bluegrass because of the unique style which he developed in the 1930s with his band, Bill Monroe and the Blue Grass Boys. A bluegrass band normally consists of a guitar, mandolin, fiddle, upright bass, and a banjo. The music is lively and clapping, singing, and dancing are perfect accompaniments. Many bluegrass festivals are held each summer throughout the United States. MerleFest, held each April in North Carolina, is one of the largest bluegrass festivals in the nation, attracting more than 65,000 people.

Featured Book

When Uncle Took the Fiddle, by Libba Moore Gray; illus. by Lloyd Bloom. Orchard, 1999.

When Uncle takes up the fiddle, everyone joins in with clapping, cheering, and dancing. This story is set in Appalachia.

Additional Books

The Heart of the Wood, by Marguerite W. Davol; illus. by Sheila Hamanaka. Simon & Schuster, 1992.

Fiddlin' Sam, by Marianna Dengler; illus. by Sibyl Graber Gerig. Rising Moon, 1999.

Activities

1. Invite a bluegrass fiddler, mandolin player, guitar player, banjo player, or singer to entertain your group.
2. Listen to recorded bluegrass music.

*May 10 Golden Spike Day

On May 10, 1869, America's transcontinental railroad was completed at Promontory Summit, Utah. An historical reenactment of the event takes place each year at Promontory Summit. The last spike driven into the rail was a golden spike engraved with the words, "The Last Spike" on one side and "May God continue the unity of our building of the Railroad that unites the two great Oceans of the World" on the other. The building of the railroad started in 1863 with one company working from Sacramento, California, and the other working from Omaha, Nebraska. Workers included Irish, German, and Italian immigrants working from the east, and over 10,000 Chinese immigrants working from the west.

A few nonfiction books, written for students in grades 3-6 tell the story of the building of the transcontinental railroad. Younger children might enjoy reading fictional stories about trains.

Featured Nonfiction Books

The Story of the Golden Spike, by R. Conrad Stein. Children's Press, 1978.

The Transcontinental Railroad, by Peter Anderson. Children's Press, 1996.

The Transcontinental Railroad: American at Its Best? by Robert Young. Silver Burdett, 1996.

Featured Fiction Books about Trains

Adelaide and the Night Train, by Liz Rosenburg; illus. by Lisa Desimini. Harper & Row. 1989.

The Caboose Who Got Loose, by Bill Peet. Houghton Mifflin, 1971.

The Mighty Santa Fe, by William H. Hooks; illus. by Angela T. Thomas. McMillan, 1993.

The Train, by David McPhail. Little Brown, 1977.

Activities

1. Visit the railroad station. Tour a train, and if possible, take a train ride.
2. Plan an imaginary train trip. Where would you go? What would you pack? On a map, find the route you would take to get there.

*May 11 Minnesota Statehood Day

On May 11, 1858, Minnesota became the thirty-second state to join the Union. Known as the *Land of 10,000 Lakes*, Minnesota is the northernmost state in the United States. The original inhabitants were the Chippewa and the Sioux Indians. The first Europeans to arrive were French-Canadian trappers. As the lumber trade grew, immigrants from Norway, Sweden, and Denmark flocked to the area. Over time, settlers arrrived from other European countries as well as from the eastern United States. Minnesota today is a major manufacturing, mining, lumbering, and agricultural state.

Featured Books

Marven of the Great North Woods, by Katheryn Lasky; illus. by Kevin Hawkes. Harcourt Brace, 1997.

Marven Lasky, a small Jewish boy from Duluth, Minnesota, is sent away from the city to a logging camp in the great north woods when the flu epidemic of 1918 sweeps through the nation.

New Hope, by Henri Sorensen. Lothrop, Lee & Shepard, 1995.

Raised in New Hope, Minnesota, Jimmy loves to hear the story of how his family, immigrants from Denmark, began the town of New Hope.

Activity

People from many different areas settled in Minnesota. What ethnic origins do the people in your neighborhood or school represent? Did most come to the United States at the same time? Make a time chart showing when different groups settled in your area.

*May 12 Limerick Day

May 12 is called Limerick Day in honor of Edward Lear, who was born on May 12, 1812, in Highgate, England. Lear's poetry, which has a strong rhythm, repetition, and catchy rhyme, appeals to children. Children may already be familiar with his poem, "The Owl and the Pussycat," or Lear's alphabet books. In addition to his more traditional poetry, Lear was a master of the limerick. Limerick Day is a good time to look at several different poems and limericks written by Edward Lear. Many excellent illustrators have created artful editions of Lear's works. A few are listed below:

Featured Books

Of Pelicans and Pussycats: Poems and Limericks, illus. by Jill Newton. Dial, 1990.

The Owl and the Pussycat, illus. by Barbara Cooney. Little, Brown and Company, 1969.

The Owl and the Pussycat, illus. by Jan Brett, Putnam, 1991.

Activities

1. Act out some of Lear's poems.
2. Try a choral reading of *The Owl and the Pussycat* or other favorite Lear poems.
3. Write a limerick of your own. Lee Bennett Hopkins provides helpful information and suggestions in his book, *Pass the Poetry, Please!* HarperTrophy, 1987.

May 13 **Cat Festival of Kattenwoensdog**

In Ypres, Belgium, the Cat Festival began in 1817 when mice overran the city's fabric mills and ruined hundreds of yards of cloth. The town brought in dozens of cats who feasted on the mice. They settled in Ypres and grew to a cat population of thousands. To reduce the number of cats, the town decided to fling the cats from the town belfry. Today the cats, made of wool or velvet, are still flung from the belfry and thousands of people gather below to try to catch them. The Cat Festival is held on the second Sunday in May. A parade, with floats based on famous real and imaginary cats, is a highlight of the day.

Featured Book

The Cats of Mrs. Calamari, by John Stadler. Orchard, 1997.

Like the people of Ypres, Mrs. Calamari's apartment is overrun by cats, but since cats are not allowed in the apartment, Mrs. Calamari must find ways to fool the landlord into thinking her cats aren't really cats.

Additional Books

A Beautiful Feast for a Big King Cat, by John Archambault and Bill Martin; illus. by Bruce Degen. HarperCollins, 1989.

Cat Up a Tree, by John and Ann Hassett. Houghton Mifflin, 1998.

Millions of Cats, by Wanda Gag. Houghton Mifflin, 1989.

When Cats Dream, by Dav Pilkey. Orchard, 1992.

Activity

Share cat stories or write a cat story of your own.

May 14 **National Police Week**

Every May 15, local police departments honor officers killed in the line of duty by celebrating Peace Office Memorial Day. The names of over 15,000 police officers who have been killed on the job in the United States are recorded on the National Law Enforcement Officers Memorial in Washington, D.C. The entire week containing May 15 is celebrated as National Police Week. It is a time to honor those who work twenty-four hours a day, seven days a week to keep us safe. The American Police Hall of Fame and Museum sponsors this event.

Featured Book

Officer Buckle and Gloria, by Peggy Rathman. Putnam, 1995.

Officer Buckle's safety speeches become much more fun when his dog, Gloria, begins helping with the presentations.

Additional Books

Dinosaurs, Beware! A Safety Guide, by Marc Brown and Stephen Krensky. Little Brown, 1984.

I'm Going to Be a Police Officer, by Edith Kunhardt. Scholastic, 1995.

Activities

1. Tour a local police station or invite a police officer to speak with your group.
2. Write letters of appreciation to local police officers.
3. Create posters which support police efforts to eliminate crime and promote safety.

*May 15 Race of the Candles

In Gubbio, Italy, teams of twenty men race through the town carrying huge wooden candles in honor of Gubbio's patron saint, Ubaldo. The contest begins at dawn when the men begin to run through the piazza and up Mt. Ingio to the town's basilica. Seafood feasts, music, and colorful processions add to the day's excitement.

Italy is known for its art. Celebrate the Race of the Candles by reading stories about artists in Italy.

Featured Books

Michelangelo's Surprise, by Tony Parillo. Farrar Straus & Giroux, 1998.

After a rare snowstorm in Florence, Signore Piero de'Medici summons Michelangelo to the palace for a special assignment.

A Tale of Two Rats, by Claude Lager; illus. by Nicole Rutten. Stewart, Tabori & Chang, 1991.

Artist Arthur the mouse finds the inspiration he needs for his paintings in Italy.

Activities

1. Imagine how the Race of the Candles looks and draw a picture of it.
2. Visit an art museum. Notice how many of the paintings are by Italian painters.
3. Study prints of the work of Michelangelo and other Italian masters. Find out when and where they lived and other interesting facts about their lives and art.

May 16 National Moving Month

May is National Moving Month. Over twenty-one million Americans move to a new community each year during the summer months. As the school year comes to an end, children may be moving from one school to another, from one house to another, or from one town to another. They will certainly be moving from one classroom to another. Chances are very good that everyone in the group will be making some kind of move in the next few months. May 16 is a good time to celebrate moving—and the challenges and opportunities that moving provides.

Featured Book

Ming Lo Moves the Mountain, by Arnold Lobel. Scholastic, 1982.

Ming Lo and his wife discover how to move the mountain away from their home.

Additional Books

Leaving Home with a Pickle Jar, by Barbara Dugan; pictures by Karen Lee Baker. Greenwillow, 1993.

Mary Ann, by Betsy James. Dutton Children's Books, 1994.

Activities

1. Discuss the kinds of moves that members of the group will be making in the next few months. If someone is actually moving away, talk about ways to say farewell and ways to welcome new children to the area.
2. Share moving experiences. Remember that there are all kinds of moves. For example, consider the move made by Ming Lo in today's featured book. Everyone can participate.

*May 17 *Syttende Mai*

Syttende Mai, Constitution Day, is Norway's most important holiday. Virtually every community in Norway holds parades and children carry flags, wear traditional costumes, and sing patriotic songs. Norway was independent during its Viking Age, but in the fourteenth century, it became a part of Denmark. That relationship continued until 1814 when Denmark ceded Norway to Sweden. The Norwegians held an assembly and drafted a constitution that was signed on May 17, 1814. They elected a king and went to war with Sweden to gain independence. Despite various governing arrangements since 1814, including occupation by the Germans during World War II, the Norwegian constitution is still in force and all Norwegians celebrate its creation on May 17.

Featured Book

Master Maid: A Tale of Norway, retold by Aaron Shepard; illus. by Pauline Ellison. Dial, 1997.

This traditional Norwegian tale involves a beautiful maiden, a stubborn boy, and a troll. Trolls play a major role in Norwegian folklore.

Additional Books

The Three Billy Goats Gruff, by Tim Arnold. Margaret K. McElderry, 1993.

The Trouble with Trolls, by Jan Brett. Putnam, 1992.

Two Silly Trolls, by Nancy Jewell; illus. by Lisa Thiesing. HarperCollins, 1992.

Activity

Draw the ugliest troll you can imagine. Combine the troll drawings onto a bulletin board. How would you outsmart these ugly trolls?

May 18 **National Bike Month**

May is National Bike Month. The League of American Bicyclists sponsors both National Bike Month and Bike to Work Day held on the third Friday in May. The league encourages people to take advantage of the good spring days to bike to work and school, to bike for fun, and to bike for fitness. May 18 is a good day to take a bike ride and then to relax by reading books about bicycling.

Featured Book

Red Racer, by Audrey Wood. Simon & Schuster, 1996.

Nona's bike is a disaster. She dreams of getting the shiny new red racer that she's seen in the store window.

Additional Books

Curious George Rides a Bike, by H. A. Rey. Houghton Mifflin, 1952.

D. W. Rides Again! by Marc Brown. Little Brown, 1993.

Activities

1. Go for a bike ride.
2. Organize a bike rodeo with a variety of bike races and obstacles courses. See who can bike the slowest, bike backwards, or bike through a maze of milk cartons. Prizes might include bike stickers and accessories.
3. Draw a picture of the perfect bike. Make it magical.

***May 19** **Youth and Sports Day**

This national holiday in Turkey begins as young athletes carry burning torches to the playing fields where games and contests will be held. The holiday celebrates the beginning of Turkish independence from Greek rule. On May 19, 1919, Mustafa Kemal, a Turkish military hero, arrived in Samsum and began a nationalist movement. By April 1920, a new provisional government elected Kemal as assembly president. On October 29, 1923, Turkey declared itself a republic and elected Kemal as president. The Grand National Assembly renamed Mustafa Kemal, *Atatürk*, which means *father of the Turks*.

Celebrate this Turkish holiday by reading folktales from Turkey.

Featured Book

"The Most Wonderful Gift," in *Tales Alive! Ten Multicultural Folktales with Activities*, retold by Susan Milord; illus. by Michael A. Donato. Williamson, 1994; 115-23.

Additional Book

"What Happened to Hadji," in *Favorite Folktales from Around the World*, edited by Jane Yolen. Pantheon, 1986; 85-87.

Activities

1. Use some of the activities provided by Susan Milord in *Tales Alive!*
2. Locate Turkey on a map of the world. Create a fact bulletin board about Turkey by doing some research about this fascinating country. Be sure to include information about sports and recreation enjoyed by people in Turkey.

May 20 Miles City Bucking Horse Sale

The third weekend in May, Miles City, Montana, holds an annual sale of rodeo horses for the upcoming rodeo season. Professional cattlemen trade and sell bucking horses and other rodeo stock. Wild horse racing and a rodeo are part of the events, so is a parade through town and a street dance. It's cowboy country and the cowboys turn out for the Bucking Horse Sale.

Featured Book

Cowboy Country, by Ann Herbert Scott; illus. by Ted Lewin. Clarion, 1993.

Although not specifically set in Montana, this book illustrates the day in the life of a cowboy including saddling the horses and going on a cattle drive.

Additional Book

Rodeo Day, by JoNelle Toriseva; illus. by Robert Cassila. Simon & Schuster, 1994.

Just Like My Dad, by Tricia Gardella; illus. by Margot Apple. Turtleback, 1993.

Activities

1. Visit a ranch or stable to learn more about horses.
2. Attend a rodeo.
3. Encourage anyone with a collection of horse models to bring them to class and share their knowledge of horses.
4. Imagine you are about to enter a rodeo. Write down all the feelings that you might have. Would you like to be a cowboy or cowgirl? Why?

*May 21 National Waitress/Waiter Day

National Waitress or Waiter Day is celebrated by many restaurants throughout the country to honor waitresses and waiters. Some restaurants hang banners recognizing the importance of the staff; others provide corsages or boutonnieres to the waitresses and waiters for the day. Waitress and Waiter Day is a good time to celebrate those who prepare and serve our meals, both at home and at school.

Featured Book

Animal Café, by John Stadler. Simon & Schuster, 1980.

Restaurant owner Maxwell doesn't understand why his shelves are empty each morning and his cash register is full of money, but his cat and dog do.

Additional Book

Roses Sing on New Snow: A Delicious Tale, by Paul Yee; illus. by Harvey Chan. Macmillan, 1991.

Activities

1. Honor those who work in the school cafeteria by drawing illustrations of them at work, making them corsages or boutonnieres, writing thank-you notes, or singing them a special song.

2. Offer to cook, serve, or cleanup supper as a special thank-you to Mom and Dad for family meals.

*May 22 Detective Day

Arthur Conan Doyle, creator of Sherlock Holmes, was born on May 22, 1859, in Edinburgh, Scotland. In 1879 he worked as an assistant to a physician in Birmingham, England, prior to becoming a ship's surgeon on a whaling voyage to the Arctic in 1880. He spent several years as a ship's surgeon and then worked in London as an ophthalmologist. He is best known, however, as author of the Sherlock Holmes detective novels. Among his most loved works are a series of short stories about Sherlock Holmes and his novel, *The Hound of the Baskervilles*. Doyle died of a heart attack in 1930. However, his character, Sherlock Holmes, continues to enchant modern readers. Several societies are devoted to Sherlock Holmes, including the Baker Street Irregulars, which is the oldest and most prestigious Holmes society in the United States.

May 22 is a great day to enjoy a good mystery or possibly to create your own.

Featured Book

The Mysteries of Harris Burdick, by Chris Van Allsburg. Houghton Mifflin, 1984.

This series of tantalizing illustrations with a single caption are part of a larger mystery of what happened to the elusive Harris Burdick. Each drawing invites authors and illustrators to fill in the blanks.

Additional Books

Nate the Great, by Majorie Weinman Sharmat; illus. by Marc Simont. Coward, McCann, Geohegan, 1972.

There are several additional titles in the *Nate the Great* series.

Something Queer at the Library: A Mystery, by Elizabeth Levy; illus. by Mordicai Gerstein. Delacorte, 1977.

There are several additional titles in the *Something Queer* series.

Activities

1. Select a mystery or detective story for pleasure reading.
2. Using the *Mysteries of Harris Burdick* as a starting point, write a story that further explains one of the mysterious illustrations.
3. Write your own mystery based on an event at school or home.
4. Invite a real live detective from the local police department to visit your group and talk about detective work.

*May 23 South Carolina Day

South Carolina joined the Union on May 23, 1788, as the eighth state. South Carolina has a long and colorful history. Prehistoric Indians lived in the area at least ten thousand years ago. In more modern time, the Cherokees and Catawbas lived in the South Carolina area. In 1521 Francisco Gordillo led an expedition to explore the region, and the Spanish started a colony along the coast in 1526. Later French and English settlers established towns.

South Carolina proved to be a good environment for planting rice. Slaves were brought to the area in the late 1600s and early 1700s to work on farms. A slave revolt in 1739 resulted in the deaths of about ninety people, both slave and free. South Carolina's economy and its culture benefited from the contributions of African Americans. Celebrate South Carolina with stories from the Black American tradition.

Featured Book

Sukey and the Mermaid, by Robert D. San Souci; illus. by Brian Pinkney. Four Winds, 1992.

Sukey's life changes when she accidentally summons Mama Jo, a beautiful black mermaid.

Additional Books

The Ballad of Belle Dorcas, by William Hooks; illus. by Brian Pinkney. Alfred A. Knopf, 1990.

The Days When the Animals Talked: Black American Folktales and How They Came to Be, by William J. Faulkner; illus. by Troy Howell. Follett, 1977.

Activities

1. Develop a fact file about South Carolina. Look up a fact about the state, write it on an index card, and post it on a bulletin board. Ask others to contribute to the board, but be sure that no fact is repeated.
2. Locate South Carolina on a map. How would you travel to South Carolina from your home? If you live in South Carolina, mark on a map all the places that you or members of your group have visited.

*May 24 Bulgaria Culture Day

This Bulgarian national holiday promotes culture and honors two brothers, St. Cyril and St. Methodius, who were missionaries to Moravia. St. Cyril is credited with developing the Cyrillic alphabet in 855.

The brothers are patron saints of Europe and both are Bulgaria's patrons of education and culture. Special masses, festivals, and parades are held on May 24 in Bulgaria.

Honor the creativity of Cyril and Methodius by looking at several of the ingenious alphabet books available. A few are listed below.

Featured Books

ABC, the Wild West, by Florence Cassen Mayers. H. N. Abrams, 1990.

The Accidental Zucchini: An Unexpected Alphabet, by Max Grover. Browndeer, 1993.

The Alphabet Theater Proudly Presents the Z Was Zapped: A Play in Twenty-Six Acts Performed by the Caslon Players, by Chris Van Allsburg. Houghton Mifflin, 1987.

Arlene Alda's ABC, by Arlene Alda. Celestial Arts, 1981.

Activity

Create your own amazing alphabet book. Consider using an unusual medium or format. Illustrate or define unusual words, possibly around a theme that interests you.

*May 25 Argentine Independence Day

On May 25, 1810, Buenos Aires declared its independence from the Spanish viceroy in Lima, Peru. Argentina remained loyal to Spain itself, and did not declare independence from Spain until July 9, 1816. Civil wars followed. April 25 is considered Argentine National Day and is celebrated throughout the country.

Argentina is the second largest country in South America. Buenos Aires, the capital, is the largest city. About a third of the people of Argentina live in Buenos Aires. It includes the rugged Andes Mountains, as well as the Pampas, a grassy plain which lies near the middle of Argentina. About 12 percent of Argentina's people live on the plains. Many live or work on *estancias*, huge ranches where *gauchos*, Argentine cowboys, herd cattle and horses.

Featured Book

On the Pampas, by María Cristina Brusca. Henry Holt, 1991.

A small Argentine girl spends the summer with her grandparents in their country home or *estancia*.

Additional Book

"The Gentle People," in *Tales Alive: Ten Multicultural Folktales with Activities*, retold by Susan Milord; illus. by Michael A. Donato. Williamson, 1994; 13-23.

Activities

1. Locate Argentina on a map. Learn more about the animals mentioned in *On the Pampas*.
2. Make a three-layer cake and serve it with whipped cream and peaches as they did on the ranch.

3. Try some of the activities listed following the story of "The Gentle People" in *Tales Alive*.

May 26 Yard Sale Saturday

Most any Saturday is a good day to hold a yard sale or to attend a flea market or rummage sale. The old saying, "One man's junk is another man's treasure," is proven true everyday by people who find their treasures at secondhand sales. Yard sales and rummage sales are wonderful ways to recycle, and often go hand in hand with spring cleaning.

Featured Books

Ragsale, by Artie Ann Bates; illustrated by Jeff Chapman-Crane. Houghton Mifflin, 1995.

Jessann and her family spend Saturday going to the ragsales of their Appalachian town.

Yard Sale, by Mitra Modarressi. DK, 2000.

When Mr. Flotsam has a yard sale in the quiet town of Spudville, his neighbors are first upset, then delighted, by their unusual purchases.

Activities

1. Go to a yard sale, a rag sale, or a flea market. Show the group what treasures you were able to find.
2. Encourage your friends and neighbors to contribute items they no longer need to your group. Hold a yard sale and donate the monies raised to a good cause.
3. Have a "white elephant sale." For this event, everyone contributes one unusual item and selects an item in exchange. It's advisable to have a few extra *white elephants* on hand so that everyone finds something they want. Consider holding a discussion about what kinds of items are appropriate prior to the exchange.

*May 27 Children's Day in Nigeria

The west African nation of Nigeria has over 120 million people, more than any other African nation. It also has one of the highest growth rates in the world. There are lots of children in Nigeria, and on May 27, Nigerians celebrate Children's Day. About 75 percent of Nigerians live in rural areas in huts of straw, dried mud or wood. Many Nigerians speak English and most are either Muslims or Christians. However, there are over 250 ethnic groups speaking many different languages and following different traditions. Most people in Nigeria wear traditional African clothing of long loose robes. Women often wear scarves or turbans, and men prefer small, round caps.

To learn more about life in Nigeria read *Emeka's Gift: An African Counting Story*, by Ifeoma Onyefulu. Dutton, 1995.

Featured Books

The Magic Tree: A Folktale from Nigeria, by T. Obinkaram Echewa; illus. by E. B. Lewis. Morrow, 1999.

Why the Sky is Far Away: A Nigerian Folktale, retold by Mary-Joan Gerson; illus. by Carla Golembe. Little Brown, 1992.

Activity

Locate Nigeria on a map. How do you imagine that life in Nigeria is different from life in your neighborhood?

May 28 Memorial Day

Memorial Day, formerly called Decoration Day, honors U.S. citizens who have died in war. Memorial Day is celebrated on the fourth Monday in May. Congress has also designated this as a day when we should all pray for peace. Religious services and parades mark the occasion in many communities. In Arlington, Virginia, at the Arlington National Cemetery, a wreath is placed on the Tomb of the Unknowns. This tomb contains the remains of unidentified soldiers from World War I, World War II, and the Korean War. Since the time of the Civil War, people have decorated the graves of soldiers who died in war, thus the name Decoration Day.

Featured Book

The Blue and the Gray, by Eve Bunting; illus. by Ned Bittinger. Scholastic, 1996.

A father and son and friend watch the building of a house on a former Civil War battleground. Text and illustrations paint a moving picture of a Civil War battle and of the modern friendship between two children of different races.

Additional Book

The Language of the Doves, by Rosemary Wells; illus. by Greg Shed. Dial, 1996.

Activities

1. Attend Memorial Day events honoring those killed in war.
2. Decorate the graves of war veterans by planting flowers at a cemetery in your town.
3. Ask parents or older neighbors to discuss their memories of wartime experiences with your group. What restrictions did those "at home" face in wartime? How was life on the home front different during war?

*May 29 Rhode Island Statehood Day

Rhode Island, the smallest state in the nation, became the thirteenth state on May 29, 1790. It was founded by Roger Williams in 1636 after he had been expelled from the Massachusetts Bay Colony. Williams was a strong believer in religious freedom and encouraged many different religious denominations to establish churches in Rhode Island. The oldest synagogue in the United States, the Touro Synagogue, was built in Newport, Rhode Island, in 1763. Although Rhode Island was the first colony to declare its independence from England, it was the last of the original colonies to join the union as the thirteenth state.

Rhode Island, nicknamed the *Ocean State* or *Little Rhody,* covers 1,212 square miles, much of it located along its 384 miles of Atlantic Ocean coastline. Rhode Island also claims thirty-six islands, many located in Narrangansett Bay. Despite its small size, Rhode Island is the second most densely populated state. Many of its people work in service industries as lawyers, doctors, nurses, teachers, computer or auto repair workers. Rhode Island is also a leading business and manufacturing state. Boat building and repair, as well as toy making are major industries.

Featured Book

Finding Providence: The Story of Roger Williams, by Avi; illus. by James Watling. HarperCollins, 1997.

This brief account of Roger William's founding of Providence, Rhode Island, emphasizes his belief in religious freedom.

Additional Books

Matthew Wheelock's Wall, by Frances Weller; illus. by Ted Lewin. Macmillan, 1992.

Mill, by David Macaulay. Houghton Mifflin, 1983.

Activities

1. Use an almanac to compare the size and population of your home state with that of Rhode Island. How does each one rank compared with the other fifty states?
2. Discuss the issue of religious freedom. Is religious freedom important today? List the many religions represented in your community (you may want to check the telephone book listing under "Churches" or "Temples" or "Synagogues"). Can you think of examples of peoples of different faiths working together? Can you think of times when religious differences have caused problems for peoples and nations?

*May 30 Anniversary of the Ice-Cream Maker

On May 30, 1848, William Young patented an ice cream maker which he called the "Johnson Patent Ice Cream Freezer." Although Mr. Young's was not necessarily the first ice-cream maker, it is the first patented by the United States Patent Office. The history of ice cream is often more folklore than fact. Some historians claim that Roman Emperor Nero Claudius Caesar invented ice cream by sending slaves to the mountains to bring snow and ice to Rome for the cooling of fruit drinks. Others claim that Marco Polo brought recipes for water ices from the Far East when he returned from his journeys to the Orient. Charles I of England and Catherine de' Medici are also cited as inventors of ice cream, or at least employers of the chefs who actually prepared ice-cream type dishes.

It is a fact that the first ice-cream parlor in America opened in New York City in 1776, and that Dolly Madison served ice cream as a dessert in the White House in 1812 at the second inaugural ball. Americans have always had a love affair with ice cream. Mrs. Nancy Johnson, a New England housewife, actually invented the hand-cranked ice-cream freezer in 1846, but did not have the resources to patent or market her invention. Whoever invented the first ice cream or the first ice-cream cone, we do credit Mr.

Young with obtaining the first patent for an ice-cream maker. April 30 is a good day to celebrate ice cream.

Featured Book

The Hokey-Pokey Man, by Steven Kroll; illus. by Deborah Kogan Ray. Holiday House, 1989.

A peddler hopes to introduce New Yorkers to the ice-cream cone immediately after the 1904 World's Fair.

Additional Book

From Cow to Ice Cream: A Photo Essay, by Bertram T. Knight. Children's Press, 1997.

Activities

1. Make ice cream using a hand-cranked ice-cream maker. If you do not own a hand-cranked ice-cream maker, ask friends or neighbors if they do. It is possible to purchase hand-cranked ice-cream makers through a department, cookware, or hardware store.
2. Visit a local dairy which produces ice cream.
3. Create a new ice cream flavor. Describe it in a short essay.

May 31 National Egg Month

The American Egg Board has named May National Egg Month to remind people that eggs are nutritious, delicious, and easy to prepare. Eggs are in high demand during the March and April Easter season, but demand decreases by May. The hens are still laying eggs, however, so prices tend to decrease during the late spring and summer months. The American Egg Board wants to remind people to continue enjoying eggs throughout the year.

Featured Book

Chickens Aren't the Only Ones, by Ruth Heller. Grosset & Dunlap, 1981.

This rhyming tribute to eggs begins with chickens, but continues to explore the surprising variety of creatures who lay eggs.

Additional Books

An Extraordinary Egg, by Leo Lionni. Alfred A. Knopf, 1994.

Rechenka's Eggs, by Patricia Polacco. Philomel, 1988.

Zinnia and Dot, by Lisa Campbell Ernst. Viking, 1992.

Activities

1. Hold an egg toss. Partners toss an egg back and forth, gradually moving further apart. The pair who breaks the egg last, is the winner.
2. Decorate eggs just for the fun of it.
3. Visit a chicken farm and learn how eggs are gathered and processed for sale.

*June 1 Tennessee Statehood Day

On June 1, 1796, Tennessee became the sixteenth state to join the Union. Located in the southeast, Tennessee is a long, narrow state known for its Great Smoky Mountains and its music. Country, gospel, rock, blues, jazz, and bluegrass are all at home in Tennessee. Elvis Presley, who was born in Mississippi, settled in Memphis at an estate called Graceland. The Grand Old Opry, home of country music, is located in Nashville.

Although Tennessee used to be a rural state known for dairy farming, its economy is increasingly industrial. Chemical, automobile, and machinery manufacturing are important to the state's economy. Many tourists travel to Tennessee to enjoy the beautiful mountains and to be entertained by Tennessee's many musicians.

Featured Book

Swamp Angel, by Anne Isaacs; illus. by Paul O. Zelinsky. Dutton, 1994.

According to this tall tale, Angelica Longrider, known as Swamp Angel, is the greatest woodswoman in Tennessee. At the age of two she built her first log cabin and by the time she was twelve she was able to lift mired wagons out of the mud, and she eventually saved Tennessee from a huge bear called Thundering Tarnation.

Additional Books

Daniels' Duck, by Clyde Robert Bulla. Harper & Row, 1979.

On Grandaddy's Farm, by Thomas B. Allen. Alfred A. Knopf, 1989.

Pulling My Leg, by Jo Carson; illus. by Julie Downing. Orchard, 1990.

Activity

Can you think of other tall tale heroes who do amazing things? Tall tales exaggerate everyday events. Write a tall tale about yourself.

June 2 Seaman's Day

In the coastal villages of Iceland, Seaman's Day, held on the first Sunday in June, is the biggest party of the year. The celebration honors those men and women who work in the fishing industry. Events include mock sea rescues, swimming tournaments, and tugs-of-war. Music, dancing, eating and drinking add to the merriment.

Although horses might not be part of the traditional Seaman's Day celebration, horses are important in Icelandic culture. The Vikings brought the first horses to Iceland during the years 874-930. Because the boats were small, only a few of the very best horses were transported across the ocean to Iceland. The horses proved invaluable. They were able to carry travelers across the rough Icelandic countryside. The Nordic horses are highly prized. They have proved to be good workhorses and dependable companions to the Icelandic people.

Featured Book

My Horse of the North, by Bruce McMillan. Scholastic, 1997.

A young Icelandic girl prepares her horse for the *rettir,* or gathering of sheep, in her community.

Additional Book

Ponies of Mykillengi, by Lonzo Anderson; illus. by Adrienne Adams. Charles Scribner's Sons, 1966.

Activity

Locate Iceland on a map. Imagine life there. How would your life be different if you lived in Iceland?

June 3 Mississippi Hospitality Month

June is Hospitality Month in Mississippi. Officially, Mississippi, nicknamed the Magnolia State is well known for its southern hospitality. In early June there are several events held in Mississippi which attract visitors from far away. For example, Clarksdale hosts the Delta Jubilee and the Mississippi State Championship Pork Barbecue-Cooking Contest, Natchez holds a literary celebration, and Indianola welcomes blues legend B. B. King back to his hometown for a special concert.

Music, especially Delta blues, is intimately connected with Mississippi's cultural heritage. Early slave work songs led to the development of a unique musical style called *the blues*. Among Mississippi's most famous blues musicians were "Mississippi" John Hurt, Robert Johnson, Willie Dixon, Muddy Waters, and B. B. King. Other famous Mississippi musicians include Elvis Presley, Charlie Pride, and opera singer Leontyne Price.

Celebrate Mississippi by reading about and listening to the blues.

Featured Book

The Blues of Flats Brown, by Walter Dean Myers; illus. by Nina Laden. Holiday House, 2000.

Flats, a junkyard dog, runs away from his mean master and makes a name for himself from Mississippi to New York City playing blues on his guitar.

Additional Book

Brother Billy Bronto's Bygone Blues Band, by David Birchman; illus. by John O'Brien. Lothrop, Lee & Shepard, 1992.

Activities

1. Listen to blues music. There are hundreds of blues albums available in music stores and libraries. *Ken Shapiro's Kindergarten Blues* (SAS Productions, 1997) includes blues songs especially written for young children.
2. Learn more about Mississippi. Locate Mississippi on a map and create a fact board about the state using reference books.

3. Trace the route of the Mississippi River. Where does it begin? Where does it end? How many states are touched by the waters of the mighty Mississippi?

*June 4 Jack Jouett's Ride Anniversary

On the night of June 3, 1781, through the morning of June 4, 1781, Jack Jouett became a Revolutionary War hero by riding forty-five miles through the Virginia countryside to warn Thomas Jefferson that the British were coming. Thanks to the brave act of Jack Jouett, many of the colonial leaders, including Thomas Jefferson, Patrick Henry, and General Stevens, were able to escape British capture. On June 15, 1781, the state of Virginia presented Jouett with a sword and a pair of pistols in grateful appreciation.

Featured Book

Jack Jouett's Ride, by Gail E. Haley. Viking, 1973.

This book retells the story of Jack Jouett through both words and pictures.

Additional Book

Paul Revere's Ride, by Henry Wadsworth Longfellow; illus. by Nancy Winslow Parker. Greenwillow, 1985.

Activities

1. Use a map of Virginia to trace the route that Jack Jouett followed in his heroic ride. Mark important Revolutionary War sites.
2. Compare the rides of Jack Jouett and Paul Revere.

*June 5 World Environment Day

The United Nations General Assembly designated June 5 World Environment Day at the opening of the United Nations Conference on the Human Environment held in 1972. This day, celebrated annually, should be devoted to activities that educate people about the environment and encourage them to take care of the earth. A recent focus of this day has been to encourage people to plant trees as a means to overcome deforestation and to provide a more generally healthful environment.

Featured Book

The People Who Hugged the Trees: An Environmental Folk Tale, retold by Deborah Lee Rose from a story of Rajasthan, India; illus. by Birgitta Saflund. Roberts Rinehart, 1990.

Additional Book

Just a Dream, by Chris Van Allsburg. Houghton Mifflin, 1990.

Activities

1. Care for the earth in your neighborhood. Pick up litter, weed a vacant lot, plant a garden.
2. Make posters promoting earth-friendly activities.

*June 6 Swaziland Independence Day

This is a national holiday which celebrates Swaziland's 1968 independence from Great Britain. This day is also called Sobhuza Day after the king of that name who ruled from 1921-1982. Swaziland is now an independent monarchy. Swaziland is a small, beautiful African country surrounded on three sides by South Africa and on the fourth by Mozambique. It has rich agricultural lands and good mineral resources. Swazi farmers measure their wealth in cattle, although they do not usually kill cattle for food. Crops include corn, sugar cane, cotton, rice, and citrus fruits.

Featured Book

Learning to Swim in Swaziland: A Child's-Eye View of a Southern African Country, by Nila K. Leigh. Scholastic, 1993.

An eight-year-old girl describes in words and pictures her life in Swaziland when her family moves there to live and work.

Additional Book

Today's additional book is a folktale from Namibia, another southern African country.

Jackal's Flying Lesson: A Khoikho Tale, retold by Verna Aardema; illus. by Dale Gottlieb. Alfred A. Knopf, 1995.

Activities

1. Locate Swaziland on the map of the world. Use a reference book to learn more about this fascinating African nation.
2. Using *Learning to Swim in Swaziland* as an example, create a book about life in your community.

June 7 National Hug Holiday

National Hug Holiday is a one week celebration held the second week in June and sponsored by the Hugs for Health Foundation. The Hugs for Health Foundation says that National Hug Holiday "is for huggers of all ages across the country. Its purpose is to honor, recognize, and express our appreciation for one another and increase hug abundance, making a difference one hug at a time." The organization is dedicated to enhancing the quality of life for nursing home residents by providing "hug therapy" and volunteer services. Members provide tips on hug etiquette and techniques which emphasize the importance of respecting others and of being gentle and friendly with one another.

Featured Book

Willie's Not the Hugging Kind, by Joyce Durham Barrett; illus. by Pat Cummings. HarperTrophy, 1991.

Willie's best friend convinces him that hugging is silly. When he stops hugging his family, he realizes how much a hug means to him.

Additional Books

Giving, by Shirley Hughes. Candlewick, 1993.

Wilfrid Gordon McDonald Partridge, by Mem Fox; illus. by Julie Vivas. Kane Miller, 1985.

Activities

1. Hug someone today.
2. Visit a nursing home and do something special for the residents: sing a song, sit and visit, play a game, present some artwork, or give a hug.

June 8 National Candy Month

Confectioner Magazine and the candy industry sponsor June as National Candy Month. All sorts of unique candy-related events are sponsored by local candy retailers during the month of June. These include chocolate festivals, contests about candy and candy making, workshops, classes on making and using candy in baking, and presentations on the history of chocolate, gum, and other kinds of candy. The sponsors hope to increase consumer awareness of the vast array of candy products produced in this country.

Featured Book

Cocoa Ice, by Diana Appelbaum; illus. by Holly Meade. Orchard, 1997.

A girl in Santo Domingo tells how cocoa is harvested during the late 1800s. Simultaneously, a girl in Maine tells about the harvesting of ice.

Additional Books

Broccoli-Flavored Bubble Gum, by Justin McGivern; illus. by Patrick Girouard. Raintree Steck-Vaughn, 1996.

Hansel and Gretel, retold by Rika Lesser; illustrated by Paul O. Zelinsky. Dodd, Mead & Company, 1984.

Activities

1. Look closely at the ingredients listed on a candy bar or a bag of hard candies. Where do these ingredients come from? How many are natural? Which ones are manufactured? Compare the calories and nutrients in various kinds of candy.
2. Make fudge or other homemade candy.
3. Make small candy baskets to give to special people.

June 9 Wedding Day

Any day in any month can be a wedding day, but a Saturday in June is a great time to celebrate weddings. According to wedding experts, June is the most popular wedding month followed by August, September, May, July, October, and December. Friday and Sunday follow Saturday as the most popular days for a wedding. Each year since 1970, over two million couples are joined in marriage. Most couples getting married are between the ages of twenty and twenty-four. However, a developing trend indicates that the age at which people are first married is increasing. On a Saturday in June, read stories about weddings while you listen for the lovely chime of wedding bells signaling the beginning of another marriage.

Featured Book

Mountain Wedding, by Faye Gibbons; illus. by Ted Rand. Morrow, 1996.

Children from two mountain families are joined when their parents marry. The new family is not particularly happy until circumstances force them to work together.

Additional Book

Snapshots from the Wedding, by Gary Soto; illus. by Stephanie Garcia. Putnam, 1997.

Activities

1. Ask members of the group to share their experiences as flower girls, ring bearers, or guests at a wedding.
2. Invite parents and grandparents to share their wedding pictures or wedding dresses with your group.

*June 10 Time Observance Day

On June 10 Emperor Tenchi of Japan (663-671) first ordered the hour to be announced by sounding the temple bells and drums. Emperor Tenchi himself is given credit for creating the first water clock, called a clepsedra, which measured time by the amount of water leaking out of a vessel. Time keeping was very unusual in seventh-century Japan. Today, Time Observance Day or Punctuality Day, is celebrated throughout Japan to remind people of the importance of keeping the correct time.

Featured Book

The Boy of the Three-Year Nap, by Dianne Snyder; illus. by Allen Say. Houghton Mifflin, 1988.

This traditional Japanese folktale tells the story of the laziest person in the village who wants to marry the beautiful daughter of the wealthy rice merchant next door.

Additional Books

The Boy Who Stopped Time, by Anthony Taber. Macmillan, 1993.

Somewhere in the World Right Now, by Stacey Schuett. Alfred A.Knopf, 1995.

Activities

1. Play with time. How well can you estimate time? Have someone with a watch keep time for one minute. Can you guess when the time is up? Try this using varying time periods?
2. Use a stopwatch to time different activities: a race, writing your name, doing a math problem, tossing a ball into the basketball hoop.
3. Write your daily schedule. How much free time do you have? How long do you sleep each night? Have you scheduled time for meals?

*June 11 Cataclysmos Day

This unusual holiday on the island of Cyprus is a day when people visit the seaside and sprinkle water on one another. It is considered bad luck not to be sprinkled this day. There is often a poetry battle where contestants insult one another in rhyming verse. If the contestants are quick and clever, the battle can last for hours.

Cataclysmos Day is a good day to enjoy funny poems.

Featured Books

For Laughing Out Loud: Poems to Tickle Your Funnybone, selected by Jack Prelutsky; illus. by Marjorie Priceman. Alfred A. Knopf, 1991.

I Thought I'd Take My Rat to School: Poems for September to June, selected by Dorothy M. Kennedy; illus. by Abby Carter. Little Brown, 1993.

Imagine That! Poems of Never-Was, selected by Jack Prelutsky; illus. by Kevin Hawkes. Alfred A. Knopf, 1998.

Never Take a Pig to Lunch and Other Poems about the Fun of Eating, selected by Nadine Bernard Westcott. Orchard, 1994.

Activities

1. Stage your own Cataclysmos Day by writing amusing and gently insulting poems to toss at one another.
2. Choose a poem, memorize it, and recite it to your group.

June 12 National Little League Baseball Week

In June of 1959, President Dwight D. Eisenhower proclaimed the second week of June as National Little League Baseball Week. There are many reasons why June is a good time to celebrate baseball. For example, on June 12, 1939, the National Baseball Hall of Fame was dedicated at Cooperstown, New York. During June the baseball season is in full swing—both in the major leagues, minor leagues, and in the little leagues. During that same year, little league baseball was founded in Williamsport, Pennsylvania, by Carl Stotz. Little league has expanded ever since and now includes teams from around the world. Over three million children participate in little league baseball each summer. Little League Baseball Week is a great time to read and enjoy baseball stories.

Featured Book

I Remember Papa, by Helen Ketteman; illus. by Gred Shed. Dial, 1998.

Audie recalls the summer that he attended a Cincinnati Reds game with his father and his sadness at losing the money he had saved to buy a glove.

Additional Books

Bats about Baseball, by Jean Little and Claire Mackay; illus. by Kim Mackay. Viking, 1995.

Hooray for Snail! by John Stadler. HarperCollins, 1984.

Mice at Bat, by Kelly Oechsli. HarperCollins, 1986.

Play Ball, Amelia Bedelia, by Peggy Parish; illus. by Wallace Tripp. HarperCollins, 1996.

What Kind of Baby-Sitter Is This? by Dolores Johnson. Macmillan, 1991.

Activities

1. Play ball!
2. Attend a baseball game.

*June 13 Spring Snow Day

On June 13, 1889, two feet of snow fell on the mountain town of Rawlins, Wyoming. While it is unusual for so much snow to fall that late in the season, it happens occasionally. On June 30, 1968, eight inches of snow fell in Mystic Lake, Montana. High mountain regions are more likely to have spring and summer snow than low-lying areas, and if the altitude is high enough, snow falls all year. Altitude even affects city weather. It can be raining on the ground level of a city skyscraper, but snowing on the roof. While it is unlikely that snow is falling outside your window on June 13, celebrate the day that snow fell on Rawlins, Wyoming, by reading stories about spring and summer snow.

Featured Book

The Summer Snowman, by Gene Zion; illus. by Margaret Bloy Graham. Harper, 1955.

Henry and his brother Pete have so much fun making their snowman in winter that they save it in the freezer and bring it out again for the Fourth of July celebration.

Additional Book

Mud Flat Spring, by James Stevenson. Greenwillow, 1999.

Activities

1. Check the weather around the country. Is it snowing anywhere today? What is the temperature where you live? What kind of precipitation is most likely? Check the newspaper or local television to find out the record high and low for June 13 in your community.
2. Cut snowflakes out of paper and decorate the room for winter.
3. Draw winter pictures.

*June 14 Flag Day

The official United States flag was adopted on June 14, 1777. The anniversary of this day has been observed by act of Congress since 1949. Prior to that time, Flag Day was observed in various states and communities. For example, on June 14, 1891, the Betsy Ross House in Philadelphia, Pennsylvania, held a Flag Day celebration, and on June 14, 1894, the governor of New York decreed that the United States flag should be displayed on all public buildings in honor of Flag Day. An annual ceremony, sponsored by the National Flag Day Foundation, is held each year at Ft. McHenry in Maryland.

Featured Books

Betsy Ross, by Alexandra Wallner. Holiday House, 1994.

A Flag for Our Country, by Eve Spencer; illus. by Mike Eagle. Raintree Steck-Vaugh, 1993.

Both books provide colorful details of the life of Betsy Ross and the creation of the United States' first flag.

Activities

1. Salute the flag by saying the pledge of allegiance to the flag of the United States of America. Do you know what each of the words means?
2. Learn proper etiquette of flag display, including how to fold the flag and on what holidays it is appropriate to display the flag.
3. Plan a Flag Day ceremony at your school or community center.

June 15 National Dairy Month

The dairy industry promotes June as a month to recognize and salute the nation's dairy farmers. The first recognition of the diary industry, sponsored by grocer organizations, was held in 1937. A few years later, dairy industry proponents declared the entire month of June as National Dairy Month.

Featured Book

Daddy Played Music for the Cows, by Maryann Weidt; illus. by Henri Sorensen. Lothrop, Lee & Shepard, 1995.

From her earliest days, music is a daily part of life for a young girl growing up on a dairy farm.

Additional Book

The Smallest Cow in the World, by Katherine Paterson; illus. by Jane Clark Brown. HarperCollins, 1991.

Activities

1. Visit a dairy farm or a local dairy which produces milk and milk products for sale.
2. Discuss the nutritional value of dairy products.
3. Share your favorite dairy recipes.

June 16 Market Day

Saturday is traditionally market day throughout Europe. Farmers bring their produce to town and shoppers stop by to purchase fresh fruits and vegetables, fresh meat, and other products including cheese, pickles, and craft items. Any Saturday can be a market day. This is a good day to go to the grocery store, a flea market, or a farmer's market in your town.

Featured Book

Bunny Cakes, by Rosemary Wells. Dial, 1997.

When Max and Ruby decide to make a cake for Grandma's birthday, Ruby sends Max to the market for the ingredients.

Additional Books

Don't Forget the Bacon! by Pat Hutchins. Greenwillow, 1976.

I Will Not Go to Market Today, by Harry Allard; illus. by James Marshall. Dial, 1979.

Tommy at the Grocery Store, by Bill Grossman; illus. by Victoria Chess. Harper & Row, 1989.

Activities

1. Make a list of the ingredients you might need to make cupcakes or some other treat.
2. Set up a pretend store in your classroom. Take turns playing the shopper and the storekeeper.
3. Make a list of ways that children can help make a trip to the market fun and fast for Mom or Dad.

*June 17 World Juggling Day

International Juggling Association sponsors World Juggling Day to demonstrate, teach, and appreciate the art of juggling. Various local juggling clubs hold festivals throughout the world to highlight the fun and skill of juggling.

Featured Book

Benny: An Adventure Story, by Bob Graham. Candlewick, 1999.

When Benny the dog steals the show from Brillo the magician, he is forced to find a new home where his rare talents such as juggling and tap dancing will be appreciated.

Additional Book

Lucy's Winter Tale, by Amy Ehrlich; illus. by Tony Howell. Dial, 1999.

Activities

1. Try juggling. Begin with two tennis balls or beanbags and gradually add a third.
2. Invite a local juggler to demonstrate juggling for your group.

June 18 **National Rose Month**

The American Rose is the national flower of the United States. Since 1969, the month of June has been recognized as National Rose Month. Roses are native to the United States and are the state flower of Georgia, Iowa, New York, North Dakota, and the District of Columbia. Portland, Oregon, is nicknamed the *City of Roses*. About eighty years ago, Portland was home to a hockey team called the Portland Rosebuds. Some historians believe that George Washington was the first American breeder of roses. Today over nine hundred acres of greenhouses in the United States are devoted to the cultivation of roses. June 18 is a day to celebrate our national flower.

Featured Book

The Rose in My Garden, by Arnold Lobel; illus. by Anita Lobel. Greenwillow, 1984.

A variety of flowers grow near the hollyhocks that give shade to the bee that sleeps on the only rose in a garden.

Additional Books

Alison's Zinnia, by Anita Lobel. Greenwillow Books, 1990.

No Roses for Harry, by Gene Zion; illus. by Margaret Bloy Graham. Harper, 1958.

Activities

1. Visit a nursery which produces roses.
2. Using photographs as a guide, draw rose pictures and use them to make flowered note cards.
3. Take a survey of married women. What flowers did they choose for their weddings? Compile the responses into a flower preference chart.

***June 19** **Juneteenth**

This is the oldest African American holiday observance and has been called by a variety of names including "Emancipation Day" and "Freedom Day." It was on January 31, 1865, that Congress passed the Thirteenth Amendment which abolished slavery in the United States. However, the message of emancipation did not reach everyone at once. As soon as the message reached each region or plantation, there was great rejoicing among the former slaves. The message of freedom reached Texas on June 19, 1865 and this is how Juneteenth got its name. These were among the last slaves to receive their freedom. Generally, slaves became free between 1863 and 1865. February 1 is called National Freedom Day because that is the date on which President Abraham Lincoln signed the Thirteenth Amendment. Currently Juneteenth is a legal holiday in Texas, and celebrations often include church services followed by community get-togethers.

Featured Book

Virgie Goes to School with Us Boys by Elizabeth Fitzgerald Howard; illus. by E. B. Lewis. Simon & Schuster, 2000.

The story of Virgie, a small girl who yearns to attend school with her older brothers, reflects the new opportunities that were available to former slaves after emancipation. When the Quakers open a school for African American children in Jonesborough, Tennessee, Virgie convinces her family that she, too, needs an education. The notes at the back of the book provide additional background material.

Additional Books

Follow the Drinking Gourd, by Jeanette Winter. Dragonfly, 1988.

Pink and Say, by Patricia Polacco. Philomel, 1994.

Sweet Clara and the Freedom Quilt, by Deborah Hopkinson; illus. by James Ransome. Alfred A. Knopf, 1993.

Activity

Discuss freedom. Why is it important? What risks will people take to gain it? How is education (or schooling) related to freedom?

*June 20 West Virginia Day

West Virginia, called the Mountain State, joined the Union on June 20, 1863, as the thirty-fifth state. During the early years of the nation, West Virginia was the western part of Virginia. As the western area developed, it became different from the rest of Virginia. Western Virginia was hillier and proved to be rich in iron, natural gas, and coal. Logging was an important industry. The break with Virginia, however, didn't happen until the Civil War. The people who lived in present-day West Virginia did not want to secede from the Union with Virginia. On October 24, 1861, they voted to break from Virginia. Two years later, they officially became a state.

Mining has always been part of West Virginia's history. While it helped to boost the nation's economy, it harmed both the people's health and the environment. Today's featured books reflect the effect the coal industry had on the lives of West Virginia's children.

Natural gas, oil, and coal are still produced in West Virginia, but these days West Virginian's make an effort to protect the environment. Iron, steel, glass and chemicals are manufactured there, too. The beautiful mountains of West Virginia continue to produce lumber and to attract tourists to the state.

Featured Books

In Coal Country, by Judith Hendershot; illus. by Thomas B. Allen. Dragonfly Books, 1992.

A child growing up in a coal mining community finds both excitement and hardwork in a life deeply affected by the local coal industry.

No Star Nights, by Anna Egan Smucker; illus. by Steve Johnson. Alfred A. Knopf, 1989.

A young girl growing up in a steel mill town in the 1950s describes her life and how it was affected by the steel industry.

When I Was Young in the Mountains, by Cynthia Rylant; illus. by Diane Goode. Dutton, 1982.

A young girl shares her memories of her gentle upbringing in the mountains of West Virginia.

Activities

1. All three books examine both the good and bad aspects of a childhood in West Virginia's coal country. List both the advantages and the problems that the authors reveal. Think of the good and the bad aspects of growing up in your neighborhood. Overall, do these authors present a happy picture of their childhoods?
2. Locate West Virginia on a map of the United States. Use reference books and nonfiction books to create a West Virginia fact board.

*June 21 New Hampshire Day

New Hampshire, called the Granite State in recognition of its plentiful deposits of granite, was the ninth state to join the Union on June 21, 1788. It was the first colony to declare its independence from England. Its citizens fought bravely in the Revolutionary War, and the state carried a large burden of debt as a result of the war.

New Hampshire is particularly beautiful with its White Mountains and its lake region. Many tourists flock to New Hampshire to enjoy the lakes, seacoast, and mountains. Much of its land is forested, and lumbering is a major industry.

Several children's books have been written about New Hampshire's early history and about the interesting peoples, including the Abnaki Indians and the Shakers (a religious group), who have chosen New Hampshire as home.

Featured Book

Ox-Cart Man, by Donald Hall; illus. by Barbara Cooney. Viking, 1979.

This Caldecott winning book describes, in word and picture, day-to-day life of an early nineteenth-century New Hampshire family.

Additional Books

The Bear That Heard Crying, by Natalie Kinsey-Warnock; illus. by Ted Rand. Cobblehill, 1993.

Little Firefly: An Algonquian Legend, retold by Terri Cohlene; illus. by Charles Reasoner. Rourke, 1990.

Activities

1. Create a play or skit based on one of today's books.
2. Locate New Hampshire on a map of the United States. How does its location play an important role in today's books?
3. Develop a tourist brochure for the state of New Hampshire. Do research to find what sites and activities a tourist might enjoy while visiting New Hampshire.

June 22 White Nights

During June 21-29, the nights are so short in St. Petersburg, Russia that the sky appears white or light gray. The city, filled with pastel buildings, is particularly beautiful during white nights, and citizens spend time walking through town and enjoying a party atmosphere. St. Petersburg holds a fine arts festival during White Nights that focuses on ballet and folk dancing, opera, musical theater and symphony concerts. The river fills with boats and rafts firing cannons, fireworks, and creating spectacular fountains. June 22 is a good time to read about Peter the Great, who founded the city of St. Petersburg, or to share folktales about life under the leadership of a Russian *tsar* (also spelled *czar*).

Featured Biography

Peter the Great, by Diane Stanley. Four Winds Press, 1986.

Stanley's illustrated biography reveals much about the founder of St. Petersburg. It will appeal to older students.

Featured Folktales about Russian Tsars

The Fool of the World and the Flying Ship: A Russian Tale, retold by Arthur Ransome; illus. by Uri Shulevitz. Farrar, Straus & Giroux, 1968.

Music for the Tsar of the Sea, by Celia Barker Lottridge; illus. by Harvey Chan. Groundwood, 1998.

Soldier and Tsar in the Forest: A Russian Tale, trans. by Richard Lourie; illus. by Uri Shulevitz. Farrar, Straus & Giroux, 1972.

Activities

1. On a map, locate St. Petersburg. What can you tell about this city from the location? Why are the nights short during a St. Petersburg summer? What effect would this location have on the winter days?
2. Russia is no longer ruled by tsars. Find out who currently leads Russia. Read the newspaper or listen to the news to see if you find references to the current leader.
3. After reading about Peter the Great or the tsar in a folktale, what conclusions can you draw about life under the tsars?

June 23 Midsummer Eve

In Sweden, Midsummer, which may have begun as a prehistoric summer solstice festival, is a time of great festivity. It is celebrated on the weekend nearest June 24. Many Swedes leave their city homes for the countryside where celebrations revolve around the village Maypole or Midsummer pole that is decorated with colorful flags, leaves, and flowers for the occasion. Children gather at the Maypole after lunch and play games or participate in traditional circle dances. Special foods include pickled herring, boiled new potatoes, and fresh strawberries. In the evening, the dancing moves to a barn or outdoor pavilion and continues well into the brightest night of the year. Many folk myths surround this event. For example, if a young woman gathers seven different wildflowers and places them under her pillow, she will dream of her future husband. Another old belief is that dew gathered on Midsummer Eve has special curative powers

Midsummer Eve is a good time to read stories from Sweden.

Featured Books

The Changeling, by Selma Lagerlöf; illus. by Jeanette Winter. Alfred A. Knopf, 1992.

The Wild Baby, by Barbro Lindgren; illus. by Eva Eriksson; adapted from Swedish by Jack Prelutsky. Greenwillow, 1981.

The Wild Baby Goes to Sea, by Barbro Lindgren; illus. by Eva Eriksson; adapted from Swedish by Jack Prelutsky. Greenwillow, 1983.

Activity

Celebrate Midsummer Eve by decorating a Maypole, eating traditional Midsummer foods like pickled herring, boiled potatoes or fresh strawberries, playing games or dancing in the moonlight.

*June 24 San Juan Pueblo Feast Day

The Pueblo Indians live in New Mexico and Arizona. The Spanish, who met these people when they explored the area in the 1500s, named them Pueblo Indians because their settlements resembled Spanish towns or villages. (*Pueblo* is the Spanish word for *town*.) There are nineteen Pueblo villages in New Mexico. Most of the towns are located along the Rio Grande River. Feast days are especially memorable days for Pueblo children. The pueblo often holds a celebration which includes dancing, games, and lots of food. The children of the Tewa tribe, who live in San Juan Pueblo in New Mexico, especially enjoy the Feast Day of St. John, for whom the Pueblo is named. June 24 is St. John's Feast Day at the San Juan Pueblo.

There are several beautifully produced books about Pueblo children.

Featured Book

Dancing Rainbows: A Pueblo Boy's Story, by Evelyn Clarke Mott. Cobblehill, 1996.

Curt and his grandpa, Andy, are preparing to celebrate the Feast Day on June 24. This photographic essay follows them through the day's activities.

Additional Books

Children of Clay: A Family of Pueblo Potters, by Rina Swentzell; photos by Bill Steen. Lerner, 1992.

Pueblo Storyteller, by Diane Hoyt-Goldsmith; photos by Lawrence Migdale. Holiday House, 1991.

Activities

1. Invite a member of a Pueblo Indian group to your class to speak or demonstrate native dances or crafts.
2. Learn more about the Pueblo Indians of New Mexico.
3. At the library, locate a book of craft projects based on American Indian arts and crafts. Select a project or two to try.

June 25 Dragon Boat Festival

This 2000-year-old Chinese festival, called Duan Wu Jie, commemorates the life of the poet Qu Yuan who lived in the third century B.C. He was an advisor to the king, but when he tried to tell the king how to keep peace with surrounding kingdoms, his advice was rejected. On hearing that the capital city was destroyed, he wrote one of China's most famous elegies and then threw himself in the Milo River. People got in their boats and raced to find him, but they were too late. The Dragon Boat Races are a reenactment of this historical event. These races also occur near the summer solstice and are said to give honor to the river god, who took the form of a dragon.

This festival continues today as one of the most colorful events in China. In the city of Nanning, over 250,000 spectators line the riverbank cheering on the teams of men and women racers. The long, thin boats are decorated to resemble dragons. They often hold up to one hundred oarsmen who race against one another with great enthusiasm even though there is no clearly defined finish line or prize for the winner.

2001	6/25	2006	5/31
2002	6/25	2007	6/19
2003	6/4	2008	6/8
2004	6/22	2009	6/28
2005	6/11	2010	6/16

Featured Book

The Paper Dragon, by Marguerite W. Davol; illus. by Robert Sabuda. Atheneum, 1997.

The humble scroll painter, Mi Fei, is the only one wise enough to confront and better Sui Jen, the dragon that has just awakened from its hundred years' sleep.

Additional Books

The Eyes of the Dragon, by Margaret Leaf; illus. by Ed Young. Lothrop, Lee & Shepard, 1987.

The Last Dragon, by Susan Miho Nunes; illus. by Chris K. Soentpiet. Clarion, 1996.

Activity

Create your own painting of a dragon or a dragon boat race.

*June 26 Barnum Festival

This annual celebration, held in late June through July 4, in Bridgeport, Connecticut, celebrates the life of P. T. Barnum, the great circus showman. Barnum lived in Bridgeport and served as its mayor in 1875. The festival promotes the city's circus image. Among the activities are a drum corps competition, entertainment by circus clowns, and other circus events.

There are many wonderful books about the circus in addition to the titles listed.

Featured Books

Ginger Jumps, by Lisa Campbell Ernst. Bradbury, 1990.

Mirette on the High Wire, by Emily Arnold McCully. Putnam, 1992.

Once Upon MacDonald's Farm, by Stephen Gammell. Four Winds, 1981.

Activities

1. Go to a circus.
2. Hold your own circus. Be sure to include clowns, acrobats, and trick bicycle riding.
3. Draw a picture of a circus based on your own experience or on one of the circus stories that you read.
4. Draw clown faces and gather them together for a display.

June 27 Strawberry Festival

The Iroquois Indians who live in the current New York state area celebrate Strawberry Festival in June when the fruit is plentiful. The people gather in a longhouse and listen to the speeches of the great Seneca prophet Handsome Lake (1735-1815). Handsome Lake expected people to participate in cooperative farming, to abstain from alcohol, and to turn away from witchcraft. The speech is followed by dances and a meal featuring strawberry drink and strawberry shortcake.

June 27 is a good day to read an Iroquois legend.

Featured Book

The Woman Who Fell from the Sky: The Iroquois Story of Creation, retold by John Bierhorst; illus. by Robert Andrew Parker. Morrow, 1993.

Sky Woman and her two sons create the earth.

Additional Books

The Dancing Stars: An Iroquois Legend, by Anne Rockwell. Thomas Y. Crowell, 1972.

Longhouse Winter, by Hettie Jones; illus. by Nicholas Gaetano. Holt, Rinehard & Winston, 1972.

Activities

1. Pick strawberries.
2. Make strawberry shortcake and share it with friends.
3. Learn more about the Iroquois Indians.

June 28 National Accordion Awareness Month

An accordion shop in California sponsors National Accordion Awareness Month to "increase public awareness of this multicultural instrument and its influence and popularity in today's music." Accordi-

ons come in a variety of types and are associated with many kinds of music. June 28 is a good time to learn more about this versatile instrument.

Featured Book

Something Special for Me, by Vera B. Williams. Greenwillow, 1983.

Rosa has difficulty choosing a special birthday present to buy with the money her mother and grandmother have saved until she hears a man playing beautiful music on an accordion.

Additional Books

Hector the Accordion-Nosed Dog, by John Stadler. Bradbury, 1983.

Music, Music for Everyone, by Vera B. Williams. Greenwillow, 1984.

Activities

1. Invite an accordion player to perform for your group and to teach you about the accordion.
2. Listen to accordion music. Almost all polka and zydeco music feature an accordian, as do many other folk and popular forms.

June 29 Kutztown Folk Festival

In late June and early July, the people of Kutztown, Pennsylvania, hold a nine-day exposition to celebrate Pennsylvania Dutch heritage. The festival features a variety of activities typical of the Amish, Mennonite, and Brethren people who settled in the area. Pageants reenact traditional Amish weddings and barn raisings. There are demonstrations of ethnic dances and tables of delicious ethnic foods. Other activities include sheep shearing, quilting, basket weaving, rug making, and horseshoeing. Although the festival celebrates Amish heritage, the Amish do not participate because of their religious convictions.

Featured Book

Raising Yoder's Barn, by Jane Yolen; illus. by Bernie Fuchs. Little Brown, 1998.

When fire destroys the family's barn, the neighbors in the Amish community come by to help with the rebuilding.

Additional Books

Just Plain Fancy, by Patricia Polacco. Bantam, 1990.

Reuben and the Fire, by Merle Good; illus. by P. Buckley Moss. Good Books, 1993.

Activities

1. The Pennsylvania Dutch are known for their many handicrafts. Design your own decorations based on the Pennsylvania Dutch style.
2. The Amish represent a tight-knit community that helps one another in difficult times. Has your group ever banded together for a good cause? Think of ways in which you might help one another or others by working together as a group.

3. Learn more about the Amish, the Mennonites, the Brethren and other religious sects. Share your information.

*June 30 Zaire Independence Day

Zaire is a huge central African nation. Pygmies were the first known inhabitants of the area now called Zaire. Other African peoples moved into the area over 2000 years ago, and in the 1400s European explorers from Portugal and Belgium visited and staked claims. For nearly 500 years, Belgium ruled the land it called the Belgium Congo. On June 30, 1960, the Congo gained its independence from Belgium. The first independence day was celebrated with fireworks in the capital city of Leopoldville. In 1971, the region changed its name to Zaire.

Today about 99 percent of the people of Zaire are black Africans belonging to many different ethnic groups. French is the official language, but over 200 separate languages are spoken. About 60 percent of the people live in small villages, but since independence, many young people have moved to urban areas seeking work. Although Zaire is a poor country, it has many natural resources including rubber, copper, and oil which it could use for development in the future. Celebrate Zaire by reading folktales from central Africa.

Featured Books

Traveling to Tondo: A Tale of the Nkundo of Zaire, retold by Verna Aardema; illus. by Will Hellenbrand. Alfred A. Knopf, 1991.

Why the Crab Has No Head: An African Tale, retold by Barbara Knutson. Carolrhoda, 1987.

Activities

1. Both of these folktales teach a lesson. Discuss the lesson in each folktale. Can you think of other stories that teach similar lessons.
2. List all of the animals mentioned in the stories. Assign an animal to pairs or groups of students. Using encyclopedias and animal reference works, find out if all mentioned animals live in Zaire. Find an additional fact or two about each.

*July 1 Canada Day

All of Canada celebrates on July 1. Canada Day commemorates the confederation of the provinces of Canada into the Dominion of Canada on July 1, 1867, under the British North America Act. Canada is a democracy, but recognizes the British queen as its ceremonial ruler. The holiday was called Dominion Day until 1982 when the name was officially changed to Canada Day.

 Canada Day is not unlike the Fourth of July in the United States. Canadians celebrate the founding of the dominion by holding picnics and parades, concerts, and fireworks displays. Canada Day is always observed on July 1 unless that date falls on a Sunday, in which case the holiday is celebrated the following Monday.

Canada is the second largest country in the world. People often forget how vast it is because only 20 percent of the country is inhabited. The United States and Canada share an unfortified border of over 5,000 miles and there is easy passage between the two countries. Canada is as diverse as the United States. It has rich natural resources and is known for its fish, lumber, and farm products.

Canada Day is an excellent time to read books that have won awards as the best in Canadian children's literature. Today's featured books are recent winners of the Elizabeth Mrazik-Cleaver Canadian Picture Book Award, sponsored by the National Library of Canada.

Featured Books

Rainbow Bay, by Stephen Eaton Hume; illus. by Pascal Milleli. Raincoast, 1997.

Ghost Train, by Paul Yee; illus. by Harvey Chan. Douglas & McIntyre, 1996.

Selina and the Bear Paw Quilt, by Barbara Smucker; illus. by Janet Wilson. Lester, 1995.

Josepha: A Prairie Boy's Story, by Jim McGugan; illus. by Murray Kimber. Red Deer, 1994.

Activities

1. Watch a travel video about Canada and use reference books to plan a trip to Canada. If you could visit only one province, which would you choose? Why? What special sights would you like to see?
2. Children in Canada study both French and English in their schools. Learn some French words and phrases, at least enough to say "hello," "please," and "thank you" the next time you visit Canada.

July 2 Be Nice to New Jersey Week

The first full week of July is Be Nice to New Jersey Week. This special celebration of apology is sponsored by Lone Star Publications of Humor in San Antonio, Texas. Lauren Barnett, editor and publisher of Lone Star Publications of Humor, began the celebration after she noticed how many New Jersey jokes are in circulation. She suggests that people tell jokes about New Jersey because of its small size and its proximity to New York. Whatever the reason, Barnett suggests that during the first week in July, everyone should be particularly nice to people from New Jersey, and if they have made jokes about the state, they should consider sending an apology to New Jersey's governor.

People who live in New Jersey are rightfully proud of their state. It was one of the original thirteen states and was third to ratify the United States Constitution. New Jersey is nicknamed *The Garden State* and ranks second in its production of cultivated blueberries. It also produces potatoes, peaches, cranberries, tomatoes, and corn. People are often surprised to learn of New Jersey's rich farmland because of the state's many large cities. Be Nice to New Jersey Week is a good time to remember that true beauty is often hidden.

Celebrate Be Nice to New Jersey Week by reading about others who were insulted despite their hidden beauty.

Featured Books

Beauty and the Beast, retold and illus. by Jan Brett. Clarion, 1989.

The Princess and the Frog, by the Brothers Grimm; adapted and illus. by Rachel Isadora. Greenwillow, 1989.

The Ugly Duckling, by Hans Christian Andersen; adapted and illus. by Jerry Pinkney. Morrow, 1999.

Activities

1. Do something nice for someone that you insulted even if the insult was not meant to hurt or criticize the person.
2. When is a joke harmful? Discuss the ways in which humor can be cruel. What can you do to avoid telling jokes that hurt others?
3. Do research to discover ten good things about New Jersey.

*July 3 Idaho Statehood Day

On July 3, 1890, Idaho became the forty-third state in the United States. Idaho's scenic beauty comes from its mountainous setting amid the Bitterroot Range and the Clearwater Mountains. The Snake River, in the southern part of the state, flows through Hell's Canyon, the deepest gorge in North America. Idaho's rivers, with their many falls and rapids, attract white-water rafters and adventurers. The Salmon River, the longest river within any state, is called "the river of no return" because its swift current makes it impossible to turn back.

Over 70 percent of Idaho's people live within thirty miles of the Snake River, and this is the area where Idaho's famous potatoes are grown. Mining and fishing are also important industries in Idaho.

Featured Book

Mailing May, by Michael O. Tunnell; illus. by Ted Rand. Greenwillow, 1997.

Based on an actual event which occurred in Idaho in 1913, this story tells of five-year-old Charlotte May Pierstorff who was mailed from one Idaho city to another.

Additional Books

Canoe Days, by Gary Paulsen; illus. by Ruth Wright Paulsen. Doubleday, 1999.

Three Days on a River in a Red Canoe, by Vera B. Williams. Greenwillow, 1981.

While neither story is specifically set in Idaho, both tell of the joys of canoeing in a wilderness area.

Activities

1. On a map of Idaho, locate towns whose names end with the word *falls*. How many are there? Why do you think so many Idaho towns are so named?
2. Invite a local postmaster to speak with your group. Perhaps he/she can describe some unusual packages or postal requests. Prepare a list of questions about the postal service.
3. Plan a three-day canoe trip. Working in teams, make a list of supplies that you might need and then rank the items from most important to least important. Compare your list with that of other teams. Did you forget anything?

*July 4 Independence Day

On July 4, 1776, fifty-six delegates to the Second Continental Congress voted to adopt the Declaration of Independence. Since that time, July 4 has been considered the birthday of the nation. Happy Birthday, America!

Featured Book

The Scrambled States of America, by Laurie Keller. Henry Holt, 1998.

When the states become bored with their locations on the map, they decide to change places.

Additional Book

Fourth of July, by Barbara M. Joosse; illus. by Emily Arnold McCully. Alfred A. Knopf, 1985.

A Fourth of July on the Plains, by Jean Van Leeuwen; illus. by Henri Sorensen, Dial, 1997.

Activities

1. Participate in your community's Fourth of July celebration.
2. Test yourself. How many states can you name? Try to remember all fifty.
3. Plan a Fourth of July picnic for your family and friends.

July 5 *Ommegang*

The *Ommegang* Pageant in Brussels, Belgium, is a fascinating event dating back to medieval times. It is based on a festival held in 1549 for the royalty of Belgium: Charles V, his son Don Philip, and his sisters Queen Eleanor of France, and Queen Mary of Hungary. Today *Ommegang* expresses the pride of the people of Belgium in their royalty. It begins with a flag procession and a horse parade. Representatives of various professions or crafts carry banners. Games and other entertainment follows.

Ommegang is a two-day event held on the first Thursday in July and on the preceding Tuesday.

Celebrate *Ommegang* with stories of medieval princes and princesses. Select any of several versions of fairy tales or folktales featuring princes, princesses, kings, or queens.

Featured Books

The Blue Fairy Book, by Andrew Lang; illus. by Ben Kutcher. David McKay, 1948. (Also look for Lang's other collections—red, green, yellow, etc.)

The Random House Book of Fairy Tales, adapted by Amy Ehrlich; illus. by Diane Goode. Random House, 1985.

The Starlight Princess and Other Princess Stories, retold by Annie Dalton; embroideries by Belinda Downes. DK, 1999.

The Tasha Tudor Book of Fairy Tales, edited and illus. by Tasha Tudor. Platt & Munk, 1961.

Activities

1. Go to the library and choose a book of fairy tales to read and enjoy. Share your favorite story titles with friends.
2. Design a banner to carry in the *Ommegang* procession. It might represent your family or your interests or your dreams and wishes.

*July 6 Birthday of the Dalai Lama

The Dalai Lama is the spiritual and political leader of Tibetan Buddhists. Tibetans who live in exile in India observe the Dalai Lama's birthday on July 6. They burn incense in honor of the local spirits and hold family picnics which feature traditional singing and dancing. Each Dalai Lama is considered the re-incarnation of the preceding one. When a Dalai Lama dies, Tibetan monks search the country and the world for the child who will become the next Dalai Lama. The present Dalai Lama was enthroned at the age of five. He and his followers have lived in Dharmsala, India, since 1959 when they were driven out of Tibet by the Chinese. Other Tibetans live in Nepal and Bhutan.

Featured Book

The Little Lama of Tibet, by Lois Raimondo. Scholastic, 1994.

Text and pictures combine to reveal the day-to-day life of six-year-old Ling Rinpoche, a high lama in the Tibetan Buddhist religion and a respected teacher of the Buddhist faith.

Additional Books

Himalaya: Vanishing Cultures, by Jan Reynolds. Harcourt Brace Jovanovich, 1991.

Tibet Through the Red Box, by Peter Sis. Farrar, Straus & Giroux, 1998.

Activities

1. Locate Tibet on a map of the world. Use reference books to find out more about this area. Create a fact board about the country of Tibet and the Himalayan Mountains.

2. Invite someone who is a Buddhist or has studied in Tibet to visit your group and discuss the Buddhist faith or Tibetan life.

*July 7 *Saba Saba*—Peasants' Day

Saba Saba is a festival in Tanzania marked by traditional dances, sports, processions, rallies, and fairs. In some parts of the country, merchants from all over Africa gather to exhibit their wares in a huge market. *Saba Saba* is celebrated on July 7 to honor the day in 1954 on which the ruling party of Tanzania, TANU, was formed.

Featured Books

My Rows and Piles of Coins, by Tololwa M. Mollel; illus. by E. B. Lewis. Clarion, 1999.

This story, based on the author's childhood in Tanzania, fits well with the theme of Saba Saba. A young boy diligently saves the ten-cent coins that he earns on market day in order to buy his own bicycle. Lewis's evocative illustrations, Mollel's use of words spoken in Tanzania, and realistic daily events help readers to picture market life in Tanzania.

Elizabeti's Doll, by Stephanie Stuve-Bodeen; illus. by Christy Hale. Lee & Low, 1998.

Elizabeti, a small Tanzanian girl, enjoys her new baby brother, but wishes for a baby of her own. Elizabeti chooses a rock, which she names Eva, to be her own special baby. The rock doll, goes everywhere with Elizabeti. Elizabeti doesn't realize how much she cares for her rock doll until she loses Eva among the fire stones.

Activities

1. Compare this child of Tanzania to a child in America. How are these children alike? How are they different?
2. Find Tanzania on a world map. How would you get there from where you live? What kind of transportation would you use?

July 8 Festival of the Giants

For three days in July, beginning on the Sunday following July 5, giants visit the town of Douai, France. As many as one hundred giants are paraded through town and are treated like guests at celebrations throughout the area. The huge figures, some twenty-six feet tall, used to be made of wicker on a frame of light wood. Now they are made of plastic. Each giant is created by a group of at least six tradesmen. Music and dancing is also a vital part of the giant parades.

Today's stories are giant tales.

Featured Book

Jack and the Beanstalk, retold by John Howe. Little Brown, 1989.

In this familiar tale, beautifully illustrated, Jack must meet and conquer a giant.

Additional Books

Brave Margaret: An Irish Adventure, by Robert D. San Souci; illus. by Sally Wern Comport. Simon & Schuster, 1999.

Finn MacCoul and His Fearless Wife: A Giant of a Tale from Ireland, retold by Robert Byrd. Dutton, 1999.

Stolen Thunder: A Norse Myth, retold by Shirley Climo; illus. by Alexander Koshkin. Clarion, 1994.

Activities

1. Create your own giant out of paper and a wooden pole. Parade through the neighborhood.
2. Draw pictures of giants. Be sure to include a normal-sized person for comparison.
3. Write a giant tale. Imagine you have met a giant on your way to the park. What do you do?

July 9 Sandcastle Days

Nearly 250,000 spectators gather at Imperial Beach, California, for a parade, food, fireworks, and band concerts while they watch contestants build sandcastles. This event usually occurs on a weekend in July. As many as 400 contestants vie for prizes of nearly $20,000 for the best sandcastles. Teams of up to ten can enter the competition, but no one can use adhesives to hold the castles together. Past castles have been in the shape of a television set, a sofa, a dog, a giant beer can, and zoo animals.

Featured Book

Johnny Castleseed, by Edward Ormondroyd; illus. by Diana Thewlis. Houghton Mifflin, 1985.

Following Johnny Appleseed's example as a planter, Evan and his father, become planters of sandcastles on their trip to the beach.

Additional Book

Castle Builder, by Dennis Nolan. Macmillan, 1987.

Activities

1. Go to the beach and build a sandcastle or sand dragon or some other fabulous sand invention.
2. If you are unable to go to the beach, go to a sandbox and build a sandcastle.
3. If you are unable to go to either the beach or the sandbox, draw a picture of the sandcastle or some other fabulous sand invention that you would like to build at the beach.

*July 10 Wyoming Statehood Day

Wyoming became the forty-fourth state on July 10, 1890. With its wide-open high plains and its beautiful mountains, Wyoming is well-known for Yellowstone Park, much of which is located in Wyoming, and for its cattle ranching. Wyoming is one of the largest states, but it has the smallest population. In fact, Wyoming has ten times as many cattle as it has people! The original inhabitants of Wyoming were various American Indian tribes.

Featured Books

Fanny's Dream, by Caralyn Buehner; illus. by Mark Buchncr. Dial, 1996.

". . . in a wild Wyoming town there lived a sturdy girl named Fanny Agnes." Fanny Agnes dreams of marrying a prince and waits for the arrival of her fairy godmother, but life has its own surprises in store for Fanny Agnes.

Jack and the Whoopee Wind, by Mary Calhoun; illus. by Dick Gackenback. Morrow, 1987.

This tall tale is based on the power of the Wyoming winds. Jack and the residents of his Wyoming town try to tame the wind.

Activities

1. What do these stories tell you about Wyoming? Locate Wyoming on a map. Find out more about this interesting state.
2. Wyoming is home to a large portion of Yellowstone Park. View slides or a video of Yellowstone Park. What makes this park unique?

*July 11 World Population Day

Sponsored by the United Nations, July 11 is observed worldwide as World Population Day. The United Nations hopes to draw attention to the importance of population issues and to encourage the nations of the world to work toward finding solutions to the rapid growth of the world's population. This holiday developed from the Day of the Five Billion, which occurred on July 11, 1987, when a baby boy, Matej Gaspar, born in Zagreb, Yugoslavia, was declared the five-billionth inhabitant of Earth. According to the United Nations, in 1987 there were 150 babies born each minute of the day. Demographers predicted that the world population would reach 6.2 billion by the year 2000.

On World Population Day celebrate the great variety of people who inhabit the Earth.

Featured Book

People, by Peter Spier. Doubleday, 1980.

Additional Books

People, People, Everywhere! by Nancy Van Laan; illus. by Nadine Bernard Westcott. Alfred A. Knopf, 1992.

Whoever You Are, by Mem Fox; illus. by Leslie Staub. Harcourt Brace, 1997.

Activities

1. Use reference sources to determine if the world's population did indeed reach 6.2 billion by the year 2000. What is the population today?
2. Make a list of the way that all people are alike. In what ways are people different? Are we more alike or more different from one another?

3. Imagine that you could create a quiet park where people in crowded places could come to find space; draw a picture of what your park would be like.
4. Watch the video, *People: A Musical Celebration,* produced by Joshua M. Greene (Lightyear Entertainment, 1995).

July 12 Anti-Boredom Month

The Boring Institute sponsors Anti-Boredom Month every July. The institute's founder, Alan Caruba, urges people to take boredom seriously because it may be a sign of depression, especially in teenagers and senior citizens. Children may become bored during the long days of summer. The middle of summer is a good time to find creative ways to avoid boredom.

Featured Book

Grandaddy's Stars, by Helen V. Griffith; illus. by James Stevenson. Greenwillow, 1995.

Janetta worries that her grandaddy will find the city boring compared to his exciting life in the Georgia countryside.

Additional Books

Bored—Nothing to Do! by Peter Spier. Doubleday, 1978.

John Willy and Freddy McGee, by Holly Meade. Marshall Cavendish, 1998.

Activities

1. Make a list of twelve exciting things to do.
2. Visit the library and check out twelve exciting books.
3. Have a boring contest. Have each person write about the most boring day imaginable. Read the paragraphs aloud to see who imagined the most boring day. Do the same exercise, but this time write about the most exciting day imaginable.

July 13 Dog Days

Dog Days, also known as canicular days, are the hottest days of the summer. Although it is impossible to know precisely which days will be dog days, they generally fall in July or early August. The ancients believed that when the "Dog Star," Sirius, was brighter than the other fixed stars, it added its heat to that of the sun making the days extremely hot. Sixteenth-century people associated Dog Days with days so hot that dogs went mad.

Dog Days are good days to read stories about stars.

Featured Book

Follow the Drinking Gourd, by Jeanette Winter. Alfred P. Knopf, 1988.

The Big Dipper serves as a guide to a slave family journeying north to freedom.

Additional Books

Her Seven Brothers, retold by Paul Goble. Simon & Schuster, 1988.

How the Stars Fell into the Sky: A Navajo Legend, retold by Jerrie Oughton; illus. by Lisa Desimini. Houghton Mifflin, 1992.

Activities

1. Take a star walk. Try to find the Big Dipper, the Milky Way, and the North Star.
2. There are many American Indian legends about the stars. Find additional stories at your library.

*July 14 Bastille Day

On July 14, 1789, the French people overthrew King Louis XVI by storming the Bastille, Paris's famous prison. The day is celebrated with parades, fireworks, and torchlight processions. For French people, Bastille Day is a symbol of their freedom from rule by a monarch. A year later, on July 14, 1790, delegates from all over France met in Paris to pledge their allegiance to a single French nation. Other European nations, as well as the new American nation, watched as the French gained self-rule.

Bastille Day is the perfect day to honor the great French storyteller Charles Perrault who gave us so many well-loved tales. These stories have been translated and illustrated by various writers and artists and are available in many different versions. Perrault's tales include:

Beauty and the Beast *Puss in Boots*
Blue Beard *Sleeping Beauty*
Cinderella *Three Wasted Wishes*
King Carol of Capri *Tom Thumb*
Little Red Riding Hood

Activities

1. Charles Perrault was born in Paris on January 12, 1628. His stories live on and are enjoyed by children throughout the world. Why have his stories fascinated people for so many years? Do you think they will remain popular during the twenty-first century?
2. Listen to and learn the French national anthem, *La Marseillaise*.
3. Invite someone who speaks French to visit and teach the group some simple French words and phrases.
4. If someone you know has visited France, invite that person to share slides or photographs with your group.

July 15 National Hot Dog Month

July is National Hot Dog Month. According to the National Hot Dog and Sausage Council, Americans will eat more than seven billion hot dogs between Memorial Day and Labor Day. They estimate that on July 4 Americans will consume 155 million hot dogs!

Everybody knows that hot dogs are made of beef or pork or turkey—not dog. Nevertheless, National Hot Dog Month is a good day to read about *dachshunds*, real dogs who are often called *hot dogs* or *wiener dogs*.

Featured Book

Noodle, by Munro Leaf; illus. by Ludwig Bemelmans. Scholastic, 1972.

When Noodle, a dachshund, is granted a wish from the good dog fairy to be any size and shape he desires, he decides to remain Noodle.

Additional Books

Pretzel, by H. A. Rey. Harper, 1944.

The Hallo-Wiener, by Dav Pilkey. Scholastic, 1995.

Activities

1. Enjoy a cookout. July is not only National Hot Dog Month, it is also National Baked Bean Month. Celebrate by having hot dogs and beans.
2. See if you can draw a picture of a dachshund. Be creative. Consider incorporating noodles into the drawing.

July 16 Cobbler's Monday

Cobbler's Monday is any Monday taken as a holiday, especially after too much partying on Sunday. The phrase is British in origin and was originally called a "Shoemaker's Holiday." There are various explanations for the term, but according to the Oxford English Dictionary, a "shoemaker's holiday" was a general term for a day's outing in the country or a day off from normal work.

Featured Book

The Bootmaker and the Elves, by Susan Lowell; illus. by Tom Curry. Orchard, 1997.

In this updated version of the familiar story of the elves and the shoemaker, a cowboy bootmaker is in serious trouble because he makes terrible boots.

Additional Book

The Shoemaker and the Elves, by the Brothers Grimm; illus. by Adrienne Adams. Charles Scribner's Sons, 1960.

Activities

1. Make a list of all the different kinds of footwear. Were you surprised at how many kinds there are?
2. Plan a Cobbler's Monday. Where would you go and what would you do?

July 17 July Belongs to Blueberries Month

The North American Blueberry Council promotes July Belongs to Blueberries Month to remind us that blueberries are a healthy and delicious treat. Blueberries grow throughout the United States and Canada. In 1999, Michigan led the United States in blueberry production with a crop of 65 million pounds. British Columbia led Canada with 32.5 million pounds of blueberries. Blueberry harvest begins in Florida about April 1 and continues throughout the summer across the nation with Michigan, Indiana, and Canada beginning the harvest on July 1.

Featured Book

Blueberry Shoe, by Ann Dixon; illus. by Evon Zerbetz. Northwest, 1999.

The shoe Baby loses on a blueberry-picking trip becomes an object of curiosity for all the animals on Ptarmigan Mountain.

Additional Books

Blueberries for Sal, by Robert McClosky. Viking Press, 1948.

A Fair Bear Share, by Stuart J. Murphy; illus. by John Speirs. HarperCollins, 1998.

Activities

1. Go blueberry picking.
2. Enjoy blueberries for a snack.
3. Have a peanut butter and blueberry jam sandwich.

July 18 World Eskimo-Indian Olympics

In mid-July native peoples gather in Fairbanks, Alaska, to participate in games of strength and endurance. Events include the blanket toss (which involves tossing a hunter high enough—as high as twenty-eight feet—to see far-off whales), a sewing competition, a seal-skinning contest, dancing, and a knuckle-hop contest (contestants get on all fours and hop on their knuckles).

Featured Book

Eskimo Boy: Life in an Inupiaq Eskimo Village, by Russ Kendall. Scholastic, 1991.

Norman Kokeok is a seven-year-old Inupiaq Eskimo boy whose daily life is chronicled in this photo-rich nonfiction book. Lively pictures help readers understand the daily rhythms of life on the northwest coast of Alaska.

Arctic Hunter, by Diane Hoyt-Goldsmith. Photos by Lawrence Migdale. Holiday, 1992.

Reggie's life in Kotzebue, Alaska, is described in this nonfiction account. Photos of Reggie, his family, and his town supplement the accounts of Eskimo life.

Additional Book

Nessa's Fish, by Nancy Luenn; illus. by Neil Waldman. Atheneum, 1990.

Activity

Compare your life to the life of an Eskimo child. In what ways is your life similar? What differences do you notice?

*July 19 Women's Rights Convention

On July 19, 1848, Lucretia Mott and Elizabeth Cady Stanton held a convention promoting women's rights in Seneca Falls, New York. The three hundred people, including forty men, who attended were concerned about laws restricting women from voting, owning property, and divorcing their husbands. The convention signaled the beginning of an organized women's rights movement in the United States. Women did not gain the right to vote quickly. Although they gradually gained the right to vote in some states, it was 1920 before women were officially granted the vote by the Nineteenth Amendment.

Featured Book

Bloomers! by Rhoda Blumberg; illus. by Mary Morgan. Bradbury, 1993.

Bloomers played an interesting role in the fight for women's rights that was waged in the mid-1800s by Amelia Bloomer, Elizabeth Cady Stanton, and Susan B. Anthony.

Additional Book

You Forgot Your Skirt, Amelia Bloomer! by Shana Corey; illus. by Chesley McLaren. Scholastic, 2000.

Activities

1. Think of the ways that the United States would be different if women could not vote. Why is it important to vote? Do you think that voting rights are worth fighting for?
2. Hold an election in your class or group. Create posters, platforms, and decide how the voting will take place.
3. Learn more about the leaders of the women's movement by researching Lucretia Mott, Elizabeth Cady Stanton, and Susan B. Anthony. What other women were involved in this movement?

*July 20 Moon Day

 On July 20, 1969, Neil Alden Armstrong and Edwin Eugene Aldrin, Jr. landed on the moon. This was the first time anyone from Earth had set foot on the moon. Their lunar module the Eagle remained on the lunar surface for twenty-one hours, thirty-six minutes, and sixteen seconds. The two men explored the surface of the moon leaving their footprints and taking with them some moon rocks before they returned to Earth.

Nonfiction Books about the Moon

The Moon Book, by Gail Gibbons. Holiday, 1997.

Moon Landing: The Race for the Moon, by Carole Stott; illus. by Richard Bonson. DK, 1999.

Moonwalk: The First Trip to the Moon, by Judy Donnelly; illus. by Dennis Davidson. Random House, 1989.

Fiction Books

Grandfather Twilight, by Barbara Berger. Philomel, 1984.

I'll Catch the Moon, by Nina Crews. Greenwillow, 1996.

Moonkey, by Mike Thaler; illus. by Giulio Maestro. Harper & Row, 1981.

The Unicorn and the Moon, by Tomie dePaola. Silver Press, 1995.

Activities

1. Read parts of a nonfiction book about the moon. Then read a fiction book about the moon. Compare the two. What do you think is the difference between nonfiction and fiction? Which would most likely be written by a scientist? Which works best as an entertaining story? List the facts and fallacies of the books you read.
2. Imagine that NASA is looking for volunteers to go to the moon. Write a brief essay explaining why you would like to go to the moon. If you would not want to go, write an essay describing the kind of person who should be chosen.
3. Imagine that it is several years in the future. What would a moon settlement look like? Draw a picture of a moon community.

July 21　　　　　North Dakota State Fair Days

In late July, the North Dakota State Fair is held in Minot, North Dakota. The fair, which lasts for nine days, features rodeos, country music, 4-H contests, and various agricultural and crafts demonstrations. The North Dakota State Fair is held annually, and like state fairs throughout the United States, draws large crowds to celebrate the state's cultural and agricultural heritage. July 21 is a good time to read about country fairs.

Featured Books

Country Fair, by Gail Gibbons. Little Brown, 1994.

County Fair, by Raymond Bial. Houghton Mifflin, 1992.

A Week at the Fair: A Country Celebration, by Patricia Harrison Easton; photographs by Herb Ferguson. Millbrook, 1995.

Activities

1. Have you been to your state fair? Find out where it is held, when, and what happens.
2. What would you like to see at the fair? Draw a picture of the fair as you imagine it to be.

3. Hold your own fair. Consider the various activities which you could have. After you plan the event, invite your friends and family to come to the fair.

July 22 Lumberjack World Championships

Held in Hayward, Wisconsin, each July, the Lumberjack World Championships attract lumberjacks eager to prove their abilities in the logrolling contests. Log rollers spin the logs through the water by standing on the logs and making them turn rapidly. The winner is the one who stays dry the longest. Like Paul Bunyan, these lumberjacks wear flannel shirts, carry axes, and love to sit by the campfire and tell spirited stories of their days in the forests. Perhaps some of them tell stories of wolves; perhaps they even tell the story of a little girl and her grandmother who were tricked by an evil wolf and rescued by a woodcutter.

Featured Books

Little Red Cowboy Hat, by Susan Lowell; illus. by Randy Cecil. Henry Holt, 1997.

The Little Red Riding Hood, by Charles Perrault; illus. by William Stobbs. Henry Z. Walck, Inc., 1972.

Little Red Riding Hood, retold by Beni Montresor. Doubleday, 1991.

Little Red Riding Hood: A Newfangled Prairie Tale, by Lisa Campbell Ernst. Simon & Schuster, 1995.

Red Riding Hood, retold by James Marshall. Dial, 1987.

Red Riding Hood: Retold in Verse for Boys and Girls to Read Themselves, by Beatrice Schenk De Regniers; illus. by Edward Gorey. Atheneum, 1972.

Activities

1. Read two or more versions of the Red Riding Hood story. How are they different? What are the essential elements that each story shares?
2. Write your own version of Little Red Riding Hood. How would the story be different if it took place in your neighborhood?
3. Discuss the role of the woodsman or hunter in the story. Why do some stories have a woodsman help Little Red Riding Hood when others do not? Which version do you like best?

July 23 Buffalo Days Celebrations

In July and August various Canadian provinces hold Buffalo Days. Ridgetown, Ontario, holds its celebration in early July. Regina, Saskatchewan, holds Buffalo Days in early August. No matter what province, Buffalo Days are fun events. They often include music, parades, sidewalk sales, and antique shows. In Regina, cooking competitions, rodeo events, and races mark the one-hundred-year-old tradition. July 23 is a good day to celebrate Buffalo Days by remembering the mighty beasts for whom the celebration is named.

Featured Book

Buffalo Woman, by Paul Goble. Bradbury, 1984.

This legend from the Great Plains tells how the people and the buffalo were joined together so tightly that the buffalo willingly sacrifice themselves for the people.

Additional Books

Buffalo Dance: A Blackfoot Legend, retold by Nancy Van Laan; illus. by Beatriz Vidal. Little Brown, 1993.

Iktomi and the Buffalo Skull, by Paul Goble. Orchard, 1991.

Activities

1. The buffalo was extremely important to the survival of the Indians of North America. Why? List the many ways in which the Indians used buffalo in their daily lives. How does this compare with the way we live today?
2. There is something intriguing about large animals like the buffalo. List other big animals and the particular traits associated with each. Choose one and draw a picture that tells the viewer something interesting about the animal and its habits.

*July 24 Amelia Earhart's Birthday

Amelia Earhart, born on July 24, 1898, in Atchison, Kansas, was the first woman to fly an airplane across the Atlantic. She accomplished a number of aviation firsts and was the first woman to receive the Distinguished Flying Cross. Her life ended mysteriously in 1937 when her plane disappeared over the Pacific Ocean.

Featured Book

Amelia and Eleanor Go for a Ride, by Pam Munoz Ryan; illus. by Brian Selznick. Scholastic, 1999.

Ryan imagines what happened the night Amelia Earhart flew Eleanor Roosevelt over Washington, D.C., in an airplane.

Additional Books

Amelia Earhart: Aviation Pioneer, by Roxane Chadwick.. Lerner Publications, 1987.

Amelia Earhart: Courage in the Sky, by Mona Kerby; illus. by Eileen McKeating. Viking, 1990.

Amelia Earhart: A Photo-Illustrated Biography, by Marilyn Rosenthal and Daniel Freeman. Bridgestone Books, 1999.

Activities

1. What qualities made Amelia Earhart a hero? Think of others who have been the first to do something important.
2. Would you like to learn to fly an airplane? Why or why not?
3. Imagine that you have the opportunity to accomplish an important "first." What would you like to do? What would you need in order to reach this goal?

*July 25 Puerto Rico Constitution Day

On July 25, 1952, Puerto Rico changed from a territory to a commonwealth and adopted its constitution. This is a legal holiday in Puerto Rico that is celebrated with fireworks, parades, speedboat races, and parties. The commonwealth agreement between Puerto Rico and the United States is unique because it is voluntary on the part of both parties. Puerto Rico elects its own governor and has a representative to the United States Congress who may speak, but not vote.

Puerto Rico is a beautiful, but crowded, island located about 1,000 miles southeast of Florida. About two-thirds of the citizens of Puerto Rico live in major cities such as Arecibo, Mayagüez, Ponce, or San Juan. Manufacturing is the main industry of Puerto Rico, although tourism and fishing are also important to the economy. Because of its island location, hurricanes are a threat from June through November.

Featured Book

Juan Bobo and the Horse of Seven Colors: A Puerto Rican Legend, retold by Jan Mike; illus. by Charles Reasoner. Troll, 1995.

Juan Bobo, the folk hero of Puerto Rico, is featured in many Puerto Rican legends. These stories may have been told originally to make fun of the silly behavior of the wealthy Spanish rulers and the Puerto Ricans who supported them.

Additional Book

Hurricane! by Jonathan London; illus. by Henri Sorensen. Lothrop, Lee & Shepard, 1998.

Activities

1. Invite someone from Puerto Rico, or who has visited Puerto Rico, to speak with your group about this tropical island.
2. Locate Puerto Rico on a map. Use reference books to learn more about it.

*July 26 New York Statehood Day

New York became one of the original thirteen states on July 26, 1788. The Dutch settled in New York in 1621, and in 1625 purchased the island of Manhattan from the local Indians for twenty-four dollars. In 1664 the British took control and renamed the island New York City. New York expanded over the next several decades to include a vast and varied area of 49,108 square miles. New York has major cities, medium-sized towns, and rural areas. It has lakes, mountains, seashore, and an extensive river and canal system. New York attractions include the Statue of Liberty and the Empire State Building in New York City and Niagara Falls, the Finger Lakes Region, and the Catskills in the greater New York State area.

There are dozens of books about New York State and New York City. Today's featured and additional books take an historical look at New York State.

Featured Book

The Baker's Dozen: A Colonial American Tale, retold by Heather Forest; illus. by Susan Gaber. Harcourt Brace Jovanovich, 1988.

A greedy baker who offends a mysterious old woman suffers misfortune in his business, until he discovers what happens when generosity replaces greed.

Additional Books

The Ice Horse, by Candace Christiansen; illus. by Thomas Locker. Dial, 1993.

The Legend of Sleepy Hollow, by Washington Irving; retold by Robert D. San Souci; illus. by Daniel San Souci. Bantam, 1995.

Activities

1. Keep a record of the number of times New York State or New York City is mentioned on the radio or television news over the course of two or three days. Why is New York in the news?
2. Bring in a newspaper story about New York (city or state). Share these current events. Look for good news stories, as well as bad.
3. Listen to the audio version of *Rip Van Winkle*, by Washington Irving; adapted and illus. by Rick Meyerowitz (Rabbit Ears, 1995). Compare its style to *The Legend of Sleepy Hollow*. What does it tell you about New York State?
4. How much is the twenty-four dollars that the Dutch paid for Manhattan in 1625 worth today? What kind of money was used in 1625?

July 27 Fun Food Friday

Every Friday is Fun Food Friday at the Linden Manor Bed & Breakfast in Nashville, Tennessee. Owners Tom and Catherine Favreau conscientiously eat their fruits and vegetables, grains and dairy products at twenty of the twenty-one meals they eat each week, but supper on Fun Food Friday is a time to eat whatever they like. Some of their favorite foods include Japanese pizza and peanut butter hot fudge sundaes. The Favreaus, who sponsor this weekly celebration, encourage everyone to eat healthy, but not to forget that mealtimes should always be fun and creative events.

Featured Book

How Are You Peeling? Foods with Moods, by Saxton Freymann and Joost Elffers. Arthur A. Levine Books, 1999.

This unique picture book combines brief text and photographs of carvings made from vegetables to introduce a variety of emotions.

Additional Book

A Most Unusual Lunch, by Robert Bender. Dial, 1994.

Activities

1. Use a variety of fruits and vegetables to carve and create your own foods with feelings. Then eat them!
2. Make up recipes for really fun foods.
3. Make or bake your favorite recipes and share them with friends.

*July 28 Beatrix Potter's Birthday

Beatrix Potter was born on July 28, 1866, in Bolton Gardens, Kensington, England. Children throughout the years have enjoyed her fanciful books about animals, but perhaps the best known of all is *The Tale of Peter Rabbit*. Even as a young child, she observed the small pets, including rabbits, mice, and snails, that her parents allowed her to keep in her rooms. She always loved to draw, and by the time she was twelve, she took private art lessons. As she grew older, she continued her interest in art and practiced by drawing detailed sketches of fungi. In 1893, when her former governess's son, Noel Moore, was ill with scarlet fever, she wrote down the story of Peter Rabbit and his sisters, Flopsy, Mopsy, and Cottontail. A few years later, she decided to enlarge it and submit it to a publisher. It was published in 1902 by Frederick Warne & Company. Potter wrote many other stories for children. The tiny size of her books and the marvelous drawings have appealed to small children for a century.

Featured Book

The Tale of Peter Rabbit, by Beatrix Potter. Frederick Warne & Co., 1928 ed.

Other Books by Beatrix Potter include:

The Tale of Jemima Puddle-Duck.
The Tale of Mrs. Tittle-Mouse.
The Tale of Squirrel Nutkin.
The Tale of Tom Kitten.

Activity

Select another book by Beatrix Potter and share it with friends and family.

July 29 UFO Days

Elmwood, Wisconsin, which bills itself as the *UFO Capital of Wisconsin* holds its annual UFO Days on the last full weekend in July. The town of 800 people gained notoriety in 1975 when a local woman and her three children noticed a particularly bright star while driving home. The object seemed to hover over their car as they drove. The woman stopped at a neighbor's house so that he, too, could see the object. A local police officer also saw what he described as a "flaming ball the size of a football field." Several other residents confirmed the citing.

The people of Elmwood continue to celebrate the UFO citing at their July festivities. A parade, food stands (featuring "UFO burgers"), a street dance, and the crowning of Miss Elmwood are all part of the

celebration. Join with the citizens of Elmwood by reading silly stories about flying saucers and space aliens.

Featured Book

Company's Coming, by Arthur Yorinks; illus. by David Small. Crown, 1988.

When a UFO lands in their backyard, Moe and Shirley invite the space aliens to stay for dinner with disastrous results.

Additional Books

Earthlets as Explained by Professor Xargle, by Jeanne Willis; illus. by Tony Ross. Dutton, 1988.

Space Case, by Edward Marshall; illus. by James Marshall. Dial, 1980.

Activities

1. Draw a picture of a vehicle or creature from outer space.
2. Imagine that you are creating foods to serve at the UFO festival. What delicious and weird space foods would you suggest? Provide recipes.

July 30 — Chincoteague Pony Roundup and Penning

On the Wednesday before the last Thursday in July, the volunteer firemen of Chincoteague Island, off Virginia's Eastern Shore, roundup the wild ponies of Assateague Island. As many as 250 or 300 foals, mares, and sires are rounded up and penned in corrals. Some of the foals are sold at auction and the other ponies are then released to return to Assateague. Legends claim that the ponies are the descendants of mustangs who survived the shipwreck of a sixteenth-century Spanish ship. Others say that they were left behind by pirates who used the island for a hideout. The annual penning draws crowds to a week of festivities including country music, oyster and clam feeds, and carnival rides.

Featured Book

Misty of Chincoteague, by Marguerite Henry; illus. by Wesley Dennis. New York: Rand McNally, 1947.

This classic story of Misty has brought the excitement of the wild ponies to children through the years. Read aloud part 1 to hook children on this series of books. (*Stormy, Misty's Foal* and *Sea Star: Orphan of Chincoteague* continue the series.)

Additional Book

Wild Ponies of Assateague Island, by Donna K. Grosvenor; photos by James L. Stanfield. National Geographic Society, 1975.

This book contains beautiful photographs of the wild ponies on Assateague and commentary about their daily lives and the once-a-year roundup.

Activity

Learn more about horses. How many kinds of horses are there? Where did horses originate? What do they eat? Do they have enemies in the wild? List various ways that horses serve people?

July 31 **The Great Serengeti Wildlife Migration**

Between June and October each year an amazing gathering of wildlife occurs in the Serengeti National Park in Tanzania, near the Kenyan border, as the rainy season comes to an end. Over three million animals migrate each year from the Serengeti National Park to Masai Mara in Kenya. The park contains plains, savannas, woodlands, and wooded grasslands which attract a variety of large mammals. Five-hundred-thousand zebra lead the migration of 1.8 million wildebeests. Other animals that migrate across the Serengeti include antelope, gazelles, lions, buffalo, and hundreds of species of birds. Elephants, giraffes, and impalas linger in the woodland areas. Celebrate the wildlife migration by reading playful stories about African animals.

Featured Books

Ndito Runs, by Laurie Halse Anderson; illus. by Anita van der Merwe. Henry Holt, 1996.

A Kenyan girl runs past the thatch-covered homes in her village, up the hillside, through the grassland, by the water hole, on her way to school.

Where Are You Going Manyoni? by Catherine Stock. Morrow, 1993.

A child living near the Limpopo River in Zimbabwe encounters several wild animals on her way to school.

Additional Books

Bringing the Rain to Kapiti Plain, by Verna Aardema; illus. by Beatriz Vidal. Dial, 1981.

Two Ways to Count to Ten: A Liberian Folktale; retold by Ruby Dee; illus. by Susan Meddagh. Henry Holt, 1988.

Activities

1. On a map of Africa, locate the Serengeti. Working in groups, select one of the animals that migrates to the Serengeti and gather some interesting facts about it.
2. Both Ndito and Manyoni encounter a variety of animals on their way to school. What animals would you find if you walked to school? What other sights would you see?

*August 1 Colorado Statehood Day

Because Colorado became a state on August 1, 1876, one hundred years after the signing of the Declaration of Independence, it is called the Centennial State. Colorado is known for its beauty. Tourists flock to Colorado to go mountain climbing, skiing, and to enjoy the spectacular views. Colorado has over 1,000 peaks above 10,000 feet high in its western area. Eastern Colorado is flatter, serving as grazing land for cattle and sheep. Colorado is cowboy and Indian country with a colorful history of long cattle drives and ancient Indian cliff dwellings and buffalo hunts. Celebrate Colorado's Statehood Day with stories from the Pueblo, Ute, Arapaho, Cheyenne or Anasazi traditions.

Featured Book

Dreamplace, by George Ella Lyon; illus. by Peter Catalanotto. Orchard, 1993.

A young girl's visit to Mesa Verde evokes images of the past when the Anasazi lived in their dwellings carved into the cliffs. Combine this book with an Indian folktale to capture the spirit of the past.

Folktales

Arrow to the Sun, by Gerald McDermott. Viking, 1974.

The Ghost and the Long Warrior: An Arapaho Legend, by C. J. Taylor. Tundra, 1991.

Quail Song: A Pueblo Indian Tale, retold by Valerie Scho Carey; illus. by Ivan Barnett. G. P. Putnam's Sons, 1990.

Activity

Talk about the folktales. What do they reveal about the people who told these stories? What do you think was important in their lives? Why do you think that these stories have survived through the years?

August 2 Admit You're Happy Month

The Secret Society of Happy People, located in Texas, has declared the entire month of August "Admit You're Happy Month." The founder of the sponsoring organization advises, "If you aren't so happy during the month, then just make note not to rain on other people's parades." Texas Governor George W. Bush signed a proclamation in 1999 urging Texans to talk about the happy events and moments in their lives. The Secret Society of Happy People encourages people to openly express their happiness.

Featured Book

Across the Blue Mountains, by Emma Chichester Clark. Gulliver, 1993.

Miss Bilberry led a lovely, quiet life and was happy except for the thought that she might be even happier if she lived on the other side of the mountains.

Additional Books

Louis the Fish, by Arthur Yorinks; illus. by Richard Egielski. Farrar, Straus & Giroux, 1980.

Owen, by Kevin Henkes. Greenwillow, 1993.

Activities

1. Begin a happiness journal and write about happy moments each day.
2. Draw a happy picture and share your pictures at a happy art show.
3. Share a happy moment with others by talking or writing about your happiest moment.

August 3 International Clown Week

The first week in August is International Clown Week. This is a time to celebrate the clowns who have made people laugh for thousands of years. Early records indicate that a clown performed in the court of Egyptian pharaoh Dadkeri-Assi in about 2500 B.C. Records in China provide evidence of clowns since 1818 B.C. Clowns come in every size, shape, color, and nationality. There are male and female clowns, child clowns, and animal clowns. Many volunteers serve as clowns in nursing homes, churches, and hospitals bringing joy and entertainment to those who cannot go to the circus. The Clowns of America International awards a special award, a Charlie, to a local chapter, called a Clown Alley, which best documents and celebrates International Clown Week.

International Clown Week is a great time to read books about the circus.

Featured Book

Emeline at the Circus, by Marjorie Priceman. Alfred A. Knopf, 1999.

When Emeline's class goes to see the circus, Emeline accidentally becomes part of the show.

Additional Books

Engelbert Joins the Circus, by Tom Paxton; illus. by Roberta Wilson. Morrow Junior Books, 1997.

Morgan the Magnificent, by Ian Wallace. Margaret K. McElderry, 1987.

Activities

1. If you could be a circus performer, which would you be? Write a brief paragraph explaining your choice.
2. Using face cutouts, decorate your very own clown face. Will your clown be happy or sad? What colors and designs will you choose to make people laugh?

August 4 Maine Lobster Festival

The first weekend in August the Annual Maine Lobster Festival is held in Rockland, Maine. Beginning in 1948, this festival focuses on lobster trapping, cooking, and eating competitions. Approximately 70,000 people attended the 1998 festival. The weekend ends with the crowning of the Maine Sea Goddess.

Featured Book

Lobster Boat, by Brenda Z. Guiberson; illus. by Megan Lloyd. Henry Holt, 1993.

Tommy spends the day on a lobster boat helping Uncle Russ tend the traps, set bait, pull up the traps, and sell their catch.

Additional Book

Sam Saves the Day, by Charles E. Martin. Greenwillow, 1987.

Activities

1. Do you think lobster fishing is easy or difficult? How does today's book help you to decide?
2. Learn more about lobsters through the use of reference and nonfiction books. Are the details in to-day's stories accurate?

*August 5 Clipping the Church Day

In St. Oswald's, Guiseley, and West Yorkshire, England, August 5 is Clipping the Church Day. Officially this is the day that the yew bushes surrounding the churches are clipped or trimmed. On the following Sunday, the church is "clipped" when the church choir and clergy, followed by children wearing flowers, parade around the church singing hymns. They join hands to make a big chain around the church and then rush forward to kick it three times. They then go to church for a "clipping sermon." The kicking is a recent addition. The "clipping" ceremony is intended to show the people's love for their local church and "clipping" actually means "hugging" or "embracing."

Featured Book

The Church Mouse, by Graham Oakley. Atheneum, 1972.

 A lonely mouse living in a church with only a friendly, sleepy cat for company devises a plan to get all the mice in town to move in with him.

Note: This is one of a series of stories by Graham Oakley about the mice living in an English church.

Additional Books

Fox Trot, by Corinne and Jozef Czarnecki. Grosset & Dunlap, 1987.

Miss Fannie's Hat, by Jan Karon. Augsburg, 1998.

Activity

Hold your own clipping-the-church ceremony. Do something special for the church by planting flowers, weeding the garden, picking up litter, or dusting the pews.

*August 6 Hiroshima Peace Ceremony

Every August 6 a ceremony is held at the Peace Memorial Park in Hiroshima, Japan, in memory of the 60,000 Japanese who died in the atomic bomb attack on Japan in 1945. The peace ceremony, held in the evening, includes prayers for peace as people set thousands of lighted lanterns adrift on the Ota River.

While peace is an extremely important subject, this topic and the featured books are most appropriate for older children who are able to discuss their concerns, as well as the issues involved.

Featured Books

Faithful Elephants: A True Story of Animals, People, and War, by Yukio Tsuchiya; trans. by Tomoko Tsuchiya Dykes; illus. by Ted Lewin. Houghton Mifflin, 1988.

This Japanese book presents a far-reaching and devastating tale of the ramifications of the war. The animals in the Ueno Zoo had to be killed, for fear that a bomb landing in the area would release the dangerous animals.

In the Wings of Peace: Writers and Illustrators Speak Out for Peace, in Memory of Hiroshima and Nagasaki; compiled by Sheila Hamanaka. Clarion, 1995.

This collection of stories, poems, letters, and illustrations by gifted artists all speak to the need for peace in the world.

Sadako, by Eleanor Coerr; illus. by Ed Young. Putnam, 1993.

The story of Sadako, who suffered from leukemia as a result of the atom bomb attack, is familiar to Japanese children. This rendition is beautifully illustrated and conveys a mood appropriate to Hiroshima Peace Day.

Activity

Make a list of the ways in which everyone can make the world a more peaceful place. Be sure to include things you can do within your own classroom, family, and neighborhood.

August 7 National Napping Month

August is National Napping Month. Relaxing and taking it easy seem to go naturally with warm summer days.

Featured Books

Hush Up! by Jim Aylesworth; illus. by Glen Rounds. Holt, Rinehart, and Winston, 1980.

When lazy Jasper Walker tips back to take a nap, the animals follow suit. But when a horsefly bites the mule on the nose, pandemonium breaks loose.

The Napping House, by Audrey Wood; illus. by Don Wood. Harcourt Brace Jovanovich, 1984.

In this cumulative tale, a wakeful flea atop a number of sleeping creatures causes a commotion with just one bite.

Activities

1. Act out either of the stories, being as dramatic as possible when the horsefly or the flea wakes you up.
2. Lay back with a good book and read until you fall asleep.

August 8 Omak Stampede and Indian Encampment

The Omak Stampede and Indian Encampment and the World Famous Suicide Race is held on the second weekend in August in Omak, Washington. Over the years the Omak Stampede, which began in 1933 as a home-town rodeo, has grown into one of the most popular events in the Pacific Northwest. For four days rodeo events, a Western and Native Art show, and an Indian pow wow attract visitors from around the country. Events include clowns, dances, steer wrestling, bull riding, saddle-bronc riding, barrel racing, calf roping, a kid's parade, and horse races. The World Famous Suicide Race is an endurance race for horse and rider, described as a "no-holds-barred wild and western event." The horses are highly conditioned by their predominantly Native American riders and must meet rigorous criteria before being allowed to race. The Omak Stampede is one of many fascinating events which takes place in Washington State. Other August events include air shows, car races, a lentil festival, the arrival of the naval fleet, tractor shows, art shows, music festivals, and local fairs. Washington festivals and events reveal the diversity of this fascinating state.

Celebrate the Omak Stampede by reading stories about horses.

Featured Book

Knots on a Counting Rope, by Bill Martin, Jr. and John Archambault; illus. by Ted Rand. Henry Holt, 1987.

A grandfather and his blind grandson, Boy-Strength-of-Blue-Horses, reminisce about the young boy's birth, his first horse, and an exciting horse race.

Additional Books

Barn Dance! by Bill Martin, Jr. and John Archambault; illus. by Ted Rand. Henry Holt, 1986.

Salute, by C.W. Anderson. Macmillan, 1940.

Activity

Imagine that you have been given the gift of a horse. What would you name it? Create a list of adjectives that describe your horse. Using the list, write a brief description of the horse or draw a picture of the horse or a horse race.

August 9 Baby Parade

On the second Thursday in August, Ocean City, New Jersey, holds a competition for children up to age ten called the Baby Parade. There are four divisions: 1) children in decorated strollers, go-carts, wagons; 2) children in vehicles and walkers with silly decorations; 3) floats; 4) large, commercial floats. Judges award prizes to the best entries in each division. Over 50,000 spectators come to watch the Baby Parade each year.

Featured Book

Julius: The Baby of the World, by Kevin Henkes. Greenwillow, 1990.

Lily is convinced that baby Julius is her worst nightmare until Cousin Garland comes to visit.

Additional Book

Darcy and Gran Don't Like Babies, by Jane Cutler; illus. by Susannah Ryan. Scholastic, 1991.

Activities

1. Hold your own baby parade. While you might not choose to use real babies, your parade could feature dolls and stuffed animals riding in decorated wagons or buggies. Decorated bikes could be in a separate category.
2. Older children could spend some time taking children from a nearby day care center for a walk. Parading along the sidewalk is fun and needn't involve any kind of competition.

*August 10 Missouri Statehood Day

On August 10, 1821, Missouri became the twenty-fourth state to join the Union. It is near the geographical center of the United States, and for much of its history, it was the point from which settlers headed westward. The city of St. Louis features a huge arch, called the Gateway Arch, which commemorates the thousands of pioneers who passed through St. Louis on their way west. The cities of Kansas City and Independence, which was nicknamed the "Gateway to the West," were starting points for the Oregon and Santa Fe Trails in the 1800s.

Missouri today is a leading agricultural state. Livestock and dairy products are important to Missouri's economy. So are its chief crops of corn, wheat, soybeans, and cotton. Mining and lumbering are also important industries. Other products made in Missouri include aircraft, automobiles, leather goods, chemicals, and beer. Missouri's rivers, the Mississippi and the Missouri, helped the state to become an important part of the country's transportation system.

Today's books feature stories of pioneers who began their journeys in Missouri.

Featured Book

Lewis & Papa: Adventures on the Santa Fe Trail, by Barbara Joosse; illus. by Jon Van Zyle. Chronicle, 1998.

Lewis and his papa leave Independence, Missouri, to travel the Santa Fe Trail all the way to New Mexico.

Additional Books

A Right Fine Life: Kit Carson on the Sante Fe Trail, by Andrew Glass. Holiday House, 1997.

Roughing It On the Oregon Trail, by Diane Stanley; illus. by Holly Berry. Joanna Cotler Books, 2000.

Activity

Using a map of the United States, trace the Santa Fe and the Oregon Trails west. How long were these trails? Through which of today's states did the pioneers travel on their way to trail's end? Think about the dangers of traveling west by covered wagon or on horseback.

August 11 Night of the Shooting Stars

An annual meteor shower called the Perseids is observable during the nights of August 10-12. As many as sixty meteors an hour cross the sky during these nights which are often referred to as the "Night of the Shooting Stars." Observers throughout the Northern Hemisphere should be able to see shooting stars on clear nights. NASA scientists recommend viewing the meteor shower with the naked eye to enable you to see the entire sky. Shooting stars may appear anywhere in the sky during this time.

Featured Book

The Lost Children: The Boys Who Were Neglected, by Paul Goble. Bradbury, 1993.

In this Blackfoot Indian legend, six neglected orphaned brothers decide to go to the Above World where they become the constellation of the "Lost Children," or Pleiades.

Additional Books

The Dancing Stars: An Iroquois Legend, retold by Anne Rockwell. Thomas Y. Crowell 1972.

Star Boy, retold by Paul Goble. Bradbury, 1983.

Activity

Watch the newspaper or television reports for word about the "Night of the Falling Stars." Go outside and try to see the shooting stars.

*August 12 Queen's Birthday in Thailand

This nationwide celebration in the Asian country of Thailand honors the birthday of Queen Sirikit who was born in 1932. Throughout Thailand buildings are decorated to honor the queen. In Bangkok the buildings and streets shimmer with colored lights.

Featured Book

The Girl Who Wore Too Much: A Folktale from Thailand, retold by Margaret Read MacDonald; Thai text by Supaporn Vathanaprida; illus. by Yvonne Lebrun Davis. August House Little Folk, 1998.

In an effort to be the most beautiful, a vain young girl puts on so many silk dresses and wears so much heavy jewelry that she is unable to make it to the dance. This story originates in northeastern Thailand.

Additional Books

Hush! by Minfong Ho; illus. by Holly Meade. Orchard, 1996.

The Whispering Cloth: A Refugee's Story, by Pegi Deitz Shea; illus. by Anita Riggio. Boyds Mills, 1995.

Activities

1. Many people from Thailand have immigrated to the United States. Many people from the United States have traveled to Thailand. Invite someone from Thailand or someone who has traveled there to visit your class and to share stories and pictures of this beautiful country.
2. Locate Thailand on a map. Draw your own map of Southeast Asia marking the various countries of that region, their capital cities, and major waterways.

*August 13 International Lefthanders Day

International Lefthanders Day was started on Friday, August 13, 1976, by Lefthanders International which published a magazine and sold products designed especially for left-handed people. When the organization folded, other businesses that sold products for left-handed people took up the cause. Today, Lefthanders Day is sponsored by Left Hand Publishing whose goal is to alert people to International Lefthanders Day and to make the world a kinder place for left-handed people. Some left-handed people celebrate the day by paying tribute to all the famous artists, athletes, entertainers, and everyday great people who are left-handed.

Among the famous artists who were left-handed or ambidextrous are Raphael, Michelangelo, Leonardo da Vinci, Hans Holbein, Dürer, Picasso, and M. C. Escher. Celebrate International Lefthanders Day by reading stories about children who struggle to become artists.

Featured Book

Drawing Lessons from a Bear, by David McPhail. Little Brown, 2000.

A bear explains how he became an artist and helps children understand how they, too, can be artists.

Additional Books

The Art Lesson, by Tomie De Paola. Putnam, 1989.

Emma's Rug, by Allen Say. Houghton Mifflin, 1996.

Activities

1. Look at reproductions of the art created by the left-handed artists listed above.
2. Try drawing using your left hand and using your right hand. Do you think you would get better with both hands if you practiced?
3. Play a ball game left-handed. Bat left-handed and run the bases backwards.
4. Set the table with the fork on the left and the knife and spoon on the right. Try eating left-handed.
5. List the ways that people are different. Then list the ways that we are all alike. Discuss whether the differences are important.

*August 14 National Hobo Day

Twenty-thousand people join to celebrate and remember the life of America's hobos on National Hobo Day in Britt, Iowa. This event, usually held in mid-August, features a hobo parade, a flea market, an-

tique car shows, hobo contests, and bicycle stunts. There is also a memorial service at the Hobo Cemetery to honor the men and women who "rode the rails" in order to find work and the means to survive during the depression. There is a coronation of a hobo king and queen and a free meal of mulligan stew, the traditional hobo meal of a soup made of whatever food is available.

The people of Britt, Iowa, who celebrate the hobo life during National Hobo Day, understand that most people became hobos because of economic hardships created by the Depression. Today's featured books are set in very different places, but both celebrate the hope and love that triumphed over the hard times, rural and urban, of the 1930s.

Featured Books

Leah's Pony, by Elizabeth Friedrich; illus. by Michael Garland. Boyds Mill, 1996.

During the hard times of the Depression, Leah sells her horse and raises enough money to buy back her father's tractor, which is up for auction.

Tree of Hope, Amy Littlesugar; illus. by Floyd Cooper. Philomel, 1999.

Florrie's father used to be a stage actor in Harlem before the Depression forced Lafayette Theater to close, but he gets a chance to act again when Orson Welles reopens the theater to stage an all black version of Macbeth.

Activities

1. Both books show ways in which children are able to help their families during hard times. Think of other ways that children are able to contribute to the welfare of their families and neighborhoods.
2. Do some research to find out how mulligan stew was made. Make and eat mulligan stew.
3. Find pictures of hobos. Using the pictures as models, hold your own hobo parade.

August 15 Hunger Hooting Festival

Homowo, the Hunger Hooting Festival, is celebrated by the Ga people of Greater Accra, Ghana. It is a celebration of a good harvest. *Homowo* begins in August, when an abundant harvest is complete, with daily drumming to remind the Ga ancestors to join the people in celebrating. Gunfire scares away any evil that lurks in the area. When people begin arriving from outlying areas, they carry baskets on their heads filled with okra, corn, tomatoes, onions, and peppers.

There are dances, and special attention is given to twins who, the Ga believe, are a blessing from the ancestors. The mothers of twins put whitish clay on their twins' faces as a way of thanking the ancestors and asking for special blessings on their twins.

Food is everywhere. Visiting and hospitality rule the day, and doors are kept open so that anyone may wander in to join the feast or *kpokpei*. *Homowo* began when the Ga people first migrated to present day Accra. A severe famine broke out, and the people embarked on a massive food production plan so that they would never be hungry again. The word *homowo* means they "hooted at hunger."

The Ga people who celebrate *Homowo* are one of about one hundred different ethnic groups in Ghana. The Ashanti and the Fante make up the majority of Ghana's population.

Featured Book

Too Much Talk, by Angela Shelf Medearis; illus. by Stefano Vitale. Candlewick, 1995.

A local chief is surprised when the yams, the fish, and the chairs begin to talk.

Additional Books

Anansi Goes Fishing, retold by Eric A. Kimmel; illus. by Janet Stevens. Holiday House, 1991.

Anansi the Spider: A Tale from the Ashanti, by Gerald McDermott. Holt, 1972.

Activities

1. Use the book, *A Good Soup Attracts Chairs: A First African Cookbook for American Kids* (Pelican, 1993) to cook up some recipes from Ghana.

2. Learn more about kente cloth, the colorful fabrics woven by the Ashanti people of Ghana. Debbi Chocolate's book, *Kente Colors* (Walker, 1996), gives some background. Use crayons to create a colorful kente design.

August 16 Summer Birthday

August 16 is a good day to celebrate summer birthdays. Children born in the summer often miss out on the excitement of a school celebration, so dedicate today to celebrating those who were born in May, June, July, or August.

Featured Book

The Birthday Swap, by Loretta Lopez. Lee & Low, 1997.

Lori is delighted and amazed when her big sister swaps her summer birthday for Lori's December one.

Additional Books

Edward in Deep Water, by Rosemary Wells. Dial, 1995.

The Summer of Stanley, by Natalie Kinsey-Warnock; illus. by Donald Gates. Cobblehill, 1997.

Activity

Have a summer birthday party with cake and party games in honor of all those whose birthdays fall between May and September.

*August 17 Indonesian Independence Day

On August 17, 1945, Indonesia declared its independence after 300 years of Dutch rule. After four more years of struggle, the Netherlands granted the Indonesians independence. Parades, athletic events, and cultural events mark the occasion. One of the special events of the day is the Caci whip duels. Caci warriors, dressed in elaborate costumes and horned helmets, circle one another. One has a whip, the other a shield. Gongs and wooden drums accompany their duel as the warrior with the whip strikes out at the other who uses his shield to protect himself. The round continues until the whip draws blood from the warrior. The scars are much admired by the women of this Indonesian tribal group.

Featured Book

Komodo! by Peter Sis. Greenwillow, 1993.

A young boy who loves dragons goes with his parents to the Indonesian island of Komodo in hopes of seeing a real dragon. Includes factual information about the Komodo dragon.

Additional Book

The Dancing Pig, by Judy Sierra; illus. by Jesse Sweetwater. Harcourt Brace, 1999.

Activities

1. Find out more about komodo dragons. Several nonfiction books exist on the topic in addition to information available in reference books.
2. Learn more about Indonesia. Locate Indonesia on a map of the world and look up additional facts about this island nation.

August 18 Return of the Leatherback Turtles

From June through September, the giant leatherback turtles swim to the Rantau Abang shores in Malaysia and begin to dig holes for their eggs. The turtles migrate through the Pacific Ocean from the western coast of Central and South America to Malaysia. The huge females weigh as much as 1300 pounds each and lay eggs in clutches of about 120. It takes a great effort for each female to dig a hole for her eggs, and she often digs a decoy hole as well, before laying the eggs, filling the hole, smoothing it over, and returning to the sea. The turtles move with grace and speed in the water, but the time ashore is awkward and difficult for them. The eggs require a fifth-five-day incubation period. Several are lost to crabs, birds, fish, or humans, but the Malaysian government protects them by transferring the turtle eggs to special hatcheries. Several thousand newborn turtles return to the sea each year. Nevertheless, leatherback turtles are an endangered species.

Featured Book

Turtle Bay, by Saviour Priotta; illus. by Milesh Mistry. Farrar, Straus & Giroux, 1997.

Jiro-San sweeps the sand on the beach while waiting for the arrival of Japanese sea turtles.

Additional Book

Tracks in the Sand, by Loreen Leedy. Doubleday, 1993.

Activity

Learn more about leatherback turtles and other endangered species by consulting reference books and nonfiction books. Share what you learn.

August 19 Pickle Festival

 On the third weekend in August, the people of Linwood, Michigan, host a three-day pickle festival in honor of its chief industry, pickle growing and processing. There is a pickle-canning contest and a pickle-eating contest. In the pickle-eating contest, the contestants must unwrap a pickle, eat it, and whistle afterward. The first one done is the winner.

Featured Book

Pickle Creature, by Daniel M. Pinkwater. Four Winds, 1979.

When grandmother sends Conrad to the supermarket for a pickle, he brings home a pickle creature instead.

Additional Book

Pickles to Pittsburgh: The Sequel to Cloudy with a Chance of Meatballs, by Judi Barrett; illus. by Ron Barrett. Athenuem, 1997.

Pickles in My Soup, by Mary Pearson; illus. by Tom Payne. Children's Press, 1999.

Activities

1. Have your own pickle-eating contest.
2. Sample a variety of pickles. Conduct a survey to see which kinds are most popular in your group or family.
3. Invite someone who makes pickles to speak to your group about the process. Perhaps your group can even help make pickles.
4. Using a large dill pickle as a base, create your own pickle creature using raisins, olives, and bits and pieces of other edible decorations. Use toothpicks to hold the decorations in place.

August 20 National Tractor Pulling Championships

Bowling Green, Ohio, is home to the National Tractor Pulling Championships held in mid-August each summer. The National Tractor Pulling Championship, which began in Ohio in 1967, is the largest outdoor truck and tractor pull in the nation. Sponsored by the Northwestern Ohio Tractor Pullers Association, this festival consists of contests to test the ability of tractors and trucks to pull a large sled designed to carry weights of up to 12,000 pounds. Huge tractors and modified trucks compete to see which can

pull the heavy sled the longest distance. Over 60,000 fans come to watch and cheer the noisy and smoky tractors as they try to win the national championship.

In Park Rapids, Minnesota, farm tractors are used in yet another entertaining way: as square dancers. Four retired couples, members of the Park Rapids' Antique Tractor and Engine Club, use their 1940 and 1950 vintage farm machines to square dance within a seventy-five foot dirt circle. The drivers steer frantically so that the tractors will do-si-do gracefully. When the tractors bump into one another, a member says, "We don't call them crashes. They're more love pats, and we call them axle bumps."

Celebrate Ohio's National Tractor Pulling Championships and Minnesota's dancing tractors by reading stories about farm tractors.

Featured Book

The Rusty, Trusty Tractor, by Joy Cowley; illus. by Olivier Dunrea. Boyds Mills, 1999.

Granpappy's old tractor makes Mr. Hill, the tractor salesman, laugh until he gets stuck and needs a tractor to pull him out of the mud.

Additional Books

One Summer Day, by Kim Lewis. Candlewick, 1996.

Tractor, by Craig Brown. Greenwillow, 1995.

Activities

1. What makes a tractor special? Why do you think farmers develop strong feelings about their farm tractors?
2. Invite group members to bring model tractors, trucks, and cars to class and to tell what is special or unique about their models.

*August 21 Hawaii Statehood Day

Hawaii, which gained statehood on August 21, 1959, is the newest state in the United States. It is the only tropical state, the only state which lies outside of the North American mainland, and the only state composed of islands. Hawaii consists of 132 volcanic islands located in the Pacific Ocean about 2,400 miles southwest of San Francisco. The island of Hawaii is the largest island. Most Hawaiians, however, live on Oahu in or near the capital city of Honolulu.

Hawaii's main industry is tourism. Millions of people travel to Hawaii every year to enjoy the warm, sandy beaches, the tropical plants and animals, and the friendly lifestyle. Hawaii's original people were Polynesians. Today, however, the people of Hawaii trace their ancestry back to Japan, China, the Philippines, and many other places throughout the world.

August 21 is a good day to read tales from Hawaii.

Featured Books

In the Night, Still Dark, by Richard Lewis; illus. by Ed Young. Atheneum, 1988.

Maui and the Secret of Fire, by Suelyn Ching Tune; illus. by Robin Yoko Burningham. University of Hawaii Press, 1991.

The Surprising Things Maui Did, by Jay Williams; illus. by Charles Mikolaycak. Four Winds, 1979.

Activities

1. Locate Hawaii on a map? What forms of transportation could you use to get from your home to Honolulu?
2. After you read today's story, list the native plants and animals of Hawaii. Do any of them live in your neighborhood? Use a reference book to identify each plant and animal and to find out its exact habitat.

*August 22 Be An Angel Day

Be An Angel Day began in 1992 as a way to encourage people around the world to be like angels and to "do one small act of service for someone; be a blessing in someone's life." Individuals are encouraged to perform small acts of service anonymously. According to sponsors, "groups might hold a joyful angel party" and plan group activities that would be of service to their communities. August 22 is a great day to read about surprising acts of kindness and service to others.

Featured Book

Wolf's Favor, by Fulvio Testa. Dial, 1986.

A simple favor from Wolf is multiplied as everyone takes a turn doing a favor for someone else.

Additional Book

Three Good Blankets, by Ida Luttrell; illus. by Michael McDermott. Atheneum, 1990.

Activity

Be an angel. Do an unexpected act of kindness for someone without letting that person know. See if, over time, that kindness is passed along to others.

August 23 National Back-to-School Month

Operation Blessing International designates August as National Back-to-School Month to bring attention to children who would otherwise lack the resources needed to succeed in school. The sponsoring organization encourages local communities to provide new clothes and school supplies to needy children. Operation Blessing International hopes to "raise awareness across the country that children living in poverty are more likely to struggle with low self-esteem, which is often linked

to poor academic success." OBI's outreach centers work with churches, schools, and other social service organizations to identify and help at-risk children.

Even children who have adequate clothing and school supplies may feel hesitant about entering school for the first time or returning to a new school or new classroom. August 23 is a good day to read comforting school stories.

Featured Book

Off to School, Baby Duck, by Amy Hest; illus. by Jill Barton. Candlewick, 1999.

Grampa helps Baby Duck cope with the fear of the first day of school.

Additional Books

Joshua's Masai Mask, by Dakari Hru; illus. by Anna Rich. Lee & Low, 1993.

Vera's First Day of School, by Vera Rosenberry. Holt, 1999.

Will I Have a Friend? by Miriam Cohen; illus. by Lillian Hoban. Collier, 1971.

Activities

1. What made the book's main character afraid of school? Was that realistic? List good things about going to school.
2. Collect new school supplies to share with less fortunate children. Distribute them through a community social service agency.

*August 24 Vesuvius Day

Vesuvius is the only active volcano in Europe, but it is probably the most famous volcano in the world. On August 24 in the year of 79 B.C., Vesuvius erupted and destroyed the cities of Herculaneum, Pompeii, and Stabiae in southern Italy. A Roman author, Pliny the Younger, witnessed the eruption and wrote about it in a famous letter. Archaeologists who have excavated the ancient city of Pompeii estimate that over 2,000 people lost their lives in the August 24 eruption. Vesuvius has erupted several times in the past. Its most recent eruption was in 1944.

Vesuvius Day is a good day to enjoy a photo essay about volcanoes.

Featured Books

Volcanoes, by Peter Murray. Child's World, 1995.

Volcanoes, by Seymour Simon. Morrow, 1988.

Activities

1. Go to the library and select a book about volcanoes, earthquakes, tornadoes, or other natural phenomena.

2. Watch the video *The Magic School Bus Blows Its Top* (Scholastic, 1996). Compare the facts mentioned in the video with the information provided by one of the nonfiction books about volcanoes. Is the information similar? Are there significant differences? If you have more questions, use a reference book to find the answers.

3. Using the book *Earthquake Games*, by Matthys Levy and Mario Salvadori (Margaret K. McElderry Books, 1997) conduct an experiment designed to teach you more about volcanoes.

August 25 Picnic Day

Any summer day is a good day for a picnic.

Featured Book

Rattlebang Picnic, by Margaret Mahy; illus. by Steven Kellogg. Dial, 1994.

The McTavishes, their seven children, and Granny McTavish drive to the country for a picnic which turns into a fantastic adventure.

Additional Books

Once Upon a Picnic, by Vivian French, conceived and illus. by John Prater. Candlewick, 1966.

The Picnic, by Ruth Brown. Dutton, 1993.

Activity

Go on a summer picnic. Bring along several good books to read after eating.

*August 26 Women's Equality Day

Also called Susan B. Anthony Day, this day honors the passage of the 19th Amendment which gave women the vote. Susan B. Anthony was a pioneer of the women's equality movement along with Elizabeth Cady Stanton and Lucretia Mott. Anthony was honored by election to the Hall of Fame for Great Americans in 1954. Her likeness also appears on the Susan B. Anthony dollar.

Featured Book

Ballot Box Battle, by Emily Arnold McCully. Random House, 1996.

A young girl witnesses Lizzie Stanton's attempt to vote in the election of 1880.

Additional Book

A Long Way to Go: A Story of Women's Right to Vote, by Zibby Oneal; illus. by Michael Dooling. Penguin, 1992.

Activities

1. Learn more about Susan B. Anthony, Elizabeth Cady Stanton, or Lucretia Mott.

2. Design a poster that Lizzie Stanton might have carried at the first women's rights convention.
3. Write your own speech about why men and women should have equal rights.
4. Invite a woman who is currently serving in an elected position (either in your state, city, or neighborhood) to come speak with your class about her experiences.

August 27 Wash Day

Wash Day is the name for any day when the dirty clothes are cleaned. Traditionally, Monday has been wash day, but in today's working parent households, wash day is often a Saturday.

Featured Book

The Day Jimmy's Boa Ate the Wash, by Trinka Hakes Noble; illus. by Steven Kellogg. Dial Press, 1980.

Jimmy's boa constrictor wreaks havoc on the class trip to a farm.

Additional Book

Washday on Noah's Ark: A Story of Noah's Ark, by Glen Rounds. Holiday House, 1985.

Activities

1. Help with the family wash.
2. List all the chores around the house that are important. Which can you do?

August 28 Frabjous Day

Any day can be a frabjous day. Lewis Carroll invented the term to mean a wonderful or an outrageously fabulous day and used it in his book *Through the Looking Glass*. Caroll wrote:

> "And hast thou slain the Jabberwock?
> Come to my arms, my beamish boy!
> O frabjous day! Callooh! Callay!
> He chortled in his joy."

August, which also contains Admit You're Happy Month and Smile Week (during the first week of August) is an appropriate time to read stories of wonderful, outrageously fabulous days.

Featured Book

Harvey Potter's Balloon Farm, by Jerdine Nolen; illus. by Mark Buehner. Lothrop, Lee & Shepard, 1993.

It is a frabjous day indeed when a young girl learns the secret of Harvey Potter's balloon farm.

Additional Books

"Could Be Worse!" by James Stevenson. Greenwillow, 1977.

Days Like This: A Collection of Small Poems, by Simon James. Candlewick, 1999.

What If? by Frances Thomas and Ross Collins. Hyperion, 1998.

Activity

What is your idea of a frabjous day? Describe the outrageously wonderful things that would happen to you on such a day.

August 29 **Children's Vision and Learning Month**

The American Foundation for Vision Awareness sponsors a monthlong campaign every August to encourage parents to have their children's vision tested. The governors of several states have supported this effort by official proclamation. Researchers estimate that approximately 25 percent of school children have vision-related learning problems. Because 80 percent of most school-based learning is dependent on vision, it is important to diagnose and correct children's vision problems. August 29 is a good time to read stories about children who wear glasses.

Featured Book

Tracks, by David Galef; illus. by Tedd Arnold. Morrow, 1996.

Albert's damaged eyeglasses cause him to create the most exciting train ride imaginable.

Additional Books

Arthur's Eyes, by Marc Brown. Little Brown, 1979.

Baby Duck and the Bad Eyeglasses, by Amy Hest; illus. by Jill Barton. Candlewick, 1996.

Activities

1. Invite an optometrist to visit with your group.
2. Make paper glasses using colored cellophane. Does the world look different? Do we all see the world around us in exactly the same way?

***August 30** **St. Rose of Lima Day**

St. Rose of Lima Day is a public holiday in Peru. Saint Rose was the first canonized saint of the New World. She was born in Lima, Peru, in 1586, and spent her life in service to God. She is remembered for her devout life and for the special care she provided for homeless children, the elderly, and the sick.

It is fitting to celebrate St. Rose of Lima Day by reading stories that the children of Peru have enjoyed through the years.

Featured Book

Llama and the Great Flood: A Folktale from Peru, by Ellen Alexander. Thomas Y. Crowell, 1989.

In this Peruvian myth about the Great Flood, a llama warns his master of the coming destruction and suggests taking refuge on a high peak in the Andes.

Additional Book

Miro in the Kingdom of the Sun, by Jane Kurtz; woodcuts by David Frampton. Houghton Mifflin, 1996.

Activity

Both of today's books are folktales. Do you think that children in the United States can enjoy the same stories as children in Peru? Why? What is the message behind these tales?

August 31 *Tomatina*

Called the Tomato Battle, this amazing food fight occurs during the last week of August in Bunol, Italy. Over 242,000 pounds of very ripe tomatoes are brought to town for a giant party. The tomato battle commemorates a similar battle at the end of World War II when teenagers started throwing tomatoes at officials and priests who had banned parties during the war. Nowadays, young people gather for eating, drinking, and tomato tossing in the town square. When all the tomatoes are tossed, big water hoses wash down the people and the town square.

August 31 is a good day to read about giant vegetables that seem to take over the people and towns who raise them.

Featured Books

The Giant Carrot, by Jan Peck; illus. by Barry Root. Dial, 1998.

The Gigantic Turnip, by Aleksei Tolstoy; illus. by Niamh Sharkey. Barefoot Books, 1998.

Activities

1. Make a vegetable salad and share it with friends.
2. Make Little Isabelle's Carrot Puddin' using the recipe in the back of the book, *The Giant Carrot*.
3. Check the vegetables in your own garden. If you have any unusually large or odd-shaped vegetables, bring them to show the group.
4. Visit a farmer's market and buy some fresh vegetables.

September 1 National Piano Month

National Piano Month is sponsored by the National Piano Foundation. Playing the piano is a way for people of all ages to learn more about music, to improve their dexterity, and to express their feelings. While some will excel, the National Piano Foundation encourages everyone to learn to play the piano for the sheer enjoyment of it. Some studies show that children who learn to play the piano actually do better in school than those who do not.

According to the National Piano Foundation, the piano was developed in 1709 by a harpsichord maker named Bartolomeo di Francesco Cristofori (1655-1731). The piano was preceded by many other stringed keyboard instruments. Some of these were the spinet, virginal, clavecin, gravicembalo, and finally, the harpsichord in the fifteenth century. Cristofori named his new instrument *gravicembalo col piano e forte* (roughly, "soft and loud keyboard instrument"). Eventually, it was shortened to fortepiano or pianoforte, and finally just piano. His earliest surviving instrument dates from 1720 and is on display at the Metropolitan Museum of Art in New York City.

There are several different types of pianos available today. These include the spinet piano, studio pianos, and grand pianos. The average piano has eighty-eight keys, and weighs from 500 to 1,000 pounds. There are more than ten million pianos in American homes and businesses.

Featured Book

Pianna, by Mary Lyn Ray; illus. by Bobbie Henba. Harcourt Brace Jovanovich, 1994.

Anna learns to play the piano and continues to play all her life.

Additional Books

The Piano Man, by Debbi Chocolate; illus. by Eric Velasquez. Walker, 1998.

Sing to the Stars, by Mary Brigid Barrett; illus. by Sandra Speidel. Little Brown, 1994.

Waiting to Sing, by Howard Kaplan; illus. by Hervé Blondon. DK, 2000.

Activities

1. Invite members of your group who play the piano to share their talent.
2. Attend a local piano concert or recital.
3. Ask a piano teacher to loan your group some recorded piano music that will appeal to young listeners.

September 2 Klondike International Outhouse Race

Since 1977 the Klondike International Outhouse Race has taken place in Dawson, Canada, in early September. Four person teams pull an outhouse, an old-fashioned outdoor toilet, on wheels for a three-kilometer race. Some teams wear outrageous costumes and decorate their outhouses with telephones, carpeted seats, etc. Some runners are serious and consider this an athletic event. Others are in the race for the laughs. The grand prize is a wooden outhouse with an engraved plaque.

Read books about races on September 2.

Featured Book

Pumpkin Runner, by Marsha Diane Arnold; illus. by Brad Sneed. Dial, 1998.

A sheep farmer in Australia enters the Koala-K race competing against younger racers. His experience running on his sheep ranch proves a big help.

Additional Books

The Great Race of the Birds and Animals, by Paul Goble. Bradbury, 1985.

The Hare and the Tortoise:A Tale from Aesop, by Helen Ward. Millbrook, 1999.

Activity

Design an unusual kind of race, clarify the rules, and then race.

September 3 The Running of the Sheep

Over 1,000 sheep flock to the town of Reedpoint, Montana, each Labor Day weekend to participate in the Running of the Sheep. They scamper down the main street of Reedpoint to the cheers of over 8,000 spectators who line the street for this special event. There are various contests, including one for the smelliest sheepherder and a Calamity Jane shooting contest. The sheep run is a fund-raiser to support the fire department, the library, and the school of this tiny town of ninety-six inhabitants. The event is all good fun—except, perhaps, for the sheep who are naturally shy and stay close together in the midst of the large crowd of onlookers.

Today's stories are about silly sheep.

Featured Book

Sheep in a Jeep, by Nancy Shaw; illus. by Margot Apple. Houghton Mifflin, 1986.

A flock of sheep out for a jeep ride suffer a variety of misadventures.

Additional Books

Sheep in a Shop, by Nancy Shaw; illus. by Margot Apple. Houghton Mifflin, 1991.

Snow Lambs, by Debi Gliori. Scholastic, 1996.

Activities

1. Think of other places where sheep might like to go, but would not naturally be. Make a long list of *sheep in a . . .*places.

2. It is not surprising that the town of Reedpoint, Montana, would have sheep in town, since it is located in sheep ranching country. What kind of animals would be likely to star in a similar event in your town? Think about the domesticated or farm animals living in your area and design an event starring one of those animals.

*September 4 Newspaper Carrier Day

Ten-year-old Barney Flaherty was hired on September 4, 1833, to be the first "newsboy" in the United States. He answered a classified advertisement in *The New York Sun* which read: "To the Unemployed— a number of steady men can find employment by vending this paper. A liberal discount is allowed to those who buy to sell again." Since Barney Flaherty took the job at *The New York Sun,* thousands of other young men and women have earned extra cash delivering newspapers door-to-door.

Featured Book

Paperboy, by Mary Kay Kroeger and Louise Borden; illus. by Ted Lewin. Clarion Books, 1996.

In Cincinnati in 1927, paperboy Willie Brinkman tries to sell "Extras" about the Dempsey-Tunney boxing match in his workingman's neighborhood.

Additional Books

The Paperboy, by Dav Pilkey. Orchard, 1996.

Race You Franny, by Emily Hearn; illus. by Mark Thurman. Women's Press, 1986.

Activities

1. Have the circulation manager of the local paper visit with your class about newspaper delivery. Who delivers the paper? What are the rewards and the difficulties?
2. Create a class newsletter and deliver it to other classes in your school.

*September 5 Be Late for Something Day

The Procrastinator's Club of America sponsors Be Late for Something Day on September 5. The sponsors want to relieve the stress and strain that results from pressure to do everything according to schedule. While we wouldn't want to be late every day, Be Late for Something Day gives us all the chance to spend one day relaxed and free from worry.

Featured Book

John Patrick Norman McHennessey: The Boy Who Was Always Late, by John Burningham. Crown, 1987.

John Patrick Norman McHennessey is always late for school, and his teacher is reluctant to believe the boy's outlandish excuses.

Additional Books

I Met a Polar Bear, by Selma and Pauline Boyd; illus. by Patience Brewster. Lothrop, Lee & Shepard, 1983.

Leo the Late Bloomer, by Robert Kraus; illus. by Jose Aruego. Windmill, 1971.

Activity

Imagine that you are late getting home from school. Make up the most outlandish excuse. Take turns sharing your ridiculous excuses.

September 6 National Save the Tiger Month

Tiger River Spas, in cooperation with the World Wildlife Fund, the Zoological Society of San Diego, and the Center for Reproduction of Endangered Species, has had September officially declared "National Save the Tiger Month." There are currently between 5,000 and 7,000 tigers living in Asia. The five species alive today are the Siberian, Bengal, Sumatran, South China, and Indo-Chinese tigers. Three other species have become extinct in the past seventy years. Unfortunately, poaching, trade in tiger parts, and the loss of tiger habitats continue to threaten these magnificent cats.

The tiger is the biggest and most powerful member of the cat family. It can reach up to nine feet in length, excluding its yard long tail. Tigers are carnivorous animals who hunt mainly at night. Tigers eat deer, bison, buffalo, and wild pigs. Tigers attack humans only when the tiger is injured or feels threatened. Celebrate National Save the Tiger Month by learning more about these fascinating mammals.

Nonfiction Books about Tigers

Tiger! by Sharon Lewis; illus. by Linda Roberts. Harper & Row, 1990.

Tiger Trek, by Ted Lewin. Macmillan, 1990.

Tigress, by Helen Cowcher. Farrar, Straus & Giroux, 1991.

Fiction Books about Tigers

Fortune, by Diane Stanley. Morrow, 1990.

Tigers, by Roland Edwards; illus. by Judith Riches. Tambourine, 1992.

Who Is the Beast? by Keith Baker. Harcourt Brace, 1990.

Activities

1. Compare a nonfiction book with a fiction book about tigers. How are the books similar? How are they different? Is one more imaginative? Is one more factual?
2. Learn more about tigers by watching the National Geographic video, *Land of the Tiger* (1985).

*September 7 Neither Snow Nor Rain Day

September 7 is the anniversary of the opening of the New York post office building at Eighth Avenue between 31st and 33rd Streets, on Labor Day, 1914. This building bears the famous inscription:

> "Neither snow nor rain nor heat nor gloom of night stays these couriers from the swift completion of their appointed rounds."

This is simply the building's motto, not the motto of the United States Postal Service. However, the saying has long been associated with the post office. September 7 is a good day to celebrate our nation's mail carriers.

Featured Book

Snowshoe Thompson, by Nancy Smiler Levinson; illus. by Joan Sandin. HarperCollins, 1992.

One winter John Thompson skied across the Sierra Nevada Mountains and created a path upon which mail and people could travel, thus earning his nickname "Snowshoe Thompson."

Additional Books

Mailing May, by Michael O. Tunnell; illus. by Ted Rand. Greenwillow, 1997.

No Mail for Mitchell, by Catherine Siracusa. Random House, 1990.

Activities

1. Visit the local post office or invite a mail carrier to come to your classroom.
2. Set up a classroom post office and offer to deliver mail throughout the school.

*September 8 International Literacy Day

On September 8, the United Nations sponsors International Literacy Day to encourage worldwide literacy. This a day to celebrate the power and joy that comes from the ability to read.

Featured Book

The Day of Ahmed's Secret, by Florence Parry Heide & Judith Heide Gilliland; illus. by Ted Lewin. Lee & Shepard, 1990.

Ahmed, a young boy in Egypt, has a great secret to share with his family—he has learned to write his name.

Additional Books

Read for Me, Mama, by Vashanti Rahaman; illus. by Lori McElrath-Eslick. Boyds Mills, 1997.

Running the Road to ABC, by Denize Lautre; illus. by Reynold Ruffins. Simon & Schuster, 1996.

Wednesday's Surprise, by Eve Bunting; illus. by Donald Carrick. Clarion, 1989.

Activities

1. Read, read, and read.
2. Help someone who is learning to read.
3. Hold a book sale and donate the proceeds to your local literacy program. Contact your public library for more information about such programs in your area.

September 9 Self-Improvement Month

The International Society of Friendship and Good Will sponsors Self-Improvement Month for the entire month of September. The purpose of Self-Improvement Month is to remind people about the value of lifelong learning and self-improvement. September is a particularly good month to think about self-improvement because so many people begin school or college. The International Society of Friendship and Good Will believes that all people, no matter what their ages, should continue learning. They suggest that during September each adult should read at least one good book and enroll in an adult education class. September is a good time to remember that although learning can be difficult, its rewards are many.

Featured Books

Thank you, Mr. Falker, by Patricia Polacco. Philomel, 1998.

Trisha has a very difficult time learning to read until her new fifth-grade teacher helps her to understand her problem and overcome it.

Today Was a Terrible Day, by Patricia Reilly Giff; illus. by Susanna Natti. Puffin, 1984.

Ronald, a second-grader, has a truly terrible day until he realizes that he learned something new.

Activities

1. Go to the library and chose a challenging book to read this month.
2. Learn something new and share your knowledge with your group.
3. Remember when you were trying to learn something new (e.g. tying your shoes) and write down how you felt. How did you feel once you mastered the skill? What would you say to someone who is discouraged about learning a new skill?

September 10 National Try Transit Week

The second full week in September is National Try Transit Week. Town and city bus companies around the country choose this week to encourage people to take the bus. Some communities offer free bus rides; others publicize the city buses with posters and advertisements.

Featured Book

The Wheels on the Bus, by Maryann Kovalski. Joy Street, 1987.

While a grandmother and grandchildren wait for the bus, they sing the title song with such enthusiasm they miss their bus.

Additional Books

Maisy Drives the Bus, by Lucy Cousins. Candlewick, 2000.

The Seals on the Bus, by Lenny Hort; illus by G. Brian Karas. Henry Holt, 2000.

Activities

1. Sing together the song "The Wheels on the Bus." Add variations.
2. Visit the local bus depot and take a bus ride.
3. Do something special to honor a favorite bus driver.

*September 11 Coptic New Year

Egypt's Coptic Orthodox Church celebrates the New Year on September 11 because the Dog Star, Sirius, reappears in the Egyptian sky on that night. This signals flooding and the beginning of a new planting season. Coptic Christians are a minority in Egypt today, but according to Egyptian law, they are allowed to worship freely. Red dates are a special food served on this day.

Featured Book

The Stars in My Geddoh's Sky, by Claire Sidhom Marze; illus. by Bill Farnsworth. Albert Whitman, 1999.

Grandfather (*Geddoh*) comes to the United States from Egypt to visit his grandson, Alex. As he talks with *Geddoh*, Alex learns much about daily life in modern-day Egypt. (Note: although a particular religion is not specifically mentioned in the story, it seems likely that the grandfather in the story is not Christian, but a Muslim who is called to prayer five times a day.)

Additional Books

The Old Testament stories of Joseph and Moses have close ties to Egypt. Two of the many picture books on this theme are:

Joseph, by Brian Wildsmith. Eerdmans, 1997.

Moses in the Bulrushes, by Warwick Hutton. Aladdin, 1992.

Activity

Locate Egypt on a map. Trace the route from Egypt to the United States. What methods of transportation are available for someone making this trip? How long would it take?

September 12 National Chicken Month

National Chicken Month is sponsored by the National Broiler Council, who's theme, "Chicken. The Smart Meal," emphasizes both the economical and the nutritional value of chicken. Chicken is eaten in every country in the world by people of all ages. In the United States, chicken is sec-second only to hamburgers as the most popular barbecued food. Chicken continues to

be a popular food choice; Americans consume approximately eighty-three pounds per year. While chicken dinners may be fun to eat, silly chickens are much more fun to read about.

Featured Books

Chicken Little, retold by Sally Hobson. Simon & Schuster, 1994.

Chicken Little, retold by Steven Kellogg. Morrow, 1985.

Henny Penny, retold by H. Werner Zimmermann. Scholastic, 1989.

The Story of Chicken Licken, by Jan Ormerod. Morrow, 1986.

All of these books are different versions of the story of a chicken who believes that the sky is falling.

Additional Books

Lottie's New Beach Towel, by Petra Mathers. Atheneum, 1998.

Zinnia and Dot, by Lisa Campbell Ernst. Viking, 1992.

Activities

1. Read two or more versions of the Chicken Little story and compare them. How does the story differ? Do the illustrations change the story from one version to the next? If so, how?
2. Research a few facts about chickens. Are chickens intelligent animals? Why are there so many stories of silly chickens? Do these stories have a basis in fact?
3. Bring a chicken to class or bring the class to a chicken farm. Touch, listen to, and observe a chicken.

September 13 Children's Good Manners Month

Children's Good Manners Month is designed by sponsors to draw attention to the importance of good manners. It is part of a year-long program which supports parents and teachers in encouraging good manners in children. Good manners are always in season.

Featured Book

Mary Louise Loses Her Manners, by Diane Cuneo; illus. by Jack E. Davis. Doubleday, 1999.

When Mary Louise starts saying "fleas" instead of "please" and "spank you" instead of "thank you," she realizes that she lost her manners and sets out to find them.

Additional Book

How My Parents Learned to Eat, by Ina R. Friedman; illus. by Allen Say. Houghton Mifflin, 1984.

Activities

1. Come up with a list of those manners that you think are the most important. Make a poster encouraging people to use their manners.
2. Plan a lunch or dinner for your group and then practice perfect manners.
3. Discuss how manners vary in different families. What manners does your family expect that are different from manners in other families or in other cultures?

*September 14 National Anthem Day

"The Star-Spangled Banner" was originally written as a poem titled "Defense of Fort McHenry" by Francis Scott Key on September 14, 1814. Key, an American patriot, was inspired to write the poem during a particularly long bombardment by the British on Baltimore Harbor. By 1843, the poem, which had been set to music and renamed "The Star-Spangled Banner," was considered the national ballad. It took 117 years, however, before the song was officially designated as the national anthem.

Featured Book

By the Dawn's Early Light: The Story of The Star-Spangled Banner, by Steven Kroll; illus. by Dan Andreasen. Scholastic, 1994.

Clear text and beautiful paintings illustrate the story behind the composition of "The Star-Spangled Banner."

Additional Book

The Star-Spangled Banner, illus. by Peter Spier. Doubleday, 1973.

Activity

Practice singing the national anthem. Does knowing the story behind the song make it more meaningful?

*September 15 Nicaragua Independence Day

On September 15, 1821, five provinces in Central America declared their independence from Spain. In addition to Nicaragua, Costa Rica, El Salvador, Guatemala, and Honduras, share September 15 as a national holiday celebrating independence. For a short time, these countries became part of the Mexican empire, but in 1823 broke away and established the United Provinces of Central America. It was several years later before Nicaragua and the other Central American countries became independent nations.

Nicaragua is located between Honduras and Costa Rica in Central America. The Spanish influence continues in its language, religion, and its ethnic heritage. Many Nicaraguans have both Indian and Spanish ancestors. The rich farmlands of Nicaragua grow coffee, cotton, sugarcane, rice, bananas, and other crops.

Featured Book

Uncle Nacho's Hat: A Folktale from Nicaragua/El Sombrero del Tio Nacho: Un Cento de Nicaragua, by Harriet Rohmer; illus. by Veg Reisbert. Children's Press, 1990.

This bilingual book tells the story of Uncle Nacho's hat which is tattered and full of holes. Although his niece Ambrosia gives him a new one, he cannot get rid of the old.

Additional Book

Mother Scorpion Country: A Legend from the Miskito Indians of Nicaragua/La Tierra de la Madre Escorpion: Una Leyenda de los Indios Miskitos de Nicaragua, by Harriet Rohmer and Dorminster Wilson;

illus. by Virginia Stearns; Spanish version by Rosalma Zubizarreta & Alma Flor Ada. Children's Book, 1987.

Activities

1. These folktales teach a lesson. What do you think the folktale tells the people of Nicaragua? Can you think of other similar folktales or stories? In what ways are you like the characters in the story?
2. Find Nicaragua on a map of the world. What can you tell about the country from its location? Do research to see if you guessed correctly and discover other interesting facts.

September 16 Idaho Spud Day

The potato, the crop of Idaho, is honored during the third week of September on Idaho Spud Day in Shelley, Idaho. This is actually a six-day festival that began in 1928 and includes parades, potato picking, potato eating, and horseshoe contests. The potato originated in South America and came to North America in the 1600s. Idaho raises more potatoes than any other state. Idaho also produces wheat, sugar beets, and barley, and Idaho leads the nation in the production of commercial trout.

Featured Book

Brave Potatoes, by Toby Speed; illus. by Barry Root. Putnam, 2000.

The prize potatoes at the country fair set out to enjoy the midway, only to be captured by a chef in need of potatoes for his stew.

Additional Books

Potato: A Tale from the Great Depression, by Kate Lied; illus. by Lisa Campbell Ernst. National Geographic Society, 1997.

The Potato Man, by Megan McDonald; illus. by Ted Lewin. Orchard, 1991.

Activities

1. How many ways can you think of to eat potatoes? Enjoy a potato feast.
2. Talk with some older adults about their memories surrounding the farming or selling of food. Did they grow their own food? Do they remember buying food from a farmer, a vendor, or a market?

*September 17 Citizenship Day

Formerly called Constitution Day, this is the day in 1787 when the Constitution of the United States was signed. Special events held on this day include parades, re-creations of the signing of the Constitution, and naturalization ceremonies.

Featured Book

The American Wei, by Marion Hess Pomeranc; illus. by DyAnne DiSalvo-Ryan. Albert Whitman, 1998.

Wei Fong's "double-lucky day" includes his family's naturalization ceremony and the loss of his first tooth.

Additional Books

Klara's New World, by Jeanette Winter. Alfred A. Knopf, 1992.

A Picnic in October, by Eve Bunting; illus. by Nancy Carpenter. Harcourt Brace, 1999.

Activities

1. Is someone in your group a naturalized citizen? If not, perhaps a parent or grandparent became a citizen after immigrating to the United States. Invite a naturalized citizen to visit and talk about the process of becoming an American citizen.
2. The United States is a country of immigrants. Why do so many people want to come to the United States?

*September 18 Independence Day in Chile

On September 18, 1810, local leaders in Chile declared independence. Since 1541, Chile had been under Spanish rule. With Napoleon Bonaparte's seizure of Spain in 1808, Napoleon's brother, Joseph Bonaparte was declared King of Spain. Chile found itself in the unsettling position of having a French king. A growing independence movement led by wealthy landowners challenged the colonial rulers by forming a *junta*. They appointed José Miguel Carrera head of the government. It took several years, but on April 15, 1818, Chile gained its independence. September 18 is a national holiday in Chile.

Featured Book

Mariana and the Merchild: A Folk Tale from Chile, by Caroline Pitcher; illus. by Jackie Morris. Eerdmans, 2000.

Mariana, an old woman, is feared by the village children, and she herself is afraid of the sea wolves who live in caves near her hut. When she adopts a merchild, her fortune changes.

Additional Book

"Piñocito: A Tale from Chile," in *Tom Thumb*, by Margaret Read MacDonald. Oryx, 1993; 37-40.

Activity

Locate Chili on a map of South America. Use reference books to learn more about this country of mountains and seacoasts.

September 19 National Farm Animal Awareness Week

The Humane Society of the United States sponsors National Farm Animals Awareness Week during the third week in September. National Farm Animals Awareness Week promotes

awareness and dispels misconceptions about farm animals. The Human Society suggests celebrating by learning more about "the complex natures and behavior of farm animals."

Featured Book

A Regular Rolling Noah, by George Ella Lyon; illus. by Stephen Gammell. Bradbury, 1986.

A young boy takes a boxcar full of farm animals from Kentucky to Canada.

Additional Books

It's a Perfect Day, by Abigail Pizer. HarperTrophy, 1990.

The Pig in the Pond, by Martin Waddell; illus. by Jill Barton. Candlewick, 1992.

When the Rooster Crowed, by Patricia Lillie; illus. by Nancy Winslow Parker. Greenwillow, 1991.

Activities

1. Visit a farm or a petting zoo.
2. Choose a farm animal and look up an interesting fact or two about the animal. Write the facts on an index card and create a bulletin board to honor the diversity and complexity of farm animals.
3. Imagine that you have a farm in Canada, India, Chile, and Kenya. What animals would you have on your farm in each different locale.

September 20 National Dog Week

The third week in September is National Dog Week. This is a time to recognize the unique relationship between people and their dogs and to emphasize the proper care and treatment of dogs.

Featured Book

Riptide, by Frances Ward Weller; illus. by Robert J. Blake. Philomel Books, 1990.

Zach's dog Riptide loves the sea and proves himself worthy of being the nineteenth lifeguard on Cape Cod's Nauset Beach.

Additional Books

Bark, George, by Jules Feiffer. HarperCollins, 1999.

Daisy Thinks She's a Baby, by Lisa Kopper. Alfred A. Knopf, 1994.

Martha Speaks, by Susan Meddaugh. Houghton Mifflin, 1992.

Activities

1. Invite everyone in your group to bring their dogs for a dog show.
2. Have each person share something special about a favorite dog.
3. Visit a local dog shelter and learn more about the different dogs and why they are without a home.
4. Invite someone who uses a Seeing Eye dog to talk about how Seeing Eye dogs help the blind.

*September 21 World Gratitude Day

Recognized by the United States Congress and forty state governors, World Gratitude Day is sponsored by an independent organization whose purpose is to encourage people to be grateful, and to share that gratitude with others around the world. The United Nations celebrates the day by exhibiting posters created by children on all five continents. Sponsors chose September 21 for World Gratitude Day because on that date the days and nights are of equal length worldwide.

Featured Book

Thanks Be to God: Prayers from around the World, by Pauline Baynes. Macmillan, 1990.

This collection features prayers of praise and thanksgiving from all traditions and places throughout the world.

Additional Books

The Circle of Days, by Reeve Lindbergh; illus. by Cathie Felstead. Candlewick, 1998.

Giving Thanks: Native American Good Morning Message, by Chief Jake Swamp; illus. by Erwin Printup, Jr. Lee & Low, 1995.

Peace on Earth, by Bijou Le Tord. Doubleday, 1992.

Activities

1. As you read today's book, note how different peoples are thankful for similar blessings. Are there other things for which you are grateful? Share your ideas with others.
2. Get together with friends for a Gratitude Tea. Serve milk and cookies, tea and crumpets, or some other favorite snacks and enjoy good feelings of gratitude.

* September 22 Elephant Appreciation Day

 Every September 22, Wildheart® Productions sponsors Elephant Appreciation Day. The sponsors, great admirers of elephants, suggest that the elephant deserves to be appreciated because it is our largest land mammal, is the most noble of beasts on earth, is entertaining and amusing, and is gentle and friendly. Elephants are fascinating animals. Their brain is four times the size of a human brain, they eat hundreds of pounds of food each day, and a large male can weigh as much as 12,000 pounds. Celebrate Elephant Appreciate Day by reading stories about elephants.

Featured Book

Where Can an Elephant Hide? by David McPhail. Doubleday, 1979.

Because of his large size, poor elephant has a terrible time finding a place to hide until a little bird comes to his rescue.

Additional Book

Engelbert the Elephant, by Tom Paxton; illus. by Steven Kellogg. Morrow, 1990.

Activities

1. Make a list of all the reasons to appreciate elephants. Which of these qualities are mentioned in today's story?
2. Go to the library and find more stories, poems, and jokes about elephants. Share with your group.
3. Create a silly Elephant Appreciation poster drawing attention to the many find qualities of elephants.

September 23 Autumnal Equinox

On two days each year, the sun is directly above the earth's equator. On March 20 or 21, the vernal equinox signals the beginning of spring in the Northern Hemisphere. On September 22 or 23 the autumnal equinox heralds the beginning of autumn in the North. In the Southern Hemisphere, the seasons are reversed. During the equinox, the days and nights are of approximately equal length.

September 23 is a day to celebrate the coming of fall.

Featured Book

Possum's Harvest Moon, by Anne Hunter. Houghton Mifflin, 1996.

Possum holds a party for his animal friends so that they can celebrate the beautiful harvest moon before winter sets in.

Additional Book

The Yellow Leaf, by Hasan Terani; illus. by Mahasti Mir. Mage, 1994.

Activities

1. Gather fall leaves and create an autumn collage.
2. Think of all the ways that animals and birds use autumn to prepare for winter. How do people adjust to the changing seasons? What fall chores do you do?
3. Go for an evening walk to look for the harvest moon and admire the autumn sky.

September 24 National Hispanic Heritage Month

In 1968, Congress authorized National Hispanic Heritage Week, beginning on September 15. Since then, this celebration has expanded to include the month from September 15 to October 15. Presidential proclamation calls on all Americans to honor this month with appropriate ceremonies and activities. National Hispanic Heritage Month is an ideal time to recognize great Americans of Hispanic heritage and to honor all peoples who have come to the United States from Central and South American nations.

Featured Book

Creativity, by John Steptoe; illus. by E. B. Lewis. Clarion, 1997.

Although two boys share the same Puerto Rican heritage, they learn to appreciate their differences.

Additional Books

Down in the Subway, by Miriam Cohen; illus. by Melanie Hope Greenberg. DK, 1998.

Isla, by Arthur Dorros; illus. by Elisa Kleven. Dutton, 1995.

Activities

1. Invite students of Hispanic heritage to share their stories with the class. What brought their families to the United States? When and how did they get here? What traditions from their Hispanic heritage do they continue to follow?
2. Invite each person in your group to share something about their own ethnic heritage. Perhaps each could bring some food, music, or art that represents their family's ethnic background.

*September 25 Pacific Ocean Day

On September 25, 1513, Vasco Nuñez de Balboa claimed the Pacific Ocean for Spain. He claimed not only the Pacific Ocean itself, but "all the shores washed by it." Since then, of course, other nations have claimed these shores. California, Oregon, Washington, and Alaska are all "washed" by the waters of the Pacific Ocean.

Featured Book

See the Ocean, by Estelle Condra; illus. by Linda Crockett-Blassingame. Ideals, 1994.

Nellie loves the ocean. From her earliest days she has visited the ocean with her family and enjoyed the wonderful feel, smells, and sounds of the ocean. Even though she is blind, she is often the first in her family to *see* the ocean.

Additional Books

At the Beach, by Huy Voun Lee. Henry Holt, 1994.

Out of the Ocean, by Debra Frasier. Harcourt Brace, 1998.

Activities

1. How many of the group have been to the ocean? How would you describe an ocean to someone who has never seen one? Think of words and images that explain an ocean. Try writing a descriptive paragraph.
2. Using a world map, look at the Pacific Ocean and record each country touched by its waters. How many of today's countries did Balboa claim for Spain?

*September 26 Johnny Appleseed's Birthday

John Chapman was born in Leominster, Massachusetts, on September 26, 1774. John attended school in Massachusetts, and according to his half sister, he loved to read. He was working full-time by age fourteen, and when he turned twenty-three, he left Massachusetts for new territory in Pennsylvania. He traveled more than three hundred miles alone with only a gun, small hatchet and knapsack. It was that knapsack that contained the apple seeds that he had collected in eastern Pennsylvania and carried west. He spent the rest of his life as "a gatherer and planter of apple seeds." Johnny Appleseed, as he came to be called, is an American folk hero. How appropriate that his birthday is in the fall at the very time when ripe apples await picking on the nation's many apple trees.

Featured Book

Johnny Appleseed, by Reeve Lindbergh; illus. by Kathy Jakobsen. Little Brown, 1990.

Lindbergh's poem is based on the life of Johnny Appleseed. Jakobsen's primitive art complements the tone of the poem.

Additional Book

Johnny Appleseed: A Tall Tale, retold by Steven Kellogg. Morrow, 1988.

Activities

1. Visit an apple orchard.
2. Purchase a variety of apples and test their taste. Which do you like best?
3. Make an apple pie, applesauce, mulled apple cider, or any other apple treat.

September 27 *Yom Kippur*

Yom Kippur is an extremely important Jewish holiday. *Yom Kippur* means *Day of Atonement*. It is a day set aside to atone for the sins of the last year. Before *Yom Kippur*, Jews must atone for wrongs committed against other people, and if possible, right these wrongs. On the holiday itself, Jews abstain from working, eating, and drinking. The twenty-five-hour fast begins before sunset on the evening before *Yom Kippur* and continues until the sun sets on the night of the holiday. The day is to be spent in prayer at the synagogue. Many people wear white on the holiday to symbolize purity and remind the wearer that God can make sins as white as snow.

2001	9/27	2006	10/2
2002	9/16	2007	9/22
2003	10/6	2008	10/9
2004	9/25	2009	9/28
2005	10/13	2010	9/17

Featured Book

K'tonton's Yom Kippur Kitten, by Sadie Rose Weilerstein; illus. by Joe Boddy. Jewish Publication Society, 1995.

When K'tonton, the Jewish Tom Thumb, feeds a hungry kitten, his act of kindness turns into disaster. Charming illustrations and a good story explain the meaning of Yom Kippur.

Additional Books

Yussel's Prayer: A Yom Kippur Story, retold by Barbara Cohen; illus. by Michael J. Deraney. Lothrop, Lee & Shepard, 1981.

The Always Prayer Shawl, by Sheldon Oberman; illus. by Ted Lewin. Boyds Mill, 1994.

Activities

1. Invite Jewish friends to talk about the meaning of Yom Kippur. Perhaps you can share a seder supper in honor of the holiday.
2. A major theme of Yom Kippur is the importance of righting wrongs committed against another person. Take this opportunity to try to right a wrong or to ask forgiveness of someone you have hurt.

*September 28 Confucius's Birthday or Teacher's Day

This national holiday in Taiwan honors Confucius, one of the most influential men in China's history. Confucius developed a code which taught obedience to family, respect for others, and selflessness. Ceremonies include lectures about Confucius, ancient music and dance, and exhibitions. Children honor their teachers with small gifts and acts of kindness.

Featured Book

Liang and the Magic Paintbrush, by Demi. Holt, Rinehart, and Winston, 1980.

In this creative tale, Liang wanted to be a painter, but he could not afford a brush. One night as he slept, an old man placed a brush in his hand and warned, "It is a magic paintbrush. Use it carefully."

Additional Books

Cricket's Cage: A Chinese Folktale, retold by Stefan Czernecki. Hyperion, 1997.

8,000 Stones: A Chinese Folktale, retold by Diane Wolkstein; illus. by Ed Young. Doubleday, 1972.

Activities

1. These folktales reinforce lessons taught by Confucius. What advice about living do these folktales teach? List other similar tales with which you are familiar.
2. Do something special to honor a teacher today.

September 29 National Sewing Month

The Home Sewing Association sponsors September as National Sewing Month. According to the association, "Children who sew may have a real edge in the high-tech service economy of the twenty-first century—where creative, flexible workers will be in high demand." Sewing leads to creativity and reduces stress. Its immediate reward is the creation of something useful or decorative. Celebrate National Sewing Month by reading about creative seamstresses and tailors.

Featured Book

Sam Johnson and the Blue Ribbon Quilt, by Lisa Campbell Ernst. Lothrop, Lee & Shepard, 1983.

Sam discovers that he enjoys sewing when he mends the awning over the pig pen. He turns his interest into a prize winning quilt.

Additional Books

Joseph Had a Little Overcoat, by Simms Taback. Viking, 1999.

The Magic Sewing Machine, by Sunny Warner. Houghton Mifflin, 1997.

Activities

1. Learn to sew a button onto a shirt.
2. Invite a seamstress or a tailor to work with your group on a simple sewing project.
3. Create your own patchwork quilt using colored squares and pasting them together for display. Perhaps you can select a theme such as "our community," or "our school," or "autumn."

September 30 National Honey Month

According to the National Honey Board, which sponsors National Honey Month, September is the month when many crops of honey are harvested. Honey bees not only make honey, but they also help the farmers with crop fertilization. When they pass from blossom to blossom gathering honey, they also collect and redistribute pollen. Many fruits, nuts, and vegetables depend on honey bees for pollination.

Celebrate honeybees by reading selected pages from the following nonfiction books.

Featured Books

A Beekeeper's Year, by Sylvia A. Johnson; photographs by Nick Von Ohlen. Little, Brown, 1994.

The Life and Times of the Honeybee, by Charles Micucci. Ticknor & Fields, 1995.

Activities

1. Sample a variety of flavors of honey. Which do you like best?
2. Make banana pops using a recipe from the National Honey Board.

You'll need:
- 1-1/3 cups topping, such as ground toasted almonds, toasted coconut, candy sprinkles or graham cracker crumbs
- 4 just-ripe bananas, peeled
- 8 wooden craft sticks
- 1/2 cup honey

Spread toppings of your choice on a plate or plates. Cut bananas in half crosswise. Insert a craft stick into each cut end. To assemble, hold one banana over plate or waxed paper to catch drips. Spoon about one tablespoon honey over banana, rotating and smoothing honey with back of spoon to coat all sides. (Or squeeze honey from a plastic honey bear container and smooth out with spoon.) Roll banana in topping of choice until coated on all sides, pressing with fingertips to help topping adhere. Place pops on waxed paper-lined cookie sheet. Repeat with remaining bananas, honey and toppings. Serve at once.

*October 1 World Vegetarian Day

The North American Vegetarian Society sponsors World Vegetarian Day annually on October 1. Vegetarians eat and enjoy their vegetables and celebrate this day as a way to "promote the joy, compassion and life-enhancing possibilities of vegetarianism." Even if you are not a vegetarian, October 1 is a great day to promote the healthy benefits of eating your vegetables!

Featured Book

The Giant Vegetable Garden, by Nadine Bernard Westcott. Little Brown, 1981.

In their desire to win the prize for finest vegetables at the fair and with the encouragement of the mayor, the townspeople grow such huge vegetables that they threaten to strangle the village.

Additional Books

Scarlette Beane, by Karen Wallace; illus. by Jon Berkeley. Dial, 1999.

The Ugly Vegetables, by Grace Lin. Charlesbridge, 1999.

Activities

1. Prepare a vegetable feast and enjoy eating together.
2. Make posters promoting the nutritional value and good taste of vegetables.

October 2 National Popcorn Poppin' Month

The Popcorn Institute reminds everyone that popcorn is harvested each fall, making October the perfect time to celebrate National Popcorn Poppin' Month. According to the Popcorn Institute, Quadequina, brother of Chief Massasoit, brought a bag of popped popcorn to the first Thanksgiving dinner as a gift for the English colonists. They also report that Americans consume nearly sixteen-billion quarts of popcorn each year; that's nearly fifty-nine quarts per person! Popcorn is certainly an all-American treat.

Featured Book

The Popcorn Book, by Tomie dePaola. Holiday, 1978.

Tiny tells all sorts of interesting popcorn facts to Tony, who is popping the popcorn.

Additional Books

The Huckabuck Family and How They Raised Popcorn in Nebraska and Quit and Came Back, by Carl Sandburg; illus. by David Small. Farrar, Strauss & Giroux, 1999.

Popcorn at the Palace, by Emily Arnold McCully. Browndeer, 1997.

Activities

1. Make popcorn and enjoy.
2. Use popcorn in a scientific experiment using the book *Science Fun with Peanuts and Popcorn*, by Rose Wyler, illustrated by Pat Stewart (Messner, 1986).

*October 3 *Tangun* or Foundation Day in Korea

October 3 marks the traditional founding of Korea. The literal translation of *tangun* is "the day the heavens opened." According to Korean mythology, this is the day that the national founder, Tangun, descended upon the earth over 4,300 years ago to create Korea. Koreans celebrate this holiday by retelling Korean myths.

Featured Book

The Chinese Mirror, adapted from a Korean folktale by Mirra Ginsburg; illus. by Margot Zemach. Harcourt Brace Jovanovich, 1988.

A mirror brought from China causes confusion for a Korean family as each member looks in it and sees a different stranger.

Additional Books

Dear Juno, by Soyung Pak; illus. by Susan Kathleen Hartung. Viking, 1999.

Mr. Pak Buys a Story, by Carol Farley; illus. by Benrei Huang. Whitman, 1997.

Activity

Korean games, recipes, stories, and crafts are all explained with directions in the following books. Try your hand at some of these projects using *Korea: A Cultural Resource Guide*, by Ann Edmonds (Milliken, 1994) or *Look What We've Brought You from Korea: Crafts, Games, Recipes, Stories and Other Cultural Activities from Korean Americans*, by Phillis Shalant (Julian Messner, 1994).

October 4 Child Health Month

The American Academy of Pediatrics has declared October Child Health Month. Child Health Day is held the first Monday in October, sponsored by the American Health Foundation. Both of these organizations want to remind parents and children of the importance of good health practices: eating well, getting plenty of exercise, visiting the doctor for preventive care, and avoiding drugs. During October, the American Academy of Pediatrics produces advertisements, posters, and programs focusing on a particular child health problem.

Celebrate Child Health Month by reading about active children enjoying time outdoors.

Featured Book

The Catspring Somersault Flying One-Handed Flip-Flop, by SuAnn Kiser; illus. by Peter Catalanotto. Orchard, 1993.

When everyone in her large family seems too busy to pay any attention to her, Willie decides to run away to find someone who will watch her do her marvelous new trick.

Additional Books

Play Ball, Zachary! by Muriel Blaustein. Harper & Row, 1988.

Soccer Sam, by Jean Marzollo; illus. by Blanche Sims. Random House, 1987.

Activities

1. Generate a list of all the healthy outdoor activities available to children in your neighborhood or school.
2. Make posters encouraging children to participate in outdoor activities.
3. Organize a neighborhood game of soccer, baseball, or some other outdoor games.
4. Play ball with a younger child.

*October 5 National Poetry Day in the United Kingdom

On October 5 and throughout the month of October, the people of the United Kingdom celebrate poetry. England, Scotland, and Wales all hold special events which include radio broadcasts of poets reading their work, school poetry competitions, poetry workshops and performances, and poetry lunches.

In the United States, National Poetry Day is celebrated on April 15 in some places and on October 15 in others. The island nations of Trinidad and Tobago celebrate World Poetry Day on October 15, as do people in thirty-nine other countries.

There is no wrong day to celebrate poetry. On October 5, celebrate with children in England, Scotland, and Wales by reading poems from collections containing poetry from the United Kingdom.

Featured Books

A Child's Garden of Verses, by Robert Louis Stevenson. Chronicle, 1989.

The Golden Treasury of Poetry, selected by Louis Untermeyer; illus. by Joan Walsh Anglund. Golden Press, 1959.

Knock at a Star: A Child's Introduction to Poetry, selected by X. J. Kennedy and Dorothy M. Kennedy; illus. by Karen Ann Weishaus. Little Brown, 1982.

A New Treasury of Poetry, selected by Neil Philip; illus. by John Lawrence. Stewart, Tabori & Chang, 1990.

The Oxford Book of Children's Verse, selected by Iona and Peter Opie. Oxford University, 1973.

Activities

1. Select one of the poems from England, Scotland, or Wales to read or recite for your class.
2. Select one of the poems read today and illustrate it. Combine the illustrations and the poems to create a bulletin board display honoring Poetry Day.
3. Try writing a poem of your own. You might model your poem after one you heard today.

October 6 Paul Bunyan Show

Hocking Technical College in Nelsonville, Ohio, and the Ohio Forestry Association sponsor the Paul Bunyan Show during the first full weekend in October as a way of focusing attention on their wood products and forest conservation. Professional and student lumberjacks demonstrate chopping and sawing, draft horses compete in a log-skidding competition, and exhibits explain modern logging to visitors. Paul Bunyan, the tall-tale hero whose stories were first published in 1910, is America's best known lumberjack.

Featured Book

Paul Bunyan: A Tall Tale, retold by Steven Kellogg. William Morrow, 1984.

Many of Paul Bunyan's amazing feats are retold, sometimes in a contemporary setting, in this lively retelling.

Additional Books

"Paul Bunyan," in *American Tall Tales*, by Mary Pope Osborne; illus. by Michael McCurdy. Alfred A. Knopf, 1991; 97-109.

"Paul Bunyan and the Winter of the Blue Snow," in *Big Men, Big Country: A Collection of American Tall Tales,* by Paul Robert Walker; illus. by James Bernadin. Harcourt Brace Jovanovich, 1993; 49-54.

Paul Bunyan Finds a Wife, by Adèle De Leeuw. Garrard, 1969.

Activity

The students and faculty at Hocking Technical College plan the weekend to show off the skills that are important to them. If you were to plan a similar celebration, what skills would you demonstrate? The Hocking students want to focus attention on wood products. What does your town produce? How can you draw attention to these important activities?

October 7 Fire Prevention Week

The National Fire Protection Association sponsors October as Fire Prevention Month. The NFPA uses this month to raise awareness of the danger of fires on fire prevention. The week containing October 9 is named Fire Prevention Week, but the campaign continues throughout the month. The Great Chicago Fire, which occurred on October 9, 1871, took more than 250 lives and destroyed 17,400 structures. The Great Chicago Fire served as impetus for this campaign. On the 40th anniversary of the fire, the Fire Marshals Association of North America sponsored the first Fire Prevention Day. In 1920, President Wilson signed a proclamation declaring Fire Prevention Day an official event. Eventually, Fire Prevention Day became an entire week of fire prevention activities. Every year since 1925, the president has signed a proclamation declaring fire prevention a national priority.

Featured Book

Firemouse, by Nina Barbaresi. Crown, 1987.

Firemouse, who has watched the way the firefighters work to save a building from fire, forms his own company of mouse fire fighters.

Additional Books

Firehorse Max, by Sara London; illus. by Ann Arnold. HarperCollins, 1997.

The Little Fire Engine That Saved the City, by Dennis Smith; illus. by Joanne Maffia. Doubleday, 1990.

Activities

1. Visit a local fire station or invite a firefighter to speak with your group about fire safety.
2. Make posters for Fire Prevention Week.
3. Watch the video *Firetrucks & Firefighters* (Firehouse Mouse Production, 1996).

October 8 Thanksgiving Day in Canada

The first North American Thanksgiving was held in Newfoundland in 1578 by Martin Frobisher, an English navigator, who wanted to give thanks to God because he survived his voyage from England. Other settlers arriving in Newfoundland followed this tradition. In 1879, the Canadian Parliament declared November 6 a national Thanksgiving Day holiday, but by 1957, the date moved to the second Monday in October and declared it "a day of General Thanksgiving to the Almighty God for the bountiful harvest with which Canada has been blessed." On Thanksgiving Canadians celebrate with a special dinner with family and friends. A typical celebration includes turkey, potatoes, cranberry sauce, yams, acorn squash, salads, and pies. With harvest over, October is the perfect time for Canadians and all of us to give thanks for the bountiful harvest.

Featured Book

Thanksgiving Day at Our House: Thanksgiving Poems for the Very Young, by Nancy White Carlstrom; illus. by R. W. Alley. Simon & Schuster, 1999.

This lovely collection of Thanksgiving poems describes the traditional holiday as celebrated in both the United States and Canada.

Additional Books

Thanks for Thanksgiving, by Heather Paterson; illus. by Mary Jane Gerber. Scholastic Canada, 1998.

Thanksgiving: Stories and Poems, edited by Caroline Feller Bauer; illus. by Nadine Bernard Westcott. HarperCollins, 1994.

Activities

1. Make a list of all the things for which you are thankful in October.
2. Make, bake, and enjoy an apple or pumpkin pie.

*October 9 Leif Eriksson Day

Leif Eriksson, a Norwegian convert to Christianity, was sent by King Olaf I to convert the Vikings of Greenland to Christianity. Stories indicate that he was blown off course and landed on the coast of North America and became the first European to set foot in America. In 1964, the United States Congress authorized the president to proclaim October 9 each year Leif Eriksson Day. This is an appropriate date because the first organized group of Norwegian immigrants arrived in the United States on October 9, 1825. Eriksson is honored for his bold adventurous spirit.

Featured Book

Focus on Vikings, by Anita Ganeri. Gloucester, 1992.

Read excerpts of this nonfiction account of the Viking. Pictures, charts, and activities supplement the text.

Additional Books

Leif the Lucky, by Ingri & Edgar Parin D'Aulaires. Doubleday, 1941.

Viking Longboats, by Margaret Mulvihill. Gloucester, 1989.

Activities

1. Do research to learn more about the Vikings and the world in which they lived.
2. Make a Viking helmet.
3. Read some Norse myths. These tales predated Christianity in the part of the world where the Vikings lived.

October 10 Roller-Skating Month

The Roller Skating Association International sponsors Roller Skating Month in October to remind people of the fun they can have skating indoors or outdoors. Roller-skating is not a new sport. The first roller-skate was developed in 1760 by Belgian inventor Joseph Merlin. He wore his skates to a party in London and crashed into an expensive mirror. It was 1863 before James Plimpton invented a roller-skate that could turn. By the 1880s roller-skating had become a popular pastime for men, women, and children. Roller-skates are much improved these days, and the invention of the in-line skate has made rolling on skates even more popular.

Featured Book

Penelope Gets Wheels, by Esther Allen Peterson; illus. by Susanna Natti. Crown, 1982.

Penelope buys roller-skates when her birthday money won't stretch to a car or bicycle, but they turn out to be the "best wheels a kid can have."

Additional Book

Rabbits on Roller Skates! by Jan Wahl; illus. by David Allender. Crown, 1986.

Activities

1. Invite everyone to spend time together on the wheels of their choice: roller-skates, in-line skates, bicycles, or scooters.
2. Go to a roller rink and try roller-skating.

October 11 Family History Month

The governors of several states have made October Family History Month by official proclamation, and genealogists worldwide promote the celebration of family history. Family History Month is a time to celebrate your family's unique accomplishments, to share family stories, and to visit with older relatives about your family's past.

Featured Books

Homeplace, by Anne Shelby; illus. by Wendy Anderson Halperin. Orchard, 1995.

A grandmother traces her family's history through the years.

When I Was Young: One Family Remembers 300 Years of History, by James Dunbar; illus. by Martin Remphry. Carolrhoda, 1999.

A young boy learns all about his family history from his grandmothers who pass down stories of previous generations.

Additional Books

Grandfather's Journey, by Allen Say. Houghton Mifflin, 1993.

The Morning Chair, by Barbara M. Joosse; illus. by Marcia Sewall. Clarion, 1995.

Activities

1. Talk to your grandparents, aunts and uncles, and parents about your family's history.
2. Write down a family story that you would like your children to know and save it with your treasures.
3. Bring a photograph of your ancestors to share with the group. Where was the photograph taken? What was the occasion? What is happening and why?

October 12 Columbus Day

On October 12, 1492, Christopher Columbus landed on a small island in the Bahamas. He named the island San Salvador. Columbus continued to believe that he landed in the East Indies even after many others recognized that he had arrived in the Americas. It is quite possible that other explorers reached America before Columbus, but his adventures have long been celebrated and are held in particularly high esteem by Italian-Americans. The first celebration of Columbus Day took place in New York City in 1792. By presidential proclamation, Columbus Day is always celebrated the second Monday in October.

Featured Book

The Log of Christopher Columbus—First Voyage: Spring, Summer, and Fall 1492, by Christopher Columbus; selections by Steve Lowe; illus. by Robert Sabuda. Philomel, 1992.

Actual selections from Columbus's log make this a fascinating view of the explorations. Each selection is dated and reduced to a manageable portion of the log.

Additional Books

Columbus Day, by Vicki Liestman; illus. by Rich Hanson. Carolrhoda, 1991.

The First Voyage of Christopher Columbus, by Barry Smith. Viking, 1992.

Follow the Dream: The Story of Christopher Columbus, by Peter Sis. Alfred A. Knopf, 1991.

Activities

1. Using a map of the world, follow the voyage of Christopher Columbus, marking various stops and the dates of the discoveries he claimed.
2. Learn more about the world in 1492. Use *1492: The Year of the New World* by Piero Ventura (G. P. Putnam's Sons, 1991) or *The World in 1492*, by Jean Fritz, et al. (Henry Holt, 1992).

October 13 National Pizza Month

Did you know that Americans eat approximately one-hundred acres of pizza each day or about 350 slices per second? Since 1987, October has been designated as National Pizza Month. The Pizzaware Gourmet Bakeware Company has compiled some fascinating pizza industry facts. For example, they report that there are 61,269 pizzerias in the United States. That's 17 percent of all restaurants. Ninety-three percent of Americans eat at least one pizza per month, and the average American eats about twenty-three pounds of pizza per year! Children between the ages of three and eleven prefer pizza over all other foods for lunch and dinner. Many would eat it for breakfast, too!
While pepperoni is America's favorite topping, people in other parts of the world have their own unique toppings. In India, pickled ginger, minced mutton and tofu are favorite toppings. In Japan, squid pizza is a favorite. A Russian treat is pizza topped with a combination of sardines, tuna, mackerel, salmon, and onions, and Costa Ricans like coconut on their pizza.

Wherever you eat pizza and whatever topping you prefer, October 13 is a good time to read about pizza.

Featured Book

Pizza for Breakfast, by Maryann Kovalski. Morrow, 1991.

When Frank and Zelda wish for more customers for their restaurant, their wish is granted; and they realize that they gained more than they expected.

Additional Book

The Little Red Hen (Makes a Pizza), retold by Philemon Sturges; illus. by Amy Walrod, Dutton, 1999.

Activities

1. Make a pizza and share it with friends.
2. Take a pizza topping survey. What is the favorite topping in your class? Your neighborhood? Your school?
3. Make a list of pizza toppings. Now make a list of all the things that would not be good pizza toppings.

October 14 National Cookie Month

The first cookies, which originated in Rome around 400 B.C., were thin unleavened wafers with a tough texture and very little taste. It was more like a cracker which the Romans dipped in wine to soften. Sweet cookies are a much more recent development. They were brought to the United States by English, Scottish, and Dutch immigrants. Some of the early cookies were called Snickerdoodles and Cry Babies. In October, National Cookie Month, we celebrate the delicious taste and smell of cookies and the feelings of warmth, friendship, and tradition that comes with cookie baking and cookie eating.

Featured Books

The Gingerbread Boy, retold and illus. by Richard Egielski. HarperCollins, 1997.

The Gingerbread Man, retold by Jim Aylesworth; illus. by Barbara McClintock. Scholastic, 1998.

The Gingerbread Man, retold by Eric A. Kimmel; illus. by Megan Lloyd. Holiday House, 1993.

These are three of the many versions of this story about the cookie that comes to life and runs away from home.

Activities

1. Bake and decorate gingerbread boys and girls.
2. Have everyone bring six cookies to share. Enjoy the variety.
3. Decorate paper cutouts of gingerbread cookies using crayons and markers.

*October 15 National Grouch Day

The sponsors of this celebration feel that grouches deserve a day to be recognized. Of course, grouches are usually recognized, but the sponsors intend National Grouch Day to be a day to honor grouches. Perhaps October 15 should be the one day all year that we allow ourselves to be grouches!

Featured Book

Mother Grumpy's Dog Biscuits: A True Tail, by Becky Wilson-Kelly. Henry Holt, 1990.

Mother Grumpy bakes the best dog biscuits for miles, but she fails miserably as a salesperson.

Additional Book

Blumpoe the Grumpoe Meets Arnold the Cat, by Jean Davies Okimoto; illus. by Howie Schneider. Little Brown, 1989.

Activities

1. Spend two minutes acting very grumpy. How does it feel? Do you enjoy being a grump? Would you like to spend your whole life as a grump?
2. Make a list of the things that make you grumpy. Are there ways to resolve the problems without grumping?
3. Draw a picture of the world's worst grump.

*October 16 Dictionary Day

On October 16, 1758, Noah Webster was born in West Hartford, Connecticut. His father was a farmer who also worked as a weaver. His mother worked at home raising Noah and his two brothers and two sisters. Noah loved learning. In 1774, when he was sixteen, he began college at Yale. He became a teacher, but he was dissatisfied with the school books available to his students. He was particularly upset that his students had to study from English textbooks. The United States had won its freedom from England while Noah was in college. The country needed its own books, and Noah Webster wrote one, *A Grammatical Institute of the English Language*, which was commonly called the *Blue-Backed Speller*. Several years later, he wrote the first American dictionary. People throughout the United States spelled, pronounced, and used words differently. Webster wanted to create a uniformity in American speech and spelling. It took Webster twenty-seven years to write his first dictionary which contained 70,000 words, many with new American spellings. For example, he used the word "color" instead of the English "colour." Over the years, millions of people have used a Webster dictionary. Webster's birth date is celebrated as Dictionary Day.

Featured Book

Fighting Words, by Eve Merriam; illus. by David Small. Morrow, 1992.

Leda and Dale hate each other and play a particularly creative game of name-calling using words from the *Oxford English Dictionary* and *Webster's Unabridged*.

Additional Books

The Barber's Cutting Edge, by Gwendolyn Battle-Lavert; illus. by Raymond Holbert. Children's Book Press, 1994.

There's an Ant in Anthony, by Bernard Most. Mulberry, 1980.

Who, Said Sue, Said Whoo? by Ellen Raskin. Atheneum, 1973.

Activities

1. Use the dictionary to find five new words. Use them correctly in a sensible sentence. Does anyone know what you mean? Be prepared to explain the meanings.

2. Create your own list of friendly words. Go through the dictionary and find interesting words that you might call a friend.
3. Make your own dictionary entry. Invent a word and explain what it means. Try to use the new word in a sentence.

*October 17 Black Poetry Day

On October 17, 1711, Jupiter Hammon, the first African American poet was born. He spent most of his life on Long Island, New York. A slave to a prominent merchant, Hammon learned how to read and published his first poem at the age of forty-nine. Eventually he published several poems and prose works. Black Poetry Day began in 1970 as a way to honor the contributions made by African Americans to our culture. This day is celebrated in various towns in New York State. African American poets are invited into schools to read their work, and students are encouraged to try writing their own poetry.

There are many wonderful collections of poetry by African American poets. Listed below is a sampling.

Featured Books

Golden Slippers: An Anthology of Negro Poetry for Young Readers, selected by Arna Bontemps; illus. by Henrietta Bruce Sharon. Harper & Brothers, 1941.

*In Daddy's Arms I Am Tall: African Americans Celebrating Father*s, illus. by Javaka Steptoe. Lee & Low, 1997.

It's Raining Laughter, by Nikki Grimes; photographs by Myles C. Pinkney. Dial, 1997.

Nathaniel Talking, by Eloise Greenfield; illus. by Jan Spivey Gilchrist. Black Butterfly, 1988.

Pass It On: African-American Poetry for Children, selected by Wade Hudson; illus. by Floyd Cooper. Scholastic, 1993.

Activities

1. Select a poem and illustrate it.
2. Memorize a verse or two of a favorite poem from the books listed. Recite it for the group.
3. Try your own hand at writing poetry. Model your poem on one in today's book.

*October 18 Alaska Day

On this date in 1867 the territory of Alaska was transferred from Russia to the United States which had purchased it on March 30. Fishing became a major industry. When gold was discovered in 1880, Alaska experienced a series of gold rushes. The United States began to appreciate the rich natural resources of Alaska and in 1912 declared Alaska a territory. Alaska remained a territory until it became a state on January 3, 1959.

Featured Book

Raven and River, by Nancy White Carlstrom; illus. by Jon Van Zyle. Little Brown, 1997.

Although the book is a celebration of spring, it begins during the cold Alaskan winter. The sights and sounds of Alaska are reproduced in both the poetry and the illustrations.

Additional Book

Goodbye Geese, by Nancy White Carlstrom; illus. by Ed Young. Philomel, 1991.

Activity

Locate Alaska on a map of the United States. Why are the images that we associate with Alaska different from those of Florida or Hawaii? What is Alaska's physical relationship to Russia; the United States? List what you have learned about Alaska.

October 19　　National School Lunch Week

The third week in October is celebrated as National School Lunch Week. The National School Lunch Program was established by an Act of Congress in 1946, "as a measure of national security to safeguard the health and well-being of the nation's children and to encourage the domestic consumption of nutritious agricultural commodities." About twenty-seven million school lunches are served every school day in 96,000 public and private schools in the United States. Schools across the nation hold special events in honor of National School Lunch Week. These events include menus built around certain themes, special food treats, and tributes to the cafeteria staffs.

Featured Book

Spider School, by Francesca Simon; illus. by Peta Coplans. Dial, 1996.

Kate's worst nightmare involves her first day at school when she is served spiders for lunch.

Additional Books

Lunch Bunnies, by Kathryn Lasky; illus. by Marilyn Hafner. Little Brown, 1996.

The Lunch Line, by Karen Berman Nagel; illus. by Jerry Zimmerman; includes math activities by Marilyn Burns. Scholastic, 1996.

Yoko, by Rosemary Wells. Hyperion, 1998.

Activities

1. Find ways to thank the cafeteria ladies for their hard work at school.
2. Make posters in honor of National School Lunch Week and hang them in the school cafeteria.
3. Work in groups to plan a week's worth of wonderful school lunch menus. Be as imaginative as you choose.

October 20　　Bridge Day

One-hundred-fifty-thousand people gather on the third Saturday in October to celebrate the New River Gorge Bridge in Fayetteville, West Virginia. The bridge is the world's longest steel-arch span and is one

of the highest bridges in the country. Food, crafts, and souvenirs are sold to those walking across the bridge. Braver souls jump from the bridge with parachutes.

The real scary things about bridges in children's literature, however, are the trolls who live beneath. Celebrate Bridge Day by reading a version of this famous Norwegian tale.

Featured Books

Hey, Pipsqueak! by Kate McMullan; illus. by Jim McMullan. HarperCollins, 1995.

3 Billy Goats Gruff, retold by Ted Dewan. Scholastic, 1994.

Three Billy Goats Gruff, retold by Tom Roberts; illustrated by David Jorgensen. Rabbit Ears Books, 1989.

The Three Billy-Goats Gruff; A Norwegian Folktale, by Peter Christen Asbjorsen; woodcuts by Susan Blair. Holt, Rinehart, and Winston, 1963.

Three Cool Kids, by Rebecca Emberley. Little Brown, 1995.

Activities

1. Compare two or more versions of the folktale. What elements remain the same? Which are different? Why do you think there are differences?
2. Draw your own picture of the bridge, the troll, or the goats.

October 21 Old Home Day

A day when a community gathers to celebrate its many virtues is often called Old Home Day. This is a time when people who have moved away return "home," to visit friends and relatives and to enjoy local parades, fairs, and picnics. It's a day when local residents celebrate their town and its history.

Featured Book

Old Home Day, by Donald Hall; illus. by Emily Arnold McCully. Browndeer Press, 1996.

The story of the growth of a New Hampshire village from prehistory to the bicentennial celebration of its founding.

Additional Book

New Hope, by Henri Sorensen. Lothrop, Lee & Shepard, 1995.

Activities

1. What makes your town special? If a tourist were to visit your community, what sights would you suggest?
2. Learn more about the history of your town or community. How old is it? Does your community hold an Old Home Day? If so, plan to participate. If not, why not?

*October 22 Abu Simbel Festival

On October 22 and on February 22, people flock to the temple of Ramses II in Abu Simbel, Egypt, as the sun rises. Only on these two days does the temple fill with light of the sun so that the inner sanctum that holds statues of Ramses II is visible. After viewing the statues of Ramses II and various Egyptian gods, the people go outside for a fair featuring folk dancing.

Featured Book

The Hundredth Name. by Shulamith Levey Oppenheim; illus. by Michael Hays. Boyds Mills, 1995.

A young Egyptian boy, Salah, is concerned because his camel seems sad. In this story from ancient Egypt, Salah finally discovers how to help not only his camel, but all the camels of the desert.

Additional Books

Master of the Royal Cats, by Jerzy Laskowski; illus. by Janina Domanska. Seabury, 1965.

The Egyptian Cinderella, by Shirley Climo; illus. by Ruth Heller. Thomas Y. Crowell, 1989.

Activity

1. Draw or construct a model of one of the pyramids. Use reference books to check for accuracy.
2. View one of the numerous videos about ancient Egyptian civilization.

October 23 International Dollhouse and Miniatures Month

Local dollhouse and miniatures retailers around the world celebrate October as International Dollhouse and Miniatures Month. They hold special workshops so that men, women, and children can experience the fun of working with miniatures. The retailers believe that dollhouse decorating and miniature construction is easy, too, so people should try this enjoyable hobby. In addition to dollhouses, miniatures include other miniature buildings, model ships, and model cars. Local retailers and hobbyists often display their work at local shopping malls and public buildings during October.

Celebrate International Dollhouse and Miniatures Month by reading fantasies about teeny tiny people.

Featured Book

Morgan and the Artist, by Donald Carrick. Clarion, 1985.

When an artist paints a small man in one of his paintings, he is surprised to have the tiny man walk out of the painting and announce that he is the painter's inspiration.

Additional Books

Little Little Sister, by Jane Louise Curry; illus. by Erik Blegvad. Margaret K. McElderry, 1989.

The Teeny Tiny Teacher, by Stephanie Calmenson; illus. by Denis Roche. Scholastic, 1998.

The Teeny Tiny Woman: A Traditional Tale, by Arthur Robins. Candlewick, 1998.

Activities

1. Invite members of the group to share their dollhouses and miniatures.

2. Imagine that you are a teeny tiny student. What problems might you encounter in your classroom or with your friends. Write a short story or draw a picture illustrating some of the problems of being tiny in a big world.

*October 24 United Nations Day

On October 24, 1945, the United Nations was formally established by representatives of the United States, Great Britain, the Soviet Union, and Nationalist China. The United Nations has encouraged conversation between the nations of the world and supported human rights, focusing on the needs of children and refugees. Every member nation celebrates United Nations Day, some with parades, international fairs, dinners, and school programs.

Celebrate United Nations Day by reading Cinderella stories from around the world. In 1893 Marian Roalfe Cox published summaries of 345 Cinderella tales. Add to that number modern retellings, and there are literally hundreds to chose from.

Featured Books

Cinderella: Or, The Little Glass Slipper, by Charles Perrault; illus. by Marcia Brown. Scribner, 1954.

The Golden Sandal: A Middle Eastern Cinderella, by Rebecca Hickox; illus. by Will Hillenbrand. Holiday House, 1998.

Jouanah, a Hmong Cinderella, adapted by Jewell Reinhart Coburn with Tzexa Cherta Lee; illus. by Ann Sibley O'Brien. Shen's Books, 1996.

The Korean Cinderella, by Shirley Climo; illus. by Ruth Heller. HarperCollins, 1993.

The Persian Cinderella, by Shirley Climo; illus. by Robert Florczak. HarperCollins, 1999.

Princess Furball, by Charlotte Huck; illus. by Anita Lobel. Greenwillow, 1989.

Raisel's Riddle, by Erica Silverman; illus. by Susan Gaber. Farrar, Straus & Giroux, 1999.

Smoky Mountain Rose: An Appalachian Cinderella, by Alan Schroeder; illus. by Brad Sneed. Dial, 1997.

Sootface: An Ojibwa Cinderella Story, retold by Robert D. San Souci; illus. by Daniel San Souci. Delacorte, 1994.

The Turkey Girl: A Zuni Cinderella, retold by Penny Pollock; illus. by Ed Young. Little Brown, 1996.

Activity

After reading two or more of the Cinderella stories, compare and contrast them. Locate on a map the setting for each story. Why do you think that so many countries share similar stories? Does the setting of the story account for certain unique aspects of a particular retelling?

October 25 Double Ninth Festival

This festival is celebrated in Hong Kong and China. Common activities include kite flying, picnicking, and visiting the cemetery. On the island of Taiwan and in the area of Fukien, on mainland China, huge crowds gather on the hills to watch kite flying contests. The kites for festival days are huge and must be flown by many handlers. They may be shaped like dragons, butterflies, frogs, or insects. It is also part of the game to try to bring down other teams' kites. There is much rivalry, so much, in fact, that police are sometimes needed to keep order. While the ancient Chinese considered it an unlucky day, modern people fully enjoy the day, focusing on the soaring kites. The date of the Double Ninth Festival varies according to the lunar calendar.

2001	10/25	2006	10/30
2002	10/14	2007	10/19
2003	10/4	2008	10/07
2004	10/22	2009	10/26
2005	10/11	2010	10/16

Featured Book

Dragon Kite of the Autumn Moon, by Valerie Reddin; illus. by Jean and Mou-Sien Tseng. Lothrop, Lee & Shepard, 1991.

With Grandfather ill, Tad-Tin is unable to finish his kite in time for the Kite's Day celebration. Flying a kite will carry away misfortune, including Grandfather's illness. Tad-Tin comes up with a creative solution; he'll use the Dragon Kite that hangs above his bed. The story takes place on the island of Taiwan, formerly called Formosa.

Additional Books

Hamlet and the Enormous Chinese Dragon Kite, by Brian Lies. Houghton Mifflin, 1994.

The Tiny Kite of Eddie Wing, by Maxine Trottier; illus. by Al Van Mil. Stoddart, 1995.

Activities
1. Design a dragon kite.
2. Make a kite.
3. Go fly a kite.

October 26 Month of the Dinosaur

The Month of the Dinosaur is promoted as a time for educational and scientific events related to dinosaurs. Many science museums take advantage of the Month of the Dinosaur to hold special exhibits, demonstrations, and talks about dinosaurs and other prehistoric creatures. Scientific conferences on the dinosaur are planned for October, as are fun events in elementary schools to educate and inform children about the prehistoric world. Many children, however, are already dinosaur experts, and there are dozens of wonderful fiction and nonfiction books available on this fascinating topic.

A Sampling of Nonfiction Books about Dinosaurs

Dinosaur Story, by Joanna Cole; illus. by Mort Kunstle. Morrow, 1974.

Dinosaur Valley, by Mitsuhiro Kurokawa. Chronicle, 1992.

Dinosaurs, by Gail Gibbons. Holiday, 1987.

My Visit to the Dinosaurs, by Aliki. HarperCollins, 1985.

A Sampling of Fiction Books about Dinosaurs

Dinosaur Bob and His Adventures with the Family Lazardo, by William Joyce. HarperCollins, 1995.

Dinosaur Chase, by Carolyn Otto; illus. by Thacher Hurd. HarperCollins, 1991.

Dinosaur Dream, by Dennis Nolan. Macmillan, 1990.

Dinosaur Garden, by Liza Donnelly. Scholastic, 1990.

I Met a Dinosaur, by Jan Wahl; illus. by Chris Sheban. Harcourt Brace, 1997.

The Last Dinosaur, by Jim Murphy; illus. by Mark Alan Weatherby. Scholastic, 1988.

Activities

1. Invite a paleontologist to talk with your group about dinosaurs.
2. Visit a natural history museum to see the dinosaur displays.
3. Read a fiction and a nonfiction book about dinosaurs. Which book is more reliable? Which is more fanciful? Discuss the differences between fiction and nonfiction.

*October 27 Subway Day

On October 27, 1904, the New York City subway system began operation. It was the first transit system in the world to be built underground. Today New York City Transit's subway system served 4.3 million customers on an average weekday and about 1.3 billion passengers a year. Five-hundred-forty-seven trains are in service during the weekday rush hours. There are twenty-five subway routes, which are interconnected and provide transportation throughout Manhattan, Queens, Brooklyn, and the Bronx. Celebrate the beginning of subway transportation in New York by reading stories about subways.

Featured Book

Subway Sparrow, by Leyla Torres. Farrar, Straus & Giroux, 1993.

When a sparrow gets trapped in a subway car, a young girl, with the help of the other passengers, tries to set it free.

Additional Books

Jamaica Louise James, by Amy Hest; illus. by Sheila White Samton. Candlewick, 1996.

Left Behind, by Carol Carrick; illus. by Donald Carrick. Clarion, 1988.

Activities

1. Use reference books to find out which cities in the world have subways. Which is the oldest, the longest, the newest?
2. Has anyone in the group ridden a subway? Share stories about subway train rides.
3. If you live in a city with a subway, arrange a tour of the subway station.

*October 28 Punky Night

In Hinton, England, on October 28, children make lanterns from hollowed out pumpkins with a candle inside. They carry these lanterns through the village chanting:

"It's Punky Night tonight
It's Punky Night tonight
Give us a candle, give us a light
It's Punky Night tonight."

The children gather in the village meeting hall where their punkies are judged and the boy and girl who collect the most money for charity are crowned Punky King and Queen. This custom began many years ago when some men from the village went to a fair in a neighboring town and stayed too late to see their own way home. Their wives made punky lamps and went to fetch their husbands.

Featured Book

Pumpkin Fiesta, by Caryn Yacowitz; illus. by Joe Cepeda. HarperCollins, 1998.

Foolish Fernando thinks he is copying Old Juana's successful pumpkin-growing routine, but he fails to copy the effort she puts into her garden.

Additional Books

Pumpkin Day, Pumpkin Night, by Anne Rockwell; illus. by Megan Halsey. Walker, 1999.

The Pumpkin People, by David Cavagnaro and Maggie Cavagnaro. Sierra Club Books, 1979.

Activities

1. Carve a pumpkin.
2. Use orange construction paper to draw a punky lamp.
3. Using *In a Pumpkin Shell: Over 20 Pumpkin Projects for Kids*, by Jennifer Storey Gillis (Storey Communications, 1992), complete your own pumpkin craft project.

*October 29 Turkey Republic Day

On Republic Day the nation of Turkey celebrates its founding and the election of its first president, Mustafa Kemal Atatürk, on October 29, 1923. Turkey was originally an Islamic country, but in 1928 declared itself a secular state. The two-day celebration includes parades, music, torchlight processions, and other festivities.

Turkey spans two continents, Asia and Europe, and is part of the Middle East. It is extremely mountainous with an average elevation of 1,100 meters above sea level. Turkey is also a land of earthquakes. It attracts many tourists each year who explore its historic sites and enjoy its fine climate and spectacular views. Celebrate Turkey's Republic Day by reading folktales from Turkey.

Featured Book

Little Mouse & Elephant: A Tale from Turkey, retold by Jane Yolen; illus. by John Segal. Simon & Schuster Books for Young Readers, 1996.

Boastful Little Mouse sets out to show that he is stronger than anyone in the forest, even Elephant, and nothing that happens can change his opinion.

Additional Books

New Patches for Old: A Turkish Folktale, retold by Barbara K. Walker and Ahmet E. Uysal; illus. by Harold Berson. Parents' Magazine Press, 1974.

Three Clever Mice: Folktales, retold and adapted by Gerda Mantinband; illus. by Martine Gourbault. Greenwillow, 1993.

Activity

Imagine that you are a tourist traveling to Turkey. Find Turkey on a map. How would you get there? How long would your trip take? Once you arrived in Turkey, what would you want to see? List some historical sites, as well as some recreational places to visit.

October 30 Lucky Day

Any day can be a lucky day. Celebrate a year of good luck on October 30.

Featured Book

The House of Gobbaleen, by Lloyd Alexander; illus. by Diane Goode. Dutton, 1995.

Tooley always complains about his luck, but despite the wise cat's warnings, he invites a little man in a green leather jacket into his home because he thinks it will change his luck.

Additional Books

Three Ducks Went Wandering, by Ron Roy; illus. by Paul Galdone. Clarion, 1979.

Three Wishes, by Lucille Clifton; illus. by Stephanie Douglas. Viking, 1974.

Activities

1. What role does luck play in today's story?
2. Are you lucky or unlucky? Find evidence of your own good luck. Do you believe that there is such a thing as luck? Do you have control over your own luck?

*October 31 Nevada Day

On October 31, 1864, Nevada became the thirty-sixth state to join the Union. It became part of the United States after the Mexican War of 1848, but over the next several years belonged to California and Utah. In 1859, the world's richest silver deposits were discovered in Nevada which led to the formation of an independent Nevada Territory in 1861. Mining towns like Virginia City, many of which are now ghost towns, began with the discovery of gold in Nevada. Gold and silver remain important to Nevada's economy. Nevada leads the nation in production of these metals. Nevada is called *The Silver State*.

Modern day Nevada is a tourist mecca. Millions of people travel to Nevada each year to participate in gambling and entertainment in the resorts of Las Vegas and Reno. Manufacturing is also important, and there is some farming in Nevada, mostly cattle ranching. Nevada's terrain is fascinating. It includes both mountains and deserts, such as the Black Rock Desert and Death Valley.

Featured Book

Sierra, by Diane Siebert; illus. by Wendell Minor. HarperCollins, 1991.

In poetry and paintings, author and artists, present California's majestic Sierra Nevada Mountains and the multitude of animals who inhabit the region.

Additional Book

Lost, by Paul Brett Johnson and Celeste Lewis; illus. by Paul Brett Johnson. Orchard, 1996.

Activities

1. What kind of terrain marks the region where you live? Are there mountains? Rivers? Deserts? If you were to choose one distinguishing feature, what would it be?
2. Locate Nevada on a map. Find the Sierra Nevada Mountain Range. Find the various deserts and the mining towns. Identify the major cities. How far is it from Las Vegas to Virginia City? How far is it from your home to Reno?

*November 1 National Authors' Day

Every November 1, by proclamation of the United States Department of Commerce, we celebrate National Authors' Day. This celebration was begun in 1929 by the General Federation of Women's Clubs, but continues as a day to show appreciation for the men and women who have created the literature that we enjoy.

Featured Book

What Do Authors Do? by Eileen Christelow. Clarion, 1995.

This book uses charming illustrations and clear text to answer the question posed by its title.

Additional Books

A Bookworm Who Hatched, by Verna Aardema; photos by Dede Smith. Richard C. Owen, 1992.

The Days Before Now: An Autobiographical Note by Margaret Wise Brown, adapted by Joan W. Blos; illus. by Thomas B. Allen. Simon & Schuster, 1993.

Activities

1. After reading about Verna Aardema or Margaret Wise Brown, read one of the author's books. Discuss the book and how the author's life might have contributed to her writing.
2. Invite a local author to visit with your group.
3. Become an author by writing a brief story from your own life.

*November 2 North Dakota Statehood Day & South Dakota Statehood Day

On November 2, 1889, both North and South Dakota gained statehood. While each state has distinct characteristics, they share many things in common both in terms of the land itself and the culture of the area. In prehistoric times, dinosaurs roamed across both states, and archeological digs are ongoing. Both states are part of the Great Plains and were inhabited by the Sioux Indians. Buffalo were plentiful on the prairies, but were routinely killed when the railroads were built and white settlers moved into the area. Today both North and South Dakota have large herds of buffalo in their state parks. Buffalo farming is becoming more popular in the western plains.

North Dakota became the thirty-ninth state. It is an extremely rural state with only about 600,000 inhabitants. The eastern part of the state is a rich agricultural area growing wheat, soybeans, sunflowers, and other grains. West of the Missouri River, much of the land is devoted to grazing. The Badlands of western North Dakota are home to buffalo, Rocky Mountain sheep, coyotes, and prairie dogs.

South Dakota became the fortieth state. Its eastern area is also rich farming land devoted to corn, wheat, soybeans, and alfalfa. West of the Missouri River the land is used for grazing until it begins to rise in jagged cliffs and ravines. The South Dakota Badlands attract hundreds of visitors each year. Mt. Rushmore, in the Black Hills, features the sculpted heads of four presidents: George Washington, Thomas Jefferson, Abraham Lincoln, and Teddy Roosevelt.

Celebrate the statehood of North and South Dakota by reading stories of the Dakota Indians.

Featured Book

Gift Horse: A Lakota Story, by S. D. Nelson. Harry N. Abrams, Inc., 1999.

A Sioux boy and his horse become involved in a conflict with an enemy tribe. Author and illustrator Nelson is a member of the Standing Rock Sioux Tribe and grew up in North Dakota.

Additional Books

The Great Race of the Birds and Animals, by Paul Goble. Bradbury, 1985.

The Legend of the White Buffalo Woman, by Paul Goble. National Geographic Society, 1998.

Activity

1. Find out more about buffalo: habitat, diet, and behavior. In what ways did the American Indians use the buffalo?
2. Look at maps of North and South Dakota. Locate the numerous Indian reservations, the Bad Lands, the Black Hills, and the Missouri River.

*November 3 Peanut Butter and Jelly Sandwich Day

On November 3, 1718, John Montague was born in England. As the Fourth Earl of Sandwich, Montague is credited with the invention of a bread and filling concoction that we now call the sandwich. November is National Peanut Butter Month in the United States. Combine these two occasions to create a new holiday, Peanut Butter and Jelly Sandwich Day.

Featured Book

The Giant Jam Sandwich, by John Vernon Lord; verses by Janet Burroway. Houghton Mifflin, 1972.

In this silly story, the citizens of Itching Down must find a way to control the four million wasps that attack their town.

Additional Books

Make Me a Peanut Butter Sandwich and a Glass of Milk, by Ken Robbins. Scholastic, 1992.

So Hungry! by Harriet Ziefert and Carol Nicklaus. Random House, 1987.

Activities

1. Make peanut butter and jelly sandwiches and enjoy eating them together.
2. Make a list of all the kinds of sandwiches that children might bring to school. Then try inventing other more interesting kinds of sandwiches. Write up the recipes for your fantastic sandwiches.

November 4 International Drum Month

The drum, a percussion instrument, is the oldest of all musical instruments. The most popular kinds of drums are snares, the bass drum, and the timpani. However, steel drums and bongos are two of many other kinds of drums popular today. The Percussion Marketing Council promotes drums and drumming during November, International Drum Month. According to the council, "Music is the universal language and rhythm is the voice that helps express its thoughts and punctuate its feelings."

Drums are used to make music, but they are also used by people of many cultures as a form of communication. In today's stories, African drums bring comfort to those far away.

Featured Book

Faraway Drums, by Virginia Kroll; illus. by Floyd Cooper. Little Brown, 1998.

Two sisters alone in a city apartment stem their fears by imagining they are in Africa listening to the sounds which their great-grandmother used to describe.

Additional Book

The Distant Talking Drum: Poems from Nigeria, by Isaac Olaleye; illus. by Frané Lessac. Boyds Mills, 1995.

Activities

1. Invite a drummer to demonstrate drumming to your group.
2. Ask everyone to make a drum out of readily available household items and to bring their drums to share with the group.
3. Borrow a set of rhythm instruments from a school or church and let the group play along with their favorite music.

*November 5 Guy Fawkes Day

The year 1605 was a dangerous time for the British king. Conspirators hid twenty barrels of gunpowder in a cellar under the Parliament and planned to blow up the Houses of Parliament and destroy King James I. The night before the planned explosion, the plot was discovered. On November 5, 1605, Guy Fawkes, the group's leader, was arrested in the cellars of the British House of Parliament and the Gunpowder Plot was ended. Guy Fawkes is considered by many to be England's most notorious traitor. He was immortalized in this old English nursery rhyme:

> "Remember, remember the fifth of November
> Gunpowder treason and plot
> We see no reason
> Why gunpowder treason
> Should ever be forgot!"

Bonfire Night is celebrated throughout the United Kingdom. Services of thanksgiving are held in churches often followed by boisterous parties involving fireworks, cannon fire, and big bonfires. Effigies of Guy Fawkes, called "guys," are paraded through villages and towns and then tossed into the bonfire.

Celebrate Guy Fawkes Day and Bonfire Night by reading English folktales.

Featured Book

Molly Limbo, by Margaret Hodges; illus. by Elizabeth Miles. Atheneum, 1996.

When an old miser buys a haunted house, he discovers that the ghost, Molly Limbo, is playful, but fair.

Additional Books

The Magpie's Nest, retold by Joanna Foster; illus. by Julie Downing. Clarion, 1995.

Wizard of Wind & Rock, by Pamela F. Service; illus. by Laura Marshall. Atheneum, 1990.

Activity

What is a traitor? Look up the word in the dictionary. Can you think of others who have been labeled traitors? What did they do?

*November 6 Saxophone Day

On November 6, 1814, Adolphe Sax was born in Dinant, Belgium, son of a cabinetmaker. He became a prolific inventor, musician, craftsman, performer, and conductor. His best known invention is the saxophone that he patented in 1846. Unfortunately, he never shared the details of how he invented the saxophone. He also invented the first working bass clarinet and made improvements to many wind and percussion instruments.

As today's stories reflect, the saxophone is most effectively used as a jazz instrument.

Featured Book

Little Lil and the Swing-Singing Sax, by Libba Moore Gray; illus. by Lisa Cohen. Simon & Schuster, 1996.

Little Lil is determined to retrieve Uncle Sudi Man's saxophone from the pawnshop. Lil knows that when the saxophone is returned, everyone will feel cheerful again.

Additional Book

Hip Cat, by Jonathan London; illus. by Woodleigh Hubbard. Chronicle, 1993.

Activities

1. Invite a saxophone player or teacher to perform for your group and to share some interesting facts about the saxophone.

2. Listen to jazz performed by such well-known saxophone players as Charlie Parker, John Coltrane, Herbie Hancock, or Branford Marsalis.
3. Do some research to find out how other musical instruments were invented or evolved.

November 7 Dewali (The Festival of Lights)

Dewali is as important to Hindus as Christmas is to Christians. It is celebrated on different dates by people from different areas, but always occurs in October or November. Hindus throughout the world honor the goddess of wealth and prosperity, Lakshmi. In northern India, Dewali marks the beginning of the new year, and people whitewash their houses, resolve old debts, and pray for success in the new year. Everyone buys new clothes for the holiday. In modern India, people even send greeting cards to one another wishing them a prosperous new year. It is a time to honor various tools used in various professions. People clean and polish their tools and decorate them with flowers. People exchange gifts of sweets and enjoy festive holiday meals together. Lamps, bonfires, and fireworks decorate houses and communities.

To Learn More about Dewali

Diwali: Hindu Festival of Light,s by Dianne M. MacMillan. Enslow, 1997.

I Am Hindu, by Devi S. Aiyengar. PowerKids Press, 1996.

What Do We Know About Hinduism? by Anita Ganeri. Peter Bedrick, 1995.

Featured Story about Dewali

"The Birth of Krishna," *Our Favorite Stories from Around the World* by Jamila Gavin; photos by Barnabas Kindersley; illus. by Amanda Hall. DK, 1997; 36-39.

This is a simple telling of the story of Krishna's birth that is written in the Hindu religious work the *Bhagavata-Purana.*

Additional Book

Sacred River, by Ted Lewin. Clarion, 1994.

Activities

1. Invite a practicing Hindu from your community to speak about the Festival of Lights.
2. Purchase some Indian breads or sweets from an Indian restaurant to share as you listen to the story.

*November 8 Montana Statehood Day

Montana, the nation's fourth largest state, is located in the northwest. It became a state on November 8, 1889. Although 75 percent of Montana is rolling prairie, its name means *mountain* in Spanish. Montana's mountains certainly are spectacular, and many people travel to Montana to enjoy the scenery or to go skiing. Montana also has many forests, and logging is one of the largest industries. Montana farms grow barley, wheat, and sugar beets. Vast herds of cattle and sheep graze on the prairie lands.

Many American Indian groups have lived in the area now called Montana. The Arapaho, Blackfeet, Crow, Cheyenne, and Assinoboine lived in the eastern area. In the western mountains, the Kutenai, Shochone, Salish, and Bannock hunted deer and bear, fished, and gathered berries. Nearly 50,000 American Indians live in Montana today. Most live on the seven reservations in the state; others live in towns and cities throughout the state working as farmers, ranchers, miners, and in service professions. During Montana summers the powwow drums beat and Indian dancers compete for prizes.

Featured Books

Buffalo Days, by Diane Hoyt-Goldsmith; photos by Lawrence Migdale. Holiday House, 1997.

Clarence Three Irons, Jr., lives on a Crow reservation near Lodge Grass, Montana. This nonfiction photographic essay follows Clarence as he participates in a wild buffalo roundup.

Eagle Drum: On the Powwow Trail with a Young Grass Dancer, by Robert Crum. Maxwell Macmillan, 1994.

A young dancer from the Pend Oreille tribe of western Montana prepares for and attends a powwow.

Powwow, by George Ancona. Harcourt Brace, 1993.

This powwow book, filled with beautiful photographs, features events on the Crow reservation in Montana.

Powwow Summer: A Family Celebrates the Circle of Life, by Marcie R. Rendon; photos by Cheryl Walsh Bellville. Carolrhoda, 1996

An Ojibway family celebrates the circle of life at a summer powwow.

Activities

1. If possible, invite a powwow dancer to visit your group.
2. Watch one of the many videos about powwows that are available through your library.
3. Listen to American Indian music.

*November 9 Sadie Hawkins Day

Cartoonist Al Capp introduced Sadie Hawkins Day into American culture on November 9, 1938 in his Li'l Abner comic strip. The unmarried women in Dogpatch, the comic strip's locale, could legally pursue the men on that day. If a girl caught a man, he was obliged to marry her. This is often the date chosen for school and college dances. At a Sadie Hawkins dance, the girl asks the boy to be her dance partner.

Sadie Hawkins Day is a good day to read about a special dance or a wedding.

Featured Book

Mirandy and Brother Wind, by Patricia McKissack; illus. by Jerry Pinkney. Alfred A. Knopf, 1988.

Mirandy searches for a partner for the cakewalk contest. The cakewalk was a traditional African American dance contest in which the winners earned a cake for their efforts.

Additional Book

The Girl Who Wouldn't Get Married, by Ruth Belov Gross; illus. by Jack Kent. Four Winds, 1983.

Activities

1. Hold a Sadie Hawkins Day dance where the girls ask the boys to dance.
2. Talk to your mother, grandmother, older sister, teacher, or neighbor. Did they ever attend a Sadie Hawkins Dance, or do they remember asking a boy for a date?

November 10 Louisiana Swine Festival

One of many pig festivals in the United States, the Louisiana Swine Festival occurs in late October or early November each year in Basile, Louisiana. There's a swine show, a greased pig contest, a carnival, and a human beauty contest. There are several other such events. These include the Possum Town Pig Fest in Columbus, Mississippi, the Marion Ham Days in Lebanon, Kentucky, and the Big Pig Jig in Vienna, Georgia.

Featured Books

Annabel, by Janice Boland; illus. by Megan Halsey. Dial, 1993.

Garth Pig Steals the Show, by Mary Rayner. Dutton, 1993.

Pig Pig and the Magic Photo Album, by David McPhail. Dutton, 1986.

Pigs Aplenty, Pigs Galore! by David McPhail. Dutton, 1993.

Pigsty, by Mark Teague. Scholastic, 1994.

Poppleton, by Cynthia Rylant; illus. by Mark Teague. Blue Sky, 1997.

Three Little Wolves and the Big Bad Pig, by Eugene Trivizas; illus. by Helen Oxenbury. Margaret K. McElderry, 1993.

Toot & Puddle: You Are My Sunshine, by Holly Hobbie. Little Brown, 1999.

Activity

Plan your own swine festival. Where and when would you hold this celebration? What activities would you plan? Would you involve other animals? What food would you sell?

*November 11 Concordia Day

This public holiday on the island of St. Maarten (or St. Martin) in the West Indies commemorates an agreement in 1648 to divide the island between the Dutch and the French. Concordia Day celebrates the peaceful coexistence of both the Dutch and the French on this one small island where only a stone monument and two signs mark the boundary. Parades and special ceremonies mark the occasion. This is also the day on which Christopher Columbus discovered the island.

St. Martin is a very small island, only thirty-seven square miles in area, with beautiful beaches and a booming tourist trade. It is located southeast of Puerto Rico between the Virgin Islands and Guadeloupe with a series of islands called the Lesser Antilles.

Featured Books

Cendrillon: A Caribbean Cinderella, by Robert D. San Souci; illus. by Brian Pinkney. Simon & Schuster, 1998.

This retelling is based on the French Creole tale of *Cendrillon*, which is similar to Perrault's *Cinderella*. It incorporates elements of the West Indies, specifically based on life on the island of Martinique.

The Faithful Friend, by Robert D. San Souci; illus. by Brian Pinkney. Simon & Schuster, 1995.

Martinique is also the setting of this story that traces its roots back to the story of *Faithful John* originally recorded by the Brothers Grimm.

Activity

Locate the islands of the West Indies on a map. Can you identify St. Marten or Martinique? Chose an island and use reference books to find out a few interesting facts about life there.

November 12 National Children's Book Week

The Children's Book Council sponsors National Children's Book Week each November the week before Thanksgiving. The Children's Book Council began this celebration in 1919 for the purpose of promoting the use and enjoyment of children's trade books. On Wednesday of Children's Book Week, Pizza Hut Restaurants join with the Children's Book Council to sponsor National Young Reader's Day. This popular celebration is marked in schools and libraries by special story hours, author visits, writing competitions, poetry readings, literary games, and field trips to literary sites. Celebrate National Children's Book Week with stories about the joys of reading.

Featured Book

A Weave of Words, by Robert D. San Souci; illus. by Raúl Colón. Orchard, 1997.

A young prince eventually learns that his ability to read, write, and weave are the keys to his survival.

Additional Books

Hog-Eye, by Susan Meddaugh. Houghton Mifflin, 1995.

Petunia, by Roger Duvoisin. Alfred A. Knopf, 1950.

Activities

1. Spend time reading to a younger child or an older person.
2. Hold a book swap. Each person can exchange a favorite book with someone else. Go to the library and select for one another or exchange well-labeled personal copies.
3. Pretend you are your favorite book character. Dress appropriately and tell a bit about your life. See if others can guess who you are.

November 13 National Geography Week

The third week in November is National Geography Week sponsored by the National Geographic Society. In 1987, the National Geographic Society conducted a survey among adults eighteen and older and discovered that the average American adult could identify less than six of ten of the United States. Three in ten adults could not use a map to tell directions or calculate distances, and only 57 percent of adults could identify England on a map of Europe. They determined that the United States was suffering from a geography crisis. In order to promote the importance of geographic literacy, the society created National Geography Week with the support and endorsement of the president of the United States.

Celebrate National Geography Week by reading tales of world travel.

Featured Book

A Cloak for the Dreamer, by Aileen Friedman; illus. by Kim Howard. Scholastic, 1994.

A tailor asks each of his sons to make a cloak for the archduke. The third son's cloak reveals his dream of traveling the world.

Additional Books

Little Fox Goes to the End of the World, by Ann Tompert; illus. by John Wallner. Crown, 1976.

Petunia Takes a Trip, by Roger Duvoisin. Alfred A. Knopf, 1953.

Activity

Where in the world would you like to go? Choose a location. On a map of the world, mark your route. How would you get there? What would you see when you arrive? Why would you choose this location?

*November 14 Children's Day

November 14 is Children's Day in India. This date was chosen because it is the birthday of India's first prime minister, Jawaharlal Nehru, who was born on November 14, 1889. Children celebrate by participating in parades and cultural programs.

Featured Books

One Grain of Rice: A Mathematical Folktale, by Demi. Scholastic, 1997.

The Rajah's Rice: A Mathematical Folktale of India, retold David Barry; illus. by Donna Perrone. W. H. Freeman, 1994.

In this tale of ancient India, a bright village girl outwits the powerful raja by using her mathematical knowledge.

Additional Books

It All Began With a Drip, Drip, Drip. . ., retold by Joan M. Lexau; illus. by Joan Sandin. Dutton, 1973.

Rum Pum Pum: A Folktale from India, retold by Maggie Duff; illus. by Jose Aruego and Ariane Dewey. Macmillan, 1978.

Activities

1. Using grains of rice, test the mathematical ideas of the folktale.
2. Do research about the children of India. What games do they play? What is school like in India? Possible informational books to use include *The Children of India*, by Jules Hermes (Carolrhoda, 1993) or *Children Just Like Me: A Unique Celebration of Children Around the World,* by Barnabas and Anabel Kindersley (DK, 1995).

November 15 *Shichi-Go-San*

This Shinto holiday takes place in Japan every year on the Sunday nearest to November 15. Children who are three, five, or seven years of age are brought to the Shinto shrine and given gifts in two packages. One contains cakes in the form of Shinto emblems; the other is filled with sacred rice to mix with the evening meal. Parents or priests also give the children a bag of "thousand year candy," a bright pink candy that is supposed to bring them good luck and long lives.

Featured Books

Little Inchkin, by Fiona French. Dial, 1994.

In this story of ancient Japan, a tiny *samurai* swordsman becomes a great hero.

The Samurai's Daughter, by Robert D. San Souci; illus. by Stephen T. Johnson. Puffin, 1992.

This tale, also of ancient Japan, features a *samurai* knight and his brave and beautiful daughter, Tokoyo. Through her bravery, she saves the island from attack by a sea serpent.

Activity

Do something nice for someone who is three, five, or seven years old today. Read a story, make a gift, or play a game with a younger child.

*November 16 Oklahoma Statehood Day

On November 16, 1907, Oklahoma became the forty-sixth state to join the Union. Oklahoma has a rich heritage of American Indian, cowboy, and homesteader history. Despite the seizure of Indian land in the 1880s when that land was opened up for homesteading, Oklahoma has the highest population of American Indians. Over 250,000 American Indians live in Oklahoma. On April 22, 1889, ten thousand people came to Oklahoma to claim the lands. In the years that followed, terrible windstorms blew the topsoil away leaving Oklahoma a "dust bowl." Much of the land has now been reclaimed for wheat, hay, and cattle ranching. Oklahoma is also an oil and manufacturing state.

The memory of the dust bowl has faded, but stories of the hardships suffered by Oklahoma's farmers persist. Today's stories are about the joys and difficulties faced by Oklahoma settlers.

Featured Book

Angels in the Dust, by Margot Theis Raven; illus. by Roger Essley. Bridgewater, 1996.

Great Grandma Annie shares the story of her life in Oklahoma during the 1930s.

Additional Book

I Have Heard of a Land, by Joyce Carol Thomas; illus. by Floyd Cooper. HarperCollins, 1998.

Activities

1. What caused the dust bowl? Do research to find out more about erosion, wind damage, and dust storms. Are any of these problems in your region? If so, what is being done to prevent major problems?
2. Find Oklahoma on a map. Locate the Indian reservations in Oklahoma. Which tribes live in Oklahoma? Learn something about each of these groups.

November 17 Ramadan

Ramadan is the holiest season of the Muslim year. Devout Muslims abstain from smoking, drinking, gambling, and other vices. Adults do not eat or drink between sunrise and sunset. Families rise before dawn for an early meal. Time is devoted to prayer, reading of the Koran, and worship in the mosque. Muslims in West Africa stage a two-day carnival before Ramadan begins.

Ramadan lasts for the entire 9th month of the Islamic calendar and falls during different seasons of the year.

2001	11/17	2006	9/24
2002	11/6	2007	9/13
2003	10/27	2008	9/2
2004	10/15	2009	8/22
2005	10/4	2010	8/11

Featured Book

Ramadan, by Suhaib Hamid Ghazi; illus. by Omar Rayyan. Holiday House, 1996.

This book describes the month of Ramadan based on the experiences of Hakeem, a young Muslim boy, and his friend. Topics include fasting, feasting, and praying, as well as a general introduction to Islam.

Additional Book

The Stars in My Geddoh's Sky, by Clair Sidhom Matze; illus. by Bill Farnsworth. Albert Whitman, 1999.

When Grandfather comes from Egypt for a visit, Alex learns about life in that largely Islamic country.

Activity

Invite a practicing Muslim to your class to talk about the holiday of Ramadan and the Islamic religion.

November 18 Elephant Roundup

In Surin, Thailand, elephant trainers use the third weekend in November to demonstrate the intelligence, strength, and obedience of their elephants. There are log pulling contests and an elephant soccer game. Thai music and dances also mark the roundup in an area of Thailand where the people train wild elephants to work in the forests of northern Thailand. The elephants carry heavy loads with their trunks or on their backs.

Thailand is a tropical country in Southeast Asia. Thailand has always been an independent, self-governed country. Most Thai people live in rural areas. Many live in houses built on stilts seven to ten feet off the ground as a precaution against floods. The elephants that live in Thailand are called Indian elephants. They live in forests and jungles of Thailand and other Southeast Asia nations. They are usually light gray in color and may have pink or white spots. The Indian elephant has two humps on its forehead just above the ears, and much smaller ears than those of the African elephant. The males have tusks that grow from four to five feet long.

Featured Book

Two Travelers, by Christopher Manson. Henry Holt, 1990.

This tale is based on an historical incident when Charlemagne sent a delegation to Baghdad. An interpreter named Isaac returned to France with an elephant named Abulabaz. Manson imagines their journey and the friendship that resulted.

Additional Books

Eleonora, by Natascha Biebow; illus. by Britta Teckentrup. W. H. Freeman, 1995.

Eleonora, an African elephant, is the favorite elephant of park rangers, Sylvia and Monty Louwrens. When Eleonora is wounded by a poacher and eventually dies, the elephants join in a special tribute to their friend.

Just a Little Bit, by Ann Tompert; illus. by Lynn Munsinger. Houghton Mifflin, 1993.

Elephant and Mouse want to play together on the seesaw, but nothing happens until their friends help out.

Activity

Create two columns on a piece of paper: *Animals I'd Like to Get to Know* and *Animals I'd Rather Avoid*. By class vote, place each of the following animals in *Get to Know* or the *Avoid* column:

Elephant	Snake	Moose	Horse
Rabbit	Tiger	Hyena	Ferret
Lion	Bear	Scorpion	Donkey
Ostrich	Snapping Turtle	Deer	Camel
Fox	Wolf	Buffalo	Zebra

Where do elephants come in your listing? Why? Did everyone generally agree about the animals? Why do we like some animals more than others?

*November 19 Have A Bad Day Day

Sponsored by the Wellness Permission League, Have A Bad Day Day is especially conceived for those people who are tired of being told to "have a nice day." The league suggests that store and restaurant owners tell customers to "have a bad day." Few are likely to actually comply, but Have A Bad Day Day recognizes that sometimes even cheerful people can have a terrible day.

Featured Book

Alexander and the Terrible, Horrible, No Good, Very Bad Day, by Judith Viorst; illus. by Ray Cruz. Atheneum, 1972.

On a day when everything goes wrong for him, Alexander is comforted by the thought that other people have bad days too.

Additional Books

Mean Soup, by Betsy Everitt. Harcourt Brace Jovanovich, 1992.

Today Was a Terrible Day, by Patricia Reilly Giff; illus. by Susanna Natti. Penguin, 1980.

Activities

1. Write your own story of a bad day. If you base your story on real events, try to make them funny in the retelling.
2. Try greeting people with the phrase, "have a bad day," and see what kind of reaction you get. Be sure to smile when you say it and then explain what you are doing and why.

November 20 National Farm–City Week

The week which contains the Thanksgiving holiday is, by presidential proclamation, National Farm-City Week. This celebration, promoted by the National Farm-City Council, continues the group's mission "to strengthen the understanding of the farm-city connections that provide our food, fiber, and shelter. Life in the city is certainly different from life in rural areas, as the town mouse and the country mouse found out.

Featured Book

Milly and Tilly: The Story of a Town Mouse and a Country Mouse, by Kate Summers; illus. by Maggie Kneen. Dutton, 1996.

This retelling of the traditional tale concludes that there is no place like home, wherever that may be.

Additional Books

The Town Mouse and the Country Mouse, by Lorinda Bryan Cauley. Putnam, 1984.

Town Mouse Country Mouse, by Jan Brett. Putnam, 1994.

Activities

1. If you live in the country, visit the city. If you live in the city, visit a farm.
2. Where would you prefer to live—city or country? Make a list of the advantages of both places. How are people in the city dependent on country people? How do city people support those in the country?

*November 21 World Hello Day

For nearly thirty years, people have celebrated World Hello Day on November 21. The celebration began in the fall of 1973 in response to the conflict between Egypt and Israel, and is now observed by people in 180 countries. It is an opportunity to promote world peace on a local level, as well as worldwide. The founders of World Hello Day encourage people to communicate with their government's leaders on November 21 to encourage them to use words rather than weapons to settle conflicts.

Featured Book

So Much in Common, by Laurie A. Jacobs; illus. by Valeri Gorbachev. Boyds Mills, 1994.

Philomena Midge and Horace Abercrombie have absolutely "nothing in common but their backyard fence." Despite their differences, they manage to become friends.

Additional Book

Frog and Toad Are Friends, by Arnold Lobel. Harper & Row, 1970.

Activities

1. Write friendly letters to children in a school faraway. You might use the Internet to locate schools overseas. Write to say "hello," but don't expect an answer. The cost of overseas stamps may be prohibitive.
2. Browse through the book *Children Just Like Me: A Unique Celebration of Children Around the World*, by Barnabas and Anabel Kindersley (DK, 1995). What activities and interests do you share with these children? Use a world map to locate their hometowns.
3. Read and discuss a selection from *Peace Tales: World Folktales to Talk About*, by Margaret Read MacDonald (Linnet Books, 1992).

November 22 Thanksgiving

Thanksgiving in the United States is celebrated on the fourth Thursday in November. It is observed in all states as a time of thankfulness for the bountiful harvest. The first Thanksgiving Day is remembered as a time of joyful feasting among the Pilgrim settlers

and their American Indian neighbors. Today's stories honor the Narragansett and Delaware Indians who harvested this land long before the arrival of the European colonists.

Featured Books

The Legend of the Cranberry: A Paleo-Indian Tale, by Ellin Greene; illus. by Brad Sneed. Simon & Schuster, 1993.

A Delaware Indian legend recounts how the Great Spirit gave the people the gift of the cranberry, a symbol of peace.

Nickommoh! A Thanksgiving Celebration, by Jackie French Koller; illus. by Marcia Sewall. Atheneum, 1999.

Nickommoh, which means "give away" or "exchange," was a traditional harvest celebration of American Indians long before the Pilgrims came to Plymouth. This recreation of *Nickommoh* is based on the practices of the Narragansett people.

Activity

Enjoy Thanksgiving dinner.

November 23 World Championship Duck Calling Contest

On the Tuesday through Saturday of Thanksgiving week, fifty to eighty of the best duck callers in the country enter the World Championship Duck Calling Contest in Stuttgart, Arkansas. Hundreds of callers participate in calling contests. The world championship callers hope to win a $5000 cash prize. Contestants are judged on the mating call, the long-distance call, the lonesome-duck call, and the chatter call. Arts and crafts shows, music and dance, and special food booths add to the excitement.

Featured Book

Make Way for Ducklings, by Robert McCloskey. Viking, 1941.

Even though Boston has changed, this wonderful story and McCloskey's tenderly drawn ducks remain fresh and inspiring.

Additional Books

The Chick and the Duckling, by Vladimir Suteyev; translated by Mirra Ginsburg; illus. by Jose Aruego and Ariane Dewey. Macmillan, 1972.

Farmer Duck, by Martin Waddell; illus. by Helen Oxenbury. Candlewick, 1992.

The Story About Ping, by Majorie Flack; illus. by Kurt Wiese. Viking, 1933.

Activities

1. Walk like a duck, quack like a duck, try talking like a duck.
2. Learn more about ducks, geese, and chickens by reading nonfiction books and encyclopedias.

November 24 Jewish Book Month

Jewish Book Month was first celebrated in 1941 in the United States in response to the Nazis attempt to destroy Jewish culture. Jewish Book Month honors authors and their works and encourages young people "to read, write, and be as creative as talent will allow." This event is sponsored every November by the Jewish Book Council whose mission is to promote reading, writing, and publication of books in English that are of interest to the Jewish community. Jewish schools hold special celebrations during November to honor the rich literary heritage of Jewish people.

Celebrate Jewish Book Month by reading some of the picture books that have recently won the National Jewish Book Awards.

Featured Books

Joseph Had a Little Overcoat, by Simms Taback. Viking, 1999.

A very old overcoat is recycled numerous times into a variety of garments. This book also won the Caldecott Award sponsored by the American Library Association.

Marven of the Great North Woods, by Kathryn Lasky; illus. by Kevin Hawkes. Harcourt Brace, 1997.

When his Jewish parents send him to a Minnesota logging camp to escape the influenza epidemic of 1918, ten-year-old Marven finds a special friend.

You Never Know: A Legend of the Lamed-Varniks, by Francine Prose; illus. by Mark Podwal. Greenwillow, 1998.

Though mocked by the rest of the villagers, poor Schmuel the shoemaker turns out to be a very special person.

Activities

1. What makes these books special? Why do you think they won the National Jewish Book Award? Think about the books that you might recommend to a friend. What criteria do you use in deciding if a book is a good book or not.
2. Go to the library and check out some Jewish folktales.

November 25 National American Indian Heritage Month

In the early 1900s Dr. Arthur C. Parker, a Seneca Indian, living in Rochester, New York, urged that a special day be set aside to honor American Indians. He first convinced the Boy Scouts of America to set aside a special day honoring American Indians, and in 1915, the Congress of the American Indian Association met in Lawrence, Kansas, and approved a plan to observe an American Indian Day. Over the course of several years, this day was celebrated in May by New York State, in September by other states, and in October, on Columbus Day, in others. In 1994, President Clinton issued a proclamation, based on a Senate resolution, designating the month of November as National American Indian Heritage Month. Each year since then, the president has continued to proclaim November as National American Indian Heritage Month. Canada honors its native population on Aboriginal Day in June.

The contributions of American Indians to our culture are extensive—in the arts, agriculture, government, science, and literature—to name a few.

Featured Book

Brother Eagle, Sister Sky: A Message from Chief Seattle; illus. by Susan Jeffers. Dial, 1991.

Artist Susan Jeffers has provided beautiful illustrations to accompany the wise words of Chief Seattle, a Suquamish Indian chief who describes his people's respect and love for the earth.

Additional Books

Gift Horse: A Lakota Story, by S. D. Nelson. Harry N. Abrams, 1999.

Lakota author and illustrator Nelson, tells the story of a Lakota youth whose father gives him a horse in preparation for his becoming a Lakota warrior.

The Green Snake Ceremony: Mary Greyfeather Learns More about Her Native American Heritage, by Sherrin Watkins; illus. by Kim Doner. Council Oak Books, 1995.

Sherrin Watkins, a lawyer of Shawnee and Cherokee heritage, explains the Green Snake Ceremony as seen through the eyes of young Mary Greyfeather.

Activities

1. Do research to find the names of famous American Indians who have made significant contributions to the arts and sciences.
2. Read about the life of American Indian children today using resources such as the "We Are Still Here" series published by Lerner. Some of the titles include: *Children of Clay: A Family of Pueblo Potters; Ininatig's Gift of Sugar: Traditional Native Sugarmaking; Kinaalda: A Navajo Girl Grows Up; The Sacred Harvest: Ojibway Wild Rice Gathering; Songs from the Loom: A Navajo Girl Learns to Weave.*
3. Go to the library and select an American Indian folktale to read independently.

November 26 National Adoption Month

In 1976, President Gerald Ford proclaimed a week in October as Adoption Week in recognition of the number of children needing adoptive families. In recent years, November has been proclaimed as National Adoption Month, and activities are held to make people aware of the need for adoptive parents to help children currently waiting for caring families. About 116,000 children are now waiting for permanent adoptive families. These children are now in the United States foster care system. During November, public and private agencies sponsor adoptive parent recognition dinners, adoption posters and buttons, and other celebrations to remind everyone of the advantages to both children and families of permanent adoptive homes.

Today's stories are imaginative tales of children and their adoptive parents.

Featured Books

Little Oh, by Laura Krauss Melmed; illus. by Jim Lamarche. Lothrop, Lee & Shepard, 1997.

The Rainbabies, by Laura Krauss Melmed; illus. by Jim LaMarche. Lothrop, Lee & Shepard, 1992.

Raising Sweetness: Sequel to Saving Sweetness, by Diane Stanley, illus. by G. Brian Karas, Putnam, 1999.

Saving Sweetness, by Diane Stanley, illus. by G. Brian Karas, Putnam, 1996.

Activities

1. Invite a family who has adopted a baby to visit with your group about the joys of adoption.
2. Discuss what makes a family a family. What does your family do together that makes it unique and special?

November 27 Belagcholly Day

Any day when a person feels melancholy because of a bad cold is called a belagcholly day. When the cold season begins, cheer up any melancholy cold sufferers with stories about sneezing.

Featured Book

Solomon Sneezes, by Marilyn Singer; illus. by Brian Floca. Harper, 1999.

When Solomon sneezes, the entire world is in danger.

Additional Books

The King Who Sneezed, by Angela McAllister; illus. by Simon Henwood. Morrow, 1988.

The Mitten: A Ukrainian Folktale, retold and illus. by Jan Brett. Putnam, 1989.

Teddy Bears Cure a Cold, by Susanna Gretz and Alison Sage. Four Winds, 1984.

Activities

1. Think of ways to cheer up people who are ill. Consider making get well cards for people in hospitals or nursing homes.
2. Do some research. What causes colds? How can they be prevented? Is there a cure?

November 28 Vegetarian Banquet for Monkeys

This unusual celebration occurs in late November or early December in Lop Buri, Thailand. The 600 monkeys who live in the trees and ruins around the city's thirteenth-century temple are invited to a vegetarian banquet at a local hotel. Tables spread with red cloths and vegetarian delicacies, including pumpkins, fruit salads, and rice, are attractively arranged for the monkeys' enjoyment. One observer noted that "when the monkeys arrive (and it sometimes takes a while, since they're often scared off by the loudspeakers, onlookers, and scores of press photographers), they soon reduce the arrangements to a mess that would make a human toddler proud." The hotel owner sponsors the banquet as a way of saying thank you for his good luck and success.

Featured Book

How Mr. Monkey Saw the Whole World, by Walter Dean Myers; illus. by Synthia Saint James. Doubleday, 1996.

When Mr. Buzzard avoids working for his food by using trickery, Mr. Monkey finds a solution to the problem.

Additional Books

Caps for Sale: A Tale of a Peddler, Some Monkeys, and Their Monkey Business, by Esphyr Slobodkina. Harper & Row, 1968.

So Say the Little Monkeys, by Nancy Van Laan; illus. by Yumi Heo. Atheneum, 1998.

Activities

1. Plan your own vegetarian banquet for monkeys, except at this banquet, you can play the part of the monkeys.
2. Act out one of today's stories.

November 29 Loaf Day

Any day when no regular work is done is a loaf day. The word "loaf" came into use in the United States in the early nineteenth century. It has nothing to do with "loaf of bread," but is more likely derived from Swedish and Dutch words that mean to take a holiday, or "leave" from work. For lazy people, every day is a loaf day. Celebrate Loaf Day by reading silly stories about lazy folks and those who want them to get some work done.

Featured Book

A Treeful of Pigs, by Arnold Lobel; illus. by Anita Lobel. Greenwillow, 1979.

The farmer's wife finds a clever way to convince her lazy husband to get back to work.

Additional Books

Lazy Jack, retold by Vivian French; illus. by Russell Ayto. Candlewick, 1995.

Tops & Bottoms, by Janet Stevens. Harcourt Brace, 1995.

Activities

1. If you had an entire day to loaf, what would you do?
2. Take the next fifteen minutes to loaf. Do nothing. At the end of the time, reflect on your feelings. Did you enjoy loafing? Do you need to be in a certain place to loaf? Would you want to loaf all day long? All week? All year? Why or why not?

November 30 Payday

 The regular weekly or monthly day on which wages or other payments are made is called Payday. For many people, payday comes on a Friday. For others, it is on the last day of the month. A day which is both a Friday and the last day of the month is bound to be a payday for millions of people. While a payday is a time to rejoice over work well done and rewards justly gained, it is also a time to remember that some rewards are worth more than money. Today's stories are about people whose efforts yield surprising benefits.

Featured Book

The Gardener, by Sarah Stewart; illus. by David Small. Farrar, Straus & Giroux, 1997.

When Lydia Grace goes to the city to live with her Uncle Jim, her love of gardening transforms Uncle Jim's home and his heart.

Additional Books

The Empty Pot, by Demi. Holt, 1990.

The Silver Cow: A Welsh Tale, retold by Susan Cooper; illus. by Warwick Hutton. Atheneum, 1983.

The Talking Eggs: A Folktale from the American South, retold by Robert D. San Souci; illus. by Jerry Pinkney. Dial, 1989.

Activity

Think of a time when you were rewarded for a job well done with something other than money. Write or talk about what happened.

*December 1 Capital Day

On December 1, 1800, Washington, D.C. became the capital of the United States. Land was taken from Virginia and Maryland and combined to form the new capital city. A French architect, Charles L'Enfant, designed the city's plan and its elegant layout remains a landmark of Washington, D.C. today. Over seventeen million tourists visit Washington, D.C. every year to view the White House, the Capitol, the national monuments, and the museums.

Featured Book

The Girl with a Watering Can, by Ewa Zadrzynska; illus. by Arnold Skolnick; paintings from the National Gallery of Art, Washington, D.C. Chameleon Books, 1990.

Once the "Girl with a Watering Can" steps out of the painting, which is in the National Gallery of Art in Washington, D.C., her curiosity leads her to visit other paintings in the museum, where her mischievous behavior causes more trouble than ever expected.

Additional Book

The Wall, by Eve Bunting; illus. by Ronald Himler. Clarion, 1990.

A boy and his father come from far away to visit the Vietnam War Memorial in Washington and find the name of the boy's grandfather who was killed in the conflict.

Activities

1. If you live close enough, visit some of the attractions in Washington, D.C.
2. Have members of your group visited Washington? If so, ask them to share pictures, slides, brochures, etc. about their visit.
3. Look at slides or a video of Washington, D.C.
4. Learn about the city of Washington by using reference books, atlases, tourist information, and web sites.

*December 2 Atom Day

December 2 is the anniversary of the 1942 conclusion of scientific experiments at the University of Chicago that ushered in the Atomic Age. The experiments were conducted by Enrico Fermi and a team of scientists. Their work led to the construction of the first atomic bomb, but it also led to a better understanding of atomic energy and eventually to nuclear power. Celebrate the amazing power of creative thinking on December 2.

Featured Book

Emma's Rug, by Allen Say. Houghton Mifflin, 1996.

A young artist finds that her creativity comes from within when the rug that she had relied upon for inspiration is destroyed.

Additional Book

The Value of Creativity: The Story of Thomas Edison, by Ann Donegan Johnson; illus. by Pileggi. Value Communications, 1981.

Activities

1. Create an alphabet of inventions. Starting with A, list inventions that have changed the world.
2. What would you like to invent that would be beneficial? Draw a picture or write a paragraph about your amazing creation.

*December 3 Illinois Statehood Day

On December 3, 1818, Illinois joined the Union as the twenty-first state. It is clear to archaeologists, however, that the area has been inhabited since 4000 B.C. While little is known about these ancient peoples, Indians called *Illinewek* (superior men) lived in the area when the first French fur traders visited in the 1600s. It is from these people that Illinois took its name.

Modern-day Illinois is a major manufacturing state. Chemicals and electronic equipment are among its important products. Chicago, the third-largest city in the United States is located in the northeast corner of the state. The Mississippi River forms the western border between Illinois and Iowa and Missouri.

Illinois is an important agricultural state that produces corn, soybeans, and various other grains. Farmers also raise cows and pigs. The Illinois countryside is dotted with family farms.

Featured Books

Family Farm, by Thomas Locker. Dial, 1988.

The beautiful farm paintings were inspired by a farm in the Galena, Illinois area, where Locker lived in the early 1970s.

Time To Go, by Beverly and David Fiday; illus. by Thomas B. Allen. Harcourt Brace Jovanovich, 1990.

As a small boy prepares to leave his Illinois farm, he remembers all the things that make the farm a cherished home.

Activity

Over the last few decades, many people have moved from farm to city. Take a survey of the people in your class or neighborhood to find out how many have farm roots. Why did their families leave the farm? How many are still farming or have family living on a farm? Combine survey data and summarize the results.

December 4 Red Letter Day

A red letter day is any day that has special significance or is a particularly happy day. This special day takes its name from the old practice of marking saints days or other importance church holidays in red

on ecclesiastical calendars. While some calendars still use red to mark special days, the phrase "Red Letter Day" refers to any days that have special meaning for individuals.

Featured Book

Dustin's Big School Day, by Alden R. Carter; photographs by Dan Young and Carol S. Carter. Albert Whitman, 1999.

For Dustin, who has Down syndrome, a visit from a puppet makes the school day special.

Lottie's Princess Dress, by Doris Dörriel; illus. by Julia Kaergel. Dial, 1999.

Wearing a special dress to school, a princess dress, makes the day special for Lottie.

Manuela's Gift, by Kristyn Rehling Estes; illus. by Claire B. Cotts. Chronicle, 1999.

For Manuela, a young Mexican girl, her birthday is a red letter day thanks to the special efforts of her loving family.

Activity

Think of ways to make this a red letter day for someone special.

*December 5 International Volunteer Day

The United Nations General Assembly designated December 5 as International Volunteer Day in 1985. According to the United Nations this should be an "annual celebration by communities, peoples, and governments of all that is achieved by voluntary effort—by volunteers—around the world. At least half the countries in the world recognize this holiday and use it to encourage people to continue their voluntary efforts to make the world a better place. Some of the activities held on International Volunteer Day include poster competitions, blood donation events, fund-raising drives, concerts, environmental clean-ups, and community improvement efforts.

Featured Book

Uncle Willie and the Soup Kitchen, by DyAnne DiSalvo-Ryan. Morrow, 1991.

A boy spends the day with Uncle Willie in the soup kitchen where he works preparing and serving food for the hungry.

Additional Books

Do I Have to Take Violet? by Sucie Stevenson. Dodd, Mead & Company. 1987.

Miss Tizzy, by Libba Moore Gray; illus. by Jada Rowland. Simon & Schuster Books for Young Readers, 1993.

The Tale of the Mandarin Ducks, by Katherine Paterson; illus. by Leo & Diane Dillon. Scholastic, 1990.

Activities

1. Discuss ways to volunteer within the family, the community, and the world. Make a list of the volunteer activities of your group members.
2. Honor your community's volunteers. Select one person or a group of persons and make thank-you cards for them in celebration of International Volunteer Day.
3. Hold a fund drive for some worthy cause. Decide what is the most appropriate cause for your group and what in particular you could do to be helpful.

*December 6 St. Nicholas's Day

St. Nicholas was Bishop of Myra, located in what is modern-day Turkey, during the fourth century. He is the patron saint of children and sailors. Tradition says that Nicholas died on December 6, in 342, and this date is celebrated throughout Europe as his feast day. Although little is known about his life, some say that he saved three young girls from being sold into slavery by tossing a bag of gold into each of their rooms on three successive nights. St. Nicholas continues to bring gifts to children throughout the world, although he does so differently in various countries.

In Germany, children put a shoe outside their bedroom door or by the fireplace on the evening of December 5. In the morning, they find the shoe filled with candies, nuts, and fruits. Similar rituals occur in Belgium and the Netherlands. In Czechoslovakia, children may hang a stocking outside the window. In the morning, they find chocolates and little presents inside. Naughty children may find carrots or a piece of coal. In America, St. Nicholas is usually called Santa Claus and makes his visit on December 24 with the help of a sleigh pulled by reindeer.

St. Nicholas's Day is a good day to read about reindeer.

Featured Book

The Wild Christmas Reindeer, by Jan Brett. Putnam, 1990.

Teeka is assigned the task of getting the reindeer ready for Christmas Eve. She is worried, though, because the reindeer seem far too wild to train in time for the big event.

Additional Books

A Caribou Journey, by Debbie S. Miller; illus. by Jon Van Zyle. Little Brown, 1994.

This nonfiction book tells about the caribou and their cousins, the reindeer, who live in the Alaskan wilds.

The Reindeer People, by Ted Lewin. Macmillan, 1994.

Lewin describes daily life for the Sami people, who live near the Arctic Circle and raise reindeer.

Activities

1. Learn more about the Sami people through reading and research.
2. Try to imagine some other animals pulling St. Nicholas's sleigh and write a funny story about what happens.

*December 7 Delaware Statehood Day

On December 7, 1787, Delaware was the first state to approve the United States Constitution. It is the oldest state in the union, sometimes called the "First State," and it is the second smallest at only ninety-six miles from north to south and thirty-five miles from east to west, The entire eastern half of Delaware borders the Atlantic Ocean. Fishing is an important industry, and Delaware is known for its coastal marshes and wildlife reserves. Snapping turtles are one of the many interesting species found in Delaware. Delaware is known for chicken farming; the state produces over 225 million broiler chickens annually. Delaware is also an important manufacturing state, particularly of chemicals, plastics, synthetic fibers, and plants.

Because Delaware is a leading chicken farming state, December 7, is a good day to read stories about chickens and their eggs.

Featured Book

The Surprise Family, by Lynn Reiser. Greenwillow, 1994.

A baby chick mistakenly thinks that her mother is a boy.

Additional Books

An Extraordinary Egg, by Leo Lionni. Alfred A. Knopf, 1994.

The Most Wonderful Egg in the World, by Helme Heine. Macmillan, 1983.

Peeping Beauties, by Mary Jane Auch. Holiday House, 1993.

Zinnia and Dot, by Lisa Campbell Ernst. Viking, 1992.

Activities

1. Visit a chicken farm.
2. Enjoy snacks made from eggs.
3. Decorate paper eggs or real eggs to see whose egg is the most extraordinary.

December 8 Festival of the Sahara

In Douz, a quiet Tunisian oasis in the Sahara, a festival, held for ten days in mid-December, draws crowds of 50,000 or more to watch horseracing and charging. Spectacular events called *fantasias* involve elaborately dressed men on horseback participating in elaborate charges while they fire rifles into the sky. Horse, camel, and dog races add to the excitement. The market is alive with the sale of fresh dates, copper handicrafts, carpets, flowers, ebony carvings, and so on. It is also a time of music, poetry reading, and other cultural events.

Featured Nonfiction Book

Sahara, by Jan Reynolds. Harcourt Brace Jovanovich, 1991.

Fascinating photographs accompany this text explaining the way of life of the Tuareg people who live in the Sahara Desert.

Featured Fiction Books

Ali: Child of the Desert, by Jonathan London; illus. by Ted Lewin. Lothrop, Lee & Shepard, 1997.

Ali lives in the Sahara. When a wind separates him from his father as they journey to the Morroccan market town of Rissani, Ali's courage and intelligence are his only hope.

One Night: A Story from the Desert, by Christina Kessler; illus. by Ian Schoenherr. Philomel, 1995.

Muhamad is a Tuareg boy who must face a desert night alone with his goats.

Activities

1. Consider the ways in which desert life is different from life in your town.
2. Water is precious, especially in a dry area like the desert. Enjoy a drink of cold water and list the many ways in which water is essential for survival.

*December 9 Tanzania Independence and Republic Day

On December 9, 1961, the country of Tanganika became an independent nation. Three years later, Tanganyika and Zanzibar joined together as one state, renamed the United Republic of Tanzania. Tanzania is a large country in Eastern Africa. It borders the Indian Ocean on the east, and is bordered by the countries of Kenya, Zambia, Malawi, Berundi, the Congo, and Rwanda. Tanzania is best known for its fascinating wildlife, including elephants, giraffes, lions, zebras, and other species who live in vast game reserves where hunting is prohibited. Africa's highest mountain, Kilimanjaro, is located in northern Tanzania, and its lakes include Lake Tanganyika and part of Lake Victoria.

Today Tanzania is headed by a president and is divided into twenty-five administrative regions. Most of the people of Tanzania live in the northern third of the country near the lakes and mountains. Most people live in rural areas and 98 percent of the people are black Africans belonging to about 120 ethnic groups. Swahili and English are the official languages, but many tribal languages, mostly in the Bantu language group, are used throughout the country.

Featured Book

Rehema's Journey: A Visit in Tanzania, by Barbara A. Margolies. Scholastic, 1990.

This photo essay follows nine-year-old Rehema as she travels with her father throughout Tanzania.

Additional Books

Big Boy, by Tolowa M. Mollel; illus. by E. B. Lewis. Clarion, 1995.

A Promise to the Sun: An African Story, by Tolowa M. Mollel; illus. by Beatriz Vidal. Little Brown, 1992.

Activity

Locate Tanzania on a map. Using atlases, almanacs, and encyclopedias, compare the December weather in Tanzania with the weather in your community. What season is it in Africa? What is the season in your community? Compare average temperatures and precipitation. How does the climate effect the way we live?

December 10 Hanukkah

Hanukkah (also called Chanukah, Feast of Dedication, or the Feast of Lights) is a Jewish holiday celebrated according to the Jewish lunar calendar from Kislev 25 to Tibet 2 (which falls between November 25 and December 26). It lasts eight days and commemorates the successful rebellion of the Jews against King Antiochus. When the battle was over, the Jewish troops, under the leadership of Judas Macabeus, wanted to rededicate the temple by relighting the candelabrum or menorah. Although they only had enough oil to last for one day, it burned continuously for eight days. This holiday celebrates the survival of Judaism and the Jewish identity. The most familiar Hanukkah custom is the lighting of the eight candles of the menorah. One candle is lit each day. They represent faith, freedom, courage, love, charity, integrity, knowledge, and peace. Other popular customs including the eating of potato pancakes (called *latkes*), games (including the *driedel* game played with a spinning top), dances, and parties.

Jewish holidays begin and end at sundown. The Jewish calendar begins with Rosh Hashanah, which is in the fall, and continues until the next Rosh Hashanah. Hanukkah is celebrated for eight days.

2001	12/10	2006	12/16
2002	11/30	2007	12/5
2003	12/20	2008	12/22
2004	12/9	2009	12/12
2005	12/26	2010	12/2

Many children's books, both fiction and nonfiction, have been written about Hanukkah.

A Sampling of Nonfiction Books about Hanukkah

A Family Hanukkah, by Bobbi Katz; illus. by Caryl Herzfeld. Random House, 1992.

Hanukkah: The Festival of Lights, by Jenny Koralek; illus. by Juan Wigngaard. Lothrop, Lee & Shepard, 1990.

A Picture Book of Hanukkah, by David A. Adler; illus. by Linda Heller. Scholastic, 1982.

A Selection of Fiction Books about Hanukkah

Grandma's Latkes, by Malka Drucker; illus. by Eve Chwast. Harcourt Brace Jovanovich, 1992.

It's Hanukkah! by Jeanne Modesitt; illus. by Robin Spowart. Holiday House, 1999.

Papa's Latkes, by Jane Breskin Zalben. Holt, 1994.

Activities

1. Invite Jewish children or adults in your neighborhood to share information about Hanukkah.
2. Make potato latkes and learn to play the driedel game.
3. Borrow one of the many books on Hanukkah crafts from the library and create something special to remind you of this holiday.

*December 11 Indiana Statehood Day

Indiana became our nineteenth state on December 11, 1816. It ranks as one of the top ten agricultural states with 80 percent of its land devoted to farming. While there are large cities in Indiana and major industries which include mining and manufacturing, the state is best known for its rural farms which raise corn, soybeans, and wheat. Sports play an important role in Indiana. The Indianapolis 500 car race takes place every Memorial Day, and basketball is a familiar pastime in both farm and city areas where large crowds gather to cheer on their favorite college and high school teams.

Featured Book

Christmas on the Prairie, by Joan Anderson; illus. by George Ancona. Clarion, 1985.

The Christmas of this book takes place in 1836 in the fictional Indiana town of Prairietown. All the townspeople join in to make the holiday a special event.

Activity

How was an Indiana Christmas in the 1800s different from Christmas in your community today?

Additional Books

In honor of Indiana's excitement over sports, December 11, is a good time to read poetry about sports.

Hoops, by Robert Burleigh; illus. by Stephen T. Johnson. Harcourt Brace, 1997.

Hosannah the Home Run! Poems about Sports, selected by Alice Fleming. Little Brown, 1972.

Activities

1. What sporting events are popular in your community? Why do you think these are the favorites?
2. Write a poem about your own favorite sport.
3. Watch *Hoosiers*, an exciting full-length movie about an Indiana high school basketball team's season.

*December 12 Poinsettia Day

The poinsettia, with its red, pink, or white flowers (which are actually upper leaves) has come to have special significance for Christmas. The shape of the blossoms is often compared to the Star of Bethlehem. This tropical plant is native to Central America and was first introduced to North America by Joel

Poinsett, the United States minister of Mexico. It gets its name from him, and we celebrate Poinsettia Day on the day that Joel Poinsett died in 1851.

Featured Book

The Legend of the Poinsettia, retold by Tomie DePaola. Putnam, 1994.

DePaola retells the Mexican legend of the poinsettia.

Activity

Create large paper poinsettias to decorate your classroom, library, or meeting room.

*December 13 Santa Lucia Day

Although this day is named for Lucia, an Italian saint who was martyred for her Christian belief in the year 304, the holiday today retains little of the original significance. Rather, it coincides with the night long considered the longest night of the year in Sweden and has become part of the Christmas celebration. Eighteenth-century reports describe young servant girls dressed in white robes with red ribbons around their waists and a crown of candles delivering trays of rolls and coffee to their mistresses and masters. During the early 1900s Stockholm shopping centers introduced Christmas processions led by girls dressed as Lucia. The idea quickly took hold. Today, this is considered a uniquely Swedish holiday and is celebrated in nearly every home, school, community, and even in offices and factories. The young girl chosen as Lucia by her family or school or community is often followed by a group of white-clad girl and boy attendants who sing special Lucia carols.

Celebrate Santa Lucia Day by reading Swedish Christmas stories.

Featured Books

Christmas in Noisy Village, by Astrid Lindgren and Ilon Wikland; trans. by Florence Lamborn. Viking, 1963.

Christmas in the Stable, by Astrid Lindgren; illus. by Harald Wiberg. Coward-McCann, 1962.

The Christmas Tomten; by Viktor Rydberg; illus. by Harald Wiberg. Coward, McCann & Geoghegan, 1981.

The Legend of the Christmas Rose, by Selma Lagerlöf; retold by Ellin Greene; illus. by Charles Mikolaycak. Holiday House, 1990.

Activities

1. Plan a modified Santa Lucia Day when you serve breakfast in bed to members of your family.
2. What unique holiday celebrations occur in your family or neighborhood which have special meaning to you, but might seem strange or unusual to someone from another culture?

*December 14 Alabama Statehood Day

On December 14, 1819, Alabama became the twenty-second state to join the Union. It had been occupied by French and Spanish settlers prior to the French and Indian War in 1763 when it came under English rule. French settlers continued to come to Alabama and helped to establish its cultural roots. The rich soil encouraged agriculture, and Alabama became a producer of cotton, peanuts, and pecans. A meeting in Montgomery, Alabama, in 1861 led to the formation of the Confederate States. In the 1950s and 1960s the Alabama cities of Birmingham, Mobile, and Montgomery took on important roles in the fight for civil rights.

Alabama has been home to many famous people including Helen Keller and Rosa Parks. Celebrate Alabama's statehood by reading the amazing deeds of Rosa Parks, who was instrumental in helping African Americans gain equal rights.

Featured Book

If a Bus Could Talk: The Story of Rosa Parks, by Faith Ringgold. Simon & Schuster, 1999.

When Marcie gets on the morning bus, she finds that it has changed into a talking version of the Cleveland Avenue bus in honor of Rosa Parks. The bus tells Marcie about Rosa Parks's life and her involvement in the Montgomery Bus Boycott.

Additional Book

A Picture Book of Rosa Parks, by David A. Adler; illus. by Robert Casilla. Holiday House, 1993.

Activities

1. What led Rosa Parks to her brave actions for equal rights? Where did she get the courage to act? What part did the state of Alabama play in the Montgomery Bus Boycott?
2. Can you name other people who have stood up for what is right? Find out where they came from? Are any from your home state?
3. Do all Americans have equal rights today? Discuss this issue.

*December 15 Bill of Rights Day

By December 15, 1791, three-fourths of the states (nine states) had ratified the first amendments to the United States Constitution. Originally 145 amendments had been proposed, but only ten, now called the Bill of Rights, made it through Congress and were ratified by the states.

There are several nonfiction books available about the Bill of Rights.

Featured Books

The Bill of Rights, by Warren Colman. Childrens Press, 1987. (Appropriate for younger children.)

The Bill of Rights and You, by Steve Jenkins, Linda Riekes, Roger Goldman, and Patricia McKissack. West, 1990.

A Kids' Guide to America's Bill of Rights: Curfews, Censorship, and the 100-Pound Giant, by Kathleen Krull; illus. by Anna Divito. Avon, 1999.

Activities

1. Select excerpts from any of the above books and focus on one right granted by the Bill of Rights. Discuss how this freedom effects daily life. Is it important to children? How?
2. View one of the many fine videos about the Bill of Rights. These include *The Bill of Rights: Bill of Responsibilities* (Cambridge Educational, 1995) and *The Bill of Rights: A Living Document* (Cambridge, 1997).
3. Invite a local judge or lawyer in to talk about how the Bill of Rights is used in today's courtroom.

*December 16 *Las Posadas*

A nine-day celebration in Mexico begins on December 16. *Las Posadas* is a reenactment of Mary and Joseph's search for shelter on the night of Jesus Christ's birth. Pilgrims go from door to door asking for shelter and are rewarded with an invitation to enter and join in a fun celebration with their neighbors. Guests try to break a *piñata*, a papier mache decoration filled with gifts and candies. There is lots of food and singing and general merrymaking on the night of *Las Posadas*.

Featured Book

The Night of Las Posadas, by Tomie dePaola. Putnam's, 1999.

At the annual celebration of Las Posadas in old Santa Fe, the husband and wife slated to play Mary and Joseph are delayed by car trouble, but a mysterious couple appear who seem perfect for the part.

Additional Books

The Christmas Piñata, by Jack Kent. Parents' Magazine Press, 1975.

Las Posadas: An Hispanic Christmas Celebration, by Diane Hoyt-Goldsmith; photographs by Lawrence Migdale. Holiday House, 1999.

Activity

Make or purchase a *piñata* and enjoy taking turns trying to break it open. Each person who attempts to break the *piñata* must use a stick and be blindfolded. Once the *piñata* is broken, everyone scrambles for the treats.

*December 17 Aviation Day

On December 17, 1903, Orville and Wilbur Wright successfully flew the first airplane near Kitty Hawk, North Carolina. Although the flight lasted less than one minute, it is the first powered airplane flight ever recorded, and it ushered in a new era of manned flight. The Wright brothers, who owned a bicycle shop, had spent years experimenting with kites and gliders before inventing their airplane. Both brothers took short flights on December 17, Orville first and then Wilbur. Since 1963, December 17 has been declared Wright Brothers Day by presidential proclamation.

Aviation Day is a good day to read about pioneers of aviation. The following biographies of the Wright brothers may be too long for reading aloud, but will provide interesting background information for further research.

Featured Books

The Wright Brothers, by Paul Joseph. Abdo & Daughters, 1996.

The Wright Brothers: The Birth of Modern Aviation, by Anna Sproule. Blackbirch, 1999.

The Wright Brothers: How They Invented the Airplane, by Russell Freedman; original photos by Wilbur and Orville Wright. Holiday House, 1991.

Books about Other Famous Aviation Events

Fly! A Brief History of Flight Illustrated, by Barry Moser. HarperCollins, 1993.

The Glorious Flight: Across the Channel with Louis Blériot July 25, 1909, by Alice and Martin Provensen. Viking, 1983.

Ruth Law Thrills a Nation, by Don Brown. Ticknor & Fields, 1993.

Activities

1. Learn more about the Wright brothers and other early aviators. Share the information with your group.
2. Watch the video *Cleared for Takeoff* (by Fred Levine Productions). This video provides younger children with a passenger-eye view of air travel.

*December 18 New Jersey Statehood Day

On December 18, 1787, New Jersey became the third state to ratify the Constitution. The people of New Jersey were particularly involved in the Revolutionary War and many battles were fought within the state's borders. Soldiers were stationed in Morristown. Washington's crossing of the Delaware River is recorded in painting and legend.

To learn more about New Jersey, refer to *July 2: Be Nice to New Jersey Day*.

Featured Book

This Time, Tempe Wick? by Patricia Lee Gauch. Putnam, 1992.

Based on a true character, this is the story of a young girl living near Morristown, New Jersey, who outwits the soldiers who try to steal the family horse.

Additional Book

The 18 Penny Goose, by Sally M. Walker; illus. by Ellen Beier. HarperCollins, 1998.

Activity

Learn more about New Jersey by using reference books and jotting down interesting facts. Combine all the facts into a bulletin board celebrating New Jersey.

December 19 Hi Neighbor Month

With Hanukkah, Christmas, and Kwanzaa all celebrated this month, December is a time when people greet their neighbors with holiday cards or personal greetings. It is officially considered Hi Neighbor Month. Today's books are about people who show goodwill toward their neighbors.

Featured Book

Raising Yoder's Barn, by Jane Yolen; illus. by Bernie Fuchs. Little Brown, 1998.

Eight-year-old Matthew tells what happens when fire destroys the barn on his family's farm and all the Amish neighbors come to rebuild it in one day.

Additional Books

Emily, by Michael Bedard; illus. by Barbara Cooney. Doubleday Book for Young Readers, 1992.

When Uncle Took the Fiddle, by Libba Moore Gray; illus. by Lloyd Bloom. Orchard, 1999.

Activities

1. Say "hi" to your neighbors.
2. Make friendly cards for people in neighboring nursing homes and hospitals.

*December 20 Louisiana Purchase Day

On December 20, 1803, the United States took possession of approximately 828,000 square miles of land in an agreement called the Louisiana Purchase. Thomas Jefferson masterminded the purchase of this vast territory from the French for the sum of fifteen-million dollars. The purchase included all or parts of the present day states of Louisiana, Arkansas, Missouri, Iowa, Minnesota, Oklahoma, Kansas, Nebraska, North and South Dakota, Colorado, Wyoming, and Montana. Meriwether Lewis, secretary to President Thomas Jefferson, and William Clark were the earliest official explorers of the Louisiana Purchase. December 20 is a good day to read about the adventures of Lewis and Clark.

Featured Book

Lewis and Clark: Explorers of the American West, by Steven Kroll; illus. by Richard Williams. Holiday House, 1994.

This well-written and beautifully illustrated account of the Lewis and Clark explorations will serve as a good read-aloud for older students.

Additional Book

The Incredible Journey of Lewis and Clark, by Rhoda Blumberg. Lothrop, Lee & Shepard, 1987.

This 143-page book is much too long to read aloud, but carefully chosen excerpts may serve to interest students in further study of the exploration of the western United States.

Activity

On a map of the United States, mark the present-day states which were purchased through the Louisiana Purchase agreement. Mark the trail used by Lewis and Clark in exploring the region.

*December 21 Forefather's Day

On December 21, 1620, seventeen Pilgrim scouts from the Mayflower went ashore at Plymouth, Massachusetts. The Pilgrims had originally formed a congregation of fifty or sixty worshippers in Scrooby Manor in England around 1606. Most of them were farmers. Their leader, a pastor named John Robinson, led the group to Holland in 1607 to avoid religious harassment in England. In 1620 they left their adopted city of Leiden to sail for the New World. Thirty-five Pilgrims and sixty-five other English people left England on September 16, 1620. After sixty-four days at sea, they reached Massachusetts. The scouts reported that Plymouth would be a good place to settle, and on January 5, 1621, the rest of the settlers arrived in Plymouth Harbor. According to tradition, they stepped ashore onto Plymouth Rock, which is still preserved as a monument to their arrival.

Featured Book

Goody O'Grumpity, by Carol Ryrie Brink; illus. by Ashley Wolff. North-South Books, 1994.

Illustrator Ashley Wolff places Carol Ryrie Brink's poem in Plymouth Plantation. Pictures reflect the Pilgrim settlement there and the daily activities of the kindly Goody O'Grumpity.

Additional Books

Across the Wide Dark Sea: The Mayflower Journey by Jean Van Leeuwen; illus. by Thomas B. Allen. Dial, 1995.

Pilgrim Voices: First Year in the New World, edited by Connie and Peter Roop; illus. by Shelley Pritchett. Walker, 1995

Activities

1. Bake Goody O'Grumpity's Spice Cake and enjoy!
2. Based on the story *Across the Wide Dark Sea* or *Pilgrim Voices*, list some of the hardships experienced by the Pilgrims both on their journey and after their arrival in the New World.

*December 22 Winter Solstice

In the Northern Hemisphere the winter solstice begins on December 22. This is the shortest day of the year and the day on which winter begins. From this date on, the days will seem to get longer—at least the period of sunlight which marks our days lasts longer. Celebrate the beginning of winter on December 22.

Featured Book

The First Snow, by David Christiana. Scholastic, 1996.

Young Mother Nature hates winter and tries to keep it away by painting the trees bright colors.

Additional Books

Dear Rebecca, Winter is Here, by Jean Craighead George; illus. by Loretta Krupinski. HarperCollins, 1993.

Winter's Child, by Mary K. Whittington; illus. by Sue Ellen Brown. Atheneum, 1992.

Activities

1. How are you preparing for winter? Make a list of all the things people in your area do as they get ready for the new season.
2. Create posters to welcome winter. Think of all the good things about the winter season and draw pictures of winter fun.
3. How would you describe winter to a child living on the equator? Try to explain what December is like in your region using vivid images of winter.

*December 23 Feast of Radishes or *La Noche de los Rábanos*

This unusual fiesta takes place on the night of December 23 in the city of Oaxaca, Mexico. The city sponsors a radish-carving contest. The radishes grown in Oaxaca are not tiny salad radishes, but grow to be a red plant of up to two feet long and four inches in diameter.

The tradition of carving radishes began about two hundred years ago when the radish crop was so abundant that a section of the field went unharvested. When two local friars pulled out these forgotten radishes in December, they were amazed to find how big they had grown. Many had grown into strange shapes, so the friars exhibited them in the town square where they attracted a large crowd.

The idea so intrigued local people that they began to carve the big radishes into shapes, many of which were nativity figures. Eventually, the people held a competition to judge who had carved the best and most original figures. Today, sculptors still carve the radishes into a variety of figures. However, the contest no longer is limited to nativity characters. Spectators begin to arrive around 4:00 p.m. to view the amazing radishes of Oaxaca.

Celebrate the Feast of the Radishes by reading Mexican Christmas stories.

Featured Book

Too Many Tamales, by Garo Soto; illus. by Ed Martinez. Putnam, 1993.

Maria enjoys helping her mother make tamales for Christmas Eve, but the fun is lost when Maria loses her mother's diamond ring.

Additional Book

The Farolitos of Christmas, by Rudolfo Anaya; illus. by Edward Gonzales. Hyperion, 1995.

Activities

1. Try your hand at carving. Since radishes may be too small, try soap carving instead.
2. Make some tamales as a special treat.
3. Celebrate the Mexican way with a piñata filled with holiday candy.
4. Recall special memories from your own school or family celebrations.

*December 24 Christmas Eve

Christmas Eve is a special time for Christians marked by church services and family get-togethers. Some families exchange gifts on Christmas Eve; others eat special foods. In some families, children eagerly anticipate the arrival of Santa Claus. But no matter where they live, Christian children look forward to the joyful celebration of Christmas that takes place on the next day.

Today's stories portray children celebrating Christmas in other places and times.

Featured Book

An Ellis Island Christmas, by Maxinne Rhea Leighton; illus. by Dennis Nolan. Viking, 1992.

Krysia and her mother arrive at Ellis Island on Christmas Eve, hoping to find Papa and to be allowed to stay in the United States.

Additional Books

Christmas in the Big House, Christmas in the Quarters; by Patricia C. McKissack and Fredrick L. McKissack; illus. by John Thompson. Scholastic, 1994.

An Island Christmas, by Lynn Joseph; illus. by Catherine Stock; Clarion, 1992.

Activity

Invite an older neighbor or an immigrant from another country to visit with your group about Christmas in another time or place.

*December 25 Christmas Day

Christmas Day, which marks the birth of Jesus Christ, is the highlight of the Christian year which is celebrated by religious and secular people throughout the world. Christians often attend special church services. Family get-togethers, special holiday meals, and gift giving are all part of the festivities. Modern Christian tradition maintains that gift giving reflects the gifts brought to the baby Jesus by the three wise men. However, some historians suggest that midwinter gifts were exchanged by the ancient Romans and spread to other European cultures. The earliest records of Christ-

mas gift giving come from Germany where sixteenth-century parents gave "Christ-bundles" to the children. Such bundles contained an assortment of gifts including coins, nuts, apples, dolls, books, and clothing. In Sweden the gifts were called *Julklapp*, which meant "Christmas knock." Christmas gift-givers would knock on doors and toss the gift inside and then run away. In the early Puritan settlements of New England, gift giving was prohibited. Today, however, there is no such ban on gift-giving, and the exchange of gifts is an accepted part of our Christmas traditions. Today's stories reflect the truth that the best gifts are sometimes unexpected.

Featured Book

The Christmas Miracle of Jonathan Toomey, by Susan Wojciechowski; illus. P. J. Lynch. Candlewick, 1995.

Gruff Jonathan Toomey reluctantly agrees to carve the figures for a Christmas creche when Mrs. McDowell and her seven-year-old son, Thomas, ask for his help.

Additional Books

A Christmas Surprise for Chabelita; by Argentia Palacios; illus. by Lori Lohstoeter. BridgeWater, 1993.

The Gingerbread Doll, by Susan Tews; illus. by Megan Lloyd. Clarion, 1990.

Silver Packages: An Appalachian Christmas Story, by Cynthia Rylant; illus. by Chris K. Soentpiet. Orchard, 1997.

Activity

Share your own memory of an unexpected gift. Why did this gift mean so much to you?

*December 26 Kwanzaa

Kwanzaa was founded by Dr. Maulana Karenga in San Diego, California, and was first observed in 1966. It is designed as a way for African Americans to celebrate their cultural heritage and family values. Kwanzaa comes from the Kiswahili word "First Fruits." The holiday lasts for seven days, from December 26 to January 1, and each day encourages recognition of a particular principle valued by African Americans. The seven principles are:

Day 1 *Umoja* (Unity)
Day 2 *Kujichagulia* (Self-determination)
Day 3 *Ujima* (Collective Work and Responsibility)
Day 4 *Ujamaa* (Cooperative Economics)
Day 5 *Nia* (Purpose)
Day 6 *Kuumba* (Creativity)
Day 7 *Imani* (Faith)

Most of the books currently available about Kwanzaa are designed to instruct children in the meaning of the holiday.

Featured Book

Imani's Gift at Kwanzaa, by Denise Burden-Patmon; illus. by Floyd Cooper. Simon & Schuster, 1993.

Imani learns about the meaning of Kwanzaa from her grandmother, M'dear, and realizes that she needs to be understanding and gentle to help a visiting child, Enna, accept her love and friendship. This book teaches about Kwanzaa within the context of the story.

Additional Books

Celebrating Kwanzaa, by Diane Hoyt-Goldsmith; photos by Lawrence Migdale. Holiday House, 1993.

It's Kwanzaa Time! by Linda Goss and Clay Goss. Putnam, 1995.

Seven Candles for Kwanzaa, by Andrea Davis Pinkney; illus. by Brian Pinkney. Dial, 1993.

Activities

1. Try one of the projects suggested in *The Children's Book of Kwanzaa: A Guide to Celebrating the Holiday*, by Dolores Johnson (Atheneum, 1996).
2. Invite someone who celebrates Kwanzaa to speak with the group about the holiday.
3. Learn some Kiswahili words. This language is spoken by approximately fifty million people, particularly in eastern and central Africa. Kiswahili is the national language of Kenya, Tanzania, and Uganda. Kiswahili dictionaries are available in most bookstores, libraries, or on the Internet.

Jambo.	Hello.
Harabi gani?	How are you?
Habari Yangu Ni Nzuri	I am fine
Salama!	Peace!

December 27 Bingo Day

The game of Bingo was invented in December 1929 by Edwin S. Lowe. While children still enjoy playing bingo, the game has grown into a five billion dollar a year fund raiser for charities. The word "bingo" has become part of our vocabulary. People often say "bingo" to signify their understanding of something or to indicate that they've succeeded. Bingo may not have been invented on December 27, but this is a good day to celebrate its invention.

Featured Book

Bingo, The Best Dog in the World, by Catherine Siracusa; illus. by Sidney Levitt. HarperCollins, 1991.

This *I Can Read* book features a happy-go-lucky dog spending a day with Stuart and Sam.

Additional Book

The Hokey Pokey, by Larry LaPrise, Charles P. Macak, and Taftt Baker; illus. by Sheila Hamanaka. Simon & Schuster, 1997.

This playful song is as familiar to children as the Bingo song. Since it is both a song and a game, it's a good match for Bingo Day.

Activities

1. Sing the Bingo song. If you are unfamiliar with this song, look at recordings of children's songs and games available at your local library.
2. Do the Hokey Pokey.
3. Play Bingo. There are many varieties of Bingo, many of them learning games designed on the bingo model.

* December 28 Iowa Statehood Day

Iowa was part of the land included in the Louisiana Purchase in 1803, and in 1832 Iowa was the site of an uprising by the Sauk and Fox Indians who wanted to rid the area of Europeans. The Indians, led by Black Hawks, were defeated, and in 1838, Iowa became a United States territory. Eight years later, on December 28, 1846, it became our twenty-ninth state.

Iowa today is a productive agricultural state. Second in corn production, Iowa leads the nation in hog farming, producing nearly 13.5 million hogs and thirty million pigs annually. Hogs are pigs weighing over 120 pounds. While there are many wonderful ways to remember Iowa, celebrate this day with books about Iowa and silly pigs.

Featured Book

Eve and Smithy: An Iowa Tale, by Michelle Edwards. Lothrop, Lee & Shepard, 1994.

Smithy wants to find the perfect gift for his neighbor who gardens and paints pictures of Iowa.

Additional Books

The Great Pig Escape, by Eileen Christelow. Clarion, 1994.

Parents in the Pigpen, Pigs in the Tub, by Amy Ehrlich; illus. by Steven Kellogg. Dial, 1992.

The Pig in the Pond, by Martin Waddell; illus. by Jill Barton. Candlewick, 1992.

Roland, The Minstrel Pig, by William Steig. Harper & Row, 1968.

Activities

1. Make up your own silly pig story. Perhaps you can imagine a pig in your classroom, attending your club meeting, or moving into your neighborhood.
2. Draw a funny pig picture by placing a pig in an unusual setting or decorating the pig in an unusual fashion.

*December 29 Texas Statehood Day

Texas joined the Union on December 29, 1845. It is our second largest state (only Alaska is bigger), and it ranks second in population. Texas was part of Mexico when the first explorers from the eastern United States arrived there in 1821. The battle of the Alamo won Texas independence, and it remained an inde-

pendent republic until its statehood in 1845. Texas had its own flag with one star. Even today, Texas is called the *Lone Star State.*

Texas is known for its cattle ranching and its oil wells. It is also the home of the Lyndon B. Johnson Space Center. About four-fifths of Texans live in urban areas. Most Texans were born in the United States. Of the 10 percent who were not, 60 percent of them came from Mexico. Because Texas shares a border and a history with Mexico, Mexican influences abound. Food, music, and language all reflect the close relationship between Texas and Mexico.

Both of today's stories focus on Mexican American children living in Texas.

Featured Book

Friends from the Other Side/Amigos del Otro Lado, by Gloria Anzaldúa; illus. by Consuelo Méndez. Children's Book Press, 1993.

Texas is the setting for this story of the friendship between a Mexican American girl, Prietita, and a Mexican boy, Joaquin. When Joaquin and his mother seek to begin a new life in Texas, Prietita helps them avoid capture by the border police.

Additional Book

Family Pictures/Cuadros de Familia, by Carmen Lomas Garza. Children's Book Press, 1990.

Activities

1. Use a southwestern cookbook to make a southwestern meal.
2. Learn a few words of Spanish. You might invite someone who is a native Spanish speaker, or a Spanish teacher, or an older student who is learning Spanish to visit with your group.

*December 30 Anniversary of the Republic of Madagascar

The island nation of Madagascar celebrates the day in 1975 on which it officially became the Republic of Madagascar. Scientists believe that Madagascar was part of Africa and broke away during a cataclysmic earthquake 165 million years ago. It was at that time an uninhabited island teeming with lemurs, dwarf hippos, giant tortoises, ten-foot tall elephant birds, and many other species with virtually no natural predators until the arrival of humans about 2,000 years ago. The first people arrived from India, Africa, and Arabia and gradually killed off most of the unique species of Madagascar.
In the 1500s Portuguese explorers arrived on the island and spread word of its beauty to France and England. Eventually the French claimed the island and by 1895, it was a French colony. In 1958, France granted Madagascar its independence, and it became a republic, first known as Malagasy, but now called Madagascar.

Featured Book

The New King, by Doreen Rappaport; illus. by E. B. Lewis. Dial, 1995.

Prince Rakoto accepts his father's death and takes on the responsibilities of a king with the help of a wise woman in this folktale from Madagascar.

Additional Book

Lemurs, by Kathy Darling; photographs by Tara Darling. Lothrop, Lee & Shepard, 1998.

Describes the physical characteristics and behavior of different kinds of lemurs encountered on a trip to a forest in southeastern Madagascar.

Activity

Locate Madagascar on a map. Learn more about the island of Madagascar and its animals, particularly lemurs, by consulting reference books and nonfiction books about African animals.

*December 31 Hogmany

December 31 is called *Hogmany* in Scotland and Northern England. In earlier times, children went from house to house asking for a gift of an oatmeal cake. This day is also called Cake Day. Until the eighteenth century, the New Year's celebration was far more boisterous than Christmas. New Year's Eve, rather than Christmas, was the occasion for giving gifts to children. The gifts were often oatmeal cakes, an apple decorated with nuts, or other tasty treats. Several interesting traditions are associated with *Hogmany*. For example, people in Scotland hope that the first person who enters their home in the new year will be a dark-haired person bringing coal, salt, and a bottle of whiskey. These are symbols of warmth, food, and happiness in the New Year. December 31 is a good day to read Scottish tales and to think about the New Year.

Featured Books

Tam Lin: An Old Ballad, retold by Jane Yolen; illus. by Chalres Mikolaycak. Harcourt Brace Jovanovich, 1990.

Whippity Stoorie, by Carolyn White; illus. by S. D. Schindler. Putnam, 1997.

Activities

1. Make a list of some of the superstitions mentioned in the story. What superstitions do you have surrounding New Year's Eve? Are there special traditions that your family follows?
2. Make a list of New Year's resolutions. Check again in one month. How many have you kept?

Resource Guide

General Holiday Resources *

Anyike, James C. *African American Holidays: A Historical Research and Resource Guide to Cultural Celebrations*. Chicago: Popular Truth, 1991.

Bellenir, Karen. *Religious Holidays and Calendars: An Encyclopedic Handbook.* 2nd ed. Detroit: Omnigraphics, 1998.

Clynes, Tom. *Wild Planet: 1001 Extraordinary Events for the Inspired Traveler*. Detroit: Visible Ink, 1995.

Cohen, Hennig and Tristam Potter Coffin. *The Folklore of American Holidays*. 2nd ed. Detroit: Gale, 1991.

Douglas, George William. *The American Book of Days*. New York: H.W. Wilson, 1948.

Dunkling, Leslie. *A Dictionary of Days*. New York: Facts on File, 1988.

Gregory, Ruth W. *Anniversaries and Holidays*. 4th ed. Chicago: ALA, 1983.

Harper, Howard V. *Days and Customs of All Faiths*. New York: Fleet, 1957.

Hatch, Jane M. *The American Book of Days*. 3rd ed. New York: H.W. Wilson, 1978.

Henderson, Helene and Sue Ellen Thompson. *Holidays, Festivals, and Celebrations of the World Dictionary*. 2nd ed. Detroit: Omnigraphics, Inc., 1997.

Jones, Lynda. *Celebrate! The Best Feasts and Festivals from Many Lands*. New York: John Wiley, 2000.

MacDonald, Margaret Read, ed. *The Folklore of World Holidays*. Detroit: Gale, 1992.

Marks, Diana F. *Let's Celebrate Today: Calendars, Events, and Holidays*. Illus. by Donna L. Farrell. Englewood, Colorado: Libraries Unlimited, Inc. 1998.

Santino, Jack. *All Around the Year: Holidays and Celebrations in American Life*. Urbana: University of Illinois, 1995.

Spicer, Dorothy Gladys. *The Book of Festivals*. Detroit: Gale, 1969.

Sublette, Guen. *The Book of Days*. New York: Perigee, 1996.

Whiteley, Sandy. *The Teacher's Calendar 1999-2000: The Day-by-Day Directory to Holidays, Historic Events, Birthdays and Special Days, Weeks and Months*. Lincolnwood, Ill.: NTC/Contemporary Publishing, 1999.

*Hundreds of additional resources, both web-based and print, were used to gather the information contained in this book.

Bibliographies of Children's Literature

Adamson, Lynda G. *Literature Connections to American History: Resources to Enhance and Entice, K-6*. Englewood, Colo.: Libraries Unlimited, 1998.

Brodie, Carolyn S. *Exploring the Plains States through Literature*. Phoenix, Ariz.: Oryx, 1994.

Doll, Carol A. *Exploring the Pacific States through Literature*. Phoenix, Ariz.: Oryx, 1994.

Frey, P. Diane. *Exploring the Northeast States through Literature*. Phoenix, Ariz.: Oryx, 1994.

Gillespie, John T. *Best Books for Children: Preschool through Grade 6*. New Providence, N.J.: R. R. Bowker, 1998.

Latrobe, Kathy Howard. *Exploring the Great Lakes States through Literature*. Phoenix, Ariz.: Oryx, 1994.

Lima, Carolyn W. and John A Lima. *A to Zoo: Subject Access to Children's Picture Books*. 5th ed. New Providence, N.J.: R. R. Bowker, 1998.

Miller-Lackmann, Lyn. *Our Family, Our Friends, Our World: An Annotated Guide to Significant Multicultural Books for Children and Teenagers*. New Providence, N.J.: R. R. Bowker, 1992.

Sharp, Pat Tipton. *Exploring the Southwest States through Literature*. Phoenix, Ariz.: Oryx, 1994.

Smith, Sharyl G. *Exploring the Mountain States through Literature*. Phoenix, Ariz.: Oryx, 1994.

Veltze, Linda. *Exploring the Southeast States through Literature*. Phoenix, Ariz.: Oryx, 1994.

Suggested Children's Books

Aardema, Verna. *Behind the Back of the Mountain: Black Folktales from Southern Africa*. Dial, 1973.

———. *A Bookworm Who Hatched*. Richard C. Owen, 1992.

———. *Bringing the Rain to Kapiti Plain*. Dial, 1981.

———. *Jackal's Flying Lesson: A Khoikho Tale*. Alfred A. Knopf, 1995.

———. *Traveling to Tondo: A Tale of the Nkundo of Zaire*. Alfred A. Knopf, 1991.

———. *Why Mosquitoes Buzz in People's Ears: A West African Tale*. Dial, 1975.

Ackerman, Karen. *Song and Dance Man*. Alfred A. Knopf, 1988.

Ada, Alma Flor. *Dear Peter Rabbit*. Atheneum, 1994.

———. *The Gold Coin*. Atheneum, 1991.

Adler, David A. *Jackie Robinson: He Was the First*. Holiday House, 1994.

———. *A Picture Book of Abraham Lincoln*, Holiday House, 1989.

———. *A Picture Book of Davy Crockett*. Holiday House, 1995.

———. *A Picture Book of Hanukkah*. Scholastic, 1982.

———. *A Picture Book of Jackie Robinson*. Holiday House, 1994.

———. *A Picture Book of Martin Luther King, Jr.* Holiday House, 1989.

———. *A Picture Book of Rosa Parks*. Holiday House, 1993.

Adoff, Arnold. *Love Letters*. Blue Sky, 1997.

Ahlbert, Janet. *The Jolly Postman*. Little Brown, 1986.

Aiyengar, Devi S. *I Am Hindu*. PowerKids Press, 1996.

Alborough, Jez.. *Cuddly Dudley*. Candlewick, 1993.

Alda, Arlene. *Arlene Alda's ABC*. Celestial Arts, 1981.

Alexander, Ellen. *Llama and the Great Flood: A Folktale from Peru*. Thomas Y. Crowell, 1989.

Alexander, Lloyd. *The House of Gobbaleen*. Dutton, 1995.

Aliki. *The Many Lives of Benjamin Franklin*. Simon & Schuster, 1977.

———. *My Visit to the Dinosaurs*. HarperCollins, 1985.

———. *A Weed Is a Flower: The Life of George Washington Carver*. Simon & Schuster, 1985.

Allaby, Michael. *How the Weather Works: 100 Ways Parents and Kids Can Share the Secrets of the Atmosphere*. Reader's Digest, 1995.

Allard, Harry. *I Will Not Go to Market Today*. Dial, 1979.

Allen, Thomas B. *On Grandaddy's Farm*. Alfred A. Knopf, 1989.

Altman, Linda Jacobs. *Amelia's Road*. Lee & Low, 1993.

Anaya, Rudolfo. *The Farolitos of Christmas*. Hyperion, 1995.

Ancona, George. *Powwow*. Harcourt Brace, 1993.

Andersen, Hans Christian. *The Ugly Duckling*. Morrow, 1999.

Anderson, C. W. *Salute*. Macmillan, 1940.

Anderson, Janet S. *Sunflower Sal*. Albert Whitman, 1997.

Anderson, Joan. *Christmas on the Prairie*. Clarion, 1985.

Anderson, Laurie Halse. *Ndito Runs*. Henry Holt, 1996.

Anderson, Lonzo. *Ponies of Mykillengi*. Charles Scribner's Sons, 1966.

Anderson, Peter. *The Pony Express*. Children's Press, 1996.

———. *The Transcontinental Railroad*. Children's Press, 1996.

Anzaldúa, Gloria. *Friends from the Other Side/Amigos del Otro Lado*. Children's Book Press, 1993.

Appelbaum, Diana. *Cocoa Ice*. Orchard, 1997.

Archambault, John and Bill Martin. *A Beautiful Feast for a Big King Cat*. HarperCollins, 1989.

Arnold, Marsha Diane. *Pumpkin Runner*. Dial, 1998.

Arnold, Tedd. *No More Water in the Tub!* Dial, 1995.

———. *Parts*. Dial, 1997.

Arnold, Tim. *The Three Billy Goats Gruff*. Margaret K. McElderry, 1993.

Aruego, Jose and Ariane. *A Crocodile's Tale: A Philippine Folk Story*. Scribner, 1972.

Asbjorsen, Peter Christen. *The Three Billy-goats Gruff; A Norwegian Folktale*. Holt, Rinehart, and Winston, 1963.

Attenborough, Liz. *The Children's Book of Poems, Prayers and Meditations*. Element, 1998.

Auch, Mary Jane. *Peeping Beauties*. Holiday House, 1993.

Avi. *Finding Providence: The Story of Roger Williams*. HarperCollins, 1997.

Aylesworth, Jim. *The Full Belly Bowl*. Atheneum, 1999.

———. *The Gingerbread Man*. Scholastic, 1998.

———. *Hush Up!* Holt, Rinehart, and Winston, 1980.

Babbitt, Natalie. *Nellie: A Cat on Her Own*. Farrar, Straus & Giroux, 1989.

Baker, Keith. *Who Is the Beast?* Harcourt Brace, 1990.

Barbaresi, Nina. *Firemouse*. Crown, 1987.

Barber, Barbara E. *Saturday at the New You*. Lee & Low, 1994.

Barrett, Joyce Durham. *Willie's Not the Hugging Kind*. HarperTrophy, 1991.

Barrett, Judi. *Cloudy with a Chance of Meatballs*. Atheneum, 1978.

———. *Pickles to Pittsburgh: The Sequel to Cloudy with a Chance of Meatballs*. Atheneum, 1997.

Barrett, Mary Brigid. *Sing to the Stars*. Little Brown, 1994.

Barry, David. *The Rajah's Rice: A Mathematical Folktale of India*. W. H. Freeman, 1994.

Bartoletti, Susan Campbell. *Dancing with Dziadziu*. Harcourt Brace, 1997.

Bates, Artie Ann. *Ragsale*. Houghton Mifflin, 1995.

Battle-Lavert, Gwendolyn. *The Barber's Cutting Edge*. Children's Book Press, 1994.

Bauer, Caroline Feller. *Thanksgiving: Stories and Poems*. HarperCollins, 1994.

Baynes, Pauline. *Thanks Be To God: Prayers from around the World*. Macmillan, 1990.

Bedard, Michael. *Emily*. Doubleday, 1992.

Belloc, Hilaire. *Matilda Who Told Such Dreadful Lies . . .* Alfred A. Knopf, 1991.

Benchley, Nathaniel. *George the Drummer Boy*. Harper & Row, 1977.

———. *Sam the Minuteman*. Harper & Row, 1969.

Bender, Robert. *A Most Unusual Lunch*. Dial, 1994.

Ben-Ezer, Ehud. *Hosni the Dreamer: An Arabian Tale*. Farrar, Straus & Giroux, 1997.

Berger, Barbara. *Grandfather Twilight*. Philomel, 1984.

Berwick, Jean. *Arthur and the Golden Guinea*. Golden Gate Junior Books, 1963.

Best, Cari. *Last Licks: A Spaldeen Story*. DK, 1998.

———. *Red Light, Green Light, Mama and Me*. Orchard, 1995.

Bial, Raymond. *County Fair*. Houghton Mifflin, 1992.

Biebow, Natascha. *Eleonora*. W. H. Freeman, 1995.

Bierhorst, John. *The Woman Who Fell from the Sky: The Iroquois Story of Creation*. Morrow, 1993.

Birchman, David. *Brother Billy Bronto's Bygone Blues Band*. Lothrop, Lee & Shepard, 1992.

Blake, Robert. *Akiak; A Tale from the Iditrod*. Philomel, 1997.

Blaustein, Muriel. *Play Ball, Zachary!* Harper & Row, 1988.

Bliss, Corinne Demas. *The Littlest Matryoshka*. Hyperion, 1999.

Blos, Joan W. *The Days Before Now: An Autobiographical Note by Margaret Wise Brown*. Simon & Schuster, 1993.

Blumberg, Rhoda. *Bloomers!* Bradbury, 1993.

———. *The Incredible Journey of Lewis and Clark*. Lothrop, Lee & Shepard, 1987.

Bogart, JoEllen and Barbara Reid. *Gifts*. Scholastic, 1994.

Boland, Janice. *Annabel*. Dial, 1993.

Bontemps, Arna. *Golden Slippers: An Anthology of Negro Poetry for Young Readers*. Harper & Brothers, 1941.

Borden, Louise. *A. Lincoln and Me*. Scholastic, 1999.

Bowman, James Cloyd and Margery Bianco. *Tales from a Finnish Tupa*. Translated by Aili Kolehmainen. Albert Whitman, 1936.

Boyd, Selma Pauline. *I Met a Polar Bear*. Lothrop, Lee & Shepard, 1983.

Bray, Rosemary L. *Martin Luther King*. Greenwillow, 1995.

Brett, Jan. *Armadillo Rodeo*. Putnam, 1995.

———. *Beauty and the Beast*. Clarion, 1989.

———. *The Mitten: A Ukrainian Folktale*. Putnam, 1989.

———. *Town Mouse Country Mouse*. Putnam, 1994.

———. *The Trouble with Trolls*. Putnam, 1992.

———. *The Wild Christmas Reindeer*. Putnam, 1990.

Briggs, Raymond. *The Mother Goose Treasury*. Coward-McCann, 1966.

Brighton, Catherine. *Mozart: Scenes from the Childhood of the Great Composer*. Doubleday, 1990.

Brink, Carol Ryrie. *Goody O'Grumpity*. North-South Books, 1994.

Brother Eagle, Sister Sky: A Message from Chief Seattle. Dial, 1991.

Brown, Craig. *Tractor*. Greenwillow, 1995.

Brown, Don. *Rare Treasure: Mary Anning and Her Remarkable Discoveries*. Houghton Mifflin, 1999.

———. *Ruth Law Thrills a Nation*. Ticknor & Fields, 1993.

Brown, Marc. *Arthur Meets the President*. Little Brown, 1991.

———. *Arthur's Pet Business*. Joy Street, 1990.

———. *Arthur's Eyes*. Little Brown, 1979.

———. *D. W. Rides Again!* Little Brown, 1993.

Brown, Marc and Stephen Krensky. *Dinosaurs, Beware! A Safety Guide*. Little Brown, 1984.

Brown, Marcia. *Stone Soup*. Charles Scribner's Sons, 1974.

Brown, Ruth. *The Picnic*. Dutton, 1993.

Bruchac, Joseph. *Fox Song*. Philomel, 1993.

Brusca, María Cristina. *On the Pampas*. Henry Holt, 1991.

Bryan, Ashley. *The Story of Lightning & Thunder*. Maxwell Macmillan International, 1993.

Buehner, Caralyn. *Fanny's Dream*. Dial, 1996.

Bulla, Clyde Robert. *Daniel's Duck*. Harper & Row, 1979.

Bunting, Eve. *The Blue and the Gray*. Scholastic, 1996.

Bunting, Eve. *Dandelions*. Harcourt Brace, 1995.

———. *Flower Garden*. Scholastic, 1994.

———. *A Picnic in October*. Harcourt Brace, 1999.

———. *The Wall*. Clarion, 1990.

———. *Wednesday's Surprise*. Clarion, 1989.

Burden-Patmon, Denise. *Imani's Gift at Kwanzaa*. Simon & Schuster, 1993.

Burleigh, Robert. *Hoops*. Harcourt Brace, 1997.

Burn, Doris. *Andrew Henry's Meadow*. Coward-McCann, 1965.

Burningham, John. *John Patrick Norman McHennessey: The Boy Who Was Always Late*. Crown, 1987.

Burns, Marilyn. *Spaghetti and Meatballs for All! A Mathematical Story*. Scholastic, 1997.

Byrd, Robert. *Finn MacCoul and His Fearless Wife: A Giant of a Tale from Ireland*. Dutton, 1999.

Calhoun, Mary. *Cross-Country Cat*. Morrow, 1979.

———. *Flood!* Morrow, 1997.

———. *Hot-Air Henry*. Morrow, 1982.

———. *Jack and the Whoopee Wind*. Morrow, 1987.

Calmenson, Stephanie. *The Teeny Tiny Teacher*. Scholastic, 1998.

Campbell, Lisa Ernst. *Sam Johnson and the Blue Ribbon Quilt*. Lothrop, Lee & Shepard, 1983.

———. *Zinnia and Dot*. Viking, 1992.

Carey, Valerie Scho. *Quail Song: A Pueblo Indian Tale*. Putnam, 1990.

Carle, Eric. *The Very Hungry Caterpillar*. Philomel, 1969.

Carlson, Nancy. *Look Out Kindergarten, Here I Come!* Viking, 1999.

———. *What If It Never Stops Raining?* Viking, 1992.

Carlstrom, Nancy White. *Goodbye Geese*. Philomel, 1991.

———. *Raven and River*. Little Brown, 1997.

———. *Thanksgiving Day at Our House: Thanksgiving Poems for the Very Young*. Simon & Schuster, 1999.

———. *Wild Wild Sunflower Child Anna*. Aladdin, 1991

Carrick, Carol. *In the Moonlight, Waiting*. Clarion, 1990.

———. *Left Behind*. Clarion, 1988.

Carrick, Donald. *Harald and the Great Stag*. Clarion, 1988.

———. *Morgan and the Artist*. Clarion, 1985.

Carson, Jo. *Pulling My Leg*. Orchard, 1990.

Carter, Alden R. *Dustin's Big School Day*. Albert Whitman, 1999.

Castle, Caroline and Peter Weevers. *Herbert Binns & the Flying Tricycle*. Dial, 1986.

Cauley, Lorinda Bryan. *The Town Mouse and the Country Mouse*. Putnam, 1984.

Cavagnaro, David and Maggie Cavagnaro. *The Pumpkin People*. Sierra Club Books, 1979.

Cazet, Denys. *Minnie and Moo Go Dancing*. DK, 1998.

Chadwick, Roxane. *Amelia Earhart: Aviation Pioneer*. Lerner Publications, 1987.

Charleston, Gordon. *Peary Reaches the North Pole*. Dillon, 1993.

Cherry, Lynne. *The Great Kakpok Tree: A Tale of the Amazon Rain Forest*. Harcourt, 1990.

Chester, Jonathon, and Kirsty Melville. *Splash! A Penguin Counting Book*. Tricycle Press, 1997

Chocolate, Debbi. *On the Day I Was Born*. Scholastic, 1995.

———. *The Piano Man*. Walker, 1998.

Chorao, Kay. *Little Farm by the Sea*. Henry Holt, 1998.

Christelow, Eileen. *The Great Pig Escape*. Clarion, 1994.

———. *What Do Authors Do?* Clarion, 1995.

Christian, Mary Blount. *April Fool.* Macmillan, 1981.

Christiana, David. *The First Snow.* Scholastic, 1996.

Christiansen, Candace. *The Ice Horse.* Dial, 1993.

Clark, Emma Chichester. *Across the Blue Mountains.* Gulliver, 1993.

Clayton, Elaine. *Ella's Trip to the Museum.* Crown, 1996.

Cleary, Beverly. *Muggie Maggie.* Morrow, 1990.

Clement, Rod. *Grandpa's Teeth.* HarperCollins, 1998.

Clifton, Lucille. *Three Wishes.* Viking, 1974.

Climo, Shirley. *The Egyptian Cinderella.* Thomas Y. Crowell, 1989.

———. *The Korean Cinderella.* HarperCollins, 1993.

———. *The Persian Cinderella.* HarperCollins, 1999.

———. *Stolen Thunder: A Norse Myth.* Clarion, 1994.

Coburn, Jewell Reinhart with Tzexa Cherta Lee. *Jouanah, a Hmong Cinderella.* Shen's Books, 1996.

Coerr, Eleanor. *The Josefina Story Quilt.* Harper & Row, 1986.

———. *Sadako.* Putnam, 1993.

Cohen, Barbara. *Yussel's Prayer: A Yom Kippur Story.* Lothrop, Lee & Shepard, 1981.

Cohen, Miriam. *Down in the Subway.* DK, 1998.

———. *Will I Have a Friend?* Collier, 1971.

Cohlene, Terri. *Little Firefly: An Algonquian Legend.* Rourke, 1990.

Cohn, Myra Livingston. *Space Songs.* Holiday, 1988.

Cole, Brock. *Buttons.* Farrar, Straus & Giroux, 2000.

Cole, Joanna. *Dinosaur Story.* Morrow, 1974.

Colman, Warren. *The Bill of Rights.* Children's Press, 1987.

Colodi, Carol. *Pinocchio.* Putnam's Sons, 1996.

Columbus, Christopher. *The Log of Christopher Columbus—First Voyage: Spring, Summer, and Fall—1492.* Philomel, 1992.

Condra, Estelle. *See the Ocean.* Ideals, 1994.

Conrad, Pam. *The Tub People.* Harper & Row, 1989.

Cooke, Trish. *So Much.* Candlewick. 1994.

Cooney, Barbara. *Island Boy,* Viking Kestrel, 1988.

Cooper, Susan. *The Silver Cow: A Welsh Tale.* Atheneum, 1983.

Corey, Shana. *You Forgot Your Skirt, Amelia Bloomer!* Scholastic, 2000.

Cousins, Lucy. *Maisy Drives the Bus.* Candlewick, 2000.

Cowcher, Helen. *Tigress.* Farrar, Straus & Giroux, 1991.

Cowen-Fletcher, Jane. *It Takes a Village.* Scholastic, 1993.

Cowley, Joy. *The Rusty, Trusty Tractor.* Boyds Mills, 1999.

Craft, Charlotte and K. Y. Craft. *King Midas and the Golden Touch.* Morrow, 1999.

Crews, Donald. *Night at the Fair.* Greenwillow, 1997.

Crews, Nina. *I'll Catch the Moon.* Greenwillow, 1996.

Crum, Robert. *Eagle Drum: On the Powwow Trail with a Young Grass Dancer.* Maxwell Macmillan, 1994.

Cuneo, Diane. *Mary Louise Loses Her Manners.* Doubleday, 1999.

Curry, Jane Louise. *Little Little Sister.* Margaret K. McElderry, 1989.

Curtis, Jamie Lee. *When I Was Little: A Four-Year-Old's Memoir of Her Youth.* HarperCollins, 1993.

Cutler, Jane. *Darcy and Gran Don't Like Babies.* Scholastic, 1991.

Czarnecki, Corinne and Jozef Czarnecki. *Fox Trot.* Grosset & Dunlap, 1987.

Czernecki, Stefan. *Cricket's Cage: A Chinese Folktale*. Hyperion, 1997.

D'Aulaires, Ingri and Edgar Parin D'Aulaires. *Leif the Lucky*. Doubleday, 1941.

Dalton, Annie. *The Starlight Princess and Other Princess Stories*. DK, 1999.

Daly, Niki. *Jamela's Dress*. Farrar, Straus & Giroux, 1999.

Darling, Kathy. *Lemurs*. Lothrop, Lee & Shepard, 1998.

Davidson, Margaret. *The Story of Jackie Robinson: Bravest Man in Baseball*. Dell, 1988.

Davol, Marguerite W. *The Heart of the Wood*. Simon & Schuster, 1992.

———. *The Paper Dragon*. Atheneum, 1997.

Day, Nancy Raines. *The Lion's Whiskers: An Ethiopian Folktale*. Scholastic, 1995.

De Gerez, Toni. *Louhi: Witch of North Farm*. Viking Kestrel, 1986.

De Leeuw, Adèle. *Paul Bunyan Finds a Wife*. Garrard, 1969.

De Paola, Tomie. *The Art Lesson*. Putnam, 1989.

———. *Days of the Blackbird: A Tale of Northern Italy*. Putnam, 1997.

———. *The Legend of Old Befana*. Harcourt Brace Jovanovich, 1980.

———. *The Legend of the Poinsettia*. Putnam, 1994.

———. *The Night of Las Posadas*. Putnam, 1999.

———. *The Popcorn Book*. Holiday, 1978.

———. *Strega Nona: An Old Tale*. Prentice-Hall, 1975.

———. *The Unicorn and the Moon*. Silver Press, 1995.

De Regneirs, Beatrice Schenk. *Little Sister and the Month Brothers*. Sebury, 1976.

——— *Red Riding Hood: Retold in Verse for Boys and Girls to Read Themselves*. Atheneum, 1972.

———. *Sing a Song of Popcorn. Every Child's Book of Poems*. Scholastic, 1988.

Dee, Ruby. *Two Ways to Count to Ten: A Liberian Folktale*. Henry Holt, 1988.

Demi. *The Empty Pot*. Holt, 1990.

———. *Liang and the Magic Paintbrush*. Holt. Reinhard and Winston, 1980.

———. *One Grain of Rice: A Mathematical Folktale*. Scholastic, 1997.

Dengler, Marianna. *Fiddlin' Sam*. Rising Moon, 1999.

———. *The Worry Stone*. Rising Moon, 1996.

Deutsch, Babette. *Heroes of the Kalevala, Finland's Saga*. Julian Messner, 1940.

Dewan, Ted. *3 Billy Goats Gruff*. Scholastic, 1994.

Dewey, Ariane. *The Narrow Escapes of Davy Crockett*. Greenwillow, 1990.

Diller, Harriet. *Grandaddy's Highway*. Boyds Mills, 1993.

DiSalvo-Ryan, DyAnne. *City Green*. Morrow, 1994.

———. *Uncle Willie and the Soup Kitchen*. Morrow, 1991.

Dixon, Ann. *Blueberry Shoe*. Northwest, 1999.

Donnelly, Judy. *Moonwalk: The First Trip to the Moon*. Random House, 1989.

Donnelly, Liza. *Dinosaur Garden*. Scholastic, 1990.

Dörriel, Doris. *Lottie's Princess Dress*. Dial, 1999.

Dorros, Arthur *Isla*. Dutton, 1995.

Downing, Julie. *Mozart Tonight*. Bradbury, 1991.

Drucker, Malka. *Grandma's Latkes*. Harcourt Brace Jovanovich, 1992.

Duff, Maggie. *Rum Pum Pum: A folktale from India*. Macmillan, 1978.

Dugan, Barbara. *Leaving Home with a Pickle Jar*. Greenwillow, 1993.

Dunbar, James. *When I Was Young: One Family Remembers 300 Years of History*. Carolrhoda, 1999.

Duncan, Pamela. *Dinorella: A Prehistoric Fairy Tale*. Hyperion, 1997.

Duvoisin, Roger. *Petunia*. Alfred A. Knopf, 1950.

Duvoisin, Roger. *Petunia Takes a Trip*. Alfred A. Knopf, 1953.

Eagan, Jim. *Metropolitan Cow*. Houghton Mifflin, 1996.

Easton, Patricia Harrison. *A Week at the Fair: A Country Celebration*. Millbrook, 1995.

Echewa, T. Obinkaram. *The Magic Tree: A Folktale from Nigeria*. Morrow, 1999.

Edwards, Michelle. *Eve and Smithy: An Iowa Tale*. Lothrop, Lee & Shepard, 1994.

Edwards, Roland. *Tigers*. Tambourine, 1992.

Egielski, Richard. *The Gingerbread Boy*. HarperCollins, 1997.

Ehlert, Lois. *Hands.* Harcourt Brace, 1997.

Ehrlich, Amy. *Lucy's Winter Tale*. Dial, 1999.

———. *Parents in the Pigpen, Pigs in the Tub*. Dial, 1992.

———. *The Random House Book of Fairy Tales*. Random House, 1985.

Emberley, Rebecca. *Three Cool Kids*. Little Brown, 1995.

English, Karen. *Nadia's Hands*. Boyds Mill, 1999.

Ernst, Lisa Campbell. *Ginger Jumps*. Bradbury, 1990.

———. *Little Red Riding Hood: A Newfangled Prairie Tale*. Simon & Schuster, 1995.

———. *Sam Johnson and the Blue Ribbon Quilt*. Lothrop, Lee & Shepard, 1983.

———. *Zinnia and Dot.* Viking, 1992.

Estes, Kristyn Rehling. *Manuela's Gift*. Chronicle, 1999.

Everitt, Betsy. *Mean Soup.* Harcourt Brace Jovanovich, 1992.

———. *TV Dinner*. Harcourt Brace, 1994.

Fain, Moira. *Snow Day.* Walker, 1996.

Farley, Carol. *Mr. Pak Buys a Story*. Whitman, 1997.

Faulkner, William J. *The Days when the Animals Talked: Black American Folktales and How They Came to Be*. Follett, 1977.

Feder, Paula Kurzband. *Where Does the Teacher Live?* Dutton, 1979.

Feiffer, Jules. *Bark, George*. HarperCollins, 1999.

Ferris, Jeri. *Arctic Explorer: The Story of Matthew Henson*. Carolhroda, 1989.

Fiday, Beverly and David Fiday. *Time To Go*. Harcourt Brace Jovanovich, 1990.

Fisher, Leonard Everett. *Galileo*. Macmillan, 1992.

Flack, Majorie. *The Story About Ping*. Viking, 1933.

Fleming, Alice. *Hosannah the Home Run! Poems about Sports*. Little Brown, 1972.

Fleming, Candace. *A Big Cheese for the White House: The True Tale of a Tremendous Cheddar.* DK, 1999.

———. *The Hatmaker's Sign: A Story of Benjamin Franklin*. Orchard, 1998.

Forest, Heather *The Baker's Dozen: A Colonial American Tale.* Harcourt Brace Jovanovich, 1988.

Foster, Joanna. *The Magpie's Nest*. Clarion, 1995.

Fox, Mem. *Possum Magic*. Omnibus, 1983.

———. *Whoever You Are*. Harcourt Brace, 1997.

———. *Wilfrid Gordon McDonald Partridge*. Kane Miller, 1985.

Frasier, Debra. *Out of the Ocean*. Harcourt Brace, 1998.

Freedman, Florence B. *Brothers: A Hebrew Legend*. Harper & Row, 1985.

Freedman, Russell. *The Wright Brothers: How They Invented the Airplane*. Holiday House, 1991.

Freeman, Don. *Ski Pup.* Viking, 1963.

French, Fiona. *The Blue Bird*. Henry Z. Walck, 1972.

———. *Little Inchkin*. Dial, 1994.

French, Vivian. *Lazy Jack*. Candlewick, 1995.

French, Vivian. *Once Upon a Picnic*. Candlewick, 1966.

Freymann, Saxton and Joost Elffers. *How Are You Peeling? Foods wth Moods*. Arthur A. Levine Books, 1999.

Friedman, Aileen. *A Cloak for the Dreamer*. Scholastic, 1994.

Friedman, Ina R. *How My Parents Learned to Eat*. Houghton Mifflin, 1984.

Friedrich, Elizabeth. *Leah's Pony*. Boyds Mill, 1996.

Fritz, Jean. *George Washington's Breakfast*. Coward-McCann, 1969.

———. *What's the Big Idea, Ben Franklin?* Coward, McCann & Geoghegan, 1976.

———. *Will You Sign Here, John Hancock?* Coward, McCann & Geoghegan, 1976.

Frost, Robert. *Birches*. Henry Holt, 1988.

———. *Stopping by Woods on a Snowy Evening*. Dutton, 1978.

———. *You Come Too: Favorite Poems for Young Readers*. Henry Holt, 1959.

Gabler, Mirko. *Alphabet Soup*. Henry Holt, 1992.

Gackenbach, Dick. *A Bag Full of Pups*. Clarion, 1981.

Gag, Wanda. *Millions of Cats*. Houghton Mifflin, 1989.

Galef, David. *Tracks*. Morrow, 1996.

Gammell, Stephen. *Once Upon MacDonald's Farm*. Four Winds, 1981.

Ganeri, Anita. *Focus on Vikings*. Gloucester, 1992.

———. *What Do We Know about Hinduism?* Peter Bedrick, 1995.

Gardella, Tricia. *Just Like My Dad*. Turtleback, 1993.

Garza, Carmen Lomas. *Family Pictures/Cuadros de Familia*. Children's Book Press, 1990.

Gauch, Patricia Lee. *This Time, Tempe Wick?* Putnam, 1992.

Gavin, Jamila. *Our Favorite Stories from around the World*. DK, 1997.

Geis, Jacqueline. *The First Ride: Blazing the Trail for the Pony Express*. Hambleton-Hill, 1994.

Gelman, Rita Golden. *More Spaghetti, I Say!* Scholastic, 1977.

George, Jean Craighead. *Dear Rebecca, Winter is Here*. HarperCollins, 1993.

Gerson, Mary-Joan. *Why the Sky is Far Away: A Nigerian Folktale*. Little Brown, 1992.

Ghazi, Suhaib Hamid. *Ramadan*. Holiday House, 1996.

Gibbons, Faye. *Mountain Wedding*. Morrow, 1996.

Gibbons, Gail. *Country Fair*. Little Brown, 1994.

———. *Dinosaurs*. Holiday, 1987.

———. *The Moon Book*. Holiday, 1997.

Giff, Patricia Reilly. *Today Was a Terrible Day*. Penguin, 1980.

Gilman, Phoebe. *Something from Nothing*. Scholastic, 1992.

Ginsburg, Mirra. *The Chinese Mirror*. Harcourt Brace Jovanovich, 1988.

———. *Clay Boy*. Greenwillow, 1997.

Glass, Andrew. *A Right Fine Life: Kit Carson on the Sante Fe Trail*. Holiday House, 1997.

Glassman, Peter. *My Working Mom*. Morrow, 1994.

Gliori, Debi. *Snow Lambs*. Scholastic, 1996.

Goble, Paul. *Buffalo Woman*. Bradbury, 1984.

———. *The Great Race of the Birds and Animals*. Bradbury, 1985.

———. *Her Seven Brothers*. Simon & Schuster, 1988.

———. *Iktomi and the Buffalo Skull*. Orchard, 1991.

———. *The Legend of the White Buffalo Woman*. National Geographic Society, 1998.

———. *The Lost Children: The Boys Who Were Neglected*. Bradbury, 1993.

———. *Star Boy*. Bradbury, 1983.

Golenbock, Peter. *Teammates.* Gulliver Books, 1990.

González, Lúcia M. *Señor Cat's Romance and Other Favorite Stories from Latin America.* Scholastic, 1997.

Good, Merle. *Reuben and the Fire.* Good Books, 1993.

Gordon, Ginger. *My Two Worlds.* Clarion, 1993.

Goss, Linda and Clay Goss. *It's Kwanzaa Time!* Putnam, 1995.

Gove, Doris. *My Mother Talks to Trees.* Peachtree, 1999.

Graham, Bob. *Benny: An Adventure Story.* Candlewick, 1999.

Graham, Georgia. *The Strongest Man This Side of Cremona.* Red Deer, 1998.

Gramatky, Hardie. *Little Toot.* Putnam, 1939.

Gray, Libba Moore. *Little Lil and the Swing-Singing Sax.* Simon & Schuster, 1996.

———. *Miss Tizzy.* Simon & Schuster, 1993.

———. *My Mama Had a Dancing Heart.* Orchard, 1995.

———. *When Uncle Took the Fiddle.* Orchard, 1999.

Greene, Ellin. *The Legend of the Cranberry: A Paleo-Indian Tale.* Simon & Schuster, 1993.

Greenfield, Eloise. *Nathaniel Talking.* Black Butterfly, 1988.

Gretz, Susanna and Alison Sage. *Teddy Bears Cure a Cold.* Four Winds, 1984.

Griffin, Judith Berry. *Phoebe and the General.* Coward, McCann & Geoghegan, 1977.

Griffith, Helen V. *Georgia Music.* Greenwillow, 1986.

———. *Grandaddy's Stars.* Greenwillow, 1995.

———. *"Mine Will," Said John.* Greenwillow, 1992.

Grimes, Nikki. *It's Raining Laughter.* Dial, 1997.

Grimm, Jacob and Wilhelm Grimm. *The Princess and the Frog.* Greenwillow, 1989.

———. *The Shoemaker and the Elves.* Charles Scribner's Sons, 1960.

Gross, Ruth Belov. *The Girl Who Wouldn't Get Married.* Four Winds, 1983.

Grossman, Bill. *Tommy at the Grocery Store.* Harper & Row, 1989.

Grosvenor, Donna K. *Wild Ponies of Assateague.* National Geographic Society, 1975.

Grove, Doris. *My Mother Talks to Trees.* Peachtree, 1999.

Grover, Eulalie Osgood. *Mother Goose.* Volland, 1915.

Grover, Max. *The Accidental Zucchini: An Unexpected Alphabet.* Browndeer, 1993.

Guiberson, Brenda Z. *Lobster Boat.* Henry Holt, 1993.

Haley, Gail E. *Jack Jouett's Ride.* Viking, 1973.

Hall, Donald. *Old Home Day.* Browndeer, 1996.

———. *Ox-Cart Man.* Viking, 1979.

Hall, Zoe. *Surprise Garden.* Scholastic, 1996.

Hamanaka, Sheila. *In the Wings of Peace: Writers and Illustrators Speak Out for Peace, in Memory of Hiroshima and Nagasaki.* Clarion, 1995.

Harness, Cheryl. *They're Off! The Story of the Pony Express.* Simon & Schuster, 1996.

Harris, Kathleen McKinley. *The Wonderful Hay Tumble.* Morrow, 1988.

Harrison, Joanna. *Dear Bear.* Carolrhoda, 1994.

Hassett, John and Ann Hassett. *Cat Up a Tree.* Houghton Mifflin, 1998.

Hearn, Emily. *Race You Franny.* Women's Press, 1986.

Heide, Florence Parry and Judith Heide Gilliland. *The Day of Ahmed's Secret.* Lothrop, Lee & Shepard, 1990.

Heine, Helme. *The Most Wonderful Egg in the World.* Macmillan, 1983.

Heller, Ruth. *Chickens Aren't the Only Ones.* Grosset & Dunlap, 1981.

Hendershot, Judith. *In Coal Country*. Dragonfly Books, 1992.

Henkes, Kevin. *Julius: The Baby of the World*. Greenwillow, 1990.

———. *Lilly's Purple Plastic Purse*. Greenwillow, 1996.

———. *Owen*. Greenwillow, 1993.

Henry, Marguerite. *Misty of Chincoteague*. Rand McNally, 1947.

Hest, Amy. *Baby Duck and the Bad Eyeglasses*. Candlewick, 1996.

———. *In the Rain with Baby Duck*. Candlewick, 1995.

———. *Jamaica Louise James*. Candlewick, 1996.

———. *Off to School, Baby Duck*. Candlewick, 1999.

Hickox, Rebecca. *The Golden Sandal: A Middle Eastern Cinderella*. Holiday House, 1998.

Ho, Minfong. *Hush!* Orchard, 1996.

Hobbie, Holly. *Toot & Puddle: You are My Sunshine*. Little Brown, 1999.

Hobson, Sally. *Chicken Little*. Simon & Schuster, 1994.

Hodges, Margaret. *Molly Limbo*. Atheneum, 1996.

———. *Saint George and the Dragon: A Golden Legend*. Little Brown, 1984.

Hoffman, Peggy and Selve Maas. *The Sea Wedding & Other Stories from Estonia*. Dillon, 1978.

Hooks, William H. *The Ballad of Belle Dorcas*. Alfred A. Knopf, 1990.

———. *The Mighty Santa Fe*. Macmillan, 1993.

Hopkins, Lee Bennett. *Blast Off! Poems about Space*. HarperCollins, 1995.

———. *Side by Side: Poems to Read Together*. Simon & Schuster, 1988.

Hopkinson, Deborah. *Sweet Clara and the Freedom Quilt*. Alfred A. Knopf, 1993.

Hopping, Lorraine Jean. *Blizzards!* Scholastic, 1998.

Hort, Lenny. *The Seals on the Bus*. Henry Holt, 2000.

Howard, Elizabeth Fitzgerald. *Aunt Flossie's Hats (and Crab Cakes Later)*. Clarion, 1991.

———. *Train to Lulu's*. Bradbury, 1988.

———. *Virgie Goes to School with Us Boys*. Simon & Schuster, 2000.

Howe, John. *Jack and the Beanstalk*. Little Brown, 1989.

Hoyt-Goldsmith, Diane. *Arctic Hunter*. Holiday, 1992.

———. *Buffalo Days*. Holiday House, 1997.

———. *Celebrating Kwanzaa*. Holiday House, 1993.

———. *Las Posadas: An Hispanic Christmas Celebration*. Holiday House, 1999.

———. *Pueblo Storyteller*. Holiday House, 1991.

Hru, Dakari. *Joshua's Masai Mask*. Lee & Low, 1993.

Huck, Charlotte. *Princess Furball*. Greenwillow, 1989.

Hudson, Wade. *Pass It On: African-American Poetry for Children*. Scholastic, 1993.

Hughes, Shirley. *Giving*. Candlewick, 1993.

Hume, Stephen Eaton. *Rainbow Bay*. Raincoast, 1997.

Hunt, Angela Elwell. *The Tale of the Three Trees: A Traditional Folktale*. Lion, 1989.

Hunt, Jonathon. *Leif's Saga: A Viking Tale*. Simon & Schuster, 1990.

Hunter, Anne. *Possum's Harvest Moon*. Houghton Mifflin, 1996.

Hurd, Thacher. *Blackberry Ramble*. Crown, 1989.

Hutchins, Pat. *Don't Forget the Bacon!* Greenwillow, 1976.

Hutton, Warwick. *Moses in the Bulrushes*. Aladdin, 1992.

Irving, Washington. *The Legend of Sleepy Hollow*. Bantam, 1995.

Isaacs, Anne. *Swamp Angel*. Dutton, 1994.

Isadora, Rachel. *Ben's Trumpet*. Greenwillow, 1979.

Isadora, Rachel. *Over the Green Hills*. Greenwillow, 1992.

Jacobs, Laurie A. *So Much in Common*. Boyds Mills, 1994.

James, Betsy. *Mary Ann*. Dutton, 1994.

James, Simon. *Days Like This: A Collection of Small Poems*. Candlewick, 1999.

———. *Dear Mr. Blueberry*. Margaret K. McElderry, 1991.

Jaquith, Priscilla. *Bo Rabbit Smart for True: Folktales from the Gullah*. Philomel, 1981.

Jeffers, Susan. *Mother Goose: If Wishes Were Horses and Other Rhymes*. Dutton, 1979.

Jenkins, Steve, et al. *The Bill of Rights and You*. West, 1990.

Jewell, Nancy. *Two Silly Trolls*. HarperCollins, 1992.

Johnson, Angela. *When I Am Old with You*. Orchard, 1990.

Johnson, Ann Donegan. *The Value of Creativity: The Story of Thomas Edison*. Value Communications, 1981.

Johnson, Crockett. *Will Spring Be Early or Will Spring Be Late?* Thomas Y. Crowell, 1959.

Johnson, Dolores. *What Kind of Baby-Sitter Is This?* Macmillan, 1991.

Johnson, Paul Brett. *The Cow Who Wouldn't Come Down*. Orchard, 1993.

Johnson, Paul Brett and Celeste Lewis. *Lost*. Orchard, 1996.

Johnson, Sylvia A. *A Beekeeper's Year*. Little Brown, 1994.

Johnston, Tony. *The Tale of Rabbit and Coyote*. Putnam, 1994.

———. *Yonder*. Dial, 1988

Jones, Hettie. *Longhouse Winter*. Holt, Rinehard & Winston, 1972.

Joosse, Barbara M. *Fourth of July*. Alfred A. Knopf, 1985.

———. *Lewis & Papa: Adventures on the Santa Fe Trail*. Chronicle, 1998.

———. *The Morning Chair*. Clarion, 1995.

Joseph, Lynn. *Coconut Kind of Day: Island Poems*. Lothrop, Lee & Shepard, 1990.

———. *An Island Christmas*. Clarion, 1992.

Joseph, Paul. *The Wright Brothers*. Abdo & Daughters, 1996.

Joyce, Susan. *Post Card Passages*. Peel, 1994.

Joyce, William. *Dinosaur Bob and His Adventures with the Family Lazardo*. HarperCollins, 1995.

Kaplan, Howard. *Waiting to Sing*. DK, 2000.

Karon, Jan. *Miss Fannie's Hat*. Augsburg, 1998.

Katz, Bobbi. *A Family Hanukkah*. Random House, 1992.

Keats, Ezra Jack. *Louie*. Greenwillow, 1975.

Keller, Holly. *Island Baby*. Scholastic, 1992.

Keller, Laurie. *The Scrambled States of America*. Henry Holt, 1998.

Kellogg, Steven. *Can I Keep Him?* Dial, 1971.

———. *Chicken Little*. Morrow, 1985.

———. *Johnny Appleseed: A Tall Tale*. Morrow, 1988.

———. *Paul Bunyan: A Tall Tale*. Morrow, 1984.

———. *Sally Ann Thunder Whirlwind Crockett: A Tall Tale*. Morrow, 1995.

Kendall, Russ. *Eskimo Boy: Life in an Inupiaq Eskimo Village*. Scholastic, 1991.

Kennedy, Dorothy M. *I Thought I'd Take My Rat to School: Poems for September to June*. Little Brown, 1993.

Kennedy, Richard. *The Leprechaun's Story*. Dutton, 1979.

Kennedy, X. J. and Dorothy M. Kennedy. *Knock at a Star: A Child's Introduction to Poetry*. Little Brown, 1982.

———. *Talking Like the Rain: A Read-to-Me Book of Poems*. Little Brown, 1992.

Kent, Jack. *The Christmas Piñata*. Parents' Magazine Press, 1975.

Kerby, Mona. *Amelia Earhart: Courage in the Sky*. Viking, 1990.

Kessler, Christina. *One Night: A Story from the Desert*. Philomel, 1995.

Ketteman, Helen. *I Remember Papa*. Dial, 1998.

Khalsa, Dayal Kaur. *My Family Vacation*. Clarkson N. Potter, 1988.

Kimmel, Eric A. *Boots and His Brothers: A Norwegian Tale*. Holiday House, 1992.

———. *The Gingerbread Man*. Holiday House, 1993.

———. *The Three Princes: A Tale from the Middle East*. Holiday House, 1994.

Kimmelman, Leslie. *Frannie's Fruits*. Harper & Row, 1989.

Kinsey-Warnock, Natalie. *The Bear That Heard Crying*. Cobblehill, 1993.

———. *The Summer of Stanley*. Cobblehill, 1997.

———. *When Spring Comes*. Dutton, 1993.

———. *The Wild Horses of Sweetbriar*. Cobblehill, 1990.

Kirby, David & Allen Woodman. *The Cows Are Going to Paris*. Caroline House, 1991.

Kiser, SuAnn. *The Catspring Somersault Flying One-Handed Flip-Flop*. Orchard, 1993.

Knight, Bertram T. *From Cow to Ice Cream: A Photo Essay*. Children's Press, 1997.

Knutson, Barbara. *Why the Crab Has No Head: An African Tale*. Carolrhoda, 1987.

Koller, Jackie French. *Nickommoh! A Thanksgiving Celebration*. Atheneum, 1999.

Kopper, Lisa. *Daisy Thinks She Is a Baby*. Alfred A. Knopf, 1994.

———. *I'm a Baby You're a Baby*. Viking, 1995.

Koralek, Jenny. *Hanukkah: The Festival of Lights*. Lothrop, Lee & Shepard, 1990.

Kovalski, Maryann. *Pizza for Breakfast*. Morrow, 1991.

———. *The Wheels on the Bus*. Joy Street , 1987.

Kraus, Robert. *Leo the Late Bloomer*. Windmill, 1971.

Kroeger, Mary Kay and Louise Borden. *Paperboy*. Clarion, 1996.

Kroll, Steven. *By the Dawn's Early Light: The Story of The Star-Spangled Banner*. Scholastic, 1994.

———. *The Hokey-Pokey Man*. Holiday House, 1989.

———. *It's Groundhog Day!* Holiday House, 1987.

———. *Lewis and Clark: Explorers of the American West*. Holiday House, 1994.

———. *Pony Express!* Scholastic, 1996.

Kroll, Virginia. *Faraway Drums*. Little Brown, 1998.

Krull, Kathleen. *A Kids' Guide to America's Bill of Rights: Curfews, Censorship, and the 100-Pound Giant*. Avon, 1999.

Kunhardt, Edith. *Honest Abe*. Greenwillow, 1993.

———. *I'm Going to Be a Police Officer*. Scholastic, 1995.

Kurokawa, Mitsuhiro. *Dinosaur Valley*. Chronicle, 1992.

Kurtz, Jane. *Fire on the Mountain*. Simon & Schuster, 1994.

———. *Miro in the Kingdom of the Sun*. Houghton Mifflin, 1996.

———. *Pulling the Lion's Tail*. Simon & Schuster, 1995.

Kurtz, Jane and Christopher Kurtz. *Only a Pigeon*. Simon & Schuster, 1997.

Lager, Claude. *A Tale of Two Rats*. Stewart, Tabori & Chang, 1991.

Lagerlöf, Selma. *The Changeling*. Alfred A. Knopf, 1992.

———. *The Legend of the Christmas Rose*. Holiday House, 1990.

Lang, Andrew. *The Blue Fairy Book*. David McKay, 1948.

LaPrise, Larry, et al. *The Hokey Pokey*. Simon & Schuster, 1997.

Laskowski, Jerzy. *Master of the Royal Cats*. Seabury, 1965.

Lasky, Kathryn. *The Librarian Who Measured the Earth.* Little Brown, 1994.

———. *Lunch Bunnies.* Little Brown, 1996.

———. *Marven of the Great North Woods.* Harcourt Brace, 1997.

Latimer, Jim. *James Bear's Pie.* Charles Scribner's Sons, 1992.

Lautre, Denize. *Running the Road to ABC.* Simon & Schuster, 1996.

Lawrence, Jacob. *Aesop's Fables.* University of Washington Press, 1997.

Le Tord, Bijou. *Peace on Earth.* Doubleday, 1992.

Leaf, Margaret. *The Eyes of the Dragon.* Lothrop, Lee & Shepard, 1987.

Leaf, Munro. *Noodle.* Scholastic, 1972.

Lear, Edward. *Of Pelicans and Pussycats: Poems and Limericks.* Dial, 1990.

———. *The Owl and the Pussycat.* Little Brown, 1969.

———. *The Owl and the Pussycat.* Putnam, 1991.

Lee, Huy Voun. *At the Beach.* Henry Holt, 1994.

Leedy, Loreen. *Tracks in the Sand.* Doubleday, 1993.

Leigh, Nila K. *Learning to Swim in Swaziland: A Child's-Eye View of a Southern African Country.* Scholastic, 1993.

Leighton, Maxinne Rhea. *An Ellis Island Christmas.* Viking, 1992.

Leine, Evan. *Not the Piano, Mrs. Medley!* Watts, 1991.

Lesser, Rika. *Hansel and Gretel.* Mead & Company, 1984.

Levine, Abby. *Gretchen Groundhog, It's Your Day!* Albert Whitman, 1998.

Levinson, Nancy Smiler. *Clara and the Bookwagon.* HarperCollins, 1988.

———. *Snowshoe Thompson.* HarperCollins, 1992.

Levy, Elizabeth. *Something Queer at the Library: A Mystery.* Delacorte, 1977.

Lewin, Ted. *Amazon Boy.* Simon & Schuster, 1993.

———. *Fair!* Lothrop, Lee & Shepard, 1997.

———. *The Reindeer People.* Macmillan, 1994.

———. *Sacred River.* Clarion, 1994.

———. *Tiger Trek.* Macmillan, 1990.

Lewis, Kim. *One Summer Day.* Candlewick, 1996.

Lewis, Richard. *In the Night, Still Dark.* Atheneum, 1988.

Lewis, Sharon. *Tiger!* Harper & Row, 1990.

Lexau, Joan M. *It All Began with a Drip, Drip, Drip. . . .* Dutton, 1973.

Lied, Kate. *Potato: A Tale from the Great Depression.* National Geographic Society, 1997.

Lies, Brian. *Hamlet and the Enormous Chinese Dragon Kite.* Houghton Mifflin, 1994.

Liestman, Vicki. *Columbus Day.* Carolrhoda, 1991.

Lillie, Patricia. *When the Rooster Crowed.* Greenwillow, 1991.

Lin, Grace. *The Ugly Vegetables.* Charlesbridge, 1999.

Lindbergh, Reeve. *The Circle of Days.* Candlewick, 1998.

———. *Johnny Appleseed.* Little Brown, 1990.

———. *North Country Spring.* Houghton Mifflin, 1997.

Lindgren, Astrid. *Christmas in the Stable.* Coward-McCann, 1962.

Lindgren, Astrid and Ilon Wikland. *Christmas in Noisy Village.* Viking, 1963.

Lindgren, Barbro. *The Wild Baby.* Greenwillow, 1981.

———. *The Wild Baby Goes to Sea.* Greenwillow, 1983.

Lines, Kathleen. *Lavender's Blue: A Book of Nursery Rhymes.* Oxford, 1954.

Lionni, Leo. *An Extraordinary Egg.* Alfred A. Knopf, 1994.

Little, Jean and Claire Mackay. *Bats about Baseball*. Viking, 1995.

Littlesugar, Amy. *Tree of Hope*. Philomel, 1999.

Lobel, Anita. *Alison's Zinnia*. Greenwillow, 1990.

Lobel, Arnold. *Frog and Toad Are Friends*. Harper & Row, 1970.

———. *Ming Lo Moves the Mountain*. Scholastic, 1982.

———. *The Rose in My Garden*. Greenwillow, 1984.

———. *A Treeful of Pigs*. Greenwillow, 1979.

Locker, Thomas. *Family Farm*. Dial, 1988.

London, Jonathan. *Ali: Child of the Desert*. Lothrop, Lee & Shepard, 1997.

———. *Hip Cat*. Chronicle, 1993.

———. *Hurricane!* Lothrop, Lee & Shepard, 1998.

London, Sara. *Firehorse Max*. HarperCollins, 1997.

Long, Sylvia. *Sylvia Long's Mother Goose*. Chronicle, 1999.

Longfellow, Henry Wadsworth. *Hiawatha*. Dutton, 1983.

———. *Hiawatha's Childhood.*. Farrar, Straus & Giroux, 1984.

———. *Paul Revere's Ride*. Dutton, 1990.

———. *Paul Revere's Ride*. Greenwillow, 1985.

———. *Paul Revere's Ride*. Thomas Y. Crowell, 1963.

Lopez, Loretta. *The Birthday Swap*. Lee & Low, 1997.

Lorbiecki, Marybeth. *Sister Anne's Hands*. Dial, 1998.

Lord, John Vernon, verses by Janet Burroway. *The Giant Jam Sandwich*. Houghton Mifflin, 1972.

Lottridge, Celia Barker. *Mother Goose: A Canadian Sampler*. Groundwood, 1994.

———. *Music for the Tsar of the Sea*. Groundwood, 1998.

———. *The Name of the Tree: A Bantu Folktale*. Margaret K. McElderry, 1989.

Lourie, Richard. *Soldier and Tsar in the Forest: A Russian Tale*. Farrar, Straus & Giroux, 1972.

Lowell, Susan. *The Bootmaker and the Elves*. Orchard, 1997.

———. *Little Red Cowboy Hat*. Henry Holt, 1997.

Luenn, Nancy. *Nessa's Fish*. Atheneum, 1990.

Luttrell, Ida. *Three Good Blankets*. Atheneum, 1990.

Lyon, George Ella. *Come a Tide*. Orchard, 1990.

———. *Dreamplace*. Orchard, 1993.

———. *One Lucky Girl*. DK, 2000.

———. *A Regular Rolling Noah*. Bradbury, 1986.

MacDonald, Margaret Read. *The Girl Who Wore Too Much: A Folktale from Thailand*. August House Little Folk, 1998.

———. *Tom Thumb*. Oryx, 1993.

MacMillan, Dianne M. *Diwali: Hindu Festival of Lights*. Enslow, 1997.

Maestro, Betsy. *Snow Day*. Scholastic, 1989.

Maestro, Betsy and Guilio Maestro. *Ferryboat*. Thomas Y. Crowell, 1986.

Mahy, Margaret. *Rattlebang Picnic*. Dial, 1994.

Manson, Christopher. *Two Travelers*. Henry Holt, 1990.

Mantinband, Gerda. *Three Clever Mice: Folktales*. Greenwillow, 1993.

Margolies, Barbara A. *Rehema's Journey: A Visit in Tanzania*. Scholastic, 1990.

Mark, Jan. *The Midas Touch*. Candlewick, 1999.

Marshall, Edward. *Space Case*. Dial, 1980.

Marshall, James. *Red Riding Hood*. Dial, 1987.

Martin, Bill, Jr. and John Archambault. *Barn Dance!* Henry Holt, 1986.

——. *Knots on a Counting Rope.* Henry Holt, 1987.

Martin, Charles E. *Sam Saves the Day.* Greenwillow, 1987.

Martin, Jacqueline Briggs. *Snowflake Bently.* Houghton Mifflin, 1998.

Martin, Rafe. *Foolish Rabbit's Big Mistake.* G. P. Putnam's Sons, 1985.

Martínez, Alejandro Cruz. *The Woman Who Outshone the Sun.* Scholastic, 1991.

Marzollo, Jean. *Happy Birthday, Martin Luther King.* Scholastic, 1993.

——. *Soccer Sam.* Random House, 1987.

Mathers, Petra. *Lottie's New Beach Towel.* Atheneum, 1998.

Matze, Clair Sidhom. *The Stars in My Geddoh's Sky.* Albert Whitman, 1999.

Mayers, Florence Cassen. *ABC, the Wild West.* Abrams, 1990.

Mazzola, Frank, Jr. *Counting Is for the Birds.* Charlesbridge, 1997.

McAllister, Angela. *The King Who Sneezed.* Morrow, 1988.

McCaughrean, Geraldine. *Saint George and the Dragon.* Doubleday, 1989.

McCloskey, Robert. *Blueberries for Sal.* Viking, 1948.

——. *Make Way for Ducklings.* Viking, 1941.

——. *One Morning in Maine.* Viking, 1952.

McCully, Emily Arnold. *Ballot Box Battle.* Random House, 1996.

——. *Beautiful Warrior: The Legend of the Nun's Kung Fu.* Scholastic, 1998.

——. *Mirette on the High Wire.* Putnam, 1992.

——. *Popcorn at the Palace.* Browndeer, 1997.

McDermott, Gerald. *Anansi the Spider: A Tale from the Ashanti.* Holt, 1972.

——. *Arrow to the Sun.* Viking, 1974.

——. *Musicians of the Sun.* Simon & Schuster, 1997.

McDonald, Megan. *The Potato Man.* Orchard, 1991.

McGivern, Justin. *Broccoli-Flavored Bubble Gum.* Raintree Steck-Vaughn, 1996.

McGugan, Jim. *Josepha: A Prairie Boy's Story.* Red Deer, 1994.

McKenzie, Ellen Kindt, *The Perfectly Orderly H-O-U-S-E.* Henry Holt, 1994.

McKissack, Patricia. *The Honest-to-Goodness Truth.* Atheneum, 2000.

——. *Mirandy and Brother Wind.* Alfred A. Knopf, 1988.

——. *Nettie Jo's Friends.* Knopf, 1989.

McKissack, Patricia and Frederick McKissack. *Christmas in the Big House, Christmas in the Quarters.* Scholastic, 1994.

——. *George Washington Carver: The Peanut Scientist.* Enslow, 1991.

McMillan, Bruce. *My Horse of the North.* Scholastic, 1997.

McMullan, Kate. *Hey, Pipsqueak!* HarperCollins, 1995.

McPhail, David. *Drawing Lessons from a Bear.* Little Brown, 2000.

——. *Edward and the Pirates.* Little Brown, 1997.

——. *Mole Music.* Henry Holt, 1999.

——. *Pig Pig and the Magic Photo Album.* Dutton, 1986.

——. *Pigs Aplenty, Pigs Galore!* Dutton, 1993.

——. *The Train.* Little Brown, 1977.

——. *Where Can an Elephant Hide?* Doubleday, 1979.

Meade, Holly. *John Willy and Freddy McGee.* Marshall Cavendish, 1998.

Meddaugh, Susan. *Hog-Eye.* Houghton Mifflin, 1995.

——. *Martha Speaks.* Houghton Mifflin, 1992.

Medearis, Angela Shelf. *Dancing with the Indians*. Holiday House, 1991.

———. *Rum-A-Tum-Tum*. Holiday House, 1997.

———. *The Singing Man: Adapted from a West African Folktale*. Holiday House, 1994.

———. *Too Much Talk*. Candlewick, 1995.

Melmed, Laura Krauss. *Little Oh*. Lothrop, Lee & Shepard, 1997.

———. *The Rainbabies*. Lothrop, Lee & Shepard, 1992.

Merriam, Eve. *Fighting Words*. Morrow, 1992.

Micucci, Charles. *The Life and Times of the Honeybee*. Ticknor & Fields, 1995.

Mike, Jan. *Juan Bobo and the Horse of Seven Colors: A Puerto Rican Legend*. Troll, 1995.

Miller, Debbie S. *A Caribou Journey*. Little Brown, 1994.

Millman, Isaac. *Moses Goes to a Concert*. Farrar, Straus & Giroux, 1998.

Milne, A. A. *The House at Pooh Corner: Stories of Winnie-the-Pooh*. Dutton, 1928.

———. *Winnie-the-Pooh*. Dutton, 1926.

Milord, Susan. *Tales Alive: Ten Multicultural Folktales with Activities*. Williamson, 1994.

Mitchell, Barbara. *A Pocketful of Goobers: A Story about George Washington Carver*. Carolrhoda, 1986.

Modarressi, Mitra. *Yard Sale*. DK, 2000.

Modesitt, Jeanne. *It's Hanukkah!* Holiday House, 1999.

Mollel, Tolowa M. *Big Boy*. Clarion, 1995.

———. *My Rows and Piles of Coins*. Clarion, 1999.

———. *A Promise to the Sun: An African Story*. Little Brown, 1992.

Montresor, Beni. *Little Red Riding Hood*. Doubleday, 1991.

Mora, Pat. *Tomás and the Library Lady*. Alfred A. Knopf. 1997.

Moroney, Lynn. *Elinda Who Danced in the Sky: An Estonian Folktale*. Children's Book Press, 1990.

Moser, Barry. *Fly! A Brief History of Flight Illustrated*. HarperCollins, 1993.

Most, Bernard. *There's an Ant in Anthony*. Mulberry, 1980.

Mott, Evelyn Clarke. *Dancing Rainbows: A Pueblo Boy's Story*. Cobblehill, 1996.

Mulvihill, Margaret. *Viking Longboats*. Gloucester, 1989.

Murphy, Jim. *The Call of the Wolves*. Scholastic, 1989.

———. *The Last Dinosaur*. Scholastic, 1988.

Murphy, Mary. *I Like It When*. Red Wagon Preschool Book, 1997.

Murphy, Stuart J. *A Fair Bear Share*. HarperCollins, 1998.

Murray, Peter. *Tornadoes*. Child's World, 1996.

———. *Volcanoes*. Child's World, 1995.

Myers, Walter Dean. *The Blues of Flats Brown*. Holiday House, 2000.

———. *How Mr. Monkey Saw the Whole World*. Doubleday, 1996.

Nagel, Karen Berman. *The Lunch Line*. Scholastic, 1996.

Neitzel, Shirley. *The House I'll Build for the Wrens*. Morrow, 1997.

Nelson, S. D. *Gift Horse: A Lakota Story*. Harry N. Abrams, 1999.

Noble, Trinka Hakes. *The Day Jimmy's Boa Ate the Wash*. Dial, 1980.

Nolan, Dennis. *Castle Builder*. Macmillan, 1987.

———. *Dinosaur Dream*. Macmillan, 1990.

Nolen, Jerdine. *Harvey Potter's Balloon Farm*. Lothrop, Lee & Shepard, 1993.

Novak, Matt. *Mouse TV*. Orchard, 1994.

Nunes, Susan Miho. *The Last Dragon*. Clarion, 1996.

Nygaard, Elizabeth. *Snake Alley Band*. Doubleday, 1998.

Oakley, Graham. *The Church Mouse*. Atheneum, 1972.

Oberman, Sheldon. *The Always Prayer Shawl*. Boyds Mill, 1994.

Oechsli, Kelly. *Mice at Bat*. HarperCollins, 1986.

Okimoto, Jean Davies. *Blumpoe the Grumpoe Meets Arnold the Cat*. Little Brown, 1989.

Olaleye, Isaac. *The Distant Talking Drum: Poems from Nigeria*. Boyds Mills, 1995.

Oneal, Zibby. *A Long Way to Go: A Story of Women's Right to Vote*. Penguin, 1992.

Opie, Iona. *My Very First Mother Goose*. Candlewick, 1996.

Opie, Iona and Peter Opie. *The Oxford Book of Children's Verse*. Oxford University, 1973.

Oppenheim, Shulamith Levey. *The Hundredth Name*. Boyds Mills, 1995.

Orgel, Doris. *The Spaghetti Party*. Bantam, 1995.

Ormerod, Jan. *The Story of Chicken Licken*. Morrow, 1986.

Ormondroyd, Edward. *Johnny Castleseed*. Houghton Mifflin, 1985.

Osborne, Mary Pope. *American Tall Tales*. Alfred A. Knopf, 1991.

Otten, Charlotte F. *January Rides the Wind: A Book of Months*. Lothrop, Lee & Shepard, 1997.

Otto, Carolyn. *Dinosaur Chase*. HarperCollins, 1991.

Oughton, Jerrie. *How the Stars Fell into the Sky: A Navajo Legend*. Houghton Mifflin, 1992.

Pak, Soyung. *Dear Juno*. Viking, 1999.

Palacios, Argentia. *A Christmas Surprise for Chabelita*. BridgeWater, 1993.

Parillo, Tony. *Michelangelo's Surprise*. Farrar, Straus & Giroux, 1998.

Parish, Peggy. *Play Ball, Amelia Bedelia*. HarperCollins, 1996.

Parker, Steve. *Galileo and the Universe*. HarperCollins, 1992.

Parnall, Peter. *Winter Barn*. Macmillan, 1986.

Patent, Dorothy Hinshaw. *West by Covered Wagon: Retracing the Pioneer Trails*. Walker, 1995.

Paterson, Heather. *Thanks for Thanksgiving*. Scholastic Canada, 1998.

Paterson, Katherine. *The Smallest Cow in the World*. HarperCollins, 1991.

———. *The Tale of the Mandarin Ducks*. Scholastic, 1990.

Paulsen, Gary. *Canoe Days*. Doubleday, 1999.

———. *Dogteam*. Delacorte, 1993.

Pawagi, Manjusha. *The Girl Who Hated Books*. Beyond Words Publishing, 1999.

Paxton, Tom. *Engelbert Joins the Circus*. Morrow, 1997.

———. *Engelbert the Elephant*. Morrow, 1990.

Pearson, Mary. *Pickles in My Soup*. Children's Press, 1999.

Peck, Jan. *The Giant Carrot*. Dial, 1998.

Peet, Bill. *Buford the Little Bighorn*. Houghton Mifflin, 1967.

———. *The Caboose Who Got Loose*. Houghton Mifflin, 1971.

Pellowski, Anne. *The Nine Crying Dolls: A Story from Poland*. Philomel, 1980.

Perrault, Charles. *Cinderella: Or, The Little Glass Slipper*. Scribner, 1954.

———. *The Little Red Riding Hood*. Henry Z. Walck, Inc., 1972.

Peterson, Esther Allen. *Penelope Gets Wheels*. Crown, 1982.

Pfister, Marcus. *Penguin Pete*. North-South Books, 1987.

Philip, Neil. *A New Treasury of Poetry*. Stewart, Tabori & Chang, 1990.

Pilkey, Dav. *The Hallo-Wiener*. Scholastic, 1995.

———. *The Paperboy*. Orchard, 1996.

———. *When Cats Dream*. Orchard, 1992.

Pinkney, Andrea Davis. *Duke Ellington*. Hyperion, 1997.

———. *Seven Candles for Kwanzaa*. Dial, 1993.

Pinkwater, Daniel M. *Pickle Creature*. Four Winds, 1979.

Pinkwater, Honest Dan'l. *Roger's Umbrella*. Dutton, 1982.

Pitcher, Caroline. *Mariana and the Merchild: A Folk Tale from Chile*. Eerdmans, 2000.

Pizer, Abigail. *It's a Perfect Day*. HarperTrophy, 1990.

Polacco, Patricia. *Chicken Sunday*. Philomel, 1992

———. *Just Plain Fancy*. Bantam, 1990.

———. *Pink and Say*. Philomel, 1994.

———. *Rechenka's Eggs*. Philomel, 1988.

———. *Thank You, Mr. Falker*. Philomel, 1998.

Politi, Leo. *Moy Moy*. Charles Scribner's Sons, 1960.

Pollock, Penny. *The Turkey Girl: A Zuni Cinderella*. Little Brown, 1996.

Pomeranc, Marion Hess. *The American Wei*. Albert Whitman, 1998.

Pomerantz, Charlotte. *The Chalk Doll*. Scholastic, 1989.

Potter, Beatrix. *The Tale of Jemima Puddle-Duck*. Frederick Warne & Co., 1908.

———. *The Tale of Mrs. Tittle-Mouse*. Frederick Warne & Co., 1910.

———. *The Tale of Peter Rabbit*. Frederick Warne & Co., 1902.

———. *The Tale of Squirrel Nutkin*. Frederick Warne & Co., 1903.

———. *The Tale of Tom Kitten*. Frederick Warne & Co., 1907.

Prelutsky, Jack. *The Beauty of the Beast: Poems from the Animal Kingdom*. Alfred A. Knopf, 1997.

———. *For Laughing Out Loud: Poems to Tickle Your Funnybone*. Alfred A. Knopf, 1991.

———. *Imagine That! Poems of Never-Was*. Alfred A. Knopf, 1998.

———. *The Random House Book of Poetry for Children: A Treasury of 572 Poems for Today's Child*. Random House, 1983.

Priceman, Marjorie. *Emeline at the Circus*. Alfred A. Knopf, 1999.

———. *How to Make an Apple Pie and See the World*. Alfred A. Knopf, 1994.

Priotta, Saviour. *Turtle Bay*. Farrar, Straus & Giroux, 1997.

Prose, Francine. *You Never Know: A Legend of the Lamed-Varniks*. Greenwillow, 1998.

Provensen, Alice and Martin Provenson. *The Glorious Flight: Across the Channel with Louis Blériot July 25, 1909*. Viking, 1983.

Rahaman, Vashanti. *Read for Me, Mama*. Boyds Mills, 1997.

Raimondo, Lois. *The Little Lama of Tibet*. Scholastic, 1994.

Rand, Gloria. *The Cabin Key*. Harcourt Brace, 1994.

Ransome, Arthur. *The Fool of the World and the Flying Ship: A Russian Tale*. Farrar, Straus & Giroux, 1968.

Rappaport, Doreen. *The New King*. Dial, 1995.

Raschka, Chris. *Mysterious Thelonious*. Orchard, 1997.

Raskin, Ellen. *Who, Said Sue, Said Whoo?* Atheneum, 1973.

Rathmann, Peggy. *Officer Buckle and Gloria*. Putnam, 1995..

———. *Ruby the Copycat*. Scholastic, 1991.

Rattigan, Jama Kim. *Dumpling Soup*. Little Brown, 1991.

Raven, Margot Theis. *Angels in the Dust*. Bridgewater, 1996.

Ray, Mary Lyn. *Pianna*. Harcourt Brace Jovanovich, 1994.

Rayner, Mary. *Garth Pig Steals the Show*. Dutton, 1993.

———. *Mrs. Pig Gets Cross and Other Stories*. Dutton, 1987.

Reddin, Valerie. *Dragon Kite of the Autumn Moon*. Lothrop, Lee & Shepard, 1991.

Reiser, Lynn. *The Surprise Family*. Greenwillow, 1994.

Rendon, Marcie R. *Powwow Summer: A Family Celebrates the Circle of Life*. Carolrhoda, 1996.

Rey, H. A. *Curious George Rides a Bike*. Houghton Mifflin, 1952.

———. *Pretzel*. Harper, 1944.

Reynolds, Jan. *Himalaya: Vanishing Cultures*. Harcourt Brace Jovanovich, 1991.

———. *Sahara*. Harcourt Brace Jovanovich, 1991.

Ringgold, Faith. *If a Bus Could Talk: The Story of Rosa Parks*. Simon & Schuster, 1999.

Robbins, Ken. *Make Me a Peanut Butter Sandwich and a Glass of Milk*. Scholastic, 1992.

Roberts, Tom. *Three Billy Goats Gruff*. Rabbit Ears Books, 1989.

Robins, Arthur. *The Teeny Tiny Woman: A Traditional Tale*. Candlewick, 1998.

Rochelle, Belinda. *Jewels*. Dutton, 1998.

Rockwell, Anne. *Befana*. Atheneum, 1974.

———. *The Dancing Stars: An Iroquois Legend*. Thomas Y. Crowell, 1972.

———. *Pumpkin Day, Pumpkin Night*. Walker, 1999.

———. *The Storm*. Hyperion, 1994.

Rohmann, Eric. *The Cinder-Eyed Cats*. Crown, 1997.

Rohmer, Harriet. *Uncle Nacho's Hat: A Folktale from Nicaragua/El Sombrero del Tío Nacho: Un Cento de Nicaragua*. Children's Book Press, 1990.

Rohmer, Harriet and Dorminster Wilson. *Mother Scorpion Country: A Legend from the Miskito Indians of Nicaragua/La tierra de la Madre Escorpion: Una Leyenda de los Indios Miskitos de Nicaragua*. Children's Book Press, 1987.

Roop, Connie and Peter Roop. *Buttons for General Washington*. Carolrhoda, 1986.

———. *Pilgrim Voices: First Year in the New World*. Walker, 1995.

———. *Stick Out Your Tongue! Jokes about Doctors and Patients*. Lerner, 1986.

Root, Phyllis. *What Baby Wants*. Candlewick, 1998.

Rose, Deborah Lee. *The People Who Hugged the Trees: An Environmental Folk Tale*. Roberts Rinehart, 1990.

Rosen, Michael J. *The Greatest Table: A Banquet to Fight Against Hunger*. Harcourt Brace, 1994.

Rosenberg, Liz. *Adelaide and the Night Train*. Harper & Row. 1989.

———. *Mama Goose: A New Mother Goose*. Philomel, 1994.

———. *Moonbathing*. Harcourt Brace Jovanovich, 1996.

Rosenberry, Vera. *Vera's First Day of School*. Henry Holt, 1999.

Rosenthal, Marilyn and Daniel Freeman. *Amelia Earhart: A Photo-Illustrated Biography*. Bridgestone Books, 1999.

Ross, Tony. *The Boy Who Cried Wolf*. Dial, 1985.

———. *Goldilocks and the Three Bears*. Macmillan, 1985.

Roth, Susan L. *The Biggest Frog in Australia*. Simon & Schuster, 1996.

Rounds, Glen. *Washday on Noah's Ark: A Story of Noah's Ark*. Holiday House, 1985.

Roy, Ron. *Three Ducks Went Wandering*. Clarion, 1979.

Rozakis, Laurie. *Matthew Henson and Robert Peary: The Race for the North Pole*. Blackbirch, 1994.

Ryan, Pam Munoz. *Amelia and Eleanor Go for a Ride*. Scholastic, 1999.

Rydberg, Viktor. *The Christmas Tomten*. Coward, McCann & Geoghegan, 1981.

Rylant, Cynthia. *Poppleton*. Blue Sky, 1997.

———. *Silver Packages: An Appalachian Christmas Story*. Orchard, 1997.

———. *When I Was Young in the Mountains*. Dutton, 1982.

San Souci, Robert D. *Brave Margaret: An Irish Adventure*. Simon & Schuster, 1999.

———. *Cendrillon: A Caribbean Cinderella*. Simon & Schuster, 1998.

San Souci, Robert D. *The Faithful Friend.* Simon & Schuster, 1995.

———. *The Hobyahs.* Doubleday, 1994.

———. *Pedro and the Monkey.* Morrow, 1996.

———. *The Samurai's Daughter.* Puffin, 1992.

———. *Sootface: An Ojibwa Cinderella Story.* Delacorte, 1994.

———. *Sukey and the Mermaid.* Four Winds, 1992.

———. *The Talking Eggs: A Folktale from the American South.* Dial, 1989.

———. *A Weave of Words.* Orchard, 1997.

Sandburg, Carl. *The Huckabuck Family and How They Raised Popcorn in Nebraska and Quit and Came Back.* Farrar, Strauss & Giroux, 1999.

Sanders, Scott Russell. *Meeting Trees.* National Geographic Society, 1996.

Sandin, Joan. *Pioneer Bear.* Random House, 1995.

Sanfield, Steve. *Strudel, Strudel, Strudel.* Orchard, 1995.

Santella, Andrew. *Jackie Robinson Breaks the Color Line.* Children's Press, 1996.

Say, Allen. *Emma's Rug.* Houghton Mifflin, 1996.

———. *Grandfather's Journey.* Houghton Mifflin, 1993.

Schertle, Alice. *The April Fool.* Lothrop, Lee & Shepard, 1981.

Schields, Gretchen. *The Water Shell.* Gulliver, 1995.

Schotter, Roni. *Nothing Ever Happens on 90th Street.* Orchard, 1997.

Schroeder, Alan. *Smoky Mountain Rose: An Appalachian Cinderella.* Dial, 1997.

Schuch, Steve. *A Symphony of Whale.* Harcourt Brace, 1999.

Schuett, Stacey. *Somewhere in the World Right Now.* Alfred A. Knopf, 1995.

Schwartz, Alvin. *All of Our Noses Are Here and Other Noodle Tales.* Harper & Row, 1985.

Scieszka, Jon and Lane Smith. *The Stinky Cheese Man and Other Fairly Stupid Tales.* Viking, 1992.

Scott, Ann Herbert. *Cowboy Country.* Clarion, 1993.

Seibert, Patricia. *Mush! Across Alaska in the World's Longest Sled-Dog Race.* Millbrook, 1992.

Service, Pamela F. *Wizard of Wind & Rock.* Atheneum, 1990.

Seuss, Dr. *And to Think That I Saw It on Mulberry Street.* Vanguard, 1937.

———. *Bartholomew and the Oobleck.* Random House, 1949.

———. *The Cat in the Hat.* Random House, 1957.

———. *The Eye Book.* Random House, 1968.

———. *The 500 Hats of Bartholomew Cubbins.* Vanguard, 1938.

———. *The Foot Book.* Random House, 1968.

———. *Fox in Socks.* Beginner Books, 1965.

———. *Green Eggs and Ham.* Beginner Books, 1960.

———. *Horton Hatches the Egg.* Random House, 1940.

———. *How the Grinch Stole Christmas.* Random House, 1957.

———. *If I Ran the Zoo.* Random House, 1950.

———. *McElligot's Pool.* Random House, 1947.

———. *On Beyond Zebra.* Random House, 1955.

Sewall, Marcia. *The Green Mist.* Houghton Mifflin, 1999.

Shannon, George. *Climbing Kansas Mountains.* Bradbury, 1993.

Sharmat, Majorie Weinman. *Nate the Great.* Coward, McCann, Geohegan, 1972.

Sharmat, Mitchell. *Gregory, the Terrible Eater.* Four Winds, 1980.

Shaw, Nancy. *Sheep in a Jeep.* Houghton Mifflin, 1986.

———. *Sheep in a Shop.* Houghton Mifflin, 1991.

Shea, Pegi Deitz. *The Whispering Cloth: A Refugee's Story*. Boyds Mills, 1995.

Shelby, Anne. *Homeplace*. Orchard, 1995.

Sheldon, Dyan. *The Whales' Song*. Dial, 1991.

Shepard, Aaron. *The Gifts of Wali Dad: A Tale of India and Pakistan*. Atheneum, 1995.

———. *Master Maid: A Tale of Norway*. Dial, 1997.

Shub, Elizabeth. *Seeing Is Believing*. Greenwillow, 1979.

Siebert, Diane. *Sierra*. HarperCollins, 1991.

Sierra, Judy. *Antarctic Antics: A Book of Penguin Poems*. Gulliver Books, 1998.

———. *The Dancing Pig*. Harcourt Brace, 1999.

———. *Tasty Baby Belly Buttons*. Alfred A. Knopf, 1999.

Silverman, Erica. *Raisel's Riddle*. Farrar, Straus & Giroux, 1999.

Simon, Francesca. *Spider School*. Dial, 1996.

Simon, Seymour. *Star Walk*. Morrow, 1995.

———. *Volcanoes*. Morrow, 1988.

Singer, Marilyn. *Chester the Out-of-Work Dog*. Henry Holt, 1992.

———. *Solomon Sneezes*. Harper, 1999.

Siracusa, Catherine. *Bingo, the Best Dog in the World*. HarperCollins, 1991.

———. *No Mail for Mitchell*. Random House, 1990.

Sis, Peter. *Follow the Dream: The Story of Christopher Columbus*. Alfred A. Knopf, 1991.

———. *Komodo!* Greenwillow, 1993.

———. *Starry Messenger: A Book Depicting the Life of a Famous Scientist, Mathematician, Astronomer, Philosopher, Physicist Galileo Galilei*. Farrar, Straus & Giroux, 1996.

———. *The Three Golden Keys*. Doubleday, 1994.

———. *Tibet through the Red Box*. Farrar, Straus & Giroux, 1998.

Sisulu, Elinor Batezat. *The Day Gogo Went to Vote: South Africa April 1994*. Little Brown, 1996.

Slate, Joseph. *Mrs. Bindergarten Gets Ready for Kindergarten*. Dutton, 1996.

Slobodkina, Esphyr. *Caps for Sale: A Tale of a Peddler, Some Monkeys, and Their Monkey Business*. Harper & Row, 1968.

Small, David. *George Washington's Cows*. Farrar, Straus & Giroux, 1994.

Smith, Barry. *The First Voyage of Christopher Columbus*. Viking, 1992.

Smith, Clara Lockhart. *Twenty-Six Rabbits Run Riot*. Little Brown, 1990.

Smith, Dennis. *The Little Fire Engine That Saved the City*. Doubleday, 1990.

Smith, Maggie. *My Grandma's Chair*. Lothrop, Lee & Shepard. 1992.

Smith, William Jay. *Ho for a Hat!* Little Brown, 1989.

———. *Laughing Time: Collection Nonsense*. Farrar, Straus & Giroux, 1990.

Smucker, Anna Egan. *No Star Nights*. Alfred A. Knopf, 1989.

Smucker, Barbara. *Selina and the Bear Paw Quilt*. Lester, 1995.

Snyder, Dianne. *The Boy of the Three-Year Nap*. Houghton Mifflin, 1988.

Sorensen, Henri. *New Hope*. Lothrop, Lee & Shepard, 1995.

Soto, Gary. *Snapshots from the Wedding*. Putnam, 1997.

———. *Too Many Tamales*. Putnam, 1993.

Speed, Toby. *Brave Potatoes*. Putnam, 2000.

Spencer, Eve. *A Flag for Our Country*. Raintree Steck-Vaugh, 1993.

Spier, Peter. *Bored—Nothing to Do!* Doubleday, 1978.

———. *People*. Doubleday, 1980.

———. *The Star-Spangled Banner*. Doubleday, 1973.

Sproule, Anna. *The Wright Brothers: The Birth of Modern Aviation*. Blackbirch, 1999.

Stadler, John. *Animal Café*. Simon & Schuster, 1980.

——. *The Cats of Mrs. Calamari*. Orchard, 1997.

——. *Hector the Accordion-Nosed Dog*. Bradbury, 1983.

——. *Hooray for Snail!* HarperCollins, 1984.

Stanley, Diane. *Fortune*. Morrow, 1990.

——. *The Gentleman and the Kitchen Maid*. Dial, 1994.

——. *Peter the Great*. Four Winds Press, 1986.

——. *Raising Sweetness: Sequel to Saving Sweetness*. Putnam, 1999.

——. *Roughing It on the Oregon Trail*. Joanna Cotler Books, 2000.

——. *Saving Sweetness*. Putnam, 1996.

Steig, William. *Brave Irene*. Farrar, Straus & Giroux, 1986.

——. *Doctor De Soto*. Farrar, Straus & Giroux, 1982.

——. *Farmer Palmer's Wagon Ride*. Farrar, Straus & Giroux, 1992.

——. *Roland, The Minstrel Pig*. Harper & Row, 1968.

——. *Sylvester and the Magic Pebble*. Windmill, 1969.

Stein, R. Conrad. *The Story of the Golden Spike*. Children's Press, 1978.

Steptoe, Javaka. *In Daddy's Arms I Am Tall: African Americans Celebrating Fathers*. Lee & Low, 1997.

Steptoe, John. *Creativity*. Clarion, 1997.

——. *Mufaro's Beautiful Daughters: An African Tale*. Lothrop, Lee & Shepard, 1987.

Stevens, Janet. *The Bremen Town Musicians*. Holiday House, 1992.

——. *Tops & Bottoms*. Harcourt Brace, 1995.

Stevenson, James. *"Could Be Worse!"* Greenwillow, 1977.

——. *July*. Greenwillow, 1990.

——. *Mud Flat Spring*. Greenwillow, 1999.

Stevenson, Robert Louis. *A Child's Garden of Verses*. Chronicle, 1989.

Stevenson, Sucie. *Do I Have to Take Violet?* Dodd, Mead & Company, 1987.

Stewart, Sarah. *The Gardener*. Farrar, Straus & Giroux, 1997.

Stock, Catherine. *Where Are You Going Manyoni?* Morrow, 1993.

Stott, Carole. *Moon Landing: The Race for the Moon*. DK, 1999.

Sturges, Philemon. *The Little Red Hen (Makes a Pizza)*. Dutton, 1999.

Stuve-Bodeen, Stephanie. *Elizabeti's Doll*. Lee & Low, 1998.

Summers, Kate. *Milly and Tilly: The Story of a Town Mouse and a Country Mouse*. Dutton, 1996.

Suteyev, Vladimir. *The Chick and the Duckling*. Translated by Mirra Ginsburg. Macmillan, 1972.

Swamp, Chief Jake. *Giving Thanks: Native American Good Morning Message*. Lee & Low, 1995.

Swentzell, Rina. *Children of Clay: A Family of Pueblo Potters*. Lerner, 1992.

Taback, Simms. *Joseph Had a Little Overcoat*. Viking, 1999.

Taber, Anthony. *The Boy Who Stopped Time*. Macmillan, 1993.

Taylor, C. J. *The Ghost and the Long Warrior: An Arapaho Legend*. Tundra, 1991.

Teague, Mark. *Pigsty*. Scholastic, 1994.

Terani, Hasan. *The Yellow Leaf*. Mage, 1994.

Testa, Fulvio. *Wolf's Favor*. Dial, 1986.

Tews, Susan. *The Gingerbread Doll*. Clarion, 1990.

Thaler, Mike. *Moonkey*. Harper & Row, 1981.

Thomas, Frances and Ross Collins. *What If?* Hyperion, 1998.

Thomas, Joyce Carol. *I Have Heard of a Land*. HarperCollins, 1998.

Tolstoy, Aleksei. *The Gigantic Turnip*. Barefoot Books, 1998.

Tompert, Ann. *Just a Little Bit*. Houghton Mifflin, 1993.

———. *Little Fox Goes to the End of the World*. Crown, 1976.

Toriseva, JoNelle. *Rodeo Day*. Simon & Schuster, 1994.

Torres, Leyla. *Saturday Sancocho*. Farrar, Straus & Giroux, 1995.

———. *Subway Sparrow*. Farrar, Straus & Giroux, 1993.

Trinca, Rod and Kerry Argent. *One Woolly Wombat*. Kane/Miller, 1985.

Trivizas, Eugene. *Three Little Wolves and the Big Bad Pig*, Margaret K. McElderry, 1993.

Trottier, Maxine. *The Tiny Kite of Eddie Wing*. Stoddart, 1995.

Tsuchiya, Yukio. *Faithful Elephants: A True Story of Animals, People, and War*. Houghton Mifflin, 1988.

Tucker, Kathy. *The Leprechaun in the Basement*. Albert Whitman, 1999.

Tudor, Tasha. *The Tasha Tudor Book of Fairy Tales*. Platt & Munk, 1961.

Tune, Suelyn Ching. *Maui and the Secret of Fire*. University of Hawaii Press, 1991.

Tunnell, Michael O. *Mailing May*. Greenwillow, 1997.

Turkle, Brinton. *The Adventures of Obadiah*. Viking, 1972.

———. *Thy Friend, Obadiah*. Viking, 1969.

Turska, Krystyna. *The Woodcutter's Duck*. Macmillan, 1972.

Uhlberg, Myron. *Flying Over Brooklyn*. Peachtree, 1999.

Untermeyer, Louis. *The Golden Treasury of Poetry*. Golden Press, 1959.

Van Allsburg, Chris. *The Alphabet Theater Proudly Presents the Z Was Zapped: A Play in Twenty-Six Acts Performed by the Caslon Players*. Houghton Mifflin, 1987.

———. *Jumanji*. Houghton Mifflin, 1981.

———. *Just a Dream*. Houghton Mifflin, 1990.

———. *The Mysteries of Harris Burdick*. Houghton Mifflin, 1984.

———. *Two Bad Ants*. Houghton Mifflin, 1988.

Van Laan, Nancy. *Buffalo Dance: A Blackfoot Legend*. Little Brown, 1993.

———. *People, People, Everywhere!* Alfred A. Knopf, 1992.

———. *So Say the Little Monkeys*. Atheneum, 1998.

Van Leeuwen, Jean. *Across the Wide Dark Sea: The Mayflower Journey*. Dial, 1995.

———. *A Fourth of July on the Plains*. Dial, 1997.

———. *Going West*. Dial, 1992.

Viorst, Judith. *Alexander and the Terrible, Horrible, No Good, Very Bad Day*. Atheneum, 1972.

Voigts, Joachim. *The Birds Beauty Contest*. Gamsberg, 1992.

Waddell, Martin. *Farmer Duck*. Candlewick, 1992.

———. *The Pig in the Pond*. Candlewick, 1992.

Wahl, Jan. *Doctor Rabbit's Foundling*. Random House, 1977.

———. *I Met a Dinosaur*. Harcourt Brace, 1997.

———. *Rabbits on Roller Skates!* Crown, 1986.

Waldman, Neil. *The Never-Ending Greenness*. Morrow, 1997.

Walker, Barbara K. and Ahmet E. Uysal. *New Patches for Old: A Turkish Folktale*. Parents' Magazine Press, 1974.

Walker, Paul Robert. *Big Men, Big Country: A Collection of American Tall Tales*. Harcourt Brace Jovanovich, 1993.

Walker, Sally M. *The 18 Penny Goose*. HarperCollins, 1998.

Wallace, Ian. *Morgan the Magnificent*. Margaret K. McElderry, 1987.

Wallace, Karen. *Scarlette Beane*. Dial, 1999.

Wallner, Alexandra. *Betsy Ross*. Holiday House, 1994.

Wangerin, Walter, Jr. *Peter's First Easter*. Zondervan, 1999.

Ward, Helen. *The Hare and the Tortoise: A Tale from Aesop*. Millbrook, 1999.

Ward, Lynd. *The Biggest Bear*. Houghton Mifflin, 1952.

Warner, Sunny. *The Magic Sewing Machine*. Houghton Mifflin, 1997.

Waters, Kate and Madeline Slovenzlow. *Lion Dancer: Ernie Wan's Chinese New Year*. Scholastic, 1990.

Watkins, Sherrin. *The Green Snake Ceremony: Mary Greyfeather Learns More about Her Native American Heritage*. Council Oak Books, 1995.

Weidt, Maryann. *Daddy Played Music for the Cows*. Lothrop, Lee & Shepard, 1995.

Weilerstein, Sadie Rose. *K'tonton's Yom Kippur Kitten*. Jewish Publication Society, 1995.

Weller, Frances Ward. *Matthew Wheelock's Wall*. Macmillan, 1992.

———. *Riptide*. Philomel, 1990.

Wells, Rosemary. *Bunny Cakes*. Dial, 1997.

———. *Edward in Deep Water*. Dial, 1995.

———. *The Language of the Doves*. Dial, 1996.

———. *Yoko*. Hyperion, 1998.

Weninger, Brigitte. *Will You Mind the Baby, Davy?* North-South Books, 1997.

Westcott, Nadine Bernard. *The Giant Vegetable Garden*. Little Brown, 1981.

———. *Never Take a Pig to Lunch and Other Poems about the Fun of Eating*. Orchard, 1994.

Wettasinghe, Sybil. *The Umbrella Thief*. Kane Miller, 1987.

White, Carolyn. *Whippity Stoorie*. Putnam, 1997.

Whittington, Mary K. *Winter's Child*. Atheneum, 1992.

Wildsmith, Brian. *The Easter Story*. Alfred A. Knopf, 1993.

———. *Joseph*. Eerdmans, 1997.

Williams, Jay. *The Surprising Things Maui Did*. Four Winds, 1979.

Williams, Vera B. *A Chair for My Mother*. Greenwillow, 1982.

———. *Cherries and Cherry Pits*. Greenwillow, 1986.

———. *"More More More" Said the Baby: 3 Love Stories*. Greenwillow, 1990.

———. *Music, Music for Everyone*. Greenwillow, 1984.

———. *Something Special for Me*. Greenwillow, 1983.

———. *Three Days on a River in a Red Canoe*. Greenwillow, 1981.

Williams, Vera B. and Jennifer Williams. *Stringbean's Trip to the Shining Sea*. Greenwillow, 1988.

Willis, Jeanne. *Earthlets As Explained by Professor Xargle*. Dutton, 1988.

Wilson, Sarah. *Three in a Balloon*. Scholastic, 1990.

Wilson-Kelly, Becky. *Mother Grumpy's Dog Biscuits: A True Tail*. Henry Holt, 1990.

Winter, Jeanette. *Follow the Drinking Gourd*. Dragonfly, 1988.

———. *Klara's New World*. Alfred A. Knopf, 1992.

Winthrop, Elizabeth. *Shoes*. Harper & Row, 1986.

Wisniewski, David. *Elfwyn's Saga*. Lothrop, Lee & Shepard, 1990.

———. *The Golem*. Clarion, 1996.

Wojciechowski, Susan. *The Christmas Miracle of Jonathan Toomey*. Candlewick, 1995.

Wolf, Jake. *Daddy, Could I Have an Elephant?* Greenwillow, 1996.

Wolff, Ashley. *The Bells of London*. Dodd, Mead & Company, 1985.

Wolkstein, Diane. *8,000 Stones: A Chinese Folktale*. Doubleday, 1972.

Wood, Audrey. *King Bidgood's in the Bathtub.* Harcourt Brace Jovanovich, 1985.

———. *The Napping House.* Harcourt Brace Jovanovich, 1984.

———. *Red Racer.* Simon & Schuster, 1996.

———. *Silly Sally.* Harcourt Brace, 1992.

Wright, Blanche Fisher. *The Real Mother Goose.* Rand McNally, 1916.

Yacowitz, Caryn. *Pumpkin Fiesta.* HarperCollins, 1998.

Yashima, Mitsu and Taro Yashima. *Plenty to Watch.* Viking, 1954.

Yashima, Taro. *Umbrella.* Viking, 1969.

Yee, Paul. *Ghost Train.* Douglas & McIntyre, 1996.

———. *Roses Sing on New Snow: A Delicious Tale.* Macmillan, 1991.

Yen, Clara. *Why Rat Comes First: A Story of the Chinese Zodiac.* Children's Book Press, 1991.

Yolen, Jane. *Bird Watch.* Philomel, 1990.

———. *Favorite Folktales from around the World.* Pantheon, 1986.

———. *Little Mouse & Elephant: A Tale from Turkey.* Simon & Schuster, 1996.

———. *Raising Yoder's Barn.* Little Brown, 1998.

———. *Tam Lin: An Old Ballad.* Harcourt Brace Jovanovich, 1990.

Yorinks, Arthur. *Company's Coming.* Crown, 1988.

———. *Hey Al.* Farrar, Straus & Giroux, 1986.

———. *Louis the Fish.* Farrar, Straus & Giroux, 1980.

Young, Robert. *The Transcontinental Railroad: America at Its Best?* Silver Burdett, 1996.

Zadrzynska, Ewa. *The Girl with a Watering Can.* Chameleon Books, 1990.

Zalben, Jane Breskin. *Papa's Latkes.* Holt, 1994.

Zemach, Kaethe. *The Character in the Book.* HarperCollins, 1998.

Ziefert, Harriet. *So Hungry!* Random House, 1987.

Zimmermann, H. Werner. *Henny Penny.* Scholastic, 1989.

Zion, Gene. *No Roses for Harry.* Harper, 1958.

———. *The Summer Snowman.* Harper, 1955.

Index

About the Author

Elizabeth A. Raum received her B.S. from the University of Vermont, her M.L.S. from Rutgers, the State University of New Jersey, and her M.A. from Montclair State University. She is currently the library director at Concordia College in Moorhead, Minnesota. Prior to becoming library director, she served as curriculum center librarian at the college where she selected and managed a collection of high-quality children's literature and teaching resources. She also worked with the college's pre-service teachers as they found ways to use literature in the elementary school classroom. She has worked as an elementary school media specialist in New Jersey and North Dakota and has published articles for professional educators, as well as stories for children. Ms. Raum and her husband live in Fargo, North Dakota.